Joshua Reynolds

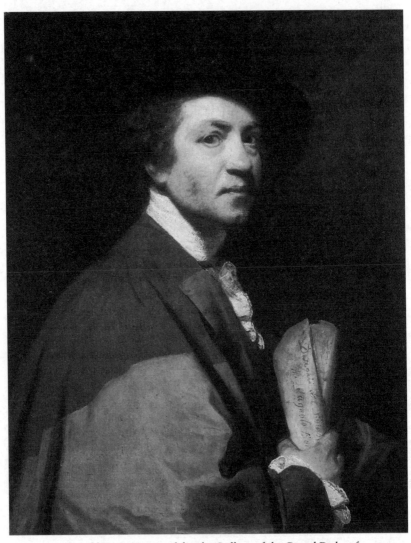

The self-portrait painted for the Gallery of the Grand Duke of Tuscany – now the Uffizi – in 1775. The Gallery's Director, Giuseppe Pelli, told Reynolds that it displayed 'all the beauties of Rembrandt's manner carried to perfection'. His former pupil Northcote, who saw the picture in Florence three years later, was less flattering: it looked, he told his brother, 'as if it was painted with his fingers'.

IAN McINTYRE

Joshua Reynolds

The Life and Times of the
First President of the Royal Academy

ALLEN LANE
an imprint of
PENGUIN BOOKS

ALLEN LANE
THE PENGUIN PRESS

Published by the Penguin Group
Penguin Books Ltd, 80 Strand, London WC2R ORL, England
Penguin Putnam Inc., 375 Hudson Street, New York, New York 10014, USA
Penguin Books Australia Ltd, 250 Camberwell Road, Camberwell, Victoria 3124, Australia
Penguin Books Canada Ltd, 10 Alcorn Avenue, Toronto, Ontario, Canada M4V 3B2
Penguin Books India (P) Ltd, 11, Community Centre, Panchsheel Park, New Delhi – 110 017, India
Penguin Books (NZ) Ltd, Cnr Rosedale and Airborne Roads, Albany, Auckland, New Zealand
Penguin Books (South Africa) (Pty) Ltd, 24 Sturdee Avenue, Rosebank 2196, South Africa

Penguin Books Ltd, Registered Offices: 80 Strand, London WC2R ORL, England

www.penguin.com

First published 2003
1

Set in 9.75/13 pt PostScript Linotype Sabon
Typeset by Rowland Phototypesetting Ltd, Bury St Edmunds, Suffolk
Printed and bound in Great Britain by Clays Ltd, St Ives plc

ISBN 0-713-99329-4

*For Andrew, Neil, Anne and Katie
with love and gratitude*

Contents

List of Plates and Illustrations

List of Colour Plates

List of Illustrations

Preface

Narcissism does not occupy a prominent place in the catalogue of English vices, and yet over several centuries, aristocratic patrons of painting commissioned little other than portraits of themselves and their forebears – not a few of the latter figments of wishful ancestral imaginings. In the spring of 1603, on his progress south from Scotland through his new kingdom, James I and VI slept at Lumley Castle, the seat of a courtier who had assembled a notable collection of portraits. He was received in Lord Lumley's absence by the dean of Durham, who claimed kinship with the family and embarked on what promised to be a lengthy account of its antiquity. James, never the most patient of men, found him tedious: 'Oh, mon, gang nae further; let me digest the knowledge I have gained, for I didna ken Adam's name was Lumley.'

Portraits served more public purposes than ancestor-worship, however. They could play a part in the long-distance arrangement of a royal marriage (Henry VIII twice dispatched Holbein to foreign courts to bring back a likeness of possible wives – in 1538 he was at Brussels to paint Christina of Denmark, and the following year at Düren to paint Anne of Cleves). Thomas More, who commissioned portraits of himself and his family from the same artist, wanted 'the images of notable men' to be set up in the market-places of his Utopia 'for the perpetual memory of their good acts; and also that the glory and renown of the ancestors may stir and provoke their posterity to virtue'. Later the portrait would be put to commercial use – the actor-manager David Garrick, for instance, a contemporary of Reynolds, was quick to exploit the possibilities it offered for self-advertisement.

Holbein, Van Dyck, Lely, Kneller – until well into the eighteenth century English portraiture was dominated by foreign painters. Lely's family was Dutch, though he was born in Westphalia. He had come to England in the 1640s and lived in great style in Covent Garden: 'a mighty proud man, and full of state', in Pepys's opinion, but he took a level-headed view of the enormous success he enjoyed. 'For God's sake, Sir Peter,' one of his patrons exclaimed, 'how came you to have so great a reputation? You know that I

know you are no painter.' 'My Lord, I know I am not,' came the reply, 'but I am the best you have.' He was unduly modest. His draughtsmanship approached that of Van Dyck, and his painting of the texture of satins and silks was masterly. 'In the power of rendering the sleepy voluptuousness which was fashionable at the court of Charles II,' wrote Ellis Waterhouse, 'he was unrivalled.'

Kneller had originally been intended for the army. Born Gottfried Kniller in Lübeck, where his father was the city's chief surveyor, he came to London in 1676 and quickly found employment at court. Knighted in 1692 and later advanced to a baronetcy, he remained, until his death in 1723, the outstanding exponent of the English baroque portrait. He worked rapidly, and was noted for expressive brushwork and his skill in achieving a good likeness. Like Lely, he ran a highly efficient – and lucrative – studio operation. This led in time to a more stylized approach and a decline in the quality of his later work. 'Where he offered one portrait to fame,' wrote Horace Walpole, 'he sacrificed twenty to lucre.'

The year of Kneller's death saw the birth of the subject of this biography. When Joshua Reynolds first took up his brush in the sunny middle years of the century, Canaletto and Tiepolo were still at work in Italy and Chardin and Fragonard in France. By the time his eyesight began to fail in 1789, the wider world was also becoming a darker and more troubled place. Europe would soon be engulfed in the Revolutionary Wars; in Paris, Jacques-Louis David would shortly abandon the neoclassicism of the Old Regime and direct his talents to the propagandist needs of the Jacobin cause.

The last quarter of a century has seen a revival of interest in the life and work of the first President of the Royal Academy. The initial impetus came from the splendid Reynolds exhibition which was seen at the Grand Palais in Paris and at Burlington House, the home of the Academy, in 1986. The catalogue of that exhibition, edited by Nicholas Penny, was a stimulating addition to Reynolds scholarship, and since then our knowledge has been further increased, most notably by Richard Wendorf, Martin Postle, Harry Mount and David Mannings. The last biography of Reynolds to appear, however, was that by Derek Hudson, in 1958.

My greatest debt in writing this new *Life* has been to David Mannings of the University of Aberdeen. His outstanding two-volume catalogue of Reynolds's paintings appeared in 2000, but he generously allowed me access to the text before publication and gave me the benefit of his unparalleled knowledge of Reynolds on many subsequent occasions. I am deeply grateful to him. I also record my indebtedness to Brian Allen, director of studies of the Paul Mellon Centre for the Study of British Art. He too gave me much wise advice, and permitted me to make use of the Centre's research facilities.

His kindness, and the unfailing helpfulness of his staff, greatly lightened my task.

I made frequent use of the resources of the London Library and the National Art Library at the Victoria & Albert Museum, and also of GroveArt, the online edition of the Macmillan *Dictionary of Art*, with its fully searchable text and many thousands of image links.

Mark Pomeroy, the Royal Academy's Archivist, guided me skilfully through the fascinating Reynolds holdings in the Library at Burlington House, and I thank him most warmly. David H. Solkin, of the Courtauld Institute, allowed me to tap into his unparalleled knowledge of how the Academy's exhibitions were organized at Somerset House after 1780. Maggie Hawes, of the Bank of England Information Centre, helped me to an understanding of foreign exchange rates in the eighteenth century; Tracey Earl, the Archivist of Coutts & Co., gave me assistance in the matter of Reynolds's banking arrangements and provided a transcript of the account which he opened at Coutts in June 1785 and which ran to his death. Kirit Patel gave me valuable ophthalmic advice relating to Reynolds's deteriorating eyesight; Fiona Hills undertook a difficult photographic assignment to make it possible to include a particularly important illustration. I am also most grateful to Richard Aylmer, who kindly kept me supplied with copies of his *Reynolds Newsletter*, a forum for the exchange of information about the descendants of Reynolds's parents.

The manuscript was delivered later than it should have been, and I appreciated the forbearance of my publisher, Stuart Proffitt. His Editorial Assistant, Liz Friend-Smith, was an unfailing source of help, and there are many others at 80 Strand to whom I had reason to be grateful both during the writing of the book and after it went into production: Richard Duguid, the Allen Lane Editorial Manager; David Ruddell, Pearson Technology's Senior Mac Analyst; Cecilia Mackay, the Penguin Press Picture Editor; Helen Eka, Production Controller and Louise Willder, Senior Copywriter responsible for cover blurbs. The Text Designer was David Pearson, and the cover the work of Antonio Colaco.

I am grateful to Hazel Bell, who compiled the index, and full of admiration for the calm and knowledgeable way in which Bela Cunha buckled down to the task of copy-editing. She must have worked on more orderly manuscripts in her time, but was much too polite to say so.

My wife once more patiently read each chapter as it was written, had many perceptive things to say about content and style and helped me in more ways than she can know. The book is dedicated to our sons and daughters.

I

Roots

Joshua. The name is rich in scriptural resonance – the Israelites passing over Jordan on dry ground, the pitching of the twelve stones in Gilgal, the covenant of the harlot Rahab, the walls of Jericho tumbling at the blast of the ram's horn.

The painter's first biographer, Edmond Malone, says that Reynolds's father thought an unusual Christian name might in later life recommend his son to 'the attention and kindness' of a benefactor of the same name. Malone had the story from Thomas Percy, Bishop of Dromore for almost thirty years, though better known for his *Reliques of English Poetry*. His Lordship, however, as bishops have been known to do, was talking nonsense. The Reverend Samuel Reynolds was much too unworldly ever to entertain such mercenary calculations. Joshua, what's more, was a Reynolds family name, borne in turn by the infant's great-grandfather in the previous century and by an uncle who was one of his godparents. Nobody noticed at the time, but either the parson or the parish clerk got the child's name wrong. On the day of his baptism in July 1723 he was entered in the register as Joseph, an error that remained uncorrected in his lifetime.

This was in the small town of Plympton, in south Devon. 'Immemorial, provincial England' was how one historian described the county – 'stable, rooted deep in the soil, unmoving, contented, and sane'.[1] To trace those roots is to journey back into British prehistory – to the palaeolithic caves at Torquay, to Bronze Age monuments on Dartmoor, to Iron Age hill-forts such as Hembury, whose occupants had affinities with the neolithic culture of northern France.

The Romans did not penetrate further west than Exeter, which they established in the reign of Nero. By the early years of the fifth century they were gone, and for the next 300 years the Celtic kingdom of Dumnonia was left to its own devices. Sizeable numbers of native Britons crossed the Channel to Armorica, giving it the name of Brittany. French historians usually describe these emigrants as refugees from the invading Saxons, but such documentary evidence as there is suggests that in overrunning Devon,

the Saxons did not meet a great deal of resistance. The Celtic population was sparse and there was plenty of land to go round. Colonization may be a better word than conquest.

Then the Danes came. The *Anglo-Saxon Chronicle* records that on their first foray to the west, in 851, they were seen off after a bloody battle at Wicganbeorg – probably near Tor Bay. Undeterred, they returned repeatedly, burning and pillaging, but never to settle. In 1016, with the rest of Wessex, Devon passed briefly under the rule of Knut, but fifty years later the links with Scandinavia were destroyed by the Norman Conquest.

It was several years before William could consolidate his victory at Hastings. In 1068 Exeter rose against the invader and surrendered only after an eighteen-day siege. William buttressed his position by distributing estates to his followers. Early in the twelfth century the honour of Plympton was bestowed on Richard de Redvers, and close to the castle he built there, on the southern fringe of Dartmoor, there grew up a small community of farmers and traders.

From the middle of that century rich deposits of tin-ore had been worked on the moor, and for a generation or two Devon was Europe's richest source of the metal. There was something of a tin-rush, and enterprising landowners planted settlements at strategic points; boroughs were created at Tavistock, Ashburton and Plympton. Later, all three became stannary towns – centres where tin was brought to be weighed and stamped – and by the early sixteenth century, the Devon tin trade had attracted a range of investors from all ranks of society. The coinage roll of 1523 shows that the Earl of Devon had three hundredweight of his coined at Plympton. Thereafter production declined. By the time Joshua Reynolds was growing up in the town the trade was virtually dead.

The Devon miners had independent courts for the regulation of their affairs, and a grim prison was built at Lydford to house offenders against the elaborate code of stannary laws. Richard Strode, who represented Plympton in the Parliament of 1512, unwisely introduced a bill at Westminster to limit mining operations near the seaports, which were being choked with mine refuse. He was hauled before all four stannary courts,* convicted of conduct subversive of the tinners' liberties and spent some weeks in 'a dungeon and deep pitte under the grounde in the Castell of Lidforde'.

There had been a religious house at Plympton before the Conquest, with extensive holdings of land in the locality, but in 1121, when the dean and

* The fourth stannary town was Chagford, which covered the north-eastern quarter of the moor.

four canons 'wold not leve their concubines',* it was suppressed by Bishop Warelwast, nephew of the Conqueror. In its place he established what later became the great Augustinian Priory of the Blessed Mary and SS. Peter and Paul. By the time of the Dissolution, in the late 1530s, it had become one of the two wealthiest houses in the west, although apart from the prior, it had only eighteen monks.†

From the middle of the fourteenth century Devon was badly hit by successive epidemics of the Black Death. The tin trade came to a complete halt; the Exeter episcopal registers show that in the first visitation of the plague, between 1349 and 1351, mortality among the Devon clergy reached 49 per cent; fragmentary poll-tax receipts for the year 1377 suggest that the population of Plympton had shrunk to 360, little more than it had been 300 years previously.

Plympton was one of only four Devon boroughs that had an unbroken parliamentary history since the so-called 'Model Parliament' of 1295. Plymouth did not regularly return a member until 1442, something which Plymptonians liked to crow about in a rustic doggerel couplet:

> Plympton was a borough Town
> When Plymouth was a vuzzy down.

It is not certain how concerned the inhabitants of the 'vuzzy down' were by this. Westminster was the best part of 200 miles away over largely non-existent roads. Until the fifteenth century membership of the Commons was seen more as a penance than a distinction. There was no passenger coach service into Devon until 1658, and the journey from Exeter to London took four days.

In the Civil War Devonian sympathies were on the whole more parliamentarian than royalist. During the siege of Plymouth, between 1642 and 1646, Plympton was occupied from time to time by royalist troops. Prince Maurice had five regiments of horse and nine of foot stationed there in 1643, but on hearing of the advance of Sir Thomas Fairfax the royalist force abandoned its defences and retreated across the county boundary into Cornwall.

Richard Strode's unfortunate experiences with the tinners did not deflect

* The phrase is John Leland's. Chaplain and librarian to Henry VIII, Leland (1506?–52) was the earliest of modern British antiquaries. In the 1530s and 1540s he made an extended tour through England and Wales, but his projected great work, *The History and Antiquities of this Nation*, never materialized. He was declared insane in 1550, and died two years later without recovering his reason.

† The largest house, with an abbot and twenty monks, was Tavistock. Once the priory at Plympton fell into disuse, it was extensively quarried by the townspeople for the building of new houses.

his descendants from the family tradition of service at Westminster. From 1601 to 1625 Plympton was represented by Sir William Strode. A strong Calvinist, he became the friend of Drake and Raleigh and commanded the local stannary regiment during the Armada campaign of 1588.

He was followed, in the troubled times of the Civil War, by his second son. This William Strode quickly established a reputation as a Puritan firebrand and was one of Charles I's most implacable enemies – Clarendon termed him 'one of those Ephori who most avowed the curbing and suppressing of majesty'.[2] Arraigned before the Star Chamber in 1629, he refused to recognize its jurisdiction and spent the next eleven years in the Tower. He was one of the managers of Strafford's impeachment, and tried to deprive him of counsel; he told the Lords that if they did not agree to the execution of Laud he would set the London mob on them.

The Treby family was also prominent in Plympton affairs. George Treby was elected to the Commons in 1677. He demonstrated his zeal for the Protestant cause as chairman of the committee of secrecy that investigated the 'Popish Plot'; as Recorder of London in 1688 he led the procession of city magnates which went out to meet William of Orange and delivered a fulsome speech of welcome. His whiggery and protestantism were rapidly rewarded. He was appointed Solicitor-General in 1689 and Attorney-General two months later, in which capacity he piloted through the Commons the Bill of Rights; three years later he was made Lord Chief Justice. He was eulogized ('Steady temper, condescending mind, / Indulgent to distress, to merit kind') by Nahum Tate, the none-too-distinguished poet laureate of the day, who, as the *Dictionary of National Biography* puts it, 'had probably tasted of his bounty'.*

Treby was four times married, and the son of his third wife also became the Member for Plympton, later serving as Secretary at War and Teller of the Exchequer. It was this George Treby who carried to completion his father's plans for the building of Plympton House. The mansion, with its lovely Queen Anne façade, was built of Portland stone and brick. There was good clay locally, and some of the bricks were made on site; an entry in the accounts shows that one John Newick was paid the sum of £44 2s 'for making 61883 bricks att 14s per thousand'.

Close by, on a fine site overlooking the estuary of the Plym, stood Saltram House. In the reign of Charles I it had been the seat of Buckingham's agent, Sir James Bagge – 'bottomless bagge' as the patriot Eliot called him. Then, in 1712, it had been bought by the Parker family, and it was they who

* Plympton had not been represented exclusively by members of well-known West Country families. One of the two burgesses returned to the first Parliament of James II in 1685 was Sir Christopher Wren.

transformed the Tudor fabric into a substantial mansion of the time of George II. John Parker, three years younger than Joshua Reynolds, was a great lover of pictures. Thrown together in boyhood, the two would be lifelong friends.

Ellis Waterhouse – a shade sniffily – wrote that the Reynolds family 'might be considered to have retained a place on the fringe of the lesser gentry'.[3] It would be more precise to say that the family tradition was clerical and academic. Samuel Reynolds's father had been vicar of St Thomas's, Exeter, and a prebendary of Exeter Cathedral; the brother who stood godfather to Joshua was a Fellow and bursar of Corpus Christi College, Oxford, and rector of Stoke Charity in Hampshire.* A half-brother, John, was a canon of St Peter's, Exeter, and for many years master of the grammar school there. He was later elected a Fellow of Eton and of King's College, Cambridge; his scholarly works included a study of the census taken before the birth of Christ, and he prospered sufficiently to endow six exhibitions at Exeter College, Oxford.†

It was at that college that Samuel himself matriculated in 1698. He was subsequently a scholar of Corpus, and in 1705 was elected chaplain-fellow of Balliol. His circle of friends at Oxford included Edward Young, later celebrated as the author of *Night Thoughts*, and the literary impostor George Psalmanazar, who had contrived to be sent to the home of lost causes to instruct prospective missionaries in 'Formosan', a language of his own invention.‡

Samuel Reynolds's years at Oxford were ended by his marriage in 1711. His bride was Theophila Potter, and she too was of Devon stock. Her great-grandfather on her father's side had been rector of Newton St Petrock and her grandfather an apothecary in Great Torrington; her maternal grandfather, the Reverend Thomas Baker, vicar of Bishop's Nympton, South Molton, devoted himself to mathematical studies and published in 1684 a treatise on the solution of biquadratic equations by a geometrical construction. Her father, Humphrey Potter, was rector of Nymet Rowland and curate-in-charge of Lostwithiel, and it was there that she was born in 1688.

Theophila Reynolds is a dimly lit figure. 'All that I have been able to learn

* He seems to have taken his duties as godfather seriously, and left his nephew £330 in his will. (Reynolds mentioned the bequest in a letter to John Palmer dated 27 October 1769 which is now in the Hyde Collection.)

† John Reynolds died in 1757 and was buried in King's College Chapel. Eton College possesses a portrait of him by his nephew, thought to have been painted shortly before his death.

‡ Psalmanazar – his real name was unknown – was a native of the south of France and was educated at a Dominican convent. He had come to England in 1703 and successfully bamboozled a large number of senior churchmen, partly by his abuse of the Jesuits. Rather more surprisingly, he took in Samuel Johnson, who used to go and sit with him at an alehouse in the city.

of her character,' wrote one of her son's Victorian biographers, 'is by incidental remarks found in letters, from which it appears she had her full share of intellect.'[4] She also had her full share of travail and sorrow. She was married when she was twenty-three, and over the next twenty years bore her husband eleven children, five of whom did not survive infancy. We know next to nothing from Joshua Reynolds's correspondence or writings of his family, but in an early commonplace book there are some details which he must have copied from the family Bible:

> 1718, Mar. 3. – Munday, betwixt one and two in the morning (almost 2), my mother was brought to bed of a daughter.
>
> Mar. 9. – She was baptiz'd by the name of Ann.
>
> 1720, April 7. – Saturday, a quarter before 9 in the morning, my sister Ann died.
>
> 1725, Aug 14. – Saturday morning, just after the Clock had struck 9, my mother was brought to bed of a Daughter (Theophila).
>
> 1726, Nov. 8. – Tuesday morning, about 7 o'clock, Offy fell out of the window, and died between 6 and 7 at night.

He records his own birth – on 16 July 1723 – in the same economical style, and provides laconic bulletins on various childhood illnesses:

> 1733, Jan 4. – I was ill of the measles. This day the measles came out; I went to bed.
>
> Jan 7. – I was in a manner Well.
>
> Jan 11. – I took Physick.

The following year, as he approached his eleventh birthday, he fell victim to smallpox:

> 1734, Mar. 10 – Munday, the 6th day of the Distemper, nothing amiss in my Regimen hitherto. I had a blister at 4 this morning.
>
> Mar. 11. – Tuesday, the 7th day, perhaps the 8th, seems to have been the worst day: then most outragious.
>
> Mar. 12. – Wednesday, the 8th day, extremely low.
>
> Mar. 13. – Thursday, the 9th day, being low, and somewhat hungry, I had broth at night, tho' contrary to Mr. Ruport's express order.
>
> Mar. 14. – Friday, the 10th day, having slept well, I was brave.
>
> Mar. 15. – Saturday, the 11th, rather the 12th day, taken out of bed.
>
> Mar. 16. – Sunday, the 13th day, I sat up.
>
> Mar. 17. – I ventured down stairs.
>
> Mar. 18. – I staid down a long time.

As the seventh child, Reynolds was well down the family pecking order; the eldest of the brood, Humphrey, was ten years his senior, and by the time Joshua was born their father was approaching his mid-forties. Family tradition had it that when he first left Oxford on his marriage Samuel Reynolds had been offered a living worth £700 a year, but that his brother John – somewhat officiously, one might think – had persuaded him to refuse it. 'Sam would not like the situation of the Living,' he had said, 'it was too much in the World.'

That could hardly be said of Plympton by the time he came to be master of the grammar school there in 1715, although the town was still prosperous enough in its quiet way. Devonshire had been strong in the kersey trade and then in serge, and in the early decades of the eighteenth century was still exporting woollens, mainly to Holland, Spain and Germany; there was wool-combing at Plympton, and hat-making; tanners, brewers, coopers and peruke-makers also contributed to the economy of the town.

There was a busy weekly market, and the slow round of the seasons was punctuated by six annual fairs – Valentine's Fair in February, Lady Day Fair in March, Holy Thursday Fair at Ascension-tide, Midsummer Fair in June, Lammas Fair in August and Luke's Fair on the saint's feast day in mid-October. Unlike many other towns, Plympton had no market-place or broad central thoroughfare, and it was therefore the Fore Street or High Street which had to accommodate the stalls and pens for the sheep and pigs and cattle brought in from the surrounding countryside. In the town centre stood the guildhall, a handsome structure with a bell-cot dating from the previous century. The grammar school had been founded in 1658, though the first master was not appointed till 1671. The stipend, derived from the rental of a farm in the neighbourhood, stood at £120 a year – the equivalent, perhaps, of £9,000 today. There was a free house, and some additional fees from boys who were not foundation scholars.

Apart from the three Rs, such education as Joshua Reynolds received in his father's handsome colonnaded schoolhouse was dominated by the study of Latin. It had been the same story fifteen years previously in Lichfield for the young Samuel Johnson and a hundred years before that for John Milton at St Paul's. The curriculum in the English grammar schools had remained set in the mould fashioned for it three centuries earlier by apostles of the new humanist learning such as John Colet and Erasmus.

Beginners were set first to memorize the rules of the language – in Latin, naturally. Then, by dint of interminable parsing and construing, by endless intoning of the paradigms of nouns and irregular verbs, the brightest among them gradually acquired some sense of what the simplest authors were driving at. If a boy seemed unduly resistant to the beauties of an ancient

tongue being drummed into his head in this way, the assault might be switched to other parts of his anatomy; no eighteenth-century classroom was without its rod and whipping-horse.

Evidence of Reynolds's formal attainments as a scholar is scanty. James Northcote, who lived in his house as a pupil for some years, asserted baldly in his biography that 'he could not be considered a correct classical scholar in any part of his life'.[5] Against that, it may be noted that when Oliver Goldsmith died, Reynolds was the first person to whom Johnson turned for an opinion about the wording of the Latin epitaph he had composed. 'I am, you know, willing to be corrected,' he wrote. 'If you think anything much amiss, keep it to yourself till we come together. I have sent two copies, but prefer the card.'*

Whatever his degree of competence in the language of Cicero and Caesar, it is plain that Reynolds harboured no resentful thoughts about the methods employed to instruct him in it. Rather the contrary. 'Repetition of what kind soever it may be is naturally pleasing to me,' he wrote in later life. 'Isaiah was allways my favorite Book of the old Testament, from having often read it, I had retained a great part of it by heart without any such intention at the time.'† We know from his commonplace book that Reynolds also frequently turned to Ecclesiasticus and that he was familiar with the works of the religious writer Robert Nelson. Of classical authors he copied extracts from Plutarch, Theophrastus and Seneca; in English literature Pope was a particular favourite, and there are also passages from Shakespeare, Milton and Dryden, from the *Spectator* and *Tatler* and, perhaps more surprisingly, from the works of Aphra Behn.

Samuel Reynolds has generally been treated rather patronizingly by his son's biographers. 'Guileless as a child, and as ignorant of the world', was Charles Leslie's judgement, and Tom Taylor let it stand.[6] Northcote says that Samuel Reynolds's innocence of heart and simplicity of manners caused people to compare him to Fielding's Parson Adams. No doubt the stories about him improved in the telling. Setting out once to visit a neighbour, he rode in a pair of gambados – heavy outer boots or gaiters which protected the rider's legs from the wet and the cold. On his arrival, his friend remarked that he had lost one of them – no mean feat, this, as gambados were generally

* Reynolds mislaid both versions, and Johnson, not having retained a copy, was understandably nettled. 'It was a sorry trick to lose it,' he wrote, with unaccustomed stiffness: 'help me if you can.'

† Letter 75. Reynolds was writing in 1778 to the Right Reverend Robert Lowth, who had recently been appointed Bishop of London. Lowth was a former professor of poetry at Oxford, and had sent Reynolds a copy of his new translation of Isaiah. (Reynolds's letters are identified by their number in the edition by John Ingamells and John Edgcumbe published in 2000.)

attached to the saddle. 'Bless me!' Reynolds exclaimed. 'It is very true, but I am sure that I had them both when I set out from home.'

His daughter Elizabeth remembered that he once encountered the famous Bamfylde Carew, king of the English gypsies and an accomplished sharper who could pass himself off equally convincingly as a wounded soldier, a ruined tradesman or a clergyman who had fallen on hard times. Samuel parted with half a guinea – it was, Elizabeth's mother told her, all the money they had in the world.*

This engaging blind spot allowed him to indulge one of his ruling passions with a clear conscience. 'If he wished for an expensive book he always purchased it,' Elizabeth told her daughter, 'altho' he could so ill afford it.' Joshua Reynolds owed a good deal to his father's bibliomania. Late in life, Reynolds told Malone that when he was eight years old, he came across a book called *The Jesuit's Perspective* lying on the window-seat of his father's parlour, 'and made himself so completely master of it that he never afterwards had occasion to study any other treatise on that subject'. Ellis Waterhouse, in his 1941 study of Reynolds, identified this as the fine folio called *Perspectiva Pictorum et Architectorum*, the work of the versatile and imaginative Italian artist Andrea Pozzo, first published in 1693. Only in 1987 did John Edgcumbe, a collateral descendant of Reynolds, establish that the book owned by the painter's father – and still in the family – was a much more modest quarto affair. It was published anonymously, but the author was one Jean Dubreuil; it was translated into English by the encyclopaedist Ephraim Chambers, and published in 1726 as *The Practice of Perspective . . . by a Jesuit of Paris*.†

Reynolds also copied prints that he found among his father's books and Dutch engravings from Jacob Cats's *Book of Emblems*. Cats was born in the Spanish Netherlands in 1577. He studied law at Leyden and Orléans, practised at The Hague, visited Oxford and Cambridge, and subsequently made a fortune out of reclaiming land from the sea in his native Zeeland.

Emblem literature, which derived from medieval allegories and bestiaries, appeared first in Italy in the sixteenth century. The fashion for it spread throughout western Europe, and it became especially popular in the

* Carew (1693–1770), the son of a Devonshire parson, ran away from Tiverton school and took up with a band of gypsies. Transported to Maryland, he escaped and made his way back to England. In one of his more ingenious ploys he avoided impressment on board a man-o'-war by pricking his hands and face and rubbing in bay salt and gunpowder, so as to simulate smallpox. He later wandered into Scotland, and is said to have followed the army of the Young Pretender to Carlisle and Derby in 1745.

† Edgcumbe also cast doubt on the statement that Reynolds never studied any other work on perspective, pointing out that when Reynolds's books were sold in 1798, the catalogue listed half a dozen volumes on the subject. See Edgcumbe.

Netherlands. Emblem books generally consisted of engravings or wood-cuts accompanied by verse and prose. Otto van Veen, to whom Rubens was apprenticed for a time, drew on the erotic verse of Ovid and other Latin poets for his contribution to the genre, but Cats addressed the ethical concerns of Calvinism, in particular those dealing with love and marriage.

In modern times he has not been universally admired ('prolix moralizing, pedestrian doggerel', snorts the current edition of the *Encyclopaedia Britannica*). Throughout the seventeenth and eighteenth centuries, however, his humour and his skill as a storyteller made him enormously popular. On Dutch bookshelves the works of 'Father Cats' had their place beside the family Bible much as *Pilgrim's Progress* had in England. Many quotations from Cats became household sayings and passed into the language. Another book on painting which Reynolds laid his hands on in his father's library was *The Tent of Darius Explained*, a translation from the work of the French art historian and critic André Félibien.*

Many years later, when he was rich and famous, Reynolds offered James Northcote a piece of advice: anyone who wanted to get to the top of the tree in their profession should concentrate their energies on doing so to the exclusion of all else – 'and not do as many very sensible men have done, who spend their time in acquiring a smattering and general kind of knowledge of every science, by which their powers become so much divided, that they were not masters of any one'. 'That,' said Northcote, the son of a Plymouth watchmaker, 'is exactly my own father.' To which Reynolds replied, 'And it was mine also.'[7]

To a scholar and country gentleman such as Samuel, the notion of arriving at any sort of professional eminence would of course have been incomprehensible; and if he had understood it he would have thought it vulgar. Devoid of ambition, he was never happier than when pursuing his private interests – in theology, or philosophy, or anatomy, or pharmacology. From time to time he would assemble his children to lecture them on some enthusiasm of the moment; Elizabeth Johnson remembered an occasion when he produced a human skull for their inspection. He spent long hours on top of the old castle at Plympton studying the stars, and used to cast

* *The Tent of Darius* was a painting by Charles Le Brun. Félibien (1619–95) is regarded as the father of art history and art criticism in France. As a young man he spent two years as secretary to Louis XIV's ambassador to the Holy See, and while in Rome became a close friend of Poussin. He later became Keeper of the King's Antiquities at the Palais Brion. He is best known for his *Entretiens sur les vies et les ouvrages des plus excellens peintres anciens et modernes*, published in ten volumes from 1666 to 1688, an erudite and stylish history of European painting from antiquity to the seventeenth century.

horoscopes;* his reading embraced sermons and political pamphlets; he was the author of a theological chronology – and of a treatise on gout.

Although in later life Reynolds would disclaim any great faith in precepts, he did occasionally trot out some of his father's sayings, such as 'The great principle of being happy in this world is, not to mind or be affected with small things.' Another was 'If you take too much care of yourself, Nature will cease to take care of you' – for this sturdy maxim Dr Reynolds acknowledged his indebtedness to his boyhood friend Zachariah Mudge.†

Our knowledge of Joshua's own boyhood is sketchy. We know that he occasionally stole fruit from an orchard adjoining the school. When he took Samuel Johnson with him on a visit to his birthplace in the 1760s, he slipped away from a dinner party one day 'to pick an apple in the orchard which had afforded Him formerly such gratification'.[8]

We also know that, like many a parson's son before and since, Reynolds was not always on his best behaviour in church. In Samuel Reynolds's day the chief political interest in Plympton lay with the Edgcumbes, a family who, as Lewis Namier put it, 'blended Parliamentary interests and naval service into one harmonious whole'.[9] Edgcumbe family tradition has it that when Reynolds was about twelve and on a visit to Mount Edgcumbe, it was noticed at morning service that he and Lord Edgcumbe's son, Richard, were misbehaving during the sermon. Dick Edgcumbe was taken to task for this on their return to the house, and his defence was that Reynolds had drawn such a capital likeness of the vicar on his thumbnail that they could not help laughing. Lord Edgcumbe, having admonished the young miniaturist with as straight a face as he could command, ordered him not to wash his hands till the following day. A boathouse on Cremill beach served as a studio; he

* This was by no means an eccentric pastime. Although astrology no longer had the intellectual and social respectability it had enjoyed in Elizabethan and Stuart days, many prominent men of science retained an interest in the subject. Richard Mead, physician to Newton, Walpole and George I and vice-president of the Royal Society, defended the influence of the sun and the moon on the human body; as late as 1779, on the eve of their departure to the West Indies under Rodney, a group of naval officers, eager to know the prospects for the success of their expedition, consulted Ebenezer Sibly, author of *Uranoscopia, or the Pure Language of the Stars.*

† Mudge, a native of Exeter, and originally a Nonconformist, had been second master in the school of Reynolds's grandfather. He later took Anglican orders, became well known as a preacher and was the incumbent of St Andrews, Plymouth, one of the most valuable livings in the west of England. His sermons were highly regarded for fifty years after his death. Pitt the Elder counted them among his favourite reading, and for many years they were prescribed for theological students at Oxford. The friendship between the two families continued into the next generation. Zachariah sent his fourth and youngest son, John, to school in Plympton, and he and Joshua became close friends.

was provided with a few common paints and a piece of boat-sail and set to copy his first sketch from the life.*

There were no indications, for all that, of a hugely precocious talent. His father, it is true, was greatly impressed when he applied what he had learned from *The Jesuit's Perspective* to a drawing of the schoolhouse;† his elder sisters, on the other hand, were sterner critics. As the family budget did not run to pencils and paper, the children were allowed to draw on the white-washed walls of a passage in the house, and Joshua's efforts there with burnt sticks were so unpromising as to earn him the sisterly nickname 'the clown'.‡

When Joshua was fourteen, a friend of his father urged that he be sent to London, and promised that he would introduce him to 'those in artistic circles'. Samuel Reynolds temporized. 'I believe,' he wrote, 'there will come something from it, if not for the present.'[10] Two years later, as Joshua approached his seventeenth birthday, his future was still undecided. His elder brother, Humphrey, now twenty-seven, was a lieutenant in the navy; Robert, a year younger than Humphrey, was an ironmonger in Exeter. Their father, writing to a friend in Bideford, a lawyer called Thomas Cutcliffe, said that so far as Joshua was concerned, he hesitated between two things.

One was that he should follow in the footsteps of his maternal great-grandfather and become an apothecary. Apothecaries originally merely pre-pared and sold drugs for medicinal purposes, but by the beginning of the eighteenth century they were increasingly assuming the role of general prac-titioners. 'Modern 'Pothecaries,' wrote the young Alexander Pope in his *Essay on Criticism*, 'taught the Art By Doctor's bills to play the Doctor's part.'§

* The Reverend Thomas Smart, who was Dick Edgcumbe's tutor as well as vicar of Maker, died shortly after being immortalized in this way, but his crudely painted portrait survives, and has a certain vitality. The eyebrows are strong and dark and he has generous bags under the eyes. He wears a fluffy white wig and broad clerical bands; his neck is obscured by several chins and his red, beefy face sits more or less directly on disproportionately narrow shoulders (Mannings, cat. no. 1632, fig. 1).

† 'Now this exemplifies what the author of the *Perspective* asserts in his Preface, that, by observing the rules laid down in this book, a man may do wonders; for this is wonderful.' Malone had the story from Boswell, who in turn had it from Reynolds.

‡ When Charles Leslie, Reynolds's Victorian biographer, visited Plympton in 1818, he was shown over the schoolhouse by the then occupant. The charcoal drawings had by then dis-appeared; they had, he wrote, 'been barbarously destroyed in the rage for whitewashing so prevalent in Devonshire'. He was also told that Reynolds had written his name with a glazier's diamond on one of the schoolroom windows, but that the pane had been carried off by an earlier master (Leslie and Taylor, i, 8, fn2).

§ Their reputation did not improve as the century advanced. Francis Grose's *Classical Diction-ary of the Vulgar Tongue*, which appeared in 1785, has an entry for 'to talk like an apothecary' – 'to use hard, or gallipot words; from the assumed gravity and affectation of knowledge generally put on by the gentlemen of that profession, who are commonly as superficial in their learnings as they are pedantic in their language'.

The other possibility was that he should be a painter. 'I mentioned this to Joshua,' his father wrote, 'who said he would rather be an apothecary than an *ordinary* painter; but if he could be bound to an eminent master, he should choose the latter.'

And so it was arranged. There were still some details to be attended to, but on 13 October 1740 Joshua travelled up to London. 'He had a most prosperous journey,' his father reported to Cutcliffe, and he continued with a warm, if somewhat muddled, expression of gratitude (the lawyer had acted as a go-between):

. . . You have ended one of the most important affairs of my life, that which I have look'd upon to be my main interest some way or other to bring about. And you have not [only] almost brought it about, but, as if Providence had breathed upon what you have done, everything hitherto has jumped out in a strange unexpected manner to a miracle.[11]

Five days later Reynolds was placed as a pupil under Thomas Hudson, a fellow Devonian, who, as Malone put it, 'though but an ordinary painter, was the most distinguished artist of that time'. An apprenticeship of four years had been agreed. The premium was to be £120, a sum found by his father and his married sister Mary Palmer.

The day was auspicious – would have been so, indeed, even if he had decided differently and chosen to serve his time as an apothecary: 18 October is the Feast of St Luke, the patron saint of both painters and physicians.

2

Apprentice and Journeyman

'I would rather be an apothecary than an *ordinary* painter.' What weighed with this seventeen-year-old when he opted for the paintbrush rather than the pestle and mortar? He had acquired the rudiments of perspective from Jean Dubreuil; the engravings of Jacob Cats had appealed to his imagination. There was, however, an author in his father's library who did more than simply instruct or give pleasure. Fifty years later, a matter of weeks before his death, Reynolds sat talking to Boswell, who was eager to write his biography. When he first read Jonathan Richardson's *Essay on the Theory of Painting*, Reynolds told Boswell, he was 'struck with admiration of the Art – thought it beyond all others'. His account of Richardson's influence also lodged in the capacious mind of Samuel Johnson, and forty years later it was pressed into service as an illustration in his 'Life of Cowley':

The true genius is a mind of large general powers, accidentally determined to some particular direction. Sir Joshua Reynolds, the great painter of the present age, had the first fondness for his art excited by the perusal of Richardson's Treatise.*

'Inspiration could be called inhaling the memory of an act never experienced.' Ned Rorem's twentieth-century definition seems to describe very precisely what happened when Reynolds first encountered Richardson's writings more than 200 years previously.

Richardson, born in 1665, was a painter before he was a writer. Pious, patriotic and not a little pompous, he hero-worshipped Milton and was constantly in the company of Pope. Horace Walpole, in his *Anecdotes of Painting*, pronounced him 'one of the best English painters of a head that has appeared in this country', although he added, with characteristic waspishness, that 'he drew nothing well below the head and was void of imagination'.[1] He established a solid enough following, for all

* *The Lives of the Poets* was published between 1779 and 1781.

that, even while Michael Dahl and Sir Godfrey Kneller were still in the field, and after Kneller's death in 1723 he had no serious rival for public patronage.*

Painting, however, was merely his profession; his vocation, which he pursued passionately in print, was to persuade anyone who would listen of what he called the 'Uses and Beauties' of art. 'This,' he wrote, 'I have apply'd my self to as the great Business of my Life.' His *Theory of Painting* had appeared in 1715, and his *Essay on the Whole Art of Criticism as It Relates to Painting and an Argument in Behalf of the Science of the Connoisseur* four years later. He subsequently collaborated with his son on *An Account of Some of the Statues, Bas-reliefs, Drawings and Pictures in Italy* (1722).† This rapidly became required reading for young men embarking on the Grand Tour, and would later win praise from such scholars as Winckelmann and Mengs.‡

His contemporaries did not all take Richardson as seriously as he took himself. When the poet Matthew Prior heard that he was planning a history of art, he suggested it should be called 'The History of Myself and My Son Jonathan with a word or two about Raphael and Michael Angelo by the way'. It is not difficult, for all that, to see how Richardson's fiery enthusiasm for Raphael and Van Dyck would excite the interest and rouse the ambition of a young boy in a small country town. Reynolds's father saw painting as a trade like any other;§ for Richardson, a mere knowledge of art set a man on the high road to moral excellence:

* Kneller, a native of Lübeck, came to England in 1676 at the age of thirty. He soon found employment at court, and became the most successful society painter of the day. He was appointed Principal Painter to William and Mary in 1688, knighted four years later and made a baronet in 1715. Michael Dahl was born in Stockholm. Settling permanently in London in 1689, he quickly became the best patronized portrait painter in the land after Kneller.

† The materials for this were collected by his son. Richardson himself did not visit Italy, although he built up a splendid collection of drawings, many of them by Italian masters of the sixteenth and seventeenth centuries. At his death it comprised 983 items. The sale extended over eighteen evenings and realized £2,060, the equivalent today of more than £160,000.

‡ Johann Joachim Winckelmann was the son of a poor shoemaker in Brandenburg. He went to Rome in 1756 and became prefect of Roman antiquities and librarian at the Vatican. He was murdered in Trieste in 1768 on his way back from a visit to Vienna. Anton Raphael Mengs (1728–79), a native of Bohemia, enjoyed great popularity in Rome as a portrait painter, especially with English visitors. He also wrote several theoretical works, in which he was much influenced by Winckelmann.

§ He used the word in a letter to Cutcliffe, where he was anxious for an assurance that Joshua would not suffer by serving a four- rather than a seven-year apprenticeship: 'Things are much better as they are without any alteration, unless there be a real inconvenience therein, as that he will not be able to practise his trade in London without molestation, or enjoy any other privileges which seven year 'prentices do' (Leslie and Taylor, i, 18).

Supposing two men perfectly equal in all other respects, only, that one is conversant with the works of the best masters (well chosen as to their subjects) and the other not; the former shall, necessarily, gain the ascendant, and have nobler ideas, more love to his country, more moral virtue, more faith, more piety and devotion than the other; he shall be a more ingenious, and a better man.

For would-be practitioners the hurdle was set formidably high:

To be an accomplished painter, a man must possess more than one liberal art, which puts him upon the level with those that do so, and makes him superior to those that possess but one in an equal degree: he must be also a curious artificer, whereby he becomes superior to one who equally possesses the other talents, but wants that. A Raphael therefore is not only equal, but superior to a Virgil, or a Livy, a Thucydides, or a Homer.

Richardson has an abundance of practical guidance to offer on such matters as composition, invention and expression:

Nothing absurd, indecent, or mean; nothing contrary to religion nor morality, must be put into a picture, or even intimated or hinted at. A dog with a bone, at a banquet, where people of the highest characters are at table; a boy making water in the best company, or the like, are faults which the authority of Paulo Veronese, or a much greater man, cannot justify . . .

In order to assist, and improve the invention, a painter ought to converse with, and observe all sorts of people, chiefly the best, and to read the best books, and no other; he should observe the different, and various effects of men's passions, and those of other animals, and in short, all nature; and make sketches of what he observes, to help his memory.

. . . Nor need any man be ashamed to be sometimes a plagiary, it is what the greatest painters, and poets have allowed themselves in.

If the style is generally high-flown, Richardson is not unaware that certain commercial practicalities arise:

Concerning what sort of resemblances portraits ought to have, opinions are divided; some are for flattery, others for exact likeness.

If the former be received, care must be taken that it be really flattery, and not too apparently so . . .

It is almost uncanny, in tracing the course of Reynolds's life, to register how much of what he absorbed from Richardson in his youth coloured

his own philosophy and practice and found repeated echoes in the Discourses which he himself would deliver during his presidency of the Royal Academy.* In one lyrical passage about the nature of portraiture, Richardson turns for inspiration to his idol Milton:

A face painter – The whole business of his life is to describe the golden age, when

> Universal *Pan*
> Knit with the *Graces* and the *Hours* in dance
> Led on th' Eternal Spring.[2]

'In general,' he continues, 'the painting-room must be like Eden before the fall, like Arcadia; no joyless, turbulent passions must enter there.' He has equally firm views about how the artist should occupy himself outside the painting room:

He should also frequent the brightest company, and avoid the rest: Raphael was perpetually conversant with the finest geniuses, and the greatest men at Rome; and such as these were his intimate friends.

Finally, there is a swelling call to greatness. Richardson looks forward to the day when 'a thing as yet unheard of, and whose very name (to our dishonour) has at present an uncouth sound, may come to be eminent in the world, I mean the English school of painting'. The English nation, he asserts, is not accustomed to do things by halves:

In ancient times we have been frequently subdued by foreigners, the Romans, Saxons, Danes, and Normans have all done it in their turns; those days are at an end long since; and we are by various steps arrived to the height of military glory by sea and land. Nor are we less eminent for learning, philosophy, mathematicks, poetry, strong and clear reasoning, and a greatness and delicacy of taste; in a word, in many of the liberal and mechanical arts we are equal to any other people, ancients or moderns, and in some perhaps superior. We are not yet come to that maturity in the art of design; our neighbours, those of nations not remarkable for their excelling in this way, as well as those that are, have made frequent and successful inroads upon us, and in this particular have lorded it over our natives here in their own country. Let us at length disdain as much to be in subjection in this respect as in any other; let us put forth our strength, and employ our national virtue, that haughty impatience of

* Interest in Richardson's writings did not die with Reynolds. They figure, for instance, in a reading list which Eugène Delacroix compiled for himself early in the following century.

subjection and inferiority, which seems to be the characteristic of our nation in this as on many other illustrious occasions, and the thing will be effected; the English school will rise and flourish.

There was nothing particularly novel about these ideas of Richardson. He was clearly familiar, for instance, with the writings of the French amateur painter and critic Roger de Piles, and these in turn derived from the theories of the Italian Renaissance.[3] Heady stuff, for all that, for a young man fresh from the English provinces, and very much in tune with the public mood at the time of his arrival in London. It was a year since Walpole, against his better judgement, had gone to war with Spain; now, in the autumn of 1740, the death of Charles VI, the last Hapsburg Emperor, threatened to embroil the greater part of Europe in a much wider conflict over the disputed succession. A matter of weeks before Reynolds set out from Devon, the masque *Alfred* had been performed for the first time, and Thomas Arne's 'Rule Britannia' gave rousing expression to that 'haughty impatience of subjection' of which Richardson had written.*

It was an interesting time to be getting a foot on the ladder. With people of the 'middle sort' increasingly affluent and better educated, the market for portraiture was expanding. Much of the formality that had characterized the portrait earlier in the century was being eroded by the popularity of the conversation piece, in which stiff poses were abandoned and the sitter was portrayed with family or friends, at ease in a domestic setting or perhaps in a garden. The trend was reinforced by a growing openness to the French rococo style. There was a lively traffic in prints from France; Hubert Gravelot, who had come to work in London in 1732, was of particular importance, and the elegance of his designs and illustrations influenced many engravers and painters.

Visitors from France did not form a uniformly high opinion of the state of English portraiture. 'At present in London the portrait painters are more numerous and more unskilful than ever they were,' wrote the Abbé le Blanc, a priest turned man-of-letters who was in England for several years from the late 1730s:

I have been to see the most noted of them; and at some distance one might easily mistake a dozen of their portraits for twelve copies of the same original. Some have their heads turned to the left, others to the right; and this is the most sensible

* The première of *Alfred* was staged at Cliveden, the country seat of Frederick, Prince of Wales, as part of a *fête* commemorating the accession of George I in 1714 and the birthday of Princess Augusta. Wagner said of 'Rule Britannia' that it expressed the entire English character in the first ten notes.

difference to be observed between them. Excepting the single countenance or likeness they have all the same neck, the same arms, the same colouring, and the same attitude. In short these pretended portraits are as void of life and action as of design in the painter.*

Although Le Blanc did not name names, he would not have been alone in placing Thomas Hudson, to whom Reynolds was now bound, at the less inspiring end of the spectrum. Hudson had been the pupil of Richardson, and had established a further connection with his master by making a runaway marriage with one of his four daughters:

His figure was rather grotesque, he being uncommonly low in stature, with a prodigious belly, and constantly wearing a large white bushy periwig. He was remarkably good tempered, and one of my first rate favorites, notwithstanding he often told me that I should certainly come to be hanged.[4]

William Hickey's cameo of Hudson dates from later in the century, when he had become prosperous enough to build himself a fine villa on the river at Twickenham; at the time he took Reynolds into his studio he was not yet forty and dividing his time between London and the West Country. His father-in-law's retirement in that same year and the return to France of the ailing Van Loo† in 1742 would bring him a substantial increase in patronage. 'The country gentlemen,' Horace Walpole wrote silkily, 'were content with his honest similitudes, and with the fair tied wigs, blue velvet coats, and white sattin waistcoats, which he bestowed liberally on his customers.'[5]

Some of Reynolds's early biographers were a good deal less polite about Hudson. 'His *business*, as it might truly be termed, was carried on like that of a manufactory,' sneered the Academician and diarist Joseph Farington:

To his ordinary heads, draperies were added by painters who chiefly confined themselves to that line of practice. No time was lost by Hudson in the study of character, or in the search of variety in the position of his figures: a few formal

* Le Blanc's strictures appeared in his *Lettres d'un Français concernant le gouvernement, la politique et les mœurs des Anglois et des François*, published in three volumes at The Hague in 1745, which won him the favour of Mme de Pompadour. His performance as the champion of state patronage of the arts did not go down well with his fellow writers, however, and he had the unusual distinction of failing on thirty occasions to secure election to the Académie Française.

† Jean-Baptiste Van Loo (1684–1745), a native of Aix-en-Provence, had come to England in 1737 and within months 'a most surprising number of the people of the first Quality sat to him'. Walpole told him that he would have made him King's Painter had it not been that the appointment of foreigners was prohibited by Act of Parliament.

attitudes served as models for all his subjects, and the display of arms and hands, being the more difficult parts, was managed with great economy by all the contrivances of concealment.

To this scene of imbecile performance, Joshua Reynolds was sent by his friends . . .[6]

Imbecile or not, reliance on drapery painters was common practice, dating back to Rubens and earlier. Kneller had done it, and so did almost all of Hudson's contemporaries. Many of them made extensive use of Joseph Van Aken, a Flemish painter who had come to London from Antwerp in the 1720s. When he died in 1749, Hogarth, who would not have dreamt of farming out any of his own canvases to be finished by another hand, produced a malicious cartoon of the funeral procession – the train of grief-stricken mourners made up almost exclusively of the portrait painters of the capital.*

Although 1740 was the year in which Hogarth painted his memorable study of Captain Coram for the Foundling Hospital ('this mighty portrait' as he himself immodestly called it) he stands somewhat outside the mainstream of portraiture – did not, indeed, regard himself as a 'phiz monger' in the accepted eighteenth-century sense.† No more did Horace Walpole. 'Having dispatched the herd of our painters in oil,' he wrote as he concluded his survey of the reign of George II in his *Anecdotes*, 'I reserved to a class by himself that great and original genius, Hogarth; considering him rather as a writer of comedy with a pencil, than as a painter.'

Walpole was never one to sacrifice a *bon mot* to the facts of the matter. Leaving aside the gifted European painters who had studios in London at the time – the Florentine Andrea Soldi, for instance, and Philip Mercier, German-born but of Huguenot origin, who was important in introducing the French rococo style‡ – the 'herd of our painters in oil' did, after all, include such considerable artists as Joseph Highmore and Francis Hayman.

Highmore, two or three years older than Hudson, was the son of a coal

* Van Aken did not work only for London painters. The Lancashire painter Hamlet Winstanley, for instance (1694–1756), who had studied under Kneller and was patronized by Lord Derby, often painted faces from the life on small pieces of canvas. These 'masks' were then sent by coach to Van Aken, who pasted them up into groups and devised appropriate postures and draperies.

† 'Phiz monger' seems to have been coined not by Hogarth, but by the French-born historical and decorative painter Jacques Parmentier (1658–1730). A Protestant, he settled in England after the Revocation of the Edict of Nantes by Louis XIV in 1685.

‡ Soldi came to London in the mid-1730s and was extensively patronized by the aristocracy. After a time, however, he began to display what Vertue called 'the singular affectation of thinking himself above the dignity of a painter', and this landed him in the Fleet Prison for debt. When he died in 1771, Reynolds met the cost of his funeral. Mercier (?1689–1760) was Principal Portrait Painter to Frederick, Prince of Wales, for some years. His paintings show the influence of both Watteau and Chardin.

merchant. He had originally been articled to an attorney, but tiring of the law enrolled at Kneller's Academy. He travelled in the Low Countries and France, and on his return secured a number of royal commissions. His ability to capture a likeness in one sitting won him a large middle-class clientèle. He was a friend of the novelist Richardson, and painted a series of illustrations for *Pamela*.*

The versatile Hayman – 'a rough man, with good natural parts, and a humourist', according to Walpole – was, like Hudson and Reynolds, a Devonian. Originally a scene painter at Goodman's Fields Theatre, he later worked at Drury Lane and did many of the large paintings for the supper boxes at Vauxhall Gardens. He turned to portrait painting only in the late 1730s, and attracted commissions from professional people and literary men. His *David Garrick and Mrs Pritchard in 'The Suspicious Husband'* was one of the earliest theatrical conversation pieces. His pupils would include Thomas Gainsborough.

The rising star of the day was Edinburgh-born Allan Ramsay, who had set up in London on his return from Italy in 1738. Ramsay, ten years older than Reynolds, was the son of the author of *The Gentle Shepherd*. During his time in Rome he had studied under Francesco Imperiali,† and had the entry to the studio of Pompeio Batoni. Batoni was a former pupil of Imperiali, and the baroque luminosity of his style strongly impressed the young Scot. Ramsay had also spent some months in Naples, where he was accepted as a pupil by Francesco Solimena, generally acknowledged as the greatest living Italian painter.

Ramsay was now installed in apartments in the great piazza on the north side of Covent Garden. He was ambitious, and he was well supported by that powerful mafia the Scottish aristocracy – in his first year in the capital he had painted the Duchess of Montrose and the Dukes of Argyll and Buccleuch. He had begun by asking 8 guineas for a bust-length portrait, a figure he was able to raise within a year or two to twelve.‡ He was also doing well enough within a year of his arrival to marry, and in a letter to his friend Alexander Cunyngham in the spring of 1740 he showed that he had every bit as much confidence in his own abilities as his friend Hogarth:

* These are now divided between the Fitzwilliam Museum in Cambridge, the Tate Gallery in London and the National Gallery of Victoria in Melbourne.

† Imperiali was born Francesco Fernandi in Milan in 1679. His work, much influenced by Poussin, was greatly admired by British visitors to Rome. He adopted the name of his patron, Cardinal Giuseppe Renato Imperiali, a confidant of the Stuart court in exile. This, and his close relations with Scottish visitors, has led to suggestions that Imperiali may have acted as a Jacobite agent.

‡ Reynolds's charge, when he settled in London in 1753, was initially 5 guineas.

'I have put all your Vanlois and Soldis, and Roscos,* to flight and now play the first fiddle my Self.'†

Although the population of London had risen above half a million by 1740, the biggest city in the world had still sprawled only modestly beyond its medieval bounds. At the time of Reynolds's arrival, John Roque was still clambering up church steeples with his theodolite to take bearings for his great map of the capital. The area to be covered was no more than 10,000 acres:

From West to East, on the North Side, from beyond *Mary-bone* Turnpike, by *Tottenham-Court*, the *New-River-Head*, *Hoxton* and Part of *Hackney* to near *Bow*: from thence, Southerly, by the Eastermost Parts of *Mile-End* and *Lime-House*, cross the River *Thames* to *Deptford* Road; from whence the Southern Side will extend Westerly, by *Newington* and *Vaux-Hall*, to that Part of *Surrey* which is opposite to *Chelsea-College*; which Building, together with some Part of *Knights-Bridge* and *Hyde-Park*, will be included in the Western Limit, which closes with the Northern beyond *Mary-bone*.‡

Those who came to the capital from elsewhere in the kingdom were appalled by the filth and noise and unpredictable dangers of the place – only two years earlier a penniless provincial hack had tried his hand at a poem on the subject, in imitation of the *Third Satire* of Juvenal:

> For who would leave, unbrib'd, Hibernia's land,
> Or change the rocks of Scotland for the Strand?
> There none are swept by sudden fate away,
> But all, whom hunger spares, with age decay:
> Here, malice, rapine, accident conspire,
> And now a rabble rages, now a fire;
> Their ambush here relentless ruffians lay,
> And here the fell attorney prowls for prey;

* Cavaliere Carlo Francesco Rusca (?1696–1769) was of Italian-Swiss origin. In 1738 George II, who had encountered him in Germany, persuaded him to come to London, where, as Horace Walpole put it, he 'painted a few pictures in a gawdy fluttering style'. He settled in Milan in 1740.
† Smart, 1992, 74. Cunyngham, later better known as Sir Alexander Dick, had studied medicine at Leyden and St Andrews and was for many years President of the Royal College of Physicians of Edinburgh. His advocacy of the medicinal properties of rhubarb was of benefit to, amongst others, Samuel Johnson, whom he got to know through Boswell.
‡ From the *Proposal* issued *c.* 1740 by Roque and his engraver John Pine, soliciting subscriptions. Reproduced in Hyde, Ralph.

Here falling houses thunder on your head,
And here a female Atheist talks you dead . . .*

The repugnance Samuel Johnson felt for London (if not that for female atheists) would moderate in time, but before then he would endure a decade of penury and struggle. For the moment he was eking out a living as a translator and political pamphleteer, contributing to Edward Cave's *Gentleman's Magazine* and hawking round the town the manuscript of the tragedy he had brought with him from Lichfield. The beginning of his friendship with Reynolds, so important to both men, lay a dozen years or so in the future.

The young friend and former pupil who had come with Johnson from the Midlands in 1737 had also had battles to fight. David Garrick had set up in business as a wine merchant, but he was hopelessly stage-struck, and when he was not in the pit or the gallery he was to be found in the taverns and coffee houses around the Covent Garden piazza, hungry for the company of the writers and stage people who congregated there. His first play, a farce called *Lethe*, had been put on at Drury Lane in the spring of 1740, and he had appeared under an assumed name in a short summer season at Ipswich. Neither Drury Lane nor Covent Garden was willing to take him on, but on 19 October – the day after Reynolds began his apprenticeship with Hudson – he made his sensational first appearance as Richard III in the small theatre at Goodman's Fields. Still desperately anxious about the reaction of his family, he appeared simply and not altogether accurately as 'A Gentleman (*who never appear'd on any Stage*)'.

Reynolds was troubled by no such conflicts, and applied himself happily to acquiring the mysteries of preparing canvases and mixing paints. 'Joshua is very sensible of his happiness in being under such a master, in such a family, in such a city, and in such employment,' his father wrote to Cutcliffe at the end of 1740.[7] Not a great deal is known of how Hudson thought it appropriate to instruct his pupils; if his method was the model for that which Reynolds adopted in later years in his own studio, it might best be characterized as benign neglect. However that may be, a number of those he taught – they included John Hamilton Mortimer and Wright of Derby – were later to distinguish themselves. Mortimer, who painted historical themes as well as portraits and conversation pieces, died before he was forty; Ellis Waterhouse judged him to have greater promise as a romantic artist than any other painter of his generation.[8] Joseph Wright (1734–97) became celebrated for his experiments in candle-lit subjects. He was the first painter

* 'London: a Poem', written in 1738. It was published anonymously, but Pope, on learning that it was by an obscure man called Johnson, told Jonathan Richardson that he would soon be '*déterré*', 'unearthed' (Mack, 732).

of any distinction to prefer living in the provinces to London.* He was much patronized by the Wedgwoods and the Arkwrights and other pioneering families of the industrial revolution; one of his finest Forge paintings was acquired by Catherine the Great.

Hudson seems initially to have been pleased with his new charge. 'I ought surely to have writ to you upon account of the character which Mr Hudson was pleased to give of my son,' Reynolds's father wrote to Cutcliffe at the beginning of 1741. The reason he had not done so was a painful one: his eldest son, Humphrey, the naval lieutenant, had been drowned on his way home from India. And hard on the heels of that bereavement, there had come another, which he described as 'a still greater sorrow' – the death of his youngest son, Martin, a boy of nine. 'I cannot write this little without great agitation of mind,' he told Cutcliffe:

My study of physic is very much dampt by the death of my last son. And yet his mother has cured a hundred as bad as he. But there was a strange infatuation in his management. A series of blunders – and all occasioned by acting with precipitation.†

We shall see that throughout his life Reynolds was capable of great warmth and steadiness in his friendships. It is much more difficult to pronounce with certainty about the nature and strength of his family attachments. One of his nephews, to whom at one period he showed considerable kindness, was nevertheless capable of writing about him as 'unfeeling and ungenerous'.‡ Very little about the members of her Streatham circle escaped the penetrating gaze of Mrs Thrale, and it is in her much-quoted word-portrait of the mature Reynolds that the startling phrase about his 'frigid heart' leaps from the page. Concerning how the young Reynolds was affected by the death of his two brothers so soon after he left the family home, however, nothing whatever has come down to us.§

Reynolds occasionally sent specimens of his work to Plympton. Although none of his letters from this period survives, we get glimpses of his progress

* He did, however, spend two years in Bath in the 1770s, in an unsuccessful attempt to fill Gainsborough's shoes.
† Leslie and Taylor, i, 21–2. It is unclear whether it is Mrs Reynolds or the family doctor who is being blamed for the child's death.
‡ Samuel Johnson was the son of Reynolds's sister Elizabeth. He was ordained in 1777, but died shortly afterwards of consumption. His letters, written from Oxford and London to his sister Betsey and other members of his family, form the basis of *Sir Joshua's Nephew, Being Letters Written 1769–1778, by a Young Man to His Sisters*, ed. S. M. Radcliffe.
§ One affecting memorial survives. At some time after the death of his father, Reynolds made a small drawing in ink which shows a child leaning on a tomb and pointing to an inscription on a scroll – 'Humphrey, Martin, Samuel, all, all are gone.'

from his father's correspondence. 'Mr Warmel, the painter, was at my house on Sunday last,' he told Cutcliffe proudly. 'He look'd upon two or three of Joshua's drawings about the room; he said not one of Mr Treby's rooms had furniture equal to this, that they all deserved frames and glasses.' He had also heard that Walpole was to be sitting to Hudson: 'Master says he has had a great longing to draw his picture, because so many have been drawn, and none like.' In the spring of the following year he was able to report that the sittings had gone well:

I had forgot to tell you that Mr Hudson had finished the head of the Earl of Orford entirely to his satisfaction, and likewise to his own. Many gentlemen admired it, and have bespoken copies. Sir Robert asked where he lived, who was his master, and wondered he had heard no more of him, and acknowledges no other picture to be his likeness but this . . .*

There is a censorious passage in Northcote which tells us that Hudson sometimes set his pupils to copy from Old Master drawings:

It appears that Hudson's instructions were evidently not of the first rate, nor his advice to his young pupil very judicious, when we find that, (probably from pure ignorance,) instead of directing him to study from the antique models, he recommended to him the careful copying of Guercino's drawings, thus trifling his time away.[9]

The casual reader might assume that this is something Northcote had from Reynolds himself – he did, after all, live in his house as a pupil for five years in the 1770s. Of all Reynolds's biographers, however, Northcote is the one who must be read with the greatest caution. Hudson certainly built up an outstanding collection of drawings over the years, in which the Italian schools of the sixteenth and seventeenth centuries were strongly represented (although his first recorded purchase was in 1741, he did not really begin collecting on a large scale until his father-in-law's posthumous sale in 1747). All the evidence is, however, that Reynolds never had anything but the greatest admiration for Guercino, who was highly regarded throughout the eighteenth century as one of the most accomplished draughtsmen of the Italian baroque. In addition to working studies his drawings included numerous landscapes and caricatures. Reynolds's notebooks show that he continued to copy Guercino's work during his stay in Rome in the 1750s, and it may well be that its influence is to be seen in the caricatures he himself

* Leslie and Taylor, i, 23, letter dated 20 April 1742. Walpole had been raised to the peerage in February of the previous year. His comments suggest that Hudson was still not all that well known in London at that time. No portrait of Walpole by Hudson survives.

produced at that time; he also more than once refers admiringly to him in the Discourses. The suggestion, therefore, that in copying Guercino Reynolds was 'trifling his time away' seems to represent nothing more than Northcote's own prejudice in the matter.*

Not that Reynolds ever considered that he had any great facility in drawing. He left a great mass of miscellaneous manuscripts at his death – rough drafts, notes jotted on the back of letters, reflections on a whole range of subjects. 'The disadvantages I have been under cannot be enough regretted,' one of them reads (it was in a bundle of papers docketed under the heading *Self*):

I began late. Facility of invention was therefore to be given up. I considered it impossible to arrive at it, but not impossible to be correct, though with more labour. I had the grace not to pretend to despise the riches I could not attain, and sometimes administered to myself some comfort in observing how often this facility *ended* in common place: though this is arguing from the abuse, for there is no necessity that it should always be the case, and it certainly may be prevented by caution.[10]

Reynolds was occasionally sent out by Hudson to the auction houses. Until the very end of the previous century, it had been technically illegal to import foreign art. Painting was held to be a craft, and the guild of the Painter-Stainers' Company exerted itself to see that the livelihood of its members was not threatened. The raising of restrictions in 1696 had led to a rapid growth in the art market, although it was sensitive to outside influences, notably the disruption to trade brought about by war. By the time Reynolds was working in Hudson's studio, anything between five and ten major picture auctions were being held each year, mostly from September to March, when the quality came up to town for the season. In 1740 339 paintings were imported from Europe; half of them from Italy, eighty-five from France and fifty-eight from Flanders. The number of prints imported was much larger, rather more than 6,500, although here Italy ceded the place of main supplier to France.[11]

A London auction house in 1740 was not a place where a young apprentice could expect to pick up a great deal about painting, although there was much to be learned about both the art of the huckster and human nature. Catalogue entries – 'A landscape. Flemish' – inclined to the sketchy, and where there were attributions, a recklessly large number of them tended to

* It is true that Guercino's popularity later declined in England, but that did not come about until the mid to late nineteenth century. Northcote's *Life* was published in 1813. The largest surviving group of Guercino's drawings, consisting of some 350 sheets, is now in the Royal Collection at Windsor.

be to Raphael or Leonardo. Some of this was due to ignorance rather than dishonesty – several of the auctioneers were not picture dealers but booksellers intent on diversification; others were members of the Upholders' Company, the livery company of the upholsterers, who since the sixteenth century had held the right to sell second-hand household goods.

One day early in March 1742 Hudson dispatched Reynolds to Cock's auction house in the Covent Garden piazza.* It was an important sale. Cock was disposing of the paintings of the Second Earl of Oxford. Indolent and unworldly, Edward Harley had been the close friend of Pope, to whom he had generously allowed the freedom of his great library. At the time of his death the previous year, his prodigality as a collector had brought him close to bankruptcy and alcoholism.

Standing at the upper end of the room, close to the auctioneer, Reynolds became aware of a bustle near the door. The auction room was very crowded and hot, he told Northcote, and he thought at first that someone had fainted:

However he soon heard the name of 'Mr. Pope, Mr. Pope,' whispered from every mouth, for it was Mr. Pope himself who then entered the room. Immediately every person drew back to make a free passage for the distinguished poet, and all those on each side held out their hands for him to touch as he passed; Reynolds, although not in the front row, put out his hand also, under the arm of the person who stood before him, and Pope took hold of his hand, as he likewise did to all as he passed.[12]

Reynolds also wrote about the encounter to Malone in later life, describing Pope as 'about four feet six inches high; very hump-backed and deformed'. He wore a black coat, and, after the fashion of the time, he had on a small sword. Reynolds was clearly already observing with a painter's eye, and the contours of the poet's face remained etched in his mind:

He had a large and very fine eye, and a long handsome nose: his mouth had those peculiar marks which are always found in the mouths of crooked persons, and the muscles which run across the cheek were so strongly marked that they seemed like small cords.†

* Cock, the leading auctioneer of the day, was immortalized in Henry Fielding's *Joseph Andrews*, where he 'appeared aloft in his pulpit, trumpeting forth the praise of a china basin and with astonishment wondering that "nobody bids more for that fine, that superb –" '.
† Prior, 1860, 429. Shortly before he died Reynolds also described the occasion and Pope's appearance to Boswell: 'Sir Joshua said he had an extraordinary face, not an everyday countenance – a pallid, studious look; not merely a sharp, keen countenance, but something grand, like Cicero's.' (Hilles, 1952, 24. These descriptions tally closely with the portrait by Richardson of *c.* 1738 now in the National Portrait Gallery in London, which shows Pope in profile and crowned with laurels.

Pope, then in his early fifties, was approaching the end of what he called 'this long Disease, my Life'. It was the only time Reynolds ever saw him.*

As the end of his second year with Hudson, the mid-point of his apprenticeship, drew near, Reynolds gave every sign of being absorbed in the work and fulfilled by it. His father sent one of his periodic reports to Cutcliffe:

As for Joshua, nobody, by his letter to me, was ever better pleased in his employment, in his master, in everything – 'While I am doing this I am the happiest creature alive,' is his expression.[13]

Then something went wrong. More precisely, something *may* have gone wrong. The exact cause of the termination of Reynolds's articles with Hudson is not known. Northcote says that the master became jealous of the pupil – just as, in sixteenth-century Venice, Titian is said to have become jealous of Tintoretto.† Farington elaborates, telling us that it arose over a portrait Reynolds painted of Hudson's cook, and that 'in this temper of mind, he availed himself of a very trifling circumstance to dismiss him'. Reynolds, we are told, had been instructed to take a canvas to Van Aken, the drapery painter, but because the weather was bad, he had delayed doing so overnight:

At breakfast, Hudson demanded why he did not take the picture the evening before? Reynolds replied 'that he delayed it on account of the rain; but that the picture was delivered that morning before Van Haaken rose from bed'. Hudson then said, 'You have not obeyed my orders, and shall not stay in my house.' On this peremptory declaration, Reynolds urged that he might be allowed time to write to his father, who might otherwise think he had committed some great crime. Hudson, though reproached by his own servant for this unreasonable and violent conduct, persisted in his determination; accordingly, Reynolds went that day from Hudson's house, to an uncle who resided in the Temple, and from thence wrote to his father, who, after consulting his neighbour, Lord Edgcumbe, directed him to come down to Devonshire.[14]

The very circumstantiality of this account throws doubt on its authenticity. It is not consistent with what we know of Reynolds's subsequent relations

* Pope died in 1744. His multiple disabilities were caused by Pott's Disease, or tuberculosis of the spine, probably contracted in infancy from the milk of his nurse or from cow's milk.
† Northcote, i, 20. If this was the reason, Hudson's jealousy burned on a slower fuse than Titian's. According to his first biographer, Tintoretto was shown the door of his master's workshop after only ten days (Ridolfi, Carlo, *La Vita di Giacopo Robusti*, Venice, 1642).

with Hudson – or with a telling passage in Malone in which Reynolds refers to 'the disagreement which induced him to leave Mr Hudson'. Nicholas Penny put the matter nicely in the catalogue to the 1986 Royal Academy Exhibition: 'It would be surprising if Reynolds had not by this date detected that his master's imaginative gifts, if more extensive than those required by an apothecary, were little more than would be expected of a fashionable tailor.'[15] Reynolds, that is to say, realized there was no more that Hudson could teach him; having absorbed what there was to know about catching a likeness, mixing colours and the running of a studio he was impatient to strike out on his own and discover whether there was not more to portraiture than mere face-painting. A letter from Reynolds's father to Cutcliffe, written little more than a fortnight after the one quoted above, hardly suggests that the parting had been acrimonious:

I have not meddled with Joshua's affair hitherto, any otherwise than by writing a letter to Joshua, which never came to hand, and which I intended as an answer both to his letter and his master's. This resolution of mine I shall persevere in, not to meddle in it; if I had I should have taken wrong steps. I shall only say, there is no controversy I was ever let into, wherein I was so little offended with either party. In the mean time I bless God, and Mr Hudson, and you, for the extreme success that has attended Joshua hitherto.[16]

On his return home Reynolds set himself up in a painting room at Plymouth Dock (the present day Devonport). A gratifying amount of work soon came his way. By the end of the year he had already completed twenty portraits. One of them, his father proudly announced, was of 'the greatest man of the place, the commissioner of the dockyard', and he had a further ten commissions in hand.[17] They included the Lieutenant-Governor of Plymouth, and a set of seven portraits of a family called Kendall. These early pictures are the work of a tyro still effectively locked in the tradition of Kneller and Richardson and Hudson – conventional poses, not much individual characterization, little in the way of texture. His charge for a bust-portrait at that time was £3 10s, pretty well in line with what other painters working in a provincial town might expect.

He was very much open to new influences, however, and he appears in the years after his return to the West Country to have absorbed valuable technical lessons from the work of an itinerant Devonshire painter called William Gandy, who had died in 1729. Ellis Waterhouse, for some reason, felt that Gandy should be high-hatted: 'A keen young man can learn a great deal from the garbage which is put in his way,' he wrote superciliously, 'and it is a matter of historical record that Reynolds first learned these qualities

from the tepid works of William Gandy.' The qualities in question, however, as Waterhouse himself concedes, were not inconsiderable – 'the effectiveness of a more or less "Rembrandtesque" chiaroscuro, and the virtues of a buttery or cheesy paint-surface'.*

The little we know of Gandy comes from Northcote, whose grandfather befriended him and whose father Gandy painted as a child. 'A man of a most untractable disposition,' according to Northcote, 'very resentful, of unbounded pride, and in the latter part of his life both idle and luxurious.' His portraits, he wrote, 'are slight and sketchy, and show more of genius than labour'. Reynolds, however, was not the first to have been impressed by his talents. Kneller, on a visit to Exeter, saw one of his portraits, and exclaimed, 'Good God! why does he bury his talents in the country when he ought immediately to come to London?'†

Before the end of 1744 Reynolds himself was once more in London and any misunderstanding with Hudson had clearly been removed. 'I understand that Joshua by his master's means is introduced into a club composed of the most famous men in their profession,' his father wrote to Cutcliffe. Club may be too tight a word, but the reference is almost certainly to the heterogeneous group of artists and literary men who congregated at Old Slaughter's Coffee House in St Martin's Lane, described by Vertue, with his customary eccentricity of punctuation, as 'a rendezvous of persons of all languages and Nations, Gentry artists and others'.‡ Its *habitués* included Hogarth, Ramsay and Hayman, the engraver Gravelot and the sculptors Rysbrack and Roubiliac.§ McArdell, who later was to engrave many of

* Waterhouse, 1941, 5. The historical record on which Waterhouse is relying is Northcote's *Life*, where Reynolds describes portraits by Gandy as 'equal to those of Rembrandt' and quotes approvingly an observation of his about colour: 'a picture ought to have a richness in its texture, as if the colours had been composed of cream or cheese, and the reverse to a hard and husky or dry manner' (Northcote, i, 22). Gandy's father, James, had also been a painter, and may have been a pupil of Van Dyck. He was taken off to Ireland by the Duke of Ormonde, and retained for many years in his household.

† Northcote supplies a possible reason, which suggests that whatever else he was, Gandy was a considerable fantasist: 'He wished to have it supposed that he was the natural son of the great Duke of Ormond, who was afterwards banished, and always insinuated that he had some secret reason for not appearing publicly in London' (Northcote, ii, 344). Gandy's 'secret reason' was presumably suspicion of Jacobite involvement; the duke, a steadfast supporter of the Stuart cause, had been in personal attendance on Charles II throughout much of the 1650s, and for some months in 1658 had returned to England as a Royalist spy.

‡ Vertue, 91. The miscellaneous writer John Lockman, born in humble circumstances at the end of the previous century and the translator of many works from the French, said that it was by frequenting Old Slaughter's that he had learned to speak the language.

§ Johannes Michel Rysbrack (1684–1770), a Fleming, had been in London since 1720. The simplicity of his style had done much to modify the heaviness which characterized English monumental sculpture. Many of the leading figures of the day – Pope, Walpole, the Duke and

Reynolds's pictures, was a regular, and Reynolds may well have encountered there the precocious Thomas Gainsborough, who had come up to London from Suffolk in 1740 at the age of thirteen and had been studying under both Gravelot and Hayman.

His introduction to Slaughter's was an important *entrée* for Reynolds, even though Hudson appears to have been somewhat on the periphery of the circle. The early 1740s were the years in which Hogarth was at the height of his activity as a portrait painter. He had visited Paris in 1743, and would almost certainly have seen in the Salon the three genre paintings exhibited that year by Chardin, the other great middle-class painter of the century. He was now at work on his six pictures of 'Marriage à la Mode', canvases in which he demonstrates a feel for the texture of paint that brings him very close to Chardin.

The importance of Rysbrack and Roubiliac lay in the powerful influence sculpture had begun to exert on painting. Portrait sculpture was much in vogue. Roubiliac's seated figure of Handel had enjoyed enormous success when it had been unveiled in Vauxhall Gardens in 1738; his bust of Hogarth, completed some three years later, had clearly affected the way in which Hogarth himself painted faces, and reinforced the break with the Kneller tradition.

Mark Girouard, writing 200 years later, described Old Slaughter's as being to the mid eighteenth century what the Café Royal was to the 1890s.[18] Many of those who assembled there in their leisure hours taught or studied at the nearby St Martin's Lane Academy which had been revived by Hogarth in 1735 – Hayman and Gravelot and Roubiliac certainly did. Although in its heyday the Academy enjoyed the patronage of Frederick, Prince of Wales, Hogarth's ideas on how it should be run were strictly democratic, non-hierarchical – and anti-gallican:

I proposed that every member should contribute an equal sum to the establishment, and have an equal right to vote in every question relative to the society. As to electing Presidents, Directors, Professors, etc., I considered it was a ridiculous imitation of the foolish parade of the French Academy . . .*

Duchess of Argyll – sat to him for their portrait busts. Louis-François Roubiliac (1702–62), a native of Lyons, came to London rather later. Northcote says his first employment was as 'a botcher of antiques'. By the early 1740s his brilliant handling of both terracotta and marble had established his reputation, and he was beginning to make inroads on the popularity of Rysbrack.

* Hogarth thought the French way of doing things not merely ridiculous but potentially tyrannical – he wanted no truck with professors paid to tell 'the younger [draughtsmen] when a leg or an arm was too long or too short' ('Apology for Painters', a manuscript written by Hogarth in the early 1760s, ed. Michael Kitson, *Walpole Society*, lxi, 1966–8, 94–5).

It is possible that Reynolds sometimes painted there; he would certainly have had occasion to see the works which its members were active in presenting to the Foundling Hospital and the paintings which decorated the supper boxes at Vauxhall Gardens, many of them collaborative efforts by Hayman, Hogarth and Gravelot.

The manager and treasurer of the Academy was George Michael Moser, who would become a close friend of Reynolds. Moser had come to England as a young man from Geneva and was a leading gold-chaser and enamell-ist.* Someone in a similar line of business was the medallist Richard Yeo, who came to prominence in 1746 as the designer of the official medal for the battle of Culloden.† Another rising young man who had trained at the Academy was the architect James Paine. Two years younger than Reynolds, he had been entrusted at the age of nineteen with the construction of Nostell Priory in the West Riding of Yorkshire. His later work included Melbourne House (the present-day Dover House) in Whitehall, and bridges and stables at Chatsworth. When they were both rich and celebrated, he would design a chimney-piece for the house Reynolds acquired in Leicester Fields, and there is a fine Reynolds portrait of him dating from 1764.

It was not only artists who made up the St Martin's Lane circle. Another *habitué* was the scientist and antiquary Martin Folkes. A friend of Newton, Folkes had been elected to the Royal Society at the age of twenty-three and had succeeded Sir Hans Sloane as President in 1741. He was a man of wide interests. For some of his contributions to the transactions of the Society – they ranged over coins, Roman antiquities and astronomy – he had been attacked as 'an errant infidel and loud scoffer'.‡

The bohemian atmosphere also attracted the novelist Henry Fielding, who had discussed Hogarth's work in the preface to *Joseph Andrews* in 1742 and who used to amuse the company by imitating Roubiliac's

* Moser (1704–83) also later became the future George III's drawing master. He enjoys modest immortality as the man who once interrupted Oliver Goldsmith in full flood by exclaiming, 'Stay, stay! Toctor Shonson is going to say something.'

† Yeo designed a second Culloden medal, a more commercial affair, which he issued by subscription and which showed on the reverse the Duke of Cumberland as Hercules, trampling upon Discord. This sold in silver for a guinea; there was also a gold version, priced at 'two guineas, for the Fashion'.

‡ A modest and affable man, Folkes may well have sought in St Martin's Lane a measure of relief from domestic unhappiness. He was married to a former actress, Lucretia Bradshaw; while they were living in Rome in the late 1720s she had succumbed to some form of religious mania and been brought home to a house for lunatics in Chelsea. Shortly afterwards, their only son had been killed in a fall from a horse in Normandy.

accent;* another notable mimic who dropped in from time to time was David Garrick, then all the rage at Drury Lane. Garrick had been quick to see the publicity value of prints and portraits. He and Hayman saw a lot of each other, and Hayman's picture of him with his friend William Windham dates from 1745.

A stimulating milieu, then, for someone so recently out of his indentures. Malone says that Reynolds had lodgings at this time in St Martin's Lane, almost opposite May's Buildings; we know from his father's correspondence that he was seeing a good deal of Hudson and that relations between them were cordial:

... Joshua's master is very kind to him; he comes to visit him pretty often, and freely tells him where his pictures are faulty, which is a great advantage; and when he has finished anything of his own, he is pleased to ask Joshua's judgment, which is a great honour.[19]

That was written in May 1745. Before the year was out, Samuel Reynolds was dead, and Joshua went home to Devon to be with his family.† His father's successor was not appointed until early in 1747, and it is possible that they were allowed to remain in the schoolmaster's house for a time. Then Mrs Reynolds went to stay with her daughter Mary, who was married to John Palmer, a lawyer in easy circumstances with a house just outside Torrington. Reynolds set up house in Plymouth Dock with his two unmarried sisters, Elizabeth and Frances. He was to stay there until the spring of 1749, although it seems likely that he made occasional forays to London.

Malone would have us believe that Reynolds later looked back on these years as a chapter of stagnation and drift:

When he recollected this period of his life, he always spoke of it as so much time thrown away, (so far as related to a knowledge of the world and of mankind,) of

* Roubiliac's domestic arrangements inclined to the disorderly. It is said that after a convivial evening, he invited a stranger home for the night, omitting only to tell him that he would find a dead Negress in his bed. Some years later a Swiss miniature painter called Theodore Gardelle, who was briefly on the fringes of the circle, carried his bohemianism too far and murdered and dismembered his landlady. He was hanged in the Haymarket, and his body was displayed in chains on Hounslow Heath; Hogarth drew his portrait at his execution.

† The memorial tablet which William Cotton later had placed in the church of Plympton St Maurice gives 1746 as the year of his death, but the parish register shows that he was buried on 26 December 1745. The mistake presumably arose because of confusion between the Julian and Gregorian calendars. Samuel was sixty-four at the time of his death.

which he ever afterwards lamented the loss. However, after some little dissipation, he sat down seriously to the study and practice of his art.[20]

'Dissipation' is a word that progressed through a range of meaning in the course of the eighteenth century. Initially it signified little more than amusement or diversion. 'I am going to Cheltenham tomorrow,' Chesterfield wrote in one of his *Letters*, 'for the dissipation and amusement of the journey.' Gradually it acquired the sense of wasting time or energy on trivialities; only later did it come to signify a way of life that was viciously indulgent or dissolute.

Reynolds was not, I think, representing his years in Plymouth Dock as some sort of provincial rake's progress. What I suspect he was really lamenting was the loss of that intellectual and professional stimulus – and no doubt the congenial company – which he had enjoyed in the noisy and bustling environs of St Martin's Lane. The evidence is that his mind very quickly became possessed by that 'one ruling idea' which in the years of his fame he was to impress so urgently on those who listened to his Discourses: 'I wished you to be persuaded, that success in your art depends almost entirely on your own industry.'[21]

The several dozen portraits which have come down to us from the years immediately following the death of his father reflect a degree of stylistic uncertainty – which is what one would expect in the work of a man still in his mid-twenties. He painted naval officers, members of the local gentry, not a few professional men and their wives. Northcote says that some of these early efforts were carelessly drawn and that the unoriginal attitudes in which he arranged his sitters betrayed the pupil of Hudson – by posing a subject with one hand tucked into his waistcoat and his hat under his arm, for instance, a painter avoided the embarrassment of revealing that hands were not his strong point:

One gentleman, whose portrait Reynolds painted, desired to have his hat on his head, in the picture, which was quickly finished, in a common place attitude, done without much study, and sent home; where, on inspection, it was soon discovered, that although this gentleman, in his portrait, had one hat upon his head, yet there was another under his arm.*

* Northcote, i, 23. A similar story circulated two centuries later in Moscow about the innumerable statues of Lenin churned out by sculptors in Moscow to adorn public squares across the USSR. When the father of the revolution was hoisted on to his plinth in some far-flung Soviet republic it was observed that he wore one proletarian cloth cap on his head while brandishing another in his hand.

Well, perhaps. And then again, perhaps not. Northcote admits that he never saw the picture in question. He lapsed into his anecdotage earlier than most, and could be quite malicious when he put his mind to it; the satirist Peter Pindar described him in one of his odes as 'walking thumb-bottle of *Aqua-fortis*'.[22]

Reynolds undertook a number of family portraits during these Plymouth years. The picture of his father, now in the Cottonian Collection there,[23] was almost certainly painted posthumously. Reynolds rarely painted in profile, and it is possible that he did so here to achieve the effect of a memorial medallion. The half-length portrait of his sister Frances, in the same collection,[24] has a faintly ethereal air. The soft lighting of these early family likenesses is distinctly Rembrandtesque; the most accomplished of them is generally agreed to be that of his sister Elizabeth,[25] who was married in 1747 to William Johnson of Torrington. In this, and in the earliest of Reynolds's self-portraits, David Mannings detects the first clear signs of a truly personal style, the shaping of the features achieved by the use of tone rather than outline, an indication that while he was in London he had paid close attention to what Hogarth was doing. Art historians are also now agreed on 1747 as the most likely date for the *Self-portrait Shading the Eyes* which hangs in the National Portrait Gallery in London,[26] another pointer to Reynolds's early interest in Rembrandt.

An early essay in group portraiture from the mid-1740s is the painting of the Eliot family,[27] which shows that Reynolds was already familiar with the work of Van Dyck – there are clear affinities with his Pembroke family group which is in the Earl of Pembroke's collection at Wilton House. Reynolds may well have seen a print.

The Eliot group includes the figure of the Hon. John Hamilton, a family friend. Malone says that the portrait of Hamilton which Reynolds painted in 1746 was the first which brought him into any considerable notice.[28] Hamilton was a sailor, although for some reason Reynolds painted him in fancy dress as a Hungarian hussar. Waterhouse thought it clearly modelled on Titian. According to Malone, when Reynolds saw this picture again later in life, he was surprised to find it so well done, and 'lamented that in such a series of years he should not have made a greater progress in his art'.*

Another essay in the manner of Titian dating from this period is his picture showing the naval officer Paul Henry Ourry with a black page-boy, originally painted for Plympton Corporation, now the property of the

* Reynolds, 1819, I, x–xi. Hamilton presented Reynolds with a copy of Roger de Piles's *Cours de Peinture par Principes*. It is now in the Yale University Library. He was drowned while coming ashore from his ship in Portsmouth harbour in 1755.

National Trust at Saltram.[29] Reynolds also painted a group of life-size three-quarter lengths of the Edgcumbe family, but all except one of them were destroyed at Mount Edgcumbe during the Second World War.

Thanks to his friendship with the Edgcumbe family, Reynolds now had a stroke of great good fortune. Early in 1749 a young naval officer called Augustus Keppel had been entrusted with a diplomatic mission to the States of Barbary. He was appointed to the chief command in the Mediterranean, and given the rank of Commodore. He left Spithead on 25 April, but his vessel sprang both her topmasts, and he was obliged to put in at Plymouth for repairs. While kicking his heels around the dockyard, he visited his friend Lord Mount Edgcumbe. There he met Reynolds, and taking a liking to him, offered him a passage to the Mediterranean.*

The *Centurion* weighed anchor on 11 May. The universal capital of the arts beckoned. Reynolds was on his way to Rome.

* Keppel had an interest in paintings. By a strange coincidence the British Library's copy of the catalogue lists him as the purchaser of a sea-piece at the very sale at Cock's where Reynolds had encountered Pope in March 1742 (see page 27 above) (Royalton-Kisch).

3

Light from Italy

Keppel – he was not yet twenty-four – was an extremely well-connected young man. His grandfather, Arnold Joost van Keppel, had come over with William of Orange as a page of honour in 1688. 'He was a cheerful young man,' wrote Bishop Burnet, 'that had the art to please.'[1] It was an art that served him well with his royal master, who created him Earl of Albemarle when he was twenty-seven and gave him the Garter four years later. On his deathbed William handed Albemarle the keys of his closet and of his private drawers. 'You know what to do with them,' he said.[2]

Keppel's father, the Second Earl, had been educated in Holland. The godson of Queen Anne,* he was appointed captain and lieutenant-colonel of the grenadier company of the Coldstream Guards at the age of fifteen and succeeded to the family titles a year later. He was made Governor of Virginia at thirty-seven, had a horse shot under him at Dettingen and commanded the first line of Cumberland's troops at Culloden. After the peace of 1748, he had been sent as ambassador extraordinary and minister plenipotentiary to Paris.

Augustus, his second son,† had already packed a good deal into his young life. After the briefest of schooling at Westminster, he had entered the navy as a midshipman at the age of ten, and after some years on the coast of Guinea and in the Mediterranean had served under Anson during his celebrated voyage round the world. In November 1741 he took part in the sacking of Payta, and had the narrowest of escapes, 'for, having on a jockey cap, one side of the peak was shaved off close to his temple by a ball, which, however, did him no other injury'.‡

* He was christened William Anne in consequence.
† Albemarle had married a daughter of the Duke of Richmond, by whom he had eight sons and seven daughters. He also fathered numerous illegitimate children.
‡ Keppel made no mention of the incident in his journal, but it was recorded in *A Voyage Round the World* by Richard Walter, Anson's chaplain, which had run through four editions when it was published in 1748. Naval uniform had not yet been introduced, and officers and men at this time still dressed as they pleased.

On his return Keppel was promoted and given his own command, the *Maidstone*, of fifty guns. In the summer of 1747, while pursuing a French ship in-shore off Belle Isle, he ran aground; the vessel was wrecked and he and his men were made prisoner. Under the gentlemanly rules of war which pertained in those days, he was allowed to return to England on parole, where he was tried by court-martial and honourably acquitted. The loss of the *Maidstone* did nothing to damage his reputation – rather the reverse. 'I join entirely with you in liking Keppel's eagerness to come at the enemy,' Anson's second-in-command wrote to him, 'and hope he will soon get a good ship to be at them again.'*

He certainly now had a good ship, and a celebrated one – it was on the *Centurion* that he had served under Anson. After her return, she had undergone a thorough repair, and the number of her guns had been reduced from sixty to fifty. 'Owing to tumble-home sides,' we are told, 'her main deck was very narrow, and her extreme breadth was only 40 feet, to a length of 144; her burthen was 1000 tons; but her bows were so lean, that she was rather lively in a head sea.'† Keppel thought so highly of her that he had had a model of her made at Portsmouth dockyard.

His 'eagerness to come at the enemy' was important, but his embassy would also test his diplomatic skills. Acts of piracy in the Mediterranean had increased sharply – hostilities in Europe meant that the Barbary corsairs had been enjoying an extended field-day. Most recently, an English packet boat, the *Prince Frederick*, bound for Falmouth from Lisbon, had been intercepted by four Algerian ships. She was detained in port for twenty-three days and effects of great value were confiscated. According to the captain's log, he was forced to hand over forty-one parcels of silver, seventy of gold and two of diamonds, valued by the bills of lading at the equivalent of £100,000 – in present-day terms, something of the order of £8 million.

Keppel's instructions from the Admiralty were explicit. Six further ships were being dispatched to join him at Gibraltar, and he was to proceed with his whole squadron to Algiers:

... You are to go on shore to the Dey, to acquaint him that you are sent by His Majesty to claim the restitution of the effects taken in the aforesaid pacquet-boat; and in consequence of his immediate complying with so reasonable a demand, to

* Keppel, i, 102. Sir Peter Warren, an Irishman, was second in command of the western squadron under Anson, and had taken part in the defeat of the French squadron off Cape Finisterre in May 1747. The immense quantities of prize-money he had made some years earlier in the West Indies made him one of the richest commoners in the kingdom.

† *United Services Journal*, December 1841, 447. 'Tumble-home' meant that the upper part of the ship's sides inclined inwards.

assure him of the friendship of His Majesty, and to hint that you have, in that case, a valuable present for him . . .

But in case the Dey should prove refractory . . . you are then to make use of such menaces as you shall judge most probable to intimidate him, and force him, by that method, to restore them; and if he should still prove inflexible, you are to stretch your squadron along the coast, and to prevent them doing any mischief to the trade of His Majesty's subjects.

The *Centurion* reached Lisbon on 24 May. Keppel had been a gracious host to his new friend. 'I had the use of his cabin,' Reynolds wrote later, 'and his study of books, as if they had been my own.' They stayed a week in the Portuguese capital – 'in which time there happened two of the greatest sights that could be seen had he staid there a whole year – a bull feast, and the procession of Corpus Christi'.[3] He was left on his own for a time at Gibraltar while Keppel crossed to attend to a little local difficulty in Morocco – the British consul had been placed under house arrest by the Moorish governor, and four fishermen from Gibraltar had been seized – but by the end of July the *Centurion* and the other six warships of the squadron were anchored in the Bay of Algiers.

Keppel's embassy got off to a shaky start. He was received with a salute of twenty-one guns, but in the return of the compliment, one of the squadron's guns was carelessly loaded with shot. Keppel immediately asked the British consul to inform the palace that this had been a mistake, and that the officer responsible had been placed under arrest. The shot had fallen short of the shore, but His Highness Mahomet Effendi, Bashaw and Dey of Algiers, made a great song and dance about it – 'which, added to the red flag you wear on your main-topmast head', he told Keppel in an exchange of letters, 'we look upon as a mark of your being of no good design, but rather threatening us with War and Blood'.

A number of English newspapers carried a highly coloured account of Keppel's first audience with the Dey:

. . . On his arrival at the palace he demanded an audience; and on his admission to the divan, laid open his embassy, requiring at the same time, in the name of his sovereign, ample satisfaction for the injuries done to the British nation. Surprised at the boldness of his remonstrances, and enraged at his demands for justice, the Dey, despising his apparent youth, for he was then only four and twenty, exclaimed that he wondered at the insolence of the King of Great Britain in sending him an insignificant, beardless boy.

On this the youthful but spirited Commodore replied, 'Had my master supposed that wisdom was measured by the length of the beard, he would have sent your

Deyship a he-goat!' The tyrant, unused to such language from the sycophants of his own court, was so enraged that he ordered his mutes to advance with the bowstring, at the same time telling the Commodore that he should pay for his audacity with his life. The Commodore listened to this menace with the utmost calmness; and being near to a window which looked out upon the Bay, directed the attention of the African chief to the squadron there at anchor, telling him that if it was his pleasure to put him to death, there were Englishmen enough on board to make him a glorious funeral pile. The Dey cooled a little at this hint, and was wise enough to permit the Commodore to depart in safety.[4]

This clearly has the makings of a Hollywood epic in glorious technicolor, but is almost certainly pure invention. Reynolds later wrote that Keppel had taken him ashore when he waited upon the Dey, and that he had 'had the honour of shaking him by the hand three several times'.[5] If Keppel had been threatened with garrotting in his presence – rather more dramatic than a bullfight, one would have thought – it is inconceivable that he would not have recorded the occasion. Keppel himself is also silent on the subject, although he later compiled a journal of his mission, running to almost 400 manuscript pages.[6]

In the middle of August the *Centurion* headed for Port Mahon, in Minorca, and Keppel introduced Reynolds to the Lieutenant-Governor, General William Blakeney.* He did so 'in so strong a manner', Reynolds recorded, that Blakeney insisted that he should be his guest throughout his stay. Keppel sailed off to continue his rounds of shuttle diplomacy, a tedious process which would last for another two years,† but the foundations had been laid for one of Reynolds's most important and enduring friendships.

It is at this juncture that we get a glimpse – tantalizingly, it is no more than that – of an older friendship of Reynolds. A letter survives which he wrote from Port Mahon in December 1749:‡ 'Dear Miss Weston, My Memory is so bad that I vow I dont remember whether or no I writ you

* Blakeney, now in his late seventies, was the son of an Irish country gentleman. His appointment to Minorca was a reward for his defence of Stirling Castle during the '45. During the Seven Years War, he would become a national hero for his seventy days' defence of Minorca. George II made him a Knight of the Bath and gave him an Irish peerage. When he died in 1761 at the age of eighty-nine, he was buried in Westminster Abbey.

† The Dey was a slippery customer, but it was also the case that his hold on power was by no means secure. At a later stage in their exchanges he admitted to Keppel that it was as much as his head was worth to restore the effects of the *Prince Frederick*. His fear of his subjects proved well founded; two years afterwards he was murdered in his own palace.

‡ It is now in the Yale Center for British Art. The second page is torn down the right-hand side, and short sections of missing text have been supplied in what looks like an early nineteenth-century hand.

about my expedition before I left England.' His memory was no worse than his punctuation:

I have been kept here near two months by an odd accident, I dont know whether to call it a lucky one or not, a fall from a horse down a precipice, which cut my face in such a manner as confined me to my room, so that I was forced to have recourse to painting for my amusement at first but have now finished as many pictures as will come to a hundred pounds the unlucky part of the Question is my lips are spoiled now for kissing for my upper lip was so bruisd that a great part of it was cut off . . .

Reynolds tells her that he will write again to let her have his address once he is settled in Rome:

In the mean time I shall be much obliged to you if you will call and see that my Goods are safe and not spoiling, I would write to him who has them could I think of his name. I should be glad if you had a spare place in your Garret that could they be at your house.

> From your slave
> J Reynolds[7]

We do not know how Miss Weston was affected by the news that her slave's lips had been spoiled for kissing; Reynolds was not the world's greatest correspondent, but a year later we find him writing from Rome, clearly disappointed that none of the three letters he had so far sent her had received an answer.[8]

Nor, for that matter, do we know how permanent the damage to his lips was. C. R. Leslie asserted that the effect of the fall 'was visible ever after in a scar on his upper lip'.[9] Leslie, however, was writing in the nineteenth century, when the *Self-portrait Shading the Eyes*, now in the National Portrait Gallery, was believed to have been painted after Reynolds's return from Italy. Modern scholarship has established fairly conclusively that it was painted before he went abroad, and the thick, uneven appearance of his upper lip is not appreciably different from the way it is painted on the earlier self-portrait thought to have been done when he was about seventeen. Later portraits throw no further light on the question. What seems most likely is that although the accident did not improve matters, there was a congenital imperfection of some sort. 'The fact is,' a collateral descendant wrote at the end of the nineteenth century, 'Sir Joshua had a slight hare lip.'*

* The descendant was Sir Robert Edgcumbe, who made a contribution to *A History of the Works of Sir Joshua Reynolds*, the monumental but uneven four-volume work by A. Graves and W. V. Cronin which appeared between 1899 and 1901.

In the intervals of painting the members of the garrison at Port Mahon and dancing with their wives at balls, he found time to keep up his reading. Nothing so frivolous as *Tom Jones* or *Clarissa*, both of which had recently appeared – during his stay on Minorca Reynolds, throughout his life a serious autodidact, was deep in Pliny's *Letters*, copying out passages that particularly appealed to him as he went along.* By the early weeks of 1750, however, he was well enough to travel. He embarked for Leghorn on 25 January, spent some time in Florence and in the middle of April reached journey's end – the centre of Christendom and seat of the papal court.

With a population of little more than 150,000 the *patria mundi*, as it liked to call itself, was much smaller than London or Paris – or, for that matter, Naples. The densely built-up quarters in the bend of the Tiber quickly gave way to open countryside; some visitors had the impression they had come to a provincial town. The city which was to be Reynolds's home for the next two years was the Rome we know from the great plan-map by Giambattista Nolli, published in 1748,† and the incomparable topographical engravings of Piranesi, who had travelled there for the first time ten years previously in the entourage of the Venetian ambassador.‡ Horace Walpole would write of 'the sublime dreams of Piranesi, who seems to have conceived visions of Rome beyond what it boasted even in the meridian of its splendour' – a polite way of saying that he indulged in a degree of artistic licence in the matter of scale. He appealed less to more conventional minds; to G. M. Trevelyan, for instance, it seemed that Piranesi represented Italy 'only too truly, as a land of gigantic ruins overgrown by verdure and crawled under by monks, beggars, and dilettanti'.§

The numbers of all three categories were swollen when Reynolds arrived because 1750 was a Jubilee year.¶ Many beggars were, in fact, members of religious orders; the impression that the life of the city was largely governed by the Church was reinforced by the tendency of many of those who worked

* Hilles, 1936, 9, 201–3. Reynolds would acknowledge Pliny as a source on many occasions in the Discourses. In one passage in Discourse VIII he brackets him with Cicero, Quintilian and Valerius Maximus, describing them as 'men of the highest character in critical knowledge'.

† Nolli was born at Montronio, on Lake Como, in 1701. The work of measuring, drawing, engraving and printing his *Nuova pianta di Roma*, generally known as the *Pianta grande*, occupied twelve years. It was dedicated to Benedict XIV. He also designed the gardens of the villa of Cardinal Alessandro Albani.

‡ Giovanni Batista Piranesi was born near Mestre on the Venetian mainland in 1720. Although he was primarily a print-maker, he always described himself as 'architetto veneziano'. His *Vedute di Roma* first appeared in 1748.

§ The phrase occurs in 'Englishmen and Italians', the British Academy lecture which Trevelyan delivered in 1919.

¶ Jubilees or Holy Years occur every twenty-five years.

in the papal bureaucracy as clerks or lawyers to take on local colour by adopting clerical garb.* The high incidence of feast days and festivals, often marked by firework displays and the distribution of food and drink, meant that the pace of economic activity was sluggish. Royal marriages were also often marked by festivities; there had been a grand fête in the Piazza Farnese in 1745 to mark the wedding of the French dauphin. Visitors from abroad quickly noticed that social barriers were more permeable and social relations less formal than in other capital cities. In the palaces of the nobility the higher clergy and well connected foreign visitors mingled easily; bishops and cardinals were regular theatre-goers and were happy to make up a party at cards.

Reynolds arrived in Rome roughly half-way through the long pontificate of Prospero Lambertini, who had been elected at the rancorous, six-month conclave of 1740 and taken the title of Benedict XIV. Horace Walpole described him as 'a monarch without favourites and a pope without a nephew', and to Montesquieu he was 'the scholars' pope'.† His pontificate was in many ways the high point of the Settecento papacy. He was a distinguished scholar with a European reputation, and his correspondents among the leading lights of the Enlightenment included Frederick II and Catherine the Great.‡ Lambertini had set the tone for his pontificate in a letter written while he was still Bishop of Ancona:

The duty of a Cardinal, and the greatest service he can render to the Holy See, is to attract learned and honest men to Rome. The Pope has no weapons or armies; he has to maintain his prestige by making Rome the model for all other cities.[10]

A main concern was to rebuild the political reputation of the papacy. He distanced his court from the exiled Stuarts;§ the thaw in relations with the House of Hanover after Culloden made life much easier for British travellers to the papal states and led to an increase in the numbers of those making the Grand Tour.

 Much of the construction of the Trevi Fountain took place during Lambertini's pontificate, and the restoration of S. Maria Maggiore and S. Croce

* The clerical population was in fact surprisingly small – about one person in fifteen or sixteen of the population as a whole. See Gross, 55–87.

† This did not prevent his *De l'Esprit des lois* being placed on the Index four years after its publication in 1748.

‡ He was, however, somewhat embarrassed by the enthusiasm of Voltaire, who cheekily dedicated his play *Mahomet* to him.

§ Although he even-handedly gave 18,000 *scudi* for the cenotaph of Queen Maria Clementina Sobieski in St Peter's.

in Gerusalemme were major contributions to Roman art and architecture –
much of the 300,000 *scudi* required for the former was met from the lottery.
He took a keen interest in the museums of Rome. He bought many antiquities
for the Museo Capitolino, which his predecessor, Clement XII, had estab-
lished as the first museum in Europe open to the public. He bought more
than 200 paintings for his Pinacoteca Capitolina, some of them acquired
from private collections to prevent their export; they included Pietro da
Cortina's celebrated *Rape of the Sabine Women*. Lambertini had a particular
passion for Chinese porcelain; so eager was he on one occasion to persuade
the Portuguese ambassador to present two pieces to him that he arranged
to have them 'stolen'.

An equally passionate, if more worldly, patron of the arts was Alessandro
Albani, who, after a brief career with the papal cavalry, had been created
a cardinal in 1721 at the age of twenty-nine. Hugely ambitious and not
over-scrupulous, he was effectively the representative of the British govern-
ment in Rome.* He was helped in the building of his collections of books
and antiquities by Winckelmann, whom from 1758 he would employ as his
librarian and antiquary. The French man of letters Charles de Brosses, who
was in Rome ten years before Reynolds's visit, summed Albani up succinctly:
'Il aime le jeu, les femmes, les spectacles, la littérature et les beaux-arts, dans
lequel il est grand connaisseur.'† He was godfather to the Contessa Gherardi
Cheruffini, who conducted a musical salon; from about 1740 she was his
lover and bore him two daughters – one of them, Vittoria, is said to have
been immortalized by Mengs in his *Parnassus*.

Rome was a more rewarding experience for some Grand Tourists than
for others. The poet Thomas Gray, who was there ten years before Reynolds,
was bowled over. 'As high as my expectation was raised,' he wrote to
his mother, 'the magnificence of this city infinitely surpasses it.'[11] That
magnificence passed many of his compatriots by. 'Il y en a qui sont gens

* Albani had since 1743 been Protector in Rome for Maria Theresa of Austria, who was
Britain's ally, and it was in this capacity that he kept an eye on British interests. After Maria
Theresa's husband became Emperor as Francis I in 1745, Albani became Imperial minister
plenipotentiary. Three years later, however, to Albani's chagrin, she had decided to entrust her
interests with the Holy See to Cardinal Mellini. She tried to mollify him with a gift of a cross
of Malta set with diamonds; the Emperor also tried to soften the blow by declaring him
Comprotector of the Empire and of the Hereditary Estates of the Empress. He usually knew in
advance about the arrival of most British visitors.

† 'He loves gaming, women, entertainments, literature and the fine arts, of which he is a great
connoisseur' (De Brosses, ii, 294). De Brosses, a friend of the *philosophes*, was later president
of the Parlement de Dijon. His *Lettres*, first published posthumously in 1799 as *Lettres familières
écrites d'Italie en 1739 et 1740*, were much admired by Stendhal. He was right about the
cardinal's fondness for gambling. One evening in 1729 Albani had lost the considerable sum
of 2,000 *scudi* to an Umbrian nobleman at the salon of the Principessa di S. Bono.

d'esprit et cherchent à s'instruire; mais c'e n'est pas le grand nombre,' wrote de Brosses, with Gallic disdain:

La plupart ont une carrosse de remise attelé dans la place d'Espagne, qui les attend tant que le jour dure, tandis qu'ils passent ensemble à jouer au billard, ou autre bel amusement pareil. J'en vois tels qui partiront de Rome sans avoir vu autre chose que des Anglais, et sans savoir où est le Colisée.*

Young men of good family usually came equipped with letters of introduction to members of the Roman nobility – families such as the Barberini, the Corsini and the Borghese – who would extend invitations to concerts and *conversaziones*. These attractions quickly palled. Some years after Reynolds's visit, the Scottish painter and connoisseur William Patoun, who accompanied both the Ninth Earl of Exeter and Clive of India on journeys to Italy, committed to paper his 'Advice on Travel'. He was not complimentary. 'Upon the whole the Resources at Rome for an English man are to be derived more from the Place than the inhabitants,' he wrote:

The Conversationi are the dullest things in the World. You go in, you make your Bow to the Lady of the House, you Stare at the Company playing at Games for Sixpences which you never are at the pains to learn and then you huddle with the groups of English into a Corner, talk loud, often at the Expence of the Company, grow tired & go home.†

The Romans viewed such boorishness no more seriously than they did the well-known eccentricities of the English; the *milordi* did have very deep pockets, after all, even if they did not always know a genuine Correggio when they saw one; the antiquarians and art dealers of the city had no complaints.

Italian attitudes to the France of the *ancien régime*, as it grew in power and assurance, were more ambivalent. Until the middle of the eighteenth century the French had come south in smaller numbers than the English, although there was one respect in which, characteristically, they were much

* 'There are some men of culture who seek for knowledge, but they are few in number. Most of them have a hired carriage stationed in the Piazza di Spagna, which waits for them throughout the day, while they get through it by playing billiards or some similar game with each other. I have known more than one Englishman who left Rome without meeting anybody except their fellow countrymen and without knowing where the Colosseum was.'

† Ingamells, xlvi. Patoun's MS is preserved in the Exeter Archives at Burghley House. He marked the sexes very differently: 'In General the Roman Ladies are Polite and decent; a great rarity in Italy. The Men of fashion at Rome & indeed all over Italy, are in general grossly ignorant, indolent and debauched.'

more highly organized. The Académie de France à Rome had been estab-
lished in 1666 by Colbert. Students who emerged with prizes from the
Académie Royale de Peinture et de Sculpture in Paris were given scholarships
and travel grants which took them to Rome for at least four years. They
were expected to immerse themselves in the classical and Renaissance riches
of Rome – and to make, on their return, an appropriate contribution to the
artistic glory of *le roi soleil* and his successors. British artists occasionally
attended the life class of the French Academy, and there are a number of
drawings extant of the posed model which suggest that Reynolds may have
done so. Years later, writing to the marine painter Nicholas Pocock, he
recalled his admiration for the work of the French landscape and marine
painter Claude-Joseph Vernet:*

I would recommend to you, above all things, to paint from nature instead of drawing;
to carry your palette and pencils to the water side. This was the practice of Vernet,
whom I knew at Rome; he then shewed me his studies in colours, which struck me
very much, for that truth which those works only have which are produced while
the impression is warm from nature.†

Another French artist with whom Reynolds struck up a friendship during
his stay in Rome was Gabriel-François Doyen, a gifted young Parisian who
had studied under Carle Vanloo and won second place in the competition
for the Prix de Rome. In a letter written many years later, he refers to the vows
of friendship exchanged with his friend 'Reinols' at the statue of Marcus
Aurelius – presumably the base of the Column of Antoninus Pius near the
Ustrinum in the Campus Martius, which had been discovered in 1703.‡

It is not known for certain where Reynolds initially lived when he was in
Rome. He had rooms for some time in the Palazzo Zuccari, at the junction
of the Via Sistina and the Via Gregoriana. In the previous century it had

* Vernet (1714–89), a native of Avignon, had been in Rome since 1734 – it is said that on his
way there he was so struck by a storm at sea that he had himself tied to the mast so that he
could observe it. The ecclesiastical connections between the Vatican and Avignon gave him a
useful entrée to many Roman prelates. He had also married the daughter of Mark Parker, the
English captain of the Pope's galleys, which made for easy relations with the British, and he
had many loyal patrons among British visitors on the Grand Tour. The year 1750 brought him
his first French royal commission.

† Letter 86. A later passage in the same letter indicates that Reynolds's admiration for Vernet
had cooled with the years, however: 'He is now reduced to a mere mannerist, and no longer
to be recommended for imitation, except you would imitate him by uniting landscape to
ship-painting, which certainly makes a more pleasing composition than either alone.'

‡ Leslie and Taylor, i, 55. Doyen subsequently had great success with his large-scale history
paintings. Later, at the invitation of Catherine the Great, he settled in Russia and was appointed
a professor at the Imperial Academy in St Petersburg, where he died in 1806.

belonged to Christina, the ex-queen of Sweden,* and it had now become in effect a boarding house for artists of various nationalities. One of Reynolds's fellow lodgers was Matthew Brettingham, a young Norfolk man who had been sent to Rome primarily to study architecture, but also to acquire antique sculptures for the Earl of Leicester at Holkham Hall.† The sculptor Joseph Wilton, later a founder member of the Royal Academy, also had lodgings there in the early part of Reynolds's stay, and so thirty years later did Reynolds's pupil Northcote. 'It is the pleasantest part of all Rome,' he told a friend. It had been built by the sixteenth-century painter Federico Zuccari, Poussin had lived opposite and the descendants of Salvator Rosa still had the house next door. 'If there is any virtue in the spot,' Northcote wrote, 'I hope to get it.'‡

Reynolds had been in Rome for several weeks before he got round to composing a bread-and-butter letter to his patron. 'I am now (thanks to your Lordship) at the height of my wishes, in the midst of the greatest works of art that the world has produced,' he wrote to Lord Edgcumbe:

Impute my not writing to the true reason: I thought it impertinent to write to your Lordship without a proper reason . . . Since I have been in Rome I have been looking about the palaces for a fit picture of which I might take a copy to present your Lordship with; though it would have been much more genteel to have sent the picture without any previous intimation of it. Any one you choose, the larger the better, as it will have a more grand effect when hung up . . .[12]

We do not know whether his lordship took him up on his offer, but a list in one of the sketch-books Reynolds kept at the time indicates that in the first few weeks of his stay he had been bustling round the villas and palazzi to some effect:

Copies of Pictures I made at Rome.
In the Villa Medici.
The vase of the 'Sacrifice of Iphigenia.'
In the Corsini Palace. – April 16, in the afternoon, 1750, anno Jubilei.
1. A study of an 'Old Man's Head, reading,' by Rubens.
2. April 17 to 19. – a portrait of Philip II, King of Spain, by Titian.

* Christina, the daughter of Gustavus Adolphus, had become queen at the age of seventeen in 1644. She abdicated ten years later, converted to Catholicism, and kept up a royal household in Rome, surrounded by cardinals.
† Brettingham's father was the earl's executive architect at Holkham.
‡ Whitley, 1928, ii, 313. Northcote was writing to the artist and writer Prince Hoare, later Honorary Foreign Secretary of the Royal Academy.

3. April 20. – Rembrandt's portrait by himself.

4. April 21 to 23. – 'St. Martino on horseback, giving the Devil, who appeared to him in the shape of a Beggar, part of his Cloak.'

Captain Blackquier's P.

An 'Old Beggar Man.'

My own picture. Jacamo's picture.

5. Began May 30, finished June 10, in the *Church of the Capuchins*, 'St. Michael,' by Guido.

A foot from my own.

6. June 13. – the 'Aurora' of Guido, a sketch.

Making copies was recommended by the European academies, but it was not a practice which Reynolds continued for very long. Years later, when the young Irish painter James Barry was studying in Rome, Reynolds sent him a letter of fatherly advice: 'Copying those ornamental pictures which the travelling gentlemen always bring home with them as furniture for their houses is far from being the most profitable manner of a student spending his time,' he wrote. 'Whoever has great views, I would recommend to him whilst at Rome, rather to live on bread and water, than lose those advantages which he can never hope to enjoy a second time.'*

If they did not have to churn out copies of Old Masters to keep the wolf from the door, young artists coming to Rome typically fell into a fairly standard routine – making drawings of the antique sculptures in the Vatican, copying Raphael's *Stanze* frescoes and perhaps the ceiling by Annibale Carracci in the Palazzo Farnese, drawing from the life in the private academies of established artists or becoming pupils in their studios. Mengs, for instance, on his first visit to Rome, had studied the nude under Marco Benefial,† and Allan Ramsay, as we have seen, had been the pupil of Imperiali.

Leslie and Taylor say that Lord Edgcumbe – 'so much was he infected by the Italian mania' – had urged Reynolds to become the pupil of Pompeo Batoni when he reached Italy, but that his advice was disregarded: 'Having served a short apprenticeship to a commonplace English painter, he was now too wise to place himself in the hands of a commonplace foreigner.'[13] Or perhaps too arrogant. When Reynolds arrived in Rome he would have discovered that Batoni was rapidly establishing himself as the most success-

* Letter 22. Reynolds was writing in the spring of 1769. He himself did not have to live on bread and water in Rome – his two married sisters had both lent him money, and the portraits he had painted at Port Mahon had brought him a useful addition to his purse.

† Benefial (1684–1764) painted frescoes, altarpieces and portraits. A strong individualist, he was unable to conceal his contempt for what he saw as the mediocrity and ignorance of his fellow members of the Accademia di S. Luca, and in 1755 this would lead to his expulsion.

ful portrait painter of the day. The son of a goldsmith in Lucca, he had made his name in the 1740s as a painter of historical and devotional pictures.* Now commissions were beginning to flood in for portraits. He was particularly successful with Irish and British visitors to Rome (many of them steered in his direction by Cardinal Albani).†

Batoni was noted for the freshness of his colouring and the vivid accuracy of his likenesses;‡ Reynolds, whose ignorance of anatomy and of linear perspective remained with him into his maturity, could also certainly have learned something from Batoni's meticulous and elegant draughtsmanship – Nicholas Penny, in the catalogue of the Royal Academy's 1986 Exhibition, did not beat about the bush:

If we compare Batoni's portraits, or those of the leading French artists, of the middle decades of the eighteenth century, with those by Reynolds at any date, we are immediately struck by Reynolds's reluctance to portray the interior of a room, and by the minimal, often perfunctory and obviously improvised outdoor settings he provides. We notice, too, how rarely Reynolds exhibits the sitter's hands in any complex open gesture. In his early portraits hands were often conveniently concealed in pockets or waistcoats, and even in his last works we may catch him extending drapery over miscalculations in composition and blunders in drawing – sometimes a hand or arm thus concealed has, with the increasing transparency of the paint, made an alarming reappearance . . .§

The contents of Reynolds's surviving notebooks¶ – sketches, laundry lists and critical jottings all jumbled together – are of limited help in reconstructing the pattern and rhythm of his life in Rome, but here and

* Batoni was noted for his piety. He went to Mass every morning at four, summer and winter; his routine was well known, and a number of beggars were usually waiting for him at the church door. 'He is of a very devout Exterior and Appearance,' the future Lord Grantham wrote to his father, 'in this prelatical world not an useless Recommendation' (Beard, Geoffrey, 'Batoni and Mengs', *Leeds Art Calendar*, 44, 1960, 23–4).

† Some 265 portraits by Batoni have survived. Of these, 200 depict British or Irish sitters.

‡ This is borne out by a label on the stretcher of a portrait in a private collection in England. The sitter, Stephen Beckingham, was painted by Batoni in 1752, but the picture was lost at sea on the return voyage. 'Some years later at a Dinner party, Mr. Beckingham was asked if he had ever been in Italy. The person who asked the question stating that he had seen in an Italian Custom House a Portrait greatly resembling him. This led to enquiry and the portrait was recovered' (Clark, 254).

§ Penny, 1986 (catalogue), 20. Reynolds did not remain blind to Batoni's merits, for all that. Ellis Waterhouse saw his portrait of Lady Anne Dawson and his two Cathcart portraits, painted in the mid-1750s after his return to England, as exercises in the style of Batoni.

¶ Nine of these volumes survive. Four are in private collections, the Museum of Modern Art and the Fogg Art Museum in Cambridge, Mass., each have one, and there are three in London, one at the Soane Museum and two in the Print Room of the British Museum.

there in the Discourses, distilled and refracted, we are offered important glimpses into the frame of mind in which he had gone to Italy and how he responded to his early experiences there. There is a good example in the second Discourse:

To a young man just arrived in *Italy*, many of the present painters of that country are ready enough to obtrude their precepts, and to offer their own performances as examples of that perfection which they affect to recommend. The Modern, however, who recommends *himself* as a standard, may justly be suspected as ignorant of the true end, and unacquainted with the proper object, of the art which he professes.[14]

Reynolds, that is to say, had arrived in Rome with an agenda that was already fully blocked out – much of it by Richardson. The 'Moderns', such as Batoni, had nothing to contribute to it. His concern was with the great painters of the past. The secrets of their technique – in particular their mastery of colour – seemed to him to have been lost. He was intent on recovering them, and on doing so in his own way. 'Few have been taught to any purpose who have not been their own teachers,' he assured his students elsewhere in the same Discourse – a surprisingly subversive assertion, one might think, from the President of a Royal Academy. 'He seems to have grasped,' wrote Ellis Water-house, 'that the art of portraiture – which English patrons at the time considered only slightly above the level of dressmaking – could be treated as a branch of historical painting and ennobled by the same resources of art.'[15]

His quest for the lost secrets of the great masters got off to a slightly wobbly start:

August 2. worked in the Vatican.
 I was let into the Capella Sistina this morning, and remained there the whole day, a great part of which I spent in walking up and down it with great self importance.

This presumably means that he was not a little pleased with himself at the nature of his response to Michelangelo's ceiling frescoes,* but smugness soon gave way to something approaching consternation: 'Passing through, on my return, the rooms of Raffaele, they appeared of an inferior order.' This failure to appreciate the genius of Raphael clearly called for rigorous self-examination, though he soon discovered that he was not the first to have had this unsettling experience:

* 'His ideas are vast and sublime,' he would write in his fifth Discourse two decades later; 'his people are a superior order of beings; there is nothing about them, nothing in the air of their actions or their attitudes, or the style and cast of their limbs or features, that reminds us of their belonging to our own species' (Reynolds, 1959, 83).

On confessing my feelings to a brother-student, of whose ingenuousness I had a high opinion, he acknowledged that the works of Raffaelle had the same effect on him . . . This was a great relief to my mind; and on inquiring further of other students, I found that those persons only, who, from natural imbecility, appeared to be incapable of ever relishing those divine performances, made pretensions to instantaneous raptures on first beholding them.[16]

He was, for all that, both disappointed and mortified that he had not himself been instantly enraptured by the works of this great master:

My not relishing them as I was conscious I ought to have done, was one of the most humiliating circumstances that ever happened to me. I found myself in the midst of works executed upon principles with which I was unacquainted: I felt my ignorance and stood abashed. All the indigested notions of painting which I had brought with me from England, where the art was in the lowest state it had ever been in, (it could not indeed be lower,) were to be totally done away, and eradicated from my mind. It was necessary, as it is expressed on a very solemn occasion, that I should become as a *little child.**

His visits to the Vatican, to stand before these 'excellent works', became even more frequent:

I viewed them again and again; I even affected to feel their merit, and to admire them, more than I really did. In a short time a new taste and new perceptions began to dawn upon me; and I was convinced that I had originally formed a false opinion of the perfection of art . . .[17]

There was a price to be paid for those long hours spent in the chilly expanses of the Vatican during two Roman winters (many British visitors chose to spend those months of the year in Naples). Reynolds caught a cold, and his hearing was seriously and permanently affected; Malone says that the damage was done by his working for a long time near a stove, 'by which the damp vapours of that edifice were attracted, and affected his head'.[18] Over the years, socially at the dinner table and professionally at the Royal Academy, he would become adept at exploiting his deafness, fumbling for his ear-trumpet every bit as effectively as Horatio Nelson would clap his glass to his sightless eye.

*

* Reynolds did not identify the fellow students in question. The 23-year-old Allan Ramsay had been similarly disappointed by the *Stanze* during his first visit to Rome fifteen years previously.

At some point in the course of 1750 Reynolds changed his lodgings and went to live on the third floor of the English Coffee House. This was in the Piazza di Spagna, not far from the entrance to the city by the Porta del Popolo and very much the focal point of both the artist community and the British colony. Rome attracted a regular stream of English visitors, but there were also large numbers of Scots and Irishmen, many of them drawn there by the presence of the exiled Stuarts. After the collapse of the 1715 rebellion, the Pretender had been acknowledged by the Pope as a reigning sovereign, but after the failure of his elder son's expedition to Scotland in 1745 he appeared much less in public; he was seen occasionally in his box at the opera, but spent more and more of his time at his summer residence in Albano. In 1747 his younger son, Henry, Duke of York, then aged twenty-two, had been made a cardinal; at the time of Reynolds's arrival in Rome his relations with his *maestro di camera*, Padre Lercari, had incurred the displeasure of both his father and the Pope, and in 1752 the pair would withdraw for a time to Bologna. Bonnie Prince Charlie, meanwhile, now entering his thirties, had been obliged to leave France in 1748 under the terms of the Treaty of Aix-la-Chapelle. For the next fifteen years he would pursue his aimless and drunken course round Europe; Rome would see his decrepit figure again only on the death of his father in 1766.

It required much determination from any English visitor to Rome to avoid the attentions of the Abbé Peter Grant, an indiscreet Scottish Jesuit who had attended the Scots College in Rome and returned there in 1737 as Roman agent to the Scottish Catholic Mission. He gave his address as Au Caffee Anglais, place d'Espagne. His aim was to be 'all things to all men', one visitor wrote – 'a Jacobite to Jacobites, a Georgite to Georgites, and an agreeable companion to every one'. Ten years earlier, Lady Mary Wortley Montagu had found him to be 'a very honest, good naturd North Briton' and there were other travellers who referred to him as 'the English Ambassador'. The more distinguished the British travellers who accepted his services as a *cicerone*, the better he was pleased, but he also took the young Scottish painter Katherine Read under his wing – she was in Rome at the same time as Reynolds.* A few years later, when Robert Adam's first visit coincided with Allan Ramsay's second, they and Grant formed a 'Caledonian Club' so that they might gossip together in the 'Mither tongue'.

* Miss Read settled in London in 1754, and achieved some success with her portraits, which show the influence of Reynolds. She struck Fanny Burney as melancholy, shrewd and clever, 'most exceedingly ugly' and negligent in her dress. She later went to India, dying on shipboard on the voyage home in 1778.

Within a few years Grant would encounter strong competition from a young Englishman called Thomas Jenkins. Jenkins, a year younger than Reynolds, had been born in Rome,* but had gone to London to study under Hudson. He would return some eighteen months after Reynolds's arrival and work for a time as a painter, but he soon began to develop antiquarian and commercial interests which proved much more profitable. Urbane and duplicitous, he became in time both very grand and very rich, receiving royalty and enjoying the favour of Pope Clement XIV. He established a bank, and was much involved in excavation; in 1774 he would form a consortium for the dredging of the Tiber. 'The people used to call Mr Jenkins Illustrisimus and kiss his hand,' wrote Northcote, 'and it was even in his power to get the freedom for one condemned to the galleys.'[19] He acquired a country retreat in a villa at Castel Gandolfo which had formerly belonged to the General of the Jesuits; Father John Thorpe, an English Jesuit who acted for Lord Arundell of Wardour, described it sourly as 'a sort of trap' for rich Englishmen with deep pockets.† It is not known how much Reynolds saw of him while he was in Rome, but many years later, when his pockets were much deeper, they had important dealings.‡

John Astley, another former pupil of Hudson, arrived in Rome a matter of weeks after Reynolds, and they were much in each other's company. Astley was the son of a Shropshire apothecary. 'He was a tall, showy man,' wrote Farington. 'He had high animal spirits, which inclined him to dissipation.'[20] He had spent the previous two years in Florence; now, keen to study drawing under Batoni, he came with a glowing testimonial from Horace Mann to Cardinal Albani ('rare application', 'irreproachable manners'). Northcote has a story about him in Rome which he presumably had from Reynolds. The English painters used to gather in the evening, and quite often made small excursions into the surrounding countryside:

On one of those occasions, on a summer afternoon, when the season was particularly hot, the whole company threw off their coats, as being an incumbrance to them, except poor Astley, who alone shewed great reluctance to follow this general example; this seemed very unaccountable to his companions, when some jokes, made on his singularity, at last obliged him to take his coat off also. The mystery was then immediately explained; for it appeared, that the hinder part of his waistcoat was

* Authorities differ on Jenkins's place of birth. In giving it as Rome I have followed Ingamells; Grove, on the other hand, says that he was born in Devon.
† Thorpe was an interested party several times over – the Jesuit Order had recently been suppressed (1773), Jenkins was one of his competitors as an antiquary and was also suspected by the Jacobites of being a British government spy.
‡ Reynolds bought a large Bernini statue from him. See p. 450 below.

made, by way of thriftiness, out of one of his own pictures, and thus displayed a tremendous waterfall on his back, to the great diversion of the spectators.*

Reynolds also made the acquaintance in Rome of Richard Dalton. Dalton, like Reynolds the son of a parson, had been apprenticed to a coach painter at Clerkenwell. He was ten years or so older than Reynolds, and had first visited Italy in 1739, where he had studied in Rome under Masucci and developed an interest in dealing. He had recently returned from a tour of Constantinople, Greece and the Levant, where he had acted as travelling draughtsman to a party led by Lord Charlemont.† Some years after his return to England he became Librarian to the future King George III; he was employed to make acquisitions for the royal collection and was much involved in the intrigues and infighting that preceded the establishment of a Royal Academy.

Reynolds, to his disappointment, had still not heard from Miss Weston, although, as we have seen, he had written to her twice since arriving in Rome. Towards the end of 1750 he decided to try again; Dalton, who was about to leave for home, would be his courier – 'and a Worthy man he is', he told Miss Weston. 'I hope he will deliver this letter himself that you may be acquainted and when I return we shall have many agreeable jaunts together.' He had a pedestrian way with words, but his enthusiasm for Rome penetrates the woodenness of his prose:

Give my service to Mr Charlton and Mr Wilks and tell them that if it was possible to give them an Idea of what is to be seen here, the Remains of Antiquity the Sculpture, Paintings, Architecture &c., they would think it worth while, nay they would break through all obstacles and set out immediatly for Rome . . .

He ends by asking her to send him 'all the newes you know, not forgetting to say something about my Goods', and there is a postscript sending remembrances to various friends – 'not forgetting the little Girl at Westminster'. He urges her to write – 'immediatly immediatly by the first post. Mr Dalton will tell you how to direct'.‡

* Northcote, i, 44. Astley's fortunes later improved. In the late 1750s he married a rich widow, Lady Dukinfield-Daniell. She obligingly died three years later, leaving him a large fortune and an estate in Cheshire. He bought Schomberg House in Pall Mall and furnished it in some style. He subsequently sold his London collection of old masters and retired with his third wife to lead the life of a country gentleman.

† Some of the drawings Dalton made on this tour are preserved in the Royal Collection at Windsor and in the Print Room of the British Museum. They are historically important as the earliest made of a number of ancient monuments.

‡ Letter 7. 'Immediatly immediatly' may be a slip. Reynolds did, on the other hand, pick up some Italian during his stay, and it may, as F. W. Hilles suggested in his 1929 edition of the *Letters*, be an echo of 'subito, subito'.

Third time lucky:

Rome. 30 April 1751

Dear Miss Weston

Your Letter I receiv'd with a great deal of Pleasure and as tis increasing a pleasure to comunicate it I read it to a great many English that were at the Coffe house but without mentioning the writer (tho if I had it would have been much to your honour) for you must know that when a Letter comes from England we are all impatient to hear news, and indeed your Letter was full of it, and however it happend every person took the same pleasure in it as my self.

One item of news in Miss Weston's letter, however, had pleased him not at all, and his punctuation became even more minimal than usual:

But nobody but me knew the westminster Girl alack alack she has been brought to bed and tis a fine Chumning boy but who is Lord John? well who would have thought it oh the nasty creature to have to do with a man . . .

The identities of the Westminster girl and the blackguardly Lord John are unknown,* but there had also been news of greater moment – a death in the royal family which in years to come would have an indirect impact on Reynolds's own fortunes:

We are all extremly afflicted for the loss of the prince of Whales who certainly would have been a great patron to Painters as he already was to Mr Dalton I feel an additional sorrow on his account I beg my compliments to him particularly and to all friends. I cannot form to my self any Idea of a person more miserable than the Princess of Whales must be, deprived at once of a Husband she loved and with him all thoughts of ambition . . .[21]

Among those who assembled in the English Coffee House in the Piazza di Spagna to gossip and hear the news from England was a painter called Thomas Patch. He had travelled to Italy, largely on foot, with Richard Dalton in 1747 – 'an intelligent and original artist with a sharp eye and louche disposition'.[22] A Devon man – his father was a surgeon in Exeter – Patch was working in Vernet's studio at the time of Reynolds's arrival, and had been commissioned by Lord Charlemont to paint views of Rome and Tivoli. In the course of 1751 he joined Reynolds in his lodgings at the

* Nor can the *Oxford English Dictionary* help with 'chumning'. 'Chumpy', perhaps, meaning plump?

coffee house and his interest in physiognomy was almost certainly a strong influence on the series of caricatures which Reynolds painted in Rome. Patch himself is known to have produced caricatures of both Lord Bruce and Lord Charlemont when they were together in Rome between 1751 and 1753, although most of his witty groups in this genre were done after his forced removal to Florence.*

Rome had a flourishing tradition of caricature. The term had first been applied to various heads drawn by the Carraccis towards the end of the sixteenth century, and the scatological caricatures of Guercino were well known – Reynolds may well have seen some of them in Hudson's studio. He would also probably have been familiar with the album of twenty-five caricatures published in facsimile by Arthur Pond in London between 1737 and 1739. Most excitingly of all, when he arrived in Italy in 1750 the great contemporary master of the genre was still alive and living in Rome. Pier Leone Ghezzi was an old man now, with a formidable reputation not only for portraits but for history paintings and decorative frescoes. He had also, since his youth, drawn caricatures. The earliest of them date from 1693, when he was nineteen, and in middle life he collected them into several volumes, which he called *Mondo nuovo*, and which are now in the Vatican.†

One of those most recently caricatured by Ghezzi was a young Irishman from Co. Kildare, a banker's son called Joseph Henry, who was no doubt not a little flattered by the great man's inscription – *Giuseppe Henry Inglese, huomo assai erudite nella antichita e en Lettera*. And it was Henry who commissioned from Reynolds the travesty of Raphael's *School of Athens*,[23] the most ambitious of the caricatures which he painted in Rome: Irish and English *milordi* and various of their hangers-on – tutors, doctors, dealers, antiquaries – taking the place of Greek philosophers. They are set against a background which is Gothic rather than classical – the suggestion, presumably, is that Rome has been overrun by northern barbarians.

* Patch remained in Florence until his death in 1782. He had been banished from Rome at Christmas 1755 'by order of the Inquisition in 24 hours for Crime well known to the Holy Office' – the assumption is that he was expelled for some homosexual offence. The painter John Parker, no friend of Patch, regaled Lord Charlemont with an extended account of the gossip surrounding his 'disgrazia': 'Some say B—y, others giving a potion to a nun to make her miscarry, must be something confessed by his boy (who died a few days before the order for his banishment in the Hospital of St John Lateran)' (HMC Rept. 12, App. pt. X, 1891, p. 222. O'Connor, 1999, 158).

† Bib. Apostolica, MSS. Ott. 3112–19. There are eight volumes, each containing between 130 and 200 caricatures, arranged and bound by Ghezzi himself. Ghezzi was hugely versatile. He had studied medicine, was a gifted musician and devised the street decorations and firework display which marked the birth of the French dauphin in 1729.

No key to the figures in *The Parody on the School of Athens* has come down to us, although Reynolds listed the sitters. They do not all seem so to modern eyes, but they were mostly very young men – the Irish peer Lord Charlemont, for instance, who was at the mid-point of an extended tour that would last almost nine years, was only twenty-three. He and Reynolds would become life-long friends. Burke spoke of his 'adorned mind' and Grattan (who entered Parliament under his auspices) wrote in his memoirs that 'the very rabble grew civilised as it approached his person'.* Other sitters included the immensely tall Lord Bruce, later Lord Ailesbury and tutor to the royal children; he also appears (as an 'eloquent beanpole') in *Four Learned Milordi*, a smaller caricature group which Reynolds painted in the same year.[24] The doyen of the group, Joseph Leeson, later Earl of Milltown, was Henry's uncle. He had used the wealth his family derived from brewing and banking to build Russborough in Co. Wicklow, one of the grandest houses in Ireland. Leeson is cast as Plato; Henry himself is cast as Diogenes the Cynic.

Lesser figures portrayed include Dr James Irwin, who had been one of the Pretender's physicians since the 1730s, but who moved freely in non-Jacobite circles. 'The best Whigs go to see him,' said Robert Adam, who had cause to consult him some years later. 'A very sensible, clever old man, who every day drinks his four or five bottles of wine.'[25] Patch also figures in the *Parody*, as does the sculptor Simon Vierpyl, a pupil of Scheemakers, who had come to Rome in 1748 and would stay for nine years. He occupied rooms in the Palazzo Zuccari, sharing at different times with Patch and Reynolds, and was much patronized as a copyist by British and Irish travellers. He was embarking at this time on his largest commission, which came, as it happens, from another of those depicted on the *Parody*. Edward Murphy, a classical scholar from Dublin, was Charlemont's tutor and major-domo of his Rome household. He claimed descent from the Kings of Leinster and occasionally signed himself *Edwardus Rex*. Something of an eccentric (one of his enthusiasms was for vulcanology), he had commissioned Vierpyl to make terracotta copies of twenty-two statues and seventy-eight busts of Roman Emperors and other figures in the Capitoline Museum.†

* Charlemont, whose health was not good and who suffered from bouts of depression, could none the less be very amusing. Early in his tour, in Turin, he had encountered David Hume, and they had briefly been rivals for the affections of a young lady. Charlemont thought his appearance 'far better suited to communicate the idea of a turtle-eating Alderman than of a refined philosopher'. They became good friends for all that, although they were poles apart both philosophically and politically.

† This 'imperial series', as Vierpyl called it, was shipped to Ireland in 1755. Murphy bequeathed it to Lord Charlemont, and it was presented to the Irish Royal Academy by his descendants in 1868.

If Northcote is to be believed, in later life Reynolds seems to have come to regard these caricatures as a piece of youthful exuberance, possibly even an indiscretion:

I have heard Reynolds himself say, that although it was universally allowed he executed subjects of this kind with much humour and spirit, he yet held it absolutely necessary to abandon the practice; since it must corrupt his taste as a portrait painter, whose duty it becomes to aim at discovering the perfections only of those whom he is to represent.[26]

That makes the President of the Royal Academy sound a very dull dog. Malone, too, strikes a feebly apologetic note, assuring us that the *Parody* 'was not like the more modern productions in that style, being done with the consent of the gentlemen represented'. If Hogarth had still been around when that appeared, he would have written something very crude in the margin.

Frivolous or not, the caricatures represent Reynolds's only serious excursion into portraiture during his time in Rome.* He was content subsequently to confine himself to filling the pages of his sketch-books, building up a memory bank of pictorial ideas. He set his face against the 'drudgery of copying'. It was 'a very erroneous method of proceeding', he told his students at the Academy twenty years later:

I consider general copying as a delusive kind of industry; the Student satisfies himself with the appearance of doing something; he falls into the dangerous habit of imitating without selecting, and of labouring without any determinate object; as it requires no effort of the mind, he sleeps over his work; and those powers of invention and composition which ought particularly to be called out, and put in action, lie torpid, and lose their energy for want of exercise.[27]

He was prepared to concede that copying had some value in teaching the 'mechanical practice' of painting, but urged his listeners to be discriminating, and select only those 'choice parts' which had recommended the work to their notice:

If its excellence consists in its general effect, it would be proper to make slight sketches of the machinery and general management of the picture. Those sketches should be kept alway by you for the regulation of your stile. Instead of copying the touches of those great masters, copy only their conceptions. Instead of treading in

* It is possible that the self-portrait now in a private collection in England (Mannings, cat. no. 3, fig. 59) was painted in Rome. David Mannings suggests that the words 'My own Picture' in the list of work done in the Corsini Palace in April 1750 (p. 48 above) may refer to this.

their footsteps, endeavour only to keep the same road. Labour to invent on their general principles and way of thinking. Possess yourself with their spirit.[28]

The notebooks are full of sketches of attitudes, verbal descriptions of expression, notes on technique and on colour. There are also drawings of ornament and of landscape (though very few of architecture); sometimes he drew diagrams to illustrate the disposition of light and shade. In one of the larger albums there are some finished drawings in red chalk of heads from Raphael's Vatican frescoes.

There are also copious notes about individual works of art. In the Palazzo del Secretario he particularly admired a picture of Pontius, the engraver, by Van Dyck: 'The best portrait I ever saw – the colouring like the head of Rembrandt in the Corsini, but wonderfully finished.' There is a detailed description of a bust by Bernini which he saw in the Church of S. Jacopo degli Spagnuoli: 'The marble is so wonderfully managed, that it appears flesh itself; the upper lip, which is covered with hair, has all the lightness of nature.' In the Palazzo Mattei he found an arresting Caravaggio – a saint disputing with an old man: 'A vast strength, and well coloured, as if the sun shone on the figures; dark shadows, but not so hard as usual; and, what one does not often find in this master, the saint is a very genteel figure. This is in every respect the best picture I ever saw of Caravaggio.'

Reynolds stayed in Rome longer than he had initially intended. The letter he wrote to Miss Weston in April 1751 indicated that he was planning shortly to move on:

I will not desire you to write any Answer to this Letter because I shall remove from Rome to Florence and other parts of Italy so that you wont know where to direct . . .

It is not known what caused him to change his mind, but in the event he did not finally leave Rome for another year. A commonplace book which he kept in 1752 shows that he continued in that time to round out his education; in a note inside the back cover he reminds himself to 'Bye a Virgil'. A slightly comical line on the first page reads like a New Year's resolution about the mending of ways – 'to look more like a man of Business and consequence no dangler nor Idler'. Some mild dissipation or backsliding over the festive season, perhaps. There was one area in which he had most certainly not been idle. The same commonplace book shows that he had been reading and making notes from Shaftesbury's *Concerning Enthusiasm*,* and at one

* Shaftesbury had written this in the form of a letter to Lord Somers in 1707. It was published anonymously the following year.

point he had tried his hand at translating an extended passage into Italian.[29]

The circle of British artists was enlarged during this last year of Reynolds's stay by the arrival of Richard Wilson. The two men may well have known each other in London in the late 1740s when Wilson frequented the St Martin's Lane Academy. A native of Penegoes in Montgomeryshire and ten years older than Reynolds, Wilson had studied under Thomas Wright in London and already had some reputation as a portrait painter before travelling to Venice in 1750. By the time he arrived in Rome in the company of Thomas Jenkins towards the end of 1751 his interest had shifted decisively towards landscape. He was quickly to establish a formidable reputation; Mengs, who painted his portrait in 1752, declared that 'he never met with but two English artists of superior genius, they were R. Wilson and Athenian Stuart'.[30] He would later become a founder member of the Royal Academy, although Reynolds's relations with him after his return to England were not of the happiest.* An important influence on both Constable and Turner,† Wilson, who was to die in poverty and obscurity, is now recognized as the classic master of British eighteenth-century landscape painting – the artist who, with Gainsborough, 'took Landscape out of the hands of dreary topographers and invested it with poetry'.[31]

Just as Reynolds was preparing to leave Italy, Lord Charlemont and others dreamed up a scheme to establish an English Academy in Rome. A dispatch from there, dated 12 May, appeared in the *Daily Advertiser* of 8 June:

The English noblemen and gentlemen at this place on their travels, having taken into consideration the disadvantages young students of their nation in Painting and Sculpture lie under here from want of the foundation of an Academy, without pensions for encouragement for those whose circumstances will not permit their studies for a sufficient time at their own expense, have begun a generous subscription towards the foundation of an Academy and have appointed Mr John Parker, history painter, to be receiver and director thereof. The generous promoters of this foundation are the Lords Bruce, Charlemont, Tylney and Kilmurray, Sir Thomas Kennedy Bt., Messrs Ward, Iremonger, Lethieullier, Bagot, Scrope, Cook, Lypeat, Murphy, and as all nations in Europe particularly the French have academies and great encouragements, it is hoped that all lovers of the Arts will promote this generous design.

* See p. 313 below.
† Wilson himself was strongly influenced by his two great French predecessors Claude Lorrain and Gaspard Dughet. 'Why, sir,' he once remarked, 'Claude for air and Gaspar for composition and sentiment; you may walk in Claude's pictures and count the miles' (quoted in Sutton, Denys, (ed.), *An Italian Sketchbook by Richard Wilson, R.A.*, i, 14).

Their hopes of counterbalancing French influence were not realized. The querulous Parker, a not very successful history painter, had been in Rome since 1740. He was a foolish choice. An injury to his leg put him out of action for a lengthy period; the Academy, it was said, became 'an asylum for artistic scamps'. Charlemont would wind it up in 1755.

Before embarking on the long journey home, Reynolds made a short visit to Naples, jotting down his impressions of the landscape on the way. He went by way of Castel Gandolfo and the Lake of Albano, stopping overnight at Velletri, where in the market-place he saw Bernini's statue of Urban VIII. His route took him down the Appian Way, through the desolation of the Pontine Marshes, fertile and populated in Roman times: 'Pliny says in his time there was here 25 towns now not a house.'[32] He did not make extensive notes of what he saw in Naples, but he visited the Cathedral and the Church of the Gesù Nuovo and mentions Luca Giordano, one of the masters of the Neapolitan baroque, and Francesco Solimena's huge theatrical fresco of the *Expulsion of Heliodorus from the Temple*. He also saw works by Domenichino, Vasari and Giovanni Lanfranco. He did not neglect to keep a note of his outgoings: 'Naples journey cost – 6–0–0. Expences on the road 2, At Naples 18.'[33]

Back in Rome, he began to prepare for the first stage of the journey to England: 'Send my chest of Cloaths Linnen &c. to Civita Vecchia to be sent to Leghorn provided it will arrive soon enough; send my colours there.'[34] He appears to have collected quite a number of prints and drawings during his two years in Rome, although it is not known whether he acquired them for himself or for others. Two lists in one of his sketch-books indicate that they included items by Piranesi, Salvator Rosa, Guercino and Michelangelo; these too were to be shipped home, but were left for the time being with Vierpyl.

Reynolds left Rome for Florence on 3 May. He travelled by easy stages – Castel-Nuovo, where he slept the first night, was only two and a half posts from Rome, a distance of about eighteen miles. The next day he reached Narni, where he stopped to see the Bridge of Augustus; he dined on 5 May at Terni, where he saw the Cascade, and pushed on to Spoleto, where he viewed the aqueduct.

The brief note he made the following day indicates that the 'new taste and new perceptions' which he believed had begun to dawn upon him as he stood in the papal apartments in the Vatican were still not fully developed:

Saw the picture by Raffaele, representing the 'Virgin and Bambino'; below, on the right hand, St. Francis and St. John Baptist; and on the other, a Cardinal kneeling (Sigismondo Conti, the donor); another old man (St. Jerome) with one hand on the Cardinal's shoulder.

Reynolds was in Foligno, and this pedestrian form of words* was the best he could manage as he stood before the *Madonna di Foligno*, the beautiful altarpiece, now in the Vatican, painted by Raphael in Rome in 1511–12. The 'Cardinal kneeling' was the private chamberlain of Pope Julius II, who had commissioned it to adorn the high altar of S. Maria in Aracoeli, a major Franciscan church in Rome. It is justly celebrated because, in his earlier paintings, the colour had sometimes seemed like an afterthought; here it is inseparable from the composition, and Raphael emerges as a master colourist. Some have found it superior even to *The Transfiguration*.

On to Assisi, where he stopped to sketch one of the gates and admired the 'fine taste' of the antique Temple of Minerva,† dating from the reign of Augustus. He noted that the church of S. Francesco, the mother church of the Franciscan order, contained the remains of the saint, but he had no eyes for the fresco cycles by Cimabue and the circle of Giotto.‡ At Perugia and Arezzo he greatly admired works by Federico Barocci, the leading altar painter in Italy in the second half of the sixteenth century, patronized by the Pope, the Emperor, the King of Spain and the Grand Duke of Tuscany.

Reynolds arrived in Florence on 10 May, and spent almost two months there. 'When I am here,' he wrote, on the day he saw the Capella di S. Lorenzo, 'I think M. Angelo superior to the whole world for greatness of taste.' But he also visited the former workshop of Giambologna, in the grand-ducal sculpture studio, and when he saw the original full-scale models for the Fountain of the Ocean, he was no longer so sure – 'I believe it would be a difficult thing to determine who was the greatest sculptor.'

He was allowed into a part of the Pitti Palace not normally open to visitors; it is possible that doors were opened for him by the collector and dealer Ignazio Hugford, to whom he had an introduction. Hugford, the son of an English watchmaker who had settled in Florence towards the end of the previous century, had trained for nine years in the studio of Anton Domenico Gabbiani and had been elected to the Accademia del Disegno in Florence at the age of twenty-six. Now approaching fifty, he had a formid-able reputation as a connoisseur and art historian. Reynolds was greatly impressed by his collection of drawings, and with good reason – after his

* Reynolds's description is also inaccurate. St Jerome's hand rests lightly not on de Conti's shoulder but on the back of his head, as if directing his gaze upwards to the Madonna and the Holy Child.

† Now the church of S. Maria.

‡ Reynolds was later to acknowledge that 'the old Gothic artists, as we call them, deserve the attention of a student, much more than many later artists. In other words, the painters before the age of Raffaelle, are better than the painters since the time of Carlo Marratti' (Cotton, 1856, 229). It should also, in fairness, be remembered that the frescoes were already in poor condition when Vasari saw them in 1563.

death in 1778, the Uffizi would buy more than 3,000 of them from his executors. Hugford told Reynolds that he had just sold a fine head by Bronzino, and he may well have done so, but his reputation as a dealer was not unblemished. He is known to have painted a 'primitive' *Madonna* over an entirely blackened panel for the collegiate church of S. Maria at Impruneta, and not long after Reynolds's departure he persuaded a gullible West Indian sugar planter called William Young to part with a large sum in exchange for a *Danae* which he assured him was by Titian.*

Reynolds's jottings on the paintings he looked at are sometimes quite technical; he is constantly alert to the way the artist has tackled a particular problem of composition or lighting. 'The figure on the white horse is painted very light,' (this of a Rubens he saw in the Pitti) 'so as not to break the mass; and between the horse's head and legs there is a light figure introduced, not to spoil the form of the mass. The King makes a dark mass; behind him two dark figures to carry off the mass of dark gradually.' On other occasions his examination of a painting prompts him to dash down a more general reflection:

In Raffiele nothing of the affectation of Guercins Painting, not dark nor light no ridiculous affected contrasts no affected masses of lights and shadows he is the medium Annibal Carach too wild
D° Michael Angelo
Domenicino too tame Guido too effeminate.[35]

He found time for some painting and sketching. The sculptor Joseph Wilton, whom he had known in Rome, had moved to Florence the previous year, and sat to Reynolds during his stay for the portrait which is now in the National Portrait Gallery in London[36] – 'a brilliant display of those qualities in which he so eminently excelled', Joseph Farington thought.[37]

In one of the sketch-books now in the Print Room of the British Museum[38] there is a sensuous, highly suggestive drawing of a young woman in elaborate undress; the skirt of her gown falls open half-way up her thigh, one foot is raised on a cushioned stool and she is tying – or perhaps untying – a garter above her knee. The small animal crouching at her feet is indifferently drawn, and at a quick glance might pass for a cat or a dog; but it could also be a monkey, a symbol of shamelessness and sensuality.

Another sketch shows a pair of legs, knock-kneed and splay-footed, surmounted by a large sketching board and a cocked hat – 'Master Hone',

* Young, who later became Governor of Dominica, was travelling abroad following storm damage to his plantations in Antigua. Horace Mann described him as 'a roaring rich West Indian' who talked of his money and swaggered in his gait 'as if both his coat pockets were full of it' (Walpole, 1937–83, xx, 330, letter from Mann dated 31 August 1752 NS).

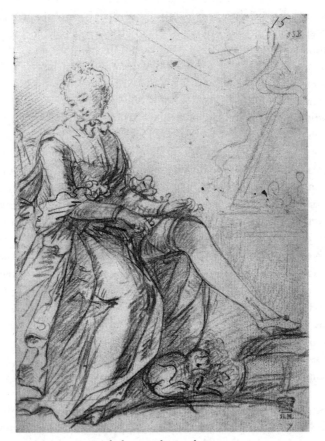

2. *A lady seated tying her garter.*
A sketch from one of the books which Reynolds filled with notes
and drawings during his stay in Italy in the early 1750s.

reads the caption. This was Samuel Hone, the son of a Dublin merchant, who earlier in the year had been sharing lodgings near the Piazza di Spagna in Rome with Richard Wilson. He and Reynolds appear to have seen a good deal of each other and to have spent some convivial hours together. 'Hone says, I look like the Altar of the Jesuits lighted up,' Reynolds scribbled in his sketch-book, and elsewhere he scrawled what may have been the beginning of a letter to their friends in Rome: 'Gentlemen and Brethren – Hone and Reynolds greeting'.*

* Hone later returned to Dublin, and subsequently went to Jamaica. Some biographers have confused him with his elder brother Nathaniel, who painted portraits and miniatures. This better-known member of the Hone family became a founder member of the Royal Academy and, as will be seen, a considerable thorn in Reynolds's side.

His sketch-book continued also to serve as both journal and memo pad. On the last leaf he jotted down a list of things to be attended to before moving on:

Buy chalk. – Voyages and maps. – Take the flowers from Dogana and the portraits. – Ultramarine. – Send for my things from Piti. – Pay Wilton for Gallery. – Ultramarine. – Receive from Hone. – Breeches made. – Not forget sheet. – Breeches mended. – Pay washerwoman. – Pay Wilton for Verpili. – Hat. – Spada. – Capella. – Bianta Scatola. – Stivali. – Canistra. – Umbrella. – Fabry, perruquiere in Piazza di San Marco, Venice. – 4 shirts; 1 pair of stockings; handkerchiefs; 2 stocks.

Reynolds was pressed by friends to extend his stay in Florence, and we find him scratching around for reasons for doing so:

I remember, whenever my father discoursed on education, it was his constant practice to give this piece of advice – 'never to be in too great a hurry to show yourself to the world; but lay in first of all as strong a foundation of learning and knowledge as possible. This may very well be applied to my present affairs, as, by being in too great a hurry, I shall perhaps ruin all, and arrive in London without reputation, and without any body's having heard of me; when, by staying a month longer, my fame will arrive before me, and, as I said before, no body will dare to find fault with me, since my conduct will have had the approbation of the greatest living painters. Then again, on the other hand, there are such pressing reasons for my returning home, that I stand as between two people pulling me different ways; so I stand still and do nothing. For the moment I take a resolution to set out, and in a manner take leave of my friends; they call me a *madman* for missing those advantages I have mentioned.

He does not enlarge on these pressing reasons for returning home – perhaps they were financial. Nor is it clear how an extra month would allow his fame to run before him to England, or who those 'greatest living painters' were whose approbation he apparently hoped to win in that short time – indeed the idea that the praise of living painters was something Reynolds valued is a novel one.

It is possible that this obscure passage relates to the Florentine Accademia del Disegno. This celebrated body had served as a model for most of the artists' associations and schools of art that had emerged in Europe during the seventeenth and eighteenth centuries. It had been constituted in 1563, largely on the initiative of Vasari, and the financial support of the Medici had ensured that its exhibitions were of great artistic importance. Whether Reynolds exhibited there during his few weeks in Florence is unknown. If it was the prospect of being admitted to that august body that tempted him to

extend his stay, he set the thought aside: 'Departed from Florence the 4 of July after dinner.' He need not have worried. When the Accademia met on 3 September, Reynolds was one of those elected to membership *in absentia.* *

From Florence he had moved on to Bologna. He stayed for less than a fortnight, but found great riches there. 'I think those who travel,' he wrote later, 'would do well to allot a much greater portion of their time to that city than it has been hitherto the custom to bestow' – a hint that he regretted not having taken longer to explore its arcaded streets and its towers of russet sandstone.[39]

His notes on the paintings of the Bolognese schools are less detailed only than those on the pictures he saw shortly afterwards in Venice. He paid next to no attention to the earlier schools of Bologna, but the influence of Bolognese classicism – the works of the Carracci, of Guido Reni, of Guercino and Domenichino and Francesco Albani – was to remain strong throughout his life. He filled the pages of his sketch-book with notes on individual paintings and with quick, expressive sketches – animals, figures from life, the occasional landscape, studies of light and shade. Although the Carracci and their pupils predominate, he also found good things in the work of lesser artists. He was impressed, for instance, by a *Flight into Egypt* which he saw in the church of S. Tommaso di Strada Maggiore. 'The Virgin resting on Giuseppe to mount the ass,' he notes; 'Christ in the mean time seems impatient to be in the Virgin's arms: by Tiarini, who has always something new in his pictures.'† In some cases it is clear that he was storing away ideas for future compositions. In the church of S. Francesco, for example, he sketched an angel from a canvas of Pasinelli's, and wrote underneath, 'Drapery in sweeps, and light at the wings. This figure will serve for a Fame.'‡

He was greatly impressed by a double altarpiece by Guido Reni in the church of the Medicanti: 'There is a certain softness in Guido that is wonderfully pleasing,' he wrote; 'this is his very best manner: the sheep and the other parts of the picture which I could reach to has the genteelest pencilling I ever saw.' His admiration of Reni, the most sophisticated, if not the most modest, of the pupils of the Carracci, is understandable. According to his biographer, Malvasia, Guido used to boast that 'he could paint heads

* He was by then in Paris. Samuel Hone was elected on the same day; his brother Nathaniel was made a member, also *in absentia*, the following January.

† Alessandro Tiarini (1577–1668) was a close contemporary of Guido Reni. Some of his religious paintings show a tendency to sentimentalism.

‡ Lorenzo Pasinelli (1629–1700) trained with Simone Cantarini, the most gifted of Guido Reni's pupils. He is mainly known for his historical and mythological pictures, which have such titles as *Diana's Nymphs Clipping the Wings of Cupid's Amorini* and *Pompey's Wife Swoons at the Sight of His Bloody Garments.*

with their eyes uplifted a hundred different ways'.* The appeal of Guercino lay partly in his subtle effects of light and shade but also in the wide range of facial expression and gesture he was able to achieve.† Francesco Albani – 'the Anacreon of painters', as he has been called – was noted for his small mythological paintings and the lyricism of his landscapes.

Reynolds's greatest praise, however, is reserved for the Carracci themselves, the brothers Agostino and Annibale and their cousin Lodovico.‡ The close artistic partnership between them, particularly in their earlier years, is epitomized by their answer when asked which of them painted the frieze in the Palazzo Magnani-Salem – 'It is by the Carracci; all of us made it.' Later their individuality became more apparent. Modern authorities insist on the pre-eminence of Annibale, but Reynolds saw most to admire in the work of Lodovico, possibly because there were many more of his paintings to be seen there.§ The great altar, in the church of S. Antonio, he thought 'the noblest picture I ever yet saw of Ludovico; the characters of the heads, the hands, legs, and feet, the nobleness of the drapery, in short, the whole is in perfection'.

Lodovico was nicknamed 'il Bue' – 'the Ox' – perhaps because his father was a butcher, possibly because he worked very slowly. His style was less classical than that of his cousins, although like them he advocated the direct study of nature – something which would find an echo in the Discourses of the mature Reynolds:

The beginning, the middle, and the end of every thing that is valuable in taste, is comprised in the knowledge of what is truly nature; for whatever notions are not conformable to those of nature, or universal opinion, must be considered as more or less capricious.[40]

* Reni (1575–1642), the most famous and successful painter of seventeenth-century Italy, was quarrelsome as well as boastful, and addicted to gambling. The son of a prominent Bolognese musician, he had studied in the workshop of the Flemish painter Denys Calvaert before transferring, along with Albani and Domenichino, to the academy run by the Carracci.

† Guercino (Giovanni Francesco Barbieri) was born in Cento in 1591. There was great rivalry between him and Reni; after the latter's death in 1642, Guercino moved to Bologna and became the city's principal painter. His popularity with English collectors remained strong until well into the nineteenth century. His rescue from Victorian neglect began in 1947 with the publication of Denis Mahon's *Studies in Seicento Art and Theory*.

‡ The family was originally from Cremona. They had settled in Bologna in the middle of the fifteenth century, earning a living as tradesmen. Agostino (1557–1602) was originally a tailor, like his father. Annibale (1560–1609) was initially taught by Lodovico, who was five years his senior. The tide of fashion flowed against all three Carraccis in the nineteenth century, but interest in their work has now revived. Annibale, in particular, is seen as an artist who revitalized the great tradition of Italian Renaissance painting; few critics today would think it unfitting that his tomb in the Pantheon should lie next to that of Raphael.

§ Lodovico spent almost all his life in Bologna, whereas his cousins worked for a number of years in Rome, Parma and elsewhere.

Reynolds would have seen Annibale's great masterpiece, the ceiling of the Galleria Farnese, when he was in Rome, but in Bologna, as he discovered when he visited the church of Corpus Domini, not everything was hung with the convenience of visiting connoisseurs in mind: '*The Resurrection of Christ*, by Annibale, in a bad light, and the picture being dark and small one cannot well judge; what is seen appears to be admirable.'

Reynolds was heading now for Venice, but Richardson and others had marked his card. There were paintings all over the north of Italy that were not to be missed, and his route from Bologna to the Serenissima resembled a dog's leg – Modena – Reggio – Parma – Mantua – Ferrara. The high point of this excursion was at Parma where he saw Correggio's *Holy Family with St Jerome* – 'The airs of the heads, expression, and colouring, are in the utmost perfection,' he noted. 'It gave me as great a pleasure as I ever received from looking on any picture.'*

He reached Venice on 24 July, and the short time he spent there was the most rewarding of his whole Italian experience:

What he absorbed in these three weeks came out in his own practice more than all the lessons of two years amid the Roman frescoes: for his mind was naturally attuned to the colour of the Venetians, his natural defects were the same as theirs, and he could learn from them, more than from any other school, useful and magnificent means for covering up his deficiency in drawing and giving a senatorial dignity to portraits of the most undistinguished sitters.[41]

Reynolds with one barrel, the Venetians with the other. Ellis Waterhouse is malicious, but he is spot-on, even though his phrase about 'senatorial dignity' is cribbed from something Reynolds himself wrote about Titian.[42] Indeed the passage as a whole is derivative of what Reynolds had to say about the Venetians in his second Discourse:

The Venetian and Flemish schools, which owe much of their fame to colouring, have enriched the cabinets of the collectors of drawings, with very few examples. Those of Titian, Paul Veronese, Tintoret, and the Bassans,† are in general slight and undetermined. Their sketches on paper are as rude as their pictures are excellent in regard to harmony of colouring.

* Not everyone was so reverential: 'The St. Jerome has the air of a miserable beggar-man, and the singing angel opens a mouth like that of a johndory' (Miller, i, 414).
† The Bassano family was active in Venice and the Veneto in the sixteenth and early seventeenth centuries. Jacopo (1510–92) is by far the most celebrated, but his father, Francesco, was a minor provincial master and two of his four artist sons also achieved some success.

That rich 'harmony of colouring' would influence him profoundly, but he would also drink in what Titian, Tintoretto, Bassano and Veronese had to tell him about light and shade. 'The method I took to avail myself of their principles was this,' he wrote:

When I observed an extraordinary effect of light and shade in any picture, I took a leaf out of my pocketbook, and darkened every part of it in the same gradation of light and shade as the picture, leaving the white paper untouched to represent the light, and this without any attention to the subject, or to the drawing of the figures . . . After a few experiments I found the paper blotted nearly alike. Their general practice appeared to be, to allow not above a quarter of the picture for the light, including in this portion both the principal and secondary lights; another quarter to be kept as dark as possible; and the remaining half kept in mezzotint or half shadow . . .

By this means you may likewise remark the various forms and shapes of those lights, as well as the objects on which they are flung; whether a figure, or the sky, a white napkin, animals, or utensils, often introduced for this purpose only. It may be observed, likewise, what portion is strongly relieved, and how much is united with its ground; for it is necessary that some part (though a small one is sufficient) should be sharp and cutting against its ground, whether it be light on a dark, or dark on a light ground, in order to give distinctness to the work; if, on the other hand, it is relieved on every side, it will appear as if inlaid on its ground.[43]

Reynolds raced round more than thirty churches during his short stay in Venice. Most of them were in the city itself, but he also made boat excursions to the islands, inspecting paintings on Murano, Burano and Torcello. The short crossing to S. Giorgio allowed him to inspect the treasures housed in Palladio's great cruciform church on the island – a *Last Supper* by Tintoretto, and a *Gathering of the Manna*, one of his most remarkable landscapes, a *Nativity* by Bassano and, in the Refectory, Veronese's celebrated *Marriage at Cana*, measuring a massive 6.69 × 9.90 m. (The picture is now in the Louvre.) Reynolds studied the composition and colour and lighting of the huge expanse intently:

The principal light in the middle Paolo himself, dressed in white, and light yellow stockings, and playing on a violino; the next is his brother going to taste the liquor: he is dressed in white, but flowered in various colours. The table-cloth, the end on the other side, with the lady, makes a large mass of light. Almost all the other figures seem to be in mezzotint; here and there a little brightness to hinder it from looking heavy, all the banisters are mezzotint; between some of them, on the right side, is seen the light building to hinder the line of shadow, so as to make the picture look half shadow and half light. The sky blue, with white clouds. The tower in the middle,

white, as the clouds; and so all the distant architecture, which grows darker and darker as it approaches the fore figures; between the dark architecture in the foreground and the light behind, are placed figures to join them, as it were, together.*

It was a picture that remained lodged in Reynolds's prodigious visual memory. More than a quarter of a century later, he called it up in his eighth Discourse to illustrate his contention that in the management of light, a painter who knew what he was about might be absolved from too strict an observance of the rules:

Though the general practice is to make a large mass about the middle of the picture surrounded by shadow, the reverse may be practised, and the spirit of the rule may still be preserved ... In the great composition of Paul Veronese, the Marriage at Cana, the figures are for the most part in half shadow; the great light is in the sky, and indeed the general effect of this picture which is so striking, is no more than what we often see in landscapes, in small pictures of fairs and country feasts; but those principles of light and shadow being transferred to a large scale, to a space containing near a hundred figures as large as life, and conducted to all appearance with as much facility, and with an attention as steadily fixed upon *the whole together*, as if it were a small picture immediately under the eye, the work justly excites our admiration; the difficulty being encreased as the extent is enlarged.[44]

The work of Titian which most excited Reynolds's admiration was his *Martyrdom of St Peter*, the last of his three great early altarpieces for Venice. It was painted between 1526 and 1530 for SS. Giovanni e Paolo, the principal Dominican church in Venice. It is now known only by engravings and prints, because it was destroyed by fire in 1867, but Vasari and others considered it to be Titian's greatest work. Reynolds scrutinized it closely:

The trees harmonise with the sky, *i.e.*, are lost in it in some place, at other places relieved smartly by means of white clouds. The angels' hair, wings, and the dark parts of their shadows, being the same colour as the trees, harmonise – the trees of a brown tint. The shadows of the white drapery the colour of the light ground. The light the colour of the face of the saint. The landscape dark ... The drawing, in general, noble, particularly of the right leg of him that flyes – His head, &c., the shadows of his eyes and nostrils determined, and a beautiful shape.[45]

* Leslie and Taylor, i, 68–9. Veronese himself is, in fact, playing a viola; the other musicians are traditionally identified as Bassano (flute), Tintoretto (violin) and Titian (bass viol).

It was not only for his mastery of colour and light and shade that Reynolds would salute Titian when he came to compose the Discourses:

> By a few strokes he knew how to mark the general image and character of whatever object he attempted; and produced, by this alone, a truer representation than his master Giovanni Bellino, or any of his predecessors, who finished every hair.[46]

This disinclination to 'finish every hair' would become one of his own trademarks, though not one of which everyone approved; after Reynolds's death, George III, who was short-sighted and therefore tended to view pictures at very close quarters, spoke of Reynolds's portraits as 'coarse and unfinished'. The remark was made to Sir William Beechey, to whom the king was sitting at the time, and Beechey, more of a courtier than Reynolds had ever been, attempted a diplomatic response. 'Your Majesty,' he said, 'who is so perfect a judge of music, knows that the effect of the finest overture may be harsh and unpleasant when we are too close to the orchestra; so the pictures of Reynolds may appear coarse if we look at them too near, but at the proper distance they are all harmony.' The king, however, was not to be fobbed off, and by way of return of service produced a magnificent *non sequitur*: 'Very good; but why did he paint red trees?'[47]

Although Reynolds obviously felt very much at home with the Venetians, he did not find it possible, when he came to erect his critical Pantheon, to assign them places of any great distinction. There are those who have found this perverse, even ungrateful. He had, after all, learned so much from their rich and transparent colouring. The appeal of Tintoretto had been especially powerful – the Italian sketch-books dwell more on his disposition of chiaroscuro than on that of any other painter – and yet when he delivered his fourth Discourse, he felt obliged to remind his listeners of Vasari's tetchy strictures:

> Of all the extraordinary geniuses that have ever practised the art of painting, for wild, capricious, extravagant and fantastical inventions, for furious impetuosity and boldness in the execution of his work, there is none like Tintoret; his strange whimsies are even beyond extravagance, and his works seem to be produced rather by chance, than in consequence of any previous design, as if he wanted to convince the world that the art was a trifle, and of the most easy attainment.*

* Reynolds is quoting, somewhat freely, from Vasari's life of Battista Franco (Vasari, v, 50): 'Nelle cose della pittura, stravagante, capriccioso, presto, e resoluto, et il più terribile cervello, che habbia havuto mai la pittura, come si può vedere in tutte le sue opere; e ne' componimenti delle storie, fantastiche, e fatte da lui diversamente, e fuori dell' uso degli altri pittori: anzi hà superato la stravaganza, con le nuove, e capricciose inventioni, e strani ghiribizzi del suo intelleto, che ha lavorato a caso, e senza disegno, quasi monstrando che quest'arte è una baia.'

To praise the Venetians too highly would also, of course, have been to differ from 'the greatest of all authorities' – from Michelangelo, that is to say – and that would never do:

This wonderful man, after having seen a picture by Titian, told Vasari, who accompanied him, 'that he liked much his colouring and manner;' but then he added, that 'it was a pity the Venetian painters did not learn to draw correctly in their early youth, and adopt a better *manner of study.*'*

Crowded as his days were in Venice, Reynolds found time to make the acquaintance of the well-known landscape painter Francesco Zuccarelli – he may well have carried a letter of introduction from Richard Wilson, who is known to have been friendly with him during his time there, and who had painted Zuccarelli's portrait in exchange for one of his landscapes. Reynolds also found time to paint a portrait while he was there, setting up his easel to do so in Zuccarelli's house. The identity of the sitter is not known, but Zuccarelli, who watched Reynolds at work, was much impressed by what he saw: '*Che spirito ha quest uomo!*' he exclaimed to another onlooker – 'What spirit this man has!'†

The onlooker was a young Italian called Giuseppe Marchi, whom Reynolds had met in Rome and offered to take with him to England. Apart from a brief period when he tried to set up on his own, Marchi would give Reynolds loyal and discreet service as his chief studio assistant for forty years, laying in his pictures, painting copies, keeping some semblance of order in his sitters' books. It is not known for certain how old he was when Reynolds took him on. Farington says that in 1795 Marchi told him he was then '73 or 74'. That would establish his age in 1752 as twenty-nine or thirty, but that does not accord with an entry Reynolds made in his notebook the day after he arrived in Venice – 'The Boy begun to eat at my Lodgings.' That must refer to Marchi, and suggests that he was still in his teens. It also tallies with the account given by Northcote, who lived in Reynolds's house for some years and must have known Marchi as well as anyone – he states that he died in London in 1808 at the age of seventy-three.[48]

* Reynolds, 1959, 66. ('Dicendo, che molto gli piacevo il colorito suo, e la maniera; mà che era un peccato, che a Venezia non s'imparasse da principio a disegnare bene, e che non havessano que' pittori miglior modo nello studio', Vasari, iii, 226.)

† Encouraged by Joseph Smith, the British consul in Venice, Zuccarelli travelled to England in 1752, remained for ten years, became a foundation Royal Academician and returned for an even more successful stay between 1765 and 1771. 'Windsor Castle,' wrote Ellis Waterhouse dismissively, 'is still full of his facile works' (Waterhouse, 1953, 173).

It is also from Northcote that we know that by the time Reynolds had been in Venice for several weeks, he was beginning to feel homesick:

Being one night at the opera, the manager of the house ordered the band to play an English ballad tune as a compliment to the English gentlemen then residing in that city. This happened to be the popular air which was played or sung in almost every street in London just at their time of leaving it; by suggesting to them that metropolis, with all its connexions and endearing circumstances, it immediately brought tears into our young painter's eyes, as well as into those of his countrymen who were present.[49]

Reynolds left Venice with Marchi on 16 August and slept that night at Padua. His appetite for looking at paintings seems to have been sated – there is nothing in the notebooks about anything he might have seen in the eight days it took to reach Milan. They skirted the southern shore of Lake Garda and pressed on through Brescia and Bergamo; they broke their journey for four days in Milan and then headed for Turin and the French border.

By the time they reached Lyons, funds were running very low – Reynolds had only six *louis* left in his purse. He gave two of them to Marchi, telling him to make his way to Paris as best he could. Marchi was clearly a solid citizen; he covered the 300-odd miles on foot, arriving only eight days after Reynolds, whose four *louis* had allowed him to make the journey more quickly and in greater comfort.

Reynolds spent a month in Paris. There was no Salon to visit that autumn (it had been turned into a biennial event the previous year), but he secured a commission to paint a man called Gauthier, a *secrétaire du roi.* * It is possible that he owed this introduction to Boucher, versatile and prolific master of the rococo, who for some years past had enjoyed the enthusiastic if not always discriminating patronage of Madame de Pompadour, *maîtresse-en-titre* to Louis XV; Reynolds is known to have visited Boucher in his studio, and recalled the occasion many years later in one of his Discourses.†

Reynolds never managed to raise more than two cheers for the French school of painting: 'The French cannot boast of above one painter of a truly

* The picture is untraced, but is known by an engraving executed ten years later by Etienne Fessard (Mannings, cat. no. 708, fig. 71).

† 'When I visited him some years since, in France, I found him at work on a very large picture, without drawings or models of any kind. On my remarking this particular circumstance, he said, when he was young, studying his art, he found it necessary to use models; but he had left them off for many years.' The passage occurs in the twelfth Discourse, delivered in 1784 (Reynolds, 1959, 225).

just and correct taste, free of any mixture of affectation or bombast, and he was always proud to own from what models he had formed his style; to wit, Raffaelle and the antique.' Tom Taylor speculated that he was referring to Le Sueur, but it is equally possible that he was thinking of Poussin. Together with Le Brun, he considered them the best the French school had to offer. He did so, however, only because he regarded them as Italians under the skin. They had modelled themselves, he declared, upon the Roman, Florentine and Bolognese schools – 'and consequently may be said, though Frenchmen, to be a colony from the Roman school'.[50]

Given his conviction that Rome, Florence and Bologna were 'the three great schools of the world in the epick style', it is perhaps not altogether surprising that Reynolds could muster so little enthusiasm for the richly diverse (and highly organized) artistic life of the French capital. Watteau's admission to the Académie thirty-five years previously as a 'Painter of *fêtes galantes*' had marked the beginning of a challenge to the ascendancy of history painting. The still lifes of Chardin had become hugely popular – indeed in the very month that Reynolds reached Paris, Chardin, now in his fifties, had been granted a pension of 500 *livres* by the king. The Prix de Rome had been awarded that year to the twenty-year-old Jean-Honoré Fragonard, who had been the pupil of both Chardin and Boucher; another young man who was beginning to make waves while still a pupil at the Académie Royale was the son of a roofer from Tournus called Greuze. Hardly exponents of the grand manner.

It was during this stay in Paris that Reynolds first encountered William Chambers, the future architect of Somerset House and first Treasurer of the Royal Academy. It was a connection that was to be both important and troublesome. Chambers was the same age as Reynolds, but their backgrounds could not have been more different. Chambers, of Scottish descent, had been born in Stockholm, where the family had been established as merchants since the early years of the century.* He was sent to be educated at the grammar school at Ripon and at the age of sixteen entered the service of the Swedish East India Company. The eight years during which he progressed from cadet to supercargo convinced him that he did not wish to be a merchant, but his three voyages to the East opened his eyes to the splendours of Cathay. He made a close study of Chinese arts and manners, and came home with something of a reputation as an amateur sinologist. His ambition was to be an architect, and an agreeable perquisite of his last post as Third Supercargo allowed him to finance an ambitious scheme of professional training – when

* The firm of Chambers and Pierson supplied stores for the royal armies – a prestigious but unprofitable business, as King Charles XII was notorious for not settling his debts.

the *Hoppet* docked at Gothenburg in July 1749, the items unloaded from the hold for Chambers included numerous cases of silks and other fabrics, twenty-three chests and forty-eight tubs of tea, a writing case and a bedstead.[51]

He had gone first to study in Paris at the École des Arts under J. F. Blondel, and then, after a year, moved on to Rome, where he would remain for the next five years, living for some of the time under the same roof as Piranesi. He was spending the summer of 1752 in Paris with a young woman called Catherine Parr, from Bromsgrove, in Worcestershire – a 'milliner girl', according to the gossipy Farington. The lovers would return to Rome together in the autumn, and were married there in March 1753; a daughter, Cornelia, was born four months later. Most of Reynolds's biographers follow Northcote in saying that the portrait of Catherine Chambers, now at Kenwood, was painted when they met in Paris, but the best modern scholarship places it some years later.[52]

We do not know what Reynolds made of Chambers at this first encounter, but his future rival, the keen-eyed and ambitious Robert Adam, who arrived in Rome towards the end of Chambers's time there, etched his portrait sharply in a letter to his brother John:

All the English who have travelled for these five years (in Italy) imagine him a prodigy for Genius, for Sense & good taste . . . His Sense is middling, but his appearance is gentell & his person good which are most material circumstances. He despises others as much as he admires his own talents which he shows with a slow and dignified air, conveying an idea of great wisdom which is no less useful than all his other endowments . . .[53]

Over the next forty years Reynolds would become very familiar with the nature of those endowments, and would have cause to appreciate some of them more than others.

Meanwhile, it was time to start on the last leg of the journey home. He and Marchi did not travel alone. Some weeks earlier, as they were negotiating the pass of Mont Cenis, they had encountered Reynolds's old master, Hudson, travelling rapidly in the other direction. He was accompanied by the sculptor Roubiliac; they seem to have planned a fairly extended tour of Italy, but in the event, for whatever reason, they quickly turned about – 'Their Tour of Italy very quick and their stay very little,' George Vertue noted briskly; 'only enough to say they have seen Rome.'* Their progress

* Vertue, 161–2. Roubiliac was profoundly depressed by what he saw in Rome. On his return he went to look at some of his own sculpture in Westminster Abbey. 'By God!' he said to Reynolds, 'my own work looked to me meagre and starved, as if made of nothing but tobacco-pipes.'

was certainly rapid; they were back in Paris before Reynolds's departure. They travelled to the Channel coast together and crossed to England on the same packet boat.

4

A Sort of Sovereignty

Apart from the death of the Prince of Wales and the belated decision in 1751 to harmonize the English calendar with the continental Gregorian system ('Give us back our eleven days'), not a great deal had happened during Reynolds's absence abroad. London, it is true, had experienced two earthquakes in the course of 1750, but they had been minor. In Dublin, the Lord-Lieutenant was at loggerheads with the Irish Parliament, but there was nothing new in that. There was, wrote Horace Walpole, 'no war, no politics, no parties, no madness, no scandal. In the memory of England there never was so inanimate an age: it is more fashionable to go to church than to either House of Parliament.'[1]

The Lords and Commons had not been entirely idle, for all that. The Disorderly Houses Act received the Royal Assent and there had been new legislation to curb the effects of spirit-drinking, recently graphically illustrated by Hogarth's twin prints *Beer Street* and *Gin Lane*. The 1751 Gin Act prohibited its sale by small distillers, chandlers and grocers – workhouse masters or gaolers who went on doing so risked a fine of £100.* The Murder Act of the following year laid down that murderers were to be hanged within two days of conviction; they were not to receive burial, but were either to be hung in chains or handed over to surgeons for dissection. Another bill provided that Scottish estates forfeited in the '45 should be bestowed on the Crown, the revenue to be used for improvements in the Highlands.

Away from Westminster, the Jockey Club had been founded, and so, in rural Hampshire, had the Hambledon Cricket Club, long, if erroneously, celebrated as the cradle of the game. Bolingbroke was dead, and so was the eccentric Captain Thomas Coram, seaman, philanthropist and founder of the London Foundling Hospital. John Cleland had published *The Memoirs of a Woman of Pleasure* and Thomas Gray *An Elegy Wrote in a Country*

* The Act was surprisingly successful. Consumption of gin – also known as kill-grief, bingo, strip-me-naked and a kick in the guts – declined from more than 11 million gallons to 7.5 million within the space of a year.

Churchyard. Novels had continued to pour from the presses, as often as not in four volumes – *Peregrine Pickle* from the pen of Tobias Smollett, *Amelia* from that of Henry Fielding. In the world of the theatre, battle royal had been joined between Covent Garden and Drury Lane; the strapping Spranger Barry and the diminutive David Garrick had exhausted themselves and their audiences by playing against each other in *Romeo and Juliet* for thirteen nights on the trot. Convent Garden had also mounted *Jephtha*, yet another oratorio by Handel (it was his twentieth).

The two Gunning sisters from County Roscommon, poor as church mice but famously beautiful, had taken London by storm, and in no time at all had done extremely well for themselves in the marriage stakes.* The word 'bluestocking' had edged its way into the language. And Londoners had a new bridge across their river, a handsome span of thirteen arches, just downstream from Lambeth Palace, that had been eleven years in the building. A decade later, during his second visit to London, James Boswell would find it a convenient place to take 'a strong, jolly young damsel' he had picked up in the Haymarket: 'I conducted her to Westminster Bridge, and then in armour complete did I engage her upon this noble edifice. The whim of doing it there with the Thames rolling below us amused me much.'[2]

Reynolds reached London on 16 October. 'He found his health in such an indifferent state,' Northcote tells us, 'as to judge it prudent to pay a visit to his native air.'[3] He remained in Devon for three months. There was family to visit – his brother-in-law, John Palmer, had just built himself a handsome new house opposite the churchyard in Torrington – and old friendships to be refreshed: in Plymouth he painted a Rembrandtesque study of John Mudge, now a rising physician.† Northcote says that he was strongly urged by Lord Edgcumbe 'to return, as soon as possible, to the metropolis, as the only place where his fame could be established and his fortune advanced'. It seems unlikely that much persuasion was required. By the early weeks of 1753 he was once more established in St Martin's Lane, eager for commissions. His youngest sister, Frances, came up from Devon to act as his housekeeper.

One of the first portraits he painted after his return to London was of Giuseppe Marchi.[4] This too, like the Mudge portrait, carries echoes of

* The elder, Maria, had married the Earl of Coventry. The younger, Elizabeth, did even better for herself. She married first, James, Sixth Duke of Hamilton, and after his death the Marquess of Lorne, later the First Duke of Argyll. Reynolds would paint them both.

† Mannings, cat. no. 1308, fig. 60. The picture, which Reynolds presented to his friend, is in a private collection. Mudge's work on smallpox inoculation would bring him, in 1771, a Fellowship of the Royal Society. His three marriages would produce twenty children.

Rembrandt. The boy wears a red coat and a striking white turban; Hudson, seeing in it little trace of anything he had taught his former pupil, is said to have exclaimed, 'By God, Reynolds, you don't paint so well as when you left England!'[5] Another visitor curious to see the Marchi portrait was John Ellys, a painter then in his early fifties who had been a pupil of Thornhill's and was very much of the old school. 'Ah! Reynolds, this will never answer,' he declared. 'Why you don't paint in the least degree in the manner of Kneller.' When Reynolds showed some disposition to argue the toss, Ellys, unaccustomed to debating such matters with his juniors, flew into a rage. 'Shakespeare in poetry, and Kneller in painting, damme!' he cried, and ran from the room.*

Reynolds struck an even more powerful blow against the Kneller tradition with a portrait of his friend Augustus Keppel. He had painted him once before, either shortly before leaving England, or perhaps during his time in Port Mahon.[6] Now, possibly as an expression of gratitude, he painted the famous full-length which made his name.[7] In the biographical essay with which he prefaced his edition of Reynolds's *Works* in 1797, Malone declared that it exhibited such powers 'that he was acknowledged to be the greatest painter that England had seen since Vandyck'. Keppel, lean and vital, strides boldly along a stormy shore. The setting presumably alludes to the wreck of the *Maidstone* some years earlier. The picture is dramatically lit – Reynolds had not forgotten what he had learned only a few months earlier in Venice from Tintoretto.

Years later, in his second Discourse, Reynolds divided the study of painting into three distinct periods. The first was confined to the rudiments. In the second, it was the business of the student to learn all that had been known and done before his own time. Only then, after this term of 'subjection and discipline', will the student move forward into the freedom of maturity:

The third and last period emancipates the Student from subjection to any authority, but what he shall himself judge to be supported by reason . . . He is from this time to regard himself as holding the same rank with those masters whom he before obeyed as teachers; and as exercising a sort of sovereignty over those rules which have hitherto restrained him.[8]

It was with *Keppel* that Reynolds himself began to exercise that sovereignty. It is also possible, as David Mannings has pointed out, to see in it the first

* Northcote, i, 54. Ellys had succeeded Mercier as Principal Painter to the Prince of Wales in 1736, but no longer did much painting. Walpole retained him for advice and to buy pictures, rewarding him with the sinecure of Keeper of the Lions in the Tower. He died in 1757.

stirrings of that tempestuous force that was to burst forth in the Romantic era in the portraits of Goya and Lawrence.[9]

Not that it was a matter of having it all his own way. Hudson continued to enjoy significant patronage after his return from Rome, commissions often coming from those who had thought highly enough of earlier work to wish to sit a second time – these included Handel, Admiral Byng and Philip Yorke, Earl of Hardwicke. He also painted a number of large group portraits, including that of the Third Duke of Marlborough and his family. In 1752, at £80 a year, he was still charging the highest rate for an apprentice of any painter in London.

Rivalry with Romney and Gainsborough lay in the future. Romney, not yet out of his teens, was still working in his father's cabinet-maker's business in the Lake District; another two years would pass before he signed indentures with the itinerant painter Christopher Steele at Kendal. Gainsborough, who had returned to Suffolk in the late 1740s to help wind up his father's estate, had been making a living of sorts, mainly from portraits, in Sudbury, but in 1752 he had moved to Ipswich, then a flourishing market town and a prosperous port trading with the continent. A population of 10,000 promised richer pickings, but these were slow in coming. 'I call'd yesterday upon a Friend in hopes of borrowing money to pay you, but was disappointed,' he wrote to his landlady in 1753; 'I'm sorry it happens so but you know I cant make money any more than yourself.'*

Reynolds, comfortably established in St Martin's Lane, could write in a very different vein. 'I find I have but a little room left so must tell you as fast I can who of the principal people that I have drawn and leave you to conclude the rest' (this at the conclusion of a long gossipy letter which he wrote early in June to Wilton in Florence):

I have finished the head of the Duke of Devonshire he himself and all the family say it is the only like picture he ever had of himself there are many copies bespoke, I have drawn a whole length of Ld. Anson and another of Commodore Kepple and his brother Ld. Bury: Ld. & Lady Kildare who is thought the handsomest woman in England. Lord & Lady Carisfort Mr Fox the Secretary at war The Ld. Godolphin and this week the Duke of Grafton is to sit I am told that the Prince of Whales intends to come and see my Pictures. I could mention more pictures but have no more room . . .[10]

* Hayes, 2001, letter 1. Gainsborough had clearly been living beyond his means for some time. When he married Margaret Burr, an illegitimate daughter of the Duke of Beaufort, in 1746, she brought with her an annuity of £200, but there is evidence that by 1751 the annuity was being used as security for substantial loans. See Rosenthal; and Sloman, 47–58.

It was a remarkable beginning; it was, after all, less than six months since he had set up his easel. The poet William Mason, whom Reynolds got to know during these early London days, says that it was Lord Edgcumbe who persuaded many of the 'first nobility' to sit. Devonshire and Grafton and the Kildares* might certainly be so described, but Carysfort came rather lower in the pecking order – he was John Proby, the MP for Stamford at the time and his barony, in the Irish peerage, dated only from the previous year.† Reynolds may well have owed the commission to paint Anson to Keppel.

Reynolds added several postscripts to his letter to Wilton. 'Liotard is here,' he wrote, 'and has vast business at 25 Guineas a head in crayons.'‡ Jean-Etienne Liotard had been born in Geneva, the child of Huguenot parents who had settled there after the Revocation of the Edict of Nantes. Since the mid-1730s he had led a peripatetic life, travelling widely throughout Europe and the Levant. Seduced by the charm of Eastern dress, he had taken to wearing it himself; a beard down to his waist completed his exotic appearance, and if some thought him a charlatan, he none the less attracted a gratifying flow of commissions. During four years in Constantinople he had painted pastel portraits of many members of the British colony; in Vienna he had found favour at the court of Maria-Theresa and in Paris he painted Louis XV and his five daughters.

He was an instant success in London: this despite another of his peculiarities, which was that he objected strongly to the use of cosmetics.§ His portraits, simply lit and totally without embellishment, achieved a startling likeness: Cromwell's injunction to Peter Lely – to 'remark all these roughnesses, pimples, warts and everything' – would in Liotard's case have been quite unnecessary.¶ Reynolds was hugely jealous; he seemed, wrote Northcote, 'to have been annoyed by the great celebrity of a very mean competitor' and gave vent to some pettishness:

* Kildare, son of the Nineteenth Earl, later became the First Duke of Leinster; his wife was the daughter of the Second Duke of Richmond and Lennox.

† Carysfort later served as a Lord of the Admiralty, but his passion for gambling eventually got the better of him and he went abroad to escape his creditors. He died at Lille in 1772. His portrait is in the Elton Hall Collection, Cambridgeshire (Mannings, cat. no. 1493, fig. 140).

‡ Another PS indicated that the arrangement with Marchi had got off to a bumpy start: 'Giuseppe is grown so intollerably proud that I fear we shall not keep long together he is above being seen in the streets with any thing in his hand.'

§ He declined to paint one lady's portrait on the grounds that 'he never copied any works but his own and God Almighty's'.

¶ The portraits which he painted of Augusta, Princess of Wales, and all her nine children, are in the Royal Collection at Windsor. 'The fact that one can discern which of the children had adenoids,' wrote Ellis Waterhouse, 'is perhaps more interesting to posterity than it was to contemporaries' (Waterhouse, 1953, 244).

The only merit in Liotard's pictures is neatness, which, as a general rule, is the characteristic of a low genius, or rather no genius at all. His pictures are just what ladies do when they paint for their amusement.*

'The Turk', as he was called, did not remain long to disturb Reynolds's tranquillity. In 1755 he removed to Holland, where he found himself a wife, although he returned to London two decades later and exhibited several times at the Royal Academy.

Reynolds may also occasionally have glanced uneasily at an English painter two or three years younger than himself who was a good deal influenced by Liotard. This was Francis Cotes, whose father, an apothecary by trade and a former mayor of Galway, had settled in London. He had been apprenticed to George Knapton, and his early pastels, in the late 1740s, attracted attention by their sharpness of outline and brilliant colouring. He had enjoyed great success during Reynolds's absence in Italy with his portraits of the Gunning sisters, which had reached a wide public through engravings, and he was now beginning to extend his practice to oils. Horace Walpole compared his work to that of Rosalba Carriera, whose crayon portraits were extremely popular with Grand Tourists in Venice, while Hogarth – who was probably being malicious – said that he was a better portrait painter than Reynolds.

There were those who said the same about another near contemporary of Reynolds, Benjamin Wilson, who had recently installed himself in Kneller's old house in Great Queen Street and built up an enviably lucrative practice. His Rembrandtesque use of chiaroscuro was not unlike that of Reynolds; indeed as late as 1759 a man named John West, who had called at Reynolds's studio to see a work in progress, reported enthusiastically about his visit to his friend Lord Nuneham. The painting, he wrote, was quite charming – 'almost as well as Wilson could have done'.[11]

Wilson cut an unusual figure among his fellow painters. He was the son of a wealthy clothier in Leeds whose business had failed. When he first came to London he had worked for a pittance as a clerk. He is thought to have spent some time in Hudson's studio; subsequently, egged on by Hogarth, he enraged and humiliated Hudson, who prided himself on his discernment as a connoisseur, by slipping a fake into a portfolio of genuine Rembrandt etchings. Fortunately perhaps for Reynolds, Wilson's interests ranged beyond portraiture. He published several treatises on electricity, and was

* Northcote, i, 60. Northcote says that Liotard had made the acquaintance at Constantinople of Dick Edgcumbe; it is possible that this contributed to Reynolds's jealousy.

elected to the Royal Society. He became involved in a lengthy controversy with Benjamin Franklin on the question of whether lightning-conductors should be round or pointed at the top.* By the time he died in 1788, he was lodged in the public mind more as a scientist than a painter.

It was also Reynolds's good fortune that when he was beginning to establish himself in London, the most elegant portrait painter of the day had temporarily removed himself from the scene. Allan Ramsay, a widower since 1743, had spent most of the winter of 1751–2 in his native Edinburgh. He had formed there an attachment to Margaret Lindsay, the elder daughter of Sir Alexander and Lady Lindsay of Evelick, in Perthshire; when it emerged that they disapproved of the association, the couple eloped, and were married at the Kirk of the Canongate in Edinburgh's Royal Mile.† Ramsay and his wife returned to London, but they left the capital again for Edinburgh towards the end of 1753, and remained there until Ramsay embarked on his second visit to Italy in the summer of the following year.‡

Apart from these domestic preoccupations, Ramsay was also at this period as busy with his pen as with his brush. In the course of 1753 he turned author, and made his debut with two extended essays. The first, 'On Ridicule', was concerned with the propriety of the use of ridicule as a test of truth, a question much debated at the time. The second, 'Letter from a Clergyman', was a refutation of a pamphlet by Henry Fielding, who had been involved in his capacity as a magistrate in the notorious Canning case, in which a brothel-keeper and an old gypsy had been convicted on a charge of abduction. The judgment was eventually quashed, and the 'victim' transported for perjury. Ramsay's intervention was seen as chiefly responsible for the overturning of the verdict; his pamphlet came to the attention of both Diderot and Voltaire, and the latter commended him as a *philosophe*.[12]

Self-portrait Frowning, Self-portrait in a Gorget, Self-portrait at the Age of Thirty-four – Simon Schama, pondering the 'exhaustive archive of his face' that Rembrandt left to posterity, wrote of 'a forty-year soliloquy'.[13]

* He won support for his view on this matter from George III, who, after he had ascertained that he was not the landscape painter Richard Wilson, declared his experiments were sufficient to convince the apple-women in Covent Garden.

† Ramsay's portrait of his second wife, perhaps his best-known work, is now in the National Gallery of Scotland in Edinburgh. Robert Adam, who got to know her well in Rome, described her as 'sweet, agreeable, chatty body' (Scottish Record Office, GD 18/4768: Robert Adam to Helen Adam, Rome, 22 March 1755).

‡ He did not return from Italy until August 1757.

Reynolds did not soliloquize to anything like the same extent, although he did paint himself on more than two dozen occasions. The particular interest of the self-portrait he completed at this time – the first after his return from Italy – is that Northcote considered it the one which caught the best likeness.[14]

He permitted himself little time, however, for gazing at the reflection of his own features. He was ferociously busy. He later claimed that for many years, he had 'laboured harder with his pencil than any mechanic had ever worked at his trade for bread'.[15] His industry was driven by an ambition that was no less intense for being largely dissembled. Northcote recalled that Reynolds used to say of himself, when young, 'that if he did not prove to be the best painter of his time when he arrived at the age of thirty years he never should be'.[16] That was the age he had now reached, and the commissions were coming thick and fast. There was young George Harcourt, baby-faced in his dark Van Dyck dress, later the Member of Parliament for St Albans and the Second Lord Nuneham;[17] Henry Vansittart, already, in his early twenties, rich from service in the East India Company, a close friend of Robert Clive's and later Governor of Bengal;[18] Lord Cathcart, an officer in the Guards who had been aide-de-camp to the Duke of Cumberland at Fontenoy.[19]

Cathcart was very proud of the wound he had received there ('It is not often a man has had a pistol bullet through the head and lived') and was insistent that the patch he wore on his cheek be prominently displayed. A letter survives which indicates that sitter and painter did not altogether see eye to eye:

Again with Mr Reynolds, and was disagreeably surprised with the figure. After some reasoning he came to be of opinion that it would not do. I breakfasted with him and stood to him a good while. I thought it was much improved, and he was extremely satisfied with the alteration so we parted in great good humour.*

Six months later, an entry in Cathcart's account book records a payment for the picture of £31, which was very much in line with Reynolds's charges for a half-length portrait at the time. He did not always see his money so quickly. Some time between 1758 and 1760, for instance, he painted Lord Beauchamp, later the Second Marquess of Hertford, as an Eton leaving portrait.[20] Payment was made only in 1792 – to Reynolds's executor, several weeks after his death. Hardly surprising, therefore, that Reynolds should

* Historical Manuscripts Commission, Rep. 2, vol. 1, Appendix, 28–9. Cathcart was later ambassador to Moscow and served for many years as Lord High Commissioner to the General Assembly of the Kirk of Scotland.

have made it his practice to ask that half the price of a portrait be paid at the first sitting.*

He did not stay long in St Martin's Lane. Before the end of 1753 he moved to a house on the north side of Great Newport Street, and in the absence of a wife, he continued to rely on his sister for help with his domestic arrangements.

Whether Reynolds ever seriously contemplated marriage is, like so much else about him, unknown. He had told Miss Weston he was her slave, but after his return from Italy, we hear of her no more. Would he, in middle life, fall at the feet of a young sitter and ask for her hand? Was there a rich widow in the frame for a time? Did he keep a mistress? Conduct the occasional affair with an aristocratic sitter? Rumour would swirl about him from time to time over the years, and he would provide much grist to the mill of the gossips and the matchmakers (when he was fifty-nine, the bluestocking Elizabeth Montagu thought he would do very nicely for the thirty-year-old Fanny Burney).

Eligibility and inclination, however, do not always march together. Many years later Boswell recorded in his journal an intriguing exchange between Malone and Reynolds as the three of them sat over their wine in the small hours of a Sunday morning. The conversation had turned to love and marriage, and Malone (a man at that time in his forties and, like Reynolds, a bachelor) had maintained that 'a man has the same fondness as a lover for a woman who has been for years his own as for the finest woman whom he has never possessed'.† Boswell, something of an authority on such matters, found this a strange assertion, and was supported by Reynolds:

Sir Joshua justly observed that admitting this was setting aside two of the strongest principles of human nature: desire of preference and novelty, which were given us for wise purposes. He said that something else very comfortable, very valuable, came in place of fondness when there had been possession; there was then affection, friendship.

Those are hardly the words of a man whose adult life has been characterized by monkish abstinence (the conversation took place in 1788, shortly after

* Henry Angelo records that Gainsborough told George III that he was obliged to complete his portraits because he had received 'sums in advance'. 'Aye, aye,' replied the king, 'a good custom that – first set on foot, by Sir Joshua – hey? an excellent custom . . . professional men cannot be too punctilious on these matters' (Angelo, i, 355).

† Malone had suffered an 'unfortunate attachment' when practising at the Irish bar as a young man; he grieved over the woman in question for the rest of his life.

Reynolds had passed his sixty-fifth birthday). He added something even more revealing:

He said the reason why he would never marry was that every woman whom he had liked had grown indifferent to him, and he had been glad that he did not marry her. He had no reason therefore to suppose that it would not be the same as to any other woman.[21]

What is Reynolds actually saying here? Those who have paused over the passage have usually taken it to mean that it was the women who came to feel indifferent to him, but Richard Wendorf, in his penetrating study of the ambivalent, 'carefully constructed character' he believes Reynolds to have been, argues that it could equally mean the converse. And it is a reading for which he could call the editors of the *Oxford English Dictionary* in evidence – we may, that is to say, be *subjectively* indifferent to people or things which are *objectively* indifferent to us.[22]

This is ammunition for those who argue that Reynolds was temperamentally a bit of a cold fish – 'not much a Man to my natural Taste', as Hester Thrale would write; 'he seems to have no Affections, and that won't do with me'.[23] Against that, it can be contended that he was simply undemonstrative, and that whatever the nature and strength of his feelings, he did not find it easy to express them. 'I never was a great professor of love and affection,' he once wrote poignantly to his niece Theophila, 'and therefore I never told you how much I loved you, for fear you should grow saucy upon it.'[24]

It is also possible that Reynolds shied away from marriage because of what the unlovely language of a later age might term his workaholic tendencies. When the talented young Irish painter James Barry was studying in Rome in the late 1760s (his journey had been financed by Edmund Burke), Reynolds wrote him a long letter full of friendly advice:

Whoever is resolved to excel in painting, or indeed in any other art, must bring all his mind to bear on that one object, from the moment he rises till he goes to bed; the effect of every object that meets a painter's eye, may give him a lesson, provided his mind is calm, unembarrassed with other subjects, and open to instruction.*

His pupils became accustomed to the same refrain. 'Those who are determined to excel,' he used to tell them, 'must go to their work whether willing

* Letter 22. Reynolds added an apologetic PS: 'On reading my letter over, I feel it requires some apology for the blunt appearance of a dictatorial style in which I have obtruded my advice. I am forced to write in a great hurry, and have little time for polishing my style.'

or unwilling, morning, noon, and night, and will find it to be no play, but, on the contrary, very hard labour.'[25]

Northcote told Ward that Reynolds seldom took exercise:

So closely was his day spent in his professional employment, that if by any chance he found himself in the street during the middle of the day, he felt ashamed, and thought everybody was looking at him.[26]

It was in the street one day that he encountered the promising young sculptor John Flaxman, who had been exhibiting at the Royal Academy since he was fifteen and was now beginning to make a name for himself by designing ceramic plaques and medallions for Josiah Wedgwood. Flaxman had with him a young woman, who walked on as the two men paused to speak. Reynolds inquired who his companion was, and the newly married Flaxman told him it was his wife. 'What, are you married?' cried Reynolds. 'Then your improvement is at an end.'*

Frances Reynolds was a young woman in her mid-twenties when she came to London to keep house for her brother. The authoress Ellis Cornelia Knight, whose mother knew Frances well, described her in her auto-biography:

She was an amiable woman, very simple in her manner, but possessed of much information and talent, for which I do not think every one did her justice, on account of the singular naïveté which was her characteristic quality, or defect, for it often gave her the appearance of want of knowledge.†

Fanny Burney, who saw her at closer quarters, was less charitable. 'I fear I have lost all reputation with her for dignity,' she wrote on one occasion, 'as I laughed immoderately at her disasters.'[27] Later, describing her as 'living in an habitual perplexity of mind, and irresolution of conduct', she would be even more severe:

Whatever she suggested or planned, one day, was reversed the next; though resorted to on the third, as if merely to be again rejected on the fourth; and so on, almost

* Farington, 1978–84, vi, 2144. Flaxman need not have worried. He went off to Rome some years later, and returned an international celebrity – Goethe called him 'the idol of all dilettanti'. His life-size marble statue of Reynolds was erected in St Paul's in 1813.

† Knight, 1960, 26. Knight (1757–1837) was for some years companion to Queen Charlotte, and later to Princess Charlotte – a change of allegiance at which the queen took mortal offence. As well as her autobiography she wrote a number of romantic tales.

endlessly; for she rang not the changes on her opinions and designs in order to bring them into harmony and practice; but wavering to stir up new combinations and difficulties; till she found herself in the midst of such chaotic obstructions as could chime in with no given purpose, but must needs be left to ring their own peal, and to begin again just where they began at first.[28]

Frances wrote poetry, painted miniatures and would later exhibit several canvases at the Royal Academy. She seems to have been unhappy in love – the villain of the piece was a 'Mr B'. A commonplace book survives in which she unburdens herself in verse perhaps most kindly described as proto-romantic:

> . . . Beneath the guise of friendship fair
> Cupid concealed his subtle snare
> But soon I felt the smart,
> 'Tis three years since nay more 'tis four
> Since first I felt its cruel power
> Since first I lost my Heart . . .

She would run her brother's household for the best part of a quarter of a century, and would be on friendly terms with many among his large acquaintance, but her relations with Reynolds gradually deteriorated. Some time in the late 1770s he would eventually send her packing and install one of their nieces in her place.

It is noticeable that from this time Reynolds began to attract an increasing number of female sitters. The appearance of David Mannings's splendid Catalogue makes it possible to study the chronology of Reynolds's portraits much more rigorously than before. One thing it confirms is that in the early 1750s he was still open to an eclectic range of influence and experimenting with a wide range of styles. Lord Cathcart, clearly well content with the prominence given to his patch, sent his wife and baby daughter along to Great Newport Street. Ellis Waterhouse saw the result – the picture now belongs to the Manchester City Art Galleries – as an exercise in the style of Batoni. It is certainly striking – a Madonna-like mother, a pudgy child with not very much hair (married at twenty to the Duke of Atholl), a heraldic-looking greyhound in support.[29]

Quite different in style is a portrait of a young woman named Sarah Stanley, later the wife of a lawyer called Christopher D'Oyly.[30] She wears a grey masquerade dress in a style that would have been fashionable more than a century earlier and carries a pink feather fan; Mannings sees the

frontal pose and the arangement of the hands as clearly derived from Rubens's *Susanna Fourment*.

So pleased was Reynolds with the half-length he painted in 1754 of a daughter of Earl Fitzwilliam[31] that he wrote on 14 July to the sitter's mother to request a favour:

My Lady

I ask pardon for keeping Lady Charlot's Picture so long, my time haveing been so much taken up in heads that I have scarce been able to do any drapery to any of my Pictures, but Lady Charlots is now finish'd and will be fit to be sent away in threeweeks time as it will take that time before it is thoroughly dry so as to be sent away without danger. I hope it will meet with your Ladyships approbation as it has of every body that has seen it, and that I am very proud of it myself the request I am going to make your ladyship will show, which is to beg the liberty of having a Mezzotinto Print from it, which will be finish'd whilst the Picture is drying, so that it will not be detain'd on that account. If your Ladyship has no objection to having a Print taken from it I shall beg the favour to know what is to be writ under the Print.[32]

Although Lady Charlotte was a girl of eight at the time, she holds up her muslin chemise in what Nicholas Penny has described as 'a manner more appropriate for adult sitters with a bosom to conceal – or reveal'.[33] Lady Fitzwilliam was unconcerned, and the engraving was made by James McArdell – probably the first to be made after any of Reynolds's pictures, and the only one which he himself published.

Penny speculates that he may have had to pay McArdell as much to engrave the plate as he was paid for painting the picture. He knew it was worth it. McArdell was the best-known of a number of Irish engravers active in London at that time. He had come over from his native Dublin in 1746, and within a few years was publishing his own prints at the Golden Head in Covent Garden. His engraving of Ramsay's portrait of Flora Macdonald had achieved wide popularity, and he had also engraved Hogarth's *Captain Coram*. By the time of his early death in 1765 he would have engraved more than forty of Reynolds's portraits. John Thomas Smith, a pupil of Nollekens and later Keeper of the Prints and Drawings in the British Museum, recorded that he had often heard Reynolds declare that McArdell's engravings 'would perpetuate his pictures when their colours should be faded and forgotten'.*

* Smith, John Thomas, 1828, ii, 292. Reynolds returned the compliment – his portrait of McArdell now hangs in the National Portrait Gallery in London (Mannings, cat. no. 1235, fig. 213).

Engravings were valued by sitters, who were able to distribute prints of their portrait to friends – we know from Reynolds's ledgers and pocketbooks that he sometimes arranged this. Their main interest to painters, however, was as a means of publicizing their work, and over the four decades of his working life, something like 400 'authorized' engravings after Reynolds would be issued.* The print trade grew phenomenally as the century wore on, and prices rose rapidly. 'Another rage is for prints of English portraits,' Horace Walpole wrote to Horace Mann in 1770. 'I have been collecting them for thirty years, and originally never gave for a mezzotinto above one or two shillings. The lowest is now a crown; most from half a guinea to a guinea.'[34]

Reynolds retained a strong preference for mezzotint over line engraving, no doubt because the process is tonal rather than linear and works from dark to light – it was, he told Smith, the style 'best calculated to express a painter-like feeling, particularly in portraits'.[35] He made use in all of some twenty engravers, and their work greatly contributed to the dispatch of business in his studio:

He kept a port-folio in his painting room, containing every print that had been taken from his portraits; so that those who came to sit, had this collection to look over, and if they fixed on any particular attitude, in preference, he would repeat it precisely in point of drapery and position; as this much facilitated the business, and was sure to please the sitter's fancy.[36]

Another female sitter during 1754 was Mrs Hugh Bonfoy – she had figured as one of the children in the Eliot family group which Reynolds had painted before going off to Italy.† She was now the wife of a naval officer and a Lady of the Bedchamber to the elder princesses. Assured but thoughtful, she gazes out to the left of the picture; the pose, which Reynolds was to employ more than once, unmistakably echoes one used by Van Dyck in several of his male portraits.[37]

This too was engraved as a mezzotint, which suggests that Reynolds was not displeased with it, although the right hand is placed rather oddly. The delicate painting of Mrs Bonfoy's light-blue dress with its pink bows also suggests that in this, as in Lady Charlotte's picture, he had made use of the services of Peter Toms.

The son of a well-known engraver, Toms was five years younger than

* The equivalent number for Gainsborough was about forty-five, and for Romney a little over 100. See the important article by Antony Griffiths in *Gainsborough and Reynolds in the British Museum*, London, 1978.

† See p. 35 above.

Reynolds, and had also passed through Hudson's studio. He had been appointed Portcullis Poursuivant in the College of Heralds in 1746, and two years later he is mentioned in the *Universal Magazine* as an 'eminent painter', although such references must be treated with some caution; the art of puffing was not confined to the world of the theatre. What is certain is that since the death of van Aken in 1749 he had been getting a lot of work as a drapery painter. For some years now he would embellish many of Reynolds's portraits. He was recognized as one of the best in the business (he would later be employed by both Cotes and Benjamin West), although Northcote records that difficulties sometimes arose; what he terms the 'manner of Toms's pencilling' did not always harmonize with Reynolds's style – 'it was heavy and wanted freedom, so that his work had too much the appearance of having been done with a stamp, as the paper-hangings for rooms are executed'.

On one occasion a misunderstanding which arose over a full-length portrait of a lady was aggravated by Reynolds's deafness:

Instead of painting her in a rural habit, as Sir Joshua had designed, he had turned it into a dress of state. When Sir Joshua saw the picture, he expostulated with Toms, and told him that it would not do by any means, and, in short, that he must paint it all over again. Toms refused, saying he had worked upon the drapery till his heart ached, and he could do no more to it; adding 'you ought to be more explicit when you give the pictures into my hands.' Sir Joshua said the drapery did not accord with the head. Toms answered, 'that is because your heads are painted on a diminished scale.' When Sir Joshua, mistaking him, in a great alarm cried out, 'What! do you say that I paint in a little manner? did you say mine is a little manner?' 'No,' replied Toms, 'but I say that your heads are less than the life.'*

A year or so after the move to Great Newport Street Reynolds painted Robert d'Arcy, the Fourth Earl of Holdernesse. At the age of twenty-six he had been sent to the Republic of Venice as ambassador; seven years later, in 1751, he had succeeded the Duke of Bedford as Secretary of State for the Southern Department. Horace Walpole described him as 'that formal piece of dulness', a view which the portrait, now in the Museum of Western Art in Tokyo, seems to confirm.[38] The picture is interesting, however, because a detailed account has come down to us by somebody who watched Reynolds at work on it. Holdernesse had recently appointed William Mason,

* Northcote, ii, 28. Reynolds was not knighted until 1769, but Northcote was writing long after the event. The story must have gone the rounds over the years. Northcote did not come to London until 1771, and by that time Toms was no longer working for Reynolds.

Cambridge poet and friend of Gray,* to be his chaplain, and presented him to a living in Yorkshire of which he was the patron. He also now employed him to arrange the times of his sittings, and when Reynolds suggested he might like to be present during them Mason, who himself dabbled in oils, did not need to be asked twice:

On his light-colored canvas he had already laid a ground of white, where he meant to place the head, and which was still wet. He had nothing upon his palette but flake-white, lake, and black; and, without making any previous sketch or outline, he began with much celerity to scumble these pigments together, till he had produced, in less than an hour, a likeness sufficiently intelligible, yet, withal, as might be expected, cold and pallid to the last degree. At the second sitting, he added, I believe, to the three other colours, a little Naples yellow; but I do not remember that he used any vermilion, neither then or at the third trial; but it is to be noted that his Lordship had a countenance much heightened by scorbutic eruption. Lake alone might produce the carnation required. However this be, the portrait turned out a striking likeness, and the attitude, so far as a three-quarters canvas would admit, perfectly natural and peculiar to his person, which at all times bespoke a fashioned gentleman. His drapery was crimson velvet, copied from a coat he then wore, and apparently not only painted but glazed with lake, which has stood to this hour perfectly well, though the face, which, as well as the whole picture, was highly varnished before he sent it home, very soon faded, and soon after the forehead particularly cracked, almost to peeling off, which it would have done long since, had not his pupil Doughty repaired it.†

Reynolds would become notorious for his 'flying colours', as they were sometimes called. Northcote describes an occasion – he was presumably Reynolds's pupil at the time, which places it twenty years or so after the painting of the Holdernesse portrait – when he plucked up his courage and tried to convince his master of the error of his ways:

I once humbly endeavoured to persuade Sir Joshua to abandon those fleeting colours, lake and carmine, which it was his practice to use in painting the flesh, and to adopt

* Gray, who for some reason called him 'Scroddles', wrote to a friend that Mason 'reads little or nothing, writes abundance, and that with a design to make a fortune by it'. Leslie Stephen, in the *Dictionary of National Biography*, described him as 'a man of considerable abilities and cultivated taste, who naturally mistook himself for a poet'. He was considered for the laureate-ship on the death of Colley Cibber in 1757; his poetry was parodied by Colman the Elder and Robert Lloyd in their 'Odes to Obscurity and Oblivion'.

† William Doughty was a Yorkshireman whom Reynolds took on as a pupil in 1775 on Mason's recommendation. Mason's familiarity with the painting is explained by the fact that Holdernesse later made him a present of it. The text of his MS is included in Cotton, 1859, 49–59.

vermilion in their stead as infinitely more durable; although not, perhaps, so exactly true to nature as the former. I remember he looked on his hand and said 'I can see no vermilion in flesh.' I replied, 'but did not Sir Godfrey Kneller always use vermilion in his flesh colour?' when Sir Joshua answered rather sharply, 'What signifies what a man used who could not colour. But you may use it if you will!'*

It was towards the end of Northcote's pupillage in 1775 that Reynolds painted the lovely – if slightly faded – picture of little Jane Bowles that is now in the Wallace Collection.[39] The child sits on the ground, clutching a somewhat apprehensive-looking pet dog in an affectionate half-Nelson. Her parents had been inclined to give the commission to Romney, who had just returned from two years in Italy and was very much the flavour of the month, but the wealthy young connoisseur Sir George Beaumont tried to steer them towards Reynolds, who was a close friend. 'But his pictures fade,' the parents objected. 'No matter,' Beaumont replied, 'take the chance; even a faded picture from Reynolds will be the finest thing you can have.'†

Sir William Lowther, who had figured in *The Parody on the School of Athens* and three of the smaller caricatures Reynolds painted in Rome, sat to him again in 1754,‡ and it seems likely that it was in the same year that Reynolds made a start on the portrait of Charles Churchill which now hangs in the National Gallery of Canada in Ottawa.[40] Churchill was the natural son of General Charles Churchill, the younger brother of the First Duke of Marlborough; his mother was the celebrated actress Anne Oldfield. When the picture was restored in 1970, Mervyn Ruggles, who carried out the work, made an interesting discovery. The portrait had been painted on a commercially prepared canvas primed with a light-grey ground – an indication, that is to say, that Reynolds was now so busy that he was no longer preparing his own canvases, but buying them already mounted on a stretcher-frame.[41]

* Northcote, ii, 18. In Reynolds's day the chemistry of paints was only imperfectly understood. For an authoritative account of his often bizarre use of pigments and the impermanence which resulted from it, see 'All Good Pictures Crack', by M. Kirby Talley, Jr, in Penny, 1986 (catalogue).

† Beaumont (1753–1827) was a passionate admirer of the works of Claude. He was so attached to his *Landscape with Hagar and the Angel*, which he acquired in 1785, that it accompanied him on his travels in a special case fitted to his coach. He was also a patron of literature, and fostered the careers of Wordsworth and Coleridge. Towards the end of his life, he orchestrated a powerful campaign which was instrumental in the creation of the National Gallery in London. Reynolds's portraits of Beaumont and his wife (Mannings, cat. nos. 144 and 145, figs. 1505 and 1310) are in the Frick Art and Historical Center at Clayton, Pittsburgh.

‡ Mannings, cat. no. 1146, fig. 106. Sir William died of a fever two years later at the age of twenty-nine. He left large legacies to many of his friends, quite a number of whom ordered replicas of the portrait.

From the beginning of 1755 it suddenly becomes much easier to piece together the detail of Reynolds's daily life, because it is from that year that we can puzzle over the invaluable series of pocketbooks which he kept for a period of more than thirty years – blots, erasures, cancellations and all.

There were numbers of such books on the market. Reynolds's first came from the publisher Robert Dodsley:

THE NEW
MEMORANDUM BOOK
IMPROV'D:
OR, THE
GENTLEMAN AND TRADESMAN'S
Daily Pocket Journal
For the Year 1755[42]

The books measure about 16 × 10 cm. Each week was allotted a two-page spread, with columns headed 'Appointments.' and 'Occasional Memor-andums.' on the left, and on the right 'WEEK's ACCOUNT.' 'Received.' and 'Paid.' Reynolds did not pay too much attention to this layout. Sitters generally occupied the whole of the left page, and occasionally, at busy times, had to be accommodated on the right; the rest of the pages on the right are mainly given over to notes to himself – a scrawled address, a reminder of how a particular picture is to be framed. Accounts were gener-ally entered separately in his ledgers,[43] which are a good deal easier to decipher. At the back of the book there is a sort of potted *Whitaker's Almanack* – weights and measures, transfer and dividend days at the bank, the names of the members of both Houses of Parliament, exchange rates for Louis d'Ors and Pistoles and Portugal Pieces.

It is clear from this first pocketbook that the press of business was now intense. He was normally at work by nine, and the appointments followed each other until late afternoon – at this period he usually dined at four o'clock. He quite often painted on a Sunday – something of which his sister Frances did not keep her disapproval to herself. Sittings rarely lasted more than an hour, but he required quite a number to complete a portrait: when John Wesley sat to Romney later in the century, he wrote in his journal, 'He struck off an exact likeness at once, and did more in one hour than Sir Joshua did in ten.'*

This was partly because Reynolds could never leave well alone; he was

* Entry dated 5 January 1789. Wesley was relying on hearsay; he never sat to Reynolds.

not receptive to the old adage about the best being the enemy of the good. Northcote told James Ward that there was scarcely a picture Reynolds painted while he was his pupil that was not better at some stage during its progress than when he finally left off:

He was never satisfied; anything he did appeared nothing in his own eyes, compared with what he thought it ought to be . . . I have heard him beg and pray of his sitters to come again and again, for he longed to have another trial, and another still. He used to say to me, 'Whilst working on my pictures I could go on for ever, but when once they are gone from me I care not if I never see them again.'[44]

There were, on the other hand, occasions when he seems to have worked with great dispatch. In August 1773, for instance, he began to paint an allegorical picture featuring his friend James Beattie. Beattie, who was professor of moral philosophy at Marischal College, Aberdeen, appears in his doctoral robes and a female personification of Truth is shown driving three demons down to perdition (Beattie identified them as Prejudice, Scepticism and Folly). There appears to have been only one sitting, and Beattie left a detailed account of it:

I sate to him five hours, in which time he finished my head, and sketched out the rest of my figure: – the likeness is most striking and the execution masterly . . . Though I sate five hours, I was not in the least fatigued; for, by placing a large looking glass opposite to my face, Sir Joshua put it in my power to see every stroke of his pencil; and I was greatly entertained to see the progress of the work; and the easy and masterly manner of the Artist, which differs as much from that of all the other painters I have seen at work, as the execution of Giardini differs from that of a common fiddler.*

Reynolds was now charging the same as Hudson – 12 guineas for a head and 48 for a whole-length. Quite the grandest of his sitters in 1755 was William Pulteney, the Earl of Bath, thought to be the only person painted by both Kneller and Reynolds.[45] He had first entered Parliament in 1705 and had been Secretary at War at the age of thirty. A powerful orator, his early friendship with Walpole had later turned to enmity; Walpole said he feared Pulteney's tongue more than another man's sword.

Reynolds also painted two of Augustus Keppel's sisters in the course of 1755. The picture of Lady Elizabeth, a girl of sixteen at the time, is

* Beattie, entry for Monday 16 August. The picture (Mannings, cat. no. 138, fig. 1071) belongs to the University of Aberdeen. One of the demons is depicted as Voltaire, something which outraged Oliver Goldsmith and occasioned a rare breach between him and Reynolds.

unremarkable, but the one he painted of her six years later, in the white and silver dress she wore as a bridesmaid at the wedding of George III, is one of his most celebrated compositions.* An elder sister, Lady Caroline, of whom Reynolds painted a charmingly demure portrait at the same time,[46] disgraced herself four years later by marrying a young medical man called Robert Adair. 'There is certainly something nasty,' wrote Lady Caroline Fox to Lady Kildare, 'in the idea of a woman of fashion falling in love with her surgeon.'[47] Just the sort of comment that made Reynolds's ear-trumpet such a useful accessory.

Not all his sitters were so high-born. In June of that year there are appointments with 'Miss Shepherd'. This was Frances, the illegitimate daughter of Samuel Shepheard, a London merchant and MP, who had left her a fortune seven years previously with some very specific strings attached: she must marry a peer, or someone likely to succeed to a peerage – so long as it was not Thomas Bromley, the son of Lord Montfort. Reynolds painted her in profile, something he did not often do.[48] Thomas Bromley's offence is not known, but Miss Shepheard made sure of her inheritance three years later by marrying Charles Ingram, who subsequently succeeded his uncle as the Ninth Viscount Irvine.

Reynolds naturally attracted sitters with connections in the West Country – one of the earliest was young John Molesworth,[49] of Pencarrow, Cornwall, who later succeeded his father in the baronetcy and was a founder of the future Lloyds Bank; he wears a white satin suit, richly embroidered, traditionally described as his wedding clothes. Another was the rising naval officer Edward Boscawen, second son of Lord Falmouth, revered by those who served under him as 'Old Dreadnought'. The full-length portrait,[50] now in the National Maritime Museum at Greenwich, shows him against a stormy seascape, wearing a grey tie wig and the undress uniform of a flag officer. Reynolds has caught the characteristic tilt of his head – another of his nicknames was 'Wry-necked Dick'. Boscawen, who had nominally represented Truro in Parliament since 1742, had just been advanced to vice-admiral. He had a first sitting with Reynolds on 4 March, but within weeks he was ordered to North America to check the encroachments of the French, and further sittings were delayed.† Reynolds also painted his wife, the prominent bluestocking hostess whose letters vividly portray the London society of her day.[51]

* Both pictures are now at Woburn Abbey. In 1764 Lady Elizabeth married the Marquess of Tavistock, the heir of the Fourth Duke of Bedford. Three years later he was killed in a hunting accident; she is said to have pined away, dying within twelve months at the age of twenty-nine.
† Two years later, when he was Commander-in-Chief, Portsmouth, it fell to Boscawen to sign the order for the execution of Admiral Byng.

One of the more raffish sitters recorded in the 1755 pocketbook is a young man called Jenison Shafto, who had an estate in Cambridgeshire, owned racehorses and spent more than was prudent on gambling; he later shot himself.[52] Reynolds also painted Dr Charles Lucas, 'the Wilkes of Ireland', who had fled from Dublin six years previously to escape imprisonment for sedition and was currently practising medicine in London.[53] Two other portraits painted during 1755 were among the first of Reynolds's pictures to find their way to the United States. These were of Sylvanus Groves and his wife; Groves was the London representative of the owner of a large estate called Tulip Hill in Maryland.[54]

These early pocketbooks do not tell us only who passed in and out of Reynolds's painting room. We also get glimpses of his social life. He had a passion for cards, and one of those who was often at his card table in 1755 was John Wilkes, who was four years younger than Reynolds. After two years at Leyden, and while still under age, he had married a woman ten years his senior, a union which brought him an estate at Aylesbury and a comfortable income. At this stage in his career, as the *Dictionary of National Biography* puts it, 'his proclivities were literary and rakish'; another two years would pass before the electors of Aylesbury were persuaded to send him to Westminster as their Member.*

The middle 1750s also saw the beginning of what was for Reynolds an infinitely more important friendship – the closest and warmest friendship, indeed, that he ever enjoyed. It seems likely that Reynolds first encountered Samuel Johnson some time in 1756. The previous year had seen the publication of what still ranks as one of the greatest single achievements of English scholarship; as the author of the *Dictionary*, *The Vanity of Human Wishes* and *The Rambler*, Johnson had established himself as one of the foremost writers of the day.

We know from a celebrated passage in Boswell that Reynolds had encountered him vicariously two or three years previously when he stumbled on his *Life of Savage*:

Sir Joshua Reynolds told me, that upon his return from Italy he met with it in Devonshire, knowing nothing of its authour, and began to read it while he was standing with his arm leaning against a chimney-piece. It seized his attention so strongly, that, not being able to lay down the book till he had finished it, when he attempted to move, he found his arm totally benumbed.[55]

* Reynolds seems never to have painted Wilkes. There are, on the other hand, eleven appointments with a Mrs Wilkes, possibly his wife, in the 1755 pocketbook. No painting has been traced.

Johnson was now in his forty-seventh year. The *Dictionary* had not made him rich. The advances he had received – something over £1,500 in all – had been spent as they came in; rattling around in the large house he rented in Gough Square, he was finding it difficult to make ends meet. At some time during 1756 his young friend Bennet Langton, who came from a wealthy family long established in Lincolnshire, persuaded his father to make the offer of a living there of which he controlled the patronage, but the idea of taking holy orders was not something Johnson could bring himself to contemplate. Although it was four years since his wife had died, he still frequently expressed in his diaries his grief at her loss. 'I beseech thee,' runs one entry he made in March 1756, 'that the remembrance of my Wife, whom thou hast taken from me, may not load my soul with unprofit-able sorrow.'

Reynolds met Johnson at the house of two maiden ladies called Cotterell, the daughters of an admiral, who kept an occasional salon. According to Boswell, Reynolds made a remark on this occasion 'so much above the common-place style of conversation', that he immediately impressed John-son as someone in the habit of thinking for himself:

The ladies were regretting the death of a friend, to whom they owed great obligations; upon which Reynolds observed, 'you have, however, the comfort of being relieved from a burthen of gratitude.' They were shocked a little at this alleviating suggestion, as too selfish; but Johnson defended it in his clear and forcible manner, and was much pleased with the mind, the fair view of human nature, which it exhibited, like some of the reflections of Rochefaucault. The consequence was, that he went home with Reynolds, and supped with him.[56]

The difference in age between them – Reynolds was still only thirty-three – seemed immaterial. It was not long before Johnson sat to his new friend. The portrait, the first of five which Reynolds would paint of him, and which he later gave to Boswell, is now in the National Gallery.[57] If Reynolds believed Johnson had 'formed his mind', Johnson more than once expressed his admiration for the mental abilities of the younger man: 'When Reynolds tells me something, I consider myself as possessed of an idea the more.'

Reynolds was clearly thinking of Johnson twenty years later, when he came to compose the passage in his seventh Discourse where he dwells on the importance to the artist of what he calls 'the industry of the mind':

Reading, if it can be made the favourite recreation of his leisure hours, will improve and enlarge his mind, without retarding his actual industry. What such partial and desultory reading cannot afford, may be supplied by the conversation of learned and

ingenious men, which is the best of all substitutes for those who have not the means or opportunities of deep study. There are many such men in this age; and they will be pleased with communicating their ideas to artists, when they see them curious and docile, if they are treated with that respect and deference which is so justly their due.[58]

The banker Thomas Coutts told Farington, years after Reynolds's death, that when he first began to make money, he had no idea what to do with it, 'being totally ignorant of such matters'. A friend had offered to place it for him in the public funds, but when Coutts made inquiries, he established that nothing had been invested in Reynolds's name. The friend eventually confessed that it had been put to more speculative use, although he assured Coutts that the money was safe. 'This unprincipled conduct,' wrote Farington, 'gave cause of alarm, but by proper management the money was gradually recovered.'*

An alternative use for Reynolds's new-found wealth soon presented itself. He had frequented the auction rooms before going to Italy, though seldom on his own account. It is clear from a note which Malone found among his unpublished papers that as his practice grew he set about collecting pictures in earnest:

I considered myself as playing a great game, and, instead of beginning to save money, I laid it out faster than I got it, in purchasing the best examples of art that could be procured; for I even borrowed money for this purpose. The possessing portraits by Titian, Van Dyck, Rembrandt and company, I considered as the best kind of wealth.[59]

The 1755 pocketbook has the occasional note of previews or sales that he planned to attend. In the course of 1756 he was a buyer on at least five occasions. He was at Langford's at the end of March for the sale of James Gibbs, the architect of St Martin-in-the-Fields and the Radcliffe Library, who had died two years previously, and at Prestage's, at the beginning of April, where the collection of John de Pester was being sold, he laid out a total of £113 on two Ruysdaels, a Van de Velde, a Lairesse and a Sebastiano Ricci. A fortnight later he bought a Mola, a Rembrandt and a copy after Veronese for £22 12s 6d, and at two further sales later in the year he acquired paintings by Karel Du Jardin, Carlo Maratta and Agostino Carracci, which cost him a total of £34 7s 6d.

Reynolds was not particularly orderly in keeping a record of what he

* Farington, 1978–84, viii, 2973. Very little is known of Reynolds's banking arrangements. Details survive in the archives of Coutts & Co. of an account with them from 1784 to 1792, but that covers only the last eight years of his life.

bought, and not all that many annotated sales catalogues from the period survive. He undoubtedly did a certain amount of dealing, but it is not possible to distinguish between those pictures he bought for himself and those he intended to sell. Those which he did keep did not all hang on his walls. Many of them would be put to practical use in the somewhat alarming experiments he conducted; Northcote says that in his investigations into the secrets of the Old Masters he was indefatigable:

I remember once, in particular, a fine picture of Parmegiano, that I bought by his order at a sale, which he rubbed and scoured down to the very pannel on which it had been painted, so that at last nothing remained of the picture.[60]

Between 1755 and 1760 Reynolds acquired at least eighty works at a cost of well over £700. If he was willing to spend freely on paintings, however, there were other areas where he could be decidedly tight-fisted: 'prudent in the matter of pins – a saver of bits of thread', as one of his servants put it. He sometimes used to walk to a fishmonger's in Coventry Street before breakfast, turn over the fish on the slab and then return home to tell Fanny what he liked the look of. According to the fishmonger she never chose, Reynolds never paid – and both drove a hard bargain.[61]

'The arts are not made an object of the public attention in England; for there is no foundation or institution in their favour, neither by the government in general, nor in particular by the crown.' André Rouquet* was quite right, but it so happened that the appearance of his *L'État des Arts en Angleterre*† in 1755 coincided neatly with a revival of interest among artists in England in the establishment of some sort of professional body.

Calls for an academy were not new. The wealthy connoisseurs who had formed the Society of Dilettanti in the 1730s toyed with the idea from time to time. In 1749 the architect John Gwynn had published 'An Essay on Design, including Proposals for Erecting a Public Academy to Be Supported by Voluntary Subscription (until a Royal Foundation can be obtain'd)'; he deplored the fact that England was a country where 'Art has been in small Estimation, unless the Artist was foreign', and advocated the establishment of chairs of fine arts at the universities of Oxford and Cambridge.

* Born in Geneva, the son of Huguenot émigrés, Rouquet (1701–58) had lived in London for thirty years, working as a painter of portrait miniatures in enamel. He was a close friend of Hogarth, and shared many of his views about what was wrong with English artistic life.
† Rouquet's work appeared the same year in an English translation under the title *The Present State of the Arts in England*.

The refrain was now taken up more insistently. The sculptor Sir Henry Cheere presented a plan for an Academy to the Society for the Encouragement of Arts, Manufactures, and Commerce, which had been founded in 1754 by a group of noblemen, scientists and clergy.* A more substantial initiative came from a group of twenty-five artists led by Francis Hayman; Hudson and Roubiliac were members of it, and so was Reynolds. They drew up proposals for 'a Royal Academy under the Direction of a Select Number of Artists', the aim of which was to be 'the refining the Taste'. They approached both the Society for the Encouragement of Arts and the Dilettanti for financial support. The latter may not have been altogether pleased by a line in the prospectus describing connoisseurs as 'those who set their Hearts on making Collections only instead of advancing the Art they profess to love', but that was not why they turned the Hayman committee down. Discussions foundered essentially on the wish of the Dilettanti to have a controlling say in the running of the Academy – their terms included automatic membership for all their number and a monopoly of the presidency.†

One prominent figure had been conspicuous by his absence from the Hayman committee. The pugnacious Hogarth was not alone among artists in his preference for something organized much more democratically – a cross between a trade association and a friendly society that would embrace the whole profession. Such a body would offer instruction and arrange exhibitions, but would have no pretensions to guide public taste. Ideology apart, the main interest of Hogarth and those who thought like him was to bypass the connoisseurs and dealers, with their fixation on Old Masters and classical antiquities, and reach a wider public who could be persuaded to buy the work of native British artists.

Reynolds already numbered several members of the Society of Dilettanti among his friends, including Richard and George Edgcumbe and the painter and architect James Stuart, who had been in Rome when Reynolds arrived there. 'Athenian' Stuart, as he became known, was the son of a Scottish mariner. He owed his nickname to his *Antiquities of Athens*, published in 1762, which brought him great celebrity. He was a member of the Society

* The Society, whose activities were biased towards the scientific and the industrial, was largely modelled on the American Philosophical Society, founded ten years previously in Philadelphia on the initiative of Benjamin Franklin.

† Tom Taylor believed that the paper which the artists submitted to the Dilettanti was written by Reynolds. F. W. Hilles contended it might equally well have been the work of Gwynn, who was also a member of the committee. 'Whoever wrote the pamphlet was a reader of the *Rambler*. Ponderous words and balanced sentences characterize the author's style and cause one to wonder whether he had submitted his manuscript to Johnson before publishing it' (Hilles, 1936, 15, n. 2).

of Arts as well as of the Dilettanti, and a year after the breakdown of the Academy discussions, he proposed Reynolds for election.* Reynolds seems to have joined for the sort of reasons that impel some men to become Freemasons or join livery companies. An ironical passage in his *Journey from London to Brentford*, written some fifteen years later, suggests that his commitment to the aims of the Society did not run particularly deep:

A Man of Studious recluse life sets out to see foreign parts, as the phrase is, and when he returns thinks he has done wonders if he discovers any more expeditious method used in manufactures or an improvement in agriculture, in short their works are stuffed with accounts of the state of Arts, Manufactures and Commerce, the Police of Nations and I know not what, which nobody cares one pin about.†

He did his bit, for all that; he was assiduous, for instance, in his attendance at the committee that judged competition drawings. What sort of contribution he was able to make to one formed in 1760 to encourage the growing of the Zante currant is not known;‡ rather more importantly, he was a member, in the same year, of the Society's committee charged with promoting the first public exhibition of paintings to be held in England.

For the year 1756 – the year which saw the outbreak of the Seven Years War, the year of the Black Hole of Calcutta – Reynolds's pocketbook is lost, and other ways must be sought of fleshing out the detail of his working life. David Mannings, for instance, in an outstanding piece of detective work, has tracked down a deposition made by Reynolds in the Court of Chancery. The object of the exercise was to date a portrait of a politician called Ralph Jenison, who was the MP for Newport, Hampshire, and whose name figures in the secret service accounts of that master of political corruption, the Duke of Newcastle. Jenison died in 1759 leaving a number of bills unpaid; Reynolds, who was one of his creditors, testified that Jenison owed him 18 guineas for a portrait 'of the Kit-Cat

* He proposed Reynolds on 1 September. Three months later he also proposed Samuel Johnson.
† *A Journey from London to Brentford, through Knightsbridge, Kensington, Hammersmith, and Turnham Green* was a good-natured parody of *A Journey from London to Genoa, through England, Portugal, Spain and France*, by his friend Giuseppe Baretti, which appeared in four volumes in 1770 and enjoyed great success. Reynolds's squib did not appear in his lifetime. It was first published in an appendix to Derek Hudson's 1958 biography.
‡ Zante was the Italian name of the Ionian island of Zakinthos when it was under Venetian rule. The word was used attributively in the names of certain of its products.

Length',* and that to the best of his recollection, he had painted it 'about three years ago'.[62]

Another politician who sat in 1756 was George Colebrooke, a young banker who had recently become the Member for Arundel; he too was close to Newcastle, a connection which secured him a number of lucrative government contracts. A pompous man, much lampooned in the press, Colebrooke later succeeded his brother as the second baronet and became Chairman of the Court of Directors of the East India Company. In the 1770s his business affairs would fall apart; bankruptcy followed, and he fled to France.[63] Waterhouse pronounced Reynolds's best portraits of this period to be in a Venetian mode, and compared the Colebrooke with a portrait by Pietro Longhi in the National Gallery.†

Politicians and distinguished soldiers, heiresses and dandies, admirals and sprigs of the aristocracy – all continued to flow through the painting room at 5 Great Newport Street. Reynolds's portrait of Admiral Francis Holburne, now in the National Maritime Museum, Greenwich, is especially fine. The admiral, who stands with his hand on the shoulder of his small son, gazes squarely out of the canvas. The boy, although he was only four at the time, is dressed in midshipman's uniform, and his father wears flag officer's undress uniform. Holburne had been promoted to Rear-Admiral of the Blue the previous year, and had served under Hawke off Brest and in the Bay of Biscay; he would shortly sit with Boscawen as a member of the court-martial on Byng. The painting of his head is interesting stylistically as an example of Reynolds's attempts, after he returned from Italy, to achieve the effects of Tintoretto and Titian by covering a monochrome underpainting with transparent glazes.[64]

John Manners, Marquess of Granby – still a familiar name two and a half centuries later because of the innumerable pubs called after him – also sat.‡ Granby, son of the Third Duke of Rutland, had entered Parliament at the age of twenty and served as a volunteer in Cumberland's army in the '45. Hard-drinking, outstandingly brave, loved by his men, he would later command the British contingent under Prince Ferdinand of Brunswick in Germany. When Reynolds painted him in 1756 – the first of sixteen portraits – he was still in his thirties and had just been promoted major-general.[65]

* See p. 110 below.

† Waterhouse, 1941, 10. Longhi (*c.* 1700–1785), best known for his small-scale genre works, was immensely popular in his day, and sometimes favourably compared with Tiepolo. He was active in Venice at the time of Reynolds's visit, and continued as instructor to the life class at the Accademia dei Pittori there until five years before his death.

‡ Another familiar name catches the eye in the list of sitters that year; Robert Shafto, later the MP for Durham and for Downton, is supposedly the original 'Bonnie Bobbie Shafto', though how an obscure English politician came to be the hero of a Scottish folk song is not clear.

The outstanding military portrait painted at this time, however – the canvas is signed 'J. Reynolds pinxit 1756' – is of an obscure Guards officer called Robert Orme. The picture, which was left on the artist's hands for more than twenty years, is now in the National Gallery in London.[66] A young officer who saw it at the exhibition of the Society of Artists of Great Britain in 1761 was greatly taken by it: 'There is an officer of the Guards with a letter in his hand, ready to mount his horse with all that fire mixed with rage that war and the love of his country can give; in the background a view of the skirmish.'[67] Orme had, in fact, just resigned from the army, having risen no higher than the rank of temporary captain; his only claim to fame was that he had served in America the previous year as aide-de-camp to General Braddock, and had been wounded in the ambush near Fort Dusquesne in which Braddock had been killed. Northcote says that the picture 'attracted much notice by its boldness'; it remained influential as a model for military portraiture well into the following century.[68]

William Chambers had recently returned to London, the fortune he had earned at sea much depleted by six years of travel and study abroad. He was installed with his wife and children in rather dingy lodgings in Russell Street, Covent Garden, next door to Tom's Coffee House, and as he waited for architectural commissions he began to work up his *Designs for Chinese Buildings*, which would appear in 1757. He and his wife both sat to Reynolds; it is now generally accepted that earlier biographers were mistaken when they followed Northcote in saying that the portrait of Mrs Chambers had been painted in Paris four years previously.[69]

As 1756 drew to a close, so too, with the death of his mother, did a chapter in Reynolds's family life. She died at Christmas-tide, just as her husband had done eleven years earlier, and was buried at Torrington on 27 December.

5

Questions of Style

Two things happened in the course of 1757 that were calculated to put Reynolds on his mettle. One was that Hogarth announced he would paint no more histories but intended to return to portrait painting. The other was that Allan Ramsay came back from his second visit to Italy. He installed himself in a handsome house in Soho Square, then one of the most fashionable in the West End,* and set about re-establishing the flourishing practice he had left behind almost four years previously.

Hogarth's announcement appeared in the *London Evening Post* towards the end of February. When he came to write his 'Autobiographical Notes', he would complain that he had previously been elbowed out of the portrait business by professional jealousy – a 'whole nest of Phizmongers' had criticized his portraits of women as 'harlots' and of men as 'charicatures'. Now he returned to the fray with the brilliant portrait of Inigo Jones which today is in the collection of the National Maritime Museum at Greenwich. It was commissioned by Sir Edward Littleton MP, who was refurbishing his Staffordshire mansion in the neoclassical style. It was finished by May: the subtle, muted colouring clearly owed much to Van Dyck. A month earlier Hogarth's friend, the Reverend John Hoadly, saw in his studio another canvas, an elegant double portrait to which he was putting the finishing touches. This was the celebrated picture of David Garrick and his wife now in the Royal Collection – the greatest actor of the day sits at his escritoire, his wife stands behind his chair, reaching over his head to take his quill, teasingly intent on disturbing him.

Hogarth, however, was now entering his sixties, and although he was appointed Sergeant-Painter to the King later in the year, it was Ramsay, still in his mid-forties, who posed the more formidable threat to Reynolds's professional prospects. Almost at once on his return from Italy he was taken

* The south side of the square was dominated by Monmouth House, a ducal mansion then occupied by the Earl of Winchelsea. Other residents of the square at the time included the Duchess of Wharton, Arthur Onslow, the Speaker of the Commons, the Bishop of Salisbury and the Venetian and Spanish ambassadors.

up by the Leicester House circle, that 'little junto' presided over by his fellow-Scot the Earl of Bute, tutor and 'dearest friend' to the heir to the throne. On 12 October he presented himself with his painting materials at Kew Palace and the Prince of Wales sat to him for the first time. Ramsay's time in Italy had been well spent. He produced what was perhaps the finest royal portrait painted in England since Van Dyck. It was engraved four years later by Rylands. The prince had by then succeeded his grandfather, and it remained for many years the best-known image of the new king.[1]

Ramsay's good fortune did not stop there, however. So pleased was the prince with his portrait that he commanded Bute should sit for his. Or rather, stand. Bute was inordinately vain. He was particularly proud of his legs – it was whispered that he used to admire them in the course of solitary walks beside the Thames. Ramsay knew his man. He also knew which side his bread was buttered on. Later he would dine out discreetly on the story of how Bute had been careful to hold his robes clear of his knees so that his shapely calves might be seen in all their glory – a posture he was obliged to maintain for a whole hour.[2]

Reynolds made a spirited – and witty – response. When a commission to paint the Seventh Earl of Lauderdale came his way shortly afterwards, he too contrived to give a clear view of everything below the knee. He wished, he said, 'to show a leg with Ramsay's Lord Bute'.[3] He also had the good sense to realize that there were things he could learn from his Scottish rival, particularly in the portrayal of women. Lady North, newly married at the age of sixteen to the future prime minister, sat to him on the first day of 1757, and the result could very easily have come from the brush of Ramsay.[4]

Although they were rivals professionally, the two men were on good terms, and they would see something of each other socially over the years. In the main, however, Reynolds did not seek out his fellow painters – in general he much preferred the company of naval officers he had met through Keppel, of West Country gentry, of stage people and of men and women from the world of literature.

Northcote says that Johnson introduced Reynolds and Fanny to the novelist Richardson, who had notoriously little conversation; if they wished to see him in good humour, he advised them, 'they must expatiate on the excellencies of his Clarissa'. Reynolds in turn took Roubiliac to visit Johnson. The sculptor was at work on a monument that was to be put up in the Abbey, and hoped he might prevail on Johnson to write an epitaph. Johnson seated himself in the famous chair that had only three legs, took up his pen, and inquired what was required of him:

On this Roubiliac, who was a true Frenchman, (as may be seen by his works,) began a most bombastic and ridiculous harangue, on what he thought should be the kind of epitaph most proper for his purpose, all which the Doctor was to write down for him in correct language; when Johnson, who could not suffer any one to dictate to him, quickly interrupted him in an angry tone of voice, saying, 'Come, come, Sir, let us have no more of this bombastic, ridiculous rhodomontade, but let me know, in simple language, the name, character, and quality, of the person whose epitaph you intend to have me write.'[5]

It seems likely that it was through Johnson that Reynolds met Bennet Langton, whose name appears frequently in the pocketbooks from the late 1750s onwards for what are clearly social occasions. Langton was one of the two young friends who took Johnson for his famous 'frisk' to Billingsgate. He was celebrated for his Greek scholarship but made a poor fist of managing his estates, apparently because he was too indolent to keep accounts. Immensely tall and thin, he was hugely popular wherever he went. He was a particular favourite at the bluestocking meetings – Burke said the ladies gathered round him like maids round a maypole. Reynolds painted him in 1759 or 1760, seated languidly at a table, his elbow resting on a volume of Clarendon's *History*.[6] After Johnson's death, Langton succeeded him as professor of ancient literature at the Royal Academy.

Reynolds's friendship with the hot-tempered Giuseppe Baretti probably came about through Lord Charlemont, whom Baretti had known in Italy and at whose suggestion he seems first to have come to London in 1751.* He was now putting the finishing touches to his *Dictionary of the English and Italian Languages*, which was published in 1760 and established his reputation as a scholar. Baretti was never afraid to speak his mind, and as little inclined as Johnson to spare the feelings of his friends. Many years later Hazlitt, in conversation with Northcote, gave his opinion of the philosopher Godwin:

'He is a strange composition of contrary qualities. He is a cold formalist, and full of ardour and enthusiasm of mind; dealing in magnificent projects and petty cavils; naturally dull, and brilliant by dint of study; pedantic and playful; a dry logician and a writer of romances.'

'You describe him,' said Northcote, 'as I remember Baretti once did Sir Joshua Reynolds at his own table, saying to him, "You are extravagant and mean, generous and selfish, envious and candid, proud and humble, a genius and a mere ordinary mortal at the same time."'[7]

*

* When Reynolds appeared as a witness for the defence at Baretti's trial for murder in 1769 (see p. 205 below), he testified that he had known him 'for fifteen or sixteen years'.

If Reynolds lost out to Ramsay in the matter of royal patronage, his pocket-books continued to bulge with the names of the aristocracy – Charles Spencer, Third Duke of Marlborough,[8] Lord Bruce, who had figured in *The Parody on the School of Athens*,[9] the Earl of Dartmouth; Reynolds presented his portrait to the Foundling Hospital, of which the earl was vice-president.[10] He also painted Peregrine Bertie, Third Duke of Ancaster, who was a general in the army, and would officiate as Lord Chamberlain at the coronation of George III. 'A very egregious blockhead,' according to Lord North, 'both mulish and intractable.' Very possibly he was, but his money was as good as anybody else's, and the sum of 48 guineas was duly entered in Reynolds's ledger.*

One of his livelier female sitters that year was Lady Caroline Fox, later Lady Holland. A daughter of the Duke of Richmond, she had made a runaway marriage at the age of twenty-one with the politician Henry Fox. Having gambled away a huge private fortune as a young man, her husband was now the MP for Windsor, and had just been appointed Paymaster-General, an office he would use during the next seven years to amass a second large fortune. Lady Caroline is shown at her needlework, dressed in the highly ornamental taste of the 1750s and with a nosegay of fresh flowers on her bodice.†

Reynolds painted several more fine female portraits in the course of 1757. There is a striking full-length of Anne Fitzroy, the young Duchess of Grafton, whose husband succeeded to the title in May that year. Writing to her sister about female fashions at the end of the decade, Lady Caroline Fox described the duchess as 'dressed like a strolling actress'. If there is a whiff of the playhouse here, her Grace is playing the most regal of roles. She wears her crimson peeress's robes over an oyster-white dress decorated with oak leaves; Reynolds has portrayed her with her luxuriant brown hair falling on to her shoulders.[11] It was a commission which marked the beginning of a life-long friendship. The duchess was divorced in 1769 and married the Earl of Upper Ossory. They became two of Reynolds's closest friends.

Towards the end of 1757 five appointments are noted with another great lady. Elizabeth Percy, later Duchess of Northumberland, was clearly no bluestocking. Writing to his friend Hertford, Horace Walpole makes her

* Mannings, cat. no. 168, fig. 301. Some years later Reynolds also painted a posthumous portrait of Bertie's father, the Second Duke, who had served as Lord Great Chamberlain at the coronation of George II.

† Mannings, cat. no. 671, fig. 988. Aileen Ribeiro, in the catalogue of the 1986 Reynolds Exhibition at the Royal Academy, notes that such flowers were kept fresh by a water-filled bosom bottle – something which the beady-eyed Horace Walpole had noted in 1754 as a new fashion from Paris.

sound like a character in a Sheridan comedy: 'There was a vast assembly at Marlborough House, and a throng in the doorway. My Lady Talbot said, "Bless me, I think this is like the Straits of Thermopylae!" My Lady Northumberland replied, "I don't know what street that is, but I wish I could get my — through." '[12]

Reynolds also painted a healthy number of 'people of the middling sort'. There was the celebrated Mrs Porter, by then long retired, but whose stage career, unhampered by 'a plain Person and a bad Voice', stretched back to the 1690s;[13] Thomas Panton, keeper of the king's running horses at Newmarket ('a disreputable horse jock', sniffed Horace Walpole);[14] a vigorous young Guards officer called William Hamilton, whose later achievements as diplomat and archaeologist are less well remembered than those of his second wife, Emma Hart, in other spheres.[15] By a strange chance, Reynolds also painted that year a charming picture of a small boy, wearing a green dress, and gazing brightly at a goldfinch perched on his right hand. The child was the three-year-old son of Sir Mathew Fetherstonhaugh, who, like Lord Bruce, had figured in *The Parody of the School of Athens*. A quarter of a century later, in the year that he was first returned as the MP for Portsmouth, young Harry Fetherstonhaugh ('good natured, formal, effeminate, and obliging' by a contemporary account) would have a natural daughter – the result of his liaison with the same Emma Hart.[16]

Fully occupied as he was at his easel, Reynolds nevertheless continued his assiduous attendance at the auction rooms. He is recorded as a purchaser at four sales in the course of 1757, and added thirteen paintings to his collection. At a two-day sale at Prestage's in February he bought mainly Dutch paintings. His most important acquisition – he paid 26 guineas for it – was a *St Bartholomew* by Rembrandt which had previously been in Jonathan Richardson's collection.[17] He also bought a *Landscape with Cattle* by Adriaen van der Velde for 21 guineas and a *Landscape with a Waterfall* – this was knocked down to him for 20½ guineas, although whether it was by Jacob van Ruisdael or the lesser-known Solomon is not clear. Later in the year he bid successfully for an *Agony in the Garden* by the Italian artist Benedetto Luti (20 guineas), an *Adoration of the Shepherds* by Rubens, for which he paid the rather odd sum of £18 1s 6d and a *Country Wedding* by an unspecified member of the Brueghel family, which cost him 13 guineas.* His growing collection did not consist only of paintings. At the George Vertue sale at Ford's, in the middle of May, he acquired 'an exceeding fine head of Milton, modelled from the life, in a glass case'.

* These figures must be multiplied by sixty or seventy to give an approximation to present-day values.

The late 1750s found Reynolds at full stretch – these were without question the busiest years of his entire professional life. Early in 1759 Bennet Langton, busy tutoring his sisters in Lincolnshire during the Oxford vacation, received a long letter full of London gossip from Johnson:

. . . Mr Reynolds has within these few days raised his price to twenty guineas a head, and Miss is much employed in Miniatures. I know not any body [else] whose prosperity has encreased since you left them.[18]

'Head' and 'three-quarters' were often used interchangeably, though a head conventionally measured 24½ × 18½ ins and a three-quarters was slightly larger at 30 × 25 ins. Matters were further complicated by the existence of 'kit-cat' portraits. These took their name from a club of Whig grandees and literary men formed in the reign of James II – the Dukes of Newcastle, Somerset, Dorset and Montagu were all members, and so were Steele, Addison, Congreve and Vanbrugh. They originally met in a pie-house near Temple Bar kept by one Christopher Cat or Catling; he was renowned for his mutton pies – which were known as 'kit-cats'.

It was the custom for members to present their portraits, and in the club's heyday, between 1700 and 1720, some forty of these were executed by Kneller, who was their resident painter. Meetings, however, had now transferred to the house of the secretary, the publisher Jacob Tonson, and to accommodate the paintings to the height of the new club room, Kneller was obliged to reduce them in size, showing only the head, shoulders and one hand. They measured 36 × 28 ins – and acquired the same nickname as the mutton pies. To complete the confusion, a half-length, which might reasonably be thought to be smaller than a three-quarters, actually measured 50 × 40 ins – and was therefore smaller only than a full-length, measuring 94 × 58 ins.

Reynolds's ledgers show that he put all his prices up at much the same time; that for a half-length rose from 30 to 40 guineas, and for a whole-length from 60 to 80. If the increases were intended to stem the flow of commissions, the effect was hardly perceptible. He told Northcote that he had found it necessary at that time to establish a waiting list,[19] and looking at the bulging pocketbooks for the end of the decade one can well believe it. In the course of 1759 alone he had more than 150 sitters – 'a greater number than even the most prodigious talent could endure without wilting', in Waterhouse's judgement.[20]

There are, to be sure, some dull single heads and the occasional rather static frontal pose. He was certainly cramming his sitters in as tightly as he

could. There were days when he accommodated as many as seven; in October 1758, when he was painting Lord Robert Spencer, the eleven-year-old son of the Duke of Marlborough, there were half a dozen sittings at five and even five thirty in the afternoon, which was well after the time Reynolds usually took dinner.

Equally, however, there are indications that he was not prepared to send a picture home before he was completely satisfied with it. One of his sitters was the Fourth Duke of Devonshire, who had served as prime minister for a few months the previous year, before making way with some relief to permit the formation of the Newcastle–Pitt coalition. He had eight sittings between the end of January and early May 1758, and a further seven the following spring – a most generous allocation: the duke's court robes, after all, would almost certainly have been sent out to a drapery painter. The reason becomes clear in a letter the duke wrote to his sister on 4 June 1759: 'Mr Reynolds the painter did not approve of the Picture he had done, so that I was forced to sit over again for it, it is now almost finishd, so I hope to send it to you very soon.'*

Why Reynolds found it necessary to receive Mrs Henry Moore into his painting room on sixteen occasions in the course of 1758 is less clear – there was even a cancelled appointment at noon on Christmas Day. Mrs Moore was thirty-one, and had two small children. Her husband, fourteen years her senior, was the Lieutenant-Governor of Jamaica – shortly afterwards, when his turn came to sit, Reynolds appears to have polished him off in three sessions.† There was one further appointment with Moore's wife early in the New Year, and later in the month, on a Sunday, a scribbled memorandum reads, 'Mrs Moore in [illegible] Street.' A social occasion? Reynolds did sometimes tear himself away from his brushes on a Sunday. An assignation? We are running low on verifiable fact. The likeness over which he laboured so long remains untraced. No payment is recorded. Did he, one wonders, make her pretty or plain?

Nothing plain about Maria, Countess Waldegrave, twenty years old and newly married. 'The first match in England,' enthused Horace Walpole in a letter to Horace Mann in Florence – 'she has not a fault in her face or person.'[21] He was prejudiced, of course, because she was his niece, the second natural daughter of his brother Edward, but the striking full-length for which she stood to Reynolds in the summer of 1759 bears him out. She

* Mannings, cat. no. 335, fig. 390. His Grace was over-sanguine. There was one more appointment in late November.

† Mannings, cat. no. 1284, fig. 477. Moore's handling of the serious slave rising in Jamaica in 1760 was rewarded with a baronetcy, and he later became Governor of New York.

wears her coronation robes, and holds her coronet rather casually in the right hand.* Reynolds is said to have asked for a lock of her hair – as a guide to colouring; this was later framed, with a paper inscribed in his handwriting, and is still in the family. After the death of the earl from smallpox in 1763, the countess was courted by the Duke of Portland, but secretly married Prince William Henry, Duke of Gloucester, the younger brother of the Prince of Wales – a marriage long unrecognized by the royal family. Over the following fifteen years, Reynolds would paint her a further eight times.

The arresting portrait of Keppel's mother, the Countess of Albemarle, now in the National Gallery, was also painted in 1759.[22] The countess is engaged in 'knotting', working on a decorative linen braid with the aid of a small shuttle. Reynolds at this time often painted women pausing in their 'work' – the expression of this particular sitter suggests she does not wish to be disturbed for too long. The formidable Lady Albermarle had been widowed five years previously, but lived on for another thirty years, alarming her friends by her predilection for champagne and cold partridge pie in the small hours.

With his full-length of the Duchess of Hamilton Reynolds presents us with something very different. Here he is already well on the way to the full-blown (some would say over-blown) grand, historical style that he was later to embrace so wholeheartedly. Farewell to intimacy and quiet perfection. When the duchess had been presented at court a few years previously, 'the noble mob in the Drawing-Room clamboured on tables and chairs to look at her'. That is what Reynolds wanted people to do in front of this picture. Under her red velvet robe lined with ermine, the duchess wears a loose muslin dress, classical and timeless (a viewer unversed in the art of the antique might have taken it for a bedgown). The impression created is almost sculptural. 'The picture,' Ellis Waterhouse wrote unkindly, 'is as nearly dead as a Reynolds of a very handsome sitter can be.'†

Like it or hate it, the picture is of incontestable importance, because it is the first illustration in paint of a cluster of ideas that Reynolds was later to articulate extensively in his Discourses. 'When a portrait is painted in the Historical Style, it is neither an exact minute representation of an individual,

* Mannings, cat. no. 1895, fig. 450. On close inspection, her fingers do not, in fact, appear to be holding the coronet at all.

† Waterhouse, 1973, 24. The duchess's first sitting with Reynolds was on 14 January 1758, only three days before her husband died 'from a cold caught out hunting'. She sat again on 20 January, but then not for twelve months. She was briefly engaged to the Duke of Bridgewater, but in March 1759 married Colonel John Campbell, Marquess of Lorne, later the Sixth Duke of Argyll.

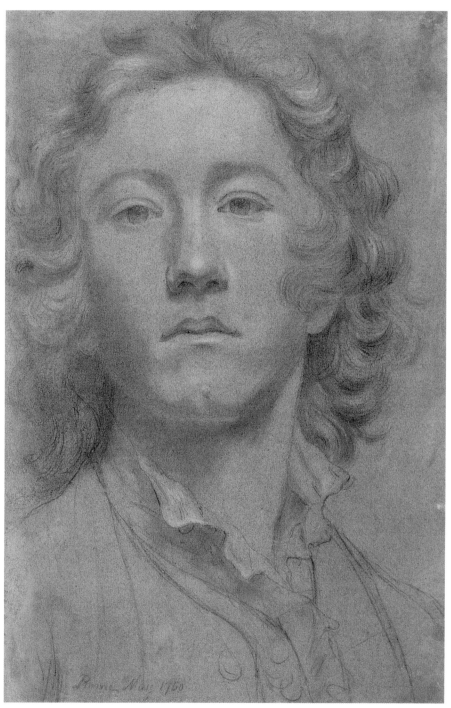

An early self-portrait, previously thought to be by John Astley. Reynolds drew it in Rome in 1750, shortly before his twenty-seventh birthday.

The Parody on the School of Athens. *One of the caricatures painted by Reynolds during his stay in Rome. The composition is derived from the celebrated fresco by Raphael in the Stanza della Segnatura.*

The Eliot Family. *This small-scale group portrait was painted sometime in the mid 1740s, several years before Reynolds went to Italy. An early example of the influence of Van Dyck, and possibly also of Hogarth.*

The Ladies Waldegrave. *'Sir Joshua has begun a charming picture of my three fair nieces, the Waldegraves, and very like,' Horace Walpole wrote to a friend in May 1780. Later, after it had hung for a while at Strawberry Hill, he was less approving – 'the details are slovenly, the faces only red and white'.*

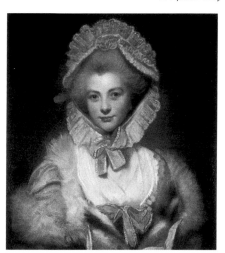

Lavinia, Countess Spencer. *A portrait dating from 1781, the year of her marriage to Viscount Althorp. 'Clever, but coarse of mind and expression and highly critical,' wrote her sister-in-law. 'Nothing escapes: character, understanding, opinions, dress, person, age, infirmities – all fall equally under her scalping knife.'*

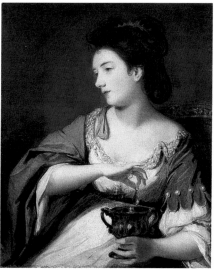

Cleopatra Dissolving the Pearl. *Probably painted in 1759, this is the earliest of the half-dozen or so portraits Reynolds painted of Kitty Fisher. The Daughter of a German stay-maker, she was one of the most celebrated courtesans of the day.*

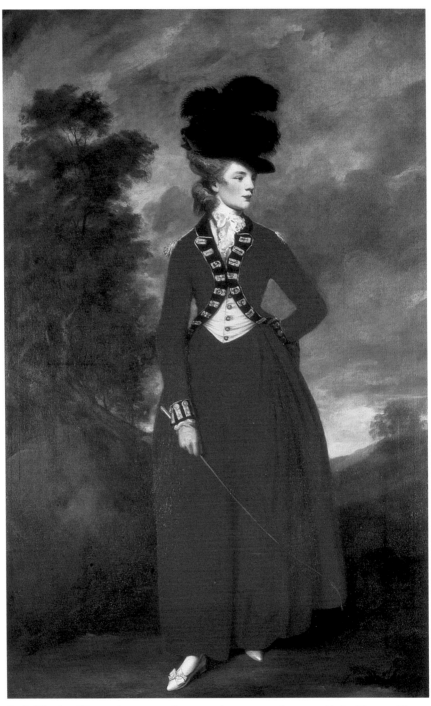

Lady Worsley. *Wars and rumours of wars made costumes that resembled military uniforms highly fashionable in the late 1770s. Lady Worsley's riding habit with its dark facings is adapted from that of her husband's regiment, the Hampshire Militia.*

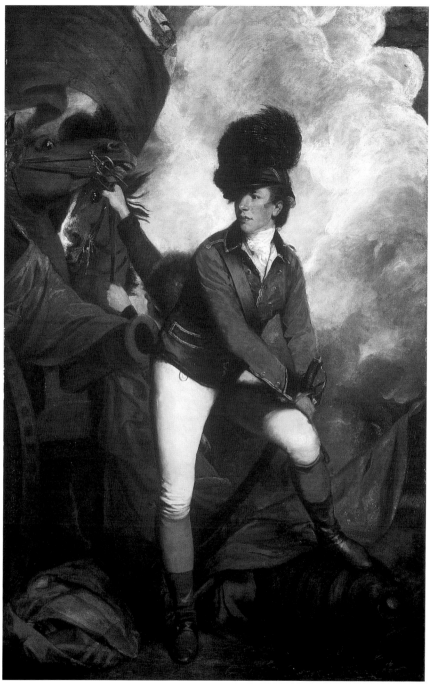

Colonel Banastre Tarleton. *Oxford educated, Tarleton was the son of a former mayor of Liverpool, where the family had long traded in cotton, sugar and slaves. He had recently returned from America under Parole, and had become the lover of the actress 'Perdita' Robinson, the discarded mistress of the Prince of Wales.*

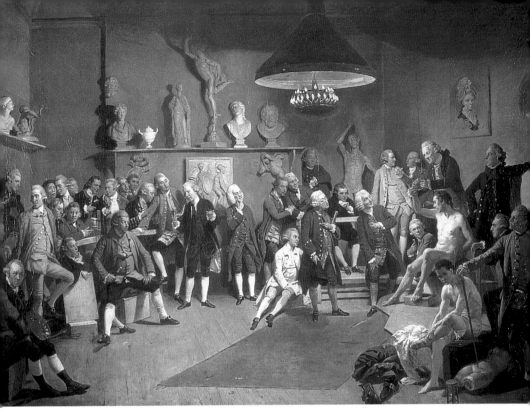

Zoffany's The Academicians of the Royal Academy, *exhibited in 1772.*
Reynolds is shown with his ear trumpet.

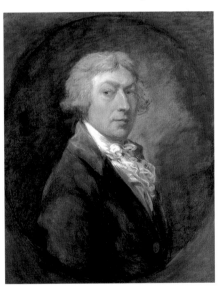

Gainsborough. A self-portrait painted a year
before his death from cancer in 1788.

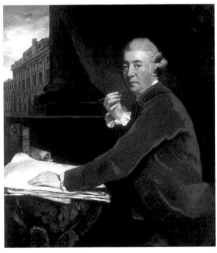

Sir William Chambers. *Painted by Reynolds*
in the late 1770s to hang in the new
Assembly Room at Somerset House.
Chambers was a prime mover in the
founding of the Academy, and became its
first treasurer. Reynolds complained
that he 'was Viceroy' over him.

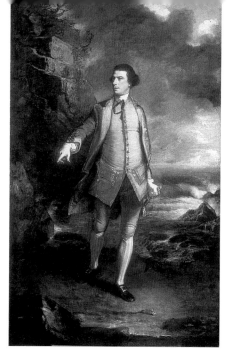

Augustus Keppel. *Dating from the early 1750s, the first of the dozen or more portraits Reynolds would paint of his old friend, it was described as 'the first thing that distinguished him after his return to his native country'.*

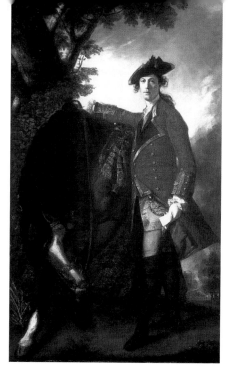

Captain Robert Orme, aide-de-camp to General Braddock in America in 1755. The portrait was displayed in Reynolds's studio where, according to Northcote, it 'attracted much notice by its boldness'.

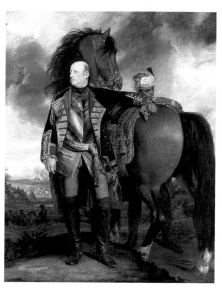

John Manners, Marquess of Granby. *Painted for Granby's defeated opponent at Vellingshausen in 1761, Victor François, duc de Broglie, Marshal of France.*

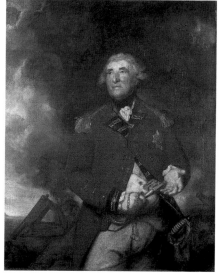

George Eliott, Lord Heathfield. *He holds the keys of Gibraltar; his defence of the Rock during the Spanish seige of 1779–83 made him a national hero.*

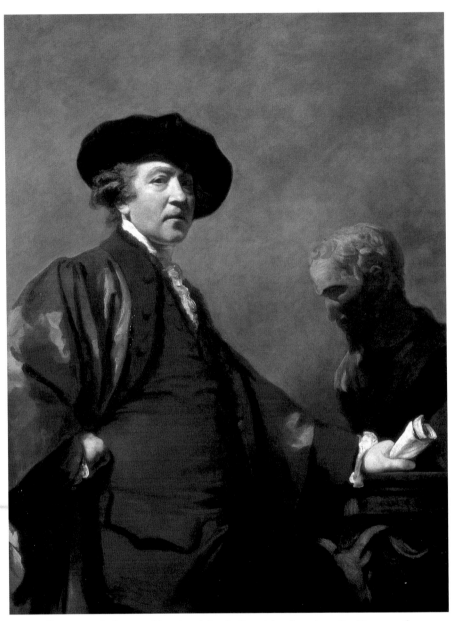

The self-portrait which Reynolds painted for the Royal Academy in 1780. He wears the gown of an Oxford Doctor of Civil Law. The bust is of his beloved Michaelangelo – 'that truly divine man,' as he called him in his last Discourse.

nor completely ideal,' he would declare in 1772. 'The simplicity of the antique air and attitude, however much to be admired, is ridiculous when joined to a figure in a modern dress.'[23]

His aesthetic theories had, however, been slowly forming in his mind long before he sat down to commit the first of his Discourses to paper in 1769. Indeed his first foray into authorship was made at the very time he was at work on the Duchess of Hamilton's portrait. 'The Idler' was a series of short periodical essays, mostly written by Johnson, which appeared between April 1758 and April 1760 in a weekly paper called *The Universal Chronicle*. Northcote says that Johnson applied to Reynolds to help him out with three pieces at short notice:

I have heard Reynolds say, that Johnson required them from him on a sudden emergency, and on that account he sat up the whole night to complete them in time; and by it he was so much disordered, that it produced a vertigo in his head.*

The nature of this 'sudden emergency' is not known; nor is the picture Northcote paints of Reynolds scrambling to meet a tight multiple deadline a convincing one; his first contribution appeared on 29 September, the second on 20 October and the last on 10 November. F. W. Hilles has also demonstrated that in composing these essays for Johnson Reynolds recycled a number of ideas which he had already jotted down in a commonplace book that he kept at the time.[24]

In his first piece, Idler no. 76, he initially takes aim at a fairly broad target:

To those who are resolved to be criticks in spite of nature, and at the same time have no great disposition to much reading and study, I would recommend to them to assume the character of connoisseur, which may be purchased at a much cheaper rate than that of a critick in poetry. The remembrance of a few names of painters, with their general characters, with a few rules of the academy, which they may pick up among the painters, will go a great way towards making a very notable connoisseur.

He tells us he has just visited Hampton Court with such a connoisseur – 'his mouth full of nothing but the grace of Raffaelle, the purity of Domenichino, the learning of Poussin'. He draws to the connoisseur's attention a whole-length of Charles I by Van Dyck: 'He agreed it was very fine, but it wanted spirit and contrast, and had not the flowing line, without which a figure

* Northcote, i, 89. Over the two-year life of the paper, Johnson farmed out twelve of the 103 pieces that were published.

could not possibly be graceful.' They move on to study Raphael's *Charge to Peter*, and the connoisseur pronounces a second time: 'Here,' says he, 'are twelve upright figures; what a pity it is that Raffaelle was not acquainted with the pyramidal principle!'

A very neat piece of stiletto work. No names have been mentioned, but it is suddenly clear what Reynolds is up to: he is ridiculing the pyramidal principle and the serpentine 'line of beauty' – theories advanced by Hogarth in his polemical work *The Analysis of Beauty* six years previously. And by a sly twist of the knife, the words are placed in the mouth of a connoisseur – a breed that Hogarth cordially detested.

The phrase 'the grand style of painting' makes an appearance in Idler no. 79, the second piece Reynolds wrote for Johnson, but we are not favoured by any particularly magisterial pronouncements. At this stage he gives the impression of someone groping his way towards a definition of some of the elements of that style, of a man attempting to clear his own mind. 'What pretence has the art to claim kindred with poetry, but by its powers over the imagination?' he asks rhetorically:

To this power the painter of genius directs his aim; in this sense he studies nature, and often arrives at his end, even by being unnatural in the confined sense of the word.

The grand style of painting requires this minute attention to be carefully avoided, and must be kept as separate from it as the style of poetry from that of history.

Reynolds's third Idler paper, no. 82, drew heavily on Adam Smith's recently published *Theory of Moral Sentiments*. In later editions it was entitled *The True Idea of Beauty*, but the writing seldom rises above the pedestrian:

... From what has been said, it may be inferred, that the works of Nature, if we compare one species with another, are all equally beautiful, and that preference is given from custom or some association of ideas: and that, in creatures of the same species, beauty is the medium or centre of all its various forms.

To conclude, then, by way of corollary: if it has been proved that the Painter, by attending to the invariable and general ideas of Nature, produce beauty, he must, by regarding minute particularities, and accidental discriminations, deviate from the universal rule, and pollute his canvass with deformity.

Reynolds later told Boswell that the six final words had been added by Johnson. It was a characteristically sonorous flourish – it adds little to the meaning, but it sounds tremendous.

*

Ramsay did not enjoy a total monopoly of royal patronage. Reynolds had a number of appointments in the course of 1758 and 1759 with the Duke of Cumberland, and these resulted in several of the many portraits he – or his studio – would paint of the victor of Culloden.* A portrait of Cumberland's brother, the Duke of York, also dates from this time.[25] Prince Edward Augustus ('that ugly little white pig' as the forthright Lady Sarah Lennox described him) sailed as a midshipman under Howe in 1758. There are three appointments with him in late December, and a note in Reynolds's pocketbook indicates that the duke's blue uniform, with the ribbon and star of the Garter, was painted by Toms.

Much more important, from Reynolds's point of view, was an appointment in the early days of 1759. An entry for ten o'clock on 12 January reads 'P. of Wales'. But if Reynolds thought he now had a foot in the door, he was mistaken. There is no record of any further appointment; he was obliged to complete the portrait as best he could on the basis of one sitting,[26] and it would be twenty years before he was given another opportunity to show what he could do with those heavy Hanoverian features.

The rich Scottish nobleman who presented himself in Great Newport Street one morning in June 1759 – 'a little, sharp-looking man, very irritable, and swore like ten thousand troopers' – was more generous with his time.[27] This was the Third Lord March, later the Fourth Duke of Queensberry, who had the distinction of being savaged in verse by both Robert Burns ('the turn-coat Duke') and William Wordsworth ('Degenerate Douglas').† Gambler, lecher, passionate patron of the opera and of the turf, March was as attentive to the welfare of his jockeys and stable boys as he was to the whims of his many mistresses. He was currently the 'protector' of the wife of a Florentine wine merchant, variously known as 'The Rena' or 'La Contessa'. He sent her to be painted by Reynolds, too, and a splendid job he made of it. Her portrait – her round-eared cap and modestly arranged fichu make her look surprisingly matronly – is in the collection of the Earl of Rosebery at Dalmeny House.[28]

This was also the year in which Reynolds painted Kitty Fisher for the first time. Miss Fisher was in the same line of business as La Contessa – 'the most celebrated Traviata of the time', as Tom Taylor coyly put it for his nineteenth-century readers. Her father may have been a silver-chaser; but

* Although there are records of only a handful of sittings, by the time of the duke's death in 1765 there were ten portraits of him by Reynolds or his assistants, together with numerous copies. The best is generally agreed to be the one now at Chatsworth (Mannings, cat. no. 1884. pl. 27, fig. 37).

† Wordsworth was referring to his morals; Burns to the fact that during the regency crisis of 1788 Queensberry, although a Lord of the Bedchamber, sided with the heir-apparent.

then again he may have been a stay-maker. He is thought to have been German, and a Lutheran; his daughter is said to have been born in Soho, and she was christened Catherine Maria. She was apprenticed to a milliner, and first seduced by an ensign. The scurrilous *Town and Country Magazine* asserted that it was under the auspices of Augustus Keppel that she 'first made her appearance as a courtezan'; contemporary gossip had it that Reynolds was another of her lovers; indeed the poisonous, if well-informed scribbler who sheltered behind the name 'Fresnoy' was still at it in 1769, two years after her death:

Catherine has sat to you in the most graceful, the most natural attitudes, and indeed I must do you the justice to say that you have come as near the original as possible.*

She was no more than twenty or twenty-one in the late 1750s, and some of the stories which circulated about her were more preposterous than others. Was she for a time kept by subscription of the entire membership at White's? Had she once made a sandwich of a £100 note? Did she really slip the diminutive Lord Montfort under her hoop petticoat to spare him a painful confrontation with the somewhat larger Lord Sandwich?

Reynolds's pocketbook records more than twenty sittings for her in the course of 1759, the first in the middle of April. A couple of weeks previously a grossly indecent pamphlet entitled 'The Juvenile Adventures of Miss Kitty F—r' had appeared. Unwisely, she allowed herself to be provoked, and dashed off a protest to the *Public Advertiser*:

To err is a Blemish intailed upon Mortality, and Indiscretions seldom or never escape from Censure; the more heavy, as the Character is more remarkable: and doubled, nay, trebled by the World, if the Progress of that Character is marked by success; then Malice shoots against it all her Stings, the Snakes of Envy are let loose; to the Humane and Generous Heart then must the Injured appeal, and certain Relief will be found in Impartial Honour. Miss Fisher is forced to sue to that Jurisdiction to protect her from the Baseness of little Scribblers, and scurvy Malevolence . . .

These rolling, sub-Johnsonian periods naturally achieved the opposite of the effect intended. The town hugged itself in glee, and awaited the promised second instalment of 'Juvenile Adventures' with impatience.

Reynolds painted her many times before her early death in 1767. His ledger

* The attack came in a long letter to the *Middlesex Journal* shortly after Reynolds had been knighted. 'Fresnoy' is thought to have been a clergyman, the Reverend James Wills, who was chaplain to the Incorporated Artists and had had a short career as a painter before taking holy orders. See pp. 200–201 below.

discloses that the picture now at Kenwood, *Cleopatra Dissolving the Pearl*, painted in 1759, was commissioned by the young Sir Charles Bingham, later Earl of Lucan.[29] The portrait of her in the Gemäldegalerie in Berlin ('certainly Reynolds's most overtly erotic picture' in David Mannings's judgement) is unfinished; it could therefore be the canvas that was on his easel during her last recorded sitting in September 1766.[30] Portraits apart, it seems probable that she sometimes obliged Reynolds by sitting to him as a model. Leonard Smelt, the cultivated captain of engineers who later became sub-governor to the royal princes, once remarked that he wondered at Reynolds's ability to 'resist the allurements of the beauty which daily exhibited itself in his painting room'. Reynolds replied that his heart, like the gravedigger's hand in Hamlet, 'had grown callous by contact with beauty'.[31]

As the decade drew to a close, not everyone was prepared to award the palm to Reynolds in the matter of female portraiture. 'Mr Reynolds and Mr Ramsay can scarce be rivals, their manners are so different,' Horace Walpole wrote to his friend Dalrymple:

The former is bold and has a kind of tempestuous colouring; yet with dignity and grace; the latter is all delicacy. Mr Reynolds seldom succeeds in women; Mr Ramsay is formed to paint them.[32]

Reynolds's was certainly the more masculine and less ornamental style, but many of his portraits of the period – those of the Keppel sisters, for instance, the *Kitty Fisher* now at Petworth[33] – demonstrate that he was well able to absorb from the work of the older man as much as it suited him to absorb.

To another of his many correspondents, Walpole wrote in a somewhat different vein – 'to congratulate you on the lustre you have thrown on this country'. He was writing to Pitt, because 1759 had been his *annus mirabilis* – the capture of Guadeloupe in May, the victory of Minden in August, the storming of the Heights of Abraham by Wolfe in September, Hawke's destruction two months later of the French fleet in Quiberon Bay.

November also saw an important development in the smaller world of the arts. The annual dinner of the Foundling Hospital was held each year on 5 November, and the company assembled as it usually did under the pictures in the Court Room. Reynolds was entitled to attend by virtue of his gift of Lord Dartmouth's portrait two years previously. It had been a light day in his painting room, with sittings only at eleven and one o'clock. His friend Wilkes, as Treasurer of the Hospital, presided at dinner, and in the course of the evening's entertainment called for silence for the singing of an ode. This invited the guests 'nobly to think on Hayman's thought' of

founding 'A great Museum all our own'. The *Royal Magazine* explained the allusion:

... a scheme of Mr Hayman's (whose excellent abilities scarce reflect a greater honour on his country than the openness and generosity of his mind) for a public receptacle to contain the works of artists for the general advantage and glory of the Nation and satisfaction of foreigners.

Hayman's scheme for a 'public receptacle' was greeted with enthusiasm, and before the guests dispersed, a resolution had been agreed:

Foundling Hospital, Nov. 5, 1759. At a meeting of the Artists, resolved: That a general meeting of all Artists in the several branches of Painting, Sculpture, Architecture, Engraving, Chasing, Seal-cutting, and Medalling, be held at the Turk's Head Tavern, in Gerrard Street, Soho, on Monday, the 12th inst., at Six in the evening to consider of a proposal for the honour and advancement of the Arts, and that it be advertised in the Public and Daily Advertisers.

This all sounds very high-minded and public-spirited. A little translation is called for. Satisfaction of foreigners? The glory of the Nation? Not exactly. That was all so much rhetorical froth – there was a lot of it about in 1759. The truth of the matter is that Hayman's 'thought' was directed, very properly, to the advantage of his fellow artists. 'A great Museum all our own' meant just what it said: a place where the artist would be king, free from the power of the patron and the dealer; a place where paintings might be exhibited and students taught – and where artists might come face to face with their public.

The meeting at the Turk's Head duly took place. It was agreed that each year, in April, there should be an exhibition of the work of living artists. An entrance charge of a shilling a head was proposed, the profits to be applied to a fund for the relief of artists who had become old and infirm.

All manner of things remained to be decided – the small matter of where such an exhibition might be held, for example, because no such thing as a public gallery existed. It was a beginning, for all that. Slowly, with the occasional halt along the way to quarrel among themselves, the English artistic community began the long march towards a Royal Academy. They would be on the road for nine years.

6

Gallipots of Varnish and Foolish Mixtures

In Reynolds's day Great Newport Street retained an almost suburban air. A short walk would take him into the green fields surrounding the Foundling Hospital to the north and on to the open country beyond which separated London from the villages of Highgate and Hampstead. One of his neighbours picked enough grapes from her vine each year to make a pipe of wine. His own house had a good garden to the rear, and another to the front – slightly tiresome this, in wet weather, because sitters' carriages could not draw up right to his door.[1]

In the course of 1760 he decided to trade up. 'House bought' reads a note in his pocketbook on 3 July, and on 28 August, 'House to be paid for'. In the week beginning 3 September he wrote 'House Payd'. Finally, on 11 September, he scrawled across two pages, 'Paid the remaining £1000 for the House in Leicester Fields'.

No front garden here to dirty Kitty Fisher's shoes, although those elegant, spare, eighteenth-century engravings which we so admire today can be deceptive; even the most fashionable London neighbourhoods were a mixture of the grand and the squalid. Reminiscing in the next century, an old man remembered Leicester Fields as a dirty place where ragged boys gathered to play chuck-farthing. In an adjoining mews there was a cistern, where the horses were watered, and behind that a horse-pond, where pickpockets caught in the neighbourhood were taken and ducked. On the south side of the square stood Mr Lucy's bagnio, where Mary Tofts, the Godalming woman who claimed to have given birth to a litter of rabbits, had been brought in 1726 to be examined by the leading *accoucheurs* of the day.*

It was several rungs up the social ladder from Great Newport Street, for all that. A low wall topped with iron railings ran round the central enclosure,

* Tofts, the illiterate wife of a journeyman clothier, said she had been frightened by a rabbit while working in the fields. Nathanael St André, Swiss-born Anatomist to George I, was taken in by her story, and his published report caused widespread alarm among women all over the country. Tofts eventually confessed to having inserted portions of rabbit into her body; St André became a laughing stock, ridiculed in the press and lampooned by Hogarth.

and in the middle stood the *Golden Horse and Man*, a gilded equestrian statue of George I in classical armour, one of the sights of the town for visiting country folk.* Standing back from the square, occupying almost half of its north side but with only a small garden to the rear, was Leicester House.† Thomas Pennant, in his *London*, dubbed it 'the Pouting-Place of Princes'; for much of the time between 1717 and 1760 it had been the town house of successive Hanoverian heirs-apparent – seat of the court-in-waiting, focus of opposition to the government of the day, echo-chamber of gossip and intrigue. Royal residence or no, it was fronted by four shoddy wooden lock-up shops.

Reynolds was not the first painter to settle in Leicester Fields. Hogarth had been established there since 1733, at a house on the east side of the square, under the sign of the Golden Head, and from here he retailed his prints. The head in question was that of Van Dyck, carved from bottle corks, glued and gilded by Hogarth himself. In 1751, enraged at the lack of interest when he had offered his 'Marriage à la Mode' pictures for sale at auction, he had torn the sign down.

The house which Reynolds took – it was number 47, on the west side of the square, with two imposing obelisk lampposts outside it – had also belonged to an artist. Henry Robert Morland specialized in genre and fancy pictures with titles such as *Girl Opening Oysters* and *A Lady's Maid Soaping Some Fine Linen*, but by 1760, in spite of a good marriage three years previously to the daughter of a Huguenot jeweller, he found himself obliged to sell up and accept charitable assistance from the Society of Artists.‡

Reynolds took a forty-seven-year lease, and paid £1,650 for it. It was not a particularly large house – narrow-fronted, it dated from about 1690 and consisted of four floors and a basement. Reynolds spent a further £1,500 on having it extended at the back by the addition of painting rooms for himself and his assistants and a gallery for the exhibition of his works.

* Some people admired it more than others. Leslie Stephen, in his *Dictionary of National Biography* article about the First Duke of Chandos, wrote that it 'helped, till 1873, to make Leicester Square hideous'. The Duke, who had amassed a large fortune as Paymaster-General, had commissioned it to adorn the grounds of the sumptuous estate he built at Canons, near Edgware. It had been acquired by the residents of the square when the house was demolished in the 1740s.

† Because the garden was so small, Frederick, Prince of Wales, had mostly preferred to spend his summer days in the spacious gardens of Carlton House.

‡ His son, the gifted but disorderly George Morland (1763?–1804), was apprenticed to his father for seven years, time chiefly employed in copying (and forging) Dutch landscapes. He later became celebrated for his scenes from rural life and pictures of smugglers and wreckers; he drank himself into a terminal coma in his early forties.

Access to this new part of the house was gained from the first half-landing; the staircase to the first floor was rebuilt, the wrought-iron balustrade curving outward to accommodate the width of ladies' dresses. Other improvements included a fine new chimney-piece designed for him by his friend James Paine, the architect; it is possible that Paine also designed the gallery and painting room.[2] These alterations raised the rateable value of the house from £80 to £100. 'In this speculation, as I have heard him confess,' wrote Northcote, 'he laid out almost the whole of the property he had then realized.'[3]

It is not clear whether this 'speculation' included the handsome carriage with which Reynolds also equipped himself at about this time. Northcote, possibly with a touch of malice, said, 'I have been told that it was an old chariot of a sheriff of London, newly done up.' It was certainly very grand. The wheels were carved and gilt, and the panels were decorated with allegories of the seasons, the work of Charles Catton, later coach painter to George III.* Reynolds was far too busy to go driving round town in this splendid rococo affair himself, but he was determined that its promotional potential should be exploited:

He insisted on it that his sister Frances should go out with it as much as possible, and let it be seen in the public streets to make a show, which she was much averse to, being a person of great shyness of disposition, as it always attracted the gaze of the populace, and made her quite ashamed to be seen in it.

When she complained that it was 'too shewy', however, her brother's reply was withering: 'What, would you have one like an apothecary's carriage?' Northcote had the story from Frances herself. It served to show, he reflected, that Reynolds 'knew the use of quackery in the world'.†

The move to Leicester Fields clearly made sizeable inroads into his capital; this is confirmed by a marked slackening in his saleroom acquisitions in the 1760s, although in February, a matter of months before buying the house, he had gone on a considerable spree: at the sale of Richard Houlditch's drawings, at Langford's, he had secured eleven of the seventy lots on offer, outbidding Hudson in the process.[4] Reynolds also permitted himself the

* Catton (1728–98) was born in Norwich, one of a family of thirty-five children. He is now mainly remembered as a painter of animals and landscapes, but he had been apprenticed to a coach painter, and breathed new life into an art then in decline. He was a founder member of the Royal Academy.

† Leslie and Taylor, i, 184. Reynolds's coachman, in his livery laced with silver, had no complaints, as he frequently got tips for showing the coach off to the curious.

expense of a lavish ball to mark – and advertise – the opening of his gallery, but then it was back to the grindstone.

His new studio was an octagonal room, measuring about twenty feet by sixteen and lit, curiously, by only one small window set high in the wall. Derek Hudson, in his 1958 biography, speculates that this had to do with the window tax, and that may not be as laughable as it sounds. Reynolds's concern for candle-ends is well documented. Looking round the house once for old canvases, he came upon 'a mop-stick put up in the corner of the back-kitchen'. He told Ralph Kirkley, the servant who came to work for him at about the time of the move to Leicester Fields, that it must not be thrown away – 'in order that its value might be deducted when the next new mop was purchased'.[5]

The projected exhibition of contemporary work had gone ahead in the spring. The Society of Arts had agreed to make available a large room it owned in the Strand, but was not willing to allow a charge for admission. The exhibition opened on 21 April. There were 130 exhibits, including works by Roubiliac, Reynolds, Hayman, Richard Wilson and Paul Sandby. The catalogue was priced at sixpence, and in the course of the next two weeks 6,582 were sold; the daily attendance is thought to have averaged well over 1,000. It was quite a promising beginning; a source of revenue had been created and £100 was invested in Consols.

That did not prevent some of the artists scratching around for something to grumble about. Many years later, in his posthumous *Anecdotes of Painters*, Edward Edwards recorded that there had been displeasure at 'the mode of admitting the spectators' – every member of the Society, it seems, 'had the discretionary privilege of introducing as many persons as he chose, by means of gratuitous tickets'. Why this should have been a source of displeasure to the artists – there was, after all, no admission charge – is not immediately plain; many of these unwelcome visitors presumably paid their sixpence for a catalogue and swelled the profits.

Matters become clearer in the next sentence: 'the company was far from being select, or suited to the wishes of the exhibitors'. Hayman and his colleagues had certainly been reluctant to accept the Society's stipulation about no admission charge – partly because they were eager to raise funds, but also from a desire to keep out the great unwashed. There was nevertheless an element of inverted snobbery in Edwards's reaction. Although he later became quite well known as a painter, and was professor of perspective at the Royal Academy, at the time of this first public exhibition he was a young man of twenty-two, the son of a chair-maker, and had just completed his apprenticeship to an upholsterer.

There was, perhaps, rather more substance to another complaint made

by some of the exhibitors, although here too an element of comedy was not lacking. The Society of Arts had recently offered prizes on its own account for history and landscape paintings, and had made it a condition of lending out their Great Room that the pictures submitted for this competition should remain there for a certain time:

As it was soon known which performances had obtained the premiums, it was naturally supposed, by such persons who were deficient in judgement, that those pictures were the best in the room, and consequently deserved the chief attention. This partial, though unmerited selection, gave displeasure to the artists in general.

Four years later Edwards himself, by now employed by John Boydell to make drawings for engravers, was awarded the Society's premium for the best historical picture in chiaroscuro. Circumstances, as they say, alter cases.

The novelty and popularity of the occasion notwithstanding, there was not a great deal of press interest. It would be another decade before newspapers began to notice exhibitions systematically. One review which did appear – in the *Imperial Magazine* – was so fulsome in its praise of Reynolds that he must surely have blushed to read it – unless, of course, he had had a hand in its composition:

This gentleman, whose merit is much beyond anything that can be said in his commendation, has obliged the public with four pieces of his hand; which are, a lady, whole length, said to be the Dutchess of Hamilton, but rather the Queen of all grace and beauty; another lady, supposed to be of the Albemarle family, of a most happy pencil; a gentleman, General Kingsley – and to say it is known by everybody is no praise at all; another of a gentleman in armour which wants nothing to be taken for a Vandyck but age only. In these pieces you see a copious and easy invention, the most graceful attitudes, great truth, sweetness, and harmony of colouring; a light bold, mellow and happy pencil; a thorough knowledge of the magic of lights and shadows, with all the parts of the art which constitute a perfect painter; and in short one living proof that genius is of all ages and countries and that Englishmen need not travel abroad to see fine things, would they but always study to cultivate and encourage genius at home.[6]

The whole-length was indeed the Duchess of Hamilton, and the lady of the Albemarle family was Keppel's sister, Lady Elizabeth. The gentleman in armour was a Colonel Vernon, who the following year became an aide-de-camp to the king. Interestingly enough, another visitor to the exhibition, Horace Walpole, noted in his catalogue that the attitude was taken from

Van Dyck; David Mannings speculates that he possibly had in mind the *Duke of Arenberg* at Holkham.[7] William Kingsley, who had distinguished himself at Minden the previous year, was a popular – and lucky – soldier of the day; at the battle of Fontenoy, a cannon-ball had passed between his legs and killed four men behind him.[8]

The varnish on this last canvas can scarcely have been dry; the 1760 pocketbook records a sitting with Kingsley as late as 27 March. Reynolds's robust ideas on the handling of pictures would horrify some modern curators. The publisher Robert Dodsley – the man who suggested to Johnson the idea of the *Dictionary* – also sat in 1760, having agreed to exchange portraits with his friend the poet William Shenstone. 'If the picture should be turned yellowish by being packed up,' he wrote to Shenstone, 'Mr Reynolds advises, that it be set in the Sun for two hours, which will quite recover it.'[9]

Another picture begun at this time has not recovered quite so well. When it was first shown the following year at Spring Gardens it was greatly admired. A letter printed in the *St James's Chronicle* describes the enthusiasm of a young man visiting the exhibition with a friend: 'And pray who is that nobleman – a portrait I cannot call it, for he breathes?'[10] The visitor, an Etonian and a university man himself, recognized the sitter as a nobleman because over his red velvet suit he wears a richly embroidered college robe of blue silk – the Oxford academic dress of the day appropriate to his rank. It was the Fifth Duke of Beaufort, who had succeeded his father at the age of twelve five years previously. Today the picture is in poor condition, with some of the dark areas in the lower part of the canvas badly scarred. M. Kirby Talley, Jr, in his contribution to the Catalogue of the 1986 Reynolds Exhibition at the Royal Academy,* suggested that Reynolds's first experiments with asphaltum date from the early 1770s, but the evidence of this portrait is that he was already pursuing his sometimes reckless interest in bizarre materials a decade earlier.

The attractions of bitumen, a naturally occurring petroleum residue, were obvious. Artists had been dissolving it in oil or turpentine to produce a rich brown glaze since the early years of the seventeenth century. There was something of the sorceror's apprentice about Reynolds. If a great Dutch master such as Rembrandt had used it successfully, why should not he employ it to achieve the same chiaroscuro effect? There were, of course, several compelling reasons why not. First of all, it never completely dries; secondly, if applied too thickly, it can crack dramatically, so that it comes almost to resemble the skin of an alligator and to reveal whatever had been used below. Philip Reinagle, a pupil and later the long-time associate of

* See p. 93 above, fn.

Ramsay, told Haydon that 'He remembered Sir Joshua's using so much asphaltum that it used to drop on the floor.'*

If Reinagle was describing an occasion when he was permitted to watch Reynolds at work he was an unusually lucky young man, because Reynolds was generally very secretive about his methods, even with his own pupils. 'All his own preparations of colour,' writes Northcote, 'were most carefully concealed from my sight and knowledge, and perpetually locked secure in his drawers; thus never to be seen or known by any one but himself.'[11] If he pursued his own experiments with the zeal of a latter-day alchemist, however, he frowned on any sign of a spirit of inquiry among his pupils. Northcote was allowed to make use only of such conventional preparations as were supplied by the colourman:

I well remember, that he was much displeased with a young painter, who showed him a picture in which experimental mixtures, composed of wax and varnishes of divers sort, had been used; and afterwards, speaking of him to me, he said, 'That boy will never do any good, if they do not take away from him all his gallipots of varnish and foolish mixtures.'[12]

From someone notorious for the indiscriminate way in which he experimented with wax, eggs, Venice turpentine and goodness knows what else, with dire consequences for the stability of what lay underneath, this was pretty rich. Northcote has a story of a young painter called John Powell, who was in Reynolds's studio some years after his own time there, and was employed to make reduced copies of portraits. Reynolds, who was generous in such matters, had allowed him to borrow a picture of a child to copy:

When he had finished his copy and was taking the picture home, a young gentleman in the street, in flourishing about the stick which he carried in his hand, by accident struck the picture, when a large part of the face and hand of the painting dropped from the canvass, to the utter astonishment and dismay of poor Powell, who was totally unable to repair the damage[13]

Tom Taylor, who had the opportunity in the middle of the nineteenth century of examining some of Reynolds's pictures which had been relined, found nothing improbable in the story:

* Reinagle was the son of a Hungarian musician who had settled in Edinburgh. He is said to have painted as many as ninety pairs of the coronation portraits of George III and his queen which were churned out by Ramsay's studio over several decades. He later turned with relief to the landscapes and animal paintings – sporting dogs, birds and dead game – for which he is now best remembered.

Where the canvas has been primed, the painted surface often detaches in a mass, showing the canvas underneath as clean as when it left the colourman's shop ... The non-adhesion of colour to cloth was owing to the rapid drying of Sir Joshua's semi-solid impasto, mainly made up with Venice turpentine and wax as vehicles.[14]

Many of the technical notes Reynolds wrote about his experiments are in Italian. It is conceivable that he regarded this as a way of encoding their contents to keep them from prying eyes, although it may possibly also indicate that the only person with whom he shared the often dodgy secrets of his painting room was Giuseppe Marchi. If we exclude Marchi, 1760 was the year in which he took on the first of his many pupils. This was Thomas Beach, a native of Dorset; he stayed with Reynolds for two years and later established himself quite successfully in Bath, sometimes working in the summer as an itinerant painter in the West Country.

Numbers of famous naval and military names figure in the pocketbook for 1760. There was Sir Charles Saunders, whom Anson had particularly asked to have with him on his celebrated voyage; now Vice-Admiral of the Blue, he had commanded the fleet which the previous year had taken Wolfe and his 8,000 troops to Quebec.[15] There was the future Admiral Lord Duncan, who towards the end of the century would famously defeat the Dutch Admiral De Winter off Camperdown; a protégé of Keppel, Adam Duncan had been a young midshipman on the *Centurion* when Reynolds sailed to Minorca; six foot four tall and broad with it, he turned heads wherever he went.[16]

A commission came from the East India Company; they wanted a portrait of Stringer Lawrence – veteran of Fontenoy and Culloden, friend of Clive, 'the Father of the Indian Army' – to hang in their Committee Room. Reynolds painted him in a short, white, no-nonsense wig and a plain red coat over a steel breastplate.[17] After his death, the Company also erected a monument to him in Westminster Abbey: 'For Discipline established, Fortresses protected, Settlements extended, French and Indian armies defeated, and Peace restored in the Carnatic.'

An even more distinguished soldier who sat to Reynolds that year was Lord Ligonier, one of the numerous Huguenot refugees from the France of Louis XIV who enriched so many areas of British life. Ligonier was then in his eightieth year. In his last battle, at Val, thirteen years previously, he had led a brilliant cavalry charge which saved Cumberland and his retreating infantry from the French horse. His own mount was killed, and he was made prisoner. Marshal Saxe brought him into the presence of Louis XV with the words, 'Sire, I present to Your Majesty a man who by one glorious

action has disconcerted all my projects.' An amusing story attaches to the portrait which demonstrates that it was not only the Old Masters and works of antiquity that Reynolds raided for inspiration. The sculptor Nollekens overheard him at a sale telling someone that the pattern of light and shadow in the picture was inspired by 'a cheap wood-cut upon a half-penny ballad, which he purchased from the wall of St Anne's Church in Princes-street'.[18] This dramatic equestrian portrait is now, appropriately, at Fort Ligonier, Pennsylvania.[19] A second version, mostly studio work, is at the Tate Gallery.

The literary lion of 1760 was Laurence Sterne. The first two volumes of *Tristram Shandy* appeared in the early days of January. When the author arrived in London from York on 4 March he found himself an instant celebrity. Richardson might declare the book 'execrable' and Johnson might be offended by its indecent innuendo, but Sterne was deluged with invitations to the dinner tables of the fashionable, and in little more than a fortnight he was sitting to Reynolds for the celebrated portrait which is now in the National Portrait Gallery.[20]

The picture does not seem to have been commissioned. It was never paid for; Reynolds submitted it to the Society of Artists' exhibition the following year, and it was presumably still in his studio when he exhibited it again seven years later. A mezzotint was made almost immediately; Nicholas Penny speculates that Reynolds had a share in the profits of the engraver, Fisher, and that it is reasonable to assume that he painted Sterne as a speculation.[21]

It is a study pared down to essentials. Sterne wears a Geneva gown; his clerical bob-wig is slightly askew; the hint of a foxy, lopsided grin plays around his mouth, but the eyes are cold and appraising. Was this what the master of 'Shandy Hall' actually looked like? It was not a question that Reynolds concerned himself with overmuch. 'The likeness,' as he would later argue, 'consists more in taking the general air, than in observing the exact similitude of every feature.'[22] The Victorian writer Anna Jameson, herself the daughter of a painter, understood precisely what he was getting at. 'This is the most astonishing head for truth of character I ever beheld,' she wrote; 'I do not except Titian.'[23]

The other outstanding picture which Reynolds began in 1760 was *Garrick between Tragedy and Comedy*.[24] It is a canvas which bears a greater weight of scholarly disquisition than anything else Reynolds ever painted. Was it his first attempt at historical composition? Can its pictorial composition be traced back to the Middle Ages? Does it derive principally from Guido Reni's *Lot and His Daughters*, or are there also traces of the influence of Rubens and Correggio and Van Dyck? What echoes are there of possible

literary sources – Shenstone's poem 'The Judgement of Hercules'? The third book of Ovid's *Amores*? What role did Garrick himself play in the evolution of the picture?

All these questions and many more have been pondered over the years by art historians and others, not all of whom have appreciated that on one level the picture is a sophisticated joke. The revered Edgar Wind singled it out for detailed analysis in his collection of essays on eighteenth-century imagery, and seems to me to have fallen flat on his face in the process. In considering the interpretation to be placed on the painting, he postulates a knowledge of Garrick's theory of acting on Reynolds's part:

In the literary Club to which both Garrick and Reynolds belonged, Goldsmith's project for a Dictionary of the Arts and Sciences was discussed – Goldsmith and Johnson were to contribute essays on literature, Reynolds on painting, Garrick on acting. And even though this plan never materialized, those concerned must have often conversed about the theory of their respective arts . . .[25]

No doubt they did, but Wind is here playing ducks and drakes with chronology. The picture was painted in 1760 and 1761; the Club was not formed until 1764; Garrick, what's more, was not admitted to membership until 1773 – largely because his election was opposed by Johnson.

Reynolds had known Garrick for some years but although they would see a great deal of each other socially for the best part of a quarter of a century, he never came to entertain for him the warmth of feeling he had for Johnson, or, later, Goldsmith. He found him amusing and sprightly company, but his admiration for the actor did not extend to the man. This has become known only in comparatively recent times. Percy Fitzgerald, for instance, in his *Life of Garrick*, published in 1868, wrote that Reynolds 'bears testimony to the charm of his company at the great tables, his gaiety, subdued vivacity, his wit on light subjects, and his acuteness and information in graver matters'.[26] That was many years before the discovery of the Boswell papers in a stable-loft at Malahide Castle in 1940. The draft of Reynolds's word-picture found among them tells a very different story. Garrick, he wrote, 'by too great a desire after the reputation of being a wit, the object from whom the whole company are to receive their entertainment, spoils every company he goes into'. And there are harsher strictures to come:

It was difficult to get him and when you had him, as difficult to keep him. He never came into company but with a plot how to get out of it. He was for ever receiving messages of his being wanted in another place. It was a rule with him never to leave

any company saturated. Being used to exhibit himself at a theatre or a large table, he did not consider an individual as worth powder and shot.

... Garrick died without a real friend, though no man had a greater number of what the world calls friends. Garrick had no friends to whom he gave orders that he was always at home, except to his doctors, of which he had two sorts, one sort administering for his body, the other for his diseased mind – in other words, his vanity. The first were generally quacks and the others sycophants.[27]

None of which prevented the painting of a masterpiece. *Garrick between Tragedy and Comedy* was the first picture of Reynolds to be exhibited (he sent it to the Society of Artists in 1762) which was not a straight portrait. Ellis Waterhouse adjudged it one of the most profoundly characteristic of English eighteenth-century masterpieces – 'an invention in the very centre of the European classical tradition'.[28]

Between seven and eight o'clock on the morning of 25 October 1760 George II fell dead of a stroke in his water-closet at Kensington Palace. At noon the following day, outside Savile House in Leicester Fields, his grandson was proclaimed king. The proclamation was repeated at Charing Cross, and the heralds of the College of Arms led the procession on to Temple Bar and the Royal Exchange. Salvoes were fired in the Park and at the Tower, the bells of the city churches rang out and after nightfall bonfires blazed.

Crowds gathered again in Leicester Fields three days later to watch the coming and going of those who came to kiss hands. Horace Walpole was impressed. 'This young man don't stand in one spot, with his eyes fixed royally on the ground, dropping bits of German news,' he wrote to Montagu. 'He walks about and speaks to everybody.'[29] Two years later, writing for public consumption in the Preface to his *Anecdotes of Painting in England*, Walpole contrived a more courtly tone: 'The Throne itself is now the altar of the graces, and whoever sacrifices to them becomingly, is sure that his offerings will be smiled upon by a Prince, who is at once the example and patron of accomplishments.'

That Reynolds coveted the prize of royal patronage is not in doubt. An intriguing story that found its way into print only after his death suggests that it may have been within his grasp at the beginning of the new reign, but that he overplayed his hand:

It is supposed that the King's disregard for Sir JOSHUA REYNOLDS originated from the following event: – Shortly after the last Coronation, a Nobleman came from the King to the Artist, to know if he could make a drawing of the Procession, in imitation of *Vandyke's* design of a similar ceremony, for Charles the First: Sir

JOSHUA replied that he was not fond of making drawings, but he would make a sketch in oil; but previous to the undertaking he wished to be assured of an adequate reward, which he calculated at One Thousand Guineas. The Nobleman assured him of the indelicacy of speaking to the King on such a subject, but consented to do it at the particular request of Sir JOSHUA; and the issue was, that the King felt himself so offended at the idea, that he relinquished the business altogether, and treated the Painter ever after with the most mortifying coldness – this occurence paved the way for the introduction of RAMSAY at St. James's.[30]

The author was John Williams, a satirical writer and critic who sheltered behind the pseudonym of Anthony Pasquin.* He was a controversial figure – Macaulay described him as 'a polecat'. The reference to Ramsay is clearly wide of the mark – as we have seen, he was already on the inside track – but the story cannot be dismissed out of hand, even though other reasons will emerge for the king's coldness towards Reynolds.

Shortly before the coronation, when the king was married to the unprepossessing Princess Charlotte of Mecklenburg-Strelitz, Reynolds was present in the Chapel Royal at St James's Palace, and made a sketch of the ceremony from the music gallery.[31] Thomas Secker, the Archbishop of Canterbury, is shown blessing the royal couple at the altar, with the Bishop of London in attendance. A bevy of bridesmaids and Ladies of the Bedchamber stand behind the queen on the left of the picture, and the king's mother and brothers and sisters are grouped at a greater distance on the right. In the left foreground, in partial shadow, there are two heralds; they are amply balanced, on the other side, by the portly figure of William, Duke of Cumberland, who had given the bride away.

The painting measures only 95.2 × 129.5 cm; the hangings of the chapel are deep red, and the small figures are sketched in almost in monochrome. Whether Reynolds was present by invitation or contrived to be there on his own initiative is unknown; perhaps the latter, because the picture remained in his studio until after his death, and did not enter the Royal Collection until the reign of either William IV or Queen Victoria.

Reynolds did not give up easily, and was determined to demonstrate what he was capable of in the way of court portraiture. One of the queen's bridesmaids had been Keppel's sister, Lady Elizabeth, who had sat to him some time previously.† Less than three weeks after the wedding, he made a start on what

* Williams (1754–1818) was originally intended for the Church, but at nineteen he entered himself as a student in the Royal Academy schools. He worked for a time as an itinerant painter in Ireland before turning to writing. He eventually emigrated to America, and died of typhus in New York.

† See pp. 95–6 above.

has remained one of his most admired full-length portraits – Lady Elizabeth, assisted by a black attendant and decked out in her splendid white and silver bridesmaid's dress, is seen adorning a statue of Hymen with a garland.[32]

Splendidly classical, and embellished with some lines from Catullus,* the picture went on display, along with *Garrick*, at the Society of Artists 1762 Exhibition, powerfully advancing Reynolds's claim to supremacy among the portrait painters of the day. The court remained deaf to such oblique lobbying. Shortly after his accession, George III sat to Ramsay for a full-length to be sent to Hanover, and for another destined for St James's Palace. Although the unspectacular John Shackleton had been absent-mindedly sworn-in again as Principal Painter,† Bute's intervention saw to it that Ramsay was appointed 'one of his Majesty's Principal Painters in Ordinary'. The salary of £200 remained with Shackleton, but the stream of commissions for state portraits that came flooding through the Lord Chamberlain's office was directed to Ramsay. A coronation portrait of the queen – a profile of the king for the coinage – a further full-length of the king for the unpopular Bute – the studio in Soho Square resembled a beehive. 'Mr Ramsay,' said the sly Sterne, 'you paint only the court cards, the King, Queen and Knave.'

Ramsay quickly endeared himself to the royal family. The queen liked him because he could converse with her in German, an accomplishment beyond most of her courtiers. Allan Cunningham says that when he was painting the king, he was sometimes invited into the palace dining room, so that the monarch might have 'the pleasure of his conversation', and criticize his work as he ate. 'When the King had finished his usual allowance of boiled mutton and turnips, he would rise and say, "Now, Ramsay, sit down in my place and take your dinner!" '[33]

Reynolds would continue to exert himself, during the early sixties, to attract royal attention by flattering portrayals of sitters close to the throne. Number 92 in the 1764 Society of Arts catalogue, for instance, was entitled simply *A Lady, Whole Length*, but the conventional anonymity deceived nobody who was anybody. 'Duchess of Ancaster,' Horace Walpole scrawled in his catalogue, 'with a view of the Queen's passage; the sea by Wright.' The duchess was Queen Charlotte's Mistress of the Robes, and had accompanied her on her journey from Germany. She is shown as Ariadne, posed beside a large tree on a hostile shore; the sky and sea are stormy, and several vessels pictured in the background could well be in trouble; somewhere along the way the goddess has mysteriously acquired a peeress's cloak.[34] Reynolds, alas, was barking up the wrong tree. The royal taste was altogether more

* Reynolds got the refrain slightly wrong.
† Hogarth's patent as Sergeant-Painter was also renewed.

domestic and down-to-earth. The grand style was not for Farmer George.

Reynolds had moved his siege artillery into position for his most deter-mined assault some time in 1762–3. The rakish Earl of Eglinton was a sportsman, a representative Scottish peer, a Lord of the Bedchamber – and a friend of Lord Bute. Reynolds, who had known him since the mid-fifties, now persuaded him to commission a portrait of Bute, who had by then become prime minister. The picture, *Lord Bute and His Secretary, Mr Jenkinson*,[35] was not finished when Bute was forced to resign in April 1763. Somehow, it was seen by the king, who expressed a desire to have it. Eglinton naturally agreed, presuming only to suggest that His Majesty might be graciously pleased to sit to Reynolds himself, and finding himself famously put down for his pains: 'Mr Ramsay is my painter, My Lord.'*

If, however – Hanoverian indifference apart – Reynolds had now pulled well away from the field as a portrait painter, he was not without rivals in the matter of the grand style. The Society of Arts top premium for a subject from English history had gone in 1760 to Robert Edge Pine, a London-born painter of much the same age as Reynolds, the son of a well-known engraver and printseller.[36] Pine had attracted attention in 1759 by a striking full-length of George II which he had painted without being granted a sitting by the king.[37] The large canvas he exhibited in 1761, *The Earl of Northumber-land Laying the Foundation Stone of the Middlesex Hospital*,† was a confi-dent exercise in the grand style and bears comparison with anything Reynolds had done up to that time.

Dissatisfaction with the conditions imposed by the Society had led the more important artists, including Reynolds, to look elsewhere, and for the 1761 Exhibition they had found a large room in Spring Gardens, Charing Cross. They also determined to forge a separate identity and call themselves 'The Society of Artists of Great Britain'. The exhibition opened on 9 May and there were 229 exhibits. The catalogue was priced at one shilling, and served as a season ticket; Hogarth, who had held aloof the previous year, designed a frontispiece and tailpiece for it. The frontispiece depicted a bust of George III; he gazes at Britannia, who is watering three saplings identified

* Two or three years previously, when the young James Boswell had run away to London with the idea of converting to Roman Catholicism, it was Eglinton, a neighbour in Ayrshire of Bos-well's father, who had tracked him down, installed him in his own apartment in Mayfair, and, as Frederick Pottle puts it, 'salvaged him from what remained of his religious error by making him a more complete libertine, in all the senses of that word'. Boswell was grateful. Eglinton, he later wrote, had introduced him 'into the circles of the great, the gay, and the ingenious'.

† Northumberland, who modestly considered himself the handsomest man in London, had a weakness for presenting his portrait to public institutions. He was advanced to a dukedom in 1766. He had sat to Reynolds some years previously, and did so again in 1762 (Mannings, cat. no. 1434, fig. 632).

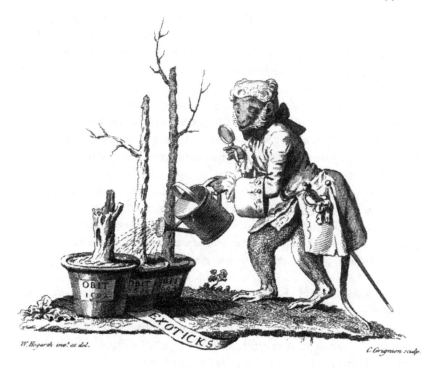

W. Hogarth inv.t et del. C. Grignion sculp.

Published according to Act of Parliament May 7, 1761.

3. *Tailpiece to the* Catalogue of Pictures Exhibited in Spring
Gardens. *Hogarth's frontispiece and satiric tailpiece helped to
boost sales of the exhibition catalogue. The catalogues went so fast
that they had to be engraved a second time. They were priced at 1s,
and some 13,000 were sold.*

as 'Painting', 'Sculpture' and 'Architecture'. The tailpiece was less anodyne:
a monkey, foppishly dressed and sporting a lorgnette, waters three withered
stumps, labelled 'Exoticks', with the dates of their death recorded as 1502,
1600 and 1604 – Hogarth's way of expressing his contempt for the prefer-
ence shown by many aristocratic connoisseurs of the day for the works of
long-dead foreign artists.

Johnson, writing to Baretti in Italy, gave news of the exhibition's success:

They please themselves much with the multitude of spectators, and imagine that the
English school will rise in reputation. Reynolds is without a rival, and continues to
add thousands to thousands, which he deserves, among other excellencies, by retain-
ing his kindness for Baretti.[38]

Reynolds was certainly 'adding thousands to thousands', and as the pictures he submitted in 1761 included his portraits of Sterne, Ligonier and the Duke of Beaufort, there was clearly nobody in sight to challenge his ascendancy. In retrospect, however, the single picture entered by one other artist can be seen as putting down an important marker. Two years previously, having pretty well drained the pool of patronage for portraits in Suffolk, Thomas Gainsborough had settled in Bath, and had begun to attract a stream of sitters; a letter from the bluestocking Mrs Delany, writing to her friend Mrs D'Ewes in October 1760, indicates that he was also attracting a good deal of attention:

This morning went with Lady Westmoreland to see Mr Gainsborough's pictures (the man that painted Mr Wise and Mr Lucy), and they may well be called what Mr Webb *unjustly* says of Rubens, 'they are *splendid impositions.*' There I saw Miss Ford's picture, a whole length with her guitar, a most extraordinary figure, handsome and bold; but I should be very sorry to have any one I loved set forth in such a manner.[39]

Ann Ford was certainly both handsome and bold. A talented musician, she played the viola da gamba and the English guitar and had a fine voice. She had overcome her father's opposition to her performing in public (he twice had her arrested to prevent it); she had also rejected with contempt an offer by the elderly and infirm Earl of Jersey to pay her £800 a year if she would become his mistress. In Gainsborough's dazzling and provocative portrait she sits with her English guitar cradled in her lap, her legs crossed above the knee. 'Such a free posture,' decreed a contemporary guide to etiquette, 'unveils more of a masculine disposition than sits decent upon a modest female' – that was possibly what Mrs Delany was tut-tutting about and probably why Gainsborough displayed the picture in his painting room, but did not send it for public exhibition.

What he sent instead was his full-length portrait of Robert Nugent, then the MP for Bristol. Nugent – later Earl Nugent – was a rollicking Irishman with an athletic frame, a stentorian brogue and no political principles. He amassed a huge fortune, largely through his skill in marrying rich widows – 'a talent so marked', says the *Dictionary of National Biography*, 'that Horace Walpole invented the word "Nugentize" to describe the adventurers who endeavoured to imitate his good fortune'.*

Gainsborough devised an unusual pose. Nugent, side-on to the viewer, sits in relaxed fashion, one arm thrown over the back of an upright chair,

* Nugent had for some years been Controller of the Household to Frederick, Prince of Wales, who borrowed large sums of money from him. These debts were never repaid, but the amiable Irishman was rewarded by nomination to high office in his royal master's imaginary administrations.

and turns his head to look directly out of the picture. The portrait does not seem to have been particularly remarked at the time, but Gainsborough had made his first pitch for the attention of the metropolitan public. The exhibition of 1761 marks the beginning of the rivalry between England's two greatest portrait painters.*

The accounts for the exhibition survive. The cost of hanging the pictures and taking them down again was £7 18s 3½d. On the night of 4 June, the king's birthday, the sum of £52 13s 10d was laid out for illuminating the building; this included an item of £2 14s for rockets, which were presumably let off from the roof of the gallery. Another entry records the payment of a guinea for two constables to stand at the door of the Turk's Head tavern during the Society's deliberations there.

The following year a shilling admission charge was decided upon in addition to the cost of the catalogue, and the Society felt that some explanation was called for. The minutes of a meeting on 20 April, just before the opening day, have an entry which reads 'Mr Reynolds having presented a preface it was agreed to and ordered to be printed', but it is unmistakably the work of Johnson:

The purpose of this exhibition is not to enrich the artist, but to advance the art; the eminent are not flattered with preference, nor the obscure insulted with contempt; whoever hopes to deserve public favor, is here invited to display his merit . . .

He concludes with an explanation for the increased charge for admission:

When the terms of admission were low, the room was thronged with such multitudes, as made access dangerous, and frightened away those whose approbation was most desired.

. . . Many artists of great abilities are unable to sell their works for their due price: – to remove this inconvenience, an annual sale will be appointed, to which every man may send his works, and them, if he will, without his name. Those works will be reviewed by the committee that conduct the exhibition; a price will be secretly set on every piece, and registered by the secretary; if the piece exposed is sold for more, the whole price shall be the artist's; but if the purchasers value it at less than the committee, the artist shall be paid the deficiency from the profits of the exhibition.

This somewhat hare-brained scheme lost the Society a good deal of money, and was not repeated. The decision to charge for entry, on the other hand, was vindicated by what happened at the rival exhibition of the Society of

* Nugent had some sittings with Reynolds at the same period, but the portrait is untraced.

Artists, just down the road in the Strand. The policy of free admission there had led to serious disturbance, much of it caused by servants in livery – 'those most baneful, idle, insolent banditti', as a contemporary writer described them. 'Who,' another indignant correspondent inquired rhetorically in May 1762, 'can examine a beautiful picture with advantage or pleasure in a sweating room, choked with clouds of dust and as rudely elbowed as if in Bartholomew Fair?' The provision of two, and then four constables to keep the peace proved insufficient; finally, at a special meeting of the Society it was resolved 'that a discretionary power be given to Mr Blake to employ eight or more constables, and to give orders as he shall think requisite relative to the Exhibition'.

Gainsborough came knocking at the door again in 1762 with his witty and suggestive portrait of William Poyntz, which was painted for the sitter's sister, Georgiana, Countess Spencer.[40] Poyntz, then a young man of twenty-eight, lounges against a tree, his dog at his feet. He holds his gun in a way which in a later age would have brought the Royal Society for the Prevention of Accidents down on him like a ton of bricks. The angle of the gun is not a piece of carelessness on the painter's part, however; he is making a coarse visual pun to suggest that Poyntz is a man of pronounced sexual vigour. Gainsborough, after all, was capable of signing off a letter to his friend William Jackson, the Exeter musician, with 'if you was a Lady I would say what I have often said in a corner by way of making the most of the last Inch. Yours up to the hilt –'*

Identifying exactly who showed what at successive exhibitions of the Society of Artists is a tricky business. A main authority is Horace Walpole, who scribbled notes in his catalogue and knew many of the sitters personally or by sight, but even the sharp-eyed Horace occasionally got things wrong or missed something. When the critic of the *St James's Chronicle* had finished praising Reynolds's whole-length of Keppel's sister Elizabeth in the 1762 show, he drew attention to a picture which had attracted less notice:

There is another portrait by the same hand, unnumbered and unregistered in the catalogue, which hangs at the other end of the room and represents a young lady well known in the town by the name of Miss Nelly O'Brien. It is a very good piece, but the arms are, I think, too red.

To describe Nelly O'Brien as 'a young lady well known in the town' was both understatement and euphemism. If she was a less notorious

* Hayes, 2001, 24. Jackson was himself a keen painter, and numbered many artists among his friends. He sat to Gainsborough, Ozias Humphry, Morland and Opie, but never to Reynolds, although he knew him well. Fanny Burney mentions meeting him at dinner at Reynolds's house.

courtesan than Kitty Fisher, the contest was not altogether uneven. Her numerous liaisons are patchily chronicled, but it is known that she was the mistress of Viscount Bolingbroke by 1763, and that she had a son the following year. The infant was christened on Christmas Eve; 'Gilly' Williams, writing to his friend George Selwyn, makes the ceremony sound distinctly Hogarthian:

Bunny [Sir Charles Bunbury] and his trull were sponsors. Now for his name; guess it if you can; it is of no less consequence in this country than Alfred; but Magill was so drunk he had like to have named it Hiccup!*

She later took up with the Earl of Thanet, and it is possible that she had two more sons by him; an undated bill survives which shows that he paid Reynolds £52 for one of the portraits he painted of her. Between 1760 and 1767 (she died in 1768), she figures in Reynolds's pocketbooks with great frequency – 'Miss Obrian', 'Miss O'Brien', 'My Lady Obrien'. In 1762 there seems to be hardly a week in which she did not make an appearance in Leicester Fields. How many of these entries relate to the three known portraits of her it is impossible to tell. Some biographers have assumed that she quite often acted as a model in Reynolds's studio for the painting of necks, busts, hands or arms ('as well as for his nymphs and Venuses', Leslie and Taylor add coyly).† Quite a number of them may well be social engagements or for all we know assignations; an entry, for instance, for six o'clock on 17 July 1762, reads 'Miss Obrien in Pell Mell, next door this side the Star & Garter'.

Northcote noted that Reynolds painted all his female sitters as 'ladies', regardless of whether they were of the blue-blooded or the 'fair and frail' variety. The point is well illustrated by the most celebrated of his portraits of Nelly O'Brien, now in the Wallace Collection.[41] She is pictured seated in the open air. Her face is in partial shadow, and she has on a quite plain, flat-brimmed straw hat which is trimmed on the crown with ribbons of dark turquoise. Her dress is of blue-and-white-striped silk, the neckline generously revealing; she wears a voluminous pink quilted petticoat and cradles on her lap a small, somewhat somnolent dog of indeterminate breed.

* Jesse, i, 339. Reynolds had painted Williams, Selwyn and Dick Edgcumbe two or three years previously in one of his rare conversation pieces (Mannings, cat. no. 563, fig. 471), now in the City Art Gallery, Bristol.

† Northcote has a nice story about Reynolds once unintentionally offending one of his lady sitters: 'When she offered to sit to him for the hands also, (she esteemed her own to be very fine,) he answered, innocently, "that he would not give her so much trouble, as he commonly painted the hands from his servants!" ' (Northcote, ii, 267).

The atmosphere is quietly pastoral; the picture was engraved in 1770 by Charles Phillips, and the second state is embellished by some lines of verse:

> Near a thick Grove whose deep embow'ring Shade
> Seem'd most for Love and contemplation made,
> Thither retir'd from Phoebus sultry Ray . . .

How well versed Miss O'Brien was in the role of symbolism in painting is not known, but Reynolds, as his graceful near-contemporary Fragonard quite often did in France, was undoubtedly employing the lapdog to convey an erotic association.

Not all his female sitters were as easy on the eye as Nelly O'Brien or Kitty Fisher. Reynolds's boyhood friend Dick Edgcumbe – wit, Member of Parliament, man-about-town – had died the previous year at the age of forty-five, and had been succeeded by his brother George, a naval officer. The new Lady Edgcumbe, now in her early thirties, was the only child of John Gilbert, Archbishop of York, and she had half a dozen appointments with Reynolds in the spring of 1762. Northcote annotated his own copy of his *Life of Reynolds* with a story told him by Mrs Gwyn – 'who had it from Reynolds himself':

Lady Edgcumbe was 'uncommonly plain or rather ugly in her person, when she was sitting to Reynolds [she said] "I do not know what you may think of my face for a picture, but this I know, That it is no common face". Reynolds to himself said, "Thank God it is not." '*

These ladies apart, the stream of sitters that had passed through his painting room in the spring and summer of 1762 was as varied and colourful as ever. There was the immensely tall Earl of Erroll, son of a Jacobite executed on Tower Hill after the '45. He had renounced his father's politics and officiated with aplomb at the coronation of George III as Lord High Constable of Scotland. Years later, in a letter from Sir William Forbes, Reynolds heard that the portrait had faded – this, hazarded Forbes, was because it had hung in Slains Castle, on the coast of Aberdeenshire, and had suffered from the sea air. In his reply Reynolds – Sir Joshua now, and President of the Royal Academy – decided to come clean:

* Mannings, cat. no. 553, fig. 616. The picture was destroyed by bombing during the Second World War. David Mannings had the story from Dr John Edgcumbe, a collateral descendant of Reynolds.

Dear Sir

Tho you very kindly insinuate an apology for the fading of the Colour of Lord Erroll's Picture, by its hanging in a Castle near the sea, yet I cannot in conscience avail myself of this excuse as I know it would have equally changed wherever it had been placed, the truth is for many years I was extremely fond of a very treacherous colour called Carmine, very beautifull to look at, but of no substance; however I have now supplied its place with a colour that defy's all climates.*

Slains was indeed close to the sea. Boswell and Johnson were entertained there by the Errolls in 1773 on their way to the Hebrides. 'The house is built quite upon the shore,' Boswell wrote; 'the windows look upon the main ocean, and the King of Denmark is Lord Erroll's nearest neighbour on the north-east.' As they took tea with Lady Erroll in the drawing room in the evening, Reynolds's portrait of her husband looked down on them:

This led Dr Johnson and me to talk of our amiable and elegant friend, whose panegyrick he concluded by saying, 'Sir Joshua Reynolds, sir, is the most invulnerable man I know; the man with whom if you should quarrel, you would find the most difficulty how to abuse.'[42]

Reynolds's most exotic sitter in 1762 was Ostenaco, the so-called 'King of the Cherokees'. The Cherokees, the largest single Indian nation, had generally sided with the British in the French and Indian War, but by 1759 trust had ebbed away, the alliance had crumbled and at the zenith of their military fortunes in America, the British had found themselves embroiled in the Cherokee War, a vicious little conflict characterized by excesses on both sides. In one episode, a militia patrol murdered and mutilated three Cherokee chiefs and then claimed the bounty Virginia offered for enemy scalps; in another, a British commander, having surrendered his fort in return for a safe passage, was scalped while still alive and forced to dance until he died. The British eventually resorted to a scorched-earth policy, burning settlements to the ground and laying waste hundreds of acres of bean- and corn-fields. The Cherokee economy had soon, in the words of a modern historian, 'spiralled down to a virtually neolithic level',[43] and in 1761 the nation had been forced to sue for peace.

To try to mend matters, Ostenaco and two other chiefs, Stalking Turkey and Pouting Pigeon, were invited to London in 1762. They were installed

* Letter 82. Reynolds was writing in 1779, shortly after Erroll's death. He went on to ask Forbes if he would raise with Lady Erroll 'a business relating to this Picture' – although it had been painted seventeen years previously, it had never been paid for. He got his money in the end, but he had to wait another four years for it.

in a house in Suffolk Street, and were generally fêted and lionized; they visited Vauxhall, and got riotously drunk; they were honoured by an audience of the king, who presented them with silver gorgets engraved with his imprint. Unfortunately, the chiefs' interpreter had died on the voyage to England, and they were reduced to communicating mainly by gesture.

The pocketbook shows a single appointment with 'The King of the "Cherokees"' on 1 July.* His appearance posed something of a challenge to Reynolds, with his usually subdued palette; an entry in the Duchess of Northumberland's diary described Ostenaco as having 'the Tail of a Comet revers'd painted in Blue on his forehead, his Left Cheek black & his Left Eyelid Scarlet his Rt Eyelid Black & his Right Cheek Scarlet'.[44]

It had been a tiring summer. Northcote speaks of Reynolds 'having impaired his health by incessant application to his profession'. He decided to pay a visit to Devon – it was ten years since he had last been home – and he invited Johnson to accompany him.

The friendship between the two men was now solidly established, although it had taken Reynolds some time to adjust to the frequency and length of Johnson's visits and his seemingly unquenchable thirst for tea. 'Miss Reynolds was a great favourite with him, and gratified him by indulging his particular inclination and habits of life,' wrote Farington:

Reynolds at that time dined at four o'clock, and immediately after dinner, tea was brought in for the Doctor, who, nevertheless, at the usual hour, again took his share of it. After supper, too, he was indulged with his favourite beverage, and he usually protracted his stay till twelve or one o'clock: often very much deranging, by his immobility, the domestic œconomy of the house.[45]

According to Northcote, there were occasions 'when Mr Reynolds was desirous of going into new company, after having been harassed by his professional occupations the whole day' (Northcote presumably heard the story some years later from Fanny):

This sometimes overcame his patience to such a degree, that, one evening in particular, on entering the room where Johnson was waiting to see him, he immediately took up his hat and went out of the house.[46]

That time was now past, and there existed between the two men a relationship characterized by respect and affection.

* There is also an appointment four days later for 'Miss Cherocke', but no portrait is known.

Reynolds, for his part, not only stood in awe of Johnson's conversation ('he qualified my mind to think justly') and writing (*Rasselas* was 'writ by an angel'); he was also, as we know from the word-portrait he painted for Boswell, able to enter imaginatively and sympathetically into Johnson's often anguished mental universe:

Solitude to him was horror; nor would he ever trust himself alone unemployed in writing or reading. He has often begged me to accompany him home with him to prevent his being alone in the coach. Any company to him was better than none . . .[47]

Since the appearance of the *Dictionary*, Johnson had struck an extended bad patch. There had been the death of his mother; headway with the edition of Shakespeare to which he had set his hand had been paralytically slow; he had been living beyond his means; he seemed to his friends to be falling increasingly into lassitude and melancholy. 'Give me thy Grace to break the chain of evil custom', reads a poignant birthday entry in his diary.

Then, in this summer of 1762, a shaft of sunlight had pierced the gloom. In the middle of July he had learned that Bute wished to offer him a Crown pension of £300 a year. He had gone round immediately to Leicester Fields to consult Reynolds. He knew he would be attacked for hypocrisy if he accepted, and belaboured with his own definition of 'pension' in the *Dictionary* – 'In England it is generally understood to mean pay given to a state hireling for treason to his country.' He asked Reynolds to consider the question and give him his opinion the following day. That was not necessary, Reynolds told him. The matter was clear. The pension was a reward for 'literary merit' – something confirmed when he was conducted into the presence of the prime minister. 'It is not offered to you for having dipped your pen in faction,' Bute told him, 'nor with a design that you ever should.'

It might not seem much to Reynolds, who was now earning £6,000 a year,* but to Johnson it was affluence. His mood as they set off for Devon was lighter than it had been for many a long day. They left London on 16 August, at two in the afternoon. They spent two nights at Winchester, and then moved on to Salisbury. They had made an arrangement to visit Lord Pembroke's seat, Wilton House. The earl and his countess (Horace Walpole thought she had 'the face of a Madonna') had both sat to Reynolds, but whether either was there to receive him is not known. Earlier in the year his

* We know this from a letter Johnson wrote that summer to Baretti, then in Milan: '. . . As you have now been long away, I suppose your curiosity may pant for some news of your old friends. Miss Williams and I live much as we did. Miss Cotterel still continues to cling to Mrs. Porter, and Charlotte is now big of the fourth child. Mr Reynolds gets six thousands a year . . .' (Johnson, Samuel, 1992–4, i, 205, letter dated 20 July 1762).

lordship had run off with one of Queen Charlotte's maids of honour; the liaison lasted no more than a couple of months, but he was not reconciled with his wife until March of the following year.*

The garden front at Wilton, and some of the handsome stone fireplaces in the interior, were by Inigo Jones. There was a great deal of water around the house, and a fine Palladian bridge; Boswell, years later, was delighted by the way the river Avon had been channelled through the turf to make fine islands with tall cedars on them. For Reynolds – as it would be for Gainsborough, who became a welcome visitor to the house from Bath† – the main attraction was the splendid collection of family portraits by Van Dyck, Lely and others. The travellers moved on to spend the night at Longford Castle, the home of Lord Folkestone. Here too, there were pictures to be seen – including Reynolds's own fine portrait of Lady Folkestone, posed beside a classical urn, which he had exhibited at the Society of Arts two years previously.[48]

In the matter of social graces, as in much else, Johnsonian theory and practice did not always coincide. On a later journey, visiting Lord Monboddo in Kincardineshire, Boswell records that he made to stand up as the ladies left the room after dinner. 'He insisted that politeness was of great consequence in society. "It is, (said he,) fictitious benevolence." '[49] Now, pausing briefly in Sturminster-Marshall, he and Reynolds were entertained by the rector, the Reverend John Harris, an Old Etonian and graduate of King's College, Cambridge. The rectory had been modernized by the installation of sash windows, although the thatched roof had been retained. This struck Johnson as unsatisfactory, and pretty well the first words he uttered to his host were 'Pull out the sashes or tile your house.' Harris replied that he had no thought at present of doing either. 'Then it is quite inconsistent,' growled Johnson.

A few miles from Sturminster-Marshall, on the other side of the river Stour, lay Kingston Lacy, the home of the Bankes family. Here were more fine paintings, including portraits by Cornelius Jansen and Van Dyck which the family had saved when Corfe Castle was destroyed during the Common-

* The maid of honour was Catherine ('Kitty') Hunter – Horace Walpole thought her 'a handsome girl with a fine person, but silly'. The elopement with Pembroke took place from a masked ball at Lord Middleton's. When she sat to Reynolds a year later he painted her holding a mask – presumably an allusion to the elopement (Mannings, cat. no. 971, fig. 717). She was by then married to a young officer called Alured Clarke, who subsequently became a field-marshal.

† Gainsborough, replying to a letter from his friend James Unwin in 1764, wrote: 'I was very agreeably favour'd with yours at my return from Wilton where I have been about a week, partly for my amusement, and partly to make a drawing from a fine horse of Ld. Pembroke's, on which I am going to set General Honeywood, as large as life' (Letter 14).

wealth. Reynolds was particularly impressed by some pictures by Sir Peter Lely; he said later he had never fully appreciated Lely's artistry until he saw the Bankes collection.

They were shown round by Mr John Bankes, then an elderly Member of Parliament, who quickly discovered that he was failing to hold the attention of one of his visitors. Reynolds later gave Boswell an account of the occasion:

. . . The conversation turning upon pictures, which Johnson could not well see, he retired to a corner of the room, stretching out his right leg as far as he could reach before him, then bringing up his left leg, and stretching his right still further on. The old gentleman observing him, went up to him, and in a very courteous manner assured him, that though it was not a new house, the flooring was perfectly safe. The Doctor started from his reverie, like a person waked out of his sleep, but spoke not a word.[50]

The travellers moved on westward – Dorchester – Bridport – Axminster – Exeter. They were heading for Torrington, home to both of Reynolds's married sisters. Elizabeth's husband, William Johnson, the son of a former vicar of Great Torrington, had been mayor of the town and would be again. He had tried his hand both at ironmongery and the wool drapery business. One of his current projects had to do with the marketing of dried salmon; he engaged Johnson's interest in the scheme, and Johnson made some inquiries for him on his return to London.

Reynolds would later lend his brother-in-law quite a lot of money – none of which he ever saw again – and his relations with that part of the family became badly strained. Matters were not improved by the fact that William Johnson, having impoverished his family, then deserted them, going off to live openly in Torrington with another woman.* Elizabeth's somewhat unbending religious views were also a factor. She disapproved even more strongly than Frances did of their brother's painting on a Sunday. In the 1770s, when Reynolds offered to take her second son, Samuel, to live with him in London and train him as an artist, the offer was refused lest the boy learn irreligious ways. Not for nothing did she later compose a commentary on the Book of Ezekiel.

Reynolds's relations with his sister Mary and her family would be much less complicated and altogether happier. John Palmer was a solid, reliable lawyer; he too, like his brother-in-law, served as mayor of Torrington.

* At the time of this 1762 visit, the Johnsons had three sons and a daughter, ranging in age from eight to two; three more daughters would subsequently be born to them.

Mary, livelier and more spontaneous than her sister, bore him five children, two of whom would later figure prominently in their uncle's life. Her literary gifts were very different from those of Elizabeth. She was the author of *A Devonshire Dialogue*, four sprightly sketches in West Country dialect which were published by her children after her death: 'Gracious Rab! you gush'd me,' cries Betty, the servant maid, as her sweetheart springs over a stile and surprises her. 'I've a' be up to vicarige, to vet a book vor dame, and was looking to zee if there be any shows in en, when you wisk'd over the stile, and galled me.' This is one of the less impenetrable passages in the dialogue, which is laced with splendid exclamations such as 'Odswinder-akins!' and words such as 'crisimore', meaning a little child, 'longscripple' (a viper) and 'galaganting', which describes someone who is large and awkward.[51]

Frances Reynolds was also present during the Torrington visit. She knew Johnson well by this time, and it is clear from the *Recollections* which she left of him in manuscript that despite his roughness of manners and what she termed his 'corporeal defects' she admired him greatly:

For being totally devoid of all deceit, free from every tinge of affectation or ostenta-tion, and unwarped by any vice, his singularities, those strong lights and shades that so peculiarly distinguish his character, may the more easily be traced to their primary and natural causes.

The luminous parts of his character, his soft affections, and I should suppose his strong intellectual powers, at least the dignified charm or radiancy of them, must be allowed to owe their origin to his strict, his rigid principles of religion and virtue . . .[52]

It is also plain that he was devoted to her – he corrected her verses, sat to her for his portrait, and took her part at times of difficulty. Indeed it was believed in the family that he had actually proposed to her: 'Frances lived to an advanced age, unmarried,' reads an entry in a notebook containing assorted poems and family anecdotes; 'might have married the great Dr. Johnson if she had chosen it.'[53]

He certainly took a close and protective interest in all her affairs. Two years after the Devonshire visit, an invitation was extended to both Frances and Johnson to sail to the Mediterranean as the guests of a naval officer called George Collier, who had recently assumed command of HMS *Edgar* – Collier's wife, who, as it happened, Reynolds had painted the previous year,[54] was also to be of the party. The invitation was conveyed to Johnson by Frances – he was in Oxford at the time – and the agitated tone of the letter he sent her in reply makes revealing reading:

My Dearest Dear:

Your letter has scarcely come soon enough to make an answer possible. I wish we could talk over the affair. I cannot go now. I must finish my book. I do not know Mr. Collier. I have not money before hand sufficient. How long have you known Collier that you should put yourself into his hands. I once told you, that Ladies were timorous and yet not cautious.

. . . I do not much like obligations, nor think the grossness of a Ship very suitable to a Lady. Do not go till I see you. I will see you as soon as I can. I am,

My Dearest, most zealously yours,

Sam. Johnson

You quite disturb me with this sudden folly.*

The Reynolds sisters were obviously eager to show off their celebrated London visitors, and Mary Palmer invited in the local schoolmaster, an intelligent and well-read man, the Reverend George Wicky. When she broke in on a conversation to introduce him, Johnson, who did not like to be interrupted in this way, muttered, 'Wicky – dicky – snicky – what a name!' and continued with the monologue he was directing at the other person. Another family story has it that Mrs Palmer informed Johnson that there were to be pancakes for dinner, and asked whether he liked them. 'Yes, Madam,' came the reply, 'but I never get enough of them.' Mrs Palmer saw to it that there was a generous supply, and Johnson got through thirteen of them.

They journeyed on to Plymouth. Johnson, eternally curious, was in his element. 'The magnificence of the navy,' wrote Boswell, 'the ship-building and all its circumstances, afforded him a grand subject of contemplation.'[55] Reynolds took him over to Mount Edgcumbe to pay their respects to Lord Edgcumbe, and then they descended for three weeks on Reynolds's old schoolfriend John Mudge. Mudge's father, Zachariah, was still very much alive, and preached a special sermon at St Andrews for Johnson's benefit. When they were received at the vicarage, Johnson excelled himself by downing seventeen cups of tea and then presenting Mrs Mudge with his cup for an eighteenth. 'What! another, Dr Johnson?' she exclaimed. 'Madam, you are rude,' came the reply.

On another occasion, Reynolds took Johnson to visit a neighbour, who, as Northcote puts it, 'placed before them every delicacy which the house afforded':

* Johnson, Samuel, 1992–4, i, 246–7. Nothing came of the idea. Collier was knighted in 1775, rose to the rank of vice-admiral and served for some years as the MP for Honiton.

The Doctor, who seldom showed much discretion in his feeding, devoured so large a quantity of new honey and of clouted cream, which is peculiar to Devonshire, besides drinking large potations of new cyder, that the entertainer found himself much embarrassed between his anxious regard for the Doctor's health, and his fear of breaking through the rules of politeness, by giving him a hint on the subject.

The strength of Johnson's constitution, however, saved him from any unpleasant consequences which might have been expected . . .[56]

Reynolds later told a friend that he had only once seen Johnson drunk, and that was during these weeks spent together in Devon:

One night after supper Johnson drank three bottles of wine, which affected his speech so much that he was unable to articulate a hard word which occurred in the course of his conversation. He attempted it three times but failed, yet, at last accomplished it, and then said, 'Well Sir Joshua I think it is now time to go to bed.'*

Although he had just passed his fifty-third birthday, these excesses had no apparent effect on Johnson's iron constitution. It is from Frances that we have the delightful story of the visitors sitting in a gentleman's drawing room, looking out on to a spacious lawn:

A young lady present boasted that she could outrun any person; on which Dr Johnson rose up and said, 'Madam, you cannot outrun me;' and, going out on the Lawn, they started. The lady at first had the advantage; but Dr Johnson happening to have slippers on much too small for his feet, kick'd them off up into the air, and ran a great length without them, leaving the lady far behind him, and, having won the victory, he returned, leading Her by the hand, with looks of high exultation and delight.[57]

It was at dinner in the same house that one of the most celebrated of all Johnsonian ripostes was uttered. 'Pray, Dr Johnson,' inquired his hostess in a loud voice before a large company, 'what made you say in your *Dictionary* that the Pastern of a Horse was the knee of an Horse?' 'Ignorance, madam, ignorance,' answered the imperturbable Johnson.

John Mudge was a close friend of the architect John Smeaton, 'the father of English Civil Engineering', whose Eddystone Lighthouse had been completed in 1759. The proposal to erect a tall stone building on such an exposed reef – the main column was seventy feet high, and the lantern with

* Northcote, ii, 161. Northcote's chronology is adrift here: in 1762 Reynolds was still plain Mr.

its ball rose a further twenty-eight feet – had been controversial, but the handsome structure, which had withstood the violent storm that had lashed the West Country only a few weeks earlier, was a sight not to be missed. The commissioner of the dockyard laid on his yacht to take the party out through the harbour, although the weather proved too rough to allow a landing on the rock.

It was during this visit that Northcote, then apprenticed to his watchmaker father, saw Reynolds for the first time. He was not yet sixteen, and had never set foot beyond the Devon country boundary:

I remember when Mr Reynolds was pointed out to me at a public meeting, where a great crowd was assembled, I got as near to him as I could from the pressure of the people, to touch the skirt of his coat, which I did with great satisfaction to my mind.[58]

The end of September was approaching. The travellers stopped briefly on the return journey at Plympton; Reynolds slipped away from the dinner table to pick an apple in the orchard adjoining his father's school. Then they headed by fast stages for London. Reynolds carried with him a present he had received at the house where Johnson had gorged himself on honey and clotted cream – 'a very large jar of old nut oil, grown fat by length of time, as it had belonged to an ancestor of the family'.[59]

It would come in very useful in his painting room. That was the centre of his universe, and he grudged time spent away from it:

He has often confessed, that when he has complied with the invitations of the nobility to spend a few days of relaxation with them at their country residences, though every luxury was afforded which the heart could desire, yet he always returned home like one who had been kept so long without his natural food.[60]

He and Johnson had returned to the capital on the afternoon of Sunday, 26 September. Almost at once, he surrendered to the welcome tyranny of the pocketbook. At eleven o'clock on Tuesday morning he received the Duchess of Douglas for her first sitting. Supplies of natural food had been resumed.

7

Our Late Excellent Hogarth

The signing of the Peace of Paris, in February 1763, coincided closely with Reynolds's fortieth birthday. The Treaty put an end to what Newcastle called Bute's 'ridiculous, popular war'. The cost had certainly been horrific,* and outside the City of London, the terms of the peace were broadly regarded as honourable. Britain must now set about ruling the world's greatest empire; across the Channel, it became the unswerving aim of French diplomacy to reverse what was seen as a humiliation, and to seek to profit – as they would most notably do in the War of American Independence – from any British distraction.

If Reynolds had views about the terms on which the war had been ended, he kept them to himself.† His friend John Wilkes, on the other hand, was one of those who took the view that France had been let off lightly, and sneered at the Treaty as 'indeed the peace of God, for it passeth understanding'. He did not stop there, however. In his address to Parliament on 19 April, the king had referred to the peace as 'honourable to my Crown and beneficial to my people'. In his paper, *The North Briton*, Wilkes described this as a falsehood, and in consequence very quickly found himself in the Tower.

Many of his friends began to desert him. Pitt described him as 'a blasphemer of his God and a libeller of his King'. Reynolds, for his part, appears to have seen no reason why Wilkes's subsequent flight to France, outlawry and expulsion from the Commons should affect their relations. Wilkes made a number of clandestine visits to England in the course of his exile. It is plain from Reynolds's pocketbooks that he exerted himself to see his friend on these occasions. In September 1765, for instance, Wilkes appears to have been

* The cost of the first year of the War of the Spanish Succession in the early 1700s was estimated at about £3.7 million; by the end of the Seven Years War the corresponding figure was £13.7 million.

† Interestingly enough, a manuscript in Ramsay's hand survives in which he gives his views about the Peace. Apparently written just before ratification, it runs to six pages, and may have been intended for the eyes of a minister. A great admirer of all things French, Ramsay argues the case for 'a lasting peace with that respectable Nation, upon equal and honourable terms' (Fitzwilliam Museum, MS. General Series, R).

holed up for a time at a farmhouse near Teddington. An entry in Reynolds's pocketbook gives directions for getting there: 'Mr Wilkes: first go to Teddington church, and turning to the right after passing the church, 2nd house on the right, Stephen, farmer and maltster, at Bolston, Hampton-Wick.'

The only visual evidence we have of what Reynolds looked like as he entered middle life is the self-portrait in the Cottonian Collection at Plymouth, thought to have been painted 1764–7.[1] He is bare-headed, and wears some sort of cape of an indeterminate grey; the gaze, as in so many of his self-portraits, is both alert and guarded. Pretty well the only verbal description of his appearance is Malone's:

He was in stature rather under the middle size; of a florid complexion, and a lively and pleasing aspect; well made, and extremely active. His appearance at first sight impressed the spectator with the idea of a well-born and well-bred English gentleman.*

To young Cornelia Knight, on the other hand, growing up in London in the sixties and seventies, his speech and appearance announced him as something of a West Country rustic. 'His pronunciation was tinctured with the Devonshire accent,' she wrote in her autobiography; 'his features were coarse, and his outward appearance slovenly.'[2]

His manners were by all accounts affable and obliging, but he was no great respecter of persons. At the time of her marriage, Horace Walpole described the young Duchess of Cumberland as having 'the most amorous eyes in the world, and eyelashes a yard long'.[3] Northcote was a pupil in Leicester Fields when she sailed into Reynolds's painting room for her first sitting:

I remember his being much diverted by her affected condescension, when she said, 'I come to your house to sit for my portrait, because I thought it would be much more convenient to you, as you would have all your materials about you and at hand.' He made her no answer, nor did he trouble himself to inform her, that there was no other way she could have had her portrait painted by him.[4]

The duchess had come a long way in a short time. She was the daughter of the First Earl Carhampton, in the Irish peerage, and had previously been briefly married to a commoner. Northcote was prepared to be understanding: 'Great allowance must be made for those who are suddenly raised high

* We know, in fact, precisely how tall Reynolds was – Farington measured him (and others) for the Royal Academy Club, established in 1787, and gives his height as 5 feet 5⅛ ins (Yale Center for British Art, MS Reynolds 53). This measurement is borne out by the three-piece silk court suit of his which survives in the collection of the late Dr John Edgcumbe.

beyond their expectation, as it not infrequently has made even the wisest giddy.' Many years later he gave Hazlitt another illustration of how little, as he put it, Reynolds 'crouched to the Great':

He never even gave them their proper titles. I never heard the words 'your lordship or your ladyship,' come from his mouth; nor did he ever say Sir in speaking to any one but Dr Johnson; and when he did not hear distinctly what the latter said (which often happened) he would then say 'Sir?' that he might repeat it. He was in this respect like a Quaker . . .*

The celebrated 'throne-chair' on which his sitters were invited to install themselves in Leicester Fields – a plain mahogany armchair, in fact, covered with leather – was raised eighteen inches from the floor. It was placed near the window and revolved on castors. Reynolds himself never sat while painting. Indeed when Lady Betty Compton sat to him, her impression was that he was never still for a moment:

His plan was to walk away several feet, then take a long look at me and the picture as we stood side by side, then rush up to the portrait and dash at it in a kind of fury. I sometimes thought he would make a mistake, and paint on me instead of the picture.†

As Kneller had done,‡ he kept a mirror in the studio – a cheval-glass was placed at an angle so that sitters might watch him at work. It occasionally served to reflect light on to the sitter's face; if he required the light to fall on a part of the face that was shaded, he employed a screen with red or yellow colour on it. Reynolds also sometimes used mirrors to achieve special effects in perspective. Mason called on him when he was at work on his *Nativity*:[5]

* Hazlitt, 1830, 289–90. Reynolds was similarly unconcerned with rank or title round his dinner table. 'At five o'clock precisely dinner was served, whether all the invited guests were arrived or not. Sir Joshua was never so fashionably ill-bred as to wait an hour, perhaps, for two or three persons of rank or title, and put the rest of the company out of humour by this invidious distinction.' Northcote (ii, 95) quotes the passage from the preface to John Courtenay's *Poetical Review of the Literary and Moral Character of Dr. Samuel Johnson*, published in 1786. Courtenay (1738–1816), a grandson of the Earl of Bute, entered the Commons as the Member for Tamworth in 1780. He lent vitriolic support to the proceedings against Warren Hastings, and later expressed ardent sympathy with the French Revolution.

† Frith, iii, 124. Lady Betty, later the Countess of Burlington, a bright young thing of twenty-one at the time she sat to Reynolds, did not take to him – 'a very pompous little man', she thought. Her portrait (Mannings, cat. no. 400, pl. 98, fig. 1347) is now in the National Gallery of Art, Washington, DC.

‡ Kneller seems to have used two mirrors, in fact, although one of them was simply to keep his sitters amused by allowing them to compare their own image with the work in progress.

Three beautiful, young, female children, with their hair dishevelled, were placed under a large mirror, which hung angularly over their heads, and from the reflection in this, he was painting that charming group as angels which surrounded the Holy Infant. He had nearly finished this part of his design, and I hardly recollect ever to have had greater pleasure than I then had in beholding and comparing beautiful nature, both in its reflection and on the canvas.[6]

Reynolds used quite long brushes – they measured about nineteen inches – and his palettes did not fit over the thumb but were held by a handle. 'Paint at the greatest distance possible from your sitter,' he urged his pupils, 'and place the picture near to the sitter, or sometimes under him, so as to see both together.' He advised them to look at whatever they were painting with eyelids half closed; this, he explained, 'gives breadth to the object, and subdues all the little unimportant parts'. Another maxim was 'Consider the object before you, whatever it may be, as more made out by light and shadow than by its lines.'

Possibly because of his deafness, Reynolds did not encourage conversation in the studio (unlike Kneller, who had been a witty and entertaining extrovert). Nor did he have much time for those who expatiated on their art. 'When a painter becomes fond of talking,' he declared, 'he had better put a padlock on his mouth, because those who can be admired for what they say will have less desire to be admired for what they can do.'[7]

Most of these stray hints and injunctions were garnered by Northcote, some of them picked up in conversation, others gleaned from written fragments that he had a sight of. Reynolds, he informed his brother in a letter shortly after his arrival in London, 'gives the most instruction when it is drawn from him by questions'.[8] He did not always wait to be asked, however. For painting in uniforms or costume, lay figures were commonly employed. Noticing on one occasion that Northcote was making a poor fist of arranging the folds of the material, Reynolds intervened:

He remarked that it would not make good drapery if set so artificially, and that whenever it did not fall into such folds as were agreeable, I should try to get it better, by taking the chance of another toss of the drapery stuff, and by that means I should get nature, which is always superior to art.*

* Northcote, ii, 27–8. Reynolds, as Lely had done, kept an extensive range of clothes and materials on hand to achieve the effect he sought. His choice did not always meet with the approval of the sitter. The Dowager Duchess of Rutland complained that Reynolds had made her try on eleven different dresses before painting her in 'that bedgown' (Leslie and Taylor, i, 248).

Northcote also records, however, that although Reynolds was generous with advice, he was also 'very tenacious of his time'. One young painter who brought a portrait of a woman to show him was greeted with 'What is this you have in your hand? You should not shew such things. What's that upon her head, a dish-clout?' The dispirited artist went home and did not take up his brushes again for more than a month.[9]

One of the more unusual pieces of advice which Reynolds offered to his pupils was that they should have two canvases in hand of the same subject, and work on them alternately:

If chance produced a lucky hit, as it often does, then, instead of working upon the same piece, and perhaps by that means destroy that beauty which chance had given, he should go to the other and improve upon that. Then return again to the first picture, which he might work upon without any fear of obliterating the excellence which chance had given it, having transposed it to the other.[10]

We do not know whether Reynolds followed his own advice. What we do know, on his own admission, is that he found it difficult to leave well alone:

I have heard him say, that while he was engaged in painting a picture, he never knew when to quit it, or leave off; and it seemed to him as if he could be content to work upon it the whole remainder of his life, encouraged by the hope of improving it: but that, when it was once gone from him, and out of his house, he as earnestly hoped he should never see it again.[11]

Next to the painting room there was a small high-ceilinged room where pupils were allowed to work. There was a good deal of clutter here – rejected or uncollected portraits, shelves with casts from the antique and, high on the walls, numbers of old canvases by Lely and others. Northcote once had a narrow escape when one of these pictures came crashing down off its nail, creating an alarming domino effect:

The easel was knocked down, together with the picture on which I was at work, and driven with violence through five or six of those unfortunate rejected portraits, as they happened to be placed one before the other, whilst the floor was covered with the fragments of the broken plaister heads which were dashed to pieces by the fall . . .[12]

Reynolds could be careless in the handling of his materials. He was indignant to be disturbed one day by a fireman, who demanded a payment of £5. A

blaze had been reported at the house, and he had been the first on the scene with his engine:

At first it was difficult to account for this mistake; but the truth is this, Sir Joshua in cleaning out a gallipot with spirits of turpentine had flung some of it into the fire, which made a sudden blaze and appeared at the top of the chimney of his painting room; for that being a very low chimney, a very small flame would soon appear at its top. The room was a separate building from the house; but the parish regulations were absolute. He was obliged to pay the demand awarded by law.[13]

Reynolds's pocketbook for 1763 does not survive, but there are occasional clues to be gathered elsewhere as to who passed through his painting room. Mrs William Johnson, for instance,[14] is pictured with the three volumes of Rousseau's *Emile*, which first appeared in an English translation that year. Another sitter was Charles Carroll, of Carrollton, Georgia, who was in England between 1751 and 1765. 'My portrait without frame will come to 25 gns,' he wrote to his father on 22 March, 'an extravagant price but you desired it should be done by the best hand.'[15]

The word 'nabob' had made its way into the language by the 1760s, and several of them found their way to Leicester Fields – John Caillaud, for instance,[16] an East India Company soldier, the contemporary of Stringer Lawrence and Clive, who would later buy the manor of Aston Rowant and pass his years of retirement as a country gentleman in Oxfordshire. Another was Clive's cousin, George; he too, had made a fortune in the East, and now, in his early forties, chose to be painted with his wife and daughter and an Indian servant, the last two decked out with a good deal of exotic jewellery.[17]

Northcote has a sly little story of one old India hand, 'a gentleman who had acquired in India more money than intellect'. An engraving was to be made of the portrait, and Reynolds received a letter about it from the nabob:

... My friends tell me of the Titian tint and the Guido air, of course you will add them; but I leave it to your judgment whether it should be done before or after the print is taken.[18]

Reynolds sent four pictures to the exhibition that year, including *Two Ladies* – a double portrait of the Ladies Elizabeth and Henrietta Montagu, which Horace Walpole pronounced 'too chalky'.[19] Intriguingly, an engraving made by Meyer in 1812 shows Lady Elizabeth with a squint; if Reynolds

painted her that way, the painting has subsequently undergone ophthalmic correction.

Gainsborough, now intent on marrying the elegance of Van Dyck with his own more unbuttoned style, continued to draw attention to himself both by his delicate handling of paint and by the poses he devised for his sitters. The portrait of the actor James Quin which he submitted that year, now in the National Gallery of Ireland in Dublin, was the boldest challenge he had yet offered to Reynolds. David Garrick, writing to his old rival, then retired to Bath, told him that it had been 'much, and deservedly admired'. (He also said that its success had piqued some of the older painters, notably Hudson.)[20] There is evidence that Reynolds was keeping a close eye on what Gainsborough was doing, and possibly paying him the compliment of imitating him. It seems likely that he was at work in the course of 1763 on the fine full-length of Mrs Thomas Riddell which is now in the Laing Art Gallery, Newcastle upon Tyne.[21] The delicate colouring marks a departure for Reynolds, and the transparent handling of the paint is reminiscent of Gainsborough.

There was now in some ways rather less reason to be watchful about Ramsay. This was partly because he never chose to exhibit at the Society of Artists, but also because he was so engrossed in running what was in effect a manufactory for royal portraits. The artist and writer Joseph Moser left a description of this extraordinary production line:

I have seen his show-room crowded with portraits of his Majesty in every stage of their operation. The ardour with which these beloved objects were sought for by distant corporations and transmarine colonies was astonishing; the painter with all the assistance he could procure could by no means satisfy the diurnal demands that were made in Soho Square upon his talents and industry, which was probably the reason why some of these pictures were not so highly finished as they ought to have been.[22]

Be that as it may, Reynolds sensibly remained alert to the quality of delicacy that informed Ramsay's female portraits. He must also have been aware that he was generally thought to be less successful than Ramsay in capturing a likeness. When Lord Kildare, Master General of the Ordnance in Ireland, was deliberating the choice of a painter for his portrait in 1762, for instance, he made preliminary visits of inspection to the studios of both Reynolds and Ramsay before deciding that the commission should go to the latter (he had already sat to Reynolds some ten years previously). He explained his decision in a letter to his wife:

I have sat to Mr Ramsay for the Holland House gallery; and of all the painters I have ever seen in London I like him the best, for when I went there he had not a picture of anyone I ever saw but I knew; and as for Mr Reynolds, I called there a few days before, and did not know anybody.*

Not many people seemed to think it mattered. To turn the pages of the sitters' books is to review the life of the nation in cavalcade. This was the year in which he began the first of his half-dozen or so portraits of the actress Fanny Abington.[23] He painted the Duke of Cumberland,[24] the Governor of South Carolina† and the diplomat George Macartney,[25] who was just setting out for St Petersburg to conclude a commercial treaty with Russia and would later distinguish himself as ambassador extraordinary and plenipotentiary to Peking. Others who sat in the revolving 'throne-chair' during 1764 included both archbishops – Secker of Canterbury, austerely elegant in his convocation dress of white rochet and black sleeveless chimere,[26] Drummond of York, resplendent in his robes as Chancellor of the Order of the Garter.[27]

Another visitor to Leicester Fields was the Chancellor of the Exchequer, George Grenville – one of the ministers who had requested the issuance of the general warrant against Wilkes.[28] He was nicely balanced by Sir Charles Pratt, the Lord Chief Justice; it was he, presiding in the Court of Common Pleas, who had declared general warrants inconsistent with the principle of parliamentary privilege. The mob shouted 'Wilkes and Liberty!' The mayor and corporation of the City of London presented Pratt with the freedom of the city in a gold casket, and commissioned Reynolds to paint his portrait for the Guildhall.[29]

He painted Kitty Fisher with a parrot on her finger,[30] and a rich, over-weight heiress from Sunbury, in Middlesex, who had recently married into the peerage: 'The Earl of Pomfret has at last taken that deep laden rich aquapulca Miss Draycott,' Lord Barrington wrote ungallantly.‡ Reynolds sometimes received rather unusual instructions about what was required of him. Another female sitter that year was Lady Bolingbroke, daughter of the Third Duke of Marlborough, a gifted amateur artist and Lady of the Bedchamber to Queen Charlotte. According to Horace Walpole, her husband

* Fitzgerald, i, 33. Lord and Lady Holland turned to both Ramsay and Reynolds in the early and mid-sixties to fill their new gallery at Holland House, converted from the old library on the first floor. The long north wall was filled with members of the Fox family, while the south side was reserved for members of Lady Holland's family, the Lennoxes.

† Thomas Boone (c. 1730–1812) had recently returned to England after three years as Governor. His portrait (Mannings, cat. no. 201) is untraced.

‡ She does look rather stately for a woman in her late twenties. 'Her *tonnage*,' quipped Charles Townshend, 'is become equal to her *poundage*' (Mannings, cat. no. 601, fig. 808).

Appointments, Bills due, and occafional Mem.	MAY, 1761.
	Monday 18.
	Brought forward.

Monday 18.
9 Lord Bromd
16 Lord W
12 Adm. Broderick

1 mrs Clumby

3 mr Gosling
2 mr Selwin

Tuesday 19.
9 mr Fane
11 Coll Maitland
12 Lord Offulftone

Wednesday 20.
9 mr Garrick
11 mr Selwin
12 mrs Pigot

1 mr Cholmby
2 mr Mudge
3 Engaged

Thursday 21.
9 Lord Bromn
1 Adm Clut
10 Admiral Pigot
12 Capt Crawford

2 Mifs Roberts
3 mr Mudge

Friday 22.
8 mr Garrick
11 mr Selwin
12 mr Pigot

3 mr Mudge
2 Mifs Kelly

Saturday 23.
9 mr Fane
11 mr Crewe

1 Lady Pembroke
1
2 mr Selwin
3

Sunday 24.

Carried over

4. *A page from Reynolds's pocketbook for 1761, when he was receiving four or five sitters a day. In this particular week they included David Garrick.*

had told Reynolds, 'You must give the eyes something of Nelly Obrien, or it will not do.'[31]

The lovely picture of the 21-year-old Anne Dashwood, now in the Metropolitan Museum of Modern Art in New York, also dates from 1764.[32] Miss Dashwood had sittings that spring immediately before her marriage to Lord Garlies, later Earl of Galloway, then MP for Morpeth. She wears a dress of pale blue silk and holds a posy of flowers to her bosom. The other arm rests lightly on a plinth, two of her fingers supporting a shepherdess's crook; the pose does not suggest she would know what to do with it, but this is, after all, Arcadia. The picture is interesting as evidence of how Reynolds stored up images for future use; the female figure on the plinth is derived from one on the Medici Vase, which he had sketched in Rome a decade or more previously.

Many of those who sat to Reynolds became his friends. He was a generous host, and entertained extensively:

His table, for above thirty years, exhibited an assemblage of all the talents of Great Britain and Ireland: there being, during that period, scarce a person in the three kingdoms distinguished for his attainments in literature or the arts, or for his exertions at the bar, in the senate, or the field, who was not occasionally found there.

Northcote makes these dinners in Leicester Fields sound rather grand, but the account by John Courtenay, cited earlier, paints a different picture:

There was something singular in the style and oeconomy of his table, that contributed to pleasantry and good-humour; a coarse inelegant plenty, without any regard to order and arrangement. A table, prepared for seven or eight, was often compelled to contain fifteen or sixteen. When this pressing difficulty was got over, a deficiency of knives and forks, plates, and glasses succeeded. The attendance was in the same style; and it was absolutely necessary to call instantly for beer, bread, or wine, that you might be supplied before the first course was over. He was once prevailed on to furnish the table with decanters and glasses at dinner, to save time, and prevent the tardy manoeuvres of two or three occasional undisciplined domestics.* As these accelerating utensils were demolished in the course of service, Sir Joshua could never be persuaded to replace them. But these trifling embarrassments only served to enhance the hilarity and singular pleasure of the entertainment.

The wine, cookery, and dishes were but little attended to; nor was the fish or

* It seems likely that Johnson was describing dinner at Reynolds's when he said to Boswell, 'Sir, the servants, instead of doing what they are bid, stand round the table in idle clusters, gaping upon the guests; and seem as unfit to attend a company, as to steer a man of war' (Boswell, 1934–50, iv, 312).

venison ever talked of, or recommended. Amidst this convivial, animated bustle among his guests, our host sat perfectly composed, always attentive to what was said, never minding what was eat or drank, but left every one at perfect liberty to scramble for himself. Temporal and spiritual peers, physicians, lawyers, actors, and musicians, composed the motley groupe, and played their parts without dissonance or discord.

At least part of the reason for this seems to have been that an informal taboo operated:

Politics and party were never introduced. Literary subjects were discussed with good sense, taste, and fancy, without pedantic, tiresome dissertations. Wit and humour occasionally enlivened the festive board; but story-telling, premeditated bon-mots, and studied witticisms, were not tolerated for a moment. Sir Joshua was excellently calculated for promoting lively rational conversation. His mind was active, perpetually at work. He aimed at originality, and threw out observations and sentiments as new, which had been often discussed by various authors; for his knowledge was principally acquired by conversation, and thereby superficial. However, he was a most pleasing, amiable companion; his manners easy, conciliating, and unaffected; He had great good sense, and an exquisite correct taste; and if his ideas were not always new, they were often set off by liveliness of imagination; and his conversation abounded in pleasing and interesting anecdotes.[33]

If politics was excluded, politicians were not – Burke, after all, became one of Reynolds's closest friends, and Courtenay himself, to whom we owe this revealing account, sat in the Commons for more than a quarter of a century and was an effective parliamentary speaker. Nor did the ban on political discussion mean that everything was always sweetness and light. One of Reynolds's lawyer friends was the celebrated John Dunning, later Lord Ashburton, who defended Wilkes in 1765 and was also, years later, one of Keppel's counsel at his second court-martial. Husky of voice (like Reynolds, he never lost his Devonshire burr) and famously ugly, he happened one day to be the first of the company to arrive. 'Well,' he inquired as he was shown in, 'and who have you got to dine with you today? for the last time I dined with you in your house, the assembly was of such a sort, that by G— I believe all the rest of the world were at peace, for that afternoon at least.'[34]

It was also at Reynolds's table one day that the long friendship between Johnson and Thomas Warton – historian of English poetry, future poet laureate and the man who had obtained for Johnson his Oxford MA degree – came perilously under strain. 'Sir, I am not used to be contradicted,'

Johnson was heard to say. 'Sir,' returned Warton, 'if you were, our admiration could not be increased, but our love might.'

Early in 1764 Reynolds's admiration for Johnson found expression in the formation of the Club. He owed the idea to Lord Charlemont, whom he had continued to see occasionally since their return from Italy. For much of those ten years Charlemont had been immersed in Irish politics, but early in 1764, having recently been advanced to the dignity of an earldom, he had acquired a town house in Mount Street, eager to continue his advocacy of Irish independence in the House of Lords as well as pursuing his patronage of art and letters.

Reynolds tried the idea out on Johnson one evening as they sat at Johnson's fireside. The great man was understandably enthusiastic at the prospect of a convivial forum where he might hold forth without interruption, but not at Reynolds's suggestion that Charlemont should be a founder member. 'No,' he said, 'we shall be called Charlemont's Club; let him come in afterwards.'[35] His view prevailed. The original membership numbered nine; Reynolds, Johnson and the 'unclubable' John Hawkins; Oliver Goldsmith, Edmund Burke, the physician Christopher Nugent, who was Burke's father-in-law, Johnson's young friends Topham Beauclerk and Bennet Langton and Anthony Chamier, who was of Huguenot descent and had made a considerable fortune as a stockbroker – something he was not allowed to forget when he later went into politics.

Burke, now in his mid-thirties, had not yet entered Parliament. His name does not appear in the pocketbooks before 1764, but Reynolds almost certainly knew him before this, through either Johnson or Charlemont – it was to the latter that Burke owed his introduction to 'Single-speech' Hamilton, whose private secretary he had been since 1759.

Reynolds had known Goldsmith since the early sixties, most probably through Johnson. After his wanderings on the continent, 'Goldy' was now slowly beginning to make something of a reputation as a writer. One morning in 1762 Johnson, not yet out of bed, had received word that he was in great distress. He at once sent him a guinea and hurried round:

I accordingly went as soon as I was drest, and found that his landlady had arrested him for his rent, at which he was in a violent passion. I perceived that he had already changed my guinea, and had got a bottle of Madeira and a glass before him. I put the cork into the bottle, desired he would be calm, and began to talk to him of the means by which he might be extricated. He then told me that he had a novel ready for the press, which he produced to me. I looked into it, and saw its merit; told the landlady I should soon return, and having gone to a bookseller, sold it for sixty pounds.[36]

Johnson told Boswell that the bookseller 'had such faint hopes of profit by his bargain, that he kept the manuscript by him a long time'. He need not have worried. At £60 *The Vicar of Wakefield* proved a positive snip.

The Club met for the first time in February. Initially they assembled each Monday evening at seven, at the Turk's Head in Gerrard Street. Charlemont was not alone in being black-balled by Johnson. Reynolds happened to mention what was going on to Garrick, who said, 'I like it much, I think I shall be of you.' Johnson, jealous of his old pupil's brilliant success in the theatre, thought otherwise: 'He'll be of us, how does he know we will permit him? The first Duke in England has no right to hold such language.'[37] Garrick had to cool his heels until 1773 – the same year, as it happens, in which Charlemont was admitted.

At some point during the summer of 1764 Reynolds became quite seriously unwell. Northcote speaks of 'a violent and very dangerous illness'; a remark many years later by Fanny Burney makes it clear that he had suffered a stroke. His friends were alarmed; Johnson was away from London, visiting Thomas Percy at his vicarage at Easton-Maudit in Northamptonshire, and on 10 August wrote a concerned letter:

Dear Sir:
I did not hear of your sickness till I heard likewise of your recovery, and therefore escaped that part of your pain, which every Man must feel to whom you are known as you are known to me.

Having had no particular account of your disorder, I know not in what state it has left you. If the amusement of my company can exhilarate the languor of a slow recovery, I will not delay a day to come to you, for I know not how I can so effectually promote my own pleasure as by pleasing you, or my own interest as by preserving you, in whom if I should lose you, I should lose almost the only Man whom I call a Friend.

Pray let me hear of you from yourself or from dear Miss Reynolds . . .[38]

By the time he received this Reynolds must have been pretty fully restored; his pocketbook records more than thirty sittings for August, very much par for the course at that quieter time of year – the season was over, and the classes from which his sitters were largely drawn had dispersed to their estates in the country.

Two months later, on the other side of Leicester Fields, William Hogarth died of an aneurysm. He had seemed in recent years increasingly isolated – too pugnacious, too much the individualist, too hostile to tradition. Any notion of hierarchy in art remained anathema to him – 'superior and inferior among artists should be avoided'. Although he had been elected to the

committee of the Society of Artists in 1761, he had not exhibited there again. In April 1762, immediately before the Society's own exhibition, he had done his best to provoke some of his fellow artists by organizing a burlesque 'Grand Exhibition of the Society of Sign Painters'.

He was undoubtedly jealous of Reynolds's success, and Reynolds in turn found it impossible to do justice to his genius – perhaps he was not equipped to understand it. It is true that he brought himself in the Discourses to refer, somewhat patronizingly, to 'our late excellent Hogarth', but there is another chilling passage in which the praise is measured out in the meanest of coffee spoons:

The painters who have applied themselves more particularly to low and vulgar characters, and who express with precision the various shades of passion, as they are exhibited by vulgar minds, (such as we see in the works of Hogarth,) deserve great praise; but as their genius has been employed on low and confined subjects, the praise which we give them must be as limited as its object.[39]

Posterity has set those limits more generously. Hogarth had certainly not succeeded in reshaping the course of English painting; what he would have dismissed as 'a ridiculous imitation of the foolish parade of the French academy' came into existence only a few years after his death and effectively marginalized his vision of art; he probably looked on himself as a failure.

Two and a half centuries after his death, things look rather different. Not only is his name part of the language in his own country; by a nice irony, the place of this most aggressively nationalist of English painters is arguably greater in the larger landscape of European art than any of his fellow countrymen, Reynolds included. He clearly had an influence in France on such exponents of *la peinture morale* as Greuze, and there are Hogarthian echoes in the work of David and Goya.

The magnitude and originality of the achievement are no longer disputed. 'He must,' wrote Ellis Waterhouse, 'have been endowed from heaven with a gift for handling the medium of oil paint.' The heights to which he elevated satirical art and his pioneering work in the humanizing of the English portrait are now freely acknowledged. So is his formidable contribution to history painting – he did, after all, leave behind many more canvases in this genre than Reynolds, and can now be seen to have passed to West the torch he had received from Thornhill.

An anecdote of Mrs Thrale's lingers in the mind:

Mr Hogarth, among the variety of kindnesses shewn to me when I was too young to have a proper sense of them, was used to be very earnest that I should obtain the

acquaintance, and if possible the friendship of Dr Johnson, whose conversation was to the talk of other men, like Titian's painting compared to Hudson's, he said: but don't you tell people now, that I say so (continued he), for the connoisseurs and I are at war you know; and because I hate them, they think I hate Titian – and let them![40]

That suggests that 'our late excellent Hogarth' was a larger spirit than Reynolds knew.

8

Foreign Bodies, Foreign Parts

Shortly after the death of Hogarth, Carle Vanloo and his nephew Louis-Michel came to England to visit private collections. Carle had long since been recognized as the most eminent history painter in France; he had been appointed *premier peintre du roi* in 1762 and was also now director of the Académie Royale. He sought out both Ramsay* and Reynolds; the writer William Seward left an amusing note about his meeting with the latter:

Sir Joshua used to say that a President of the Academy of Painting in a neighbouring country paid him a visit, and that he showed him his foreign pictures, to the originality of many of which he made objections. At last, coming to a copy of a female Satyr, made by Sir Joshua after Rubens, he cried out – 'This is an original, I see the squirt of Rubens's pencil.' Sir Joshua had the good nature and the good manners not to undeceive the pretended connoisseur.†

Not everyone was so well-mannered. Hogarth might rest in Chiswick churchyard, but some verses that were going the rounds in 1764 demonstrated that his brand of xenophobia had not died with him:

Lines to an English Painter

Your genius and humour and talents and taste
Each picture you paint plainly shows,
But your time you misspend and your colours you waste
For *an Englishman*, 'nobody knows.'

* Vanloo's elder brother, Jean-Baptiste, was one of those foreign painters in London whom Ramsay had long before boasted of having 'put to flight'.
† Whitley, 1928, i, 210. Northcote tells the same story, but says that the picture was a copy of an old woman's head by Rembrandt (Northcote, ii, 25). Vanloo died in Paris the following July at the age of sixty.

Go abroad – take your palette and pencils to Rome,
And when you return from your tour
If a few foreign graces and airs you assume
You will charm a complete connoisseur.

Go abroad then, in Italy study *virtu*,
No reward *here* your labours will crown;
Every dauber from Rome is brought forward to view,
But *an Englishman's* always kept down.

It is possible that this was aimed at Benjamin West. The young Quaker from Pennsylvania had arrived in London in 1763 after three years in Rome. He was the first American artist to visit Italy,* and had been an object of curiosity there; Cardinal Albani, now in his late sixties and almost blind, was said to have assumed at first that he must be a Red Indian, although this may be part of the legend West subsequently fostered of himself as some sort of untutored prodigy of nature.† Taken to see the *Apollo Belvedere* he is said to have exclaimed, 'My God, how like it is to a young Mohawk warrior!', a remark which did not initially go down entirely well, but his charm and good looks carried all before them. He was taught by Mengs, and elected to the academies at Bologna, Florence and Parma.

He was as well received in London as he had been in Rome. Richard Wilson and Reynolds both took a kindly interest in him, and encouraged him to exhibit at the Society of Artists two historical paintings he had brought with him from Rome; he also submitted a portrait of General Monckton, who had been Wolfe's principal lieutenant at Quebec four years previously. Horace Walpole was dismissive of the subject pictures, pronouncing them 'very tawdry, after the manner of Baroccio', but they were much admired, and West was soon being talked of as 'the American Raphael'.‡

He quickly abandoned all thought of returning home. Before setting out for Europe he had been engaged to a young woman from Philadelphia; she now joined him in London, and they were married in St Martin-in-the-Fields.

* West was born in what is now Swarthmore in 1738, the youngest of ten children of a country innkeeper. The family had gone to America in 1699 from Long Crendon in Buckinghamshire.
† The first biography of West was by the Scottish writer John Galt. 'It was written,' Ellis Waterhouse observed drily in the 1950s, 'in a spirit which we are more accustomed to find applied to South Italian Saints than to a Quaker Academician who lived into the last century' (Waterhouse, 1953, 200).
‡ The pictures were called *Cimon and Iphigenia* and *Angelica and Medoro*. He had painted them at the suggestion of Mengs. Both are today untraced.

At the 1766 Exhibition he showed two neoclassical works he had painted in Rome, and they created something of a sensation.* One of his American patrons, the Chief Justice of Pennsylvania, William Allen, happened to be in London at the time. 'He really is a wonder of a man,' he wrote admiringly to a friend in Philadelphia. 'If he keeps his health he will make money very fast.'

He did make money – a very great deal of it – although not immediately. History paintings such as *Pylades and Orestes* were still something of a novelty:

His house was soon filled with visitors from all quarters to see it; and those amongst the highest rank, who were not able to come to his house to satisfy their curiosity, desired his permission to have it sent to them; nor did they fail, every time it was returned to him, to accompany it with compliments of the highest commendation on its great merits. But the most wonderful part of the story is, that, notwithstanding all this vast bustle and commendation, bestowed upon this justly admired picture, by which Mr West's servant gained upwards of thirty pounds for showing it, yet no one mortal ever asked the price of the work, or so much as offered to give him a commission to paint any other subject. Indeed there was one gentleman so highly delighted with the picture, and who spoke of it with such great praise to his father, that he immediately asked him the reason he did not purchase, as he so much admired it, when he answered – 'What could I do, if I had it? – you would not surely have me hang up a modern English picture in my house, unless it was a portrait?'[1]

West was not detained for long at this checkpoint on the high-road to prosperity. In Parma, when he had been elected to the Academy, he had had an audience at court. Quaker-fashion, he had kept his hat on throughout – to the dismay, it seems, of the courtiers, but to the delight of the duke. Now, in London, these plain Quaker manners bowled over the upper clergy, and he was cosseted by liberal bishops – 'one cannot help wondering', Ellis Waterhouse wrote, 'whether the reason for this was not some obscure feeling of transferred missionary endeavour'.† Archbishop Drummond of York, who had sat to Reynolds in 1764, commissioned *Agrippina Landing at Brundisium with the Ashes of Germanicus*; better still, he introduced West to George III, and that was the making of him. He completed the *Departure*

* *Pylades and Orestes* is now in the Tate Gallery in London; *The Continence of Scipio* is in the Fitzwilliam Museum in Cambridge.

† Waterhouse, 1953, 201. Two bishops in particular took an interest in West and his work. Thomas Newton, Bishop of Bristol, commissioned him to paint *The Parting of Hector and Andromache* and sat to him for his portrait; for James Johnson, Bishop of Worcester, he painted *The Return of the Prodigal Son*.

of Regulus for his royal patron in 1767, and by 1772 he had been appointed Historical Painter to the King.

During his stay in Rome, West had met the young Swiss painter Angelica Kauffmann, newly arrived in Italy, and they had drawn each other's portraits. She too now came to England, although not as a completely unknown quantity. A portrait of David Garrick, which she had painted in Naples, had been exhibited in London the previous year, and Reynolds's old friend John Parker, later Lord Boringdon, who had been in Italy on his honeymoon, had also sat to her there. West seems to have been one of the few members of the Roman art colony not to have lost his heart to this talented and versatile young woman – the Irish portrait painter Thomas Hickey and the Scot Gavin Hamilton certainly did and Nathaniel Dance, a former pupil of Francis Hayman, who had been in Rome since 1754, fell desperately in love with her. Farington, on the authority of Dance's brother, states that she encouraged his suit, that he followed her back to England and that 'it was settled between them that they should marry'.[2]

Dance soon became aware of a cooling in her affections, however, and accused her of setting her cap at Reynolds. His remonstrances were not well received, and she threw him over. The nature of her relations with Reynolds is far from clear, and such evidence as the diarists and gossip writers have to offer is conflicting. Farington says that he 'showed her much attention';[3] Anthony Pasquin, on the other hand, living up to Macaulay's description of him as 'a polecat', has it that 'the cold President was too abstracted in thought for the interests of the Paphian boy'.*

She was not beautiful, but she had great liveliness and charm of manner.†

* Pasquin, 1796, 113. Pasquin is careless about dates. Reynolds would not become President of the Royal Academy for another two years.

† 'She never was beautiful,' Dance's brother told Farington many years later, 'but there was something amiable & feminine in Her appearance that engaged people to Her' (Farington, 1978–84, ix, 3192, entry dated 6 January 1808). An earlier entry throws interesting light on Reynolds's idea of female beauty; Farington had been dining with Reynolds's niece, Mary Palmer, now Lady Thomond:

Female beauty was spoken of. Lady Thomond said that Her Uncle, Sir Joshua Reynolds, had often declared that *Mrs Crewe*, now Lady Crewe, was in her face the most regular beauty He had ever seen, but He did not add or mean, that her face was the most *interesting*. – Her Ladyship said that the woman who had above all others made the strongest impression on Sir Joshua's mind, was *Miss Hamilton*, who married Moore, author of the World &c. – Sir Joshua said that while reading a novel or any work in which the imagination was employed to represent an image of what was interesting and beautiful, the idea of Miss Hamilton was always uppermost in his mind (vii, 2754, entry dated 9 May 1806).

Reynolds had painted Jane Hamilton very early in his career. As she is referred to as 'Miss Hamilton' it seems likely that she sat to him before he went to Italy – her marriage to the dramatist Edward Moore took place in 1749 or 1750; she may be the 'Miss Hambleton'

She was an undoubted coquette. Equally undoubtedly, Reynolds greatly admired her. Frequent pocketbook entries of 'Miss Angelica' show that she was quite often in Leicester Fields – she sometimes appears as 'Miss Angel', and on one occasion the word 'fiori' appears beside her name; possibly he was reminding himself that he must visit a florist. Writing to her father in October 1766, Angelica described Reynolds as one of her 'kindest friends'. He was, she said, 'never done praising me to everyone'. As proof of his admiration for her, she added, 'he has asked me to sit for my picture to him, and in return I am to paint him'.[4]

Years later, Henry Bate Dudley, a crony of Gainsborough and a man generally extremely well informed about the private lives of the artists of his day, asserted that Reynolds had made a proposal of marriage but had been turned down:

> She had long refused many advantageous offers of various suitors, and among them one from Sir Joshua Reynolds, who at the same time that he admired her style of painting thought Angelica a divine subject to adorn the hymeneal temple.*

That was written in 1781, by which time a sadder and wiser 'Miss Angel' was emerging from the hymeneal temple for the second time. In 1767, in a Catholic chapel, she had entered into a clandestine marriage with someone calling himself Count Frederic de Horn. He was an impostor – allegedly the real count's valet – and a bigamist into the bargain. He was bribed to leave the country and a deed of separation was procured from the Vatican; Reynolds was one of those who took a hand in the arrangements. Angelica remained legally bound to the man until his death fourteen years later. She then married the Venetian painter Antonio Zucchi, who had also come to London in the mid-1760s, and had become Robert Adam's chief decorative painter. They left almost immediately for Italy, settling eventually in Rome.

Angelica's disastrous first marriage continued to excite all manner of speculative gossip. Some years after her death, Laetitia Hawkins, in her *Memoirs*, revived the story that it had been a plot to ruin her devised by a disappointed lover:

Reynolds refers to in one of his letters from Rome to Miss Weston (Letter 8). The portrait, now untraced, shows her in a black cloak and hood, which partially shades her face. According to Graves and Cronin, Reynolds painted it on a whim and presented it to the sitter. It is a pleasant face, young and unformed – Miss Hamilton may have been as young as sixteen when it was painted.

* Whitley, 1928, i, 372. Although he was in holy orders, Bate (1745–1824) devoted most of his energies to journalism, editing successively the *Morning Post* and the *Morning Herald*. His readiness to settle disagreements with his fists earned him the nickname of the 'Fighting Parson'. He was created a baronet in 1813.

I have heard it said that she was addressed by a painter of the first eminence – I do not like to name him, it was not Sir Joshua – she refused him and in cruel revenge he dressed up a smart fellow of a low description but of some talent. This man he introduced to her as a person of distinction, and teaching him to profess a passion for her, his specious recommendations deceived her and she married him. They parted immediately – I hope the story may not be true.[5]

The 'painter of the first eminence' could only be Dance.* The story sounds altogether too Neapolitan and operatic to be credible, but there can be no question about the depth of Dance's bitterness. The Earl of Harewood owns a pencil sketch by him, dating from 1766 or 1767, which is clearly intended to expose Reynolds and Angelica to ridicule. They sit close together on upright chairs. Angelica holds a palette in her left hand; her right is placed over her heart. Reynolds, his legs crossed, leans ponderously towards her; he holds a snuff-box, and his left hand is cupped round his ear – at once an allusion to his deafness and a reminder that he was eighteen years her senior. (Dance was twelve years younger than Reynolds.) In the background, lightly sketched in, stands the figure of a woman with a guitar. She turns her back to the couple – a chaperone, perhaps, under instructions not to take her duties too seriously.[6]

Angelica, who retained her maiden name, remained in Italy for the rest of her life. Having charmed Reynolds, Dance and many others in her youth, she captivated Goethe, Herder, Canova and a great many more in middle age. She almost certainly came closer than any other woman to breaching the defences of Reynolds's bachelor state, but there is evidence that she was not the only one to trouble his heart in these middle years. Sir Henry Bunbury,† who was Reynolds's godson, said that there was a family tradition that when Reynolds was painting his aunt, Mary Horneck, he became so enamoured of her that during one sitting he fell on his knees and asked for her hand.

The Hornecks were a Plymouth family whom Reynolds had known for many years. He had painted the father, an officer in the Royal Engineers, before going to Italy[7] and Mrs Horneck a decade later.[8] Their two daughters, Mary and Catherine, had a number of appointments for a double portrait

* Angelica's compatriot, Henry Fuseli, who had come to London in 1764, can be ruled out. He was the same age as Angelica, and undoubtedly a passionate admirer, but he had not yet abandoned literature and philosophy for art; his eminence as a painter lay some years in the future.

† Bunbury (1778-1860) was the son of the well-known amateur artist Henry Bunbury, a close friend of Reynolds. He was a lieutenant-general on the retired list, and wrote a number of historical works. In 1815 he was one of two commissioners appointed to communicate to Napoleon the decision of the British Cabinet to exile him to St Helena.

between 1765 and 1767, when both were in their early or mid-teens;[9] Mary sat to him again a decade or so later, probably in 1775 – the pocketbook for that year is lost – by which time she was a young woman in her mid-twenties. Goldsmith, another friend of the family, is also said to have been in love with her, and it was from some verses of his that she became known as 'The Jessamy Bride'. In 1779 she married Colonel, later General, Francis Gwyn, an equerry to George III; she herself became a Lady of the Bedchamber to Queen Charlotte. She retained her beauty into old age; Hazlitt, who saw her more than fifty years after she sat to Reynolds, compared her to Ninon de Lenclos.* Reynolds painted her in Turkish masquerade costume. The portrait was exhibited at the 1775 Royal Academy Exhibition, but he never parted with it, and bequeathed it to her in his will: 'to Mrs Gwyn her own Picture with a Turban'.[10]

The Society of Artists had been granted a royal charter in 1765, and assumed the weightier title of The Incorporated Society of Artists of Great Britain. George Lambert became the first President, but died within a matter of days and was succeeded by Hayman.† Reynolds declined election as a director; those who agreed to serve included Wilson, James Paine and Cotes.

Cotes was now in full fashionable practice. He was making considerable use of Peter Toms to paint his draperies, and his prices – 20, 40 and 80 guineas – fell somewhere between those of Reynolds and Gainsborough. To the modern eye, he lacks the psychological penetration achieved by Reynolds. 'He went all out for health and youth and fine clothes,' wrote Ellis Waterhouse, 'a strong likeness and no nonsense. His complexions are usually of milk and roses, his men bear no burden of intellect.'[11] None of that was of any concern to the fashionable world of the 1760s, and they flocked in increasing numbers to the rather grand house he had taken at 32 Cavendish Square. In 1767 he painted the queen and two of the elder princesses. By the end of the decade, he was attracting almost as many sitters as Reynolds had a decade earlier.

Gainsborough, too, from his Bath stronghold, was steadily consolidating his position. He had recently removed from Lansdowne Road to the Circus, which although some way from the centre of town was already fashionable. Pitt the elder and the Duke of Bedford were both neighbours; in 1766,

* Not everyone would have been flattered by the comparison. Lenclos (*c.* 1620–1705), renowned for her wit and beauty, was equally celebrated for what her French biographers describe as her '*aventures galantes*'. Her salon was frequented by her life-long friend Saint-Evremond and other free-thinkers of the day.

† Lambert (1700–1765), who had become the first chairman of the Society of Artists in 1761, is best known for his topographical paintings and imaginary landscapes; he had painted the landscape in the large canvases Hogarth executed for St Bartholomew's Hospital in the 1730s.

shattered in health, Clive took a house there on his final return from India.

To the 1765 London exhibition Gainsborough submitted his ambitious equestrian portrait *General Honeywood*[12] and the following year he sent a picture showing Garrick with an arm placed in somewhat proprietorial fashion round a bust of Shakespeare – it was catalogued simply as *A Gentleman*, but that deceived nobody.[13] During the sittings, Garrick, who was a great joker, had tested Gainsborough's friendship by constantly changing his expression:

When he was sketching in the eyebrows and thought he had hit upon the precise situation and then looked a second time at the model he found the eyebrows lifted up to the middle of the forehead; and when he looked a third time they were dropped like a curtain, close over the eye. So flexible and universal was the countenance of this great player that it was as impossible to catch his likeness as it is to catch the form of a passing cloud.*

That year's exhibition was the subject of a pamphlet in verse entitled 'A Candid Display of the Genius and Merits of the Several Masters Whose Works Are Now Offered to the Public at Spring Gardens. By an Impartial Hand'. Reynolds and Gainsborough, who were the undoubted stars of the exhibition, were dispatched in one perfunctory, if complimentary, couplet:

> There Gainsborough shines, much honoured name,
> There veteran Reynolds, worthy of his fame.

How much Reynolds, who had just passed his forty-second birthday, appreciated being called a veteran is not known. At all events the 'Impartial Hand' dealt much more effusively with a young painter called Matthew William Peters, whose contributions included *A Florentine Lady in the Tuscan Dress* and *A Lady in a Pisan Dress*. Peters, who had studied under both Hudson and Batoni, would later develop a line of genre painting, variously described as 'coquettish' and 'risqué', in which the young women portrayed were much more scantily dressed. Later still he entered the Church, became chaplain to both the Prince of Wales and the Royal Academy and took to producing lugubrious religious paintings with titles such as *Angel Carrying the Spirit of a Child to Paradise*.[14]

* The account appeared in the obituary notice of Gainsborough in the *Morning Chronicle*, the writer claiming he had had the story from Gainsborough himself. Oddly enough, Garrick's widow used to say that nobody had ever caught a better likeness of her 'dear Davy'.

Peters rated twenty lines; Benjamin West got several pages. 'Impartial Hand' relates that just as he was about to ascend the staircase at Spring Gardens to view the exhibition he was accosted:

> Sly Malice pluck'd my sleeve and did assure
> That most above were Modern, Mean and Poor
> But *West* and *Genius* met me at the Door;
> Virgilian West, who hides his happy Art
> And steals, through Nature's inlets, to the Heart,
> Pathetic, Simple, Pure, through every part . . .

The very qualities which had appealed to the unsophisticated George III. West's Quaker simplicity and purity were soon to be exposed to corrupting Old World influences, however. The American painter Washington Allston, who knew West in London in the early years of the next century, told an amusing story about a subsequent year in which West and Wilson were appointed joint hangers to the exhibition:

It was a memorable year for the crudities of the performances, in consequence, I suppose, of the unusual number of new adventurers. When the pictures were all up Wilson began to rub his eyes as if to clear them of something painful. 'I'll tell you what, West,' he said, 'this will never do. We shall lose the little credit we have, for the public will never stand such a shower of chalk and brickdust.' 'Well,' said West, 'but what is to be done? We can't reject their pictures now.' 'No, but we can mend their manners.' 'What do you mean?' 'You shall see,' said Wilson, 'what Indian ink and Spanish liquorice can do.' He accordingly despatched the porter to the colourman and druggist for these *reformers*, and dissolving them in water, actually washed nearly half the pictures in the exhibition with this original glaze. 'There!' he said, 'it's as good as asphaltum, with this advantage that if the artists don't like it they can wash it off when they get the pictures home.' And Mr West acknowledged that they were all the better for it.*

West – Cotes – Gainsborough. All three were now demonstrating great accomplishment in their annual submissions to Spring Gardens, but as the 1760s wore on Reynolds, now at the height of his powers, continued to demonstrate his superior inventiveness and versatility – 'Damn him, how various he is!' as the exasperated Gainsborough would famously cry.† And

* Whitley, 1928, i, 198–9. Allston was writing to the American artist and playwright William Dunlap, who had worked with West in England between 1784 and 1787.
† Garrick excited similar emotions in his profession. 'Damn him!' cried the actress Kitty Clive, 'he could act a gridiron!'

so he was. If West appropriates a prophet from Raphael he becomes no more than another prophet. When Reynolds helps himself to a sibyl from a Michelangelo fresco in the Sistine Chapel, he transforms her into a duchess playing with her baby.[15] Cotes never ventures beyond straightforward portraiture. In *Garrick between Tragedy and Comedy* Reynolds, with subtle mastery, combines a tribute to the great actor's ascendancy as both tragedian and comedian with a witty allusion to the classical theme of the Choice of Hercules – a choice between vice and virtue. In a further nuance, he paints Tragedy in the style of Guido Reni and Comedy in the manner of Correggio.

Of the three it was Gainsborough who consistently ran closest to his shoulder; there are, indeed, respects in which it can be argued that he sometimes drew ahead. When he delivered his fourteenth Discourse, only a few months after the death of his great rival, Reynolds paid tribute to 'that striking resemblance for which his portraits are so remarkable' – not something that could always be claimed for his own pictures. It is also the case that there are very few of Gainsborough's portraits which were not entirely the work of his own hand. Where Reynolds ultimately triumphs is in the width of his range of reference: the fruit of his years in Italy and of the single-mindedness, then and later, with which he studied and analysed – and borrowed from – the works of the Old Masters.

There were profound differences of character and temperament between the two men. Gainsborough was highly strung and not particularly strong. 'He always dined at 3 o clock,' his daughter told Farington, 'began to paint abt. eleven o Clock and was generally exhausted by dinner time' – a striking contrast to the routine of the robust workhorse Reynolds, equable to the point of stolidity and with an unparalleled capacity, assistants and drapery painters notwithstanding, for taking pains to get the smallest detail absolutely right. One of his sitters during 1767, for instance, was the then Speaker of the House of Commons, Sir John Cust, who had five morning appointments in the middle of July. A note in the pocketbook reads 'The Speakers wig at Thede Perukemakers, Middle Temple', and this is followed by 'Mr Stevens, house keeper of the House of Commons, to send a day or two before for the Mace'.*

Gainsborough was also all too easily tempted into dissipation; a few days in London in the company of some of his loose-living friends could render him incapable of work for a week afterwards:

* The portrait (Mannings, cat. no. 467, fig. 913) is now at Belton House, Lincolnshire, the property of the National Trust. Cust was much mocked in his day for the shortness of his nose. Reynolds, ever the diplomat, has painted him almost full-face, and well back from the plane of the canvas.

Such is the Nature of that D— place, or such that of this T.G that I declare I never made a Journey to London th[at] ever did what I intended. 'tis a shocking place for *that* and I wonder amongst the number of things [*words scratched out in a different ink*] I leave undone which should be done, that I don't do many more which ought not to be done.[16]

Although he recognized its importance as a means of keeping himself in the public eye, Gainsborough's attitude to the annual exhibition, which was his main reason for visiting the capital, was ambivalent. He was characteristically frank about his reservations in a letter to David Garrick in May 1766:

I don't look upon the Exhibition, as it is conducted at present, to be calculated so much to bring out good Painters as bad ones. There is certainly a false taste and an impudent stile prevailing, which if Vandyke was living would put him out of countenance; & I think even his work would appear so, opposed to such a Glare. Nature is modest, and the Artist should be so in his addresses to her . . .[17]

Reynolds, although more inclined to keep his views about such matters to himself, liked the exhibitions no better – they had, he said, 'a mischievous tendency, by seducing the Painter to an ambition of pleasing indiscriminately the mixed multitude of people who resort to them'.

Nothing remotely 'mixed' about the body of which Reynolds became a member in the course of 1766. On the proposal of Lord Charlemont, he was elected to the Society of Dilettanti. Many of his friends and sitters – George Edgcumbe, Lord Ossory, Sir Charles Bunbury, Lord Holdernesse – were already members, and Reynolds became a regular attender at their Sunday evening dinners, the master of ceremonies resplendent in a robe of crimson taffeta and rich hussar cap and equipped with a Toledo rapier. The Society had been established in 1734, originally as a dining club for those who had made the Grand Tour – 'the nominal qualification for membership is having been in Italy', sniffed Horace Walpole, 'and the real one, being drunk'.

Reynolds clearly qualified on the first count, and had nothing against conviviality. In his *Dictionary*, Johnson had defined a club as 'an assembly of good fellows meeting under certain conditions'. Georgian London was awash with them, ranging from the libertine Society for the Propagation of Sicilian Amorology to the rather more political Calves' Head, whose annual banquet commemorated the beheading of Charles I. The Roaring Boys catered for roaring boys; gentler members of the male sex whose interest inclined to cross-dressing might join the Mollies Club.

Apart from the Club and the Dilettanti, Reynolds belonged to the Devonshire and the Sons of the Clergy. He was also a member of the Thursday-night Club, which drank hard and played high at the Star and Garter in Pall Mall. Reynolds was extremely fond of whist, but apparently very bad at it. His niece Mary told Farington that he did once emerge from a sitting 70 guineas the richer, but that was the largest sum he ever won – 'If he went into a Company where there was a Pharo table, or any game of chance, He generally left behind him whatever money He had abt. him.' This compulsion – because that is what it sounds like – seems occasionally to have troubled Reynolds; his niece retailed to Farington a rather strange attempt he made to rationalize it:

He was convinced it was inherent in human nature. He said that the principle of it appeared in a variety of instances. – Offer a beggar as much per week to work moderately as He wd. confess He obtained by soliciting Alms, & He wd. refuse it. – In one case certainty would preclude hope. – Tell a man of 50 that His life shd. be secured to 90 but then it must terminate, He wd. rather take his chance.[18]

Early in 1767 John Shackleton, who had been absent-mindedly continued in office as Principal Painter in Ordinary at the start of the new reign, fell dangerously ill. Reynolds would dearly have liked to succeed him, but was quite unable to match the lobbying fire-power mobilized by Allan Ramsay. David Hume, a close friend of Ramsay, wrote to Lord Hertford, whose secretary he had been in the Paris embassy and who the previous year had conveniently become Lord Chamberlain. Bute, too, although now obliged to keep his distance from the king, was still a force to be reckoned with in any such dealings 'behind the curtain'. A letter survives which Ramsay wrote to him on 13 March:

My Lord,
My heart is so full of gratitude for the generous part you take in my protection that I am altogether unable to express it. I hope my conduct will be better able to speak what I feel . . .[19]

Shackleton died four days later, and before the month was out Ramsay's appointment was announced.

If Reynolds was disappointed, he cannot have been particularly surprised. Northcote's assertion that 'politics never amused him nor ever employed his thoughts a moment' needs a good deal of qualification. Although it is true that politicians of every stripe passed through his painting room, Reynolds was undoubtedly viewed with suspicion at court because of the

political complexion of much of his social circle. The king's opinion of the old Whig families who had effectively monopolized power during the preceding reign was well known. It had been strikingly formulated by Bute, a few days before his resignation, in a letter to the Duke of Bedford. The king was resolved, the Favourite wrote, 'never upon any account to suffer those ministers of the late reign who have attempted to fetter and enslave him ever to come into his service while he lives to hold the sceptre'.[20] The royal resolve was never more than imperfectly executed, but those whom he associated with the various groupings who had annoyed or insulted him – the parties of Grenville, Rockingham and Bedford – could not expect to bask too warmly in the royal favour.

There was also Reynolds's friendship with Wilkes, soon to return from France and stir the pot as the candidate first for the City of London and then for Middlesex; there was his intimacy with Burke, who had been Rockingham's private secretary and had himself entered Parliament the previous year as the Member for Wendover. There were his even older ties of friendship with Lord Edgcumbe – another Rockingham Whig, with four Cornish boroughs at his command – who had recently been dismissed as Treasurer of the Household on his refusal to exchange his office for a Lordship of the Bedchamber. This slight to the Rockinghams triggered the departure of most of their adherents who had been willing to serve with Chatham, including Reynolds's friends Keppel and Sir Charles Saunders, both of whom resigned as Lords Commissioners of the Admiralty.

It was not only politics that deprived Reynolds of royal patronage, however. Northcote, in conversation with a friend not long before his death, reminded him that the king and queen never again sat to Reynolds after the portraits he painted of them for the Royal Academy in 1779 and asserted that the king and queen had been afraid of his old master. The friend expressed astonishment:

Have I not heard you say that he was courteous to every one, that his manners were so gracious that even a journeyman framemaker, sent by his master to take the measure for a picture and to receive orders for a frame, went away elevated in his own self-esteem from the gratification of the interview?

Northcote considered his friend naïve. 'Bless my soul, how artless you are!' he told him:

Can't you see that one of his native dignity was more likely to strike awe into the King and Queen, who were comparatively young and inexperienced, than for him to be overawed by them? The one was only King of a great nation; the other was the

greatest painter in the world. Hence, the balance of greatness preponderating on the side of the subject, the King, sensibly conscious from the ease and self-dependence of manner of the painter which was the greater man of the two, looked at the Queen with an expression that intimated 'the sooner we are relieved from the annoyance of these sittings so much the more agreeable'; it was settled that they would never again expose themselves to a similar experience. I know that I am right. The King and Queen could not endure the presence of him; he was poison to their sight . . .*

Northcote makes the point extravagantly – the king, immature as he remained in many ways, was already in his forties by 1779, and had been on the throne for nineteen years – but he was not alone in noting that Reynolds was no courtier. In 1785 'Peter Pindar', in his *Lyric Odes to the Royal Academicians* for that year, drew a contrast between the king's neglect of Reynolds and the patronage he lavished on West:

> While WEST was whelping, 'midst his paints,
> Moses and Aaron, and all sorts of Saints!
> Adams and Eves, and snakes and apples,
> And dev'ls for beautifying *certain* Chapels;
> But REYNOLDS is no favourite, that's the matter;
> He has not learnt the noble art – to flatter![21]

The 1767 Exhibition attracted almost 23,000 visitors. 'It may be safely asserted,' wrote an anonymous pamphleteer, 'without any trespassing against truth, that even from the *first*, and that but a few years ago, down to the *Present Exhibition*, the *Painting Art* has been brought forward half a century, in comparison with its wonted crawling progress, before that animating Æra.'[22]

The existence of an annual showcase had certainly greatly enlarged the scope for artists to display their work and to appeal to a broader public than the wealthy elite on whom they had been so heavily dependent for patronage; for those eager to diversify or bold enough to experiment, there was now something of a safety net. It also opened up a rich new vein for those who earned their living by hack work for the public prints; in May 1767 another nameless scribbler offered the readers of the *Public Advertiser* *An infallible Receipt to make an* EXHIBITION CRITIC, *copied verbatim from the original lately given to Mr* Nicodemus Bluntquill, *an inhabitant of Grub-Street, by his Bookseller*:

* The identity of the friend is not known. The exchange is recorded in Whitley, 1928, i, 255–6.

. . . When you have shaken off the pleasing Sensation that such a Number of ingenious Performances must necessarily give you, direct your whole Attention to the Company, particularly to such of them as you observe use Glasses or wear Spectacles; lose not a Word of what they say, for as the Wasp steals the Honey he cannot make himself, so you are to avail yourself of every Thing these Gentlemen who are titled *Connoisseurs* utter, by which Means you will Procure a large Quantity of the *Essence of Prejudice*; and observe, that of this Essence you cannot have too much. You may next direct your Attention to the Ladies, of whom you will easily obtain two or three Ounces of *Exhibition Salvolatile*, or Epithets such as *horrid! shocking! abominable! a perfect Dawb! &c., &c*; cork these up immediately lest they should evaporate. Then turn your Eyes towards such Persons as you will observe to wear a Kind of *green and yellow Melancholy*, who swell and look *askaunce*, who *knit the Brow and Bite the Lip*, who walk in Couples, point and utter themselves in half Whispers; from these, on Account of their speaking low, you will with some Difficulty gain a most valuable Extract of *Envy, Detraction, Competition* and *personal Pique . . .*

Reynolds sent nothing to the exhibition that year; the honours in portraiture went to Gainsborough, whose submissions included full-lengths of Lady Grosvenor and of the Duke of Argyll. Another of the show-pieces of the year was Cotes's portrait in crayons of the queen and the little Princess Royal: 'The Queen fine, the child incomparable', Horace Walpole noted in his catalogue. Burke, writing to James Barry in Italy, gave a not entirely convincing explanation for Reynolds's absence:

The exhibition will be opened tomorrow. Reynolds, though he has, I think, some better Pourtraits than he ever before painted, does not think meer heads sufficient; and having no piece of Fancy finished, sends in nothing this time . . .[23]

More probably he wished to distance himself from the frequent bickering which increasingly characterized the Society's affairs; there was quite as much 'Envy, Detraction, Competition and personal Pique' among the artists as Nicodemus Bluntquill had observed in the exhibition room. Cotes seems to have been responsible for some of this. In addition to his royal portrait, he had submitted one of the Duchess of Hamilton; some of his fellow artists felt that as a member of the hanging committee he had abused his position as a director:

One of the committee occupied as usual, two principal situations; in one of which he hung a picture of her majesty, and in the other, that of a lady of quality. The carpenters going to place a fine piece of shipping belonging to a celebrated artist in that branch of painting, over that of the queen, the director called out with great

vehemence, 'You must not hang that picture there: "Why? – " It will hurt my queen.' Accordingly it was taken to the opposite end of the room, when the director called out with still more violence, 'It must not be hung there.' 'Why, Sir? – 'O! it will kill my dutchess.'[24]

The hanging of pictures at the exhibition was not the only cause of dissension. Another senior member whose activities were viewed with some resentment was Reynolds's acquaintance from his Rome days, Richard Dalton. Dalton, who was the Society's Treasurer, had done very well for himself since his return from Italy. As Librarian to the King (and a protégé of Bute) he had been active in building up the royal collection; in 1762, for instance, he had been involved in the acquisition of the collection of Joseph Smith, the British consul in Venice, with its splendid Canalettos. He had also established a print warehouse in premises which he had acquired from Lamb the auctioneer in Pall Mall. It was believed that when this got into financial difficulties, he had exploited his royal connections to secure a promise of support from the king in turning it into an academy. The words 'Print Warehouse' over the door gave way to 'The Royal Academy' and the former St Martin's Lane Academy was persuaded to transfer its activities there for a time. The enterprise did not prosper, but some members of the Society felt that it had retarded the creation of the sort of public academy they wished to see established.*

Reynolds evidently judged it prudent not to let Gainsborough have the field to himself two years running, and sent to the 1768 Exhibition a *Portrait of a Young Lady with a Dog, Whole Length*. The young lady was the five-year-old Hester Cholmondeley, who is shown humping her surprisingly unprotesting pet across a stream.† Gainsborough countered with two full-lengths, of Captain Needham and of Captain Augustus Hervey, later the Third Earl of Bristol: 'Very good and one of the best modern portraits', noted Horace Walpole.[25] Both men were also represented at a special exhibition mounted later in the year in honour of the visiting king of Denmark, but by the time it opened, at the end of September, Reynolds had left London for a visit to France.

He had not been abroad since his return from Italy fifteen years previously, and why he chose to head for Paris at this particular moment can only be a matter for speculation. A phrase in a letter from the man who accompanied

* Dalton disposed of the premises to James Christie (1731–1803), who had resigned a commission in the navy to set up as an auctioneer. His first sale took place there in December 1766.
† Mannings, cat. no. 364, fig. 903. Hester's mother, Mary, was the younger sister of the celebrated Irish actress Peg Woffington, who had been Garrick's mistress during his early days in the theatre.

him – 'Mr Reynolds and I made this scamper together' – suggests that it may have been a casual thought thrown out on the spur of the moment, but whose idea it was is not known.

His travelling companion was William Burke – he and Edmund were close friends, and called each other cousin, but it has not been established that there was a blood relationship. He had served as under-secretary to Conway in both the Southern and Northern Departments during the Rockingham administration. Returned to Parliament for Great Bedwin, Wiltshire, two years previously, he had temporarily lost his seat and was possibly at a loose end.* It is also conceivable that he had to go to Paris on business; he and Edmund Burke were known to be involved together in a number of speculative ventures; the pencilled notes of engagements which Reynolds jotted in his pocketbook during their stay in the French capital include several meetings with a Monsieur Panchaud, who acted as agent and banker for numbers of visiting Englishmen.

One reason which might have prompted Reynolds to accept an invitation to join Burke in a short 'scamper' to Paris was that he was deprived for a time of the domestic services of his sister Fanny. She, as it happens, had also gone to France, where she was visiting a family called Flint. The father was a Scottish teacher of English living in Paris because of his Jacobite sympathies. His daughter, Louisa Henrietta, had translated Johnson's Preface for the French edition of his *Shakespeare*. A letter survives in which, writing in French, he roguishly chides her for robbing Fanny's friends at home of her company:

. . . Mais comment m'empescher de me plaindre de ces appas par lesquelles vous avez gagne sur l'Esprit de Mademoiselle Reynolds jusqu'a ce qu'elle ne se souvient plus ni de sa patrie ni de ses amis. C'est peu de nous louer, c'est peu de repandre nos ouvrages par des traductions les plus belles, pendant que vous nous privez de plaisir de voir Mademoiselle Reynolds et de l'écouter . . .†

'Go calmly and look English.' It would be another twenty years or so before subjects of George III would require Bagehot's advice about how to emerge

* He is described in the *Dictionary of National Biography* as 'an active pushing man, well acquainted with the leaders of the whig party, though generally disliked by them'. Horace Walpole was similarly dismissive: 'As an orator, he had neither manner nor talents, and yet wanted little of his cousin's presumption' (Walpole, 1845, ii, 274).

† '. . . But how can I not complain of those charms by which you have gained such sway over Miss Reynolds that she no longer remembers either her native country or her friends? It avails little to praise us, and to make our writings more widely known by elegant translations, if at the same time you deprive us of the pleasure of Miss Reynolds's company and conversation . . .' (Johnson, Samuel, 1992–4, i, 321–2, letter dated 31 March 1769).

unscathed from a Parisian uprising.* In 1768 the monarchy was still the fountainhead of all authority. France had just bought Corsica from the Genoese Republic, and would shortly egg on the Turks to declare war on Russia – in defence of Polish liberties. A marriage had been negotiated between the fourteen-year-old dauphin and the Archduchess Marie-Antoinette, who was a year younger. The boy's grandfather, Louis XV, was doing battle with the Jesuits on one front and with the *encyclopédistes* on the other, but public interest centred mainly on his new mistress. Mme la comtesse du Barry, it was said, was the most athletic streetwalker in history – she could make it from the Pont-Neuf to the Throne in one jump. (The Throne was a gate at the entrance to the Faubourg Saint-Antoine – quite some way from the Pont-Neuf, a quarter frequented by prostitutes.)

The crossing from Dover to Calais had taken fifteen hours, and Reynolds and Burke had twice been delayed between there and Chantilly by a broken axle-tree. Settled at a hotel in the rue Pelletier, they now embarked on an enjoyable tourist round – the Italian Opera, a performance of *Le Misanthrope*, tea at the Flints', visits to Versailles and to the Sèvres porcelain manufactory.

Anyone arriving in Paris in mid-September would have been able to visit the Salon, which usually opened towards the end of August for about six weeks. Whether Reynolds did so is not clear, although a sentence in a letter he wrote to Burke suggests he might have done: 'I shall leave till I come to England my opinion of the Ta Blews as they call them in their damn'd lingo which by the by I cannot yet speak for my life tho' I have tried at it ever since I have been here.'[26] Hogarth would have been proud of him.

Whether or not Reynolds cast a supercilious eye over what his French contemporaries had to offer, he certainly spent a lot of time looking at Old Masters – in churches, in private collections, in the shops of picture-dealers. He had an enthusiastic companion in Burke. 'The collections here are wonderful,' he wrote to Barry, 'and the magnificence of their furniture transcends ours by far.'[27] Reynolds had been buying very little since the move to Leicester Fields, but he was now able to spend much more freely again, and during his stay in Paris he acquired six pictures, laying out £300 for Guido Reni's *Il Giovanni* and £153 for a Poussin which cannot now be identified.

* Northcote records that Miss Flint did not emerge unscathed; that she married a French nobleman, was widowed, and guillotined together with her only son. Northcote was dramatically misinformed. She did indeed marry in 1783, although her husband, Antoine Rivarol, was not the count he claimed to be. A brilliant conversationalist and penetrating political satirist, he was hailed by Burke as 'the Tacitus of the French Revolution'. He was less highly regarded by the Revolutionaries, and in 1792 he prudently decamped to Brussels – leaving his wife and son to be imprisoned during the Terror.

He renewed his acquaintance with Gabriel-François Doyen, whom he had known in Rome, and who helped him with some of his purchases. These may have included two pastoral landscapes by Claude Lorrain which had appeared in the de Merval sale in Paris in May of that year. One of them is now in the Timken Art Gallery, San Diego, the other in the Metropolitan Museum of Art, New York. Reynolds's reverence for the Old Masters never prevented him from making improvements to their work when he thought they were called for, and it was widely known within a few years of his death that he had overpainted the San Diego picture. The Library of the Victoria and Albert Museum has a catalogue of the sale in which the picture appeared in 1795, and it is annotated, 'this Picture has been touched by Sir Joshua'. Sir Abraham Hume (to whom, as it happens, the other landscape passed – Reynolds bequeathed to him 'the choice of his Claude Lorraines') was also present at this sale, and he too made a note in the margin of his catalogue: 'Been painted over by Sir J. Reynolds whose it was and spoilt. Captain Bailie and Mr Cox [say] Sir Joshua never knew when to stop his brush!'*

Reynolds was not much of a hand at letter-writing, and he knew it. 'If I felt the same reluctance in taking a Pencil† in my hand as I do a pen,' he once wrote to Boswell, 'I should be as bad a Painter as I am a correspondent.'[28] The several hundred of his letters that have come down to us have none of the spontaneity and exuberance of a Garrick or a Gainsborough or the elegant malice of a Walpole. Much of the letter he wrote to Burke from Paris is taken up with a rather pedestrian defence of the French against the misrepresentations of English travel writers:

I am well acquainted with the opinion the English entertain in regard to the French, it is generally believed that the French are Ignorant in Philosophy and Bigots in Religion, that they wear nothing but wooden shoes, and have never a shirt in their whole country ... I have seen many men working in the fields and in Paris with shirts some of which were blue and some orange colour, and more than that I am convinced and I have that many if not all the Quality in France were shirts of the finest holand, for though I never saw of them strip I have seen what is an equivalent proof, I have seen on the Bulwarks of Paris above twenty entire shirts hanging to dry that the best Gentlemen in England might wear without disparagement.

* Sir Abraham's catalogue is in the Library of the Courtauld Institute. William Baillie (1723–1810) was an amateur engraver and etcher. Mr Cox was possibly Peter Coxe (d. 1844), a minor poet who worked for a time as an auctioneer.
† I.e. a paintbrush.

When he moves on to defend the French against the charges of bigotry and ignorance, however, what he has to say is much more interesting – not because of any particularly penetrating insights into Parisian intellectual life (his problems with 'their damn'd lingo' would have made that difficult), but because of the rare but revealing glimpse it affords us of Reynolds's own views about religion:

> I will venture to say they have as much intellectual freedom as the English have political, we have been in company with some of their Witts, and it is amazing how impatient they are to assure you that they think for themselves, that they are not priest ridden in short that they have the honour to be *spriforts* that is in English an Atheist however with all my partiality I cannot help thinking that they look down with too much contempt on those who still retain the early prejudices of education or have not that strong understanding which enables a man to shake them off, this is certainly very unreasonable, and very unphilosophical for I am of opinion a man may be a good member of society and even a man of good sense in other things not tho' he may be weak enough to be a believer in – or even a Christian.[29]

It is unlikely that he ever expressed his 'partiality to atheism' with such openness to his sisters: still less his view that Christianity was no more than some sort of handicap – unfortunate, of course, but not so serious as to prevent one still being 'a good member of society and even a man of sense in other things'. But the letter makes it easier to understand why his sister Elizabeth later declined Reynolds's proposal that her son Samuel, who had shown some talent at drawing, should go up to London and live with him in Leicester Fields. Elizabeth, who was deeply religious, did much more than tut-tut in an elder-sisterly way at her brother's deplorable habit of painting on Sundays. 'Thy soul is a shocking spectacle of poverty,' she would write to him in 1776 (signing herself 'thy best friend, Eliz. Johnson'):

> When thy outside is, as thy inside now is, as I told thee ten years since I will not shut the door against thee. But it may be, thy soul is past all recovery. If so, I shall never see thee more. Thy vissitation is not yet come: and who knows in what shape it will come: or whether it will come at all. Wo be to thee if it does not come.[30]

At the time of his Paris visit, relations with his sister Fanny had not yet deteriorated. He breakfasted with her towards the end of his stay, and the accounts scrawled in his pocketbook show that he gave her £50. It might well have been to his advantage to be more generous. Fanny later told Northcote about a sale of pictures she had attended – fine portraits by Titian and Van Dyck, and a huge historical painting by Rembrandt in which the

figures were life-size. (Later, when she described it to Reynolds, he thought it must have been worth £3,000.) It was, she said, 'a capital collection', yet the sale was so private that the catalogue was not printed, but written by hand and passed round the room:

All of those she saw sold for next to nothing, for there were but few bidders in the room; and being without money herself to make purchases, she viewed with inward torture those precious articles knocked down for the most trifling sums ... Some few of these she did buy, and at a very small price, which were very fine; these she sent to England, to her brother Sir Joshua, who, unluckily, not having sufficient reliance on her judgement in pictures, had not previously commissioned her to make any purchases for him.[31]

Although Reynolds seems to have enjoyed haggling with dealers, his inclination to watch the pennies did sometimes deny him what would have been notable acquisitions. There was, for instance, an occasion when another £50 would have made him the owner of a fine portrait of Susanna Fourment by Rubens. Again, in the autumn of 1781, at the posthumous sale of Pieter Calkoen's collection, he had commissioned the Amsterdam dealer Pieter Yver to buy a number of paintings. In the event only one picture was knocked down to him – an outcome for which there was, as Yver wrote to explain, the simplest of reasons:

... La raison pour la quelle je n'ai fait pour vous Monsieur l'acquisition d'un seul Tableau dans la vente de Mr. P. Calkoen, est que les autres ont excédé de beaucoup les prix que vous m'avez marquez.*

Such disappointments still lay veiled in the future. Now, in the autumn of 1768, the travellers prepared to leave Paris for home. They moved towards Calais by easy stages, spending the first night at Senlis, the second at Peronne, the third at Arras ('the Cathedral not worth seeing', Reynolds noted in his pocketbook).

* Yver went on to detail the margin by which, except in the case of the Vanderheyden, the prices achieved had exceeded Reynolds's limits:

No.					
	4	de Bakhuizen,	£200	acheté	£720
..	63	Vanderheyden	£600	..	£415
..	116	Ruisdaal	£250	..	£450
..	123	Jan Steen	£350	..	£500
..	133	G: van de Velde	£2000	..	£2900
..	149	le Weenix	£400	..	£740

(Yale Center for British Art, MS Reynolds 10; quoted in Mount, Harry, Appendix 4)

Three days later, on 23 October, he was back in England – where Edmund Burke, newly installed on his 600-acre, heavily mortgaged estate in Buckinghamshire, awaited his opinion of the French 'Ta Blews'; and where, within a few short weeks, he would be called upon to mumble his way through his introductory Discourse as the first President of the Royal Academy.*

* Northcote says that on one occasion a nobleman who was in the audience came up to Reynolds afterwards and said, 'Sir Joshua, you read your discourse in so low a tone that I did not distinguish one word you said.' Reynolds smiled, and replied, 'That was to my advantage' (Northcote, i, 179).

9

From Accommodations to Ornaments

Reynolds would refer in his inaugural Discourse to 'the numberless and ineffectual consultations which I have had ... to form plans and concert schemes for an Academy'. Attempts at historical revision are uncommon in the early infancy of an institution, but that is what he appears to have been about. It was a good try, but a case for regarding him as one of the founding fathers is difficult to make.

It is no easier, however, to establish just what part he did play in the intense caballing that went on in those closing months of 1768. Ellis Waterhouse suggests that his visit to Paris was a tactical withdrawal equivalent to a diplomatic indisposition – 'dissociating himself by the simple policy of absence from any intrigues which might be in the air'.[1]

Certainly it was while he was in France that the smouldering resentments and jealousies within the Incorporated Society of Artists finally flared into open warfare. The touch-powder had been lit by a relatively trivial episode during the special exhibition arranged to honour the King of Denmark. This exclusive, two-day affair was not open to the public. Tickets for the first day were sent to the Danish minister, to be distributed at the discretion of his royal master; the second day was reserved for members of the Society and other contributors. It was said that one of the greatest ladies in the land had applied to the directors for a ticket, but had been refused; word got about, however, that one of those directors, William Chambers, had managed to lay his hands on twelve tickets for his friends.

Chambers now had a lucrative architectural practice.* In 1761 he had been appointed one of two Architects of the Works – roughly equivalent to the French *architecte du roi*; he had been much in the public eye as architect of the refashioned and magnificently furnished Buckingham House, now known as the Queen's House. Ill-feeling over the affair of the tickets was no doubt compounded by jealousy at his ostentatious style of life; he lived in a

* The archives of Drummonds, Royal Bank of Scotland, at Charing Cross show that his standing credit in the years 1767, 1768 and 1769 was £10,783 10s 0d, £5,496 8s 7d and £9,940 7s 11d respectively (Harris, 174).

handsome town house in Berners Street, enjoyed the use of an official residence at Hampton Court and was also now installed in a grand Palladian villa in the grounds of the Duke of Argyll's former estate at Whitton in Middlesex.*

The Society's membership, now swollen to some 200, did not consist only of fashionable portrait painters such as Reynolds, whose eyes were mainly fixed on the lucrative market provided by the aristocracy and landed gentry. Further down the pecking order there were artists of lesser ability and more modest aspirations – some of them oil painters, others miniaturists, engravers, artists working in crayon or pastel. The ambitions and concerns of these less prosperous members, some of whom regarded themselves as not much more than skilled tradesmen, were more mundane, and would have struck a chord with a modern trade unionist. Their interests ran principally to extending the opportunities for exhibiting to younger artists and devising measures of mutual support for themselves and their dependants.

These rank-and-file members had become increasingly restive under what they saw as the oligarchical yoke of prosperous royal favourites such as Dalton and Chambers. Although the constitution of the Society provided for the annual election of directors, there had been very little change over the years. There was now clamour for the introduction of retirement by rotation; the advice of the Attorney-General was sought; an appropriate by-law was passed; Hayman, as President, was turned out in favour of Joshua Kirby, and sixteen of the directors were also voted out of office. Kirby derived little pleasure from his elevation. 'It is an honour unexpected and undeserved,' he wrote to his brother. 'It is very like dressing a man in a fine robe, and then fixing a weight to the train of it that he with all his abilities is but just able to tug after him.'[2]

The election had taken place a matter of days before Reynolds's return from France. Chambers, rather surprisingly, was not one of the victims of this night of the long knives, but three weeks later he and the seven other directors who had survived – they included West and Wilson – resigned. Those elected in their place included both Reynolds and Gainsborough, but to Kirby's consternation neither was willing to serve. Reynolds, in a letter dated 25 November, pleaded the virtue of consistency:

. . . As I have for some years past entirely declined acting as a Director I must now request the favour of resigning that honour, the doing which I hope will not be

* The rivalry between Chambers and his fellow architect James Paine, both eager to be entrusted with the design of a building for the Society, was also a cause of division; West's biographer, John Galt, says that this was the cause of West's resignation as a director, 'disgusted with the bickering animosities which disgraced the proceedings at their meetings' (Galt, i, 35).

understood as proceeding from any want of respect as I made the same request to the former set of Directors.[3]

Gainsborough's refusal was even more painful to Kirby. The two men could not have been more different – Kirby was intensely pious – but they had been friends since Kirby had settled in Ipswich in the 1730s as a house and coach painter, and his son had been Gainsborough's pupil. 'Mr President & Gentlemen Directors of The Society of Artists of Great Britain,' Gainsborough wrote from Bath on 5 December, 'I thank ye for the honor done me in appointing me one of your Directors, but for Particular Reasons I beg leave to resign.'*

There was only one particular reason, in fact, and that was that he had just been invited to become a member of a new Academy under royal patronage. The proposal had been formulated by what their opponents came to describe as a 'junto' composed of Chambers, West, Cotes and Moser. Apart from Cotes, they all had good royal connections. Moser had been drawing master to the king during his boyhood, and on his accession had engraved his first great seal. West had seen a good deal of George III while he was at work on *Regulus*, and according to Galt, the king, in one of their late-night conversations, declared 'that he would gladly patronise any association which might be formed more immediately calculated to improve the arts'. By Galt's account it was West who communicated this to the others. Chambers, as energetic as he was ambitious, was the prime mover, and on 28 November he waited on the king to present a memorial, or petition:

To the King's Most Excellent Majesty:
May it please your Majesty, We, your Majesty's most faithful subjects, Painters, Sculptors, and Architects of this metropolis, being desirous of establishing a Society for promoting the Arts of Design, and sensible how ineffectual every establishment of that nature must be without the Royal influence, most humbly beg leave to solicit your Majesty's gracious assistance, patronage, and protection, in carrying this useful plan into execution.

It would be intruding too much upon your Majesty's time to offer a minute detail of our plan. We only beg leave to inform your Majesty, that the two principal objects we have in view are, the establishing a well-regulated School or Academy of Design, for the use of students in the Arts, and an Annual Exhibition, open to all artists of distinguished merit, where they may offer their performances to public inspection,

* Hayes, 2001, 12. Gainsborough was so attached to his old friend that he requested in his will to be buried beside him in Kew churchyard.

and acquire that degree of reputation and encouragement which they shall be deemed to deserve.

We apprehend that the profits arising from the last of these institutions will fully answer all the expenses of the first; we even flatter ourselves that there will be more than necessary for that purpose, and that we shall be enabled annually to distribute somewhat in useful charities.

Your Majesty's avowed patronage and protection, is, therefore, all that we at present humbly sue for; but should we be disappointed in our expectations, and find that the profits of the Society are insufficient to defray its expenses, we humbly hope that your Majesty will not deem that expense ill-applied which may be found necessary to support so useful an institution. We are, with the earnest sentiments of duty and respect,

> Your Majesty's
> Most dutiful subjects and servants,

Benjamin West	Richard Yeo
Francesco Zuccharelli	Mary Moser
Nathaniel Dance	Augostino Carlini
Richard Wilson	Francis Cotes
George Michael Moser	William Chambers
Samuel Wale	Edward Penny
G. Baptis. Cipriani	Joseph Wilton
Jeremiah Meyer	George Barret
Angelica Kauffman	Fra. Milner Newton
Charles Catton	Paul Sandby
Francesco Bartolozzi	Francis Hayman[4]

It was a skilful piece of drafting, almost certainly the work of Chambers himself. In a minute preserved in the Academy archives he is thanked 'for his Active and able Conduct in planning and forming the Royal Academy', and in his own *Autobiographical Note* he records immodestly that 'the whole institution was planned by me and was completed through my efforts'.[5] The passage in which the king's 'dutiful subjects and servants' calmly inform him, in effect, that he would be expected to dip into the privy purse if they found themselves a bit short can surely only have been included with the monarch's approval, and Chambers's position in the Office of Works meant that he was well enough established in the royal favour to broach such a question informally.

Reynolds, it will be noted, was not one of the petitioners, although he had been back in London for several weeks. Olympian detachment or prudent calculation? Sir Walter Armstrong, whose biography appeared at

the turn of the last century, puts the matter rather nicely; his behaviour at this juncture, he writes, demonstrates 'how free he was from those eager enthusiasms which are supposed to go with the artistic gift'.[6] That he had not been asked to sign seems improbable; that he did not know what was going on is inconceivable, even though the king, always eager to restrict the number of things into which the politicians might get their fingers, had required that the matter be carried forward in the strictest secrecy.

Northcote asserts that Reynolds had been assured by Kirby, who was a good friend, that there was no question of the Chambers initiative receiving royal patronage; Kirby, after all, as 'Designer in Perspective to his Majesty' and Clerk of the Works at Kew, also had the royal ear, and might be expected to know how things stood. Was the naturally cautious Reynolds, well aware that he was not a great favourite at court, simply waiting to see which way the cat would jump? If so, he did not have long to wait.

George III, a great man for detail, had asked for more information. After rapid consultations, Chambers presented him on 7 December with a much fuller draft. To this he secured agreement, although apparently not before the king had sensibly vetoed a proposal that the membership should include a number of art patrons drawn from the nobility – a curious echo of one of the sticking points when there had been discussions with the Society of Dilettanti in 1755.

Then there was a hitch. The scheme proposed that the number of Academicians should be restricted to forty – possibly by analogy with the Académie Française and other similar bodies – and the king wanted to know what names were to be added to those of the original petitioners and who was proposed for the various offices. The 'junto' drew up a list of thirty-odd names. They included that of Reynolds – but did not seek his consent to their doing so. Whereupon he proceeded to play hard to get.

Reynolds himself left no record of these events – all we have, in a letter written the following spring to William Hamilton, then minister plenipotentiary at Naples, are the words 'to the surprise of every body I have the honour of being President, and it is only honour for there is no salary annex'd to this dignity'.[7] The versions given by Northcote and by John Galt, in his biography of West, are in some respects contradictory. The most convincing account is that recorded thirty-five years later by Farington:

West told Smirke and me that at a meeting at Wiltons where the subject of planning & forming the Royal Academy was discussed, Sir Wm. Chambers seemd. inclined to be the *President*, but Penny was decided, That a *painter* ought to be the *President*. It was then offered to Mr. Reynolds, afterwards Sir Joshua, though he had not attended at any of those meetings which were held at Mr. Wiltons. – Mr. West was

the person appointed to call on Sir Joshua, to bring him to a meeting at Mr. Wiltons, where an offer of the Presidency was made to him, to which Mr. Reynolds replied that He desired to consult His friends Dr. Johnson and Mr. Burke upon it. This hesitation was mentioned by Sir Wm. Chambers to the King, who from that time entertained a prejudice against Reynolds, for both Johnson and Burke were then disliked by the King, the latter particularly on political accounts.*

Accounts of the chronology of these various toings and froings also conflict. Northcote says that it took Reynolds a fortnight to make up his mind, but that cannot be the case. On 9 December the whole scheme – known as the 'Instrument' – was written out on both sides of two large sheets of paper, each about twenty inches by thirty; the following day, at St James's, it was laid before the king and he endorsed it with his own hand: 'I approve of this Plan; let it be put in execution. George, R.' Then, on 14 December, after the text had been read to the General Assembly, twenty-eight of the thirty-four Academicians nominated by the king signed a declaration of obedience and fidelity to the new institution, and formally elected its officers. The minutes are signed with a flourish – 'J. Reynolds, President'.†

That Chambers should have made Reynolds's hesitations known to the king was entirely in character. He was a determined place-seeker; a revealing letter survives, written the following February when he succeeded Flitcroft as Comptroller of the Works: 'An old gentleman who has kept me out of a very good place for these eight years past is at last advanced to sing hallelujahs in heaven,' he wrote to Lord Charlemont.[8]

So far as the Academy was concerned, he had in any event secured quite the most powerful place for himself – he had seen to that in drafting Article VIII of the Instrument:

There shall be a Treasurer of the Royal Academy, who, as the King is graciously pleased to pay all deficiencies, shall be appointed by His Majesty from amongst the Academicians, that he may have a person in whom he places full confidence, in an office where his interest is concerned; and His Majesty doth hereby nominate and appoint William Chambers, Esquire, Architect of his Works, to be Treasurer of the

* Farington, 1978–84, vi, 2469, entry dated 12 December 1804. Robert Smirke (1753–1845) was a subject painter and illustrator. He had been an Academician since 1793, but when he was elected to succeed Wilton as Keeper in 1804, George III refused to confirm the appointment, fearful of the influence on the students of Smirke's freely expressed radical views.

† It is interesting to note that although there were two women – Angelica Kauffmann and Mary Moser – among the original members, no others were appointed until the 1920s. Mary Moser (1744–1819) was George Moser's daughter. She had won a silver medal from the Society of Arts as a precocious fifteen-year-old. Her best-known work, painted for Queen Charlotte, is a whole room of flower pictures at Frogmore, which survives.

Royal Academy of Arts, which office he shall hold, together with the emoluments thereof, from the date of these presents, and during His Majesty's pleasure.

The Treasurer's duties were defined with precision:

His business shall be to receive the rents and profits of the Academy, to pay its expences, to superintend repairs of the buildings and alterations, to examine all bills, and to conclude all bargains; he shall once in every quarter lay a fair state of his Accounts before the Council, and when they have passed examination and been approved there, he shall lay them before the Keeper of His Majesty's Privy Purse, to be by him finally audited, and the deficiencies paid . . .

Chambers is the only Academician mentioned by name in the Instrument. He had cleverly engineered for himself a position analogous to that of a finance director in a modern plc with a direct line to the chairman. Small wonder that Reynolds was later to grumble that 'though he was President, Sir Wm. was Viceroy over him'.[9]

The Instrument provided for a Council, consisting of the President and eight others. Members were to serve for two years, the places to be filled by rotation with four members retiring each year. Chambers, Cotes, Wilton and Nathaniel Hone were all elected to the first Council, together with Edward Penny, George Barret, Jeremiah Meyer and Paul Sandby.* The Secretary of the Academy was to be elected by ballot from among the Academicians and his appointment required the approval of the king; the post went initially to the portrait painter Francis Milner Newton, who had previously been secretary of the Incorporated Society. The position of Keeper went to Moser. His responsibilities related to the proposed Schools of Design and to the Academy's servants; he was also to be in attendance at the exhibitions, 'and be constantly at hand to preserve order and decorum'. Alone among the officers, he was to have a 'convenient apartment' allotted to him in the Academy, 'where he shall constantly reside'.

The Keeper was to be assisted in the Schools of Design by nine Academicians, to be called Visitors; elected annually, they were to attend the schools for a month at a time, in rotation, 'to examine the performances of the Students, to advise and instruct them, to endeavour to form their taste, and turn their attention towards that branch of the Arts for which they shall

* Penny (1714–91), a pupil of Hudson and of Benefial in Rome, had been Vice-President of the Society of Artists; Barret (?1728–84), a native of Dublin, was one of the best landscape painters of the day; Meyer (1735–89), born in Tübingen, was a talented miniaturist, and since 1764 had been Enamel-Painter to the King; Sandby (1730–1809) worked mainly in watercolour and gouache and was one of the great pioneers of natural English landscape painting.

seem to have the aptest disposition'. They were to be paid an allowance of ten shillings and sixpence for a two-hour session – and fined the same amount if they neglected to attend without appointing a proxy. West was one of the first Visitors, as were Peter Toms, Francis Hayman and Richard Wilson.

There were to be four professorships – of anatomy, of architecture, of painting and of perspective and geometry. Penny was appointed to the chair of painting and Thomas Sandby, the brother of Paul, to that of architecture. Samuel Wale, the first professor of perspective, had been a pupil of Hayman and was mainly a designer of book illustrations and bookplates; the chair of anatomy went to the Scot William Hunter, by then the capital's leading obstetrician and Physician Extraordinary to Queen Charlotte.

Chambers had been nothing if not thorough in his drafting of the Instrument; there was provision for a Porter, who was to receive a room in the Academy and whose salary was to be £25 a year, and a Sweeper, who was to receive £10. The Keeper engaged a husband-and-wife team called John and Elizabeth Malin to fill these positions; Malin, originally a waterman, had been porter at the St Martin's Lane Academy;* his wife's job description was not interpreted too literally, and her joints, roasted on a string, came to be much appreciated.

Chambers had also had an eye to good order and discipline. The menacing tone of Clause XXIV clearly reflects his determination that there should be less bickering and unpleasantness in the Academy than there had been in the Society: 'If any Member of the Society shall, by any means, become obnoxious, it may be put to the ballot, in the General Assembly, whether he shall be expelled . . .'

The Academy was to be officially declared open by Reynolds on 2 January, which meant that he had little more than two weeks to decide what he was going to say to his fellow Academicians. It was not, in fact, anywhere laid down that he should say anything at all. More than twenty years later, in his farewell Discourse, he explained why he had. The President, he had felt, 'for his own credit would wish to say something more than mere words of compliment' when presenting prizes to the students: 'While in one respect I may be considered as a volunteer, in another view it seems as if I were involuntarily pressed into this service.'[10]

His opening remarks on this inaugural occasion combined appropriate words about their royal patron with what could be construed as an oblique thrust at the Society of Arts:

* He had a fine head, and was sometimes used as a model. There is a bust of him by the sculptor Thomas Banks.

An Academy, in which the Polite Arts may be regularly cultivated, is at last opened among us by Royal Munificence. This must appear an event in the highest degree interesting, not only to the Artists, but to the whole nation . . .

An Institution like this has often been recommended upon considerations merely mercantile; but an Academy, founded upon such principles, can never effect even its own narrow purposes. If it has an origin no higher, no taste can ever be formed in manufactures; but if the higher Arts of Design flourish, these inferior ends will be answered of course.

What follows is something of a hotchpotch. He floats the idea that the Academy should build up a collection of Old Masters; concedes that the young learn more easily from their contemporaries than from their elders and betters; offers to his colleagues, although with a show of some diffidence, a few hints for the avoidance of errors ('These the Professors and Visitors may reject or adopt as they shall think proper').

It is not a sophisticated performance; there is no great profundity in what he has to say and there is the occasional whiff of midnight oil in the way he says it. And yet it is all of a piece, and Walter Armstrong, in characteristically unflattering terms, puts his finger on the reason why. In reading Reynolds, he writes, 'we feel that he is inside his subject, groping his way out'.

Reynolds concluded by expressing his hopes for the Academy's future:

That the present age may vie in Arts with that of Leo the Tenth; and that *the dignity of the dying Art* (to make use of an expression of Pliny) may be revived under the Reign of GEORGE THE THIRD.

He was aiming high, even if, as Robert Wark has pointed out, his scholarship was slightly suspect; Julius II, who was Pope from 1503 to 1513, has a stronger claim than his successor to be regarded as the great Maecenas of the High Renaissance. No matter. A resolution was passed thanking him for his 'Ingenious, useful, and Elegant Speech' and requesting that it be printed 'for the Use of the Academy'. A review in the *Gentleman's Magazine* declared that the Discourse 'certainly does honour to the president as a painter, if any honour can be added to that he has acquired by his pencil: it has besides great merit as a literary composition'.[11]

The Academy had made an early appointment of Giovanni Molini, a bookseller and publisher in Paris, as its Foreign Bookseller, and the pamphlet had some circulation on the continent; it received brief favourable notice in the Leipzig periodical *Neue Bibliothek der schönen Wissenschaften und der freyen Künste*. It was also translated into French by Fanny's friend Louisa Flint, who succeeded in having it printed.

The Academy had an august patron and a skilfully written constitution, but it had precious little else. It had no working capital, and the premises it had to make do with in Dalton's print warehouse, opposite what is now the Royal Opera Arcade, were distinctly modest. It would be eleven years before the Academy was self-supporting, and in that time the king would have dipped into the privy purse to the tune of £5,116. The first exhibition would not be held until April. Meanwhile, there were salaries to be paid, and male models to be employed for the schools; initially there were four of them, and they were paid a retaining fee of five shillings plus a further shilling for each night's work.

The 'Rules and Orders, relating to the School of Design' – like so much else they were the work of Chambers – had been approved on 2 January. Chambers had taken as his model Colbert's revised rules of 1663 for the French Academy; the main difference was that entry, rather than through the studio of an Academician, was to be by interview and an elaborate process of examination. Discipline was to be firmly enforced: 'Any Student that shall deface or damage the Plaister Casts, Models, Books or any other Moveable belonging to the Royal Academy shall be expelled.' The procedure to be followed in the life-class was set out in precise detail:

The Model shall be set by the Visitor and continue in the Attitude two Hours (by the Hour-Glass) exclusive of the Time required for resting . . .

While the Visitor is setting the Model, the Students shall draw Lots for their Places, of which they shall take Possession so soon as the Visitor hath set the Figure.

During the time the Model is sitting the Students shall remain quiet in their Places.

As soon as any Student, hath done Drawing or Modeling, he shall put out his Candles, and while Drawing or Modeling, he shall be careful to keep them under the Bells.[12]

Academy business now began to occupy a great deal of Reynolds's time. In the course of 1769 the Council met on thirty-six occasions and there were seven general assemblies. It was agreed that the first exhibition should open on 26 April and run until 27 May. There were second thoughts about the exclusion of engravers, and the Council proposed the admission of not more than six with Associate status. This idea was then developed and it was decided to incorporate them in a new category, to be known as Associates of the Royal Academy; they would be chosen from participants in the annual exhibition, their number not to exceed twenty.

By the end of January the first six students had been admitted. The Instrument of Foundation provided that £200 from the profits of the exhibition should go to indigent artists or their families, and applications for the

'Royal Charity' were invited within a matter of weeks. The first payments, ranging from 3 to 10 guineas, were made in June. A payment of 11 guineas is also recorded for a son of Charles Brooking to be apprenticed to a peruke-maker – Brooking was a talented painter of marine subjects who had died ten years previously in his mid-thirties.

It was decided that the lectures by the professors should begin in October; those on anatomy by William Hunter were to prove particularly popular, possibly because in his demonstrations he used not only living models but the corpses of hanged criminals. When the sculptor John Deare* was a pupil, he wrote to tell his father that he had been to see two men hanged and afterwards witnessed the partial dissection of one of them at Surgeons' Hall. The muscular development of the second man was so remarkable, however, that Hunter declined to dissect the body, saying that it was worth preserving. It was accordingly taken to the Academy schools, where the sculptor Carlini† undertook to make a cast from it. The body, which was that of a smuggler, was placed in the attitude of the dying Gladiator, and Carlini's cast, known to the students as 'Smugglerius', remained in the schools for many years.

Arrangements were also agreed to provide a female model. There was to be a charge of half a guinea a sitting, and much thought was given to how any complaints of impropriety might be forestalled. This resulted in a decree that 'no Student under the Age of twenty be admitted to draw after the Female Model, unless he be a married Man'. It was further stipulated that 'no Person (the Royal Family excepted) be admitted . . . during the time the Female Model is sitting'.

Less than two months into his presidency, the talk of the town was that Reynolds had threatened to resign. The reason seems to have been personal rather than professional. David Garrick heard the gossip in a letter from his friend John Sharp:

The arts and sciences, I find, are at variance, as we prophesied they soon would be. The President Reynolds, I am told, has desired to resign; that the King sent to him and insisted on his continuing; Reynolds returned that he owed his Majesty the duty of a subject, but no more; and that as his Majesty had never sat to him, as he had to many others, he desired to adhere to his resolution. The King then said he *would* sit to him: since then another of the artists has applied for the like honour.[13]

* Whitley, 1928, i, 277. Deare (1759–98) was the son of a Liverpool jeweller and tax-collector. He became the youngest artist to win the Academy's gold medal. After studying in Rome for three years on an Academy stipend he decided to settle there.

† Agostino Carlini (*c.* 1718–90), a native of Genoa, came to England early in life and was one of the three sculptors appointed foundation members of the Academy. He succeeded Moser as Keeper in 1783.

The king did not, in fact, sit to Reynolds for another ten years, but he did, on 22 April, confer on him the honour of knighthood. Many years afterwards West told Farington that the king did not knight Reynolds as President of the Royal Academy 'but in consequence of an application from the Duke of Grafton', the prime minister of the day.[14] A report in the *Public Advertiser* of 24 April claimed that Ramsay had first been offered the same honour, but had felt obliged to decline it, declaring that 'by the Country he came from he had already Enemies enough, and by this title should get more'.* Whereupon, the paper continued, 'the King sent for Mr Reynolds, and knighted him'.

Whatever the truth of the matter (the *Advertiser* acknowledged two days later that its story had been 'entirely without Foundation'), Johnson marked his delight at the honour done to his friend in signal fashion. 'After a ten years' forbearance of every fluid, except tea and sherbet,' he told George Steevens, 'I drank one glass of wine to the health of Sir Joshua Reynolds, on the evening of the day on which he was knighted.'† Burke was equally gratified, remarking, according to Northcote, 'that the sound of the name was so well adapted for a title, that it seemed as if it had been chosen for the purpose'.‡

Johnson was present five days later when Reynolds invited a small number of close friends to what one of them, Dr Percy, described as 'a Treat occasioned by his being Knighted'. They were joined by several other members of the Club – Burke, Bennet Langton, Dr Nugent and Robert Chambers, the brilliant young Vinerian Professor of Law at Oxford. Other guests included the Irish historian Thomas Leland, a friend of Burke who had recently been installed as a prebendary of St Patrick's Cathedral, Dublin; Reynolds also invited the oriental scholar Thomas Jones, then tutor to the young Lord Althorp, later a distinguished jurist and judge of the High Court in Calcutta.§ No painter was present, nor anyone connected in any way with the Royal Academy.

* Ill-feeling against the Scots continued to run high. Bute was still regularly accused of promoting policies with which he had nothing to do, and that year the rabble had demonstrated in disorderly fashion outside his house in South Audley Street.

† Hill, G. B., ii, 321–2. Johnson was either forgetful or exaggerating for effect. His conversion to water-drinking was of more recent date. 'I have made no reformation,' he lamented in his 'Meditations' for Good Friday, 1764; 'more sensual in thought, and more addicted to wine and meat' (Boswell, 1934–50, i, 482).

‡ Northcote, i, 173. Northcote adds a footnote: 'Sir Godfrey Kneller affected, in his drollery, to treat his titles of knight and baronet which he possessed, as beneath him; saying, that being a man of genius, he was one of God Almighty's nobles.' This is presumably a sly way of telling us that Reynolds was more than a little pleased about his title.

§ Jones, who was knighted in 1783, was regarded in his day as a prodigy of learning. He is remembered today mainly as a pioneer of Sanskrit scholarship; he was said to know thirteen languages 'thoroughly' and twenty-eight more 'fairly well'.

The Academy's first exhibition had opened in Pall Mall the previous day. The size of the room available – it was some thirty feet long – made it a fairly modest affair. Of the 136 works exhibited seventy-nine were by Academicians and fifty-seven by other exhibitors. The catalogue sold for sixpence, something which was felt to call for an explanation:

Advertisement

As the present exhibition is a part of the institution of an Academy supported by Royal munificence, the public may naturally expect the liberty of being admitted without any expense.

The Academicians, therefore, think it necessary to declare that this was very much their desire, but they have not been able to suggest any other means than that of receiving money for admittance, to prevent the rooms from being filled by improper persons, to the entire exclusion of those for whom the exhibition is apparently intended.

Just over 14,000 'proper' persons squeezed in during the course of the exhibition. Their sixpence entitled them to view three portraits and a figure picture by Reynolds, seven portraits by Cotes and three portraits and a large landscape by Gainsborough. There were rather more landscapes than portraits on display (forty-eight to forty), together with twenty-two pieces on subjects from history, scripture and poetry. West exhibited his *Regulus* and also *Venus Lamenting the Death of Adonis*.

Reynolds's exhibits were not universally admired at the time and have been even more harshly handled by modern critics. Ellis Waterhouse, in his Jayne Lectures for 1964, was particularly rough: 'He must have been obsessed at this moment – almost to the point of near lunacy – with trying to impose his own notions of grandeur upon the rising national school.'[15] Reynolds was certainly now well launched into his classical phase. Although he was far too hard-headed to think it made any sort of commercial sense to abandon the lowly genre of 'face-painting', he would try repeatedly over the next decade or so to demonstrate that it could in some way be fused with the much grander tradition of history painting and improve its pedigree in the process.

His portrait of Mrs Blake, the unhappily married sister of his friends the Bunburys, shows her as Juno, receiving from Venus the Cestus, or girdle, which was reputed to bestow beauty and grace on the wearer.[16] Horace Walpole was unimpressed. 'Very bad', he wrote in his catalogue. Nor was he much taken with *A Portrait of a Lady and Her Son, Whole-lengths, in the Character of Diana Disarming Love*.[17] This was the amply proportioned

Duchess of Manchester, who wears a plum-coloured pastoral dress and bends teasingly over her son, Lord Mandeville, a child of six at the time, who is got up as Cupid. 'Bad attitude,' snorted Walpole.

The proceeds of the exhibition amounted to £699 17s 6d and expenses to £116 14s 2d, leaving a surplus of £583 3s 4d. By the time the 'Royal Charities' had been distributed and the general expenses of the Academy had been met, Chambers's accounts to the Keeper of the Privy Purse would show a deficit for the Academy's first year of £903 17s 7d. The Academy showed its appreciation of their royal patron by giving an entertainment to mark his birthday in June; the whole front of the building was decked out with illuminations, with lamps of various colours and transparent paintings:

In the centre compartment appeared a graceful female figure seated, representing Painting, surrounded with Genii, some of which guided her pencil, whilst others dictated subjects to her: at her feet were various youths employed in the study of the art; and over her head hovered a celestial form, representing Royal Munificence, attended by several other figures supporting a cornucopia filled with honors and rewards.[18]

The Incorporated Society showed no sign of quitting the field. Its financial position was much healthier than the infant Academy's; it had more than £3,000 invested in government funds and earned an exhibition income of anything between £600 and £1,000 a year. Immediately after the setting up of the Academy, the Society had petitioned the king for confirmation of his support; Kirby told his membership at a general meeting on 10 January that it had been 'graciously received', but he had little else for their comfort:

I am commanded by his Majesty to tell you in answer. That you are *protected* by your Charter. That his Majesty's *principal object* is the *Royal Academy*, but that he will encourage without *distinction* every Society for the promoting and advancing of the *liberal arts*; therefore our body will not be deprived of his Majesty's attention.

The king was as good as his word. He and the queen turned up at the Society's exhibition at Spring Gardens, taking with them for good measure the queen's two brothers, the Princes of Mecklenburg-Strelitz. Their Majesties were reported to have expressed 'their satisfaction at the great Number of ingenious Performances exhibited there', and for that year attendance was still marginally ahead of the Academy's.* But then the Society began to

* By the following year the Academy had pulled ahead, with 19,428 visitors to the Society's 12,503.

make mistakes. The rules of the Academy stipulated that Academicians should not be members of any other society of artists established in London; at its general meeting in June, the Society passed a tit-for-tat resolution expelling those members who had exhibited at the Academy – there were thirty-five of them, including Reynolds and Gainsborough. The aim was presumably to deprive the Academy of the numbers of paintings it needed to mount substantial exhibitions, but the result was that from then on, support for its own exhibitions steadily declined.

Two years later they made an even bigger mistake. The architect James Paine, Chambers's old rival, had now succeeded Kirby as President, and he conceived a grandiose scheme for a new building. A site was found on the north side of the Strand at a cost of more than £2,500. Paine then designed a building containing the largest exhibition space in the capital. The gallery, with green-distempered walls and a chocolate-coloured dado, measured forty feet by eighty – twice as big as the one in Spring Gardens. The music at the opening ceremony in May 1772 was conducted by the celebrated Giardini and the soprano Fredericka Weichsel, a pupil of J. C. Bach, was engaged as principal vocalist. 'Behold the Arts around us bloom,' she warbled:

> And its muse-devoted Dome
> Rivals the work of Athens and of Rome.

Not for long, however. The site had been bought at the height of a property boom; the building had cost £5,000; the Society soon began to experience what a later age would term cash-flow problems; its pension fund went into terminal decline. In September 1776 'the best gallery in the Kingdom' was sold at auction by James Christie for £4,770.

From then on the Society had to exhibit in such galleries as it could afford to hire. In 1777 all that was available was Philips's auction room; the critic of the *Morning Post* was not impressed:

The persecuted and wandering members of this drooping Society, driven from their own elegant room in the Strand by the decrease of their funds, have just strength enough to make another exhibition in its consumptive state at an auction room in Piccadilly, which seems the last melancholy receptacle of this departing body.

As an obituary, it was premature. The Society's exhibitions continued until 1791, and artists of the stature of Romney, Stubbs and Wright of Derby remained faithful for a time, but it would now operate increasingly in the shadow of the Academy.

*

The feuds and animosities which had consumed so much of the time and energies of the artistic community did not die with the establishment of the Academy. Recriminations continued well into the 1770s, and Reynolds, now thrust into greater prominence as President, began to experience one of the less agreeable aspects of public life.

The first attack came in a letter to the *Middlesex Journal*, one of the most radical papers of the day, shortly after the award of his knighthood. The writer, signing himself 'Fresnoy', alleged that Reynolds had behaved deviously in the dispute between the two factions:

Each part being resolved to destroy or be destroyed, and each wanting a good General, the Incorporated Society had not the least doubt of having you. It was at this time, Sir Joshua, that you flung yourself like Mahomet between the one part and the other. The Society solicited you to take the chair as their President with that confidence with which your own word and honour had inspired them. You faintly pleaded an unfortunate defect in your head.

Fresnoy suggested that having used his deafness as an excuse for not committing himself to one side, Reynolds was seduced into support for the other by purely mercenary considerations:

You well knew that if you were to remain with the Society of Artists you could not possibly gain anything more than a good name, and that there were the most flattering hopes that should you give a civil leer at the other you might gain a title . . . This was the goal you were aiming at from first to last, Sir Joshua . . . it was a matter of the utmost indifference to you who was damned for it so that you got up to the heaven of a knighthood.

Fresnoy then gives his mind to the question of why Reynolds should have exchanged his honour for a title, and decides that he can best answer it by getting right down into the gutter:

Have you received a frown from salacious Catherine, the tailor's maid, or is the affection of the fair creature alienated from you entirely since her elevation to matrimony – from you, alas! and many others?

'Salacious Catherine' is, of course, Kitty Fisher. She had, indeed, been 'elevated to matrimony' some years previously. In the autumn of 1766 she had become the wife of the MP for Rye, a man called John Norris who was the spendthrift son of a Kent landowner. But Fresnoy would also have known, as all the world did, that a matter of months after her marriage

she had gone into a rapid decline and that on the way to visit the Bristol Hotwells she had died in her husband's arms at the Three Tuns tavern in Bath.

Fresnoy is thought to have been the Reverend James Wills, who since the previous year had been chaplain to the Incorporated Artists. He had studied in Rome as a young man, and had been active as a director of the St Martin's Lane Academy in the 1740s before being admitted to holy orders in 1754. It was not the last time that his poisonous pen would be deployed against Reynolds and the Academy.

They also came under attack in 1771 from the engraver Robert Strange in a pamphlet called 'The Conduct of the Royal Academicians while Members of the Incorporated Society of Artists'. Strange was an unusual member of the London art community. A Scot – more precisely an Orcadian – he had fought in the army of the Young Pretender at Culloden,* although his Jacobite sympathies seem to have counted less against him than his natural prickliness and truculence. He had studied in France and Italy; his work was highly acclaimed, and had won him membership of the Académie Royale in Paris and of several Italian academies.

His pamphlet lacked the *ad hominem* virulence of Fresnoy's writing, although he repeated the charge that Reynolds had been swayed in his allegiance by the hint of a knighthood. For Strange the main villain of the piece is Chambers, who, he says, on one occasion 'could not contain his intemperance, but broke forth into much coarseness, and indecency of expression'. Dalton also comes in for rough handling over the matter of his print warehouse, but there had been bad blood between the two for years – Strange was convinced that Dalton and Bartolozzi† had been guilty of sharp practice in Italy some years previously and had conspired to deny him access to paintings he had chosen to copy. It is also necessary to aim off for Strange's resentment at the initial exclusion of engravers from the Academy, and his indignation when Bartolozzi was subsequently admitted, ostensibly as a painter.‡

* He was also married to the sister of Andrew Lumsden, the Old Pretender's assistant secretary in Rome.

† Francesco Bartolozzi, born in Florence in 1728, had studied engraving in Venice. He had come to England in 1764 at Dalton's invitation to engrave the Guercino drawings in the Royal Collection.

‡ He would revisit his grievances at tedious length four years later in a book called *An Inquiry into the Rise and Establishment of the Royal Academy of Arts*, which is prefaced by an interminable letter of complaint to Bute: 'an effusion of pride and malevolence', Chambers thought. Towards the end of his life, however, largely through the good offices of West, the tide of royal favour turned for Strange. In 1787 he was knighted – 'Unless, Mr. Strange,' George III added slyly, 'you object to be knighted by the Elector of Hanover!'

Reynolds's duties as President made substantial inroads into his professional life – the pocketbook for 1769 lists only seventy-seven appointments – but his social life was as full and lively as ever. He dined with Wilkes, with Goldsmith, with the Hornecks. He was frequently at the theatre. There were visits to Vauxhall and to the Richmond Assembly, and engagements with the Duke of Grafton, with Lord Charlemont, with the Burkes, with Lord Ossory. In October he was one of the guests at a dinner party James Boswell gave at his lodgings in Old Bond Street; Goldsmith and Garrick were there, and so, of course, was Johnson:

Garrick played round him with a fond vivacity, taking hold of the breasts of his coat, and, looking up in his face with a lively archness, complimented him on the good health which he then seemed to enjoy; while the sage, shaking his head, beheld him with a gentle complacency.

None of which disposed Johnson to let the hapless Goldsmith off lightly when he started strutting about and showing off his new suit of clothes:

'Well, let me tell you (said Goldsmith,) when my tailor brought home my bloom-coloured coat, he said, "Sir, I have a favour to beg of you. When any body asks you who made your clothes, be pleased to mention John Filby, at the Harrow, in Water-lane."' JOHNSON. 'Why, Sir, that was because he knew the strange colour would attract crouds to gaze at it, and thus they might hear of him, and see how well he could make a coat even of so absurd a colour.'[19]

Reynolds escaped with a less severe mauling. Mrs Montagu's recently published essay on Shakespeare came up in conversation, and Reynolds ventured the view that it did her honour:

JOHNSON. 'Yes, Sir; it does *her* honour, but it would do nobody else honour. I have, indeed, not read it all. But when I take up the end of a web, and find it packthread, I do not expect, by looking further, to find embroidery. Sir, I will venture to say, there is not one sentence of true criticism in her book.'[20]

Four days later Reynolds and several of Boswell's other guests came together again, but in less convivial circumstances. They were called to attend as character witnesses at the Old Bailey, where their friend Baretti, who had recently been appointed Secretary for Foreign Correspondence at the Academy, faced a charge of murder.

Some weeks previously Baretti had been accosted in the Haymarket by two prostitutes, one of whom grasped him painfully by the genitals. The

Italian, whose sight was poor, had struck out angrily, and one of the women received a blow on the face. He was then set upon by three ruffians, whom the woman's screams had brought upon the scene. Unlike most Englishmen of the day, he had no knowledge of how to use his fists. In a panic, he drew a small fruit knife which he had in his pocket and stabbed one of his assailants in the side. He then took to his heels along Panton Street. Another of his pursuers tried several times to seize him by the hair, which he wore in a tail; Baretti lashed out at him several times, and the man fell to the ground, groaning. Close to exhaustion, Baretti finally ran into a shop in Oxendon Street, brandishing his knife and threatening to strike anyone who approached him; eventually a constable appeared, and Baretti raised his hands and gave himself up.

He was taken before the blind magistrate Sir John Fielding, half-brother to the novelist Henry, to whose place he had succeeded. A messenger was sent to Reynolds, who came quickly with other friends to be with him. When a surgeon appeared from the Middlesex Hospital to testify that one of the wounded men, Morgan, was in danger, Fielding had no choice but to commit Baretti to prison, and he was sent to Tothill Fields. Reynolds and Goldsmith insisted on going with him;* the coachman lost his way in the dark, and the whole party was obliged to alight and find its way to the prison on foot.

Morgan died the following night. Baretti was brought before Lord Mansfield, the Chief Justice, who accepted sureties of £500 from Burke, William Fitzherbert,† Reynolds and Garrick. Mansfield, before getting down to the business in hand, launched into a commentary on Othello's 'Put out the light' soliloquy, apparently by way of showing off in front of Garrick. Reynolds was not impressed; he later told Malone that he was 'grievously disappointed in finding this *great lawyer* so *little* at the same time'.[21]

Things did not look good for Baretti. 'He has been admitted to bail with difficulty,' a friend wrote to Lord Charlemont, 'from the idea of an Italian and a stiletto.' Johnson and Burke had visited him in prison and urged him

* A tribute, this, to Goldsmith's generosity, as the two men could not stand each other. Baretti considered Goldsmith 'an unpolished man and an absurd companion'; Goldsmith, for his part, regarded Baretti as 'an insolent, overbearing foreigner' (Collison-Morley, 193–4).

† Fitzherbert was the Member of Parliament for Derby and one of the Commissioners for Trade and Plantations. Reynolds had painted him a few years previously, and there is a note in the 1766 pocketbook of their attending an auction together. In 1772 he got into financial difficulties and hanged himself in his stable with a bridle. Boswell recorded Johnson's opinion of him: 'He made every body quite easy, overpowered nobody by the superiority of his talents, made no man think worse of himself by being his rival, seemed always to listen, did not oblige you to hear much from him, and did not oppose what you said' (Boswell, 1934–50, iii, 148–9).

not to build up his hopes of acquittal. He also had a visit from a fellow countryman, who delicately asked for a letter of recommendation for the teaching of his pupils after he was hanged. Baretti flew into a rage. 'You rascal!' he shouted. 'If I were not in *my own apartment* I would kick you downstairs directly!'

Burke and Johnson were both present on the night before the trial at a meeting held at the house of Baretti's solicitor. They apparently disagreed about the best line of defence, but the elegant cadences of Baretti's address the following day suggest that they may have had a hand in its drafting:

I hope your Lordship, and every person present, will think that a man of my age, character, and way of life, would not spontaneously quit my pen to engage in an outrageous tumult. I hope it will easily be conceived, that a man almost blind could not but be seized with terror on such a sudden attack as this. I hope it will be seen, that my knife was neither a weapon of offence or defence: I wear it to carve fruit and sweetmeats, and not to kill my fellow-creatures . . .

Baretti waived the privilege of having six of his own countrymen among the twelve jurymen – 'for if my honour is not saved', he declared melodramatically, 'I cannot much wish for the preservation of my life'. When evidence of character was called for, his friends did him proud. 'Never,' wrote Boswell, 'did such a constellation of genius enlighten the awful Sessions-House, emphatically called JUSTICE HALL.'*

Garrick disposed briskly of the matter of the weapon:

QUESTION: When you travel abroad, do you carry such knives as this?
MR GARRICK: Yes, or we should have no victuals.

'A man that I never knew to be otherwise than peaceful,' declared Johnson, 'and a man that I take to be rather timorous.'

QUESTION: Was he addicted to pick up women in the street?
DR JOHNSON: I never knew that he was.
QUESTION: How is he as to his eye-sight?
DR JOHNSON: He does not see me now, nor I do not see him.†

* Boswell himself liked Baretti even less than Goldsmith did. Dining at Mrs Thrale's some years later when both men were present, the Reverend Dr Thomas Campbell was told that they were mortal foes – 'so much so that Murphy and Mrs Thrale agreed that Boswell expressed a desire that Baretti should be hanged upon that unfortunate affair of his killing &c' (Hill, G. B., ii, 44).
† Reynolds's portrait of Baretti (Mannings, cat. no. 107, pl. 72, fig. 1067), painted four years after the trial, shows him reading from a book held so close that it almost touches his nose.

Burke described Baretti as 'a man of remarkable humanity; a thorough good-natured man'. Reynolds told the court he had known him for fifteen or sixteen years:

He is a gentleman of good temper; I never knew him quarrelsome in my life. He is of a sober disposition; he never drank any more than three glasses in my company. I never heard of his being in passions or quarrelling.

The trial lasted five hours. The jury found that Baretti had acted in self-defence, and he was acquitted, although the judge thought fit to caution him. The weapon with which he had defended himself was returned to him; long afterwards, eating dessert at Mrs Thrale's table, he drew attention to the fact that the pocket-knife he was using was the one that had put an end to Morgan.

Reynolds had more time to prepare his second Discourse, and it is a longer and altogether more substantial affair than the first. It was also delivered to a wider audience. By the end of 1769 seventy-seven students had been admitted to the Academy's schools. Of the thirty-six who studied painting ten eventually became Academicians; they included Richard Cosway, Francis Wheatley, Joseph Farington and John Flaxman.

Reynolds rose to address them at the distribution of prizes on 11 December. The tone of his introduction was diffident. 'I flatter myself,' he told them, 'that I shall be acquitted of vanity in offering some hints to your consideration. They are indeed in a great degree founded upon my own mistakes in the same pursuit.' That diffidence, however, quickly falls away; this is no longer the Reynolds who, in his first epistle to 'The Idler', ten years previously, confessed that he loved to give his opinions 'without much fatigue of thinking'. He was already England's most successful painter; he is now clearly on his mettle to establish a comparable reputation for literary art.

He begins by defining the three periods through which the student of painting must pass in order to emancipate himself from 'subjection to any authority'. Having undergone that disciplined process, he is now free 'to try the power of his imagination'; his mind may 'venture to play on the borders of the wildest extravagance'. He now stands among his former instructors 'not as an imitator, but a rival'.

Several of the themes which will run like a thread through all the Discourses make their first appearance here, notably the practice of imitation, that 'following of other masters' which was at the core of his own painting. (As with his brush, so with his pen; the incorporation and assimilation of

other men's thoughts – of Dryden, of Fresnoy, of Richardson, of Burke, of Johnson – would equally become a characteristic of the Discourses themselves.) We also glimpse for the first time that uneasiness about the concept of genius that was so marked in Reynolds, and which leads him to propound a precept which he asserts will be disputed only by 'the vain, the ignorant, and the idle':

You must have no dependence on your own genius. If you have great talents, industry will improve them; if you have but moderate abilities, industry will supply their deficiency. Nothing is denied to well directed labour: nothing is to be obtained without it. Not to enter into metaphysical discussions on the nature or essence of genius, I will venture to assert, that assiduity unabated by difficulty, and a disposition eagerly directed to the object of its pursuit, will produce effects similar to those which some call the result of *natural powers*.

He turns, as he so often will in the Discourses, to Italy, but he does so, as was seen in a passage quoted earlier, to sound a note of caution – 'many of the present painters of that country are ready enough to obtrude their precepts, and to offer their own performances as examples of that perfection which they affect to recommend'. Present-day admirers of Batoni and Tiepolo, of Guardi and Bellotto, might find that a shade parochial, but to Reynolds these 'Moderns', recommending themselves as a standard, could only mislead the student and divert his attention from those great masters of the past whose work had stood the test of ages:

The duration and stability of their fame, is sufficient to evince that it has not been suspended upon the slender thread of fashion and caprice.

Caprice also played a part in politics, as several of Reynolds's friends would be reminded before 1770 was many weeks old. If it was the case that he owed his knighthood to the good offices of Grafton rather than his appointment as President, it was as well for Reynolds that the prime minister had intervened when he did, because by the end of January, weakened by almost two years of crisis and a savage press campaign against him, he was out of office.

The previous year had been dominated by the affairs of John Wilkes, but many other problems crowded in upon Grafton's uneasy Cabinet coalition, some to do with personalities, some with affairs of state. There had been friction with the French as Choiseul moved towards the annexation of Corsica, posing a threat to British trade routes to Italy and the Levant. The Cabinet's decision, by a narrow majority, to remind the American colonies

of Parliament's right to tax by retaining the tea duty had gone down badly, and not only on the other side of the Atlantic.

Wilkes, for his part, flourishing on grievances, had continued to make rings round his opponents. The running comedy of serial expulsion and re-election to the Commons provided excellent entertainment for the groundlings during the spring, and was followed in the summer by a great wave of extra-parliamentary activity, the mob running riot to the cry of 'Wilkes and Liberty'. He had strong support in London and Middlesex and in many provincial towns; 60,000 signatures were collected for petitions in his favour.

After the re-assembly of Parliament in the New Year, the administration began to fall apart. At the end of January, his majority down to forty-four, Grafton resigned and was replaced by Lord North; most of Reynolds's friends in the administration – the Marquess of Granby, Camden, the Lord Chancellor, the Duke of Beaufort, the Earl of Coventry – had already gone.

In his first important Commons division, on yet another motion relating to Wilkes, North could not command a more respectable majority than his predecessor, but before long his administration's majority settled more comfortably around the hundred mark. Whether Reynolds, averse to political quarrels, managed to stifle discussion around his dinner table of what remained the burning question of the day, is not known. Two of his closest friends were ranged on opposite sides of the issue. Burke, when he published his *Thoughts on the Present Discontents* in April, defended the popular discontent, declaring that 'in all disputes between the people and their rulers the presumption was at least upon a par in favour of the people'.

On the other hand, Johnson, in a piece of polemical knockabout called *The False Alarm*, entered a spirited defence of the decision by the Commons to reject Wilkes's election by the Middlesex voters. He dashed it off in Mrs Thrale's house in little more than twenty-four hours, and clearly enjoyed himself; he later told Boswell that he thought it the better of his two political pamphlets.* Johnson pictures the circulation of the petitions from town to town, the inhabitants flocking to stare at what they have heard will be 'sent to the king':

One man signs because he hates the papists; another because he has vowed destruction to the turnpikes; one because it will vex the parson; another because he owes

* The other was about the Falklands. Boswell, being Boswell, could not refrain from asking whether it was true, as rumoured, that North had rewarded him by an increase of £200 in his pension. Johnson did not regard the question as offensive: 'No, Sir. Except what I had from the bookseller, I did not get a farthing by them' (Boswell, 1934–50, ii, 147).

his landlord nothing; one because he is rich; another because he is poor; one to shew that he is not afraid, and another to shew that he can write.[22]

Plenty there to keep Reynolds busy with his snuff-box and his ear-trumpet.

Calipash and Calipee

I suppose there has been a million of letters sent to Italy with an account of our Exhibition, so it will be only telling you what you know already to say Reynolds was like himself in pictures which you have seen; Gainsborough beyond himself in a portrait of a gentleman in a Vandyke habit; and Zoffany superior to everybody in a portrait of Garrick in the character of Abel Drugger ... Sir Joshua agreed to give a hundred guineas for the picture; Lord Carlisle half an hour afterwards offered Reynolds twenty to part with it, which the Knight generously refused, resigned his intended purchase to the Lord, and the emolument to his brother artist. (He is a gentleman!) ...*

Mary Moser was writing to Fuseli, who had just gone off to study in Rome. The 1770 Academy Exhibition had opened to the public on 24 April (the king had been given a preview four days earlier). A precautionary resolution, passed before the opening, decreed 'that no needle-work, artificial flowers, cut paper, shell-work, or any such baubles, should be admitted' – an attempt, perhaps, to put clear blue water between the Academy and the Incorporated Society, where such 'baubles' were still regarded as acceptable.

Miss Moser also told Fuseli that 'Sir Joshua a few days ago entertained the Council and Visitors with Calipash and Calipee' – had treated them, that is to say, to a feast of turtle.† This was also the year which saw the inauguration of the Academy banquet, held on the eve of opening in the Pall Mall gallery; the President's liver took a good deal of punishment at exhibition time. The entertainment is described in contemporary accounts as 'grand' and 'elegant'; those present included the Duke of Devonshire, the

* Leslie and Taylor, i, 359. A contemporary account says that Lord Ossory also coveted the picture, and would happily have given 50 guineas more than the sum paid by Carlisle. It is now at Castle Howard.

† Calipash is that part of the turtle next to the upper shell containing a dull green gelatinous substance; calipee the part next to the lower shell, and lightish yellow in colour. The *Oxford English Dictionary* suggests the words may be of West Indian origin.

Earl of Carlisle, Horace Walpole and David Garrick. A more exotic guest
was a Chinese artist from Canton called Chitqua who was then working in
England, and to whom George III had given several commissions for small
coloured busts in clay.*

Reynolds's own submissions to the 1770 Exhibition were altogether more
interesting and impressive than those of the previous year. He exhibited
eight pictures in all, including three described simply as *A Portrait of a
Gentleman: Three-quarters*. All three were of close friends, and that of
George Colman,[1] now Garrick's rival as the manager of Covent Garden,
did not reach the walls of the exhibition in the best of condition. It had been
painted during the winter months, and the dampness of the atmosphere had
prevented it from drying properly. According to Northcote, Reynolds placed
it near a fire, whereupon 'a sudden gust of wind rushed down the chimney
and . . . sprinkled the picture all over with soot and dust, which it was
impossible to brush entirely off'. Although this darkened the picture, North-
cote says it did not spoil the 'harmony or effect', but it later suffered further
indignities. Before its rediscovery and sale at auction in Tunbridge Wells in
1987, it had spent some time in an outhouse; it is now, understandably, not
in especially good shape.

The other two portraits were of Johnson and Goldsmith. They were
acquired as a pair by the Duke of Dorset, and have remained together ever
since.[2] In spite of its poor condition (there is a good deal of bitumen damage)
the Johnson portrait remains a powerful and striking image. Reynolds,
unusually, has painted his friend in profile. He wears no wig, his eyes are
half-closed; the hands are raised in front of his chest, the fingers curled
tensely in a gesture of urgency – he might be a philosopher wrestling with a
difficult concept, a conductor willing the members of his orchestra to
understand what he is asking of them. In the penetrating literary portrait
discovered among the Boswell papers in the last century, Reynolds has a
description of what happened if Johnson was ever left out of the conver-
sation: 'His mind appeared to be preying on itself; he fell into a reverie
accompanied with strange antic gesticulations.' It may well be, as Nicholas
Penny suggested in the catalogue to the 1986 Exhibition, that it is those
gesticulations which are depicted here.[3]

Johnson, at all events, was pleased with the picture. Reynolds presented

* There is a colourful description of Chitqua in a letter to Josiah Wedgwood from his partner
Thomas Bentley: 'His dresses are chiefly of satin and I have seen him in crimson and black,' he
wrote. 'His arms are very slender like those of a delicate woman, and his fingers very long; all
his limbs extremely supple, his long hair is cut off before and he has a long tail hanging down
to the bottom of his back' (Whitley, 1928, i, 270). He figures in Zoffany's *The Life School in
the Royal Academy*, painted the following year for the king and now in the Royal Collection.

Johnson's stepdaughter, Lucy Porter, with a studio replica of it, which was taken to Lichfield, where Johnson saw it the following summer. 'I found that my portrait had been much visited, and much admired,' he wrote to Reynolds.

Every man has a lurking wish to appear considerable in his native place; and I was pleased with the dignity conferred by such a testimony of your regard.[4]

The Goldsmith portrait was praised by Fanny Reynolds: 'Sir Joshua, I have often thought, never exhibited a more striking proof of his excellence in portrait-Painting, than in giving Dignity to Dr Goldsmith's countenance, and yet preserving a strong likeness.'* Visitors to the 1770 Exhibition would have understood the juxtaposition of the two portraits; Johnson and Goldsmith had just been honoured by the Academy, the former being appointed to the chair of ancient literature, the latter to that of ancient history. Goldsmith, in a whimsical letter to his younger brother Maurice in Ireland, told him that no salary attached to his new dignity:

I took it rather as a compliment to the institution than any benefit to myself. Honours to one in my situation, are something like ruffles to a man that wants a shirt.[5]

He was genuinely pleased, for all that, and deeply grateful to the friend to whom he owed it. He had been working for the past two years on his poem *The Deserted Village*, and when, after many postponements, it was published at the end of May, it contained a touching dedication to Reynolds. 'I can have no expectations in an address of this kind, either to add to your reputation or to establish my own,' Goldsmith wrote:

You can gain nothing from my admiration, as I am ignorant of the art in which you are said to excel, and I may lose much by the severity of your judgment, as few have a juster taste in poetry than you. Setting interest, therefore, aside – to which I never paid much attention – I must be indulged at present in following my affections. The only dedication I ever made was to my brother, because I loved him better than most other men. He is since dead. Permit me to inscribe this poem to you.†

* Hill, G. B., ii, 268. The passage occurs in the manuscript 'Recollections', published after her death. Northcote remembered her reaction rather differently: it was, she told him, a very great likeness, 'but the most flattered picture she ever knew her brother to have painted' (Northcote, i, 326).

† Goldsmith was referring to his revered elder brother, Henry, who had been a curate in the Church of Ireland. It was to him that he had dedicated his poem *The Traveller* in 1764, and his death four years later had been a severe blow. Reynolds returned the compliment by dedicating one of the pictures he exhibited the following year to Goldsmith.

Reynolds also exhibited an entirely new kind of picture at the 1770 Exhibition. *The Archers*[6] is, of course, on one level, simply a double portrait of two young men posing against a background of trees with bows and arrows – there are similar subjects by Hudson and Ramsay. Reynolds, however, has here attempted something more – an ambitious exercise in history painting, reflecting a strong debt to Rubens and the Venetians, aimed at extending the boundaries of English portraiture. John Acland, a young colonel in the Devon militia, and his friend Lord Sydney appear subsequently to have quarrelled, and neither took delivery of the picture. A late payment of £300 is recorded in Reynolds's ledger in June 1779; the painting was most recently sold at Christie's in 2000 and realized £1,500,000.

Gainsborough sent five portraits to the 1770 Exhibition, together with a landscape and a 'book of drawings'. He did not think he had given a particularly good account of himself. 'I fear my Lad I shall have it this Exhibition,' he wrote to his friend William Jackson, 'for never was such slight dabs presented to the Eyes of a Million.'[7] It can only be assumed that his critical sense had been blunted by overwork or depression when he wrote that, because one of those 'slight dabs' – the one referred to by Mary Moser as 'Gainsborough beyond himself' – was his spectacular full-length of Jonathan Buttall, *The Blue Boy.**

There was also, as it happens, a portrait of Jackson, and in another letter to him later in the year there is the first indication of Gainsborough's dissatisfaction with the way paintings were hung at the Academy. 'I saw you at the Exhibition,' he wrote, 'and as I expected, hung a mile high – I wish you had been a created Lord before my sending the Picture, then that puppy Newton would have taken care you had been in sight. I wonder if any of your Acquaintance knew you beside myself!'[8]

For some years now both Gainsborough and Reynolds had had reason to keep a wary eye on Cotes, who since establishing himself in Cavendish Square seven years previously had been going from strength to strength. He exhibited eleven portraits in 1770, but it was his last challenge to their ascendancy. He had suffered for some years from the 'stone', and he had been tempted by the claims made for lixivium, which was water impregnated with alkaline salts extracted from wood ashes. Some of his contemporaries swore by it – 'I have got health, voice Spirits & Strength, & lost my belly,' Garrick wrote jubilantly to a friend.[9] Cotes was less fortunate, and before the summer was out he was dead at the age of forty-five.

Receipts for the 1770 Exhibition amounted to £971 6s. Expenses of

* Now in the Huntington Art Collections, San Marino, California. Buttall was the son of an ironmonger in Soho.

£192 0s 7¾d were incurred and grants of relief were made totalling
£173 5s. There were also management and maintenance costs to be met;
the call on the privy purse was for £727 14s 11¾d.

Although Reynolds bought relatively few paintings during the 1770s, he
was still keeping an eye on the salerooms, and occasionally had reason to
regret not being more adventurous. A large collection of pictures and
antiquities went on sale at Langford's in March 1770. It had belonged to
Lady Elizabeth Germain, daughter of the Second Earl of Berkeley and widow
of Sir John Germain, who had died fifty years earlier. 'I hear you had
your Choice of Lady Betty Germains Pictures,' Reynolds wrote to William
Hamilton in Naples:

I have no doubt of your chusing the best. I sent no commission for any con-
cluding they would all be sold above their value but the Julio Romano to my great
vexation was sold for fifty Guineas, it is some alleviation that a person possesses
it that knows the value of it Lord Ossory and I have the pleasure of seeing it very
often.*

Early in August Reynolds made one of his rare sorties out of London and
visited York. It is possible that he was the guest of Mason, who for some
years had been precentor and a canon residentiary there and was in residence
for three months in the year. Numbers of Reynolds's sitters were from
Yorkshire, and it is conceivable that he travelled north to assist with hanging
or to do some retouching; pictures did not always take kindly to long
journeys over eighteenth-century roads.

He was back in town by the middle of the month, and resumed work on
a full-length of Mrs Trecothick, the recently married second wife of Barlow
Trecothick, who had just succeeded Beckford as Lord Mayor.† Reynolds
was also at work on a portrait commissioned by Sir Charles Bunbury. He
had painted Bunbury's wife, the former Lady Sarah Lennox, at the time of
their marriage in 1762, but they were now separated. The present sitter's
name was Kennedy, but her identity is uncertain, as there were several
courtesans of that name. Reynolds wrote to Sir Charles early in September
to report progress:

* Letter 25. Reynolds's punctuation here obscures the sense. Lord Ossory's posthumous sale,
at Christie's on 8 April 1819, included a *Rape of a Nymph by a Sea God* by Giulio Romano.
† Mannings, cat. no. 1771, fig. 1015. Trecothick, an ex-Bostonian, was perhaps the richest of
the London merchants who traded with North America and an important military contractor.
He had been prominent among those petitioning the House of Commons to testify to the
distressed state of trade with America and to the damage the Stamp Act had done to the British
economy.

I have finished the face very much to my own satisfaction; it has more grace and dignity than anything I have ever done and it is the best coloured. As to the dress, I should be glad it might be left undetermined till I return from my fortnight's tour, when I return I will try different dresses. The Eastern dresses are very rich and have one sort of dignity, but it is a mock dignity in comparison of the simplicity of the antique. The impatience I have to finish it will shorten my stay in the country. I shall set out in an hour's time.[10]

Sir Charles and his mistress were not won over by Reynolds's arguments in favour of the 'simplicity of the antique'. The finished portrait shows Miss Kennedy in a brocaded gown edged with ermine and a cone-shaped head-dress of oriental inspiration; mock dignity had carried the day.[11]

Reynolds was going to Devonshire. He set out on 7 September, dined the following day at Wilton with Lord Pembroke and was at Saltram, the home of his friend John Parker, two days later. He stayed there for a week – hunting, partridge-shooting, visiting Mount Edgcumbe, going to church at Plympton. His pocketbook shows that he also enjoyed the occasional wager:

Mr Parker bets Sir Joshua five guineas that he does not beat Mr Robinson; and ten guineas that Mr Montagu does not beat Mr Parker; to shoot with Mr Treby's bullet gun at 100 yards distance; and a sheet of paper to be put up, and the person who shoots nearest the centre wins.[12]

Reynolds was twice in Torrington during this visit to Devonshire. His brother-in-law, John Palmer, died that autumn, and when Reynolds returned to London his niece Theophila, a young girl of fourteen, travelled with him. 'Offy' was Mary Palmer's second daughter, and with a break of some months in 1773, she would live in Leicester Fields until her marriage in 1781.

Baretti had a great success this year with the publication of *A Journey from London to Genoa, through England, Portugal, Spain and France*. The journey had been made ten years earlier, and an account of it, written as a series of letters, had already appeared in Italy. The English volumes – Tom Davies paid him £500 for them – were dedicated to the President and Members of the Royal Academy. 'I know not whether the world has ever seen such travels before,' Johnson wrote to Mrs Thrale. 'Those whose lot it is to ramble can seldom write, and those who know how to write very seldom ramble.'

Reynolds decided to amuse himself at his friend's expense, and composed an engaging parody called *A Journey from London to Brentford, through Knightsbridge, Kensington, Hammersmith, and Turnham Green.* It is cleverly done. Rinaldo, as the author calls himself, has a sharp eye for the extravagances and absurdities of Baretti's style. The journey through Kensington takes him past a fashionable girls' boarding school of the day, and he has a little sly fun with the way the daughters of the well-to-do are educated:

At the end of this celebrated town is Cambden house which is a Nunnery for the Education of all the young Ladies in London, here they remain until they are mariageable, they are then carried by their Mothers Aunts or some Relation to market. Of these markets there are two large ones beside a great many lesser, one is call'd Ranelagh the other Vauxhall . . .

A little further on, an imposing private residence comes into view:

Immediatly after we pass'd the last Gate of the town I observed on the right a Building in the Gothic Stile which is the Seat of a Peer who by a lucrative office under the crown call'd a Public Defaulter has acquired an immense fortune, they say many Millions.

This is much rougher stuff. Rinaldo was passing Holland House, and its owner was Henry Fox, First Baron Holland, who had become immensely rich as Paymaster-General. He had been forced to resign in 1765, but four years later Beckford, the Lord Mayor, had presented the king with a petition from the livery of the City of London against his ministers, a petition in which Fox was singled out as 'the public defaulter of unaccounted millions'. One begins to understand why Reynolds felt that this particular *jeu d'esprit* should remain among his private papers.*

At Hammersmith Rinaldo ventures into the Assembly Rooms – an occasion to parody the absurd gallantries of Baretti during his Spanish travels. Then on to 'the famous plain called Turnham Green', in Reynolds's day a squalid and desolate place:

I will not attempt to describe the various beauties of this Scene, it beggars all description, it is a second Elysium, beautifully and thickly inhabited by poultry and swine as well as men . . .

* The manuscript, written in Reynolds's own hand on foolscap paper, remains to this day in the family of one of Reynolds's collateral descendants.

There, at the Packhorse, Rinaldo's 'Calassero' stops 'to drink a pot of Porter which he calld wetting his Whistle':

About fifty yards from the Packhorse, all carriages stop for a few minutes and their drivers whistle a tune, I enquired what all this meant what was the cause of our stoping and why the Calassero whistled, he answered with an arch leer that they [stopd] that the Horses might p—s and whistled that they might p—s to some tune. It is amazing and appears incredible that those drivers have certain diuretic notes which when a horse hears he cannot contain his urine for affection, this tune I have learnt to whistle and will get my friend Gardini to prick down the musick that it may be publish'd, for perhaps it may have the same effect upon Christians . . .

On to Brentford, and back to the contemporary political scene; the town, notorious for its mud and its rowdy elections, was the polling place for Middlesex:

The King of England has a Chateau directly opposite the town, here he constantly resides and it is said that if this precaution had not been taken Don John Alderman Wilks would certainly before this have been elected King of Brentford. This Don John is the Idol of the inhabitants of this town, his name is wrote on every door window shutter and dead wall throughout the Town either with letters or Hiroglifick figures.

All very entertaining. A revealing glimpse of the lively private man that lay behind the bland and affable exterior which the President of the Royal Academy presented to the outside world. And very different from the measured periods which he must now devise to clothe the substance of his third Discourse, in which he would attempt to develop a theory of aesthetics.

In this Discourse, delivered on 14 December 1770, Reynolds sets out to describe what he sees as the nature of Beauty and points to ways in which the artist is to attain it. 'There are excellencies in the art of painting beyond what is commonly called the imitation of nature,' he declares. He contends that all the arts receive their perfection from an ideal beauty, 'superior to what is to be found in individual nature', and that this is demonstrated by the poets, orators and rhetoricians of antiquity. Nor are the Moderns less convinced of it; every language has a phrase that defines this particular form of excellence:

The *gusto grande* of the Italians, the *beau ideal* of the French, and the *great style*, *genius*, and *taste* among the English, are but different appellations of the same thing. It is this intellectual dignity, they say, that ennobles the painter's art; that lays the line between him and the mere mechanick.

His reason for urging students to go beyond the mere imitation of nature is at first sight a startling one – 'all the objects which are exhibited to our view by nature, upon close examination will be found to have their blemishes and defects'. Only by laborious study will the painter learn to compensate for these imperfections:

His eye being enabled to distinguish the accidental deficiencies, excrescences, and deformities of things, from their general figures, he makes out an abstract idea of their forms more perfect than any one original; and what may seem a paradox, he learns to design naturally by drawing his figures unlike to any one object. This idea of the perfect state of nature, which the Artist calls the Ideal Beauty, is the great leading principle, by which works of genius are conducted.

He challenges Bacon's contention that the painter 'must do it by a kind of felicity . . . and not by rule':

It is not safe to question any opinion of so great a writer, and so profound a thinker, as undoubtedly Bacon was. But he studies brevity to excess; and therefore his meaning is sometimes doubtful. If he means that beauty has nothing to do with rule, he is mistaken. There is a rule, obtained out of general nature, to contradict which is to fall into deformity.

The pedigree of the theories Reynolds expounds here is a long one. It can be traced back through seventeenth-century Italian and French writers on aesthetics to Aristotle. The argument is dense, and given the inadequacies of Reynolds's delivery, cannot have been easy to follow. Just occasionally he tries to make it easier for his listeners – as when he is impressing on them the importance of separating 'simple chaste nature' from those 'affected and forced airs' with which, he alleges, 'she is loaded by modern education':

Perhaps I cannot better explain what I mean, than by reminding you of what was taught us by the Professor of Anatomy, in respect to the natural position and movement of the feet. He observed that the fashion of turning them outwards was contrary to the intent of nature, as might be seen from the structure of the bones, and from the weakness that proceeded from that manner of standing. To this we may add the erect position of the head, the projection of the chest, the walking with straight knees, and many other such actions, which we know to be merely the result of fashion, and what nature never warranted . . .

He could have been describing the mincing gait of Horace Walpole; he,

according to Letitia Hawkins, walked 'like a peewit', his legs splayed out from the knees, 'stepping on tip-toe as if afraid of a wet floor'.

To a later age Reynolds's bed of excellence can look more than a little Procrustean:

Albert Durer, as Vasari has justly remarked, would, probably, have been one of the first painters of his age, (and he lived in an era of great artists,) had he been initiated into those great principles of the art, which were so well understood and practised by his contemporaries in Italy.

The landscapes of Claude, the 'French Gallantries' of Watteau, the sea-views of van der Velde each receive their measure of condescending approval:

All these painters have, in general, the same right, in different degrees, to the name of a painter, which a satirist, an epigrammatist, a sonneteer, a writer of pastorals, or descriptive poetry, has to that of a poet.

He does not, to be fair, spare himself, because he continues, 'In the same rank, and perhaps of not so great merit, is the cold painter of portraits.' And then, perhaps revealingly, he adds this:

A man is not weak, though he may not be able to wield the club of Hercules; nor does a man always practise that which he esteems the best; but does that which he can best do.

More and more, as he advances into middle age, Reynolds will give his mind to 'that which he esteems the best'. This was to some extent made easier for him by the decline in the number of commissions which were now coming his way – sixty or seventy sitters a year, as compared with twice that number a decade earlier. But to devote his energies to fancy pictures and historical painting was increasingly also a matter of inclination. He could still polish off the face of a portrait in three or four sittings before handing it over to an assistant or a drapery painter to be completed, but to his subject paintings he would devote months of his time – conducting experiments with materials (some of them more sensible than others), trying out new theories on colour, pondering some of the ideas he would advance in the Discourses. And the evidence is that he did it not only because he 'esteemed it the best' but because it gave him both satisfaction and pleasure.

He was at work on *Ugolino and His Children in the Dungeon*,[13] his first major foray into the field of high art, as early as the summer of 1770; an

entry in the pocketbook for 12 June reads 'Beggar Hugolino'. Count Ugolino was head of the Guelph faction in thirteenth-century Pisa. Seized by the citizenry, he was imprisoned in a tower with two of his sons and two grandchildren; the key was flung into the River Arno. Dante used the story in the *Inferno*, and Reynolds's interest in it may have been roused by a passage in Richardson where he describes Michelangelo's treatment of the scene in the dungeon and suggests that a great painter might carry the subject still further.

His model for Ugolino was an Irishman called George White, a beggar who had formerly worked as a paviour. Reynolds seems simply to have picked him off the street:

He owed the ease in which he passed his latter days, in a great measure to Sir Joshua Reynolds, who found him exerting himself in the laborious employment of thumping down stones in the street; and observing not only the grand and majestic traits of his countenance, but the dignity of his muscular figure, took him out of a situation to which his strength was by no means equal, clothed, fed, and had him, first as a model in his own painting room, then introduced him as a subject for the students of the Royal Academy to copy from.

'Old George', as he was known, served as a model for several other works in the early 1770s and became sought after by other painters, including Hone and West. William Hunter was another who found a use for his services:

Dr Hunter . . . thought Old George the finest muscular subject that he had ever seen, and, in consequence, had him, during the course of his lectures, at his Theatre, in order, by comparison, to elucidate the superficial anatomy of the human system. The benevolence of the Doctor induced him to do more, for he took him into his house where he resided some time; but I have understood that the irregularity of Old George, his inmate, who had been used to a dissolute course of life, induced his patron at last to part with him, though I think he received an allowance both from him, Sir Joshua, and others, that rendered his old age comfortable.*

During the summer of 1770 the surveyors of the Board of Works had been sent to inspect what were known as the royal apartments at Old Somerset House. The ancient palace, lying between the Strand and the river, had originally been built for that Duke of Somerset known as the Protector. On his attainder in 1552 it had become the hereditary property of the Crown;

* Moser. Moser was the nephew of Reynolds's colleague, the Keeper of the Academy.

it had served as the residence of several queens, and in the time of the Stuarts had been the scene of magnificent and lavish entertainments. George III now directed that some of its apartments should be appropriated for the use of the Academy. Repairs and alterations were set in hand, and on the evening of 14 January 1771 the Academy met there for the first time. Reynolds addressed a fashionable gathering that included the king's brother, the Duke of Cumberland, and expressed the Academy's appreciation of the gracious indulgence of the monarch in presenting them with apartments in a royal palace.

The schools, libraries and lecture rooms were henceforth housed in that part of Somerset House which had been added to the original building in the previous century by Inigo Jones. The annual exhibition would continue to be held for some years in the gallery in Pall Mall. A print made after a drawing of the 1771 Exhibition by Charles Brandoin shows how cramped the conditions were. The top-lighted room is divided in two by a screen as high as the walls; for royal visits and private views the plain boards of the floor were covered with green baize. Such seating as there was consisted of planks set on rough legs; to Whitley, writing in the early part of the last century, they resembled the benches seen at the doors of country alehouses.[14]

Reynolds devoted a good deal of time to fancy subjects in the spring of 1771. He was painting extensively from child models – the pocketbook is dotted with entries of 'boy', 'child' and 'beggar' – and he sent more subject pictures than portraits to that year's exhibition. The model for his *Girl Reading* (she is absorbed in *Clarissa Harlow*) was his niece, Offy. Horace Walpole thought it 'charming', but the subject is said to have been put out by the title, and to have complained, 'I think they might have put "A Young Lady" .' Walpole was also charmed by *Venus Chiding Cupid for Learning to Cast Accompts*,[15] an indication of Reynolds's growing interest in mythological subjects; he found the colouring better than usual, although he thought the drawing faulty. Another visitor to the exhibition was less admiring:

The posture of the Venus is disagreeable. She has the appearance of a body and head, without legs or thighs. Her Countenance wants dignity: and she is drawn too young. She looks more like the sister of Cupid than like his mother; and one would imagine the painter had drawn her from some girl in low life of thirteen or fourteen years of age.[16]

None of which bothered Lord Charlemont, who bought it three years later for £100.

Another picture distinguished by its generous display of flesh was James

Barry's *Adam and Eve*. Barry was newly back from Italy and exhibiting for the first time. His picture was given the place of honour in the centre of the principal wall, and attracted much attention. 'The only objection to this piece,' wrote one critic, 'is an insufficiency of drapery; a fault common to most painters immediately after the tour of Italy, on account of the difference of climate.'[17]

West exhibited a whole raft of history paintings at the 1771 Exhibition, most notably his *Death of Wolfe*. It is an important picture, because it marked a decisive shift in the style of history painting by portraying the characters in contemporary military costume. According to West's biographer, John Galt, the king quizzed West about this departure, 'observing that it was thought very ridiculous to exhibit heroes in coats, breeches, and cock'd hats'. Galt says that Drummond, the Archbishop of York, brought Reynolds to reason with West and urge him to retain the 'classic costume of antiquity' as much more appropriate to the inherent greatness of his subject. West asked Reynolds to suspend judgement until the work was finished, assuring him that if it did not then meet with his approval, he would 'consign it to the closet'. Galt says that Reynolds subjected the finished canvas to minute and lengthy scrutiny: 'He then rose, and said to His Grace, "Mr West has conquered," ' adding for good measure that he thought the picture would 'occasion a revolution in the art'.*

Although it is sometimes necessary to aim off for Galt's tendency to slither into hagiography, there is no reason to doubt the broad outline of his account. The picture – it was bought by Lord Grosvenor for £400† – enjoyed an unprecedented success at the Academy. Pitt the Elder – the minister who had given Wolfe his command – went to see it. He pronounced it well executed on the whole, but thought there was too much dejection in the face of the dying hero and the surrounding officers. As Englishmen, he said, they 'should forget all traces of private misfortunes when they had so grandly conquered for their country'. Another visitor was David Garrick, who, when a good-looking young woman expressed an opinion similar to Pitt's

* Some years after Reynolds's death, when a proposed statue of Lord Cornwallis was under discussion, West, who was by then President of the Academy, told the Council that 'the prejudice in favor of representing Moderns in Ancient dresses was an absurdity. – That Sir Joshua Reynolds in his opinion had judged ill in accustoming himself to dress his women in fancied drapery and wd. have rendered them more interesting to posterity had He followed their fancies and described them in the fashion of their day with all the taste he was master of' (Farington, 1978–84, ii, 369–70, entry dated 24 July 1795).

† West did extremely well out of the picture, painting a further four copies of it – for the king, the Prince of Waldeck, Lord Bristol and General Monckton, Wolfe's second-in-command. The original remained in Lord Grosvenor's family until 1918, when it was presented by the Duke of Westminster to the Dominion of Canada.

about the expression on Wolfe's face, found it difficult to restrain his instinct to show off and quickly surrendered to histrionics:

The actor agreed with her that it was wrong and declared that he could show her and the rest of the company what was wanting in the rendering of the face. Supported by two gentlemen he placed himself in the attitude of Wolfe and 'displayed in his features the exact countenance depicted by the artist.' He then assumed the expression of the transient rapture felt by the dying general when he heard the cry 'They run, they run!' Garrick's feat was loudly applauded, but he said politely that the whole credit belonged to the lady who first pointed out the defect.[18]

As it happened, Reynolds's submissions included an outstanding picture of that bane of Garrick's life, the actress Mrs Abington. Reynolds was an ardent admirer – the following year he would gallantly take twelve tickets for her benefit night, and in 1775 he took forty. Here he portrays her casually seated, her arms resting on a Hepplewhite chairback; a vulgar pose, unthinkable for a lady, but Reynolds is portraying her in the character of Miss Prue in Congreve's *Love for Love*.[19] She gazes saucily out of the canvas, the thumb of one hand resting on her lower lip. Horace Walpole scribbled an approving note on his catalogue: 'Easy and very like'.

It was quite a theatrical year for Reynolds. He painted an actress called Mrs Quarrington, a portrait which was exhibited at the Academy the following year as *A Lady in the Character of St Agnes*.[20] Horace Walpole, noting the harmony and simplicity of the picture, was greatly impressed – 'one of his best'. Reynolds also started work on his *Nymph with Young Bacchus* for which the models were a young actress called Elizabeth Hartley and her child. When Garrick saw her some years later as Rosamond in Thomas Hull's *King Henry II*, he was enthusiastic. 'A finer creature than Mrs Hartly I never saw – her make is perfect,' he wrote to a friend.[21] Although she had many admirers (*Nymph with Young Bacchus* was paid for by Lord Carysfort), Mrs Hartley's head was not easily turned. Reynolds painted her again some years later as Jane Shore, and when he offered her a compliment on her beauty she is said to have replied, 'Nay, my face may be well enough for shape, but sure 'tis freckled as a toad's belly.'[22]

Another actress who had sittings with Reynolds in the summer of 1771 was the celebrated Mrs Baddeley. The daughter of a theatrical musician who had been Serjeant-Trumpeter to George II, Sophia Baddeley was greatly admired for her vivacious personality, her sweet singing voice and her exceptional beauty, but her personal life was highly complicated. Her husband, who, it was said, 'loved as great variety in his amours as in his

clothes', seems to have been indifferent to her infidelities, but insisted that she should contribute to his expenses; George Garrick, the actor-manager's younger brother and factotum, got so excited about this that he called Baddeley out.

The two men had faced each other in Hyde Park on a morning in March the previous year. Baddeley fired first and missed; at this point Mrs Baddeley leapt out of a hackney coach and implored George to spare her husband's life; Garrick sportingly fired in the air and the two men shook hands. Mrs Baddeley had then gone off to Ireland to spend the summer with her latest protector, a Captain William Hanger, who was the son and heir of Lord Coleraine. He set her up most handsomely with a house and carriage, and it is his name that appears in Reynolds's ledger as having paid the sum of 35 guineas for Mrs Baddeley's portrait.*

In the early summer of 1771 James Northcote set out from Plymouth for London. The son of a watchmaker, he had received the scantiest of educations, and since leaving school had been kept at his father's trade. Now twenty-five years old, he had never previously been more than twenty miles from his birthplace. He left home on Whit Sunday, accompanied by his brother Samuel. He had 10 guineas in his pocket, and he had told his parents he would return in a fortnight. What neither his father nor his brother knew was that he was carrying letters of introduction to Reynolds from John Mudge and from a friend of his father called Henry Tolcher, a Plymouth alderman who had encouraged Northcote's interest in art and more than once urged that he be sent to London.†

They made much of the journey on foot. His brother stayed for only a week, but Northcote took lodgings at a grocer's in the Strand. 'I make no doubt you are surprised at my remaining in London after Samuel left it, but I must beg the liberty of staying some little time,' he wrote to his father on 14 June:

Probably I shall not like it long, though now I prefer it to every place I ever saw. I intend to copy one or two pictures of Sir Joshua Reynolds', he is vastly kind. Last Monday I dined with him at five o'clock and had mackerel . . . I wish Polly could see Sir Joshua Reynolds' house, it is to me a heaven.[23]

* Mannings, cat. no. 91, fig. 1041. The portrait, now untraced, is known only through an engraving in the British Museum. Mrs Baddeley is shown clutching a kitten to her bosom.
† On a visit to London a dozen years previously, Tolcher had shown one of Northcote's drawings to Reynolds and to the engraver McArdell, both of whom had made encouraging noises. He had also, some years later, tried to interest Northcote's father in the idea of apprenticing him to the engraver Edward Fisher (Gwynn, 33–6).

A month later, in a letter to his brother, he says that he has copied a Ruisdael and a Vandevelde in Reynolds's gallery and that Miss Reynolds has complimented him on his industry. Northcote was making ends meet by colouring prints of birds for a printseller on Ludgate Hill; he was paid a shilling a sheet, and managed to colour one first thing in the morning before putting in an appearance at Leicester Fields at about nine o'clock. Towards the end of July he dashed off another letter to Plymouth, this time to his father. He was in a state of high excitement:

Ever since I have been at Sir Joshua Reynolds' he has behaved with the utmost kindness, but he has now given me a proof of his friendship which I could not possibly have conceived; I hope it will meet with your approbation as I should be very backward to take any steps without your consent; but last Tuesday evening as I was looking at the pictures in the Gallery, Sir Joshua Reynolds came in and asked if I was examining the paintings and where I lodged and what I gave for my lodging. He then said to me if it was agreeable to me I should come to live at his house for five or six years; and then, says he, first I shall be of assistance to you and then you to me, and so we shall assist each other, for there was no doubt, he thought, that I should make a good painter from my attention to it.

 The pleasure this gave me was more than I ever felt before in my whole life, for that I can express. I told him it would be the most excessive pleasure to me but asked him if I was not too old; he said, no, for the only objection to persons of my age was that they were commonly too fond of dissipation, which put an end to all study; but with application it was the best time of life because they were more capable of making observations and a quicker progress than a boy of fourteen . . .[24]

Reynolds had two other pupils at the time, a young Irishman called Thomas Clark, who had come over from Dublin to enrol at the Academy schools in 1769, and a native of Bath, Charles Gill, whose father was a wealthy pastrycook there, with a fine house in the Circus and a country seat at Bathampton. Northcote did not take to Clark, who was always talking about his great relations in Ireland, but Gill he found to be full of good sense. 'He behaves with all the good nature possible to me and I think is pleased with my company,' he wrote to Samuel, 'but he damns all the others in the house.'*

 Clark and Gill were quick to mark Northcote's card about what he could

* Whitley, 1928, ii, 284. Gill left Reynolds in 1774, and eventually settled in Bath. He exhibited intermittently at the Academy, but in the 1780s he became partly crippled and he did not prosper. Later, at a time when Northcote was on the Council, he became the occasional recipient of charity from the Academy. He lived on until the late 1820s.

expect in the way of tuition. They were 'absolute strangers to Sir Joshua's manner of working', one of them told him:

He made use of colours and varnishes which they knew nothing of, and always painted in a room distant from him; that they never saw him unless he wanted to paint a hand or a piece of drapery from them, and then they were always dismissed as soon as he had done with them.[25]

Northcote's own initial impression of Reynolds was that he was a man of few words who appeared 'continually full of thought'. Fanny Reynolds, on the other hand, seems to have quickly taken the new pupil under her wing – and to have gossiped fairly freely to him about her brother:*

Miss Reynolds said one day it was almost a pity the science had ever been known, it so entirely employed the minds of those who have ever made great painters that they neglected every other thing in this life and very seldom thought of the future; alluding to the neglect of the Church, which is disagreeable to her. She said her brother had lost as much as he had gained, that is all the pleasure of society, which he had sacrificed to gain a name; but he is surely a man of vast capacity and a great scholar.[26]

Fanny was obviously talking nonsense about Reynolds's social life; when she spoke of neglect, she was clearly talking about herself. 'Between ourselves,' Northcote wrote to his brother soon after he had moved into Leicester Fields, 'I believe [he] but seldom converses as we used to do in our family, and never instructs her in painting. I found she knew nothing of his having invited me to be his scholar and live in the house till I told her of it; she has the command of the household and the servants as much as he has.'[27]

Fanny, as it happens, was in a state of some anxiety that summer about the behaviour of her nephew Samuel Johnson, the eldest of her sister Elizabeth's seven children, who was an undergraduate at Oxford and had got into financial difficulty. It is unclear how she had become involved, but she appears to have appealed for help to the young man's distinguished namesake, possibly because he had been briefly at the same college. Johnson was away visiting a friend in Derbyshire, and at the end of July, Fanny received a letter from him calculated to increase her agitation:

* And not only about her brother. Many years later Allan Cunningham recorded a conversation with Reynolds's niece Theophila: 'She was surprised at what Northcote said about conversations at which he could not have been present, and she imagined that he got them from her aunt, Miss Reynolds, who was partial to her townsman and liked to hear him talk' (Gwynn, 81).

Dearest Madam:

As the business relating to young Mr. – was transacted between you and me, I think it more proper to communicate to you than to Sir Joshua, a letter which I have received this day from Dr. Griffith of Pembroke College.

'Your Friend – when he took leave for the vacation left me two bills of ten pounds each, to pay his Debts. To my great surprise they are neither of them accepted. I have unluckily forgot to take his address, and I shall be much obliged to you if you will acquaint me how I may direct to him or to his Friends.'

I am sorry about it, and cannot judge here what can be done. If you could immediately send the twenty pounds, before I write to the Doctor, it would save the young gentleman's credit. If his Father cannot pay: I think I must be five pounds and you five pounds, and Sir Joshua ten. Perhaps the whole difficulty proceeds from accident or mistake, but the present state of the affair is disreputable, and though the money shall at last be paid, there will still be loss of credit, which a speedy remittance will effectually prevent.

This will come to you on Saturday. Be pleased to write to me on Saturday night, I will not answer Dr Griffith till I have heard from you. You must not wonder, my Dearest, that I seem more in earnest than the value of twenty pounds may seem to deserve. There is little money at Oxford, and therefore small sums are there of great importance . . .

I am, my Dearest Dear, Your most obedient and most humble servant,

Sam. Johnson[28]

How the matter was immediately resolved is not known. Young Johnson continued to struggle financially, and was obliged to leave Oxford the following year; it was at this juncture that Reynolds's offer to take him in as a pupil was declined by Elizabeth Johnson on the grounds of what she saw as her brother's irreligion.

Reynolds went down to Windsor towards the end of July to witness an installation ceremony for the Order of the Garter. The new royal knights were the Prince of Wales, the Dukes of York and Cumberland, the Prince of Brunswick and the Duke of Mecklenburg, and they were joined by the Dukes of Marlborough and Grafton, the Earl of Albemarle and the Earl Gower. The ceremony lasted four hours, and was followed by a banquet in St George's Hall and a ball in the great Guard Room. All the English knights installed had sat to Reynolds; the bloom was slightly taken off the day only because in the crush he lost both his laced hat and a gold snuff-box.

Then, early in August, he set out for Paris. Louis-Antoine Crozat, baron de Thiers, had died the previous December, and his heirs, eager to get their hands on some money, had decided to dispose of his magnificent collection

of pictures.* Reynolds had seen the collection on his last visit three years previously, and was now hoping to bid at the auction which he understood was shortly to take place.† He was not the only Englishman who had travelled to Paris for that purpose. Horace Walpole had arrived there some weeks earlier, only to make a disagreeable discovery: Catherine the Great, he wrote to his friend Conway at the end of July, had 'offered to purchase the whole Crozat collection of pictures at which I intended to ruin myself'.[29]

The Russian Empress had been persuaded to take an interest in the collection by Diderot. He had proposed that in order to establish a fair price, each side should appoint a representative to catalogue the collection and set a price on each picture; a third party should then be invited to arbitrate between the two. The Crozat heirs appointed a man called Remi; Diderot secured for Catherine the services of his friend Augustin Ménageot, a well-known art dealer whom he described as 'un homme dont c'est le métier depuis quarante ans d'apprécier des tableaux, artiste et brocanteur, et qui jouit de la réputation d'honnête homme'‡.[30]

The name suggested by Diderot as an arbitrator puts a question mark over how even-handed he intended the process to be. François Tronchin was a wealthy and influential Swiss collector and patron of the arts. Now in his late sixties, he had been drawn to Paris as a young man, and had become the friend of Diderot, Grimm and Voltaire; his tragedy *Marie Stuart* had been produced in Paris in 1734. Back in Geneva, he dabbled briefly in finance and later held various civic offices in the republic; when Voltaire settled in Switzerland, it was from Tronchin that he bought the estate of 'Les Delices'. He had begun to acquire Old Masters in his thirties, favouring particularly works of the Dutch and Flemish schools; in 1770 he had sold ninety-five pictures from his collection – to Catherine the Great.

Tronchin was invited to inspect the collection in August, but did not do so until September; a price would not be agreed until 8 October. The process of arbitration was therefore still in progress when Reynolds arrived in Paris, and there is reason to believe that both he and Walpole entertained hopes that the negotiation might fall through and that they could still be in the hunt. Walpole's diary indicates that after dinner on 15 August he took Reynolds to see an old man called Pierre-Jean Mariette. Mariette, a figure of some importance in the French art establishment, had been closely

* The collection had been formed by his uncle Pierre Crozat, but the baron had considerably enlarged it.

† Northcote told his brother that he had also been commissioned by George III to paint a portrait of the French king. It sounds improbable, and there is no evidence for it.

‡ 'A man with forty years' experience of valuing paintings, an artist and a dealer, and someone with a reputation for integrity.'

associated with the baron de Thiers, had written a great deal about the collection, and had catalogued part of it when it was to be sold twenty years previously. We also know from Walpole's diary that the following day he and Reynolds went together to the Hôtel de Thiers.

Reynolds carried with him on this visit to Paris a small notebook, and almost a third of its pages are filled with cryptic notes about the collection. These take the form of two parallel columns of figures, the first identifying pictures by numbers, the second indicating (whether in guineas or pounds is not clear) either what Reynolds thought they would go for or the limit to which he himself was prepared to bid. Occasionally between the two columns there are words or abbreviations noting either the painter's name ('Rub' for Rubens, 'Tit' for Titian, 'P.V' for Veronese) or the subject of the painting ('A boat with Casks', 'Setting out for Hawking', 'A Naked Wo').

None of this was known until the second half of the twentieth century. The notebook, now at the Yale Center for British Art, remained for many years in the Reynolds family, and it was only in the late 1960s that the French art historian Margret Stuffmann and the American scholar F. W. Hilles published the fruits of their researches into this Paris visit in contributions to the *Gazette des Beaux-Arts*.[31] Mlle Stuffmann's article demonstrated that the numbers used by Reynolds correspond, with a few exceptions, to those that appear in the inventory from which Tronchin would work a few weeks later.

The collection consisted of more than 500 pictures. Reynolds listed just over 100 of them, and the prices he jotted down in his second column add up to 8,000 guineas or £8,400. Tronchin selected just over 400 paintings, which he valued at 527,950 *livres* – equivalent at that time to approximately £20,700. The Empress eventually secured the entire collection for 460,000 *livers*, which was generally agreed to be something of a bargain. Diderot believed that if the pictures had been sold individually at auction, they would have realized over 700,000 *livres* (£27,450). Reynolds, in a letter the following spring to Lord Grantham, named an even higher figure: 'Last summer I went to Paris for a month in order to buy some of the Crozat collection but the Empress of Russia had bought the whole together for 18000£ which I think is not above half of what they would have sold for by auction.'[32] The Empress clearly did rather well out of her friendship with the *philosophes* of the French Enlightenment.

If, however, Reynolds considered the collection undervalued, why did he pitch his own estimates so low? Three pictures, for instance, which Tronchin valued each at 4,000 *livres* – Rembrandt's *Parable of the Talents*, a *Virgin and Child* by Lodovico Carracci and *Christ at the Sepulchre* by Veronese –

were estimated by Reynolds at 50, 100 and 150 guineas respectively. It is possible, of course, that he had come with commissions from others – his services were by now much sought after both as adviser and agent – and that in some cases he was merely observing instructions.* What seems more likely, however, is that it is simply a further instance of his instinct to keep the purse-strings fairly tight.

Some of the most important works in the collection are missing from Reynolds's list – several portraits by Tintoretto, the Raphael *Madonna*, a *St Sebastian* by Leonardo.† The two pictures on which he placed the highest value were a *Bacchus* by Rubens at 550 guineas and Guido Reni's *Madonna of the Sewing Circle* at fifty less. These were followed by two Claudes, another Rubens and one painting each by Rembrandt, Domenichino, Le Sueur and Van Dyck. It is notable that painters from the north predominate in the nine paintings which he valued most highly; only two are by Italian artists, and neither of those from the Roman school whose praises he sang so consistently in his Discourses. Raphael and other painters of the Italian school – Maratti, Guercino, Jacopo Bassano – get a look in only when his valuations drop to the hundred mark. The Joshua Reynolds who stood scribbling in his notebook in the Hôtel de Thiers and the Joshua Reynolds pronouncing *ex cathedra* at the Royal Academy were clearly two different people – something that would be illustrated by the fourth of his Discourses, to be delivered shortly after his return to London.

He would not return to London empty-handed, however, in spite of his disappointment. His notebook has an entry which reads 'Menageau/Rembrant -20/Claude 80', which suggests that his transactions with Augustin Ménageot were not confined to discussing the Crozat collection. Neither the Rembrandt nor the Claude has been identified. It does, however, seem likely that Reynolds also acquired a Rubens on this visit. The *Portrait of the Archduke Ferdinand*, now in the John and Mable Ringling Museum of Art, Sarasota, Florida, has an inscription on the back which says 'bought by Sir Joshua Reynolds for 100 gs. in 1771'. It was his most important acquisition of the decade.

Reynolds did not spend all his time in Paris looking at paintings. He called

* There is ample evidence in Reynolds's ledgers, now in the Fitzwilliam Museum, Cambridge, that he bought and sold quite extensively: 'Sent a Bill to Lord Carlile for Pictures Sold 493–10 & Paid the same day,' runs a typical entry dating from 1769–70; 'sold a Picture of Rubens to Do.: 300 Guineas likewise paid' (Cormack, 105–69).

† Hilles points out that the Leonardo was described as being in poor condition, and that Mariette had been sceptical about the attribution. Mariette's annotated copy of the catalogue of 1755 is in the Frick Art Reference Library, New York.

on the young Lady Barrymore, daughter of the Earl of Harrington; she had first come to his painting room early in 1770, and had given him no fewer than thirteen sittings for her portrait. He also sought out Mrs Abington. She was very much at home in the French capital – so much so that she occasionally fell foul of scribblers at home for the eagerness with which she embraced Parisian fashions. One deplored 'the absurdity of wearing *red* powder':

Her influence on the *ton* is too well known – let her at once deviate from this unnatural French custom, or, if she is determined to continue a *red head*, let her frizeur throw a little brick-dust on her arches*.[33]

Reynolds, too, had views about French ways of doing things, and in particular about French cuisine. 'Want of simplicity even in their eating,' he scribbled in his notebook – 'sugar with pease'. The phrase which followed – 'Its delicacy: shit on the fricasee and butter' – struck one of his collateral descendants in the early nineteenth century as rather less than delicate, and he pasted his bookplate over it.

The Hôtel de Thiers was not the only grand house to which he was admitted to view pictures. He saw the duc de Choiseul's collection of Flemish paintings, also soon to be broken up. Reynolds noted eleven of them as particularly fine – exactly the number that would follow the Crozat collection to St Petersburg a year later. He also visited the homes of the prince of Monaco and the duc de Penthièvre, grandson of Louis XIV.

Reynolds was entertained during his stay by his opposite number, Jean-Baptiste-Marie Pierre, who had succeeded Boucher the previous year as director of the Academy and *premier peintre du roi*. His fellow guests included 'Messrs Costou and Cochen' – Charles-Nicolas Cochin *fils*, the outstanding engraver and illustrator who since 1755 had been *secrétaire perpétuel* of the Academy and the sculptor Guillaume Coustou, who was known for the statues of *Mars* and *Venus* which Frederick the Great had commissioned for Potsdam. He renewed old Roman friendships with Vernet and Doyen; he dined with the architect Julien-David Le Roy, whom he may well also have known in Rome and whom Benjamin Franklin later arranged to have elected to the American Philosophical Society. At Le Roy's table he met the Swedish painter Alexander Roslin. A close friend of Boucher, Roslin had been established in Paris for almost twenty years. Rather like Batoni in Rome, he had cornered much of the market in visiting foreigners. He had just been visited by the Swedish king, and his ambitious triple portrait

* I.e. her eyebrows.

Gustav III with his Brothers Frederick Adolf and Karl was attracting much attention at that year's Salon.[34]

The Salon opened as usual on 25 August, the feast day of St Louis, and the President of the Royal Academy was able to savour the principal public entertainment in the capital's calendar. The walls of the Salon carré of the Louvre – the huge box-like room from which the exhibition took its name – were crammed with pictures right up to the ceiling, and the overflow of genre and still-life paintings spilled down the walls of the adjoining stair-cases. The crush was sometimes so great that it was impossible to move – estimates of eighteenth-century attendance at the Salon vary from 20,000 to 100,000. The art critic Pidansat de Mairobert, writing in his clandestine news-sheet *L'Espion anglais*, made it all sound slightly alarming:

You emerge through a stairwell like a trapdoor, which is always choked despite its considerable width. Having escaped that painful gauntlet, you cannot catch your breath before being plunged into an abyss of heat and a whirlpool of dust. Air so pestilential and impregnated with the exhalations of so many unhealthy persons should in the end produce either lightning or plague. Finally you are deafened by a continuous noise like that of the crashing waves in an angry sea. But here nevertheless is a thing to delight the eye of an Englishman: the mixing, men and women together, of all the orders and all the ranks of the state ... This is perhaps the only public place in France where he could find that precious liberty visible everywhere in London. This enchanting spectacle pleases me even more than the works displayed in the temple of the arts. Here the Savoyard odd-job man rubs shoulders with the great noble in his *cordon bleu*; the fishwife trades her perfumes with those of a lady of quality, making the latter resort to holding her nose to combat the strong odour of cheap brandy drifting her way ...[35]

It was not one of the Salon's better years. 'This superb collection,' wrote a critic in the dissenting news-sheet *Mémoires secrets*, 'which dazzles at first sight, soon collapses into nothing.' The dramatist and song-writer Charles Collé was similarly unimpressed. 'The great masters have submitted noth-ing,' he wrote in his journal. 'People spoke of a few pieces by Vernet and Lagrenée; only the worst things were said about the rest.'[36] Chardin would still exhibit till the end of the decade and in 1771 had submitted a picture called *Autumn*, and three *Pastel Studies for Heads*, including one *Self-Portrait*. Greuze had largely abandoned genre pictures for history painting. Stunned by the avalanche of criticism that had greeted his *Septimius Severus* two years previously, he had abandoned the Salon and would not exhibit there again until 1800. Reynolds's spelling of proper names, especially in France, veers from the phonetic to the impressionistic. 'Creux' in the

notebook looks like a stab at 'Greuze' and it seems probable that the two men met.

Reynolds's attention was drawn to the work of a young woman painter called Anne Vallayer, who had been *reçue* by the Academy only the previous year. She had spent her childhood at Gobelins, where her father was a goldsmith, and at this, her first Salon, she showed still-lifes which reminded some of Chardin and genre scenes reminiscent of Greuze. The pieces of Louis Lagrenée, noticed by Collé, also caught his eye. Lagrenée, like Doyen a pupil of Carle Vanloo, had spent two years in St Petersburg as director of the Academy there and was now a professor at the Académie Royale. And there were things to admire in the work of Hubert Robert, a protégé of Choiseul and a friend of Fragonard. Robert was a landscape painter who specialized in architectural scenes where topographical elements derived from the buildings and monuments of ancient and modern Italy and of France are combined, often in fantastic juxtapositions.

The main talking-point, however, although Reynolds made no mention of it, was an enormous seated portrait called *Madame du Barry as Muse*, which the king's mistress had herself commissioned from François-Hubert Drouais. The picture, now at Versailles, was later altered, but contemporary accounts make it plain why it scandalized some visitors and aroused the derision of others:

She is partly veiled by a light and transparent drapery, which is gathered above the left nipple and leaves her legs uncovered to the knees and exposes nudity in all the rest of her body.*

The picture was withdrawn.

When the cat's away ... Northcote, writing to his brother, described how in Reynolds's absence, the house rules at Leicester Fields were somewhat relaxed:

This evening Miss Reynolds was out on a visit with the coach and men servants, and the maids she gave leave to go to Vauxhall; and because we should remain home in the evening she left with us (that is Mr Clark, Sir Joshua's other pupil and myself) the keys of the library and we had the great pleasure of seeing a great collection of

* This description of it appeared on 14 September 1771 in an underground manuscript gazette, one of many *chroniques scandaleuses* which circulated in Paris at the time. It later appeared, in thirty-six volumes, as *Mémoires secrets pour servir à l'histoire de la République des Letters en France depuis 1762 jusqu' à nos jours*, published between 1777 and 1789.

original drawings by the great masters and some prints and sketches of Sir Joshua's own.[37]

Northcote also gave Samuel details of what he had managed to pick up about Reynolds's colouring technique:

I often ask questions of Sir Joshua for my improvement, but this his pupils seldom do, and they tell me I have had more talk with him than any pupil ever had before. He advises me to use as few colours as possible, he has often attempted to use vermilion because it never fades, but always laid it aside again for it is too heavy a colour; and lake, yellow ochre, blue, and black are sufficient, he says, to paint anything, but he uses the more expensive colours of the same kind, carmine, ultramarine and Naples yellow. He uses his colours with varnishes of his own because the oils give the colours a dirty yellowness in time, but this method of his has an inconvenience full as bad, which is that his pictures crack; sometimes before he has got them out of his hands . . . Sir Joshua always paints on the bare cloth unprepared, after the manner of the Venetians, whom he much admires (don't show this part of the letter to anybody because Sir Joshua would not choose to have it known).[38]

Reynolds returned from Paris in the first week of September. Bennet Langton had been pressing him and Goldsmith to spend some time in Lincolnshire, but Goldsmith was busy trying to place the comedy he had just finished (it was not yet called *She Stoops to Conquer*) and Reynolds felt that he had been away from his painting room for long enough. Goldsmith wrote to Langton making their excuses: 'Reynolds is just returned from Paris and finds himself now in the case of a truant that must make up for his idle time.'[39]

The affairs of the Academy and his studio apart, Reynolds was preoccupied with a house he was having built at Richmond. Although he was almost as tied to the capital as Johnson, the idea of a place in the country had been in his mind for some time – an entry in his pocketbook four years previously reads 'Richmond to see a h'. It was a part of the world favoured by many of his friends and acquaintances. Horace Walpole was at Twickenham, and so was his old master, Hudson; Garrick was at Hampton, George Colman had a house on the Petersham Road below Richmond Hill, Chambers was established at Whitton.

It was to Chambers that he had turned as an architect. He had found a plot at the top of the hill between the Star and Garter alehouse and the Bull's Head Inn, land belonging to the Earl of Dysart, who was Lord of the Manor of Petersham. The conveyance was drawn for him by his friend Joseph Hickey, father of the diarist, a successful Irish attorney who also

acted for the Burkes. It was not an ideal site – Reynolds's niece Mary later wrote of it as 'stuck upon the top of a hill, without a bit of garden or ground of any sort near it but what is as public as St James's Park'.* What mattered to Reynolds, however, was the view down over the Thames; years later he would make it the subject of one of his very few landscapes.[40]

On 29 September he went down to Richmond to inspect progress. The work was clearly not moving forward as quickly as planned, and the tone of the surviving correspondence suggests that relations with Chambers were not of the best during the building of the house – it is possible that Reynolds had recently put Chambers's back up by turning to James Paine for some architectural work in Leicester Fields. Chambers was employing a team of craftsmen who had worked for him on earlier projects – a carpenter called Bell from Richmond, Francis Engleheart, a plasterer from Kew, and Solomon Brown, a bricklayer, who had built the pagoda in Kew Gardens and who seems to have acted as Clerk of Works.

Chambers wrote to Bell in October about two windows which had settled, partly as a result of the steep slope of the site towards the Thames, partly because Reynolds had asked at the last minute to have a canted-bay front. A month later, writing to Brown, he sounds a distinct note of impatience:

I send you the plan and directions for fitting up the Offices of Sr Jos: house which you will communicate to Mr Bell &c, & I beg it may be done as expeditiously as possible. Pray give my Service to Mr Englehart & desire he will loose no time with his Work. I thought it had gone on very slowly when I was there last.[41]

He was still having to chivvy them the following spring: 'I am sorry to see things go on so slowly at Sr Joshua's,' he wrote to Bell, 'pray get done there immediately.'[42] In the event, they did not 'get done' till the autumn. Reynolds, who had already paid out £940 cannot have been pleased to be told that the balance due amounted to £715 1s 4½d. He is even less likely to have appreciated the tone of the letter in which this unwelcome news was conveyed:

Dr Sir,
I herewth send you your Bills for the House at Richmond which you will find exceed what you proposed to lay out there cheifly owing to the changes that have from time to time been made in the 1st Design.

You may remember that your 1st Intention was only to have one large room which

* Cotton, 1856, 177–8. She was writing to her cousin William Johnson in 1789: 'A place, to tell you the truth, I hate,' she wrote; 'for one has all the inconveniences of town and country put together and not one of the comforts.'

was to be on the Parlour Floor & only to have atticks over It. You then desired to have the large room up stairs & an eating Room upon the parlour floor &c: this was done & attended wth some additional Expense when finished. However your friends thought there was not Elbow Room enough so a good part of what was done was demolished & a large eating room wth a bow Broke out was made at a considerable expence. Your little Garden wth the Pales that enclose it has likewise cost Something & as the Ground was all a very stiff Clay the digging part, of which there is a good deal, exceeded what I expected & I was under a necessity of making a new Sewer of a considerable Length to take off the water as the one wh runs by your Building was not deep enough to drain it.

Reynolds appears at some stage to have asked why his house should have cost more than George Colman's. This clearly irritated Chambers – Sir William as he was now allowed to call himself – beyond measure.* It was, after all, to his plans that the old Buckingham House had been palatially transformed into the Queen's House; he had recently won commissions to design Melbourne House in Piccadilly and Dundas House in Edinburgh – not to mention the estimate of some £28,000 he had just submitted for demolishing the old house and building a new one at Milton Abbey in Dorset. Reynolds's villa, with its 'little Garden wth the Pales that enclose it' was very small beer, and Chambers made no attempt to conceal his disdain:

As I have never examined Colemans House I cannot tell weither it be cheap or dear at 1000£s. But since You spoke to me I made some enquiry about it & was told that the man who undertook to build it lost 500£s by the Bargain & that it is besides as ill built a house as can be. Whether all this be true or not I cannot tell but you may be assured that your own house is worth all the mony it has cost you & I do not doubt but you might meet wth a Chapman for it any day you Pleased. I am Dr Sr &c.[43]

Reynolds called his villa Wick House. It was not the most poetic of names – 'wick' was an old word for an enclosed piece of ground. It was discovered at a late stage that the cellars of the house encroached eastward onto the Manor of Richmond, 'to the damage of the Lady thereof'. The Lady of the Manor took Reynolds to court, but graciously agreed to let him off the hook provided he paid rent of a shilling a year.[44] He was to use the house

* In April 1770 Gustav III of Sweden had made Chambers a 'Chevalier de l'ordre d'Etoile Polaire' – a Knight of the Order of the Polar Star – and George III had given him permission to adopt the style of English knighthood. The honour was the cause of some hilarity; Chambers, Horace Walpole wrote, had 'Sir Williamized himself' (Walpole, 1937–83, xxviii, 28–9, letter to Mason dated 9 May 1772).

only occasionally, although he liked to entertain friends there in the summer. He agreed to become a trustee under the Petersham Highways Act, which conferred duties of attending to street lighting and road repairs; the Petersham Vestry Books show that he turned up for a meeting in 1775.

Reynolds appears to have done little painting at Wick House. His neighbours were well aware that they had a celebrity in their midst, but he did not go out of his way to establish local connections. One day in 1774 he received a letter from a Richmond worthy:

Sir

Having been so fortunate as to make Two Astronomical Discoveries, which will probably incline Posterity to wish for a lively Resemblance of me, I would willingly avail myself of your Masterly Pencil to gratify them therein. If you should incline to become my *Magnus Apollo* in this Attempt, I will communicate to you the Ways and Means I would recommend to make the Portrait acceptable, by the Introduction of Machinery, of which I can furnish you with great Choice.

My feeble State of Health will not permit me to sit to you in London, so if you should accede to my Proposal, I hope it will prove agreable to you to take the Face here, upon your next Retreat to our little *Alps*. – I shall be attending to know your Pleasure in due Season, and am with Regard

 Sir

 Yr. most obedt. Servt –

 W. Gardiner[45]

This was one honour which Reynolds felt he could decline. Posterity has borne the disappointment well.

He saw something of Hudson from time to time. His old master, by then in his early seventies, was largely retired, and spent much of his time at his villa in Twickenham, just across the Thames from Richmond Hill. 'Little did I think we should ever have country-houses opposite to each other,' he is supposed to have said. 'Little did I think,' replied Reynolds, 'when I was a young man, that I should at any time look down upon Mr Hudson.'[46]

11

A Tendency to Mischief

Northcote's family in Devon, it seems, did not think highly of his handwriting. It pleased him greatly, therefore, to be able to announce in a letter to his brother a week before Christmas that this opinion was not shared in the wider world in which he now moved. 'So bad as my hand was always thought,' he told Samuel, 'Sir Joshua liked it very well, and I writ out his discourse which he read from at the Royal Academy.'

Reynolds had delivered his fourth Discourse on 10 December, and in it he fleshed out the defining principles of the grand style which he had adumbrated a year previously:

I have formerly observed, that perfect form is produced by leaving out particularities, and retaining only general ideas: I shall now endeavour to shew that this principle . . . extends itself to every part of the Art; that it gives what is called the *grand style*, to Invention, to Composition, to Expression, and even to Colouring and Drapery.[1]

He singles out for the highest praise the schools of Rome, Florence and Bologna:

These are the three great schools of the world in the epick stile. The best of the French school, Poussin, Le Sueur, and Le Brun, have formed themselves upon these models, and consequently may be said, though Frenchmen, to be a colony from the Roman school. Next to these, but in a very different stile of excellence, we may rank the Venetian, together with the Flemish and the Dutch schools; all professing to depart from the great purposes of painting, and catching at applause by inferior qualities.[2]

He is especially hard on the Venetians. He partially exonerates Titian, but cautions his listeners against the 'seducing qualities' of Veronese and Tintoretto:

These are the persons who may be said to have exhausted all the powers of florid eloquence, to debauch the young and unexperienced . . . By them, and their imitators, a style merely ornamental has been disseminated throughout all Europe. Rubens carried it to Flanders; Voet*, to France; and Luca Giordano, to Spain and Naples.

All of which comes rather oddly from the man who had so recently been disappointed in his wish to bid for the treasures housed in the Hôtel de Thiers. Roughly half the Italian pictures in which he had registered an interest there were the work of Venetian painters; some four out of five of the non-Italian paintings on his list were Flemish or Dutch.

The inconsistency is perhaps more apparent than real. Wearing his presidential hat, Reynolds saw it as his duty to persuade young painters that 'the great style is always more or less contaminated by any meaner mix' – even though, as his own work showed, that was where his own predilections lay. Ellis Waterhouse regarded this over-emphasis on the defects of his own favourites ('The Venetian is indeed the most splendid of the schools of elegance') as proof of what he termed the 'critical poise' of Reynolds's mind, although he also saw it as a rationalization of his own practice in portrait painting – of restricting his ambition, that is to say, to the pursuit of excellence in one of the humbler branches of art.

The mind of Reynolds the collector, on the other hand, as he scrutinized the Crozat canvases, had been unclouded by any such academic considerations; theoretical notions about the pecking order between various schools had concerned him not at all. His eye and his mind were concentrated on the search for the best the collection had to offer – 'for every picture has value when it has a decided character, and is excellent of its kind'.†

It must also be remembered that Reynolds was no ordinary collector. He did not buy paintings merely to furnish his walls in Leicester Fields or on Richmond Hill.‡ He often bought them as a speculation and sometimes for what he hoped he could learn from them, even if that meant ruining them in the process. Malone says that he was so anxious to discover the method used by the Venetians 'that he destroyed some valuable ancient pictures by

* Reynolds is not on particularly firm ground in citing Simon Vouet, whose pupils included Le Sueur and Le Brun. Vouet (1590–1649) was certainly strongly influenced by the Venetians, but he spent only two years in Venice as a young man, as opposed to thirteen in Rome, before he was summoned to Paris by Louis XIII at the age of thirty-seven to become *premier peintre du roi*.

† Reynolds used the phrase in the fourth Discourse, in the same passage in which he conceded that the Venetian was 'the most splendid of the schools of elegance' (Reynolds, 1959, 67–8).

‡ There is a scornful reference in a letter he wrote to James Barry, who was studying in Rome, to 'those ornamental pictures which the travelling gentlemen always bring home with them as furniture for their houses' (Letter 22).

rubbing out the various layers of colour in order to investigate and ascertain it'. Reynolds himself told Sir Abraham Hume that he had destroyed a fine Watteau with the same object.[3]

Although Reynolds seldom offered anything in the way of conventional instruction to his pupils, they were occasionally treated to a display of his virtuosity. Northcote found the experience dispiriting:

It was very provoking, after I had been for hours labouring on the drapery of one of his portraits from a lay-figure, to see him, with a few masterly sweeps of his pencil, destroy nearly all my work, and turn it into something much finer.[4]

There were compensations, however. Just as Reynolds had been sent out to the auction rooms by Hudson during his apprenticeship, so now Northcote found his education being similarly improved. Jonathan Richardson Junior had died the previous autumn and the collection of prints and drawings which he and his father had assembled was to be sold at Langford's auction room, under the Covent Garden piazza:

I attended every evening of the sale, by Sir Joshua's desire, and much to my own gratification, as I had never before seen such excellent works. I purchased for Sir Joshua those lots which he had marked, consisting of a vast number of extraordinary fine drawings and prints by and from old masters; which greatly increased his valuable collection. One drawing in particular I remember, a descent from the cross by Rembrant; in which were to be discovered sixteen alterations, or *pentimenti*, as the Italians term it, made by Rembrant, on bits of paper stuck upon the different parts of the drawing, and finished according to his second thoughts.*

Reynolds did not allow his presidency of the Academy to interfere with his social life. Attending the drawing room on the queen's birthday, as he did on 18 January, was perhaps as much duty as pleasure, but his presence four days later at the opening night of the Pantheon, built in Oxford Street at a cost of £60,000, was clearly not by royal command. Its huge neoclassical dome was lit by thousands of candles. Nobody was clear about what it was for; people went there to see and to be seen; it would soon become, like Ranelagh and Vauxhall, an important location of the marriage market.

* Northcote, i, 261–2. The sale took place in February 1772. *The Lamentation at the Foot of the Cross* is now in the British Museum. It is executed in pen and brown ink and wash, with grey oil colours over red and black chalks. Northcote also mentioned in a letter to his brother two months later that he had recently acquired for Reynolds 'a full-length as large as life of a naked figure tied to a tree to be flayed, by the famous Michael Angelo' (Whitley, 1928, ii, 290). The picture has not been identified.

Excitement ran high on the opening night, because word had gone about that the proprietors were determined to deny entrance to actors, actresses – and other 'women of slight character'. This did not go down at all well with the sort of young bloods Reynolds mixed with at the Thursday-night Club's meetings at the Star and Garter. A group of them resolved that whoever might be excluded, the delicious Sophia Baddeley would not be of their number. When she was set down in her chair under the portico, her escort had swollen to some fifty gentlemen. The constables crossed their staves, and said their orders were to admit no players. (They were being polite – Mrs Baddeley would have been excluded by her reputation, whatever her profession.) Whereupon her escort drew their swords and formed an arch through which she made a triumphal entry into the brilliantly lit Rotunda.

With Mrs Baddeley safely inside, a messenger sped off to tell Mrs Abington that she should now try her luck. When she too had made a successful entrance, it was plain that those attempting to make distinctions between different degrees of vice were fighting a losing battle. This was confirmed by an advertisement which appeared a few days later in the morning papers. 'As it was not convenient for ladies always to carry the certificates of their marriages about them,' it stated, 'the subscribers were resolved, in opposition to the managers, to protect the ladies to whom they gave their tickets.'[5]

'The Pantheon,' wrote Edward Gibbon, 'in point of ennui and magnificence, is the wonder of the eighteenth century and of the British empire.'[6] When Boswell and Johnson went to inspect it, Boswell ventured the view that 'there was not half a guinea's worth of pleasure in seeing this place' (half a guinea had been set as the price of admission):

JOHNSON. 'But, Sir, there is half a guinea's worth of inferiority to other people in not having seen it.' BOSWELL. 'I doubt, Sir, whether there are many happy people here.' JOHNSON. 'Yes, Sir, there are many happy people here. There are many people here who are watching hundreds, and who think hundreds are watching them.'[7]

Reynolds, for his part, thought well enough of it to return there for a masquerade on 30 April. He went in domino – not impersonating a particular character, that is to say, but dressed in a loose cloak and wearing a small mask that covered the upper part of the face. A good many of his sitters were among the 2,000 who attended – Lady Gideon as a spinning-girl, Mrs Crewe as a Spanish nun.

Mrs Crewe figured in somewhat different guise at that year's Academy

exhibition, which had opened six days previously. The dates of sittings in the pocketbook indicate that Reynolds had been working on her portrait right up to the last minute. It was described, in the manner of the day, simply as *A Lady, Whole Length*, but nobody who was anybody would have been in any doubt about who Reynolds had chosen to represent as St Genevieve.[8] She is seated in the open air, absorbed in a book, surrounded by sheep. The dog at her feet looks uncommonly like the one he had planted on Mrs Abington's lap when he painted her as Miss Prue. It is one of his loveliest portraits. Horace Walpole thought it 'one of his best', noting in his copy of the catalogue its 'great harmony and simplicity'.

Reynolds also exhibited a striking portrait of Mary Meyer, the second daughter of his friend Jeremiah Meyer, painter of miniatures and founder member of the Academy. She is depicted as Hebe, the cup-bearer to the gods, who had the power of restoring the aged to youth and beauty.[9] The graceful figure is shown ascending a rainbow pathway. She is preceded by an eagle, representing Jupiter; he clutches a thunderbolt in his claws, and his expression suggests he might have it in mind to peck Miss Meyer in the midriff.

This ferocious specimen was presumably painted from the eagle which Northcote tells us Reynolds kept chained to its perch in the back area of the house in Leicester Fields:

When this bird died, I took the body and suspended it by strings so as to give it an action as if it was alive, with its wings spread, intending to paint a picture from it myself. But when Sir Joshua saw me about it he seemed pleased, and told me to do it as well as I was able; and when I had finished the work to the best of my power, he took the picture and the bird into his own painting room, and in about a quarter of an hour gave it such touches of animation as made it truly fine, though executed with a bad light, for I remember it was late in the day when he did it, having been the night before at a masquerade, which had occasioned his remaining very long in bed that day.[10]

More conventionally, Reynolds exhibited portraits of his lawyer friend Joseph Hickey and of William Robertson, Principal of the University of Edinburgh. A technical memorandum which he scribbled in the back of his ledger about the Hickey portrait confirms that by this time he had started to use asphaltum: 'Stabilito in maniera de servirsi di Jew's pitch' – 'I am settled in the way I use asphaltum.'[11] The philosopher Dugald Stewart, writing twenty years later, thought the Robertson portrait a striking likeness, but described the colours as 'already much faded'.[12]

Gainsborough, still working in Bath, sent up four portraits to the 1772

Exhibition, together with two large, and ten smaller 'drawings in imitation of oil painting', some of them on as many as six pieces of paper joined together. He was fully sensible of the importance of belonging to the Academy, although he groaned privately at the check it put on his somewhat bohemian ways. A revealing letter survives which he wrote to the Hon. Edward Stratford on 1 May. Stratford, the son and heir of the Earl of Aldborough, had been bombarding him by every post with complaints about the delay in completing the portraits of his wife and himself, in train since March of the previous year. Gainsborough was all contrition. 'When you mention *Exhibition* Pictures, you touch upon a String, which once broke, all is at an End with me,' he wrote:

... I do solemnly promise you to finish your Pictures in my best manner before any other from this time. I was obliged to cobble up somthing for the Exhibition or else (so far from being knighted) I should have been expel'd the Society, and have been look'd upon as a deserter, unworthy my *Diploma* sign'd with the Kings own hand, which I believe you have seen most beautifully framed & hung up in my Painting-Room, *behind the Door* –*

Reynolds's knighthood clearly rankled with Gainsborough. There had been an earlier thrust at him in a burst of correspondence the previous year with Lord Dartmouth. Lady Dartmouth, who was sitting to him at the time, had requested that he should paint her in the sort of generalized classical drapery favoured by Reynolds to give a timeless look to the picture. Gainsborough hated the idea, believing that it masked the individuality of the sitter. He argued his case stubbornly – he loosed off three letters at five-day intervals – and with mounting exasperation:

My Lord
Here it is then – Nothing can be more absurd than the foolish custom of Painters dressing people like scaramouches, and expecting the likeness to appear . . .

He eventually compromised by portraying Lady Dartmouth in a Van Dyck dress, for which there was a fashion at the time, but he held to his view that

* Hayes, 2001, 101. One of the things Gainsborough had 'cobbled up' for the exhibition was his full-length portrait of William Pulteney, of Westerhall, Dumfriesshire, later the Fifth Baronet, who made a fortune by land purchases in America. Stratford, although he was immensely rich, had commissioned only half-lengths – possibly thus easing the strain on Gainsborough's conscience in setting him aside. He did not, at all events, take Stratford's remonstrances too seriously. 'He Writes every post,' he told another of his correspondents, 'partly to shew me how Angry he is, & partly how well he can Write' (Hayes, 2001, 94).

likeness depended partly on the use of contemporary dress,* and left her husband in no doubt about where his criticism was principally directed:

I believe I shall remain an Ignorant fellow to the end of my days because I never could have patience to read Poetical impossibilities, the very food of a Painter: especially if he intends to be *Knighted* in this Land of Roast Beef. So well do Serious People love froth –[13]

A patronizing press notice about his exhibits which appeared as the 1772 Exhibition opened was not calculated to make Gainsborough feel any more warmly towards Reynolds. 'No one need be informed of Mr Gainsborough's excellence in portrait painting,' wrote the *Middlesex Journal*:

It may safely be affirmed that his performances of this year will lose him none of the fame which he has so justly acquired by his former productions. He seems, however, to have one fault although a fault upon the side of excess, his colours are too glaring. It would be well for him if he would borrow a little of the modest colouring of Sir Joshua Reynolds.[14]

Many years later Northcote told James Ward that Reynolds had a high opinion of Gainsborough, 'but Gainsborough and he could not stable their horses together, for there was jealousy between them'. There was also, on Reynolds's part, a certain lack of generosity:

Gainsborough, I remember, solicited Sir Joshua to sit for him for his portrait, and he no doubt expected to be requested to sit to Sir Joshua in return. But I heard Sir Joshua say, 'I suppose he expects me to ask him to sit to me; I shall do no such thing!'[15]

It is possible, however, that Gainsborough had another and more specific reason for harbouring feelings of resentment towards Reynolds in the spring of 1772. Horace Walpole pasted on to the last page of his Academy catalogue a cutting from the *Public Advertiser* of 4 May:

We hear that the Gentlemen upon the Committee for managing the Royal Academy have been guilty of a scandalous meanness to a capital artist by secreting a whole length picture of an English Countess for fear their Majesties should see it; and this only upon a full conviction that it was the best finished picture sent this year to the

* Gainsborough also believed it important to know whether his female sitters wore make-up in society: 'I must know if Lady Dartmouth Powders or not in common,' he told her husband (Hayes, 2001, 89–90).

exhibition. The same artist has been affronted in this manner several times before, from which they may depend upon his implacable resentment, and will hear from him in a manner that will very much displease them.

The English countess most likely to be anathema to the royal gaze was Walpole's niece, the widowed Lady Waldegrave, who six years earlier had clandestinely married George III's favourite brother, the Duke of Gloucester, and who was now pregnant. The discovery of Gloucester's matrimonial shenanigans was only slightly less painful to the king than the antics of his clownish brother, Cumberland, in the same department. Two years previously he had stood trial for 'criminal conversation' with Lady Grosvenor; now he had married Mrs Anne Horton, the widowed daughter of the notorious libertine, the First Earl Carhampton, and fled with his bride to France – she had, wrote Horace Walpole, 'the most amorous eyes in the world, and eyelashes a yard long'.[16]

Which was why it was that the king had demanded that legislation be rushed through Parliament to protect the purity of the dynastic blood by preventing royal marriages without the consent of the sovereign. The Royal Marriages Bill had had a very rough ride through both Houses a matter of weeks before the opening of the exhibition. Burke inveighed loftily against it; Sir Joseph Mawbey, a Vauxhall distiller who, with Henry Thrale, sat for Southwark, thought it should be called 'an act for enlarging and extending the prerogative of the crown, and for the encouragement of adultery and fornication'.[17]

William Whitley, Gainsborough's biographer, speculates convincingly that Gainsborough had painted a portrait of Lady Waldegrave and sent it to the Academy; and that Reynolds, anxious to avoid offending the Academy's royal patron, had gained the support of the Council for excluding it from the exhibition. He also notes that the tone of the *Advertiser* piece is very much that of the fiery and impetuous Gainsborough. Reynolds had himself first painted the countess in 1760 and she had sat to him on numerous occasions since then. What Gainsborough may not have known is that a matter of weeks before the opening of the exhibition, Reynolds had received the Duchess of Cumberland into his painting room. This is taken to be the occasion which Reynolds later described to a Miss Sayer. The duchess was accompanied by the duke, who 'tumbled about the room in his awkward manner' without speaking to Reynolds:

The duchess thought it too bad, and whispered to him her opinion; upon which he came, and leaning upon Sir Joshua's chair while he was painting, said; 'What! you always begin with the head first, do you?'[18]

Reynolds completed full-lengths of both the duchess and the duke within the year, and although relations with the king and queen remained frosty, Reynolds felt able to show both pictures at the following year's exhibition.* If Whitley's line of conjecture is correct, Gainsborough may well have felt that there was one law for the President and another for mere Academicians; that the exclusion of his portrait owed less to political exigency than to professional skulduggery.

At their final meeting of 1771 the Council of the Academy had agreed that their French counterparts might be invited to attend certain of the Academy's functions without fee and to exhibit their work – this very possibly at the suggestion of Reynolds, recently returned from his visit to Paris.

Quite the most gifted of those who accepted was Philippe Jacques De Loutherbourg, a former pupil of Carle Vanloo, who had been one of the most prolific painters exhibiting in recent years at the Paris Salon. His reputation until then had been principally as a painter of landscapes, shipwreck scenes and battle-pieces, but he brought with him a letter of introduction to Garrick from Jean Monnet, the director of the Opéra-Comique ('un de nos plus grand peintres et garçon fort aimable'). He presented the Drury Lane manager with a comprehensive proposal for the improvement of the lighting and of the mechanical and scenic systems of the theatre; he would become the most inventive and influential scene designer of the century. He continued to produce refreshingly original landscapes and was elected to the Academy in 1781.

Later, under the influence of Cagliostro and Mesmer, he and his wife developed an interest in mysticism and faith healing. A fellow believer unwisely published *A List of a Few Cures Performed by Mr. and Mrs. De Loutherbourg of Hammersmith Terrace without Medicine, by a Lover of the Lamb of God*. Some of their cures proved less efficacious than others; their house was attacked by a mob and their safety threatened. In November 1789 the *Morning Chronicle* reported that 'Loutherbourg has entirely given up the practice of working miracles and taken to his pencils again.'

De Loutherbourg was one of a dozen or more French Academicians who came to try their fortune in London in 1772. Another was the architect and painter Charles-Louis Clérisseau, who had been at the Académie Française

* The picture of the duchess (Mannings, cat. no. 879, fig. 1066) is now in the James A. de Rothschild Collection at Waddesdon Manor. The portrait of the duke (Mannings, cat. no. 878, fig. 1051) is in the Royal Collection. Northcote was permitted to paint the drapery – 'the most considerable job I have yet done' (Letter of 8 April 1772 to his brother, quoted in Whitley, 1928, ii, 292). The original full-length showed the duke in his installation robes as a Knight of the Garter, with a view of Windsor Castle, but the picture, damaged by a fire at Carlton House in 1824, was subsequently cut down and framed as an oval.

in Rome at the time of Reynolds's stay; he had also, although with scant acknowledgement, provided most of the drawings used to illustrate Robert Adam's *Ruins of the Palace of the Emperor Diocletian at Spalato in Dalmatia*, which had appeared in 1764. Reynolds's attitude to his Gallic visitors seems to have been one of benign indifference. He conceded, in a letter to Lord Grantham, that they might well contribute something to the success of the exhibition, but he was not to be shaken in his generally low view of French art:

There is no employment for them in France either from the Poverty of the nation or from the declining of all Arts amongst them except that of furnishing Europe with bauble, The Arts of Painting and Sculpture are practiced only at the Gobelins and at Seve, as I have often said they seem to me to be returning to barbarism. they have gone round the circle and are pretty near at present to where they sat out.[19]

The exhibition was a success, as it happened, although receipts, at £976 5s were slightly down on the previous year, and the privy purse had to make up a deficit of £623 10s 7¾d. The number of works displayed rose to 310, and fourteen paintings had to be omitted for lack of space. The Incorporated Society had still not given up the struggle. This year, for the first time, its exhibition was held in the new building in the Strand, near Exeter Exchange, designed by Payne. (It 'quite eclipses the Royal Academy', Northcote wrote to Samuel.) Romney, Stubbs and Wright of Derby all exhibited, and the organizers managed to assemble a catalogue of 427 works, although that total included such items as 'a flower-piece made of tin, inlaid with the white part of the horse-muscle shell' and 'the arms of His Royal Highness the Prince of Wales, in human hair'. The officers of the Royal Academy were invited to attend the opening ceremony; some thought the committee's decision to decline ungracious.

It was a summer of drama in the City of London. There had been rapid economic growth after the spasmodic recessions of the 1760s, and suddenly there was a crisis of confidence. The fiscal recession of 1772 was less serious than the crash which had led to the bursting of the South Sea Bubble half a century earlier, but for a time it looked as if the speculation in paper securities had got dangerously out of hand. The most prominent victim of the recession was a Scottish banker called Alexander Fordyce, a larger-than-life figure whom Reynolds had painted more than a decade previously.* Fordyce was

* Mannings, cat. no. 659. The portrait, for which Fordyce sat in 1761, is now lost. Reynolds charged him 20 guineas, plus 3 guineas for the frame.

the son of a former Provost of Aberdeen, and the most active partner in the banking firm of Neal, James, Fordyce and Down. The firm speculated freely – they had done particularly well out of a rise in East India stock in 1764–5 – and Fordyce became immensely rich. He married a daughter of the Earl of Balcarres, lived in great magnificence at Roehampton and had spent huge sums on trying – unsuccessfully – to enter Parliament.

In 1771 his luck had begun to turn. He lost heavily in the market fluctuations brought about by the dispute with Spain over the Falklands. He had also retained an interest in financial affairs in Scotland – 'that land of projects' as the poet Richard Glover had characterized it in testimony to the House of Commons – and when the Ayr Bank fell victim to speculative mania, he knew that he had made his last throw. He tried initially to bluff his way out by flashing at his partners a huge pile of bank notes – but they had been borrowed for the purpose a few hours earlier. He then absconded, the bank stopped payment, and there was general panic. He did eventually return to face his creditors, but they got no more than a dividend of 4s. The ripples of the crash spread very wide. For a time trade was largely paralysed. The Bank of England was obliged to step in to prop up some of the shakiest firms.

The East India stock out of which Fordyce had done so well had also attracted the attention of Reynolds, and he had bought in heavily. (The days and hours for the receipt of dividends at India House were noted in his pocketbook.) His interest had almost certainly been stimulated by his friendship with the Burkes. Edmund was phenomenally well informed about Indian affairs, and William had speculated largely in the Company's stock.

Now it seemed that the credit crisis might threaten the very existence of 'the Grandest Society of Merchants in the Universe'. The absurd expectations which investors persisted in entertaining of India simply could not be matched by trading prospects. The situation had been aggravated by an appalling famine in Bengal, triggered by the failure of the 1769 monsoon – people devoured their seed-grain, sold their children, resorted eventually to cannibalism. By the summer of 1772 the Company found itself liable for over £1.5 million in bills of exchange alone. The directors suspended dividend payments and applied to the government for a £1 million loan; stock values plummeted and Parliament was recalled. The Regulating Act of the following year would represent the first step in state intervention; the participation of government in the administration of India would steadily increase until the dissolution of the Company in 1858.

Henry Thrale was one of those who had narrowly escaped bankruptcy and his wife was going through a difficult pregnancy, but they kept up their usual style of entertaining, and Reynolds was a frequent visitor to Streatham

that summer. He was by now at work on the series of portraits of their friends which the Thrales had commissioned, and he seems occasionally to have broken his general rule of painting only on home ground. The series would not be completed until 1781, when his portrait of Charles Burney, now in the National Portrait Gallery[20] – 'the last chasm in the chain of Streatham worthies', as Mrs Thrale put it – filled the last space on the library wall between those of Baretti, which dates from 1773,[21] and Burke, which was painted in the following year.[22]

One of the earliest in the series – it is now in the National Gallery of Ireland in Dublin – was that of Goldsmith, a replica of the portrait Reynolds had exhibited at the Academy in 1770.[23] The portrait he painted of Johnson for Streatham is now in the Tate.[24] He wears a brown suit, and a puzzled frown (David Mannings takes the view that he is suffering from indigestion). Johnson himself did not much like it. Reynolds might paint himself as deaf as he chose, he told Mrs Thrale, 'but I will not be blinking Sam'. (The self-portrait which Reynolds contributed to the series, also now in the Tate, has him cupping his hand behind his left ear.)[25] This readiness to draw attention to physical deficiencies shows an interesting disregard for the prevailing convention of portraiture.

One portrait which Reynolds had to set aside for a time in the summer of 1772 was that of Joseph Banks – 'that ardent young student', as Charles Leslie describes him, 'whose singular passion for natural history had survived an education at Eton and Oxford'.[26] The future President of the Royal Society was not yet thirty, but he was already a considerable celebrity. His attainments in botany had won him his Fellowship of the Royal Society at the age of twenty-three. Through the influence of Lord Sandwich, the First Lord of the Admiralty, he had obtained permission to accompany Cook's round-the-world expedition on the *Endeavour*; since their triumphant return the previous summer he had been the lion both of the scientific world and of the *beau monde*.

Johnson, meeting Banks at dinner in Leicester Fields, experienced one of his occasional rushes of enthusiasm for foreign travel and toyed briefly with the improbable notion of applying to go on the second round-the-world voyage then being mooted. The following day he asked Reynolds to forward a note saying how much pleasure he had derived from the conversation of Banks and Dr Solander.* That conversation had clearly not been exclusively scientific; he also enclosed a Latin distich for the collar of the goat

* Dr Daniel Solander (1736–82) was a Swedish botanist who had been with Banks on the *Endeavour*. A pupil of Linnaeus, he had catalogued the natural history collections at the British Museum. Noted equally for his charm and his indolence, he later became Banks's secretary and librarian.

which had sailed with them on the *Endeavour* to provide a supply of milk.*

Reynolds's portrait[27] shows Banks preparing to rise from his chair; there is a globe at his side, and an expanse of water visible through the window. The energetic alertness of the handsome young man recalls that early portrait of Keppel which had done so much for Reynolds's reputation twenty years previously. Banks's hand rests on a sheaf of papers which carries an inscription from Horace: '*Cras Ingens Iterabimus aequor*' – 'Tomorrow we shall resume our voyage over the mighty sea'. And that was precisely what he did, sailing off in July to Iceland, where he climbed to the top of Mount Hecla. He returned in October, but did not sit to Reynolds again until a few days before Christmas.

During the summer the Corporation of Plympton decided that the time had come to honour its famous son. Northcote retailed the news to his brother in a letter in June:

I believe Sir Joshua will go down to Devonshire because he is to be made an Alderman of Plympton, and I think Miss Palmer will go with him because I know her sister is constantly grumbling that she cannot come up, and now 'tis her turn.[28]

Samuel was unimpressed – partly because it was not news to him, partly because he had a low opinion of those charged with the conduct of municipal affairs:

I had heard of this indeed from Mr Mudge, but I gave not the least credit to the information, looking upon the foul transactions of a dirty borough as things quite foreign to Sir Joshua Reynolds's pursuits. Indeed, the only way I can account for this is by supposing that Sir Joshua's mind has been so much engaged in the pursuits of knowledge in the art that he has not looked abroad to observe the villainy and corruption in those affairs. But, on the contrary, he perhaps retains somewhat of the ideas he had of a Plympton alderman when he was a boy looking up at them all as persons of dignity. How much will he be surprised when he finds into what a nasty jakes he has put his hand! He will be as much surprised as the landlord of the alehouse who found his wife with another man, and the reply she made to her husband when he upbraided her may, with a little alteration, be applied to Sir Joshua: 'These things must be done, my dear, if we sell ale.'[29]

Northcote no doubt kept his brother's earthy commentary to himself. Reynolds had confirmation of his election in a letter from Lord Edgcumbe

* The literary celebrity of Banks's goat was short-lived. It had been put out to grass at Mile End, and died there two months after the dinner party.

in September. He did not, in the event, travel down to Devon, but he wrote to his old friend Paul Henry Ourry, then MP for Plympton, asking him to convey his appreciation to the rest of the Bench. 'I am sorry it was not in my power to pay my respects to you this year and return my thanks in person,' he wrote, 'however next year I hope to do myself that honour.'*

He was busy during the autumn on the beautiful portrait of Garrick and his wife now in the National Portrait Gallery.[30] Northcote, at work in the adjoining room during one of Garrick's sittings, overheard him roundly abusing the dramatist Cumberland, the author of numerous sentimental comedies who was pilloried as Sir Fretful Plagiary by Sheridan in *The Critic*:

I remember his expression was this – 'Damn his dish-clout face! His plays would never do for the stage if I did not cook them up and make epilogues and prologues too for him, and so they go down with the public.' He also added, 'He hates you, Sir Joshua, because you do not admire his Correggio.' 'What Correggio?' answered Sir Joshua. 'Why, his Correggio,' replied Garrick, 'is Romney the painter.'[31]

Northcote, all eyes and ears, also told his brother that Reynolds was mulling over at this time the idea of an ambitious multiple portrait of Garrick:

Sir Joshua talks of painting a large picture of him in a great many different characters; he is to be in his proper character in the middle, speaking a Prologue, and about fifteen of the most remarkable characters which he has acted to be standing round hearkening to him; and he will sit for all these . . . It is to be painted in Sir Joshua's great room at Richmond next summer; you need not mention it as it may never happen.[32]

Garrick's listing in the *British Museum Catalogue of Engraved British Portraits* is exceeded only by that of Queen Victoria; this would have made a notable addition to it, but it was never painted.

Northcote had come to be treated very much as a member of the family, and when he wrote to Samuel about the daily round in Leicester Fields, he often did so in the first person plural. 'I have just finished a picture of our cook, which is thought much like her but rather handsomer,' he wrote to his brother early in October:

I will give you a proof of the likeness which made us all laugh. Miss Reynolds had been at Richmond for some time, and when she returned she desired I would show

* Letter 32. Reynolds had painted Ourry before going to Italy, when he was Captain Edgcumbe's first lieutenant. The portrait (Mannings, cat. no. 1372, pl. 3, fig. 48) is now at Saltram. Ourry left the Commons in 1775 and became Commissioner of Plymouth Dockyard.

her something which I had done since her absence. I brought the cook's picture and placed it on the floor, against a chair. Now Sir Joshua has a macaw which is a very sensible bird and he was walking about the room, but as soon as ever he saw the picture he flew over to it with the utmost fury and bit at the hands and face, when he found he could not gt hold of it he looked so very cunning, and went to the side and back to examine it. The bird had been ill used by the cook, and he hates her and will alway bite her when he can if there is any other person in the room, but he is so knowing that if she only is in the parlour he is good-natured enough. Sir Joshua and Miss Reynolds and all laughed very much. This is almost as extraordinary as the old story of the bunch of grapes, which Sir Joshua then mentioned, and said that birds and beasts were as good judges as men.[33]

The bird's master was greatly pleased with its performance, and the routine became something of a party piece for the amusement of Burke, Johnson, Goldsmith and other friends.

The annual presentation of prizes at the Academy loomed. Reynolds never found the process of composition easy. As 10 December approached each year, Northcote often heard him pacing up and down in the small hours.[34] On this occasion he was hard put to it to have the final text of his Discourse ready in time. 'He left it till the last day he was to speak in the evening,' Northcote told Samuel, 'so that if Gill had not assisted me it could not have been done soon enough.'[35]

Reynolds is attempting a great many different things in the Discourses. Some offer lessons in technique, others are essentially essays in philosophy; much of the one delivered in 1772 – his fifth – is concerned with practical criticism. Having exhorted his hearers to keep their attention 'fixed upon the higher excellencies', he embarks on an extended consideration of the relative merits of Raphael and Michelangelo:

If we put these great artists in a light of comparison with each other, Raffaelle had more Taste and Fancy, Michael Angelo more Genius and Imagination. The one excelled in beauty, the other in energy. Michael Angelo had more of the Poetical Inspiration; his ideas are vast and sublime; his people are a superior order of beings; there is nothing about them, nothing in the air of their actions or their attitudes, or the style and cast of their limbs and features, that reminds us of their belonging to our own species. Raffaelle's imagination is not so elevated; his figures are not so much disjoined from our own diminutive race of beings, though his ideas are chaste, noble, and of great conformity to their subjects.

To the question of which ought to hold the first rank, he contrives, with a helping hand from Longinus, a Solomonic non-answer:

If it is to be given to him who possessed a greater combination of the higher qualities of the art than any other man, there is no doubt but Raffaelle is the first. But if, as Longinus thinks, the sublime, being the highest excellence that human composition can attain to, abundantly compensates the absence of every other beauty, and atones for all other deficiencies, then Michael Angelo demands the preference.[36]

Reynolds is, however, prepared to allow some merit to another style, 'because it shews that those who cultivated it were men of lively and vigorous imagination'. This he calls 'the original or characteristical style', citing as a prime example the work of Salvator Rosa. Here he identifies a perfect correspondence between the subjects chosen and the manner in which they are treated: 'Every thing is of a piece: his Rocks, Trees, Sky, even to his handling, have the same rude and wild character which animates his figures.'[37]

He passes to Rubens and Poussin, painters entirely dissimilar and yet 'each consistent with himself and possessing a manner entirely his own'. He finds fault with Rubens's composition ('his art is too apparent') and with his colouring ('too much of what we call tinted'):

Throughout the whole of his works, there is a proportionable want of that nicety of distinction and elegance of mind, which is required in the higher walks of painting; and to this want it may be in some degree ascribed, that those qualities which make the excellency of this subordinate style, appear in him with their greatest lustre . . .

Opposed to this florid, careless loose and inaccurate style, that of the simple, careful, pure, and correct style of Poussin seems to be a complete contrast. Yet however opposite their characters, in one thing they agreed; both of them always preserving a perfect correspondence between all parts of their respective manners: insomuch that it may be doubted whether any alteration of what is considered as defective in either, would not destroy the effect of the whole.[38]

As he approaches his conclusion, he sounds a cautionary note: 'Without the love of fame you can never do any thing excellent; but by an excessive and undistinguishing thirst after it, you will come to have vulgar views.' He commends to the students the splendidly lordly retort made by Euripides to a rash Athenian critic: 'I do not compose my works in order to be corrected by you, but to instruct you.' Then, delivered almost as a throw-away, a brief coda which may have startled some of his fellow Academicians:

I mention this, because our Exhibitions, while they produce such admirable effects by nourishing emulation and calling out genius, have also a mischievous tendency,

by seducing the Painter to an ambition of pleasing indiscriminately the mixed multitude of people who resort to them.[39]

Reynolds was right in what he said about a mischievous tendency; the potential for mischief afforded by the exhibition would soon be demonstrated, although not in the way he had in mind; it would be directed, what's more, at his own person.

12

Two Score Years and Ten

Reynolds and other members of the Club were much concerned in the early weeks of 1773 with keeping Goldsmith afloat. He had been seriously ill the previous autumn with a bladder complaint; his finances were once more in disarray; during the winter he was still begging Colman to come to a decision about the play he had been sitting on for so long. 'I have as you know a large sum of money to make up shortly,' he wrote:

For God sake take the play and let us make the best of it, and let me have the same measure at least which you have given as bad plays as mine.[1]

Even after Colman's grudging acceptance of the piece, his lack of enthusiasm communicated itself to the Covent Garden players, and several leading members of the company refused to be cast. The Club weighed in to lend what support it could. Johnson and Reynolds turned up at rehearsals. Reynolds took a poor view of *She Stoops to Conquer* as a title, and told Goldsmith he should call it *The Belle's Stratagem* – 'and if you do not I will damn it', he threatened, with mock severity. It may have been no more than a happy coincidence, but when the Club assembled three days before the first night, Garrick, who had turned down Goldsmith's earlier play, was admitted to a place at the table for the first time – having perhaps already composed the prologue which he had agreed to write for the rival house.*

On the night, Johnson presided over dinner at the Shakespeare tavern near the theatre. Reynolds and the Burkes were there, and the party also

* Garrick still chose to be malicious, even though it had been Goldsmith who seconded his nomination for election to the Club. The conceit of the prologue is that comedy was afflicted by a surfeit of sentimentality, and that Dr Goldsmith was going to prescribe a cure. It was wittily done, but Garrick could not resist lending currency to the well-founded rumour that Goldsmith's medical degree was a fiction. 'Should he succeed, you'll give him his degree,' he concluded slyly:

> The college, *you*, must his profession back,
> Pronounce him *regular*, or dub him *quack*.

included a Scotsman called Adam Drummond, a useful man on the first night of a comedy because of the braying laugh that he could summon effortlessly on cue. Goldsmith was so agitated that he could barely swallow a mouthful, and did not accompany the others to Covent Garden. Later in the evening an acquaintance found him wandering miserably in the Mall and persuaded him to go to the theatre; if he had gone sooner, he could have basked in the gales of laughter which had punctuated the performance from the second act onwards. Colman's reputation as a judge of comedy was badly dented; lampooned in the press and baited round the dinner table, he fled for a time to Bath. 'Colman is so distressed with abuse about his play,' Johnson wrote to Mrs Thrale, 'that he has solicited Goldsmith to *take him off the rack of the newspapers.*'[2]

Membership of the Club was a coveted distinction, and there was a good deal of lobbying on behalf of those who aspired to election. Another candidate that year was the Irish MP Agmondesham Vesey, who had been proposed by Burke. His wife, Elizabeth, was a prominent bluestocking, and Reynolds's support was solicited by Elizabeth Montagu, the 'Queen of the Blues' herself. His smooth, mildly ironic reply makes entertaining reading:

Mr Burk spoke of Mr Vesey when he proposed him last Friday in the same manner as you have done, and I think in the very words, that he was good humoured sensible, well bred, and had all the social virtues; it was left for you to say that he was a man of Tast without pretensions and so without jealousy and envy. I have too good an opinion of our club to entertain the least suspicion that such a man will not be unanimously elected . . .[3]

Vesey was elected on 2 April. Six years later, when Malone was up for election – unsuccessfully, as it turned out – he wrote to Lord Charlemont: 'I am not quite so anxious as Agmondesham Vesey was, who I am told, had couriers stationed to bring him the quickest intelligence of his success.'[4] At the end of April a candidate of a rather different stripe waited after dinner at Beauclerk's house to hear his fate:

I sat in a state of anxiety which even the charming conversation of Lady Di Beauclerk could not entirely dissipate. In a short time I received the agreeable intelligence that I was chosen. I hastened to the place of meeting, and was introduced to such a society as can seldom be found. Mr Edmund Burke, whom I then saw for the first time, and whose splendid talents had long made me ardently wish for his acquaintance . . .

It was only later in the year, as they bowled through the wilds of Kincardineshire together on their way to the Hebrides, that Boswell learned from

5. *Elizabeth Montagu. Reynolds painted 'The Queen of the Blues',*
as Johnson dubbed her, in 1775. The portrait, commissioned by
the sitter's cousin, Richard Robinson, Primate of Ireland, has been
untraced since early in the last century.

Johnson that his ardent wish for Burke's acquaintance had not been immedi-
ately reciprocated:

'Several of the members wished to keep you out. Burke told me, he doubted if you
were fit for it: but, now you are in, none of them are sorry. Burke says, that you have
so much good humour naturally, it is scarce a virtue.' – *Boswell*. 'They were afraid
of you, sir, as it was you who proposed me.' – *Johnson*. 'Sir, they knew, that if they
refused you, they'd probably never have got in another. I'd have kept them all out.
Beauclerk was very earnest for you.' *Boswell*. 'Beauclerk has a keenness of mind
which is very uncommon.'[5]

There had been talk in the Academy of decorating the chapel in that part of
Old Somerset House which the king had assigned to them with paintings.

Reynolds now came up with a bolder and more ambitious plan, which won the approval of his fellow Academicians and which he described in a letter to Lord Grantham, who was still at the embassy in Madrid:

We are upon a scheme at present to adorn St. Pauls Church with pictures, five of us, and I fear there is not more qualified for this purpose, have agreed each to give a large Picture, they are so poor that we must give the Pictures for they have but the Interest of 30000£ to keep that great building in repair which is not near sufficient for the purpose. All those whose consent is necessary have freely given it. We think this will be a means of introducing a general fashon for Churches to have Altar Pieces, and that St. Pauls will lead the fashon in Pictures, as St. Jamess does for dress, It will certainly be in vain to make Historical Painters if there is no means found for employing them. After we have done this we propose to extend our scheme to have the future Monuments erected there instead of Westminster Abby, the size of the Figures and places for them, so as to be an ornament to the building to be under the Inspection of the Academy I have had a long conversation with the Bishop of Bristol who is Dean of St Pauls and who has the entire direction of the Church, and he favours the scheme extremely.*

Apart from Reynolds himself, the artists who had agreed to paint a scriptural history – six in all, in fact, not five – were West, Angelica Kauffmann, Cipriani, Barry and Nathaniel Dance. Reynolds and the Council had drawn up an address to the king in which they applauded the lead he had given by commissioning biblical paintings to decorate St George's Hall and the Royal Chapel at Windsor:

Herein you have directed the arts to their true end, the cultivation of religion and virtue; for it is by such means only that they have risen to perfection in Greece and Italy . . .

As artists, as lovers of virtue and our country, we anxiously wish to see the truly royal example which your Majesty has given, followed in the Principal Church of these kingdoms, St Paul's Cathedral, according to the intention of its architect; instead of the present unfinished state of its inside . . .

This anticipation of Disraeli's advice to Matthew Arnold that flattery, when directed at royalty, should be laid on with a trowel, had the desired effect. The reference to Wren's original design was shrewd; Wren had indeed initially envisaged that the walls of his basilica should be decorated with

* Letter 35. Reynolds was writing in July, but Northcote had described the scheme in a letter to his brother five months previously.

paintings and bas-reliefs; Parliament, however, had appropriated part of the fabric-money to fight King William's wars, causing Wren to complain that 'his wings were clipt'.

It was certainly the case that Dr Newton, in those pluralist days both Bishop of Bristol and Dean of St Paul's, favoured the scheme; it seems likely, indeed, that it had first been seriously mooted at his dinner table when his guests included both Reynolds and West.* The Archbishop of York and the Lord Mayor were also enthusiastic. But Reynolds was mistaken when he told Grantham that all those whose consent was necessary had freely given it. The Archbishop of Canterbury and the Bishop of London, as trustees of the fabric, had also to be consulted, and they both disapproved. Richard Terrick, the Bishop of London, was particularly unyielding. It is possible that he was offended at not being the first to be approached; at all events his reply to Newton at once put an end to the matter:

My Good Lord, – I have already been informed that such an affair is in contemplation; but whilst I live, and have the power, I will never suffer the doors of the Metropolitan Church to be opened for the introduction of Popery.

It was probably just as well. Monumental painting would have been a new departure for most of the artists who had volunteered their services, and it is by no means certain that their work would have embellished the cathedral in the way Wren had in mind. Reynolds had intended to take as his subject the Nativity, and one of West's entries to the following year's exhibition bore the wistful title *Moses Receiving the Tables, a Design for a Picture, Intended to Have Been Painted for St Paul's Cathedral.* In the event, he turned the bishop's veto to his own financial advantage. Ten years later he painted a massive picture of the subject for the chapel in Windsor Castle – it measured 18 ft × 12 ft 2 ins and he was paid £1,284 for it.†

Reynolds made a start that spring on another portrait for the Streatham gallery; the sitter was the immensely rich Lord Sandys, an Oxford friend of Thrale, who before succeeding his father had been the MP for Westminster.‡

* Newton was sitting to Reynolds that spring. The portrait (Mannings, cat. no. 1338, fig. 1084) was exhibited at the Academy the following year. It is now at Lambeth Palace.
† For some reason the painting was never delivered, and the ownership of it was returned to West's sons by George IV in 1828. It now hangs in the Palace of Westminster.
‡ Mannings, cat. no. 1574, fig. 1086. Later in the year Reynolds began work on another Streatham portrait, that of Robert Chambers, Vinerian Professor of Law at Oxford, an original member of the Club (Mannings, cat. no. 343, fig. 1077).

Reynolds dined at Streatham on 21 April, an occasion enlivened by a memorable Johnsonian riposte. The author and sometime actor Arthur Murphy had launched an attack on the absent Garrick for his vanity. Johnson himself was frequently critical of his old pupil, but that was a privilege he was not prepared to extend to others. 'No wonder, Sir, that he is vain,' he told Murphy; 'a man who is perpetually flattered in every mode that can be conceived. So many bellows have blown the fire, that one wonders he is not by this time become a cinder.'*

It was to Garrick, a few weeks earlier, that Gainsborough had confided his reasons for not exhibiting that year at the Academy. 'I don't send to the Exhibition this year,' he wrote; 'they hang my likenesses too high to be seen, & have refused to lower one sail to oblige me.'⁶ He was not the only absentee. Horace Walpole scribbled a note in his catalogue: 'Gainsborough and Dance, having disagreed with Sir J. Reynolds, did not send any pictures to this exhibition.'†

Their absence passed largely unnoticed. With the election of James Barry the full complement of forty Academicians had been attained. The number of works hung rose to 359, of which a dozen were by Reynolds. Whether this was the occasion on which Gainsborough famously burst out with 'Damn him, how various he is!' is not known, but the range and versatility of the President's exhibits in 1773 could well have provoked such an exasperated response – the Garricks, the Cumberlands, Joseph Banks, Mrs Hartley in the *Nymph with Young Bacchus* which he had painted two years earlier. He also exhibited two very different subject pictures – his *Ugolino*, on which he had been intermittently at work since 1770, and a picture which bore the title *A Strawberry Girl*.

This was one of the character studies of children that would bulk increasingly large in Reynolds's output of 'fancy pictures' during the 1770s and 1780s. Young girls from poor families sometimes earned a few coppers in the summer months working in 'Strawberry Gardens' – an occupation roughly parallel to that of 'link' boys, who lit people around the city streets with their torches. The composition has come down to us in two versions,⁷ and there are a great many copies.‡ Northcote says that it was a picture of which Reynolds was extremely proud:

* Boswell, 1934–50, ii, 227. Murphy would later be one of Garrick's first biographers.
† As it happens, Gainsborough and Nathaniel Dance were the only two founding Academicians not included in a group portrait which Zoffany had exhibited the previous year.
‡ When the Tate Gallery's conservation department recently examined Reynolds's *The Age of Innocence* (Mannings, cat. no. 2008, fig. 1575), it was discovered that it had been painted over an incomplete version of *The Strawberry Girl*.

He considered it as one of his best works; observing, that no man ever could produce more than about half a dozen really original works in his life, 'and that picture,' he added, 'is one of mine.' The picture was exhibited and repeated by him several times; not so much for the sake of profit, as for that of improvement: for he always advised, as a good mode of study, that a painter should have two pictures in hand of precisely the same subject and design, and should work on them alternately.[8]

There is a striking echo here of a passage in an unfinished essay of Reynolds on Shakespeare. It was never published in his lifetime, and the pages of the manuscript were dispersed, some finding their way to the Royal Academy, some to the Boswell papers now housed at Yale. F. W. Hilles pieced them together again, and the essay appeared in the collection of hitherto unknown Reynolds manuscripts which he published in 1952:

The mind appears to me of that nature and construction that it requires being employed on two things in order that it may do one thing well. Perhaps this disposition proceeds from the mind having always been accustomed to do many things at once, as in reading and writing, in which, from long habit, the operation of the mind comes to be no operation, or at least not perceptible. This double operation, what it has been so long accustomed to, begins at last to be a thing necessary, and required even, in affairs where a man would wish the whole powers of his mind to concentrate.[9]

Ugolino was the first treatment in the late eighteenth century of a subject that would continue to fascinate artists, particularly in France, down to the time of Rodin. Horace Walpole thought Reynolds's interpretation of this grisly tale of imprisonment, deprivation and cannibalism 'most admirable' – an unsurprising verdict, perhaps, from the author of *The Castle of Otranto*. Later critics were less impressed. Allan Cunningham, in the following century, thought that Reynolds had depicted Dante's tragic hero 'like a famished mendicant, deficient in any commanding qualities of intellect, and regardless of his dying children, who cluster around his knees'.[10] What is most interesting about the painting today is that it clearly establishes the detached, Olympian Reynolds, the chronicler of an age of seeming reason and decorum, as one of the forerunners of Romanticism.

A week after the opening of the exhibition, the *Morning Chronicle* published a letter addressed to 'Sir Joshua Reynolds, President of the Royal Academy'. The writer signed himself 'Fabius Pector'.* Reynolds had never before been attacked in terms of such savage condescension:

* A slip on the part of the printer or the writer himself, who presumably intended a play on the word 'pictor'. The original Fabius Pictor was the earliest prose writer of Roman history.

Sir,

if you are as wise in some parts of conduct as you are in others, let me advise you to keep to Portrait Painting; you have often succeeded in it very happily: and although as the arts are rising fast 'tis not over-likely that you will always be able to preserve the first name, yet you will ever be deemed a man of considerable excellence in that way.

It were indeed a pity that any falling off in your business, as a Portrait Painter should oblige you, at so late a time of your life, to begin wrestling with the difficulties of a new profession; the painting of history is new and strange to you, as appears but too evidently from your unfledged picture last year of Venus and Cupid casting up accounts and the Ugolino and his family now in the present exhibition. Why Sir, if those pictures were shown even in France or Italy, where you may be ever so little known, every body would, at first glance, judge them to be the rude disorderly abortions of an unstudied man, of a portrait painter, who quitting the confined track where he was calculated to move in safety, had ridiculously bewildered himself in unknown regions, unfurnished with either chart or compass. Be advised, Sir Joshua, keep to your portraits which will do yourself and your country credit, and leave history painting (as you do watch-making or navigation) for those who have studied it . . .

This will mortify you, no doubt, but as you are a *very cool man* with your passions always in a proper subordination to your interests I have great hopes that you will make a prudent use of the hints (they are but hints) that I have given you . . .

This triggered a spirited correspondence. Two days later 'Fresnoy' entered the fray, with a letter addressed to 'James B—y'. He did not accuse Barry in so many words, but he clearly believed that he was the author of the attack, attributing to him such delicate remarks as 'Sir Joshua Reynolds! why he knows no more of art than my a—':

. . . That you have had every advantage an artist can possibly have is not to be denied; you have studied in all the repositories abroad, you were there supported by your friends and in such a manner that you were never under the necessity of drudging for interest.

. . . Now you know, Mr. Barry, that to save your soul from perdition you could not paint a picture in which so much *simple* knowledge of the art is shown as in that of the Strawberry Girl by your *friend* Sir Joshua Reynolds, whose ignorance is your constant theme in every place but at his own table, where you are his constant guest. I am amazed he will suffer you to enter his doors for he must have heard of your notorious calumnies . . .

Another correspondent, identified only by initials, attributed the attack to Barry's vanity:

A few days ago, at the hanging of the pictures in the exhibition room, the Committee (appointed for that purpose) had placed his *Jupiter* and *Juno* next to Sir Joshua's picture of *Hugolino* . . . Sir Joshua coming there next day, full of a tender concern for Mr. B—'s fate, insisted upon the Jupiter and Juno's being removed out of that, and placed in some less dangerous neighbourhood, which was done accordingly: Mr B—y's vanity took the alarm when it was told to him, and so he so misconceived everything, as to insinuate to his friends (at least 'tis so reported, for the story has taken wind) that Sir Joshua's only concern was for the effect of his own picture . . .[11]

Barry did not put his head above the parapet in the course of these exchanges. It has never been established beyond doubt that he was 'Fabius Pector', although there are close similarities between the letter and Barry's *Inquiry into the Real and Imaginary Obstructions to the Acquisition of the Arts in England* published two years later. There is no reference to the episode in Reynolds's correspondence, but Northcote records a telling remark; he once heard Reynolds say that it was a bad thing to hate any man, but that he feared he did hate Barry.[12]

Reynolds had every reason to be pleased with the impact of 'Hugolino' as he generally spelt it. It 'got me more credit than any I ever did before,' he wrote to Lord Grantham; 'it is at present at the Engravers to make a Mezzotinto Print from it which when finish'd I will do myself the honour of sending one to your Lordship.'[13] When John Dixon's fine print was published the following February it was priced at 15s, which was as much as the large plates after Reynolds's full-length portraits of society beauties. The mezzotint was marketed on the continent, and became hugely influential, particularly in France. The sculptor Falconet expressed his admiration for it; Martin Postle believes it may well have helped to shape the composition of David's *Lictors Returning to Brutus the Bodies of His Sons* which was exhibited at the Paris Salon of 1789.[14] The painting remained in Reynold's studio until 1775, when it was sold to the Duke of Dorset for £420.*

It was a busy summer and autumn for Reynolds, and he was quite often away from his painting room. In June he travelled down to the Isle of Wight with his friend Thomas Fitzmaurice, Lord Shelburne's brother, who had an estate there at Niton. Then he moved on to Portsmouth and was the guest

* That is the price entered in Reynolds's ledger. In the duke's account book it is given as £315.

of his friend Lord Edgcumbe at a big naval review. Three years previously, in her first Turkish war, Catherine the Great had been greatly beholden to Britain, who had made it possible for her Baltic fleet to make a dramatic appearance in the Aegean. Now there were suspicions that France and Spain were concerting measures to strike at the Russian fleet, and the ministry had decided to demonstrate its continuing support for the Tsarina against the Bourbons with a show of naval strength. A fleet of twenty ships of the line, together with two frigates and three sloops, was assembled at Spithead, and between 22 and 26 June it was reviewed by the king.

Reynolds had a grandstand view of the proceedings from Edgcumbe's flagship, the *Ocean*. Salutes boomed out from the guns of Blockhouse Fort and South Sea Castle; the fleet, moored in two lines abreast, manned yards and saluted as the king passed by in the royal barge. Reynolds was still full of the occasion when he wrote to Lord Grantham several weeks later:

The King is exceeding delighted with his reception at Portsmouth, he said to a person about that he was convinced that he was not so unpopular as the news papers would represent him to be, the Acclamations of the people were indeed prodigeous, On his return all the country assembled in the Towns where he changed horses. At Godalmin everyman had a branch of a tree in his hand and every woman a nosegay which they presented to the King (the horses moving as slow as possible) till he was up to the knees in Flowers, and they all singing in a tumultuous manner, God save the King, The King was so affected that he could not refrain shedding abundance of tears, and even joined in the Chorus. I told the King what I had heard at Godalmin as I pass'd through the day after . . .

He paints an affecting picture of the king's eagerness to be home:

When he came to Kew he was so impatient to see the Queen that he opened the chase himself and jumped out before any of his attendants could come to his assistance he seized the Queen whom he met at the door, round the wast and carried her in his arms to the room . . .

Reynolds also had some personal news, which he conveyed to Grantham with diffidence but obvious pride:

What I am going to say of myself is not perhaps quite so interesting as speaking of the King but it is with no less pleasure to myself. I beg leave therefore to acquaint your Lordship that I received at the Encenia at Oxford every mark of distinction

possible. my name was hitched in the Verses spoken by the young Gentlemen, I was presented with a Doctors degree amidst the acclamations of the whole Theatre. Mr Vansittart who presented us all, made me some very handsome compliments besides the general common place ones.[15]

The ceremony in the Sheldonian Theatre at which Reynolds was made Doctor of Civil Law took place on 9 July. Before returning to London he took up a long-standing invitation from the Duke of Marlborough to visit him at Blenheim. He was, says Northcote, 'much mortified' to find that he was coolly received by both the duke and his duchess; his sister Fanny, however, was quickly able to tell him why:

She asked him if he appeared before them in his boots, just as he came off his journey, and not in his evening dress; he answered yes. Then said she, that was the very reason; they thought it a mark of great disrespect in your not complying with the etiquette.[16]

There had been fifteen candidates for honorary degrees. When Dr Vansittart presented them to the newly installed Chancellor (who happened to be the prime minister, Lord North), he delivered encomia on only two of them – one was Reynolds, the other was Dr James Beattie, the professor of moral philosophy at Marischal College, Aberdeen. Beattie was the son of a shopkeeper and small farmer from Laurencekirk, in Kincardineshire. Reynolds had met him two years previously through Johnson (he had come to London with a letter of recommendation from Boswell). In the spring of 1773 he had come south again, hoping to be awarded a pension – to which end, wrote the modern editor of his diaries, 'he directed all his energies, determined to leave, if necessary, no official unpestered and no man of influence unplagued'. As the author of the *Essay on the Immutability of Truth* – it had gone through four editions in three years – he had been lionized much as Sterne had been. 'Beattie,' Johnson wrote to Boswell, 'is so caressed, and invited, and treated, and liked, and flattered, by the great, that I can see nothing of him.'*

Reynolds, on the other hand, saw a great deal of him. Beattie had already sat for his portrait to Fanny Reynolds – who, he wrote in his diary, 'wishes to engage her brother, Sir Joshua, to take another picture of me, and is sure

* Boswell, 1934–50, ii, 264. The previous year, when Boswell thanked him for the civilities he had shown Beattie, Johnson had replied, 'Sir, I should thank *you*. We all love Beattie. Mrs Thrale says, if ever she has another husband, she'll have Beattie' (Boswell, 1934–50, ii, 148). Beattie, as it happens, already had a wife, although his domestic life would soon become clouded by her insanity.

he will do it, if he can by any means find time'.[17] That was in June. Reynolds and he were much in each other's company after their return from Oxford, and by early August the matter was settled. 'Sir Joshua,' he wrote in his diary, 'proposes to paint an Allegorical picture representing me and one or two more lashing Infidelity &c. down to the bottomless pit.'[18]

Word of the project soon got around. Mrs Montagu wrote to Beattie to express her delight. 'I class Sir Joshua with the greatest geniuses that have ever appeared in the art of painting,' she gushed:

He has the spirit of a Grecian artist. The Athenians did not employ such men in painting portraits to place over a chimney, or the door of a private cabinet. I long to see the picture he is now designing; virtue and truth are subjects worthy of the artist and the man . . .[19]

Reynolds entertained Beattie and his wife to dinner on 14 August, and pressed them to accompany him the next day – a Sunday – to Richmond to enjoy a haunch of venison. Fanny and Baretti were also of the party, and they drove down to Wick House in Reynolds's coach and a post-chaise. Beattie spent much of the day in conversation with his host 'on critical and philosophical subjects' – 'I find him to be a man, not only of excellent taste in painting and poetry, but of an enlarged understanding and truly philosophical mind.' He seems to have been treated to a mini-discourse, and was swept off his feet:

He speaks with contempt of those who conceive grace to consist in erect position, turned out toes, or the frippery of modern dress. Indeed, whatever account we make of the colouring of this great artist (which some people object to), it is impossible to deny him the praise of being the greatest designer of any age.

The next morning work began on the portrait, and Beattie set down a detailed account of the sitting in his diary:

I stand at one end of the picture dressed in a Doctor of Laws gown & band. & wt. the essay on Truth under my arm; the figure as large as life: the plan is not as yet fixed for the rest of the picture, but Sir Joshua means to finish it wt. all expedition, and proposes a print to be done from it.

A week later, he wrote, with coy prolixity, to Mrs Montagu:

My face, for which I sat, is finished, and is a most striking likeness; only, I believe it will be allowed that Sir Joshua is more liberal in the articles of spirit and elegance than

his friend Nature thought proper to be . . . Indeed, if I had been qualified to give any hints on the subject, which is not at all the case, you will readily believe that I would not be at all instrumental in forwarding a work that is so very flattering to me.

The picture caused something of a stir. Some thought it unduly flattering to the subject. The three demons whom a female personification of Truth is shown driving down to perdition were also controversial – one of them looked like Voltaire, while some detected a resemblance in the other two to Hume (to whose scepticism Beattie was strongly opposed) and Gibbon.

Goldsmith, resentful of the acclaim with which Beattie's work had been greeted, was indignant, and remonstrated with Reynolds – the only occasion on which harsh words are known to have passed between them:

It very ill becomes a man of your eminence and character, Sir Joshua, to condescend to be a mean flatterer, or to wish to degrade so high a genius as Voltaire before so mean a writer as Dr. Beattie; for Dr. Beattie and his book together will, in the space of ten years, not be known ever to have been in existence, but your allegorical picture, and the fame of Voltaire will live for ever to your disgrace as a flatterer.*

Writing to Beattie some months later to tell him that the painting was almost finished, Reynolds was unperturbed. He had clearly heard the gossip about the identity of the demons, and was not disposed to go out of his way to deny it:

Mr Hume has heard from somebody, that he is introduced in the picture, not much to his credit; there is only a figure covering his face with his hands, which they may call Hume, or any body else; it is true it has a tolerable broad back. As for Voltaire, I intended he should be one of the group.[20]

In September Reynolds set off for the West Country. Having been made an alderman of Plympton the previous year, he was now to be elected mayor. Walking out with some dinner guests at Richmond during the summer, he had unexpectedly encountered the king and other members of the royal family. The monarch immediately turned the conversation to Plympton. Was it not one of the finest towns in the world? Was Reynolds not very proud to be chosen as its mayor? Reynolds acknowledged that he was, but such was his surprise that the king should be informed of 'so minute and

* Northcote, i, 300. Goldsmith also grumbled jealously about Beattie one day in Johnson's presence: 'Here's such a stir about a fellow that has written one book, and I have written many.' Johnson put him down relatively gently: 'Ah, Doctor, there go two-and-forty sixpences you know to one guinea' (Hill, G. B., i, 269–70).

inconsiderable a circumstance' that he narrowly avoided a monumental *faux pas*. It was, he assured his Majesty, an honour which gave him more pleasure than any other he had ever received in his life – and then, recollecting himself in the nick of time, he added 'except that which your Majesty was graciously pleased to bestow upon me'.[21]

His first call after leaving London was on his old friend John Parker, the MP for Devon; his portrait of Mrs Parker, who was Lord Grantham's younger sister, had been exhibited at the Academy in April.[22] The picture had been painted mostly in 1770, but Reynolds had been dilatory in putting the finishing touches to it. 'Sir Joshua is very lazy,' Theresa Parker wrote to her brother. 'Mr Parker says I am drawn feeling my pulse: it may not be the less like for that, as I am apt to do so.' The picture was designed to hang in Robert Adam's new saloon at Saltram House, where it may still be seen today. Mrs Parker, whose beauty Reynolds greatly admired,* leans on a pedestal against a dark, romantic landscape, her face in profile. She wears a cloak of pink and blue silk, and the way in which her left hand is placed on her right wrist does indeed suggest that she is checking her pulse rate.

Reynolds stopped in Bath for two days, and was entertained to dinner in the Guildhall and by Lord Shelburne. He also went to the theatre, and saw the rising star John Henderson. Henderson had originally studied drawing with the engraver and draughtsman Daniel Fournier, and had won a prize at the Society of Arts. Stage-struck, he had auditioned for Drury Lane, but Garrick's verdict was that 'he had in his mouth too much wool or worsted'. Now, at twenty-six, he had taken Bath by storm. Gainsborough, indeed, who was every bit as enthusiastic a theatre-goer as Reynolds, had written to Garrick about him only a few months previously:

. . . an amazing copy of you has appear'd on our stage . . . for my own part, I think he must be your Bastard. He is absolutely a Garrick through a Glass not quite drawn to its focus, a little mist hangs about his outlines, and a little fuzziness in the tone of his voice, otherwise the very ape of all your tricks. . .

O that I could but touch his features, clean his Person, and sharpen him out into a real Garrick . . .[23]

Reynolds moved on to Bristol, where he dined with the bishop, Dr Newton. He reached Plympton on 22 September, and for the best part of a fortnight was caught up in a round of visits to old friends in the neighbourhood. Samuel Northcote, in the manner of those who live in small towns, kept a sharp eye on his goings out and comings in:

* See p. 296 below.

Dear Brother,

... I believe Sir Joshua went to Mount Edgcumbe this morning; your mother saw him ride up before our house with Mr Mudge in a post-chaise. He speaks of leaving Plymouth on Tuesday morning; but those who know anything of mayor-swearing think it cannot be so soon, as there is so much concomitant business to be done. I find Sir Joshua's receiving the sacrament is one particular. This the thorough-paced call 'qualifying.' Besides the Plympton folks are all on tiptoe ready for a dance, and surely Sir Joshua will not leave them without giving a ball ...

It seems unlikely that the wish of the good people of Plympton was gratified. Reynolds did not leave on the Tuesday, which was the day he was sworn in as mayor, but he did start on the first leg of his journey back to London the following afternoon: 'Sat out for Torrington', he scrawled in his pocketbook, 'lay at Tavistoke'.

Reynolds had more than once promised Lord Mount Edgcumbe and Commissioner Ourry that he would send them a self-portrait to be hung in the Guildhall at Plympton. Some time shortly before the mayoral ceremony he had finally dashed one off – it was, he wrote to his young friend William Elford,* 'begun & finished in the same day'; he was sending it off in a packing case addressed to Elford, and he begged him, 'as secretly as might be', to get it hung before the ceremony took place. The plan misfired. The picture did not arrive in time, and when it did, it was discovered that sawdust '& other foul matter' from the packing case had stuck to the varnish – a note at the back of Reynolds's first ledger indicates that the canvas had been prepared with copal varnish and the finished picture waxed before being varnished without oil.†

The portrait, showing Reynolds in his doctoral robes, was eventually hung – between two old pictures, Elford reported, which acted as a foil, and set it off to great advantage. Reynolds was hugely amused: the two old paintings were early (and rather fine) portraits of his own, one of Ourry, the other of George Edgcumbe, both painted before he went to Italy.

Two years after his election as mayor, Reynolds would give an interesting demonstration of just how much the honour meant to him. On his admission

* Elford (1749–1837), like Reynolds the son of a West Country parson, was an artist of some ability, and from 1774 exhibited at the Royal Academy. A friend of Pitt the Younger, he later entered Parliament as MP for Plymouth; he was mayor of the town for a time, and a partner in a banking house there. He was created a baronet in 1800.

† Cormack, 105, n69. The note, as corrected by Mannings, reads in full: 'My own Picture sent to Plimpton, Cera poi verniciato/senza olio – colori: Cologns earth, vermillion/the cloth varnished first with copal varnish/white and blue [struck through] on a common Colouring Cloth on a raw Cloth.' Cologne earth is a brown pigment prepared from lignite, originally from a bed near Cologne.

to the Academy at Florence, an invitation came from the Grand Duke of Tuscany to contribute a self-portrait to the Medici Collection.[24] He once again painted himself in doctoral robes. On the back of the canvas he inscribed in Latin his various distinctions: his knighthood, his presidency of the Academy, his Oxford doctorate, his fellowship of the Royal Society. Then, a final proud flourish, more elaborate than what has gone before – '*nec non oppidi natalis, dicti Plimpton comitatu Devon, Praefectus, iusticiarius Morumque Censor*'*.

A tradition handed down in the Edgcumbe family has it that Reynolds was eager to emulate Christopher Wren and represent Plympton in Parliament; that he applied to Lord Mount Edgcumbe for his interest in the borough, but was refused; and that this was the cause of a temporary coolness between them. The story is supported by a passage in the papers of the wit and diplomatist Caleb Whitefoord, who was sitting to Reynolds at the end of 1773;[25] Reynolds apparently spoke of his ambition, but added that he 'had no manner of chance'. Whitefoord tried to encourage him with an atrocious pun: 'I totally differ from you Sir Jos: and I wish you wod but try, for if you do [you] will certainly succeed, for I am sure nobody makes a better Figure upon a Canvas.'†

Whitefoord lived in Craven Street, in the Strand, and had struck up a friendship with his neighbour there, Benjamin Franklin, then the agent for Massachusetts. Relations with the American colonists were becoming increasingly tense. The previous year eight boatloads of Rhode Islanders had boarded a revenue cutter, the *Gaspée*, aground off Pawtucket, wounded her commander and set the ship on fire; in September 1773 Franklin, hitherto an exponent of conciliation, published anonymously in the *Gentleman's Magazine* a satire entitled 'Rules by Which a Great Empire May Be Reduced to a Small One'. It was a clever and unusually savage piece of writing, cataloguing the steps by which the colonists had been alienated as if they had been deliberate acts of policy: 'Suppose them always inclined to revolt, and treat them accordingly . . . By this means, like the husband who uses his wife ill from suspicion, you may in time convert your suspicions into realities.' If you require money from the colonies, 'despise . . . their voluntary grants, and resolve to harass them with novel taxes'.

In American eyes the Tea Act which had passed into law earlier that year constituted just such a novel tax. Ostensibly it was aimed at assisting the

* 'and also Mayor and Chief Magistrate of his native town of Plympton in the County of Devon.'
† Whitefoord Papers, British Museum. Add. MSS. 36596, f. 229. Not everyone in Reynolds's circle thought highly of Whitefoord's witticisms. Burke dismisses him as a mere '*diseur de bons mots*'. He later served as secretary to the commission which concluded peace with America.

East India Company; by reducing the duty on tea re-exported to the colonies, it made British tea cheaper than the smuggled article in America. The colonists saw it as provocative – a characteristically devious way of milking them of a contribution to the imperial exchequer. On 16 December, in Boston, the Sons of Liberty, disguised as Indian braves, boarded the first tea ships to arrive in the harbour and dumped their cargo of 298 tea-chests overboard.

Lord North's four-year political honeymoon was at an end. As 1773 drew to a close, Reynolds was at work on a new portrait of one of his predecessors who knew better than most how abruptly the wheel of political fortune turned. 'I have the honour to copy Lord Bute's face,' Northcote wrote to his brother, 'as there is to be two whole-lengths made of him.' The man who had been George III's 'dear friend' had effectively withdrawn from public life some years earlier, his spirit broken by the relentless mud-slinging he had had to endure. The death of the princess dowager the previous year had left him, he told Lord Holland, 'without a single friend near the royal person'. He was now sixty. 'He is a tall genteel figure with a mean Scotch face,' Northcote told Samuel:

He must find it very different from the time when he was forced to have bruisers behind his coach to protect him, for now he comes in a chair without any servants and often walks home on foot in his surtout without any state.[26]

Reynolds, with no literary preoccupations that winter,* was putting the finishing touches to the celebrated picture of Lady Cockburn and her three sons which now hangs in the National Gallery in London.[27] Desmond Shawe-Taylor describes it as 'an image of adoring, preoccupied mother-hood'.[28] 'Abstracted' might be closer to the mark – possibly even 'dazed'. Still in her early twenties, Lady Cockburn had gone through three confine-ments in little more than two years. The chubby elder boys (it is not clear why they are half-naked) are obviously a handful; one of them clambers up her back and peeps out over her left shoulder; the youngest she holds absent-mindedly on her lap. Shawe-Taylor instances the painting as evidence of the spread of Rousseau-esque thinking about the upbringing of children, and notes that by the 1770s French visitors were remarking with approval on 'the maternal tenderness of the English Ladies of all ranks'.† The baby clearly knows its *Emile* and has thoughts for nothing but mother's milk, but Lady Cockburn, in her abstraction, has neglected to loosen her creamy-white

* The Discourses would from now on be delivered every other year.
† He cites Madame Fiquet du Bocage's *Letters Concerning England, Holland and Italy*, which had appeared in two volumes in London in 1770.

dress to facilitate this. Perched on a ledge to the right of the group, but ostentatiously turning its back on the proceedings, is Reynolds's macaw; the bird's expression suggests that it did not hold with progressive notions about the rearing of children.

If the physique of the Cockburn boys recalls Rubens (a modern paediatrician would no doubt pronounce them clinically obese), so does Reynolds's palette – he has moved some distance from the subdued lustre of Van Dyck. The picture is a prime illustration of the extent to which he made use of 'quotations' from other painters – an echo of some classical theme, a gesture here, an attitude there. It is a practice which some regarded as plagiarism, which Horace Walpole defined as a form of wit and which Blake would later memorably denounce as 'thievery'. The pose of the oldest Cockburn child, for instance, is plainly derived from the Cupid in Velázquez's *Toilet of Venus* now in the National Gallery; the Italian scholar Giovanna Perini has traced the composition of the picture to Van Dyck's *The Wet Nurse*, engraved by Ludovico Mattioli.[29]

Whatever its genesis, the painting was greatly admired in its own day.* Reynolds sent it to the Academy the following April. 'When it was first brought in to the room,' writes Northcote, 'all the painters then present were so struck with its extraordinary splendour and excellence, that they testified their approbation of it by suddenly clapping with their hands.'[30]

* The fact that Reynolds signed and dated the picture – something he did only rarely in the 1770s and 1780s – suggests that he was not displeased with the way it had come out. The inscription – 1773/J REYNOLDS: PINX – appears as if woven into the hem of Lady Cockburn's cloak.

13

Stop Thief!

Life was clouded for Reynolds at Easter 1774 by the death of Goldsmith. Northcote records that he was greatly affected: 'He did not touch the pencil for that day, a circumstance most extraordinary for him.'* The two friends had recently been much in each other's company. 'Our club has dwindled away to nothing,' Beauclerk had complained in a letter to Lord Charlemont a few weeks previously. 'Sir Joshua and Goldsmith have got into such a round of pleasures, that they have no time.'†

It had been a harsh winter and a wet spring. Goldsmith's finances were in their usual deplorable state, and he had been far from well. He had retreated to the single room he had rented in a farmhouse at Hyde, west of the Edgware Road, desperate to complete his *History of the Earth and Animated Nature* on which he had been at work since 1769. He had travelled up to town for a meeting of the Club on 5 March, but his candidate for election, Edward Gibbon, had been blackballed. By 25 March he had been forced to take to his bed at Brick Court. He died in the early hours of Easter Monday, most likely of an infection of the kidneys; his death was almost certainly hastened by excessive, self-prescribed doses of Dr James's Fever Powders, which induced violent vomiting. The fantasy of being a qualified doctor, which he had sustained for seventeen years, was at an end.

It fell to Reynolds to put his tangled affairs in order. There was initially talk of a public funeral in the Abbey. Reynolds, as executor, had already received some subscriptions, and he, Burke, Garrick, Lord Shelburne and Lord Louth had been selected as pallbearers. These plans were abandoned, however, when the full extent of Goldsmith's debts became apparent –

* Northcote, i, 325. Burke, as he usually did on such occasions, wept when the news was brought to him.

† Hardy, i, 350. Some of the pleasures were of a fairly simple kind. Reynolds's nephew, Samuel Johnson, visiting Leicester Fields early in 1773, ended a letter to his sister with 'Dr Goldsmith and Uncle are at draughts close by me, so I can write no more' (Johnson, Reverend Samuel, 11).

Reynolds estimated that they were of the order of £2,000.* He was buried instead in the graveyard on the north side of the Temple Church. Curiously, no close friends were present; Reynolds arranged for his nephew, the Reverend Joseph Palmer, to act as chief mourner.

Some years after Goldsmith's death – probably in 1776 – Reynolds attempted a biographical sketch of his friend, possibly for incorporation in the biography which Percy began but eventually abandoned. Reynolds's account was never published in his lifetime, and indeed it is far from complete – a number of preliminary notes, a rough draft of the body of the essay, and an expanded and revised version which lacks a beginning and an end. The composite text assembled in the 1950s by Frederick Hilles is nevertheless a document of remarkable subtlety and penetration. Reynolds begins by remarking on the rich vein offered to the would-be biographer by the contradictions inherent in human nature:

Those only are the favourite characters of a biographer in which are united qualities which seem incompatible with each other, which appear impossible to exist together at the same time and in the same person. The writer reigns here and revels.[1]

No question then, of casual eulogy, but a dispassionate appraisal of the complexity of the man – and of some of the received opinion entertained about him:

Among those . . . who knew him but superficially, many suspected he was not the author of his own works, whilst others pronounced him an idiot inspired† . . . His more intimate acquaintances easily perceived his absurdities proceeded from other causes than from a feebleness of intellect, and that his follies were not those of a fool.

The draft is full of illuminating insights:

The Doctor came late into the great world. He had lived a great part of his life with mean people. All his old habits were against him. It was too late to learn new ones, or at least for the new to sit easy on him . . .

It must be confessed that whoever excelled in any art or science, however different from his own, was sure to be considered by him as a rival. It was sufficient that he was an object of praise, as if he thought that the world had but a certain quantity of

* 'Sir Joshua is of opinion that he owed not less than two thousand pounds,' Johnson wrote to Boswell. 'Was ever poet so trusted before?' (Johnson, Samuel, 1992–4, ii, 146, 4 July 1774).
† The remark 'an inspired idiot' was first attributed to Walpole in Thomas Davies's *Life of Garrick* in 1781. Boswell repeats it in a note to the *Life*.

that commodity to give away, and what was bestowed on others made less come to his share . . .*

Goldsmith's mind was entirely unfurnished. When he was engaged in a work, he had all his knowledge to find, which when he found, he knew how to use, but forgot it immediately after he had used it . . .

He felt with great exactness, far above what words can teach, the propriety in composition, how one sentiment breeds another in the mind, preferring this as naturally to grow out of the preceding and rejecting another, though more brilliant, as breaking the chain of ideas. In short, he felt by a kind of instinct or intuition all those nice discriminations which to grosser minds appear to have no difference. This instinct is real genius if any thing can be so called.[2]

Goldsmith, for his part, left a finely observed verse-portrait of Reynolds. His poem 'Retaliation' was a response to a competition in extempore epitaph-writing at the St James's Coffee House in which he had been the butt of Garrick's wit.† He settled that score triumphantly, but went on to pen entertaining cameos of several of the others who had been present.‡ The poem was not published until a week after his death, and was even then unfinished – a visitor came upon a blotted manuscript lying in his room a few days before he died. His lines on Reynolds are as perceptive as they are warm:

> Here Reynolds is laid; and to tell you my mind,
> He has not left a better or wiser behind;
> His pencil was striking, resistless, and grand,
> His manners were gentle, complying, and bland;
> Still born to improve us in every part,
> His pencil our faces, his manners our heart:
> To coxcombs averse, yet most civilly steering,
> When they judged without skill, he was still hard of hearing;
> When they talked of their Raffaelles, Corregios, and stuff,
> He shifted his trumpet, and only took snuff.

* Reynolds rehearsed this point rather more vividly on one occasion to Northcote: 'Sir Joshua used to say, that Goldsmith looked at, or considered, public notoriety, or fame, as one great parcel, to the whole of which he laid claim, and whoever partook of any part of it, whether dancer, singer, slight of hand man, or tumbler, deprived him of his right, and drew off the attention of the world from himself, and which he was striving to gain' (Northcote, i, 248).

† 'Here lies Nolly Goldsmith, for shortness called "Noll," / Who wrote like an angel, but talked like poor Poll.'

‡ The dinner party had included the Burkes, Johnson, Whitefoord, Hickey, Cumberland, Dr Barnard, the Dean of Derry, and Dr John Douglas, later Bishop of Salisbury.

Reynolds had barely three weeks after the death of Goldsmith to prepare for that year's exhibition.* 'I have been forced to supply the deficiencies of others,' he wrote virtuously to Lord Grantham, 'and have sent this year thirteen pictures to the Exhibition.'³ Gainsborough, it is true, had chosen once again not to exhibit, but it is not clear whose deficiencies Reynolds felt he was supplying: at 354, the number of works exhibited was only five fewer than the previous year.† He offered Grantham a brief critique:

The Pictures of Dance Cipriani and Penny are superior to any they have done before Mr. Wests is rather inferior, however he himself thinks different, and speaks of it as the very best Picture he ever painted but nobody else is of that opinion.

There are many good Landskips of Lutherbourg, but they are very much *manierata* & they seem to be the works of a man who has taken his Ideas at second hand, from other Pictures instead of Nature . . .

Reynolds does not specify which of the three pictures exhibited by West he is referring to. It is possible that his strictures mask a certain irritation at the fact that since 1772 West had taken to describing himself in the Academy's catalogue as 'Historical Painter to the King'.

Reynolds's own group of thirteen canvases once again displayed great versatility – 'it is impossible to resist the conclusion', wrote Ellis Waterhouse, 'that Sir Joshua was showing off'.⁴ In addition to Lady Cockburn and her children and Dr Beattie, lording it over Voltaire and Hume, there was a rather cloying picture of the Princess Sophia Matilda lolling on the grass with a lapdog,⁵ a portrait of her mother, the Duchess of Gloucester,⁶ and a dandyish full-length of the Earl of Bellamont, dressed to kill in white satin and the robes of a Knight of the Bath;⁷ there was also the half-length of Bishop Newton, now at Lambeth Palace,⁸ and the fine three-quarters of Baretti commissioned by the Thrales for Streatham.⁹ Reynolds's eagle got another outing, its wings extended over a rather petulant-looking *Infant Jupiter* in a composition clearly modelled on Carlo Maratta's *Infant Jesus Adored by Angels*; the picture also featured a goat, which Horace Walpole thought poorly painted.‡

* He did, however, find time, in the two days before it opened, to attend the sale of the pictures of his friend Sir George Colebrooke, the MP for Arundel, whom he had painted in the 1750s and whose family banking house had gone under in the previous year's crash. Colebrooke had also been Chairman of the Board of the East India Company. His withdrawal from public life was followed by bankruptcy and he fled for a time to France.

† They included works by two of Reynolds's pupils, Northcote and Gill, and by his sister Fanny, described in the catalogue simply as *A Lady*.

‡ Mannings, cat. no. 2098, fig. 1645. The picture, later bought by the Duke of Rutland, was one of nineteen works by Reynolds destroyed by fire at Belvoir Castle in 1816.

The evanescent nature of Reynolds's colouring attracted some adverse comment. The Newton portrait was described in the *Public Advertiser* as 'a fine picture but the colours fled'; another critic homed in on the portrait of the Duchess of Gloucester, and bemoaned the fact that although 'uncommonly elegant when first executed it has lost nearly the whole of its force with the beauties of its colouring'.

The most ambitious of his exhibits, and one of Reynolds's boldest and most elaborate attempts at the great style was *Three Ladies Adorning a Term of Hymen*, now in the Tate Gallery.[10] The ladies in question were the daughters of Sir William Montgomery; they were, the *Complete Peerage* assures us, 'reckoned the most beautiful women in Europe, and were called the Irish Graces'. The commission had come from Luke Gardiner, later Lord Mountjoy, the MP for Co. Dublin and a member of the Privy Council in Ireland, who was engaged to be married to the eldest sister. 'I wish to have their portraits together at full length,' he had written, 'representing some emblematical or historical subject,' and that was what Reynolds provided – in spades. 'This picture is the great object of my mind at present,' he wrote to Gardiner:

I have every inducement to exert myself on this occasion, both from the confidence you have placed in me, and from the subjects you have presented to me, which are such as I am never likely to meet with again as long as I live, and I flatter myself that, however inferior the picture may be to what I wish it, or what it ought, it will be the best picture I ever painted.[11]

It was not the first time he had 'flattered' himself in that way, and it would not be the last.* It is certainly one of his more successful attempts to combine portraiture with history painting, although it has not been universally admired down the years. Ruskin was full of praise for the composition and for the delicacy of Reynolds's touch. The critic and painter F. G. Stephens, on the other hand, found the design 'singularly whimsical'. 'The ladies,' he wrote, 'skip with the most absurdly artificial airs' – a judgement some might think a little rich from a founder-member of the Pre-Raphaelite Brotherhood. John Steegman, in the elegant biographical essay he published in the 1930s, had only faint praise to bestow: 'The accessories show the Reynolds workshop at its most competent, and the whole is a picture which would be a distinction to any public gallery in Europe and almost impossible in a private house.'[12] Sir Ernst Gombrich felt able to be more generous: 'The

* He would say the same thing, for instance, about his picture of Sheridan's wife as St Cecilia: 'It is with great regret I part with the best picture I ever painted' (Letter 191).

resounding language of classical coinage which Poussin has made his natural idiom has become a graceful play.'

Not long after the close of the exhibition, Gainsborough upped sticks and removed from Bath to London. His reasons can only be surmised. There had been a recent decline in the number of commissions; life in Bath was not cheap; possibly he felt that his prospects of attracting more fashionable clients would be greater in the capital; perhaps his differences with the Academy were a factor. The decision seems to have been made fairly suddenly; as late as 11 March, Broadwoods, the piano manufacturers, dispatched to Bath a harpsichord selected for him a few days earlier by his friend Giardini, the violinist, an unlikely delivery if a move had already been on the cards.

At all events, by midsummer he was installed in the western portion of Schomberg House in Pall Mall at a rent of £150 per annum. His arrival in London did not immediately put an end to friction with the Academy – he would not exhibit again until 1777 – but he was, at the end of the year, appointed to the Council, and even received one vote in the annual election for the presidency.*

The significance of Gainsborough's settling in London would not be lost on Reynolds, although it is important not to project back into their century posterity's view of them as rivals of commensurate stature. That was not how they appeared to most of their contemporaries, even after Gainsborough had been established in the capital for a decade or more. In the late 1780s, for instance, when the question arose of commissioning a portrait of Earl Spencer for his old college at Cambridge (he had been at Trinity), he received some brisk guidance from his countess: 'I can't bear the idea of anybody having a picture by Sir Joshua of you beside myself,' she wrote. 'I think a daub by Gainsborough would do full well as another for them.'†

Robert Chambers, one of the earliest members of the Club, had recently married the fifteen-year-old daughter of the sculptor Wilton – Reynolds is said to have played the matchmaker. Chambers had also just been made Second Judge of the recently established Supreme Court of Judicature in Bengal,‡ an appointment from which Reynolds was able to derive some

* Presumably his own.

† Althorp MSS, letter dated 24 May 1787. Lady Spencer was knowledgeable about painting. In 1790 she visited the studio of the young Martin Archer Shee, later Reynolds's successor several times removed as President of the Academy. He described her in a letter to his brother as 'a great proficient in the art, and a most formidable critic . . . a female connoisseur' (Shee, i, 135).

‡ Oxford had agreed that he might keep his Vinerian Chair of Law for three years until he saw whether the Indian climate agreed with him.

family advantage; when Chambers sailed for Calcutta on the *Anson* in April, he had under his care Reynolds's nephew Billy, the second son of his sister Elizabeth. Before long he had been found a position as Clerk of the Crown, and within three years he would be making remittances to his mother and sisters – help, as will be seen, which was badly needed.

Reynolds had less success later in the year when he attempted to promote the interests of Joseph Palmer, the nephew who had acted as chief mourner at Goldsmith's funeral. Extraordinary numbers of eighteenth-century Anglican clergy laboured under the delusion that they had it in them to write a tragedy. Palmer called his *Zaphira*, and Reynolds, unwisely, sent it to Garrick:

...I should not take this liberty if I was not in some measure authorised by the approbation of Edd Burk and Johnson. The latter contrary to his custom read it quite through.[13]

Garrick was constantly being plagued in this way. His reply is now lost, but Reynolds took offence at it, and responded with uncharacteristic huffiness:

I thought of delaying to answer your note till I should hear from the author, who is in the country; but on second thoughts it must needs be altogether unnecessary to give you the trouble of reading the play, as you say it cannot be acted even if you should approve of it, for these two years to come. He will undoubtedly understand your answer to be an absolute refusal to take it at any rate; I must therefore, beg that it may be returned.[14]

Garrick had a notoriously short fuse: he was also, as it happens, laid up at Hampton with gout.* 'Dear Sir, I was too much in pain to write to you Yesterday,' he replied:

So far from refusing plays the Complaint is that I take too many: or supposing me capable of such a practice with Authors, at least don't think me so lost to my interest, to refuse a play, a Line of which I never saw, & which comes so recommended to me.

What I wrote to Sir Joshua Reynolds was upon my honour the real situation of my affairs at present – I have no less than Seven Plays, Each of 5 acts, & two smaller pieces for representation; these with our reviv'd Plays will be as much as any Manager can thrust with all his might into two Seasons . . . that my Acquaintance Sir Joshua

* 'The Strawberry Gazette is very barren of news,' Horace Walpole wrote to the Countess of Ossory on 14 September. 'Mr Garrick has the gout, which is of more importance to the metropolis than to Twitnumshire' (Walpole, 1937–83, xxxii, 207).

Reynolds, shou'd think for the Author, that I wou'd say the thing that is not, to clear myself from a performance recommended by him Dr Johnson & Mr Burke is not a little unpleasing to me –[15]

Garrick did, in fact, in his usual rigorous fashion, study the play with close attention, analysing its strengths and weaknesses scene by scene – he had an incomparable sense of what would actually work on stage. He thought it had some merit, and pronounced the writing generally 'natural and spirited'. His conclusion, however, was that even with some alteration and abridgement, the piece was not likely to succeed, principally because it lacked a scene of compelling interest in the last act.*

It did not prove necessary to prolong the correspondence, however, because Reynolds, always eager for conciliation, was quick to make amends. 'I am now perfectly satisfied that I was mistaken,' he wrote, adding graciously, 'any appearance of sollicitude from Mr Garrick that there should be no misunderstanding is very flattering to his sincere friend & admirer Joshua Reynolds.'[16] The matter was closed, although it lodged in a corner of Garrick's mind: 'I wish you had seen Sr J's play,' he wrote to George Colman some months later, 'yr opinion would have confirm'd me – I hate this traffick wth friends.'[17]

Shortly after these exchanges with Garrick, Reynolds set off for the West Country. While he was there, Lord North surprised the opposition by calling an election six months earlier than the Septennial Act required, and Parliament was dissolved on 30 September. Reynolds, at the tail-end of his year as mayor, discovered that this obliged him to delay his return to London. 'Sir Joshua Reynolds finds to his sorrow that he must stay in the country till the election of the Plympton member is over,' Samuel Northcote wrote to his brother:

He purposes to go to Torrington and make a short stay there, and return to Plympton. As I have told you before, I believe he was not aware of the dirtiness of borough matters.[18]

The dissolution had been the cause of some anxiety to Burke, who seemed for a time in danger of being left without a seat. His patron at Wendover, Lord Verney, found himself compelled to seek candidates who could bear the charges of the borough, and Burke was obliged to look elsewhere. Happily, as he sat at dinner on 11 October, a delegation arrived from Bristol

* His comments survive in a note preserved in the Forster Collection in the Victoria and Albert Museum. See Garrick, i, 646.

to say that he had been nominated for that city, and he was returned by a majority of 251, along with a radical merchant from New York called Henry Cruger. Cruger supinely declared himself willing to obey the instructions of his constituents, but Burke felt they deserved better than that, and offered them a loftier view of the constitutional position of a parliamentary representative. 'He owes you,' he declared, 'not his industry only, but his judgment; and he betrays instead of serving you if he sacrifices it to your opinion.'

There was certainly never any inclination on Reynolds's part to sacrifice his judgement to the opinions of those who listened to his Discourses. One of his core beliefs related to what he termed the 'following of other masters' or, more directly, 'imitation'. It was central not only to his painting, but also to his writing. Even more than his paintings, the Discourses incorporate the ideas he has assimilated from those who have gone before. 'He fortified himself,' as Lawrence Lipking crisply puts it, 'by building upon received opinion.'[19] And so persuaded was he of the importance of the practice, that he devoted the whole of his sixth Discourse to it – 'It is in vain,' he told his hearers, 'for painters or poets to endeavour to invent without materials on which the mind may work.'[20]

This is the Discourse, delivered in December 1774, in which Reynolds, drawing with remarkable objectivity on his own experience and practice, offers an account of the development of an artist's mind. Received opinion about genius and inspiration receive short shrift:

To derive all from native power, to owe nothing to another, is the praise which men, who do not think much on what they are saying, bestow sometimes upon others, and sometimes upon themselves; and their imaginary dignity is naturally heightened by a supercilious censure of the low, the barren, the groveling, the servile imitator.

. . . I am on the contrary persuaded, that by imitation only, variety, and even originality of invention, is produced. I will go further; even genius, at least what generally is so called, is the child of imitation.[21]

Reynolds was well aware that he was not preaching to the converted: 'As this appears to be contrary to the general opinion, I must explain my position before I enforce it.' Which he proceeds to do, forcefully and occasionally provocatively:

Invention is one of the great marks of genius; but if we consult experience, we shall find, that it is by being conversant with the inventions of others, that we learn to invent; as by reading the thoughts of others we learn to think . . .

The mind is but a barren soil; a soil which is soon exhausted, and will produce no

crop, or only one, unless it be continually fertilized and enriched with foreign matter . . .

The greatest natural genius cannot subsist on its own stock: he who resolves never to ransack any mind but his own, will be soon reduced, from mere barrenness, to the poorest of all imitations; he will be obliged to imitate himself . . .

There can be no doubt but that he who has the most materials has the greatest means of invention; and if he has not the power of using them, it must proceed from a feebleness of intellect . . .

The truth is, he whose feebleness is such, as to make other men's thoughts an incumbrance to him, can have no very great strength of mind or genius of his own to be destroyed; so that not much harm will be done at worst . . .

The purport of this discourse . . . is, to caution you against that false opinion, but too prevalent among artists, of the imaginary power of native genius, and its sufficiency in great works. This opinion, according to the temper of mind it meets with, almost always produces, either a vain confidence, or a sluggish despair, both equally fatal to all proficiency.[22]

It was the most assured and coherent Discourse Reynolds had yet delivered. Its dry and sceptical tone was no more to the liking of some of his hearers than its assault on their romantic notions about the nature of the creative imagination – 'too wounding to professional vanity to be generally accepted', as Ellis Waterhouse put it.[23] But it commanded the approval of one discerning critic by whose opinion he set great store. Shortly before the Discourse was delivered, Reynolds, who had been working on his text the night before, received a morning visit from Burke. 'I was at work in the adjoining room,' writes Northcote, 'and could easily overhear their conversation, which as Sir Joshua was deaf, was very distinct.' Reynolds read aloud to his friend a paragraph from his draft, and Burke commended it in the highest terms: 'This is, indeed, excellent, nobody can mend it, no man could say it better.'* The sixth Discourse also won the approval of the bluestockings. 'In my poor judgment,' wrote Hannah More, 'it is a masterpiece for matter as well as style, and that we have scarcely a finer writer.'[24]

* Northcote, ii, 316. Towards the end of his life, Northcote told Hazlitt that Reynolds may have received more than critical approval from Burke: 'I can't help thinking he had a hand in the Discourses; that he gave some of the fine, graceful turns; for Sir Joshua paid a greater deference to him than to any body else, and put up with freedoms that he would only have submitted to from some peculiar obligation. Indeed, Miss Reynolds used to complain that whenever any of Burke's poor Irish relations came over, they were all poured in upon them to dinner; but Sir Joshua never took any notice, but bore it all with the greatest patience and tranquillity' (Hazlitt, 1830, 84). There is no evidence to support this contention. It is, on the other hand, well established that he received some assistance, essentially on points of style, from Johnson and Malone (see Hilles, 1936, Chapter 8).

The pocketbooks for the years 1774 to 1776 are lost, but we know from entries in the ledger that Reynolds was at work at this time on his portrait of Mrs Jodrell, which belonged for a time to Duveen and is now in the Detroit Institute of Arts.[25] A hair-raising technical memorandum at the end of the second ledger reveals that Reynolds was still in reckless pursuit of the finish achieved by the Old Masters: 'Mrs Jodrell – Head oil, cerata, varnisht with ova poi varn. con Wolf, Panni, Cera senza olio, Verniciato con ovo poi con Wolf.' Coming across the entry years later, the history painter Benjamin Haydon, like Reynolds a product of Plympton Grammar School, registered incredulity:

Good heavens! Let us recapitulate in English. The head painted in oil, then waxed, varnished, egged, varnished again with Wolff's, then waxed, sized, oiled, egged again, and then finally varnished with Wolff!!! That is, varnished three times with different varnishes, and egged twice, oiled twice, and waxed twice, and sized – perhaps in 24 hours. The surface Sir Joshua got was exquisite, his delight must have been intense, and though the reward was worth the risk, in such extraordinary infatuation he must be a beacon*.†

Reynolds continued to take a keen interest in the theatre. In February 1775 he attended the first night of Robert Jephson's tragedy *Braganza* at Drury Lane, with Mrs Yates in the role of the duchess. Relations with the manager were obviously restored – Garrick invited him to sit with him in the orchestra, a place Reynolds preferred because of his deafness. Garrick had pushed the boat out and spent heavily on costumes and scenery. Horace Walpole was also in the audience, and reported to Mason that at the catastrophe in the fifth act, the audience was transported: 'They clapped, shouted, hussaed, cried bravo, and thundered out applause.' Reynolds, turning to see Garrick's reaction, saw that his eyes were suffused with tears.[26]

He was at Drury Lane again in March. Having promised Mrs Abington to bring 'a body of wits' to her benefit, he secured forty places in the front boxes. Johnson was of the party, and so was Boswell:

Johnson sat on the seat directly behind me; and as he could neither see nor hear at such a distance from the stage, he was wrapped up in grave abstraction, and seemed quite a cloud, amidst all the sunshine of glitter and gaiety. I wondered at his patience in sitting out a play of five acts, and a farce of two.[27]

* I.e. a warning.
† Haydon, 1960–63, 574. Haydon also quotes Sir William Beechey: 'His egg-varnish *alone* would in short time tear any Picture to pieces painted with such materials as he made use of' (Ibid., 578).

The farce – *Bon Ton, or High Life above Stairs* – was one of Garrick's own, a miniature comedy of manners strongly reminiscent of Restoration comedy. Mrs Abington took the part of Miss Lucretia Tittup; in the main piece, Isaac Bickerstaffe's *The Hypocrite*, she played Charlotte. The bills had said 'Send Servants by Four to prevent Confusion'. There was a good house, and the treasurer's book at the theatre shows that Mrs Abington went home the richer by £223 5s 6d.

Boswell has also left an account of a day in April when he was engaged with Reynolds and Johnson to dine with Richard Cambridge, best remembered for his mock-heroic poem *The Scribleriad*, who lived in some style in a villa at Twickenham. 'Dr Johnson's tardiness was such,' wrote Boswell, 'that Sir Joshua, who had an appointment at Richmond, early in the day, was obliged to go by himself on horseback, leaving his coach to Johnson and me.' Their conversation turned on portraiture. 'Miss Reynolds ought not to paint,' Johnson declared. 'Publick practice of any art, (he observed,) and staring into men's faces, is very indelicate in a female.'[28]

Reynolds had reached Twickenham before them:

No sooner had we made our bow to Mr Cambridge, in his library, than Johnson ran eagerly to one side of the room, intent on poring over the backs of the books. Sir Joshua observed, (aside,) 'He runs to the books, as I do to the pictures: but I have the advantage. I can see much more of the pictures than he can of the books.'[29]

Reynolds did not always see eye to eye with William Chambers on Academy matters. There had been discussion of some distinctive style of dress for Academicians to wear on formal occasions – it is possible that the idea had been planted in Reynolds's mind by the Doctor of Civil Law gown he had worn when he was admitted to his honorary degree and in which he had painted himself for the Uffizi. A letter which he wrote to Chambers suggests that the latter may have been dragging his feet:

Dear Sir
At the last general Meeting they wished very much that the dress of the President and the Academicians might be shewn to the King, for many reasons, first, to have his majesty's opinion of it, and in the next place, that it would fix the dress so that no future President or Academician will presume to Change from any whim or fancy of [his] own, and above all that his majesty having seen and approved of them, it would come to them as an order, and be a real honour to the wearer, which they think it would not be without such Sanction and Authority.

I have an Academicians gown finished and the presidents finished on one Side, which I will send to you if you approve of this proposal

I am with the greatest respect

Yours

J Reynolds[30]

Chambers replied two days later. 'I am inclined to believe, we are in the wrong box with respect to the Academy dresses,' he wrote, in his rather lordly style:

I am ready to follow the majority in what ever shall be thought proper: but submit it to your consideration, whether we should proceed; or, by taking advantage of the objections made by some of our members, lay the project aside.[31]

Which was indeed what happened. The episode illustrates the pervasive influence wielded by Chambers as Treasurer and explains why Reynolds saw him as 'the Viceroy over him'.*

Reynolds's relations with his sister Elizabeth and her family declined sharply in the spring and summer of 1775. His nephew Samuel had come up to London in January. This was the young man whom he had earlier offered to take into his studio and who had had to leave Oxford two years previously because of unpaid debts.† He had now been sent up from Devon to consult lawyers in an effort to put some semblance of order into his family's affairs; not for the first time, they were in serious disarray.

Elizabeth's husband, William Johnson, the son of a former vicar of Great Torrington, was seven years younger than his wife. He had been in business in Torrington as an ironmonger and draper, and had twice been mayor of the town in the fifties and sixties. His business enterprises had not prospered, and in 1768 he had been sent to prison in Exeter for debt, although this did not stand in the way of his becoming mayor a third time in 1772. In 1773 he had acquired some property at Ware (the present-day Weare Giffard) and had tried his hand at running a tannery; but he was able to do so only with the help of a substantial injection of capital from Reynolds, and that lay at the root of the dissensions which now arose.

Most of what is known about this tangled tale comes from letters written

* Farington, 1819, 10 December 1804. It was Farington who raised the question again after Reynolds's death. In preference to gowns, he suggested that 'a blue coat, with some distinction of collar, cuff and button would be sufficient, and would subject the Members to no real addition of expence' (Farington, 1819, 25 November 1793). The suggestion was not adopted.
† See p. 226 above.

by Samuel to his sister Betsey. Partly to save money and partly for secrecy, he often wrote to her in what was known as 'Natural Shorthand'. It was called 'natural' because the forms of the signs were supposed to be based on the position of the lips and tongue when speaking, but it is not easy for the uninitiated to see the connection. There was a separate sign for each letter, but the vowels were usually omitted, and many of the signs are so similar that it is sometimes impossible to make out what is meant.* It is also the case that Samuel sometimes recounts not just what he himself has seen or heard, but what he has been told by his aunt Fanny, who by this time had grievances of her own against her brother; Reynolds's side of the story would no doubt read rather differently.†

He seems to have treated his nephew with every consideration, receiving him warmly at the Academy ('My Uncle, I think, did me great Honour, for He Rose from His Chair to shake hands with me before a very large Company'), lending him his horse to ride out to Putney ('I could hardly keep it within bounds'), inviting him to dinner at Leicester Fields. 'I will not tell you what my Uncle said about you and your Sisters,' Samuel wrote to Betsey at the end of February, 'but I assure you he has taken more notice of the Family than he ever us'd to . . .'

Reynolds asked him to dinner one evening because he thought he would like the chance to meet Elizabeth Sheridan, who was to be there with her husband (Sheridan's first play, *The Rivals*, had got off to a shaky start at Covent Garden a few weeks previously). Samuel was predictably bowled over:

The young ones were all very handsome and agreeable, but appear'd to great disadvantage with Mrs. Sheridan, who is the greatest Beauty in England, and most agreeable woman. (She is now sitting for Her Picture.)

Shortly afterwards, Samuel got a sight of this work-in-progress, and his enthusiasm knew no bounds:

Her picture is going forwards, and I assure you 'tis a sight quite worth coming from Devonshire to see, I cannot suppose that there was ever a greater Beauty in the world, not even Helen or Cleopatra could have exceeded her.[32]

* The system had been invented in the mid-1760s by William Holdsworth and William Aldridge, of the Bank of England. A copy of their work is preserved in the British Museum.
† It did not take Samuel long to get the measure of Fanny. ' 'Tis impossible to depend on my aunt,' he told Betsey, 'for she does not continue in the same mind two hours, or else she speaks without design, or forgets what she says' (Johnson, Reverend Samuel, 126–7).

Samuel also met Johnson at Leicester Fields. 'His Knowledge is infinite,' he told Betsey, 'and my aunt says that she never found him ignorant of one thing but the method of splitting Pease.' He also comments, a shade patronizingly, on the great man's assiduity in church attendance – and on Reynolds's laxness in that regard:

... the next thing which I am going to say in his favour recommends him to me more than all his works; He is a constant attendant on the evening Prayer at St. Clement's, and this is a great thing when we find a certain Person, who is reckon'd an amiable man and is perhaps the best of his set, has not seen the inside of a church for years.

We get a sense in Samuel's letters of his excitement at the glimpse he was afforded of the great world as he sat at his uncle's table:

I was in hopes of being able to send a very great piece of news into Devonshire, but I see it is got into the Papers before I have had an opportunity, I mean about Lord North's motion, and the change of measures which He has adopted, which I heard of at my Uncle's before it reach'd the Papers, and thought to have been the first person who would have sent down the account.

Burke had just made his celebrated speech advocating conciliation with the American colonies. 'Magnanimity in politics is not seldom the truest wisdom,' he declared, 'and a great Empire and little minds go ill together' – a sentiment which has been admired by posterity but made little impact on his contemporaries. What Samuel had got wind of in Leicester Fields was the somewhat limp olive branch now extended by North – that those colonies which returned to their obedience and were prepared to volunteer their fair share of imperial support should be exempted from taxation by the Westminster Parliament. Samuel was writing towards the end of February. By the time the news of this gesture had crossed the Atlantic, shots had already been fired at Lexington and Concord.

At the beginning of March Samuel heard from his sister that their father's remaining assets had dwindled to nothing. To add insult to injury, he had deserted their mother and set up not far from the family home with another woman. 'I read your letter to Aunt Fanny,' Samuel told Betsey. 'She is astonished at the insolence Mama has received, and fears that it will turn her brain if she does not immediately remove.'

Elizabeth and her other children did move back from Ware to Torrington but Reynolds, angry at the losses he had incurred through his dealings with his brother-in-law, seems to have refused her any financial assistance. Fanny, concerned at her sister's distress, initially agreed to stand security for a sum

of £300 if their sister Mrs Palmer would lend it, but the latter was not then in a position to do so. Later, when she found that she could lend the money, she revived the suggestion, but by then Fanny had changed her mind.

Samuel still visited her occasionally at Leicester Fields, but he wrote bitterly to his mother about Reynolds:

I have receiv'd your letter, and carried it to my Aunt Fanny, with whom I din'd; – (I ought not to say with my Uncle, for I never go to see him) . . . She is not without bitterness of her own and that from [a Brother] as unfeeling and ungenerous as yours, who deserves nothing from any of his relations, for I assure you you are not singled out; there is not one, I believe, that has escaped mortification from him – but all this must be buried in oblivion . . . My aunt has two or three times given me hopes, but they are snow in sunshine.

By Samuel's account Reynolds had stipulated that the interest on £1,000 of the sum he had made available to his brother-in-law – which was to be at 10 per cent – should be paid to Fanny: an annual sum, that is to say, of £100. This served to redeem a promise which he had twice made to provide her with an annual income (she had shown Samuel a letter from Reynolds in which he promised her £70 a year 'as long as He lives or has got it to give'). At some point, however, to Fanny's indignation, he had had second thoughts, and required that the interest payments be redirected to him. After some time this arrangement, too, was superseded, and Reynolds seems to have entered into some form of partnership with William.

His anger seems to have been directed not only at his brother-in-law but also at Elizabeth. 'Nothing,' Samuel wrote to her, 'can persuade my Uncle, that it is not by your means that his fortune has been so broken, your getting the money out of him, and not seeing into characters better.' When Fanny had pleaded her sister's case, Reynolds had been unmoved. 'If she suffers it is her own fault,' he retorted coldly. Samuel's message to his mother was a bleak one:

There is no comfort for you from this quarter. Your suppos'd Brother and you could never have had the same parents or be known to one another in your infancy. He desires He may be look'd on as if He did not exist, for He will do nothing for you . . . I never heard of such a man. So you must sit down and die.

Elizabeth, however, was made of sterner stuff than that. Somehow or other she managed to keep afloat – within a year she was toying with the idea of settling in London and starting to deal in the coal trade, 'in which I should have a great advantage in my Brother's and Sister's acquaintance'. (One of

her descendants blotted the sentence out.) Samuel remained in London and found work as an usher at Mr Hobden's Academy in Hounslow.

By the turn of the year, Reynolds's anger with the family seems to have abated. He invited Betsey to come and make her home in Leicester Fields for a time – Mary Palmer had gone back to Torrington to visit her mother. He also relented sufficiently to let Samuel have the £50 needed to settle his outstanding debts in Oxford, and this cleared the way for him, as 'Founder's kin', to take up the Reynolds Exhibition at Exeter College which had been established in 1757 by his great-uncle John. He was ordained in 1777; a year later he died of consumption at the age of twenty-four.

In addition to the usual clutch of ministers, courtiers and grandees, Reynolds's guests at the Academy dinner that year included Garrick, the violinist Giardini and Sir John Pringle, the President of the Royal Society, who had sat to him the previous year.* Horace Walpole, as always, was present, and sat down on his return home to give Mann in Florence his impressions of the 390 works exhibited. 'We do not beat Titian or Guido yet,' he wrote. 'Sir Joshua Reynolds is a great painter; but unfortunately, his colours seldom stand longer than crayons.'[33]

Reynolds, in fact, once again made a strong showing. His twelve canvases included some particularly fine female portraits, one of them, as it happens, of Walpole's niece Charlotte Tollemache, Countess of Dysart.[34] 'I am two and twenty,' she had said to her sister at the time of her betrothal fifteen years earlier. 'Some people say I am handsome, some say I am not. I believe that I am likely to be large and go off soon.'[35] Her skin has certainly gone off, and has paled dramatically, but the picture, now at Ham House in Surrey, remains in good condition, and the countess makes a fine figure in her ruched white silk robe and high Medici collar.

The portrait of Jane, Duchess of Gordon, now at Goodwood, was also on display.[36] This boisterous daughter of a Wigtownshire baronet was still in her twenties; it was not so many years since she had ridden down the Royal Mile in Edinburgh on the back of a sow. To the striking looks captured by Reynolds she added a quick wit and a coarse tongue. She would be disappointed in her hopes of marrying her eldest daughter off to William Pitt, but three daughters became duchesses and one a marchioness; the fifth had to make do with a baronet.

There was much praise for the picture of Elizabeth Linley which had

* Mannings, cat. no. 1486, fig. 1109. Pringle presented the picture to the Royal Society in 1777, and it is still in their possession.

so captivated young Samuel Johnson. Fanny Burney had also seen it in Reynolds's studio during the winter – 'the beautiful Mrs Sheridan, who is taken seated at a Harpsichord, a whole Figure, in Character of Saint Cecilia, a denomination she greatly merits. My Father is to supply Sir Joshua with some Greek music to place before her.'[37]

Sheridan's insistence that his wife should no longer sing, either professionally or socially, after their marriage was still much discussed in society. The question had come up during Reynolds's visit to Richard Cambridge at Twickenham a week before the opening of the exhibition. 'It was questioned,' wrote Boswell, 'whether the young gentleman, who had not a shilling in the world, but was blest with very uncommon talents, was not foolishly delicate, or foolishly proud.' Johnson, 'with all the high spirit of a Roman senator', pronounced on the matter:

He resolved wisely and nobly to be sure. He is a brave man. Would not a gentleman be disgraced by having his wife singing publickly for hire? No, Sir, there can be no doubt here.[38]

Reynolds is not recorded as having expressed an opinion on that occasion, but we know from an amusing story of Northcote's that he had one, and that it did not coincide with Johnson's:

Sir Joshua invited them to dinner, together with a large company, with a full hope that he should gratify his guests with a song from so famous a performer, and accordingly had procured a fine toned piano-forte in perfect order for the purpose: when lo! to his great mortification, on hints being given that a song from her would be received as a great gratification and favour, Mr Sheridan answered that Mrs Sheridan, with his assent, had come to a resolution never again to sing in public company – Sir Joshua repeated this next day in my hearing with some degree of anger, saying 'what reason could they think I had to invite them to dinner, unless it was to hear her sing, for she cannot talk?'[39]

Reynolds had to contend with a bizarre piece of personal and professional unpleasantness from a fellow Academician at the time of the exhibition. Nathaniel Hone was the elder brother of Samuel Hone, whom Reynolds had known in Italy. Born in Dublin, and largely self-taught, he had started as an itinerant painter in the English provinces and quickly made a name for himself, particularly as a miniaturist on enamel. Having married money in York in 1742, he came to London and established himself in St James's Place. A founder member of the Academy, he had some success as a portrait painter, but he was consumed with jealousy of Reynolds and out of sympathy

with his attachment to the classicism of the Italian Renaissance, inclining more to the style of domestic settings favoured by the Dutch.

The Academy's receiving days for its seventh annual exhibition were Monday and Tuesday 10 and 11 April; the selection was made the following day, and one of the pictures admitted was a large painting by Hone entitled *The Pictorial Conjuror, Displaying the Whole Art of Optical Deception.* The central figure is a bearded magician who sits in an armchair with a young girl leaning against his knee. He is surrounded by the traditional paraphernalia of his trade – an owl, a globe – and with his long white wand he has conjured from the air a clutch of engravings of what appear to be works by Old Masters. These cascade down into a fire at the bottom of the canvas; out of the flames we see emerging a painting in a gilded frame.* The girl looks across at another print, which the conjuror holds in his left hand; the print rests on a large open folio, of which one can just make out the title: ADVANTAG / EOUSCOPIES / FROMVARIOU. / MAS . . .

In the top-left corner of the canvas is a view of St Paul's, and in front of the cathedral anyone looking at the picture today – it hangs in the National Gallery of Ireland in Dublin – sees a group of roisterers drinking at a table. In the days immediately before the opening of the 1775 Exhibition, however, they would have seen something rather different. Modern X-rays reveal a row of prancing, gesticulating nude figures; they are of both sexes, and one of them, possibly a female, brandishes a shell-shaped object – a powder horn, perhaps; or a conch, such as the Tritons blew on as they prepared for battle; or some sort of trumpet.

That was certainly what one of Hone's fellow Academicians took it to be. An outraged Angelica Kauffmann demanded that the painting should be withdrawn, asserting that the figure 'presenting a trompet' was meant to be her. It could hardly be a question of physical likeness – all the figures were very crudely drawn – but there were two suggestive associations. The cavorting figures clearly alluded to the six Academicians – they included Kauffmann and Reynolds – who had recently been in line to decorate St Paul's; Hone may well have been bitter at not being included. And the 'trompet' may well have been a depiction not of a musical instrument but of the sort of hearing-aid used by the President – a sly allusion to the gossip which almost since her arrival in England had linked his name with hers.

There followed several days of intensive – and highly comical – diplomatic activity. Chambers and other members of the Council were deputed to call on Hone, who managed to persuade them that the offending figure was a

* It could be argued that he is summoning the prints from the fire rather than consigning them to it.

6. *Nathaniel Hone's* The Conjuror, *which ruffled numbers of feathers and added not a little to the gaiety of the nation at the time of the Academy Exhibition of 1775.*

man. He also, having twice been denied admittance to Miss Kauffmann's house in Golden Square, took up pen and paper; his letter makes plain that he must have been taken to County Cork as a boy to kiss the Blarney stone:

... I immediately perceived that some busy medlar, to say no worse a name, had imposed this extravagant lye, (of whose making God knows) upon your understanding ... I never at any time saw your works, but with the greatest pleasure, and that respect due to a lady whom I esteem as the first of her sex in painting, and among the loveliest of women in person ...[40]

He was, he declared, prepared so far to alter the offending figure 'that it would be impossible to suppose it to be a woman'. He would be happy to dress it, or paint in a beard. Two letters from Angelica to the Council survive which show that she was not going to be easily mollified:

I have had the honour of a visit from Sir Will Chambers – the purpose of which was to reconcile me to Submit to the exhibition of a Picture which gave me offence ...

She was not specific about the nature of the offence, but she presented the Academy with an ultimatum – if *The Conjuror* went on display she would withdraw her own pictures. She appears subsequently to have softened her position slightly and to have settled for having the offending figure painted out – 'but that same figure must be totally destroyed – and no other put in its place'. By then, however, things had moved on at the Academy and its decision was conveyed to Hone in a letter from Newton, the Secretary:

Sir,
I am desired to acquaint you that a Ballot having been taken by the Council, whether your Picture called the Conjuror should be admitted to the Exhibition, it was determined in the Negative.

You are therefore desired to send for the Picture as soon as it may be convenient.[41]

The Council had been divided, for all that. A draft of a letter preserved in the Library of the Royal Institute of British Architects shows that even after this, Chambers was still trying to persuade Angelica that she was mistaken, and that he took a sour view of the Council's decision:

I can assure you not only from the Evidence of my own Eyes but from the opinion of five or Six other Gentlemen very well Skilld in the Naked that the figure you and your friends have mistaken for a Woman is absolutely a man and designed to represent Mr Newton our Secretary . . .

They have however Judged it expedient to make the cursed picture in question of more consequence than they at first intended by honouring it with a formal exclusion

Hone was not disposed, as he put it, to 'acquiesce supinely under the heavy reproach of having offered a picture unfit for the public eye'. On the opening day of the Academy exhibition, an advertisement appeared in *The Gazetteer and New Daily Advertiser*:

A Picture called the Conjuror Historical, having been sent among others by Mr HONE, to the Exhibition of the Royal Academy, had passed the inspection of the Council of the said Academy, and actually hung up there, was, after detaining it a whole week, rejudged, and refused to be exhibited. Mr HONE has resolved, by the advice of his friends, to make a Publick Exhibition of the said Conjuror, together with upwards of Fourscore Pictures, both Large and small, painted by his own hands, many of which have been in former Exhibitions . . .

Hone mounted his show in a room at 70 St Martin's Lane, opposite Old Slaughter's Coffee House. It was, in effect, the first 'retrospective' in British art history, and with the help of a little judicious puffing ('We have undoubted authority to say, Mr Hone has been offered 150 guineas for this picture by one of the first rate connoisseurs in the kingdom') it attracted a gratifying amount of attention.

Angelica had of course been a sideshow. Hone's main target was the President of the Academy himself. The old wizard shown transmuting Old Master engravings into a contemporary canvas (Hone had cheekily used George White, Reynolds's Ugolino, as his model) is a witty satirical thrust at Reynolds's predilection for ransacking the works of those Old Masters for his own compositions. He had, indeed, handed Hone a marvellous text on the subject only four months previously in his most recent Discourse:

Such imitation is so far from having any thing in it of the servility of plagiarism, that it is a perpetual exercise of the mind, a continual invention. Borrowing or stealing with such art and caution, will have a right to the same lenity as was used by the Lacedemonians; who did not punish theft, but the want of artifice to conceal it.[42]

Contemporary reviewers were quick to see what was intended. A review in the *London Evening Post* on 9 May noted that three of the prints in Hone's picture clearly related to pictures recently exhibited by Reynolds – *Hugolino*, the *Infant Jupiter* and the *Montgomery Sisters*. In a brilliant piece of historical detective work in the catalogue to the Royal Academy's 1986 Reynolds Exhibition, John Newman dug much deeper. He identified references to six other paintings of Reynolds, only one of which had been exhibited at the Academy.[43]

Hone had clearly done his homework, although it is difficult to gauge the extent to which this would have been appreciated by his contemporaries and how much damage it did to Reynolds's reputation. Newman regards the frankness he showed about his working methods in the sixth Discourse as a display of cynicism:

This is not to deny Reynolds the praise he richly deserves for raising British portraiture to an entirely new level of resourcefulness and sophistication. It is rather to admit that he is not in any genuine sense heir to the great tradition he ransacked so freely.[44]

Newman's most intriguing suggestion – tentatively advanced some years earlier by Martin Butlin[45] – concerns the identity of the young girl who leans with such easy familiarity on the conjuror's knee. He points out that she bears a strong resemblance to a bust-portrait of herself in the character of

Hope which Angelica Kauffmann had presented to the Accademia di San Luca in Rome and which had become known in London in February 1775 in a print. The features and posture are certainly very similar; and the theory would lend ironic significance to Hone's protestation to Chambers 'that he had not intended to represent any female figure in that picture, except the child leaning on the conjuror's knee'. If the child was meant to be Angelica, the implication is clear; the conjuror, by drawing her attention to one of his cribbed designs, is leading her astray – artistically, and possibly in other ways too. It is, of course, conceivable that this was what had outraged Angelica in the first place, but that she could not bring herself to make that the ground of her complaint. Either way, the subtle and caddish Hone appears to have had the last laugh.

Reynolds seems to have displayed his usual cat-like ability to avoid direct involvement in the controversy, although it is inconceivable that he did not play a role behind the scenes; it would normally, for instance, have fallen to him to take the chair at the meeting of the Council which decided that the picture should be disqualified. Hone – it was not the first time he had sailed close to the wind in this way* – managed a relaxed and witty reply to the Secretary's letter:

Whether ye Council of ye Academy have done an act of injustice to ye academy by ballotting for ye Admission or non admission of a picture of mine a week after it had been presented & passed ye examination of ye sd council is not my business to determine. I thought as ye Act of Parliament against conjurors had been long since repealed by ye great council of ye nation no after act of ye little council of ye Academy could have availed against a painted Conjuror whose only fault appears that I had taken a deal of pains . . .[46]

The picture remained in Hone's studio until his death in 1784. When his sale took place the following spring, it was knocked down for 92 guineas. One of those present was John Thomas Smith, later Keeper of Prints and Drawings at the British Museum: 'I saw Sir Joshua Reynolds most attentively view the picture of the Conjuror for full ten minutes,' he wrote.†

* In 1770 he had sent for exhibition a picture of Captain Francis Grose, the antiquary, and Theodosius Forrest masquerading as two friars. The treatment was considered to verge on the blasphemous, and he was obliged to modify it by replacing a crucifix with a punch ladle.

† Smith, John Thomas, 1828, i, 155–6. Although Reynolds is not recorded as a buyer at the sale, many drawings from his collection bear Hone's mark. Angelica Kauffmann had by then settled in Rome.

14

Intimations of Mortality

My Lord

I am extremely sorry for the accident which has happened to the Whole-length Picture. The circumstance of the Bar getting loose never happened to me before.

Reynolds was writing towards the end of 1775 to the Earl of Carlisle. His portrait seems not to have been securely crated, and the canvas had suffered in transit to Castle Howard:

The damage that is done can only be reme[died] by lining the Picture; for which it must be sent back again to Town . . . The Painter being luckily still living he can restore it to its original.

I beg leave to return my thanks for Your Lordship kind hint of wishing to see me in the North, a journey which I do not despair of being able to accomplish once more before I dye . . .*

It is the first hint we have that Reynolds was beginning to feel his age. There is further evidence that he was becoming aware of the passing of the years in a letter he wrote a few weeks before his fifty-third birthday to Giuseppe Pelli, the director of the Florentine Gallery (Baretti drafted it for him in Italian). He expressed his pleasure at hearing that his portrait had met with the approval of the grand duke, and that it had been hung in the 'First Room' among the portraits of the most illustrious painters. 'How proud I would be, if I came back to Italy, to see myself among the most celebrated of my profession,' he wrote. 'But, to tell the truth, my time for travel is now over, though that does not prevent me from often imagining myself in Italy.'[1]

He had reached the age when gaps were beginning to appear in the ranks of his older friends. One of the first to go was Admiral Sir Charles Saunders,

* Letter 52. The portrait (Mannings, cat. no. 946, pl. 69, fig. 967) is still in the Castle Howard Collection. It was painted in 1769, but not paid for (150 guineas) until September 1775.

ten years his senior; he had first sat to Reynolds in 1760, fresh from his exploits in conveying Wolfe's army to Quebec. He died, we are told, 'of an access of gout in the stomach', and was buried privately in the Abbey. Another loss was Christopher Nugent, Burke's father-in-law, who had been one of the original members of the Club and had remained stalwart in his attendance. Nugent, a Roman Catholic, was scrupulous in observing the ordinances of his Church, and insisted, at the Club's Friday suppers,* on ordering an omelette. 'I remember,' wrote Mrs Thrale, 'Mr Johnson felt very painful sensations at the sight of that dish soon after his death, and cried, "Ah! my poor dear friend! I shall never eat omelet with *thee* again!" quite in an agony.'[2]

Goldsmith had been four years his junior, but now, with the death of John Parker's wife, Reynolds lost a dear friend who was even younger. Theresa Robinson, the sister of his friend Lord Grantham, had married Parker as his second wife only six years previously. Reynolds had always been made welcome at Saltram on his visits to the West Country, and had seen a great deal of them socially in London; only a few months earlier, in his methodical way, he had recorded in his ledger a payment of 7½ guineas won from Mrs Parker at cards. She died just before Christmas, shortly after the birth of her daughter Theresa. She was thirty years old. The anonymous tribute which appeared in the *Public Advertiser* on 29 December was written by Reynolds:

... Her amiable disposition, her softness and gentleness of manners, endeared her to every one that had the happiness of knowing her ... As she made no parade or ostentation of her virtues, she excited no envy, but if there had existed a being of so black and malignant a disposition as to wish to wound so fair an object it must have searched in vain for a weak part wherein to inflict the venom. Her virtues were habitual, uniform and quiet. They were not occasionally put on, she wore them continually, they seemed to grow to her and be a part of herself, and it seemed to be impossible for her to lay them aside or be other than what she was ...

Some of Mrs Parker's friends took exception to the piece on the grounds that it made no mention of her celebrated grace and beauty. When Reynolds's authorship became known, an acquaintance challenged him: 'I suppose by your silence on that article the lady was plain in her person?' 'Upon my honour,' Reynolds replied, 'I was so wholly engrossed by the idea of her wonderful merit that I totally forgot her exterior charms.'[3] When the tribute was reprinted in the *Gentleman's Magazine* three months later, Reynolds

* The night of meeting had been changed from Monday to Friday in 1772.

added a sentence which repaired the omission: 'Her person was eminently beautiful; but the expression of her countenance was far above all beauty that proceeds from regularity of features only.'[4]

If the loss of friends was painful, the death of criminals excited curiosity. Reynolds was at Tyburn in January to witness the hanging of Robert and Daniel Perreau; the crowd was large and unruly, and one young man was killed in the crush. The twin brothers had been sentenced for forgery. The trial had been controversial, and there were many who believed that Daniel's former mistress, the versatile femme fatale Margaret Caroline Rudd, should have stood on the scaffold with them. It was she who had forged the bonds and promissory notes against which the brothers had borrowed to fund their speculations; Mrs Rudd turned king's evidence, however, and it was her testimony that led to their conviction. Northcote, who also went to Tyburn, told his brother that the case had been hotly debated in the Reynolds household:

Miss Reynolds thinks of nothing else, and thinks them quite innocent and that they have been badly used; of late it has been the subject of everybody's talk. Miss Reynolds went to see the Perreaus' house in Harley Street before the sale and was surprised at the vast elegance of the furniture.[5]

Boswell, arriving in London shortly afterwards, was eager to meet the fascinating Mrs Rudd. Never one to linger unduly over the preliminaries, he had pressed her 'silken hand' to his lips and advised her that love was quite the best remedy for all the troubles she had undergone. Later, excited as much by her notoriety as by her person, he became her lover, and their relationship continued, on and off, for almost a decade. Characteristically, he was unable to resist boasting about his involvement with this 'enchantress' and when he visited Reynolds at Richmond in 1785, he was offered a cautionary lecture on the subject:

Sir Joshua also talked of Mrs. Rudd, and said that if a man were known to have a connexion with her, it would sink him. 'You,' said he, 'are known not to be formally accurate' (or some such phrase) 'in your conduct. But it would ruin you should you be known to have such a connexion.'

Boswell, enclosed as always in a cocoon of ignorance about such matters, was puzzled. 'I did not see,' he wrote in his diary, 'why this should appear so peculiarly bad.'[6]

Another visitor to London in the early months of 1776 was Hannah More, who came up from Bristol eager to find a publisher for her poem 'Sir

Eldred of the Bower'.* Garrick and his wife treated her very much as the daughter they never had, but Reynolds too was attentive, entertaining her and her sister Sarah to dinner in Leicester Fields, escorting them to an auction house, receiving them in his studio. 'I wish you could see a picture Sir Joshua has just finished, of the prophet Samuel,' Hannah wrote to her family:

Sir Joshua tells me that he is exceedingly mortified when he shows this picture to some of the great – they ask him who Samuel was? I told him he must get some-body to make an Oratorio of Samuel, and then it would not be vulgar to confess that they knew something of him. He said he was glad to find that I was intimately acquainted with that devoted prophet . . . I tell him that I hope the poets and painters will at last bring the Bible into fashion, and that people will get to like it from taste, though they are insensible to its spirit, and afraid of its doctrines. I love this great genius, for not being ashamed to take his subjects from the most unfashionable of all books.†

Elizabeth Johnson would have had difficulty in recognizing this description of the brother she had come to regard as godless and uncaring. Reynolds himself would not have thought it necessary to explain to Miss More that he was concerned more with exploring and illuminating the works of the Old Masters than with popularizing the Old Testament.

We get a further glimpse of Reynolds through Hannah More's eyes in the spring when she was his guest at Wick House. The party included the Burkes, the Garricks and Edward Gibbon – the first volume of his *Decline and Fall* had just appeared. 'It was select, though much too large to please me,' she wrote:

We had a great deal of laugh, as there were so many leaders among the patriots, and had a great deal of attacking and defending, with much wit and good humour.[7]

The 'attacking and defending' related to the conduct of the American war. Belatedly, General Gage's political masters had heeded his advice: 'If you think ten thousand men enough, send twenty; if a million is thought enough, give two; you will save both blood and Treasure in the end.' Military

* She succeeded. Cadell gave her 40 guineas for it.
† Roberts, W., i, 71–2. It seems likely that the picture was *The Calling of Samuel* (Mannings, cat. no. 2150, fig. 1692) rather than the *Infant Samuel* (Mannings, cat. no. 2149), which was destroyed by the fire at Belvoir Castle in 1816. It is not clear which of the two was exhibited at the Academy in 1776; to confuse the matter further, the picture was described in some editions of the exhibition catalogue as the *Infant Daniel*.

estimates had soared, and men and supplies were now pouring across the Atlantic. Tom Paine, who had sailed to America two years previously with an introduction from Franklin, had just published his *Common Sense*, declaring that the colonists' link with the king was a delusion and that the only logical end of the course on which they had embarked was independence – advice which they would follow before the summer was out. Northcote records that Reynolds's views on the matter found characteristically oblique expression:

Of the political sentiments of Sir Joshua at that time I may merely state, that during the contest between England and America, so strongly was it the opinion of many persons that we should conquer them in the end, that Sir Joshua, who thought the contrary, actually received five guineas each from several gentlemen under a promise to pay them in return one thousand pounds if ever he painted the portait of General Washington in England, and which he was not to refuse to do in case the General should be brought to him to that intent.[8]

Garrick had recently announced his retirement from the stage. 'I shall shake off my Chains,' he wrote to his brother, '& no Culprit at a Jail delivery will be happier.'[9] He had sold his share of Drury Lane to Sheridan, and was now in the middle of a punishing sequence of farewell appearances. Hannah More wrote to a friend about his performance in *Lear*:

It is literally true that my spirits have not yet recovered from the shock they sustained . . . I called today in Leicester Fields, and Sir Joshua declared it was full three days before he got the better of it.[10]

Reynolds would exhibit his last portrait of Garrick at that year's exhibition – the so-called *Prologue Portrait*, which he sold to the Duke of Dorset two years later and which is now at Knole.*

Reynolds's relations with Johnson came under some strain in the spring of 1776. Not for the first time, Johnson expressed disapproval of his friend's drinking habits. 'Reynolds has taken too much to strong liquor,' he had written to Boswell a year previously, 'and seems to delight in his new character.'[11] Now, one evening in April, Boswell found himself in the company of both men at the Crown and Anchor tavern, together with Bennet Langton and two fellow Scots – the banker Sir William Forbes, who

* Mannings, cat. no. 705, fig. 1139. Northcote mistakenly believed that this was the portrait Reynolds painted for the Thrales, but the Streatham portrait, and those now at the Garrick Club, the Folger Shakespeare Library in Washington and in the Royal Collection are all studio replicas.

was sitting to Reynolds at about that time and subsequently wrote a *Life* of Beattie, and a lawyer called William Nairne, later a judge of the Court of Session. The conversation turned to 'whether drinking improved conversation and benevolence'. When Reynolds maintained that it did, Johnson immediately contradicted him:

Sir Joshua said the Doctor was talking of the effects of excess in wine; but that a moderate glass enlivened the mind, by giving a proper circulation to the blood. 'I am (said he,) in very good spirits when I get up in the morning. By dinner-time I am exhausted; wine puts me in the same state as when I got up; and I am sure that moderate drinking makes people talk better.' JOHNSON. 'No, Sir; wine gives not light, gay, ideal hilarity; but tumultuous, noisy, clamorous merriment. I have heard none of those drunken, – nay, drunken is a coarse word, – none of those *vinous* flights.' SIR JOSHUA. 'Because you have sat by, quite sober, and felt an envy of the happiness of those who were drinking.' JOHNSON. 'Perhaps, contempt.'[12]

Much earlier in his career Reynolds had painted Elizabeth Chudleigh, the daughter of the Lieutenant-Governor of Chelsea Hospital, who had been maid of honour to Augusta, Princess of Wales.[13] She was very good-looking, and renowned for the freedom of her behaviour; she had once appeared at a subscription masquerade at Ranelagh as Iphigenia – 'so naked', Horace Walpole wrote to Mann, 'that you would have taken her for Andromeda'.[14] She was for many years the mistress of the Duke of Kingston, and in 1769 her impatience to become his duchess led her to cut corners in trying to extricate herself from a much earlier (but secret) marriage to Augustus Hervey, later the Third Earl of Bristol. Which was why, in April 1776, she found herself arraigned before her peers in Westminster Hall on a charge of bigamy.

The trial ran on until two days before the opening of the Academy's exhibition, and the inclusion of the playwright Samuel Foote among the guests at the annual dinner is agreeable evidence of Reynolds's strong sense of loyalty to his friends – even those as tiresome and unpredictable as Foote could be.* The previous year he had written a play called *A Trip to Calais* in which the duchess was ridiculed in the guise of a character called Lady Kitty Crocodile.† When an attempt to buy Foote off failed (she is said to

* 'Having no good opinion of the fellow, I was resolved not to be pleased,' Johnson told Boswell, describing his first encounter with Foote. 'I went on eating my dinner pretty sullenly, affecting not to mind him. But the dog was so very comical, that I was obliged to lay down my knife and fork, throw myself back upon my chair, and fairly laugh it out. No Sir, he was irresistible' (Boswell, 1934–50, iii, 69–70).

† The duchess had retreated to Calais when the charge of bigamy was first brought against her.

have offered him £1,600), the duchess resorted to friends in high places, and the Lord Chamberlain refused the play a licence. Foote had much the better of the somewhat ludicrous correspondence which ensued between them, but the duchess then induced a disreputable Irish clergyman called William Jackson, who was the publisher of the *Public Ledger*, to float allegations that Foote had attempted extortion – and that he was homosexual. That the town was awash with these rumours was to Reynolds a matter of indifference. Foote took his place at table with the Academy's other guests.*

As public spectacle, the Kingston trial in Westminster Hall rivalled Garrick's farewell performances at Drury Lane. The *ton* was there in force – Hannah More (who was taken along by Mrs Garrick) picked out Georgiana, the young Duchess of Devonshire, and the lovely Countess of Derby, 'with their work-bags full of good things' to keep them from feeling peckish during the proceedings. Prurient interest was not confined to the English upper classes; foreigners drawn to London at the time included the 25-year-old Marchesa Paola Castiglioni-Litta. She also found her way to Leicester Fields, and sat to Reynolds; an entry in his ledger for September 1776 records a payment of 35 guineas from 'Marchioness Castiglione, of Milan'.†

The 1776 Exhibition opened two days after the conclusion of the Kingston trial (the duchess had been found guilty but escaped branding on the hand). Reynolds again sent thirteen pictures, and they included the striking full-length of the Duchess of Devonshire, now in the Huntington Art Gallery, which had been painted for the sitter's father, Lord Spencer.‡ Georgiana had married the taciturn duke on her seventeenth birthday, two years earlier. It was hugely unfashionable for a husband and wife to be seen too much in each other's company. While he spent half the night at the card tables at Brooks's, she whirled from one rout and assembly to another and had quickly become a byword for reckless frivolity. 'The excess to which pleasure and dissipation are now carried among the *ton* exceeds all bounds,' sniffed the *Morning Post*:

* Three months later a discharged coachman of Foote's (procured, it is thought, by Jackson) laid a charge of homosexual assault against his former employer. He was tried before Lord Mansfield and a special jury and acquitted. His health was undermined by the ordeal. He died the following year in Brighton on his way to winter in the south of France.

† Mannings, cat. no. 320, fig. 1728. The marchesa (1751–1846), daughter of the genealogist Pompeio Litta, was the wife of the Marchese Castiglioni Stampa. She presided over a celebrated literary salon and was the inspiration for *Il dono*, one of the best-known odes of the poet Giuseppe Parini.

‡ Ibid, cat. no. 327, pl. 77, fig. 1166. It was almost certainly intended as a companion piece to the portrait of the duchess's younger brother, Lord Althorp, which was also exhibited (Mannings, cat. no. 1675, pl. 76, fig. 1128).

The duchess of D—e has almost ruined her constitution by the hurrying life which she had led for some time; her mother, Lady S—r has mentioned it with concern to the Duke, who only answers, 'Let her alone – she is but a girl.'*

Reynolds painted her with her hair dressed high and adorned with pearls and white and pink feathers. It was Fanny Abington who had first piled up her hair into a ziggurat, but Georgiana's talent for excess allowed her to go one better and create the three-foot hair tower, a style which meant that one could only ride in a carriage if one sat on the floor. She also showed great ingenuity in decorating the summit of this confection – waxed fruit, stuffed birds, miniature ships in full sail were all called in aid.

Another sumptuous full-length of a young woman was that of Mrs Lloyd, who had married an officer in the Foot Guards the previous year and is shown carving his name on the bark of a tree, a device derived from Italian baroque painting and familiar to theatre-goers from such plays as *As You Like It*.[15] She is dressed in what the *Morning Post* described, somewhat prosaically, as 'a loose fancy vest' – one of those classically inspired gowns, that is to say, so much favoured by Reynolds, although in this case it does cling alluringly to her hips and thighs. Reynolds had not forgotten an injunction he had laid on the students in his very first Discourse – 'let their ambition be directed to contend, which shall dispose his drapery in the most graceful folds, which shall give the most grace and dignity to the human figure'.[16] As with Georgiana, the hair is piled high on the head. Reynolds's nephew, Samuel, was clearly much struck by the fashion and described it with mathematical precision to his sister. 'The Ladies' heads,' he wrote, 'without stretching an inch, were a yard high reckoning from their chin, or their lowermost hair behind.'[17]

A very different portrait was that of Omai,[18] the young South Sea Islander brought to England two years previously in the sister-ship of Captain Cook's *Resolution* – the task of teaching him English on board had been assigned to a young lieutenant called Jem Burney, the brother of Fanny. Omai was lionized in society and fêted by the literati; he was presented at court, where he addressed a startled George III as 'King Tosh'.† It pleased those who

* 11 March 1776. The duchess, in fact, was every bit as ardent a gambler as her husband. 'Gaming among the females at Chatsworth has been carried to such a pitch,' the *Post* reported later in the year, 'that the phlegmatic duke has been provoked to express at it and he has spoken to the duchess in the severest terms against a conduct which has driven many from the house who could not afford to partake of amusements carried on at the expense of £500 or £1000 a night' (*Morning Post*, 4 September 1776).

† His way with English words was a constant source of amusement. Lord Sandwich's butler was 'King of the Bottles'; when Lord Townshend offered him a pinch of snuff, the reply was, 'No tank you, Sir. Me nose be no hungry.'

pressed round him in the drawing rooms of the capital to think that they had to do with an example of Rousseau's 'noble savage'.

Reynolds painted him in a long white robe and a turban, which makes him look as if he came from Rajasthan rather than Tahiti, but the picture has been universally admired to this day. 'For a memorable moment,' wrote Joseph Burke in the volume he contributed to *The Oxford History of English Art*, 'the classical and romantic tendencies of the eighteenth century are fused in perfect reconciliation.'[19]

Reynolds seems to have painted the portrait for his own interest; it remained in his studio, and no payment is recorded. Omai was his guest on a number of occasions, and Fanny Reynolds tells a comical story about his being the unwitting cause of a breach between Johnson and Baretti. The Italian, it seems, was twice beaten at chess by Omai at Reynolds's house, something which he found altogether too mortifying to confess.

'Do you think,' said he to Johnson, 'that I should be conquered at Chess by a savage?' 'I know you were,' says Johnson. Baretti insisting upon the contrary, Johnson rose from his seat in a most violent rage, 'I'll hear no more.' On which Baretti in a fright flew out of his House, and perhaps never entered it after.*

Quite the most entertaining picture exhibited by Reynolds that year was one entitled *Portrait of a Boy in the Character of Harry the Eighth*.[20] Henry VIII was a popular masquerade costume at the time, and the boy was the four-year-old son of Lady Crewe, the prominent Whig hostess, who herself sat to Reynolds on at least three occasions. Horace Walpole was full of praise: 'Is not there humour and satire in Sir Joshua's reducing Holbein's swaggering and colossal haughtiness of Henry 8th. to the boyish jollity of master Crewe?'[21] There was indeed. And possibly also a show of defiance on the subject of borrowing – a spirited riposte to the sort of criticism levelled at him the previous year by Hone in *The Conjuror*.

Shortly after the close of the exhibition, Reynolds lost the services of Northcote, who was now twenty-nine and eager to visit Italy. His letters to his brother make it clear that he had been thinking of leaving for some months. 'I have made as many marks with chalk on a stick as I have days to remain here and with much pleasure do I rub one out every morning,' he had written to Samuel in February:

* Hill, G. B., ii, 292–3. Fanny was told the story by Johnson's companion, Mrs Williams, who witnessed the dispute. Mrs Thrale, in a marginal note to the 1816 edition of the *Life*, wrote: 'When Omai played at Chess & at Backgammon with Baretti, everybody admired at the Savage's good Breeding, & at the European's impatient Spirit' (Boswell, 1934–50, ii, 469).

As to staying with Sir Joshua he never gave more than a hundred guineas and their board to anyone, and it will be a sad story for me if I cannot get more than that, besides being employed so much more to my liking by painting heads instead of satin gowns and silk curtains, which I hate because anybody could do that.[22]

This presumably meant even more painting of satin gowns and silk curtains for his fellow pupil William Doughty, who had come to Reynolds from York the previous year on the recommendation of William Mason. He enrolled at the Academy schools, and remained with Reynolds for three years. He exhibited at the Academy during that time; his style was modelled closely on that of Reynolds; he showed a good deal of promise, but it was not given to him to fulfil it. In 1780 he married one of Reynolds's domestic servants and set out for India; he was taken ill during the voyage and died at Lisbon at the age of twenty-five.

Reynolds had chosen the place in Westminster Abbey for the monument to Goldsmith. Johnson had been at work on the epitaph, and in the middle of May he sent it to Reynolds:

Read it first yourself, and if You then think it right, show it to the Club. I am, you know, willing enough to be corrected. If you think any thing much amiss, keep it to yourself, till we come together. I have sent two copies, but prefer the card.[23]

He was not best pleased to hear some weeks later from Fanny that neither copy was to be found, and this earned Reynolds an uncharacteristically stiff note:

Sir: Miss Reynolds has a mind to send the Epitaph to Dr. Beattie, I am very willing, but having no copy, cannot immediately recollect it. She tells me you have lost it. Try to recollect and put down as much as you retain; you may perhaps have kept what I have dropped. The lines for which I am at a loss, are something of *Rerum civilium sivè naturalium*. It was a sorry trick to lose it, help me if you can.[24]

He added a postscript, which suggests an additional reason for his gruff tone – 'The Gout grows better, but slowly.' Too slowly, it seems, for him to be present at dinner in Leicester Fields shortly afterwards when the epitaph was discussed at length. It was a distinguished company – Dr Barnard, Burke, Joseph Warton, Colman, Sheridan and Gibbon were all present. Several changes were suggested, and it was felt that the inscription would be better in English than Latin. The question was, who could summon the courage to put this to the great man? Eventually someone hit on the idea of

ROUND ROBIN, *addressed to* SAMUEL JOHNSON, L.L.D. *with* FAC SIMILES *of the Signatures.*

We the Circumscribers, having read with great pleasure, an intended Epitaph for the Monument of Dr. Goldsmith, which considered abstractedly, appears to be, for elegant Composition and Masterly Stile, in every respect worthy of the pen of its learned Author: are yet of opinion, that the Character of the Deceased as a Writer, particularly as a Poet, is, perhaps, not delineated with all the exactness which Dr. Johnson is Capable of giving it — We therefore, with deference to his Superior Judgement, humbly request, that he would at least take the trouble of revising it; & of making such additions and alterations as he shall think proper, upon a further perusal: — But if We might venture to express our Wishes, they would lead us to request, that he would write the Epitaph in English, rather than in Latin: As We think that the Memory of so eminent an English Writer ought to be perpetuated in the language, to which his Works are likely to be so lasting an Ornament, Which we also know to have been the opinion of The late Doctor himself.

London Published as the Act directs, 10 April 1791, by Charles Dilly.

7. *The round robin addressed to Johnson in 1776 when some of his friends thought the Latin epitaph he had written for Goldsmith was susceptible of improvement. Reynolds was deputed to carry it to him. Johnson declared himself open to any suggestions so far as sense was concerned, but said that 'he would never consent to disgrace the walls of Westminster Abbey with an English inscription'.*

a round robin. Barnard drew up a humorous address, Burke took out some of the jokes to protect them from the charge of levity and Reynolds agreed to be the messenger.

This 'Remonstrance to the Monarch of Literature' as Boswell termed it, was received 'with much good humour':

He desired Sir Joshua to tell the gentlemen, that he would alter the Epitaph in any manner they pleased, as to the sense of it; but *he would never consent to disgrace the walls of Westminster Abbey with an English inscription.*

He snorted at the sight of Warton's name among the 'circumscribers', as they described themselves. 'I wonder that Joe Warton, a scholar by profession, should be such a fool,' he told Reynolds, and he added, 'I should have thought Mund Burke would have had more sense.' Later, when someone tried once more to argue in favour of English, Johnson silenced him with, 'Consider, Sir; how you should feel, were you to find at Rotterdam an epitaph upon Erasmus *in Dutch*!' Unsurprisingly, the original Johnsonian version was engraved upon Goldsmith's monument without amendment.*

George Romney had returned to London the previous summer and was now established in the rather grand house and studio in Cavendish Square which had belonged to Francis Cotes. He had profited greatly from his two years in Italy; he is said to have carried a letter to the Pope from the Duke of Gloucester which won him the privilege of having scaffolding erected in the Vatican *stanze*. Although he did not exhibit, he quickly began to attract fashionable attention, partly because he kept his prices appreciably lower than those of either Reynolds or Gainsborough. He also worked very quickly. His sitters' books show that between 1776 and 1795 he attracted 1,500 sitters. Some days have as many as six or seven appointments; like Reynolds, he sometimes worked on a Sunday. He paid great attention to the surface qualities of skin and hair and showed skill in capturing the set of a subject's mouth or the tilt of their head.

Years later, Lord Thurlow, who had been Lord Chancellor, told the society portrait painter John Hoppner that in his time there were two factions, 'one the Reynolds faction – the other the Romney faction. For his part He was of the Romney faction.'[25] Hoppner had responded by speaking warmly of the portrait Reynolds had painted of Thurlow:

* Boswell, 1934–50, iii, 82–5. Boswell was not present at the dinner, having recently returned to Scotland. His informant was Sir William Forbes.

His Lordship did not seem to like it & said it was once well but was afterwards spoiled. Hoppner observed that Sir Joshua was always striving for excellence & sometimes failed in the attempt. 'Sir Joshuas motive was no excuse for awkwardness.'

Thurlow was presumably referring to Reynolds's use of fugitive colours. The true reason for his preference may well have been that Romney, by placing less emphasis on his swarthy complexion and dark bushy eyebrows, made him look more handsome and less forbidding. The Reynolds portrait,[26] now at Longleat, is, in fact, one of his finest pictures, and when it was shown at the Academy in 1781 was held to be a striking likeness. 'The Lord Chancellor,' wrote the critic of the *Morning Herald*, 'seems to breathe, to speak, and we almost pause to hearken him.' The likeness was not purely physical. Reynolds, with a subtlety that was beyond Romney, managed to convey in paint what Charles James Fox wittily expressed in words: 'No man could be so wise as Lord Thurlow looked.'

Reynolds knew well enough that he was as vulnerable to fashionability as the next man. Northcote, reminiscing in old age to James Ward about his old master, said that Romney 'ran away with the world in a great measure from him':

To be sure, he was able to bring them back again in some degree by the beautiful things he did, but still he never after had the run he had at first. But Sir Joshua acted like a prudent man, for whilst the run lasted he feathered his nest, and then didn't care; it also allowed him time for those beautiful fancy pictures, which have so charmed the world ever since.*

Reynolds could polish off the face of a portrait in three or four one-hour sittings, but those 'beautiful fancy pictures' were an entirely different matter; when he was at work on them, his painting room became his laboratory:

I have known him to work days and weeks on his fancy subjects, on which he could practice every experiment at pleasure, while numbers of his portraits remained unfinished, for the completion of which the most earnest solicitations were made; and when he also well knew he should have received his price for them the moment they were sent home. Such was his delight in working on those fancy subjects that he was content to indulge it even at the expence of his immediate interest.[27]

* Fletcher, 178. Northcote was echoing something said to him by the sculptor Joseph Wilton: Reynolds, he thought, 'was the only eminent painter that had been able to call back the public to himself after they had grown tired of him, and which he had done more than once' (Northcote, ii, 127).

Reynolds's subject pictures constitute only a small part of his *œuvre* – few more than 200 have come down to us, as against almost 2,000 portraits – and until recently they received scant attention.*

Did the first President of the Royal Academy dabble occasionally in pornography? Not a question heard all that frequently above the tinkling of the teacups in the Friends' Room at Burlington House, perhaps, but one which does arise from a consideration of Reynolds's subject pictures, particularly of certain paintings in the fancy-picture genre – *Mercury as a Cut Purse*, for example, or *Cupid as a Link Boy* – which are highly charged with sexual innuendo.

The word pornography would not enter the English language until half a century or more after Reynolds's death,† but erotic art is even older than erotic literature – witness some of the paintings and carved reliefs in the paleolithic caves of southern France. The generally libertine spirit of the European Enlightenment, worldly and freethinking, stimulated a heightened interest in eroticism. Salacious fiction published in the middle years of the century had included Diderot's *Les Bijoux indiscrets* and Voltaire's *La Pucelle* in France and John Cleland's *Memoirs of a Woman of Pleasure* in England. In painting, the fascination which sexual matters held for Hogarth is plain from his two *Before* and *After* series which chronicle the violation of a young girl. Sexual themes also informed the design of jewellery and *objects d'art*; a small snuff-box made in Birmingham around 1765, for instance – it is now in the Wolverhampton Art Gallery – has a false lid which shows a soldier copulating with a nun on an altar.

In France, Boucher, court painter to Louis XV, showed an abiding interest in the sexual adventures of Venus. It was for the king's mistress, Madame de Pompadour, that he painted the set of four *Loves of Venus* now in the Wallace Collection in London; she also commissioned from him the *Venus, Mercury and Cupid*, now in Berlin, in which Mercury is depicted with an erection. The king, for his part, presented her with six explicit rustic scenes by Boucher; another of the king's mistresses, Louise O'Murphy, is thought to have been the subject of Boucher's *Reclining Nude*, now in Munich; her provocatively displayed buttocks are widely considered one of the most erotic images in Western art.

* Martin Postle's *Sir Joshua Reynolds: the Subject Pictures* (Cambridge) did not appear until 1995.

† In France, on the other hand, Restif de la Bretonne had coined the word *pornographe* in 1769 – although he did so in the title of a book advocating the establishment of state-run brothels as a means of cementing social stability (*Le Pornographe ou Idées d'un honnête homme sur un project de règlement pour les prostituées*).

We do not know whether his visits to the Vatican allowed Reynolds to see the notorious *History of Venus* frescoes with which Raphael adorned Cardinal Bibbiena's bathroom.* What is known is that the ruins of Pompeii had only recently yielded up their secrets during the time he was in Italy. Wall paintings such as that in the house of the Vettii, where a god is shown weighing his enormous penis in the scales against an assortment of fruit and crops, appealed strongly to members of the Society of Dilettanti, whose enthusiasm for erotica was well known. Nor was such enthusiasm confined to rich young *milordi* making the Grand Tour; when Joseph Nollekens was in Naples in the 1760s, he made a terracotta copy of the celebrated Pompeii sculpture of Pan indulging in intercourse with a goat.†

Mercury as a Cut Purse and *Cupid as a Link Boy* have as their theme sexual adventure. They were painted as pendants and bought by the Duke of Dorset in 1774. John Frederick Sackville had succeeded to the title at the age of twenty-four and had gone off almost at once to Italy, taking with him his physician, his current mistress, Nancy Parsons,‡ and a train of singers and actors. It was an eventful Grand Tour; his Piedmontese courier was shot dead by the ferryman as they crossed the Garigliano and later he is said to have retrieved Miss Parsons just as she was about to be abducted from a masked ball by a Venetian nobleman.

Sackville was a vain man, and not over-endowed with intelligence. In England he was noted for his passion for cricket – he once lost a 500 guinea bet on the result of a match – and his devastating good looks. 'I have always looked on him as the most dangerous of men,' wrote the Duchess of Devonshire (she would later be one of his lovers). His year in Italy was devoted mainly to gallantry and to the acquisition of works of art. He bought a number of ancient marbles and a great many paintings, often at very high prices; these included a *Madonna and Child* supposedly by Raphael, 'scarce a foot square', for which he paid £300.[28]

He had sat to Reynolds in 1769 and again in 1776, and would become not only a particular friend but one of his most important patrons. He also became active in promoting Reynolds's interests abroad. In the 1780s, when he was ambassador to Paris, he bought *Venus and the Piping Boy* on behalf

* They were covered with whitewash in the nineteenth century and are now off limits to visitors.

† The original is now in the Museo e Gallerie Nazionali di Capodimonte, Naples. Nollekens's copy is in the British Museum.

‡ Miss Parsons, the daughter of a Bond Street tailor, had previously been the mistress of the Duke of Grafton, a liaison which had attracted the attention of Junius: 'The Prime Minister of Great Britain,' he wrote in one of his letters, 'in a rural retirement and in the arms of faded beauty, has lost all memory of his sovereign, his country, and himself.' She later married Viscount Maynard.

of a French marquis, who paid 400 guineas for it.* Reynolds presented Dorset with a copy of the self-portrait he had sent to the Uffizi,† and at the time of the duke's death in 1799 there were twenty of Reynolds's pictures in the collection at Knole, the Sackville family seat.

Reynolds manages to cram an extraordinary amount of wittily erotic allusion into both *Cupid* and *Mercury*. Link boys were street arabs who lit people through the London streets with their torches of flaming pitch – Hogarth included one in *A Night Encounter*, painted about 1740, which depicts a late-night brawl: Sir Edward Walpole, emerging from a tavern, has fallen into the gutter, and is defended by Lord Boyne from the assault of a watchman.[29] Like Cupid, link boys had a reputation for being light-fingered; some of them, as a coarse poem of Lord Rochester's from 1680 makes plain, supplemented their earnings by operating as bisexual rent boys:

> Nor shall our love fits, Chloris be forgot,
> When each the well looked link boy strove to enjoy,
> And the best kiss was the deciding lot
> Whether the boy fucked you, or I enjoyed the boy.[30]

Reynolds's Cupid is a sad-faced urchin, tousle-headed and out at elbow. His torch, which his chubby hand can barely encompass, is plainly phallic; a burning brand was a very old emblem of lust, employed by Jacopo Bassano in the sixteenth century and later by members of the Utrecht School. The link boy's left hand rests on his right forearm in an obscene gesture common to many cultures.‡ On a nearby rooftop, two alley cats are engaged in a mating ritual.

Mercury, the messenger of the gods, was also the god of commerce; in Roman art he generally holds a caduceus and a purse. In *Mercury as a Cutpurse*, Reynolds depicts the god as a mousy-faced little pickpocket. Under the winged hat, his large eyes are fixed on the ground in glum vacancy; the commerce in which he has been engaged is clearly sexual. He holds what was known as a wallet purse, a closed tube of netted silk with a slit in the centre. Its usefulness was not confined to carrying money – for those who could afford such objects they sometimes served as condoms. The contents

* See p. 436 below. The painting (Mannings, cat. no. 2176) is now in the National Trust Collection at Polesden Lacey. Dorset may also have acted as intermediary in acquiring a picture for Louis XVI (see Postle, 205).

† That, at least, is what an inscription on the back of the portrait says (it is still at Knole). An entry in the duke's account book for 1778, however, records a payment to Reynolds of £37 16s for a self-portrait (Mannings, cat. no. 17, fig. 1150).

‡ For instance, in Hungarian, a language with impressive reserves of gross verbal aggression, it translates as 'A horse's prick up your arse'.

of this purse have been spent; loosely held in the child's left palm, it droops limply down on either side.

It is impossible at this distance of time to establish much about the genesis of these pictures. We cannot know whether they flowed directly from Reynolds's own fancy or whether in some instances he was catering to what he knew of the predilections of his patrons. Did Dorset's catholic sexual tastes extend to boys? What did the many women in his life think of his exotic taste in pictures? Years later, during his time at the Paris embassy, the anglophile Marie-Antoinette was rumoured to be one of his conquests, but his mistress-in-residence at the time he acquired *Cupid* and *Mercury* was the Italian dancer Giovanna Baccelli.*

One of Dorset's later acquisitions also has a strong sexual charge. *Lesbia*,[31] which he bought from Reynolds in 1786, shows a bright-eyed, voluptuous-looking young girl with a sparrow perched on her shoulder; Lesbia was the name Catullus gave to his lover Clodia, and one of her tribulations, recorded in the twenty-five poems devoted to her, was the loss of a pet sparrow. Reynolds depicts her feeding the bird with her right hand; her left arm rests lightly on the top of an empty cage. An animal or a bird in a cage symbolized captive love – Reynolds would have known that from his study of Jacob Cats many years earlier; the humble sparrow, popularly believed to be a bird of outstandingly industrious breeding habits, had long been an emblem of lechery. Reynolds may well have been familiar with Greuze's celebrated *Une jeune fille qui pleure son oiseau*, exhibited at the 1765 Salon.[32] This too derives from Catullus; Diderot, in a celebrated text, analysed it as a metaphor for the loss of virginity.

It is important not to become too owlish in such matters and to load these pictures with a weight of symbolic significance Reynolds never intended them to have. Even the President of the Royal Academy is permitted occasionally to have his tongue in his cheek. Important, too, to remember that he lived well before the age of Freud. That pictures like *Cupid* and *Mercury* had as their main purpose the sexual arousal of the beholder must therefore be regarded improbable.

Nor do they constitute any sort of social commentary on the life of the urban poor, although it was on the streets of London that he found his models.† He was 'for ever painting from beggars', Northcote told Ward:

* Dorset commissioned portraits of her from both Gainsborough and Reynolds (Mannings, cat. no. 90, fig. 1371). He also installed a life-size nude statue of her in the attitude of the Borghese Hermaphrodite. A native of Venice, her real name was Zanerini. She bore Dorset a son, who became an ensign in the army and married a pastrycook's daughter.
† Gainsborough, too, often came across the models for his pictures of children in the streets or fields.

Good G—d! how he used to fill his painting room with such malkins; you would have been afraid to come near them, and yet from these people he produced his celebrated pictures. When any of the great people came, Sir Joshua used to flounce them into another room until he wanted them again.[33]

One of the attractions of painting from models of this sort was that Reynolds had complete control over them. 'Being dependent people,' as Northcote put it, 'they were quiet and gave no trouble.' Serendipity could also claim a role, and when it did, Reynolds was quick to improvise:

When the Beggar Infant who was sitting to him for some other picture, during the sitting fell asleep, Reynolds was so pleased with the innocence of the object, that he would not disturb its repose to go on with the picture on which he was engaged, but took up a fresh canvas, and quickly painted the child's head as it lay before it moved; and as the infant altered its position, still in sleep, he sketched another view of its head on the same canvas.*

Next to nothing is known of these child models used by Reynolds for his fancy pictures, but it is just possible that the Victorian painter William Powell Frith came across one of them many years later. The evidence is not conclusive, but the passage in Frith's *Autobiography and Reminiscences*, in which he recounts a conversation with an old man he wanted to employ as a model in the late 1830s, makes intriguing reading. Frith inquired whether he had ever modelled before:

'Yes, once, when I was a boy. A deaf gent done it; leastways he had a trumpet, and I shouted at 'im.'

'A deaf man?' (Gracious goodness, could it be Reynolds!). 'What kind of man was he – where did he live?'

'What kind of man? Ah, it's a vast of years ago, you see, and I didn't take particular notice. Civil spoken he was, and gave me a kind of crook to hold.'

The old man was not easily persuaded to sit for Frith:

You'll want my coat and waistcoat and shirt off, as the deaf gent did, and you see I was young then and didn't mind it; but I should get the rheumatics or something. No, I couldn't do it.'

* Northcote, i, 284–5. Northcote says that this was the origin of *Children in the Wood* (Mannings, cat. no. 2044, fig. 1598). He must have heard the story from Reynolds himself or from a third party, because the picture was exhibited at the Academy the year before Reynolds took him on as a pupil.

'Bless the man! I don't want to take off any of your clothes. I only want just to take your likeness – that is, the likeness of your face.'

'Oh, is that all? Then why did the old gent make me take off all but my trousers, and give me a crook to hold? There was a lamb in the picture as the old gent done.'*

This strongly suggests that the young Ennis, as he was called, had been the model for the various paintings now known as *Child Baptist in the Wilderness*. The prime version, destroyed in the Belvoir fire of 1816, was almost certainly the picture exhibited by Reynolds at the 1776 Exhibition as *St John*.[34] The lamb and the crook are there; the infant Baptist sits lopsidedly on a rock, legs splayed wide, one arm flung dramatically upwards – the gesture of a gospel preacher haranguing a sluggard congregation. The mouth is wide open ('I shouted at 'im') – the voice of one crying in the wilderness? The child is certainly wearing very little – even less than the trousers the deaf old gent had let him keep: an indeterminate garment of minimal proportions is draped over one leg and falls between his thighs.

The business of the Academy continued to take up a good deal of Reynolds's time. Francis Hayman had died early in 1776, and his place as Librarian was taken by Richard Wilson, an appointment which, as the Academy's first historian put it, 'happily rescued him from utter starvation'.[35] He proved a stern guardian of what had been entrusted to him. 'Don't paw the leaves, sirrah,' he said to one student. 'Have you got eyes in your fingers, boy?'[36]

Wilson never enjoyed the success which his outstanding talents as a landscape painter deserved, and he became crabbed and bitter. Although he and Reynolds had been thrown together during their time in Rome, they were no longer particularly close. Northcote has a story about Reynolds joining the company at the Artists' Club at the Turk's Head one evening and waxing enthusiastic about a Gainsborough landscape he had just seen – he was, he declared, 'certainly the first landscape painter now in Europe'. He had possibly not noticed that Wilson was present, but his inattention earned him a tart rejoinder: 'Well, Sir Joshua, and it is my opinion that he is also the greatest portrait painter at this time in Europe.' Reynolds accepted the rebuke, and immediately apologized.[37]

The Council of the Academy met a dozen or more times in the course of each year, and the President was rarely absent from the chair. The meeting in October 1776 was an important one; Chambers, not usually

* Frith, ii, 104, 108. Frith (1819–1909) began as a portrait painter, but later established his reputation with literary and historical subjects. He was much vilified by the Pre-Raphaelites. Unusually, he had to be persuaded to take up art by his parents; he himself had wanted to be an auctioneer.

over-assiduous in his attendance – he was a man with many irons in the fire – presented his plans for the Academy's new schools and exhibition rooms in the new Somerset House and secured the Council's approval.

The Academy was to benefit enormously from the decision to centralize numerous offices of government in the new Somerset House. Two years previously George III had cannily consented to the demolition of the old palace – in exchange for the settlement of Buckingham House on Queen Charlotte as her official dower house. Chambers, who had been intriguing to secure the commission for some time, had been appointed architect for the project in late 1775. It was a spacious six-acre site, although there were constraints, notably the requirement to keep to the plan of the old Strand front – a protruding neck of land enclosed on either side by private buildings. The architectural challenge paled into insignificance, however, beside the politics of inter-departmental allocation. Space had to be found for Hawkers and Pedlars, Privy Seal and Signet, Hackney Coach and Barge Masters. Audit, Salt, Clerk of the Estreats and the Duchies of Cornwall and Lancaster all jostled for precedence; the navy had to be allotted the best part of two whole wings. The Academy was to be housed in the Strand block to the west of the vestibule, the Royal Society and the Society of Antiquaries to the east.

Reynolds's Discourses were now firmly established as biennial events. He began the seventh, delivered in December 1776, by reminding his hearers of the ruling idea that he had been at pains from the start to impress on them above all others:

I wished you to be persuaded, that success in your art depends almost entirely on your own industry; but the industry which I principally recommended, is not the industry of the *hands*, but of the *mind*.[38]

A painter, he tells his audience, 'stands in need of more knowledge than is to be picked off his pallet', and he catalogues a number of desirable accomplishments:

Every man whose business is description, ought to be tolerably conversant with the poets . . .

He ought not to be wholly unacquainted with that part of philosophy which gives an insight into human nature . . .

He ought to know *something* concerning the mind, as well as *a great deal* concerning the body of man . . .

Then, a much-quoted passage which is purely autobiographical:

It is not necessary that he should go into such a compass of reading, as must, by distracting his attention, disqualify him for the practical part of his profession, and make him sink the performer in the critick. Reading, if it can be made the favourite recreation of his leisure hours, will improve and enlarge his mind, without retarding his actual industry. What such partial and desultory reading cannot afford, may be supplied by the conversation of learned and ingenious men, which is the best of all substitutes for those who have not the means or opportunities of deep study.

This seventh lecture is more discursive than many of the Discourses and of looser construction. The voice is that of Reynolds the industrious rationalist, critical of the 'mysterious and incomprehensible language' in which discussion of the arts is often conducted, scornful of those 'towering talkers' who would deny that genius and taste can have any connection with reason or common sense:

If, in order to be intelligible, I appear to degrade art by bringing her down from her visionary situation in the clouds, it is only to give her a more solid mansion upon the earth.

To poetry he is prepared to be indulgent; to a poet he will allow a certain degree of obscurity – 'when his meaning is not well known to himself', he adds slyly:

But when, in plain prose, we gravely talk of courting the muse in shady bowers; waiting the call and inspiration of Genius, finding out where he inhabits, and where he is to be invoked with the greatest success; of attending to times and seasons when the imagination shoots with the greatest vigour, whether at the summer solstice or the vernal equinox; sagaciously observing how much the wild freedom and liberty of imagination is cramped by attention to established rules; and how this same imagination begins to grow dim in advanced age, smothered and deadened by too much judgment; when we talk such language, or entertain such sentiments as these, we generally rest contented with mere words, or at best entertain notions not only groundless, but pernicious.

Not difficult, in passages like these, to see the roots of that uncomprehending hostility to Reynolds that would well up in William Blake.* And easy to identify Reynolds's indebtedness to the 'learned and ingenious men' among whom he himself spent much of his leisure time. To one of them in particular

* See p. 431 below. Blake was only nineteen at this time, and still serving his apprenticeship to the engraver Basire. He would not exhibit at the Academy until 1780.

– the lines have a distinctly Johnsonian ring; indeed similar thoughts about the nature of the creative process are to be found in more than one chapter of *Rasselas*.[39]

Reynolds, as we have seen, was as proficient as the next man at plucking the threads of that intricate cat's cradle of patronage which constituted the mechanism for getting so much done in the eighteenth century – the funding of wars, the election of parliaments, the securing of favours to advance the careers of relatives or friends. Johnson had appealed to him during the summer on behalf of a young man called Paterson – 'He is the Son of a Man for whom I have long had a kindness, and who is now abroad in distress.' He was, in fact, Johnson's godson, and his father was the auctioneer and bookseller Samuel Paterson, an excellent bibliographer whose preference for reading books rather than selling them constantly landed him in business difficulties. The son wanted to enter the Academy as a student. 'Your character and station enable you to give a young man great encouragement by very easy means,' Johnson wrote. 'You have heard of a Man who asked no other favour of Sir Robert Walpole, than that he would bow to him at his levee . . .'[40] Charles Paterson was admitted to the Academy schools as a student of painting.

It was sometimes necessary to shift from patron to client mode in the course of one transaction. Later in the year Reynolds was asked for a recommendation by a young painter called Charles Smith, a nephew of his friend Caleb Whitefoord, who was setting out for the West Indies. Smith, a native of Orkney, had studied at the Academy, but found it difficult to retain patrons because of his extreme and violently expressed political opinions. Reynolds nevertheless wrote on his behalf to Lord Macartney, who had sat to him in 1764 and was now Captain-General and Governor of the Caribbee islands (Grenada, the Grenadines and Tobago). He described Smith as 'a very ingenious young Painter belonging to our Academy', which may have been cleverly ambiguous, but the lumbering sentence which followed showed that this was a department in which he lacked Johnson's sureness of touch:

Tho' I am far from renouncing my obligation for any favour bestowed on the bearer of this letter, or that some apology may not be necessary for the liberty I have taken Yet I cannot help flattering myself that I have done *your State some Service* and have given your Lordship an opportunity of adding, to the more solid and substantial good, which I have no doubt attends your administration, one, at least of the ornaments of life, and which without doubt will contribute not a little to civilize your barbarous subjects . . .*

* Letter 58. 'I have done the state some service, and they know't' is a line from Act V of *Othello*. Reynolds quite liked to show off his familiarity with the literary canon.

It is not known how Smith fared among Macartney's 'barbarous subjects'. Later he spent some years in India.* From Calcutta he sent Reynolds a present of some yellow pigment; Reynolds's letter of thanks has survived, and affords pleasing evidence of his generous interest in the work of younger painters:

I hope you meet with the success you so well deserve. I am only concerned that you are so much out of the way of making that improvement which your Genius would certainly have enabled you to make, if you had staid in England . . .

I saw the other day, at Mr Bromil's, a picture of a child with a dog, which, after a pretty close examination, I thought my own painting; but it was a copy, it seems, that you made many years ago.†

* On his return he took to styling himself 'painter to the Great Mogul'.
† Letter 130. Reynolds was writing in 1784. William Brummell, private secretary to Lord North from 1770 to 1782, was the father of Beau Brummell.

15

Sacred and Profane

Reynolds had to look to his laurels in 1777 – after an absence of four years, Gainsborough made a cleverly judged return to the exhibition. He had a gratifying reception from the press. ' 'Tis hard to say in which Branch of the Art Mr Gainsborough most excels,' wrote the *Public Advertiser*, 'Landscape or Portrait Painting.'[1] The *Morning Chronicle* compared him favourably with Reynolds – 'he treads so close upon the heels of the Chief of the Science, that it is not always evident Sir Joshua has a superiority'.* It was, however, from his friend Henry Bate, the editor of the *Morning Post*, that he received real heavyweight support. The 'Fighting Parson' proved not only a skilled cheer-leader for Gainsborough – he also landed a number of shrewdly telling punches on Reynolds.

'Thomas Gainsborough, R.A.', ran the headline of the *Post*'s opening notice of the exhibition. 'As the pencil of this gentleman has evidently entitled him to this distinction,' Bate wrote, 'we have impartially placed him at the head of the artists we are about to review.' Gainsborough had clearly prepared his re-entry into the lists with great care. His large landscape *The Watering Place*,[2] with its powerful bank of dark trees, was widely admired. Horace Walpole's catalogue note reads: 'In the Style of Rubens, & by far the finest Landscape ever painted in England, & equal to the great Masters'. Bate described it as 'a masterpiece of its kind', but was critical of its hanging – 'viewed to every possible disadvantage from the situation in which the directors have thought proper to place it'.†

Gainsborough also sent several outstanding portraits to the exhibition. The brilliant Venetian colouring of *Carl Friedrich Abel*, now in the Huntington Collections at San Marino, might have come from the palette of a

* 25 April 1777. Only the *Gazetteer* chose to disregard his return: 'Were it not for Sir Joshua and Mr Loutherbourg the present Exhibition would be the meanest collection of pictures ever seen in this metropolis.'
† Gainsborough had written twice to the Academy in the weeks before the exhibition. The minutes of the Council indicate in their economical way that he made certain requests about hanging which were not met. Bate's comment suggests that he was aware of the correspondence.

Veronese. A dog at his feet, his viola da gamba and bow resting somewhat improbably against his leg, the great virtuoso rests his quill and looks up indulgently from the score on which he is at work. Even more spectacular was the beautiful *Mrs Graham*, now in the National Gallery of Scotland in Edinburgh.* 'Portrait of a lady,' the critic of the *Morning Chronicle* wrote swooningly – 'rather of a divinity!' and Tom Taylor, when he saw it at the great Art Treasures Exhibition in Manchester in 1857, was captivated by its 'bewitching loveliness'. The incomparable flesh tones, the luxuriance of the drapery, the theatrical menace of the stormy sky combine to make it one of Gainsborough's masterpieces.

Having descanted on the merits of Gainsborough, Bate turned his attention to Reynolds. The portrait of Lady Bampfylde, now in the Tate,[3] won qualified approval; he praised the 'harmonious softness of colouring', but criticized the drawing of the right arm as 'very incorrect'. Then, brushing away a crocodile tear, he put the boot in:

With reluctance . . . Sir Joshua's present productions are by no means equal in point of merit, to those which he has formerly exhibited upon a similar occasion. The critics have long found fault with his style of colouring, asserting, that its brilliancy must soon fly off; he seems determined, however, to obviate that objection in future, by giving all his portraits the *lasting* copper-complexion of a *Gentoo* family!

There were no captains of the race relations industry to slap Bate on the wrist; Gentoo – 'a pagan inhabitant of Hindostan' in the *Oxford English Dictionary*'s succinct definition† – would have registered with his readers much as 'jungle-bunny' might today.

He was more than a little partisan. Apart from Lady Bampfylde, Reynolds's exhibits included his portrait of Lady Caroline Scott[4] which so entranced Horace Walpole. 'But of all delicious [w]it,' he wrote to Lady Ossory, 'is a picture of a little girl of the Duke of Buccleugh, [who] is overlaid with a long cloak, bonnet and muff, [in the] midst of the snow, and is perished blue and red with cold, but looks so smiling and so good-humoured that one longs to catch her up in one's arms and kiss her till she is in a sweat and squalls.'[5]

Another fine picture shown by Reynolds was *A Fortune Teller*, which he

* The second daughter of Lord Cathcart, Catherine Graham, had been married three years previously at the age of seventeen. Her health was never good, and she died on board ship off Hyères in 1791. Her husband then embarked on a military career. He achieved distinction as one of Wellington's generals, was created Lord Lynedoch, and lived to the age of ninety-five.
† The word is a corruption of the Portuguese *gentio*, meaning a gentile, or heathen, which they applied to Hindus as distinct from Muslims.

sold to the Duke of Dorset the following year and which is now at Waddesdon.[6] The critics differed – as if it mattered – over whether it was a history painting or a 'fancy' picture. A young girl, sitting on her lover's knee, laughs excitedly at whatever it is the gipsy has read in her hand; the young man looks more thoughtful. Reynolds also exhibited a lavish full-length of the Countess of Derby, now known to us only from a fine engraving by William Dickinson in the British Museum;[7] it was painted for her husband, the Twelfth Earl, who is thought to have destroyed it after his wife left him.

Reynolds was taking a fair amount of stick in the press at this time. Not everybody was well disposed to the Academy, and the President's high profile made him a convenient cock-shy. He also attracted a good deal of more personal abuse, much of it anonymous. One particularly venomous piece, which appeared in the *Public Advertiser*, combined a dig at the instability of his colouring with a charge of self-advertisement:

> When R . . . s with incessant Puff
> Bedaubs himself with nauseous stuff,
> I think the Man is Mad.
> Self Adulation should confine
> Her Breath to him who paints a sign,
> Because his works are bad.
>
> But that this Lord of gaudy tints
> Should trust his fame to DAILY PRINTS
> I own I can't forgive . . .
> 'Hold there' a surly Critic cried,
> 'The tints and papers coincide,
> Alike they're FUGITIVE.'

Caleb Whitefoord took up the cudgels on Reynolds's behalf and complained to Henry Sampson Woodfall, the editor of the *Advertiser*. Woodfall replied that the doggerel had been inserted without his knowledge, which was not the most convincing excuse from the man who had published the *Letters* of 'Junius', but Reynolds was not short of allies who could respond in kind, and a reply of sorts appeared a few days later:

> And dost thou think, thou scribbling elf,
> Or is it downright lying,
> That worthy Reynolds puffs himself
> Both sense and shame defying?

He scorns to act so vile a part,
Thy part we well divine.
How ill, poor Bard, thou read'st *his* heart,
How legible is thine!

His fame throughout the world shall fly,
Thine is a passing vapour,
His works with time alone shall die,
Thine with a daily paper.

It was rare for the House of Commons to concern itself with the arts, but four days after the opening of the 1777 Exhibition, Reynolds's friend John Wilkes, now the Member for Middlesex, rose in his place to draw attention to what he considered a matter of national importance:

The *British Museum*, Mr Speaker, possesses few valuable *paintings*, yet we are anxious to have an *English School* of painters. If we expect to rival the Italian, the Flemish, or even the French school, our artists must have before their eyes the finished works of the greatest masters. Such an opportunity, if I am rightly informed, will soon present itself. I understand that an application is intended to parliament, that one of the first collections of Europe, that at *Houghton*, made by Sir Robert Walpole, of acknowledged superiority to most in Italy and scarcely inferior even to the Duke of Orleans's in the Palais Royal at Paris, may be sold by the family. I hope it will not be dispersed, but purchased by parliament, and added to the *British Museum*. I wish, Sir, the eye of painting as fully gratified, as the ear of music is in this island, which at last bids fair to become a favourite abode of the polite arts. A noble gallery ought to be built in the spacious garden of the *British Museum* for the reception of that invaluable treasure . . .[8]

The Walpole estate had been in decline since the death of the former prime minister three decades earlier – improvident management by his heirs had seen to that. 'How can I describe the devastation I found?' Horace Walpole wrote despairingly to Mann after a visit in the summer of 1773:

The estate overwhelmed by mortgages, the livings sold, the glorious house dilapidated, and open in many parts to the weather; the garden destroyed by horses, the park half unpaled, and overgrown with nettles and brambles, a crew of plunderers quartered on all parts . . .[9]

Whether Wilkes consulted Reynolds before making his speech is not known. At all events, his intervention came to nothing. The following year Walpole's

spendthrift nephew George – Lord Orford, the 'mad Earl' – asked James Christie, in 'the most profound secrecy', to value the collection. Christie, who knew more about precious stones than about paintings, entrusted the task to Benjamin West and G. B. Cipriani. They, together with the painter-dealer Phillip Tassaert, valued the 178 pictures at £40,455. By July 1779 a deal had been struck with the Russian ambassador to the Court of St James's, Count Alexei Semyonovitch Musin-Pushkin.* Catherine the Great, for whom the amassing of pictures was an arm of state policy, thus acquired yet another major European collection;† the 'mad Earl' named a favourite greyhound bitch 'Czarina' in her honour, and took pleasure in his later years from her many victories in the coursing field; the coincidence of the sale with the loss of the American colonies prompted his uncle Horace to draw a comparison between 'the shipwreck of my family' and the dismemberment of the British Empire.‡

Wilkes's speech about the Houghton collection was not calculated to improve relations between the king and the President of his Royal Academy. His friendship with Reynolds was common knowledge, and the proceedings of the Commons did not go unnoticed at court. In characteristic fashion, Wilkes had buttressed his plea for the establishment of a National Gallery with an attack on George III for removing the Raphael Cartoons from Hampton Court Palace to Buckingham House and a disobliging comparison between the House of Hanover and the House of Orange:

Such an important acquisition as the Houghton collection would in some degree alleviate the concern which every man of taste now feels at being deprived of seeing those prodigies of art, the Cartoons of the divine Raphael. King William, although a Dutchman, really loved and understood the polite arts. He built the princely suite of apartments at Hampton Court on purpose for the reception of these heavenly guests. The nation at large were then admitted to the rapturous enjoyment of their beauties. They remained there until this reign. At present they are perishing in a late Baronet's smoky house at the end of a great smoky town.

They are entirely secluded from the public eye, yet, Sir, they were purchased

* Who seems to have beaten Orford down to a figure of little more than £36,000. See *Houghton Hall: the Prime Minister, the Empress and the Heritage*, London, 1996, published to coincide with the exhibition of that name at Norwich Castle Museum and The Iveagh Bequest, Kenwood, in 1996–7 and Brownell, 2001.

† It included major works by Rembrandt, Rubens, Van Dyck, Maratti and Poussin, many of which still adorn the walls of the Hermitage today.

‡ Walpole, 1937–83, xxv, 133. He was writing to Horace Mann in 1781. Walpole had made one last attempt to save the pictures by appealing directly to the king through his cousin the Marquess of Hertford, who was Lord Chamberlain at the time, but to no avail (Walpole, 1937–83, xxxix, 337, letter from Hertford to Walpole dated 2 August 1779).

with public money before the accession of the Brunswick line, not brought from Herrenhausen. Can there be, Sir, a greater mortification to any gentleman of taste than to be thus deprived of feasting his delighted view with what he most admired, and had always considered as the pride of our Island, as an invaluable national treasure, as a common blessing, not as private property. The Kings of France and Spain permit their subjects the view of all the pictures in their collections.*

A passage elsewhere in Wilkes's speech suggests that he and Reynolds may have put their heads together on another matter. Terrick, the Bishop of London, on whose opposition the scheme to decorate the interior of St Paul's had foundered two years previously, had recently died. His successor, Robert Louth, was thought to be a prelate of broader views whose consent might be more easily forthcoming.† Wilkes made a plea for the scheme to be reconsidered and for the government to lend its support to those working in the industrial arts:

I hope, hereafter, even in this cold, raw, climate, to be warmed with the glowing colours of our own Gobelins tapestry, and I wish encouragement was given by Parliament to that noble manufacture which in France almost rivals the power of painting.

Wilkes's eloquence fell on deaf ears, but a few months later Reynolds became involved in a scheme of ecclesiastical decoration of a rather different sort. For some years the stained glass in the chapel of New College, Oxford, had been undergoing renovation. The work had originally been entrusted to the Yorkshire glass-painter William Peckitt, whose previous commissions included the east window at Lincoln Cathedral and the west window at Exeter; more recently, he had completed, from a design by Cipriani, what the *Dictionary of National Biography* describes as the 'absurd and pretentious' window in the Library of Trinity College, Cambridge, into which he introduced portraits of Francis Bacon, Isaac Newton and George III.

In 1777, however, Peckitt was replaced by the Dublin-born Thomas Jervais, who painted on glass in opaque colours, and had developed a new technique for burning enamel colour into white glass. Jervais proposed to

* The 'late Baronet' was Sir Charles Sheffield, the former owner of Buckingham House. Herrenhausen was the Electoral palace at Hanover.
† Louth (1710–87) was a former professor of poetry at Oxford and had been tutor to the sons of the Duke of Devonshire. Meeting John Wesley at dinner, he refused to sit above him; he was, Wesley wrote in his *Journal*, 'in his whole behaviour worthy of a Christian bishop'. He was a noted Hebrew scholar, and believed it was the language spoken in Paradise.

the college that Benjamin West should be invited to produce designs for him. At this point, however, Reynolds's friend Joseph Warton, the headmaster of Winchester, intervened, and the commission was offered instead to Reynolds. 'I shall very gladly undertake the making Cartoons for the windows you mentioned of New College,' he wrote to Warton on 5 July:

I shall have an opportunity of seeing the Chapel where they are to be placed the latter end of this month, and shall then be able to form a better judgment of the expence than I can at present, tho' I think it cannot be less than twenty Guineas each figure.[10]

Jervais reached formal agreement with the college on 16 July and a schedule of work was drawn up. The original intention had been to decorate several windows in different parts of the chapel, but Reynolds and Jervais proposed that their work should be concentrated in the large west window, even though this would involve some modification to the stone work. Early in January 1778 Reynolds sent the warden, the Reverend John Oglander, a drawing of his design:

My Idea is to paint in the great Space in the centre Christ in the Manger, on the Principle that Corregio has done it in the famous Picture calld the Notte,* making all the light proceed from Christ, these tricks of the art, as they may be called, seem to be more properly adapted to Glass painting than any other kind. The middle space will be filled with the Virgin, Christ, Joseph, and Angels, the two smaller spaces on each side I shall fill with the shepherds coming to worship, and the seven divisions below filld with the figures of Faith Hope and Charity and the four Cardinal Virtues . . .

Mr Jervais is happy in the thought of having so large a field for the display of his Art, and I verily believe it will be the first work of this species of Art, that the world has yet exhibited.[11]

Although Reynolds had originally been asked to provide cartoons, Mason, calling on him some time after he had made a start on the commission, found that he had painted the figure of Faith on canvas:

The reason for this, as he said, was, that he had been so long in the use of the pallet and brushes, that he found it easier to him to paint them, to drawing. 'Jervas, the painter on glass,' says he, 'will have a better original to copy; and I suppose persons hereafter may be found to purchase my paintings.'[12]

* Correggio's Notte, of 1522, now in the Gemäldgalerie, Dresden.

Which they were. The Duke of Rutland bought *The Nativity* from him for £1,200, and – before it was destroyed in the Belvoir Castle fire of 1816 – was said to have been offered the enormous sum of £10,000 for it.[13] Reynolds would eventually make finished paintings for thirteen panels of the window; eight of them were exhibited at the Academy between 1779 and 1782, and were not, as will be seen, universally admired. Jervais's painting on glass would also divide opinion. The diarist John Byng (a nephew of the hapless admiral) saw several of the Virtues after they had been installed in the chapel in 1781 and was distinctly unimpressed: 'these twisting emblematic figures appear to me half-dress'd languishing harlots', he wrote.* Reynolds himself told Mason that he was 'grievously disappointed' with the end result:

I had frequently pleased myself with reflecting, after I had produced what I thought a brilliant effect of light and shade on my canvas, how greatly that effect would be heightened by the transparency which the painting on glass would be sure to produce. It turned out quite the reverse.[14]

Modern art historians have been generally unimpressed, and Ellis Waterhouse was particularly severe. 'These mark the extreme stage of his Bolognese classicism,' he wrote, 'and with their completion he seems to have worked the poison out of his system.'[15]

In his letter to Joseph Warton about the New College window, Reynolds mentioned that he would shortly be setting out for Blenheim 'to Paint the whole Marlborough Family in one Picture'. There are frequent appointments in Reynolds's pocketbook for 1777 with the Duke and Duchess of Marlborough and their children. It is not known precisely when he had been commissioned to paint the huge family portrait now at Blenheim;[16] involving as it does eight sitters, it was by far the most ambitious group portrait he had so far attempted. He set out for Blenheim on 13 August and returned to London on 4 September; most of his time there seems to have been spent painting the children. The story goes that while he stood at his easel, the duchess ordered a servant to bring a broom and sweep up his snuff from the carpet:

Sir Joshua, who always withstood the fantastic head-tossings of some of his sitters, by never suffering any interruption to take place during his application to his Art, when the man entered the room, desired him to let the snuff remain till he had

* Byng, i, 55. Byng, an obscure figure in his lifetime, became known only with the publication of his diaries in the twentieth century. He succeeded his brother in the title only weeks before his death.

8. A Family Piece. *A caricature, dating from 1781, and thought to
represent Reynolds. The two doves and the quiver of arrows
indicate that the mother was to be represented as Venus, the
odious child as Cupid. The portrait painter tries his best to smile; a
commission was a commission, and they didn't all come from
duchesses or admirals or leading ladies at Drury Lane.*

finished his picture, observing, that the dust raised by the broom would do much
more injury to his picture than the snuff could possibly do the carpet.*

Sir William Beechey, a young man in his twenties at the time,† later told
Tom Taylor that he happened to be in Reynolds's painting room shortly
after the picture had been brought to town. The Duchess of Bedford, mother
of the Duchess of Marlborough, came in. 'Sir Joshua, I don't think the head
of my daughter a bit like,' she announced:

* Smith, J. T., 1828, ii, 295. Reynolds's addiction to snuff is well documented. 'He not only
carried a double Box, with two sorts of Snuff in it,' Steevens told Farington, 'but regaled himself
out of every Box that appeared at the table where He sat; and, did His neighbour happen to
have one, He absolutely fed upon him. When I expected to meet Sir Joshua in company added
He I always carried an additional allowance' (Farington, 1978–84, ii, 472, entry dated 16
January 1796).

† Beechey (1753–1839) received some teaching from Zoffany. He was made Portrait Painter
to Queen Charlotte in 1793, became an Academician in 1798 and was knighted the same year.

Reynolds bowed and said, 'I am glad you are pleased with it. Everybody thinks it the best likeness I ever painted.' 'But I don't think it *like*.' Sir Joshua still bowed as if she had paid him a compliment. She then applied to Beechey. 'Pray, Sir, will you tell him I don't think it like?' He excused himself; and somebody else coming in who was older and more intimate with Reynolds, she said, 'I can't make Sir Joshua hear; I wish you would tell him I don't think my daughter's portrait like.' The gentleman accordingly bawled out the unpleasant remark, and Sir Joshua said, 'Not like? then we will make it like.' But Beechey thought he heard the Duchess from the first.[17]

The picture was exhibited at the Academy the following year. In the *Morning Post*, Bate expressed admiration for the variety of poses but was critical of the 'absurdly indiscriminate' distribution of light and shade. For Ellis Waterhouse, it remained the most monumental achievement of British portraiture, and it is difficult to dissent from that judgement. 'It is the one occasion,' he wrote, 'when Reynolds was able to demonstrate to the full the possibilities of applying the historical grand style to portraiture.'[18]

It was on the eve of his departure for Blenheim that Reynolds wrote the moving and revealing letter to his niece Offy that was quoted in Chapter 4. 'I never was a great professor of love and affection,' he told her, 'and therefore I never told you how much I loved you, for fear you should grow saucy upon it.'* His warm feelings for his nieces were in sharp contrast to his increasing exasperation with Fanny.

She still basked in the affection of Johnson, who continued to offer her every encouragement in her literary ambitions. 'My dearest Dear,' he had written to her during an indisposition the previous summer:

When I am grown better, which is, I hope, at no great distance, for I mend gradually, We will take a little time to ourselves, and look over your dear little production, and try to make it such as we may both like it. I will not forget it, nor neglect it, for I love your tenderness . . .[19]

It was plain to their circle that these were not her brother's sentiments. 'He certainly does not love her as one should expect a Man to love a Sister he has so much Reason to be proud of,' Mrs Thrale wrote in her diary in the summer of 1777, and she was inclined to ascribe it partly to jealousy:

Perhaps She paints too well, or has learned too much Latin, and is a better Scholar than her Brother: and upon more Reflection I fancy it must be so, for if he only did not like her as an Inmate why should not he give her a genteel Annuity, & let her

* See p. 86 above.

live where and how She likes: the poor Lady is always miserable, always fretful; yet she seems resolved – nobly enough – not to keep her Post by Flattery if She cannot keep it by Kindness: – this is a Flight so far beyond my power that I respect her for it, and do love dearly to hear her criticize Sir Joshua's Painting, or indeed his Connoisseurship, which I think she always does with Justice and Judgment . . .

She confessed herself baffled by Reynolds:

He is not a covetous Man in any Sense I believe, but seems proud to give, proud to spend, and even proud to be cheated – which however I don't mean as a peculiarity – many low People oddly come to Fortune are so too. but then why should he who is niggardly to nobody, who leaves 200£ in a Draw'r and forgets it – an unlocked Drawer I mean, who lets his Man Ralph maintain his Wife and Family in the house by Connivance; and does a hundred things of the same sort; why should he refuse his Purse and even his Civilities to a Sister so amiable & so accomplished as Miss Reynolds? – I cannot find it out.

Just when Reynolds finally dispensed with Fanny's services as his house-keeper in Leicester Fields is unclear. Her correspondence with Johnson indicates that the break had certainly taken place by early 1779, and that she had by then moved to an address in Dover Street. Not for the first time, she seems to have appealed to Johnson to intercede with Reynolds on her behalf;* it is obvious from Johnson's reply that he felt he was being badgered:

Dearest Madam:
I have never deserved to be treated as You treat me; when you employed me before, I undertook your affair, and succeeded, but then I succeeded by chusing a proper time, and a proper time I will try to chuse again . . .

I will wait on You as soon as I can, and yet You must resolve to talk things over without anger, and you must leave me to catch opportunities; and be assured, Dearest Dear, that I should have very little enjoyment of the day in which I had rejected any opportunity of doing good to you . . .[20]

And yet just how much he exerted himself on her behalf is shown by a letter he did eventually draft for her to send to Reynolds:

* Northcote – the assumption must be that he heard this from Fanny herself – mentions an earlier occasion when Johnson volunteered to help her set out her grievances against Reynolds. Northcote says she felt obliged to reject the letter he drafted, 'as the whole contents of it were so very unlike her own diction' (Northcote, i, 203).

Dear Brother,

I know that complainers are never welcome yet you must allow me to complain of your unkindness, because it lies heavy at my heart and because I am not conscious that I ever deserved it . . .

If you ask me what I suffer from you, I can answer that I suffer too much in the loss of your notice; but to that is added the neglect of the world which is the consequence of yours.

If you ask what will satisfy me, I shall be satisfied with such a degree of attention when I visit you, as may set me above the contempt of your servants, with your calling now and then at my lodgings and with your inviting me from time to time with such parties as I may properly appear in. This is not much for a sister who has at least done you no harm . . .

'This is my letter, which at least I like better than yours,' Johnson told Fanny. 'But take your choice, and if you like mine alter any thing that you think not ladylike.'[21] The draft bears no date, and whether it was used is not known. Johnson's efforts were at all events unavailing. Fanny's place at Leicester Fields passed permanently to her nieces, although Reynolds allowed her to make use of his house at Richmond. Johnson was a frequent caller at her lodgings in town, and from time to time sent her touchingly tender messages:

Dear Madam:

I want no company but yours, nor wish for any other. I will wait on you on Saturday, and am so well that I am very able to find my way without a carriage . . .[22]

Gradually she began to adapt to her changed circumstances. 'I dined on Tuesday with Renny,' Johnson wrote to Mrs Thrale, 'and hope her little head begins to settle.'[23] It is far from certain that it ever did.

Mrs Thrale did not confine her strictures on Reynolds to his treatment of Fanny in her unsparing diary entries in the summer of 1777. He was the subject at that time of a certain amount of flattering attention for his literary abilities. Some effusive if somewhat tortured verses, purportedly written at the Bedford Coffee House – 'On the transcendent Merit of SIR JOSHUA REYNOLDS President of the Royal Academy of Painting as a Writer, and a Painter' – have been preserved in manuscript at the British Museum:

> *Learn'd in two Languages* had long been thought
> The highest Compliment that cou'd be wrought
> To praise Mæcenas Patron of the Muse;
> Horace' Authority who'd dare refuse? –

A greater Ornament can England boast;
Pronounce Ye Critics, who excels the most –
REYNOLDS th'APELLES of our modern Days,
Shines forth superior, tho in different ways;
Has of *two* Arts attain'd the lawrel'd Heights;
Paints with a Pen, and with a Pencil Writes![24]

The text of his latest Discourse had also recently been published, and his growing prestige as a writer clearly irritated Mrs Thrale not a little:

Sir Joshua is indeed sufficiently puffed up with the Credit he had acquired for his written Discourses, a Praise he is more pleased with than that he obtains by his Profession; besides that he seems to set up as a sort of Patron to Literature; so that no Book goes rapidly thro' a first Edition now, but the Author is at Reynolds's Table in a Trice . . .

There could be a more specific reason for her sour tone. Reynolds was in the habit of distributing the printed version of each Discourse as it appeared to various friends and acquaintances. Newton, West, Nollekens, Joseph Banks, Garrick and Horace Walpole were all regular recipients, and copies presented to Mary Moser, Mrs Montagu and Mrs Vesey are also extant; there is no record of Mrs Thrale being favoured in this way.* Whatever the reason, it is evident that Reynolds's celebrity was not something from which she derived any great pleasure:

. . . *his* Thoughts are tending how to propagate Letters written in his Praise, how to make himself respected as a Doctor at Oxford, and how to disseminate his Praise for himself, now Goldsmith is gone who used to do it for him. *He* was while he lived the Person Sir Joshua seemed to have most Friendship for; he lent him Money, loved his Company, and a *little* lamented his Death.[25]

Sometime in 1777 Reynolds decided that the seven Discourses he had so far delivered should be reprinted in a collected edition. Plans were already afoot for them to be published in Italy. Johnson, writing to Boswell shortly before Christmas the previous year, had told him that Baretti 'has got five-and-twenty guineas by translating Sir Joshua's Discourses into Italian',†

* Henry Thrale did, however, receive a presentation copy of the sixth Discourse when it was published in 1775.
† The book was published in Florence, but not until 1778. It was enthusiastically received, although not by Baretti, who discovered that it bore little resemblance to his original manuscript and that the name of the translator did not appear on the title page.

and it was to Johnson that Reynolds turned for help in December as he revised the text for the collected edition: 'I am making additions, and should wish you to see it all together,' he wrote. 'I have not courage enough to appear in public without your imprimatur.'[26]

Although his relations with the king were far from cordial, Reynolds felt that the volume must carry a dedication to the Academy's royal patron. Composing it was not a task he relished. 'Writing a dedication is a knack,' he once told Boswell. 'It is like writing an advertisement.'[27] Once again he turned to Johnson, who obliged his friend with one of his best-known pieces of occasional writing:

<div align="center">

TO

THE KING

</div>

The regular progress of cultivated life is from necessaries to accommodations, from accommodations to ornament. By your illustrious predecessors were established marts for manufactures, and colleges for science; but for the arts of elegance, those arts by which manufactures are embellished, and science is refined, to found an Academy was reserved for Your Majesty.

Had such patronage been without effect, there had been reason to believe that Nature had, by some insurmountable impediment, obstructed our proficiency; but the annual improvement of the Exhibitions which Your Majesty has been pleased to encourage, shews that only encouragement had been wanting . . .

Northcote (who believed it had been written by Reynolds) records that it was received as a model of its kind – 'a hint both to writers and painters, that a portrait may be well drawn, without being varnished, and highly coloured without being daubed'.[28] A writer in the *Gentleman's Magazine* was so impressed that he passed over the Discourses in one flattering sentence and devoted the rest of his review to the dedication. Evidence that the book sold well is preserved in the Theater Collection of the Harvard College Library:

Receiv'd Novr. 27.1778 of Mr Cadell sixty two Pounds Nine Shillings in full for my moiety of the Profit on the first Edition of my Discourses (the octavo edition)

<div align="right">

J Reynolds

</div>

Reynolds valued his literary reputation highly, and was sensitive to any suggestion that it had not been earned by his own efforts. Years later, after the first volume of the *Life of Johnson* had been set up in print, he asked Boswell to cancel a page which alluded to Johnson's authorship of the dedication.

<div align="center">

*

</div>

Reynolds spent some time in the autumn of 1777 experimenting with a new optical instrument called a delineator. It had been invented by a Norfolk man called Storer, who claimed in his patent description that it marked an advance on the camera obscura – 'being used without the assistance of the sun in day-time, and also by candlelight, for drawing the human face, inside of rooms or buildings, also perspectives, landscapes, foliage and fibres of trees and flowers, exactly representing the true outlines, lights, shades, and colours'.[29]

Horace Walpole, who had a weakness for new toys, enthused about it to Mason:

This is but a codicil to my last, but I forgot to mention in it a new discovery that charms me more than Harlequin did at ten years old, and will bring all paradise before your eyes even more perfectly than you can paint it to the good women of your parish. It will be the delight of your solitude, and will rival your own celestinette ... Sir Joshua Reynolds and West are gone mad with it, and it will be their own faults if they do not excel Rubens in light and shade, and all the Flemish masters in truth.*

It would take a keen eye to detect an enhanced precision of outline in the work of either painter. The ascendancy of the Flemish masters was not seriously challenged. The likelihood is that Reynolds's delineator speedily found itself consigned to the garret.

Reynolds set great store by his membership of the Dilettanti Society and was assiduous in his attendance at their Sunday dinners. 'There has been a great encrease of members lately, a new room has been built for their meeting,' he wrote to Lord Grantham in the autumn of 1777. 'I am now drawing two pictures for the two ends of the room.'†

Seated centrally in the first of these two life-sized groups[30] is Sir William Hamilton, who had been received into the Society earlier in the year – a friend of twenty years standing, ambassador to the Court of Naples and one of the first British subjects to appreciate and collect Greek vases. Hamilton's celebrated connection with Emma Hart – and Nelson – lay some years in the future. He was best known at this time for his remarkable

* Walpole, 1937–83, xxviii, 328, letter dated 21 September 1777. West was also playing around at this time with a camera lucida, which reflects the rays of light from an object through a prism. These experiments were terminated when his pupil Gilbert Stuart dropped the instrument. Stuart stood with his back to West, bracing himself for the inevitable storm, but West, after a short pause, merely said, 'Well, Stuart, you may as well pick up the pieces' (Alberts, 130).
† Letter 65. The new room was leased from the Star and Garter tavern.

collections of antiquities;* a vase stands on the table before him, and he points to an illustration of it in a sumptuous folio volume.

Reynolds also introduces allusions to two of the Society's less scholarly interests. Several members of the group hold wine glasses, while one, John Taylor, of Lysson Hall, Jamaica – he would be created a baronet the following year – wears a quiet smirk and flourishes a lady's garter, an object guaranteed to set the Dilettanti table in a juvenile roar.

The figure sitting at the left is Sir Watkin Williams Wynn, attired, as President for the evening, in the scarlet toga of his office. It had been resolved in the early 1740s 'that a Roman dress is thought necessary for the President of the Society'.† A good deal of rather ponderous jocularity attached to the practices and regulations of the Dilettanti. An entry in the minutes for 1778 instructed the Secretary to require Reynolds's attendance at the next meeting 'to shew cause why he should not be punish'd for having neglected so long to finish the two groups which he undertook to do'. A later motion reads 'That Mr Steward be desired to undertake to have the folds of the Toga newly arrang'd which have been derang'd by the ill Taste of the Painter with whom it had been intrusted.'

Most of those included in the second picture are seated round a table furnished with fruit and bottles of claret, and three of them are clinking their glasses. Those portrayed include Joseph Banks, John Charles Crowle, a well-known lawyer and antiquary who was Secretary to the Society, and Charles Greville, who was Hamilton's nephew and later the first owner of Reynolds's *Thaïs*,[31] a portrait of the notorious courtesan Emily Warren, who was for a time his mistress.

These members are giving their attention not to vases but to precious stones; three of them – the Earl of Seaforth, Lord Carmarthen and Thomas Dundas – are all pictured holding gems set in rings. In doing so, Dundas is also making an extremely ancient lewd gesture. The hand is held aloft, the palm facing away from his body, the thumb and forefinger touching to form a circle, the other three fingers extended and slightly spread.

Today, this 'ring' gesture embraces a cluster of meanings – precision, approval, agreement, praise. That, indeed, is what it signified to Quintilian

* Hamilton's collections would become the basis of the British Museum's major holdings in classical antiquity. He was also interested in volcanoes; he had ascended Vesuvius twenty-two times in the course of four years, at some risk to life and limb.

† The Society, like the Medmenhamites, went in for a good deal of dressing up. The Secretary's rig had been designed 'according to the dress of Machiavelli the celebrated Florentine Secretary'; the Very High Steward was required to wear 'a small Bacchus bestriding a Tun with a silver chain'; the minutes record that the 'properest dress' for the Arch Master was deemed to be 'a long Crimson Taffest robe full pleated with a rich Hungarian cap and a long Spanish Toledo' (see Cust, 28–9).

in the first century AD.* Much earlier, however – the usage has been traced back to early Greek vase paintings – the circular shape is seen as representing a body orifice. The gesture is therefore an obscene insult, representing either a vulgar comment or an invitation of a sexual nature. As the two paintings were designed to face each other, it is possible that Dundas is responding to Taylor's display of the garter as a trophy at the other end of the room.†

Rather different from the New College window, but pretty mild stuff by the standards of the Dilettanti. Many of their number had been initiated on the Grand Tour into much more than the pleasures of connoisseurship, and retained quite as much enthusiasm for fornication as they did for *virtu*. Phallic objects, and the scenes of vigorous intercourse with which they were familiar from antique vases, provided them with an unfailing source of amusement.

It was one of the Society's founders who twenty years previously had commissioned Hogarth's blasphemous *Sir Francis Dashwood at His Devotions*, in which Dashwood is portrayed as a priest on his knees before a miniature recumbent Venus.[32] And it was the Dilettanti Society which would later order the printing of Richard Payne Knight's *The Account of the Worship of Priapus*. This was based on a report sent to the Society by Hamilton, describing an ancient priapic cult that survived in the village of Isernia in the Italian Molise. One of the illustrations showed a satyr copulating with a goat, and one of Knight's more provocative suggestions was that the crucifix was a symbol of the organs of generation. The book was not well received, and the author went round town buying up every copy he could lay his hands on.

Reynolds worked on and off at the Dilettanti portraits until 1779. The sitters each paid him 35 guineas. The pictures were never offered for the inspection of the mixed society that thronged the exhibition of the Royal Academy. It must have been that garter.

* See his *Institutio Oratoria*, Book XI, III, 104: 'If the first finger touch the middle of the right-hand edge of the thumb-nail with its extremity, the other fingers being relaxed, we shall have a graceful gesture well suited to express approval.'

† For a wide-ranging and often entertaining academic study of the significance of gestures, see Morris, Collett, Marsh and O'Shaughnessy. Robin Simon has speculated convincingly that in their original position, the two portraits may have been complemented by a statue of a female nude placed between them, or possibly by the real thing – a live stripper, although the Dilettanti of the period would have used the more polite-sounding term of a 'posture woman' (see 'Reynolds and the Double-entendre. The Society of Dilettanti Portraits' in *The British Art Journal*, Autumn 2001, 69–77).

16

Sword of Honour

Dear Sir
My neglect in answering your Letter and your great kindness and good nature in
forgiving me covers me with confusion.

Reynolds was constantly apologizing to his friends for being an indifferent
correspondent. He was writing to Sir William Forbes, the banker, who spent
much of his time in Aberdeenshire and Edinburgh, and expressed the regret
he felt at their separation:

I am sorry to hear you have no thoughts of coming amongst us again, Boswell makes
nothing of the journey, he seems to set out for England as a man would go a few
miles in the Country to dine with a friend.[1]

The indefatigable Boswell had made the journey again in that spring of
1778, and his journal for the two months he spent in London gives numerous
glimpses of Reynolds in his leisure hours – parties at Leicester Fields,
conversations at the Club, a dinner at General Paoli's. Boswell is never dull,
but his jottings are of particular value in a year for which Reynolds's
pocketbook is missing. Some of them are tantalizingly brief – an unpublished
entry for April, for instance, now in the Hyde Collection, which reads
simply, 'I said that Sir Joshua Reynolds would like to marry the rich widow
Wymondesold.'
 When Boswell dined with Reynolds early that month, his fellow guests
included Johnson, Gibbon, Bennet Langton and Allan Ramsay, who
had just returned from his third visit to Italy and discoursed at length about
his visit to Horace's Sabine villa. After dinner they were joined in the
drawing room by Garrick, Burney, Mrs Cholmondeley and Hannah
More. The straitlaced Hannah found the company entirely to her liking –
'scarce an expletive man or woman among them', she wrote to one of her
sisters.[2]
 Boswell records an exchange at table about Goldsmith's *Traveller*:

SIR JOSHUA. 'I was glad to hear Charles Fox say, it was one of the finest poems in the English language.' LANGTON. 'Why was you glad? You surely had no doubt of this before.' JOHNSON. 'No; the merit of "The Traveller" is so well established, that Mr. Fox's praise cannot augment it, nor his censure diminish it.'[3]

Calling at Bolt Court the next morning, Boswell resumed the conversation, observing, as only he could, that Johnson had been in remarkably good humour. 'There was not one capital conviction,' he said. 'It was a maiden assize. You had on your white gloves.' He reminded Johnson that he and Langton had taken Reynolds up on Fox's remark about Goldsmith:

JOHNSON. 'Yes, sir, I knocked Fox on the head, without ceremony. Reynolds is too much under Fox and Burke at present. He is under the *Fox star* and the *Irish constellation*. He is always under some planet.'[4]

Johnson, forty years Fox's senior, was clearly jealous of what he saw as the younger man's influence over his old friend, and there was almost certainly a political edge to his remark, even though Boswell does not record any discussion of politics the previous evening. Fox at that time was unremitting in his attacks on the ministry for their conduct of the American war, and the plan for the conciliation of the colonies which North had presented to a stunned Parliament two months previously – it conceded virtually everything except independence – might have been drafted for him by Burke.

Burgoyne's surrender at Saratoga the previous autumn, although not disastrous militarily – his forces numbered only 5,000 – had proved a watershed.* It had emboldened the French to negotiate a full-scale alliance with the rebels, recognizing their independence and granting generous terms of trade. North's Commons majority, usually solid at more than 150, dipped down into double figures. Three per cent Consols, which had stood at 92 in late 1774, had dropped to 60. It was not all plain sailing for the opposition, however, because Saratoga had also prompted an upsurge of patriotic feeling; it was one thing to be a friend of the Americans, quite another to seem well disposed to the French. At Drury Lane, Sheridan mounted a lavish production of Cumberland's new tragedy, *The Battle of Hastings*. 'This piece was received with uncommon applause,' reported the *London Magazine*. '[Earl

* 'Gentleman Johnny', as Burgoyne was known, won fairly easy terms from Gates, the American commander – although in the event it was not honoured, the instrument signed was a convention, not a surrender. A band played 'Yankee Doodle' and toasts were drunk to King George and General Washington. Reynolds's fine portrait of Burgoyne, dating from 1766 (Mannings, cat. no. 283, pl. 62, fig. 874), is now in the Frick Collection, New York.

Edwin's] heroic exclamation – "all private feuds should cease when England's glory is at stake" – was so sensibly felt by the audience that a repetition was called for, but judiciously refused, as out of character in a tragedy.'⁵

Two days before Reynolds's dinner party, a striking scene of real-life theatre had been played out in the House of Lords when the dying Chatham, against the advice of his physician, made what proved to be his valedictory speech. Wrapped in flannel, propped up on crutches, the great commoner made a barely audible appeal for national unity; when he attempted to rise a second time, he fell backwards in a fit; he was carried into the Prince's Chamber and the debate was adjourned. When he was buried in the Abbey early in June, Burke would be one of the pallbearers.

War with France was now inevitable, although the first clash between the ships of the two nations did not come until the summer. New regiments of volunteers were raised – 'Camps everywhere,' Horace Walpole wrote to Mann, 'and the ladies in the uniform of their husbands.'* The fear of invasion was widespread, but not confined to England. Boswell, dining at the house of his Corsican hero, General Paoli, heard that Andrew Frazer, a lieutenant-colonel of engineers recently returned from Dunkirk, had reported that the French were as strongly convinced that they were about to be invaded.†

It was at this dinner party that Reynolds once again came under attack from Johnson for his drinking habits. 'I was at this time myself a water-drinker, upon trial, by Johnson's recommendation,' Boswell informs us:

JOHNSON. 'Boswell is a bolder combatant than Sir Joshua: he argues for wine without the help of wine; but Sir Joshua with it.' SIR JOSHUA REYNOLDS. 'But to please one's company is a strong motive.' JOHNSON. (who, from drinking only water, supposed every body who drank wine to be elevated,) 'I won't argue any more with you, Sir. You are too far gone.' SIR JOSHUA. 'I should have thought so indeed, Sir, had I made such a speech as you have now done.' JOHNSON. (drawing himself in, and, I really thought blushing,) 'Nay, don't be angry. I did not mean to offend you.'⁶

Reynolds's response was uncharacteristically sharp. Some years earlier – it was during their jaunt to the Highlands – Johnson had declared to Boswell

* Walpole, 1937–83, xxiv, 384, letter dated 31 May 1778. This was a common practice. Reynolds, in his portrait of Lady Worsley, painted some two years previously, depicts her in a deep red riding habit with dark facings adapted from the uniform of her husband's regiment, the Hampshire Militia. The picture (Mannings, cat. no. 1935, pl. 86, fig. 1205) is now at Harewood House.

† Frazer had been the British commissary appointed to superintend the demolition of fortifications there in accordance with treaty obligations.

that 'Sir Joshua was the most invulnerable man he knew.' He was also – a professional deformation, perhaps, born of long years spent observing his sitters – deeply read in human nature, and he saw his old friend very clearly. They were in company again together some weeks later, this time at Ramsay's house. Boswell was present, and the other guests included Mrs Boscawen, widow of the admiral, and William Robertson, the Principal of the University of Edinburgh, who had sat to Reynolds some years previously. Before Johnson's arrival, Boswell confessed to hero-worship, prompting a mild demurral from Robertson. 'But some of you spoil him,' he protested; 'you should not worship him; you should worship no man.'

BOSWELL. 'His power of reasoning is very strong, and he has a peculiar art of drawing characters, which is as rare as good portrait painting.' SIR JOSHUA REYNOLDS. 'He is undoubtedly admirable in this; but, in order to mark the characters which he draws, he overcharges them, and gives people more than they really have, whether of good or bad.'

At which point, Johnson was announced:

No sooner did he, of whom we had thus been talking so easily, arrive, than we were all as quiet as a school upon the entrance of the head-master.[7]

Curiously enough, Gainsborough's drinking habits were also the subject of censorious attention at this time. His prim friend William Jackson of Exeter expressed his concern in a letter to Ozias Humphry:

My old Friendship for Gainsborough I am afraid has suffered some abatement – his Oddities will at last get the better of his Good Qualities, which is ten thousand Pities! I am satisfied if that Man had been properly educated & connected, he would have been one of the first that ever lived. He has given Abel as many Pictures & Drawings as are worth as some hundreds of Pounds, & he in return has taught him to drink himself into a premature blind Old-Age – Like Wilson, he will soon be considered as a Ruin, & if so, I hope a venerable one.[8]

Jackson's prissy forebodings were not realized. Gainsborough's bohemian ways and fondness for the company of musicians had not the slightest effect on his painting,* or, for that matter, on his finances – in the summer of

* Jack Lindsay, in his 1981 biography, laid emphasis on the close connection between Gainsborough's painting and his response to music (*Thomas Gainsborough: His Life and Art*, 76–7, 171, 175).

1777 he had had enough money to spare to invest in government stock, and he would do so again twelve months later.[9]

He once more showed in great strength at the 1778 Exhibition, with eight portraits and two landscapes, and he again benefited from the sophisticated puffing of Bate in the *Morning Post* – 'the *Apelles* of the Royal Academy' – 'the cows in this piece seem to have a force that detaches them from the canvas' – 'infinitely superior to Reynolds in the brilliancy of his colouring' – 'a competitor of Rubens'.[10] Others were more critical, noting a certain lack of finish, and there was a good deal of sly comment about his choice of female sitters. 'It should appear from this artist's female portraits that he is a favourite among the demi-reps,' wrote the *Morning Chronicle*:

... he is rather apt to put that sort of complexion upon the countenances of his female portraits which is laughingly described in *The School for Scandal* as 'coming in the morning and going away at night,' than to what is, properly speaking, Nature's own red and white.

Even Bate joined in: 'The portraits which he has exhibited on this occasion consist chiefly of *filles de joie*, and are all admirable likenesses, No. 114 particularly being that of the beautiful Mrs E.' Mrs E was Mrs Elliot. Born Grace Dalrymple, into a distinguished Scottish family, she was one of the more notorious courtesans of the day; well above average height, she was regularly satirized in the press as 'Dally the Tall'. Her many lovers included Lord Valentia (from whom her husband secured £12,000 in damages), the Prince of Wales (by whom she had a daughter) and the Duke of Orleans. Her posthumous autobiography gave an account of numerous improbable experiences in four Parisian jails during the French Revolution, and claimed that she had received an offer of marriage from Napoleon.

Reynolds rose cunningly to the challenge with a mere four exhibits. He trumped Gainsborough's colourful gallery of the *demi-monde* with his massive *Marlborough Family* (it measures 318 × 289 cm). He also showed the fine half-length of William Markham, the newly consecrated Archbishop of York, which is now at Christ Church, Oxford,[11] and the outstanding whole-length of John Campbell, then the MP for Nairnshire, later the First Baron Cawdor, a portrait hailed by the critic in the *Morning Chronicle* for 'the truth of the resemblance, the boldness of the figure and the freedom and spirit of the design'.[12]

Wright of Derby exhibited at the Academy that year for the first time – he had previously remained faithful to the Incorporated Society. More than 400 works were exhibited. Receipts, at £1,475 11s, were larger than on any previous occasion. Expenses amounted to £363 16s 5d and grants of aid

accounted for a further £100. After the annual contribution had been made to the pension fund, the deficit to be supplied by the privy purse came to £236 11s 4d.

Reynolds's pocketbook for 1778 is lost, but we know that he was at work on a number of notable female portraits in the course of the year. He painted Lady Henrietta Herbert, daughter of the Earl of Powis and later daughter-in-law of Clive of India.[13] He made a start on the picture of Mrs Thrale and her daughter Queeney which eventually hung over the chimney-piece at Streatham, and is now in the Beaverbrook Art Gallery in Fredericton, New Brunswick.[14] The bluestocking Mary Monckton, who would later become the second wife of Reynolds's friend the Earl of Cork and Orrery, also sat to him.[15] Then in her early thirties, she was renowned for her vivacity and her sparkling conversation. Fanny Burney described her as 'very short, very fat, but handsome; splendidly and fantastically dressed, rouged not unbecomingly, yet evidently and palpably desirous of gaining notice and admiration'. In old age – she lived into her nineties – she would become eccentric, and something of a kleptomaniac. When she dined out, indulgent hosts would leave a pewter fork or spoon in the hall for her to secrete in her muff. Disraeli knew her well, and took her as the model for Lady Bellair in *Henrietta Temple*.

The portrait of the Countess of Bute, daughter of Lady Mary Wortley-Montagu, also dates from this time.[16] She is shown walking outdoors,* holding an umbrella – 'a proof', C. R. Leslie wrote, 'how little inclined the painter was, sometimes, to sacrifice character to beauty'.[17] The umbrella was only beginning to gain acceptance in England at that time, even by men; women used parasols to protect their complexion from the elements, but they seldom featured in fashionable portraits. Until it was included in the Royal Academy's Reynolds Exhibition in 1986, the picture, now at Mount Stuart, had not been seen in public for more than a century. 'As an apparently uncontrived, direct and informal whole-length portrait,' David Mannings wrote in the catalogue, 'it is unsurpassed in the eighteenth century.'[18]

Totally different in almost every way is the whole-length of Sir John Fleming's daughter, Jane,[19] who would shortly become the wife of Charles Stanhope, heir to the Earl of Harrington and recently Burgoyne's aide-de-camp in North America.† She is posed against a stormy sky in a Capability Brown-style parkland, one hand resting lightly on the balustrade behind her, the other extended in a gesture which could be either rhetorical or

* Possibly in the grounds of Luton Hoo, which her husband had bought in 1762. The picture originally hung in the library there.
† Stanhope had arrived back in England on Christmas Eve the previous year with dispatches announcing the surrender at Saratoga; the news, unfortunately, had travelled ahead of him.

simply indicative. Her dark hair is decorated with white plumes and a coloured scarf, but her dress comes close to defying description – she appears to have got tangled up in an interminable bale of salmon-coloured silk. 'The drapery,' one modern critic has written, 'is downright impossible: the Countess couldn't walk a yard without tripping, swathed in this giant, pink bed-cover.'[20] It was presumably this aspect of Reynolds's addiction to the historical style which Gainsborough had in mind some years earlier when he wrote mockingly to Lord Dartmouth of 'the foolish custom of Painters dressing people like scaramouches'.

Male sitters in the course of 1778 included Sir William Chambers, whose portrait was to hang in the new Assembly Room at Somerset House,[21] and the lawyer and politician John Hely Hutchinson, notorious for the single-mindedness with which he feathered his own nest and secured lucrative posts for his relatives. 'If England and Ireland were given to this man,' observed Lord North, 'he would solicit the Isle of Man for a potato garden.'[22]

Reynolds also painted the portrait of John Hayes St Leger which is now at Waddesdon Manor.[23] He wears the uniform of the 55th Foot – he was a captain in the regiment at the time. St Leger was a friend of the Prince of Wales, who later commissioned the portrait of him by Gainsborough now in the Royal Collection. Gainsborough has him leaning nonchalantly against his horse, gazing mildly out to the right of the picture. Reynolds's portrait is altogether more dramatic. He has provided the menacing background of dark cloud which convention decreed for pictures of warriors; St Leger, alert and virile – he was only twenty-two at the time – stands ready to draw his sword. There are echoes of Reynolds's early portrait of Keppel. Ellis Waterhouse admired it greatly. 'A most remarkable experiment,' says a manuscript note preserved at the Getty Center Library at Santa Monica, 'like Greco in figure proportion and like Goya in the boyish military mode.'[24]

Reynolds was never short of invitations from his grand friends to escape from the grime and smells of London in the summer months and breathe a little country air:

My Lord

I am endeavouring to settle my affairs working hard and postponing as much business as will enable me to take three more days of pleasure, tho I thought my holydays were over for this Summer, but Newnham is so pleasant both indoors and outdoors that it is irresistble.

My nieces desire their most respectfull compliments, are extremely happy with the thought of seeing Newnham, and extremely proud of the honour of waiting on Lady Harcourt.[25]

Nuneham Park, near Oxford, was the seat of his friend George Harcourt, who had succeeded to the title the previous year when his father, the First Earl, had drowned in a well while trying to extricate a favourite dog.* The son took a keen amateur interest in landscape gardening and engraving, and he enlisted Reynolds's assistance in the restoration of pictures at Nuneham. A fellow guest on this occasion was Horace Walpole. 'I have passed four most agreeable days at Nuneham,' he wrote to Lady Ossory. 'Mr Mason, Miss Fauquier, and Sir Joshua Reynolds with his two nieces were there.'[26]

It became a fashionable pastime that year to visit the various militia camps that had sprung up around the southern counties, and which afforded a novel and agreeable location for picnic parties and flirtation. 'The Parliament is to have only short adjournments,' Horace Walpole wrote to Mann; 'and our senators, instead of retiring to horse-races (*their* plough), are all turned soldiers, and disciplining militia.'[27] There was one at Warley Common, in Essex. Bennet Langton, a captain in the Lincolnshire militia, was stationed there, and managed to persuade both Reynolds and Johnson to trundle down and visit him.† Reynolds also visited the camps at Coxheath, in Kent, and at Winchester. He was the guest while there of his friend Joseph Warton, whose long, chaotic reign at the College had still not run half its course. 'Thrice in his headmastership,' records the *Dictionary of National Biography*, 'the boys openly mutinied against him, and inflicted on him ludicrous humiliations.'

George III was also doing the rounds of the camps. It happened that he was at Winchester at the time of Reynolds's visit, and was to pass his troops in review on the Downs. Reynolds's fellow guests at Warton's included Garrick and his wife. On the morning of the review the English Roscius turned up on horseback. At one point he dismounted, and the horse escaped his grasp and ran off. According to Northcote, Reynolds used to recount what happened next 'with great humour':

Throwing himself immediately into his professional attitude he cried out, as if on Bosworth Field, 'A horse! a horse! my kingdom for a horse!' This exclamation, and the accompanying attitude, excited great amazement among the surrounding

* As former governor to the Prince of Wales, it was he who had been dispatched to Mecklenburg-Strelitz in 1761 to request the hand of the Princess Charlotte for the young king. He had also been ambassador to Paris and Lord Lieutenant of Ireland. His resiting of the village to Nuneham is thought to have been the inspiration for Goldsmith's *Deserted Village*. Reynolds had painted him in the 1750s (Mannings, cat. no. 835, fig. 111).

† Langton later told Boswell that Johnson stayed the best part of a week and took the keenest interest in everything, sitting in on a regimental court-martial and inquiring the weight of musket balls (Boswell, 1934–50, iii, 361).

spectators, who knew him not; but it could not escape his Majesty's quick apprehension, for it being within his hearing, he immediately said, 'Those must be the tones of Garrick! see if he is not on the ground.' The theatrical and dismounted monarch was immediately brought to his Majesty, who not only condoled with him most good humouredly on his misfortune, but flatteringly added, 'that his delivery of Shakespeare could never pass undiscovered.'[28]

A young man called George Huddesford, whose father had been president of Trinity College, Oxford, had been a pupil of Reynolds for a time in the early 1770s, and had had a number of pictures accepted for exhibition at the Academy. More recently he had turned his attention to humorous verse, and in the autumn of 1778 he published anonymously 'Warley, a Satire', which held up to ridicule the military reviews which were such a frequent feature of life in the militia camps. It carried a dedication to Reynolds modulating in tone from the fulsome to the impertinent:

> May the Produce of Reynolds's Pencil divine,
> Be forgotten when Phoebus no longer shall shine! . . .
> May wine, brandy, and beer, be his constant potation,
> 'Til, like Caesar, exciting the world's admiration,
> Too great for a country of Prejudice grown,
> Some Cassius supplants him or – Conjuror Hone.

Huddesford also commissioned from Reynolds a portrait of himself and a friend called John Bampfylde, a young Cambridge graduate who wrote poetry and was a gifted amateur musician. The painting, one of Reynolds's few essays in Renaissance style 'friendship portraiture', is now in the Tate Gallery.[29] The two friends are seated side by side. Huddesford, in a black silk Van Dyck dress, looks out at the viewer; Bampfylde, dressed in grey, looks down at a print, identified as that made by J. R. Smith in 1777 of Reynolds's portrait of Joseph Warton[30] (Huddesford was a Wykehamist and had been briefly a Fellow of New College).

For Reynolds the commission was to have a disagreeable sequel. Bampfylde – Reynolds's portrait of his mother had been exhibited the previous year* – came of a prominent Devon family. He was a gifted young man with a taste for solitude. He had lived for some years in a secluded farmhouse near Chudleigh, on the River Teign, but had then yielded to family pressure to take up the law. London seems to have been a severe cultural shock, and he drifted into a life of irregularity and dissipation. He

* See p. 319, above.

also fell in love with Mary Palmer, and when he published his *Sixteen Sonnets* in 1778, they were dedicated to her:

> To Miss Palmer,
> These Sonnets,
> which have been honored with her Approbation,
> Are dedicated By Her Very Sincere And devoted humble servant,
> JOHN BAMPFYLDE

He was no latter-day Milton, but his 'Stanzas to a Lady' suggest that he was badly smitten:

> In vain from clime to clime I stray
> To chase thy beauteous form away,
> And banish every care;
> In vain to quit thy charms I try,
> Since every thought creates a sigh,
> And every wish a tear.

Mary – she was said to have had as many suitors as Penelope – turned him down, even though he had kept up the pressure by publishing his 'Sonnet to Miss Palmer's Monkey'. Bampfylde became importunate, and Reynolds instructed his footman that he was no longer to be admitted to the house.

Early in March there was a concert at the Freemasons' Hall. The French composer François André Philidor* had collaborated with Baretti to set Horace's *Carmen Seculare* to music.† Mary, escorted by Reynolds and Johnson, was present at the second performance, and so was Bampfylde, who apparently made a scene. 'The Company were greatly alarmed by the irregular and violent Behaviour of Mr B—,' reported the *Public Advertiser*.[31] Later in the evening he turned up in Leicester Fields, smashed some of Reynolds's windows, and was arrested. He appeared before the local magistrate, and was bound over in the sum of £20. Huddesford stood bail for him, and so did one Josiah Millidge, the printer who had published his poems:

* Philidor (1726–95) was also the leading chess player of his day. His ability to play several games simultaneously without seeing the board was commemorated by Diderot in his article 'Échecs' in the *Encyclopédie* as an extraordinary example of power of memory and imagination.
† Johnson, pressed by Baretti for an opinion about the merit of the translation, replied, 'Sir, I do not say that it may not be made a very good translation' (Boswell, 1934–50, iii, 373).

Upon condition that the said John Bampfylde do personally appear at the next General Quarter Sessions of the Peace, to be held for the said City and Liberty, at Guildhall, in King-street, Westminster, then and there to answer what shall be objected against him by Sr Joshua Reynolds Knt and in the mean time to be upon his good behaviour towards our Sovereign Lord the King and all his subjects, especially towards the said Sr Joshua Reynolds . . .[32]

The case was dropped. Reynolds did not lose the services of his housekeeper. Bampfylde became insane, and was confined to a private madhouse in Sloane Street. He recovered his senses only shortly before his death from consumption in the mid-1790s.[33]

The beginning of the year had seen the anonymous publication of Fanny Burney's *Evelina*. Her sister Hetty, meeting Fanny Reynolds, heard that Reynolds had vowed he would give £50 to know the author:

Sir Joshua, who began it one Day when he was too much engaged to go on with it, was so much caught by it, that he could think of nothing else, & was quite *absent* all the Day, not knowing a word that was said to him: &, when he took it up again, found himself so much interested in it, that he sat up all night to finish it! –*

In the middle of September he and his two nieces had visited Mrs Thrale at Streatham, where the young author was a house guest (Fanny's father had for several years past been giving music lessons to Queeney Thrale). In the course of the day Reynolds was let into the secret. He was hugely impressed. 'If he were conscious to himself of any trick, or any affectation,' he remarked to Johnson, 'there is Nobody he should so much fear as this little Burney!'[34] Much to his chagrin he was obliged to decline a second invitation from Mrs Thrale to return for dinner two days later:

Dear Madam

I would (to use Dr Goldsmiths mode) give five pounds to dine with you tomorrow, and I would as Mrs Thrale very justly thinks, put off a common dinner engagement, but I have unluckily above a dozen people dine with me tomorrow on Venison which Lord Granby has sent me.

If Mrs. Montagu has read Evelina she will tomorrow receive the same satisfaction that we have received in seeing the Author of which pleasure anxious as I was I

* Burney, Fanny, 1994, 78–9. Reynolds's three-volume copy of the first edition of *Evelina*, with his signature on the fly-leaf, came up for sale at Sotheby's in the 1920s and fetched £950.

begun to despair, and little expected to find the Author correspond to our romantic imaginations. She seems to be herself the great *sublime* she draws.[35]

Fanny had been left with an equally favourable impression of Reynolds. 'I like his Countenance, & I like his manners,' she wrote, 'the former I think expressive, soft, & sensible: the latter gentle, unassuming, & engaging.'[36] Towards the end of the year, she made her first visit to Leicester Fields. It was quite some time before her host appeared, but having paid his compliments to everyone, he drew up a chair next to hers:

'So, you were afraid to come among us?' . . . He went on, saying I might as well fear *Hob goblins*, – & that I had only to hold up my Head, to be above them all! –

After this address, his behaviour was exactly what I should myself have *dictated* to him, for my own ease & quietness; for he never once even alluded to my Book, nor paid any sort of compliments to me – nor treated me with any sort of particularity, but conversed rationally, gayly, & *serenely*: & so I became more comfortable than I had been ever since the first entrance of Company.[37]

Later, having rescued her from the attentions of the larger-than-life Mrs Cholmondeley ('Come, come, Mrs Cholmondeley, I won't have her overpowered here!'), Reynolds made her sit next to him at supper:

Mr William Burke was at my other side. – though, afterwards, I lost the *knight of Plymton*, who, as he Eats no suppers, made way for Mr Gwatkin, &, as the Table was Crowded, stood at the Fire himself. He was *extremely* polite & flattering in his manners towards me, & entirely avoided all mention or hint at Evelina the whole Evening; indeed, I think I have met with more scrupulous delicacy from Sir Joshua than from any body, – although I have *heard* more of his approbation than of almost any Other persons.[38]

They met again soon afterwards, this time at the house of Mrs Cholmondeley, who proved less dragon-like on her home ground. Sheridan was present, and declared that she should write a comedy:

Sir Joshua. I am sure *I* think so; & hope she *will*.

I could only answer by *incredulous* exclamations.

'Consider,' continued Sir Joshua, 'you have already had all the applause & fame you *can* have given you in the *Clozet*, – but the Acclamation of a *Theatre* will be *new* to you.'

And then he put down his Trumpet, & began a violent clapping of his Hands. I

actually shook from Head to foot! I felt myself already in Drury Lane, amidst the *Hub bub* of a first Night.

'O no! cried I, 'there *may* be a Noise, – but it will be just the *reverse*, –' And I returned his salute with a Hissing.[39]

Reynolds was obliged to resubmit himself each year for election to the presidency. The ballot was held on 10 December at the distribution of prizes, immediately after the delivery of his Discourse. For the first four years he had been elected *nem. con.* A sprinking of rival candidates then began to put themselves forward from time to time, although one can hardly talk of a contest; in 1775, for instance, Penny received three votes and Chambers, Nathaniel Dance and Hone each received one (presumably their own) as against Reynolds's sixteen, with two of the twenty-four present choosing to abstain. Gainsborough, who had gained one vote in 1774, stood again in 1778 and did no better; Reynolds secured the support of nineteen of his fellow Academicians, with three choosing not to cast a vote.

The Discourse which Reynolds delivered that year – it was the eighth – is in the nature of a revisionist master class. He is now less concerned with the needs of the younger student, and goes some way towards qualifying and refining certain of his earlier pronouncements:

I thought it necessary in a former discourse, speaking of the difference of the sublime and ornamental style of painting – in order to excite your attention to the more manly, noble, and dignified manner, to leave perhaps an impression too contemptuous of those ornamental parts of our Art . . .

I said then, what I thought it was right at that time to say; I supposed the disposition of young men more inclinable to splendid negligence, than perseverance in laborious application to acquire correctness; and therefore did as we do in making what is crooked straight, by bending it the contrary way, in order that it may remain straight at last.

For this purpose then, and to correct excess or neglect of any kind, we may here add, that it is not enough that a work be learned; it must be pleasing: the painter must add grace to strength, if he desires to secure the first impression in his favour.[40]

Although he stops a long way short of actually jettisoning the rule book, Reynolds is now prepared to countenance a much greater degree of sophistication in its interpretation. 'There are some rules, whose absolute authority, like that of our nurses, continues no longer than while we are in a state of childhood,' he tells his listeners:

One of the first rules, for instance, that I believe every master would give to a young pupil, respecting his conduct and management of light and shadow, would be what Lionardo da Vinci has actually given; that you must oppose a light ground to the shadowed side of your figure, and a dark ground to the light side. If Lionardo had lived to see the superior splendour and effect which has been since produced by the exactly contrary conduct, – by joining light to light, and shadow to shadow, – though without doubt he would have admired it, yet, as it ought not, so probably it would not be the first rule with which he would have begun his instructions.

Reynolds also advocates a degree of flexibility in what he terms 'the artificial management of the figures', where a similar rule of contrast generally applies – 'that if one figure opposes his front to the spectator, the next figure is to have his back turned, and that the limbs of each individual figure be contrasted; that is, if the right leg be put forward, the right arm is to be drawn back'. It is, he maintains, entirely proper that such rules should be taught in the Academy:

But when students are more advanced, they will find that the greatest beauties of character and expression are produced without contrast; nay more, that this contrast would ruin and destroy that natural energy of men engaged in real action, unsolicitous of grace. St Paul preaching at Athens in one of the Cartoons, far from any affected academical contrast of limbs, stands equally on both legs, and both hands are in the same attitude: add contrast, and the whole energy and unaffected grace of the figure is destroyed.

Another area in which he now thinks it right to allow greater liberty from prescription is in the management of light; it may well be that his thinking on this was influenced by his designs for the New College window, which were a major preoccupation at this time:

Whether this principal broad light be in the middle space of ground, as in the School of Athens; or in the sky, as in the Marriage at Cana, in the Andromeda, and in most of the pictures of Paul Veronese; or whether the light be on the groups; whatever mode of composition is adopted, every variety and licence is allowable: this only is indisputably necessary, that to prevent the eye from being distracted and confused by a multiplicity of objects of equal magnitude, those objects, whether they consist of lights, shadows, or figures, must be disposed in large masses and groups properly varied and contrasted; that to a certain quantity of action a proportioned space of plain ground is required; that light is to be supported by sufficient shadow; and, we may add, that a certain quantity of cold colours is necessary to give value and lustre to the warm colours: what

those proportions are cannot be so well learnt by precept as by observation on pictures, and in this knowledge bad pictures will instruct as well as good.[41]

His aim, he emphasizes, as he draws to a close, is not to place the artist above rules, but to teach him the reason for them:

... to prevent him from entertaining a narrow confined conception of Art; to clear his mind from a perplexed variety of rules and their exceptions, by directing his attention to an intimate acquaintance with the passions and affections of the mind, from which all rules arise, and to which they are all referable.[42]

It is one of the most lucid of the Discourses, sharply written, full of practical advice drawn from Reynolds's own vast experience and with less of that broad generalization which sometimes takes the edge off what he has to say. Reynolds himself was clearly pleased with it. He placed an order with Thomas Cadell to have 150 copies bound in marble paper, together with six 'in Gold Paper with the Edges gilt' – these for presentation to the king.*

The older generation of artists was passing away. Knapton had died the previous year and now, early in 1779, he was followed by Reynolds's old master, Thomas Hudson. He had spent most of the past twelve years at his villa on the Thames at Twickenham, surrounded by the best pieces he had collected – by the time of his retirement in the 1760s his collection of drawings had been one of the best in London. The contents of his rooms in King Street, Covent Garden, and the unframed drawings and prints at Twickenham were dispersed in two sales soon after his death. His pictures and terracotta models were sold at Langford's early in March in eighty-three lots, and the drawings and prints later in the month in 840 lots, some containing as many as sixty-four items. Reynolds attended the sale, but we do not know what he bought.

David Garrick also died that winter, a few days short of his sixty-second birthday. The findings of the post-mortem make it seem remarkable that he lived as long as he did:

The viscera of the thorax and abdomen were perfectly free from the least appearance of disease. No stone was found in the bladder, but on moving the peritoneum covering the kidneys, the coats of the left only remained, as a cyst full of pus; and not a vestige of the right could be found.[43]

* Letter 79. Cadell had been appointed Printer to the Academy when Thomas Davies went bankrupt in 1778.

The likelihood is, therefore, that he had been born with only one kidney, which had been either congenitally cystic or destroyed by infection. A modern death certificate would say that he died of uraemia.

The funeral arrangements were made by Sheridan, and there were those who thought they went some way over the top. Horace Walpole found a characteristically malicious angle: 'The Court was delighted to see a more noble and splendid appearance at the interment of a comedian than had waited on the remains of the great Earl of Chatham.'[44] There were thirty-three mourning coaches, each drawn by six horses; Reynolds rode in one of them with Fox. Inside the Abbey there was music by Purcell and Handel, and the Dean read the service in a low voice. 'Hardly a dry eye,' Hannah More wrote to her sister – 'the very players, bred to the trade of counter-feiting, shed genuine tears'. Johnson's cheeks were also bathed in tears, and Burke sobbed openly.

Reynolds was not observed to weep. It is true that when writing to Sir Robert Chambers in Bengal later in the year he made appropriate conventional noises – 'The Death of Garrick indeed is such a loss, as the public have not had for these many years'[45] – but it is clear, as we have seen from the unfinished character sketch found at Malahide, that privately he viewed Garrick with a critical and far from friendly eye. There may have been an element of jealousy. He acknowledged Garrick's genius as an actor, but did not warm to his vanity and his gargantuan appetite for applause, on and off the stage. Garrick, he believed, had become the slave of his reputation: 'The habit of seeking fame in this manner left his mind unfit for the cultivation of private friendship.' That is a harsh judgement, and one not born out by the evidence of Garrick's relations with, say, Lord Camden, or Hannah More or Dr Burney and his children, but Reynolds reiterates the point relentlessly:

An inordinate desire after fame produces an entire neglect of their old friends, or we may rather say they never have any friends; their whole desire and ambition is centered in extending their reputation by showing their tricks before fresh new men.[46]

Neglect of old friends was certainly not a charge that could be laid against Reynolds, and at the very moment of Garrick's funeral, it so happened that one of his very oldest friends stood in need of all the support he could muster – for the second time in his life, Augustus Keppel had been summoned before a court-martial.

Keppel, appointed to command the Channel fleet the previous year, had encountered the French off Ushant. The engagement was initially inconclus-

ive; when the signal to renew the attack was given, it was obeyed by the van, but disregarded by Sir Hugh Palliser, who had command of the rear; night came on, and the French were able to slip away. Their commander, Isaac de la Clocheterie, received a hero's welcome and was personally decorated by the king. Fashionable ladies of the court began to wear their hair 'à la Belle Poule' – the name of his ship – a huge pompadour surmounted, improbably, by a model of a full-rigged frigate.

Although Keppel glossed over his dissatisfaction with Palliser in his dispatches, word of their differences got into the papers, and Palliser wrote to Keppel requesting that he should contradict 'these scandalous reports'. When Keppel declined, Palliser retaliated by bringing charges of misconduct and neglect of duty against him. The decision of the Admiralty to appoint a court-martial caused outrage in all ranks of the navy. Twelve admirals, headed by Keppel's old commander, the veteran Hawke, presented a powerfully worded memorial to the king: 'It will not be easy for men attentive to their honour to serve your Majesty, particularly in situations of principal command, if the practice now stated to your Majesty be countenanced.'[47]

The king assured them that their representations would receive 'his most serious attention'. They heard no more. Keppel was taken into custody by the Provost Marshal, and gave his word of honour that he would appear at Portsmouth to be tried. There were five counts to the charge. If Keppel were to be found guilty on the first – 'not making the necessary preparation for fight' – the court had discretionary power as to the sentence of capital punishment. The remaining four – they included 'not doing the utmost in his power to sink, burn, or destroy the enemy'* and 'not causing the fleet to pursue the flying enemy' – would have left the court no alternative, if proved, but to condemn the prisoner to death.

The trial was highly charged politically. Both men were Members of Parliament. Palliser was a supporter of Lord North, Keppel was closely connected with the opposition.† A great many of his friends travelled down to Portsmouth in a show of solidarity; they included the king's brothers Cumberland and Gloucester and the Dukes of Portland, Richmond and Bolton. The Marquess of Granby was there, and so were Fox, Burke and Sheridan – all three had to post back to London for Garrick's funeral.

* This came under the 12th Article of War, which was that on which the death sentence on Byng had been framed twenty-two years previously. Keppel, then a captain, had been the junior member of that court-martial and had subsequently, with two colleagues, made attempts to have the sentence commuted.

† He was the MP for Windsor. At one election George III went round the town exhorting shopkeepers not to vote for him.

The proceedings extended over five weeks. Wherever Keppel appeared during that time, he was loudly cheered and applauded; Palliser never showed himself without being hissed, and was the subject of vigorous street ballads. The trial ended on 11 February. The court found the charges against Keppel 'malicious and ill-founded'. He was honourably acquitted, and his sword was restored to him. Portsmouth went wild. Keppel was escorted to his lodgings to the strains of 'See the Conquering Hero Comes'. A signal gun carried the news to Spithead, and the East India fleet, lying at the Mother Bank, fired nineteen broadsides. Bells rang throughout the day, and the night sky was lit by bonfires and fireworks.

The news of his friend's acquittal reached Reynolds the next day, and he immediately put pen to paper. 'We talk of nothing but your heroic conduct in voluntarily submitting to suspicions against yourself, in order to screen Sir Hugh Palliser and preserve unanimity in the navy,' he wrote:

... Lord North said of himself, that he was kicked up stairs; I will not use so harsh an expression, but it is the universal opinion that your court-martial is unique of its kind. It would have been thought sufficient if you had had no honour taken from you, – nobody expected that you could have had more heaped on a measure already full.

He regaled Keppel with details of the celebrations in London – an account not entirely free of *schadenfreude*:

Poor Sir Hugh's house in Pall Mall was entirely gutted, and its contents burnt in St James's-square, in spite of a large body of horse and foot, who came to protect it.

Lord North and Lord Bute had their windows broke. The Admiralty gates were unhinged, and the windows of Lord Sandwich and Lord Lisburne broke . . . tonight, I hear, Sir Hugh is to be burnt in effigy before your door.*

One newspaper report stated that 'many of the mob seemed not to be of the lower class'. The young Duke of Ancaster was among those arrested, and passed the night in the novel surroundings of the watchhouse.† The theatres rapidly climbed on the bandwagon; at the Haymarket an ode entitled 'Victory' was performed in Keppel's honour; at Covent Garden a new farce

* Letter 77. Sandwich was First Lord of the Admiralty and Lisburne a Lord of the Admiralty.
† The disorder was not confined to London. Horace Walpole, writing to Lady Ossory, told her 'a shocking history' about Palliser's sister, who lived at York. 'As if the poor woman was not wretched enough with his disgrace and ruin,' he wrote, 'the mob there has demolished her house and she is gone mad' (Walpole, 1937–83, xxxiii, 96, letter dated 23 February 1779).

called *The Liverpool Prize* concluded with a chorus commemorating his acquittal.

Nor did Reynolds overlook the commercial possibilities of the occasion. 'I have taken the liberty,' he wrote at the end of his letter to Keppel, 'without waiting for leave, to lend your picture to an engraver, to make a large print from it.'* This was the portrait which Reynolds had painted mainly in 1765 – there are versions at both the National Maritime Museum, Greenwich and the National Portrait Gallery.[48]

Shortly after his acquittal, Keppel wrote to thank John Lee, one of the lawyers who had defended him. In reply Lee said that he would keep the letter as long as he lived, but insisted on declining 'the very munificent present which your letter encloses' – Keppel had sent him two bank notes, each of £500. One thing, however, he would accept: 'Will you make me a present of your picture, painted by Mr Dance, who takes excellent like-nesses?'[49]

Lee got his picture, but, unsurprisingly, the commission was redirected to Leicester Fields. Keppel, red-faced and paunchy now, gazes steadily out of the canvas, his right hand resting almost demonstratively on his sword. Reynolds has hit on a characteristically elegant and understated way of alluding with his brush to the words of the presiding officer at the court-martial: 'In delivering to you your sword, I am to congratulate you on its being restored to you with so much honour.'†

* The engraver was Reynolds's former pupil William Doughty. He worked very quickly, and his mezzotint was published on 12 March.

† Mannings, cat. no. 1042, pl. 93, fig. 1302. The portrait is now at the National Maritime Museum, Greenwich. Keppel ordered five more or less identical versions of it for presentation to his lawyers and supporters (Mannings, cat. nos. 1043–7).

17

Alarums and Excursions

The Ministry and the court party had done themselves a serious injury. Keppel addressed a dignified and powerful letter to the king: 'I trust your Majesty will see my reputation cannot continue safe in hands who have already done all they could to ruin it.' After acrimonious exchanges with the Admiralty, he was directed to strike his flag and come on shore.

There were angry exchanges in the Commons. Fox described Lord Sandwich, the First Lord of the Admiralty, as 'a greater traitor to the nation than the man who sat fire to the dock-yards'* and moved – unsuccessfully – for his removal from office.† On 12 April Palliser, in his turn, went on trial (ironically, on board the *Sandwich*). The Admiralty saw to it that the court was packed. After twenty days spent examining witnesses and three of loud dispute, Palliser was censured but acquitted, although neither unanimously nor honourably. He was not reinstated, but to the outrage of the navy, Sandwich appointed him to the governorship of Greenwich Hospital.

Public interest in the proceedings was so great that press coverage of that year's Academy exhibition was greatly reduced. The *Morning Post* promised a notice 'in a future paper' but it never appeared, which meant that Gainsborough did not that year enjoy the flattering attention of Bate. He was noticed elsewhere, although some critics found fault with what they saw as the artificiality of his colouring; the *St James's Chronicle* thought his portrait of the Duchess of Gloucester finely drawn and a striking likeness, but felt that he was 'less happy in his attitudes than Sir Joshua'.

Reynolds's own major exhibit was his *Nativity* for the New College

* In 1777 a man called James Hall had set fire to the dockyard at Portsmouth. He was hanged in chains on a gallows sixty feet high.

† Sandwich was having a rough time domestically as well as politically. He had lived for seventeen years with a woman called Martha Ray, by whom he had nine children. A few days previously, in a fit of jealous rage, a clergyman called Hackman had shot her as she was leaving Covent Garden Theatre; he was hanged on the day of Fox's motion. Boswell, always keenly interested in such matters, had attended both his trial and execution, and found Johnson 'much interested' in his account of the proceedings (Boswell, 1934–50, iii, 383–4).

window.[1] He had been hard at work on it in the early months of the year. The pocketbook records sittings in January for 'boys' and 'girls'. Presumably he was at work on the central part of the window, and they were required as models for the angels round the crib. His friend Mason called on him at this time. 'His painting room presented me with a very singular and pleasing prospect. The effect may be imagined, but it cannot be described,' he wrote:

The head of the Virgin in this capital picture was first a profile. I told him it appeared to me so very *Corregiesque*, that I feared it would be throughout thought too close an imitation of that master . . . when I saw the picture the next time, the head was altered entirely: part of the retiring cheek was brought forward, and, as he told me, he had got *Mrs Sheridan* to sit for it to him.[2]

There is an entry 'Child for the Christ' on 12 February and several entries of 'Boy & Mother' in February and March. On 9 April, less than two weeks before he was due to escort the king on his customary preview of the exhibition, there is an entry 'the ox'. It was clearly touch and go whether the picture would be ready in time.* 'The day of opening approached too hastily upon Sir Joshua,' Mason writes:

I saw him at work upon it, even the very day before it was to be sent thither; and it grieved me to see him laying loads of colour and varnish upon it, at the same time prognosticating to myself that it would never stand the test of time . . .[3]

Reynolds's own technical note on the picture survives: 'Praesepi on Raw cloth senzo olio – Venice Turp. & cera' ('Nativity, painted on raw cloth, without oil, with wax and Venice Turpentine'). Mason was no doubt wise to hold his tongue as he watched the frantic last-minute efforts to finish the picture, but his prognostication was correct. Five years later, we find Reynolds writing apologetically but unconvincingly to the Duke of Rutland, who had paid him £1,200 for it:

In regard to the Nativity the falling off of the Colour must be occasioned by the shaking in the Carriage, but as it is now in a state of rest it will remain as it is for ever, what it wants I will next year go on purpose to mend it . . .

* Although it was a rule that exhibits would not be received after the appointed time, artists frequently came up with a range of excuses – that their paintings were not dry, or that they were held up for frames. The Council Minutes for 1779 give a list almost two pages long of those 'craving indulgencies' in this way – not the best way to achieve popularity with the hanging committee (RA Council Minutes, i, 268–9).

In fact it became necessary to have the painting restored yet again some years after Reynolds's death. Giuseppi Marchi travelled to Belvoir Castle in 1796 and attended to it 'by infusing a preparation of paste through the cracks'. He told Farington that the picture 'was unluckily painted on a *floor Cloth* canvass doubled, which prevented him from lining the picture', but thought that after his treatment it would remain sound for forty years.* The matter was decided otherwise by the Belvoir fire in 1816.

The *Nativity* met with a mixed reception at the 1779 Exhibition. 'His Virgin,' wrote a critic in the *Gazetteer*, 'a fine blooming young lady, about seventeen, seems very ill matched with poor Joseph who, by way of contrast appears to be above eighty, and extremely ugly; upon a near view Joseph is our old acquaintance Count Hugolino, who was starved with his children in a former exhibition, but with less aggravated features, and in better care'.[4] As well as using George White as a model, Reynolds introduced Jervais and himself as shepherds.

Reynolds also exhibited his designs for the three Christian or 'theological' virtues – Faith, Hope and Charity – which were to occupy the lower lights of the Oxford window immediately beneath the *Nativity*.[5] These, too, divided opinion. Charity, as 'the greatest of these', has pride of place in the centre, modelled, like the Virgin in the *Nativity*, by Mrs Sheridan. 'Very middling,' sniffed Horace Walpole. The *St James's Chronicle* thought that Hope 'has something in its drapery, and the Formation of its lower parts, which give disgust' – a reference, presumably, to the way in which her bare left foot and the billowing folds of her garment combine to produce a slight see-through effect. A writer in the *Public Advertiser* ventured a general criticism which he recognized might be thought heretical by those 'who are taught to look up to Sir Joshua as infallible'. He readily subscribed to the President's excellence as a portrait painter – 'yet this, and his other *historical* exhibitions prove, he is not equal to all the parts of his profession'.[6]

Reaction would continue to be mixed as succeeding elements of the design were exhibited. *Justice*[7] was shown at the 1780 Exhibition, and two more of the cardinal virtues, *Temperance* and *Fortitude*,[8] a year later.† *Justice* was roughly handled. 'The figure is painted in the best style of Sir Joshua,' wrote the *St James's Chronicle*, 'but the emblems and the disposition of

* Farington, 1978–84, iii, 669, entry dated 3 October 1796. Marchi told Farington that somebody had previously been dabbling with the picture 'in a very clumsy manner'. He had cleaned nineteen other pictures by Reynolds while he was about it.

† It is unclear why Reynolds did not exhibit *Prudence*. Jervais's glass painting was shown at Pinchbeck's Rooms in the Haymarket in 1780.

them are suggested by the taste of a Petit-Maitre'.[9] A purist in the *Morning Post* was even more severe:

This picture, though a fine drawn figure, is emblematically repugnant to the antients' ideas of *Justice*, all of whom represent her holding *scales* equally poized; but Sir Joshua has, in violation of this, decked her hands with a pair of *stilliards*, in imitation no doubt of the wife of a Clare-market butcher weighing out a leg of mutton to her dainty customer!*

It was strongly rumoured at the time of the exhibition that Reynolds was ill. 'I was at the Exhibition yesterday & heard nothing but a general Murmur of Lamentation that poor Sir Joshua Reynolds had had a paralytick Stroke,' Mrs Thrale wrote in her diary on 1 May:

I hope it is not true: he is a Man very generally beloved: some say he has lost the Use of his Hands & fingers . . . but I hope all will be well again: he is a glorious Painter, a pleasing Companion & a Sensible Man. he is however not much a Man to my natural Taste: he seems to have no Affections, and that won't do with me – I feel great discomfort in the Society of a Pococurante: Sir Joshua is at the same time an extremely agreeable Acquaintance, & one does not want every body to be a *Friend* or an *Admirer*; I am impatient to hear how he is, Mrs Boscawen shed Tears about His Illness today, while She was contemplating his pictures of Faith Hope & Charity.†

It seems to have been no more than a rumour. He certainly had fewer sitters than usual that year, but there are no tell-tale gaps in the pocketbook to indicate that he had been incapacitated in any way and his social round was as busy as ever. On 1 April he had been at the Club, relaxing in the sort of company he found most congenial. 'I love the correspondence of viva voce over a bottle,' as he once told Boswell, 'with a great deal of noise and a great deal of nonsense.'[10] How much noise and nonsense there was on this particular occasion is not known, because Boswell was not present to note it down, but the Club book records that Reynolds, Beauclerk, Gibbon and Sheridan managed between them to put away six bottles of claret and two of port.

His own dinner guests on 7 April included both Boswell and Johnson, an occasion enlivened by a lengthy harangue from the latter on the subject of drink. He spoke with great contempt of claret, Boswell records, 'as so weak,

* 2 May 1780. A stilliard, or steelyard, was a balance consisting of a lever with unequal arms.
† Piozzi, 1942, i, 382.

that "a man would be drowned by it before it made him drunk"'. The company pressed him to substantiate his view:

He was persuaded to drink one glass of it, that he might judge, not from recollection, which might be dim, but from immediate sensation. He shook his head, and said, 'Poor stuff! No, Sir, claret is the liquor for boys; port for men; but he who aspires to be a hero (smiling) must drink brandy.'[11]

Later in the month, Boswell, who had been resistant to Johnson's advice that he should become a water-drinker, succumbed simultaneously to gout and depression, and was laid up at his lodgings in South Audley Street. Reynolds and Johnson went and sat with him one evening. 'I need scarcely say,' Boswell wrote gratefully, 'that their conversation, while they sate by my bedside, was the most pleasing opiate to pain that could have been administered.'[12]

Gibbon had a number of sittings to Reynolds in the early summer of 1779 for the portrait exhibited at the Academy the following year.[13] Malone, whom Reynolds was also painting at this time, thought it a good example of his ability to 'animate' his portraits. 'Instead of confining himself to mere likeness,' he wrote, 'he dived, as it were, into the mind, and habits, and manners, of those who sat to him.'[14] Reynolds was also seeing a good deal of Gibbon socially. He seems to some extent to have filled the gap left by the death of Goldsmith, and the two men were frequently in each other's company at masquerades and other places of entertainment.

Although Reynolds was now in his mid-fifties, there were Grub Street hacks who occasionally filled their space by portraying his private life as no less colourful than that of many of his sitters. *Town and Country Magazine* ran a regular feature called *Histories of the Tête-à-Tête*. This purported to offer biographical sketches of figures in the public eye, but there was a monotonous – and usually salacious – emphasis on what those members of the *ton* were alleged to get up to in their own and other people's bedrooms. The article in the issue for August 1779 carried the subtitle 'The Modern Apelles and the Amiable Laura'. A review of Reynolds's early career includes a suggestive paragraph about his time in Italy:

But whilst he was studying the Roman beauties on canvas, or chiseled in marble, his mind was not so totally ingrossed with art, but that nature often prevailed, and the living Venus's frequently supplied the place of that of Medicis.

Later, we are asked to believe that he had fathered a child by one of his aristocratic sitters:

Lady G—r was a constant visiter of our hero one spring, soon after her adventure that made so much noise: it is true that her picture was then painting, but as she often visited him in the evening as well as in the morning, and assisted at his *petits soupers*, there is reason to believe her ladyship was willing, that the knight should give a resemblance of her in the most natural way: and if fame says true, a few months after her ladyship made a temporary retreat, and was not heard of by her friends for some weeks.

This sounds like a reference to Lady Grosvenor, whose liaison with the king's brother, the Duke of Cumberland, had led to an action for criminal conversation and an award of damages of £10,000 against the prince in 1770.* If so, the hack had failed to do his homework. Gainsborough had exhibited a portrait of Lady Grosvenor at the Society of Artists in 1767, but she never sat to Reynolds.

Most of the piece, however, is devoted to the story of Laura J—gs, described as the daughter of a naval officer who had served under Reynolds's friend Admiral Boscawen. Left penniless on the death in action of her father, she falls into the clutches of her milliner, 'who, like most of her fraternity, had more professions than one'. The procuress dangles her before an elderly peer, who behaves generously to her: 'His lordship *doated* upon her in every sense of the word, anticipating all her wants – gratifying all her desires *in his power.*'

Reynolds enters the narrative through the peer's wish to have Laura's portrait painted. The young woman's beauty, we read, throws the modern Apelles into an 'enchanting delirium'. When the unnecessarily protracted series of sittings comes to an end, Miss J—gs presents Reynolds with a bank note for £100; he returns it to her in a gold snuff-box containing his own miniature. Lord F— discovers the box on her dressing table; his suspicions are confirmed and he throws her over. Only a small prize is offered for guessing the dénouement:

No sooner had our hero learnt that his lordship had quitted Miss J—gs, than he waited upon her; and after a few introductory compliments, offered his purse and person. Her present situation would not let her refuse either, as it would have been ridiculous to have laid claim to virtue, though she probably might to chastity, from his lordship's inabilities; and as the knight had already made a very favourable impression on her, she, with seeming reluctance, yielded to his proposal, and since that time there is great reason to believe they have been mutually happy.[15]

* The case had been a gift to the *Tête-à-Tête* series; later the same year it had demonstrated its even-handedness in such matters by exposing the adultery of Lady Grosvenor's husband.

It is an unpleasant piece of journalism, and not only because of the repeated allusion to Lord F—'s impotence. 'Miss J—gs' does not correspond to any known sitter of Reynolds's. A much more illuminating – and entertaining – piece of contemporary writing about him is to be found in Fanny Burney's diary later in the year. She was staying at Brighton with Mrs Thrale, and had made the acquaintance of one Edward Blakeney – 'An Irish Gentleman, late a Commissary in Germany. He is between 60 & 70, but means to pass for about 30,' she wrote to her sister Susanna – '*empty*, conceited & parading.' Blakeney, it seems, was notorious for the contempt in which he held any sort of artist:

... the other Day, when *Painting* was discussed, he *downed* Sir Joshua Reynolds as if he had been upon a level with a Carpenter or Farrier! – 'Did you ever, said Mrs. Thrale, see his Nativity?'

'No, Madam: – but I know his Pictures very well; I knew him many Years ago, in Minorca,* – he Drew my Picture there, – & then he knew how to take a moderate Price, – but now, – I vow to God, Ma'am, 'tis scandalous! – scandalous indeed! – to pay a fellow here 70 Guineas for scratching out a Head! –'

'Sir, cried Dr. Delap, (who is here perpetually,) you must not run down Sir Joshua Reynolds, because he is Miss Burney's Friend. –'

'Sir, answered he, I don't want to run the man down; – I like him well enough, in his proper place, – he is as decent as any man of that sort I ever knew, – but for all that, Sir, his Prices are shameful! – Why he would not – (looking at the poor Doctor with an enraged contempt) he would not do *your* Head, under 70 Guineas!'

'Well, said Mrs. Thrale, he had *one* Portrait at the last Exhibition, that I think hardly *could* be paid enough for, – it was of a Mr Stuart, – I had never done admiring it.'

'What stuff is this, Ma'am! cried Mr. Blakeney, how can 2 or 3 Dabs of Paint ever be worth such a sum as that!' –

'Sir, said Mr. Selwyn, (always willing to draw him out,) you know not how much he is improved since you knew him in Minorca; he is now the finest Painter, perhaps, in the World.'

'Pho, pho, – Sir, – cried he, how can *you* talk so? – you, Mr. Selwyn, who have seen so many capital Pictures abroad? –'

'Come, come, Sir, said the ever odd Dr Delap, you must not go on so undervaluing him, for, I tell you, he is a Friend of Miss Burneys.'

'Sir, said Mr. Blakeney, I tell you again I have no objection to the man, – I have Dined in his Company 2 or 3 Times, – a very decent man he is, – fit to keep Company

* Blakeney had been private secretary to his famous cousin, Lieutenant-General William Blakeney, later Lord Blakeney, who had been Lieutenant-Governor of Minorca at the time of Reynolds's stay there.

with Gentlemen; – but, Lord God, Ma'am! – what are all your modern Dablers put together to one ancient? – Nothing! – a set of – Not a Rubens among them! – I vow to God, Ma'am, not a Rubens among them!' –[16]

Blakeney was misinformed about how much Reynolds charged for his '2 or 3 Dabs of Paint'. It is true that his price for a 'head', which is how a three-quarters was often somewhat confusingly described, had gone up that year, but to 50 guineas, having remained at 35 guineas since the 1760s. For 70 guineas, Blakeney could still have had himself portrayed at half-length, although he would have had to look sharp, because that too would shortly be raised – Keppel, for instance, would pay £100 for each of the four 'acquittal' portrait replicas.* Reynolds's price for a whole-length had also remained unchanged for some fifteen years; it too now rose, from 150 to 200 guineas, and would not be increased further in his lifetime. It would be some years before Gainsborough began to approach this final scale of prices set by his rival; he did not start charging 160 guineas for a whole-length until 1787.†

Although Blakeney's outrage is ostensibly generated by Reynolds's prices, there are odd tell-tale phrases – 'I like him well enough, in his proper place', 'he is as decent as any man of that sort I ever knew' – which give the game away. Reynolds's real offence – like Garrick's‡ – was that he had breached a class barrier; here was a mere face-painter who was on terms of easy friendship with members of the leisured classes, who was invited to their country estates to share in their patrician pleasures. Social mobility is not attractive to those whose concern is with order and rank and exclusivity.

To Reynolds, Blakeney's views about his social station would have been a matter of indifference. He was happy to enjoy what society had to offer, but he was remarkably detached and self-contained. He was also, even after thirty years, totally wrapped up in his work; the hours he spent each day in his painting room were still of much greater importance to him than anything else. A letter survives which he wrote to Lord Ossory in September of that

* Reynolds clearly did not believe in offering discounts, even to old friends. He priced these four pictures as originals, not copies. For the replicas of Lord Suffolk's picture in 1780, on the other hand, he charged only 50 guineas (Mannings, cat. no. 950, fig. 1273; cat. no. 951, fig. 1274; cat. no. 952, untraced; cat. no. 953, fig. 1275 and cat. no. 954, fig. 1276).

† Details of Reynolds's charges from the 1740s onwards are set out on pp. 21–2 of the text volume of Mannings.

‡ 'When Mr Garrick was mentioned, he honoured him with much the same style of Compliment as he had done Sir Joshua Reynolds,' Fanny told her sister. 'Lord God, Ma'am, 'tis a shame to think of such things! – an Actor Living like a person of Quality! – scandalous! – I vow to God, scandalous! –' (Burney, Fanny, 1994, iii, 417).

year, thanking him for a gift of venison. 'It is remarkably fine, and worthy for its beauty to sit for its picture,' he wrote:

I have been as busy this summer in my little way as the rest of the world have been in preparing against the invasion: from the emptiness of the town I have been able to do more work than I think I ever did in any summer before. My mind has been so much occupied with my business that I have escaped feeling those terrors that seem to have possessed all the rest of mankind. It is to be hoped that it is now all over, at least for this year.[17]

Those terrors had seemed real enough during the summer months. A French and Spanish fleet had blockaded Plymouth; Jersey had been attacked in May, and in July the Dover and Ostend packet had been captured by a French frigate; one of those taken prisoner was the Duchess of Leinster, who had been sitting to Reynolds only two months previously.[18] Another passenger was Mrs Damer, widow of the sculptor John Damer; Reynolds had painted her portrait in 1771.[19]

His hope that it was all over for the year was a forlorn one. The versatile John Paul Jones – slave trader, smuggler, commander in the American navy – was still making a nuisance of himself in British coastal waters; the fact that he was a Scottish gardener's son from Kirkcudbrightshire increased the irritation. He had made prizes off Carrickfergus the previous year and attempted to kidnap the Earl of Selkirk. This summer, in a converted French East Indiaman, he had penetrated the Firth of Forth and come almost within gunshot of Leith; within days of Reynolds's letter to Ossory he would attack a British convoy from the Baltic off Flamborough Head.

Reynolds was always happy in the company of sailors – 'Mediterranean friends', as he affectionately called them. He was at work towards the end of the year on yet another of those splendid portraits of naval men – there are fifteen of them – now at the National Maritime Museum at Greenwich. Admiral Barrington sat to him in November, but the picture* was returned to Reynolds within a matter of months because the blue of the sky had turned to green. In a letter to the admiral's brother, Reynolds expressed incredulity, and laid the blame elsewhere:

I could *scarce* believe it to be the picture I painted, the effect was so completely destroyed by the green sky. This was occasioned by a blunder of my colourman,

* Mannings, cat. no. 120, fig. 1306. Barrington (1729–1800) had joined the navy as a boy of ten. He had been with Keppel in the operations against Belle Isle in 1761; he had recently declined the command of the Channel fleet because of the chicanery which had threatened Keppel's life and honour.

who sent blue verditer (a colour which changes green within a month), instead of ultramarine, which lasts for ever.[20]

To Mason, however, Reynolds appears to have given a franker explanation, and to have owned to some carelessness:

Sir Joshua once bought, at a very considerable price, of some itinerant foreigner, I believe a German, a parcel of what he pretended was genuine ultramarine, which, in point of color, seemed fully to answer its title. Without bringing it to any chemical test, the artist ventured to use it, and by it spoiled, as he assured me, several pictures; for the fictitious pigment soon changed into a muddy green, which he was obliged to repair, by painting over it.[21]

Earlier in the year, at the time of the exhibition, Reynolds had at long last been granted a number of appointments with the king. Now, in early December, the queen also sat to him. The sittings hardly represented a thaw in his relations with the court; indeed given the court's attitude to Keppel, there is a nice irony in the fact that the king eventually consented to be painted in the year that Reynolds was busily turning out the 'acquittal' replicas. The royal portraits were intended for the new Academy rooms in Somerset House which were now approaching completion. It was presumably inconceivable that anyone other than the Academy's President should be asked to paint them; it was widely believed that Reynolds had made royal sittings a condition of his acceptance of the presidency; he cannot have expected to wait ten years for them. The king, seated in the coronation chair and swathed in interminable ermine, appears bored; Queen Charlotte looks tight-lipped but dutiful. They are dull, lifeless portraits, and Reynolds cannot have derived much pleasure from painting them.*

The Club's original membership of nine had increased steadily. By 1780 it had risen to more than thirty, but in the course of that year its ranks were thinned by the death of two of the original members. Topham Beauclerk had been well enough to preside at the first meeting of the year on 14 January, but less than two months later he was dead at the age of forty. 'Poor dear Beauclerk,' Johnson wrote to Boswell. 'His wit and his folly, his acuteness and maliciousness, his merriment and reasoning, are now over. Such another will not often be found among mankind.'[22] Reynolds's *The Character of Spencer's Una*, which he exhibited at that year's Academy,

* That of Queen Charlotte is not a patch on the superb portrait exhibited at the Academy by Gainsborough two years later and now in the Royal Collection.

was a portrait of Beauclerk's daughter Mary.* Later in the year Anthony Chamier died. Reynolds had been a frequent guest at his country house at Streatham and had painted him three times;[23] his death occurred in September, scarcely more than a month after his re-election as the Member for Tamworth.

Early in April the Secretary to the Lords of the Treasury wrote to Chambers to inform him that the apartments allotted to the Academy in New Somerset House were now ready for their use. The tone of the letter suggests that their Lordships regarded artists as an even lower form of life than did Fanny Burney's Mr Blakeney:

... And you are to signify to the officers of the Academy that they, their families, servants, tradesmen, and visitors, are to use for their apartments the stair of communication only, and not to use the great stair for any common purposes; and as the residence of the secretary in the Academy is an indulgence lately proposed, which upon trial may be found inconvenient, or the rooms he occupies be hereafter wanted for other purposes, you are to signify to him that he holds the same merely at pleasure, to be resumed whenever it shall be thought proper. And to the end that all the parts of the new building may be preserved in good repair, clean, undamaged, and undisfigured, you are strictly to direct and order that no tubs or pots of earth, either with or without flowers or trees, creepers, or other shrubs, be placed in the gutters of the said building, or upon the roofs and parapets, or upon the court area or windows, niches, or any other aperture of the same; and also that no plaster, paper, or other thing be put up, plastered, or pasted against any of the walls thereof, under any pretence whatever . . .[24]

The Academy's new home was much grander than its old quarters in Pall Mall – the rooms are described by Baretti in the guide he published the following year. The doorway was surmounted by a bust of Michelangelo, the work of Joseph Wilton. Passing through a Doric screen from the entrance hall, the visitor faced a long climb up the elliptical staircase. It afforded, Baretti wrote, 'a constant-moving Picture of every gay and brilliant Object which graces the Beau-Monde of this vast Capital, pleasantly contrasted with wise Connoisseurs and sprightly Dilettantes of every size and denomination'.[25]

Twenty years later the sardonic eye of Thomas Rowlandson took it in rather differently, as can be seen from his caricature *The Academy Stare-*

* Mannings, cat. no. 143, fig. 1269. The subject is taken from Spenser's *Faerie Queene*. The virgin Una stands for true religion; the lion, tamed by the sight of her beauty, symbolizes England.

Case. It was recognized that the climb was arduous: when Queen Charlotte was expected at the exhibition, a chair was placed on each landing. For scribblers with space to fill in the public prints the staircase was a godsend, and they recycled the same joke, with varying degrees of roguishness, year after year. 'Some perambulate the rooms to view the *heads*', the *Morning Post* informed its readers in 1785, 'others remain at the bottom to view the *legs*.' Another hack, writing in the *World, Fashionable Advertiser*, two years later, declared that although some exhibitions might have more merit, none was so attractive as that at Somerset House – 'for, besides the exhibition of pictures living and inanimate, there is the *raree-show* of neat ancles up the stair-case – which is not less inviting.'

The principal floor contained the Academy of Antiques and the Library, the coved ceiling decorated with Reynolds's *Theory*, which he had completed the previous year.[26] Baretti described the central figure as 'an elegant and majestick female, seated in the clouds, and looking upwards, as contemplating the Heavens'. She does so in Burlington House to this day, although there is no sign of the compass which Baretti says she holds in one hand – possibly Reynolds briefed him about his design before starting work and then changed his mind, or for some reason or other subsequently painted it out. A scroll in her right hand bears the words 'THEORY *is the knowledge of what is truly* NATURE' – an encapsulation of one of the recurring themes of the Discourses. The room was further ornamented by casts from Ghiberti's bronze doors from the Baptistery in Florence,* and, for less obvious reasons, by cases of stuffed owls and hawks, a feature which was the cause of some hilarity. The ceiling of the Council Chamber, or Assembly Room, on the same floor, was decorated with Benjamin West's *Four Elements* grouped round *The Graces Unveiling Nature* and by four roundels of Angelica Kauffmann representing *Genius, Design, Composition* and *Painting*.† Here too were Reynolds's portraits of the king and queen and of himself and Chambers.

At the top of the next flight of stairs was the Great Exhibition Room. It measured some fifty-three feet by forty-three feet and was lit by a huge skylight and four arched windows. 'Let no Stranger to the Muses enter' enjoined the motto inscribed over the door – in Greek, naturally. A good

* These had been presented to the Academy in 1773 by someone recently returned from Italy, although the minutes do not identify the donor. 'These gates have long been objects of curiosity among the virtuosi of Europe,' wrote the *Public Advertiser*, 'insomuch so that the great Michael Angelo looking at them one day very attentively exclaimed "these gates are fit for nothing but the gates of Paradise" ' (Whitley, 1928, i, 350).
† All now in the vestibule of Burlington House.

impression can be formed of how it looked in those early days from an engraving made some years later by Pietro Antonio Martini. The pictures are crammed together hugger-mugger, frames touching, from floor to ceiling; in the foreground the Prince of Wales is being escorted by Reynolds, identifiable by his ear-trumpet.

The artists responded to the challenge of these new surroundings and a total of 489 paintings went on show. Gainsborough sent six landscapes and a number of portraits, including studies of his friends Bate and the actor Henderson; West was represented by portraits of the royal children and several historical works, including his *Battle of the Boyne* and *La Hogue*. His compatriot, Copley, was also represented, although by only one picture. This was a portrait of a Major Montgomery, 'who signalised himself by the destruction of the Cherokee settlements last war'. The major wears Highland uniform, and is posed against a background of blazing wigwams. Fuseli had also now become a regular exhibitor, and submitted *Satan Starting from the Touch of Ithuriel's Spear*. Horace Walpole was unimpressed: 'Extravagant and ridiculous,' he scribbled on his catalogue. Reynolds again demonstrated his versatility, his portfolio including his head of Gibbon, a full-length of the Duke of Gloucester's son, Prince William Frederick,* his portrait of Beauclerk's daughter and the finished design for *Justice* for the New College window.

Some visitors reacted prudishly to the casts from famous statues displayed in the Academy of Antiques and on the staircases and aired their views in the press. One correspondent addressed his appeal to Reynolds personally, imploring him, 'though neither husband nor father yourself', to remove the casts which were 'the terror of every decent woman who enters the Antique Room'. Another, slyly signing himself 'No Conjuror', had a whole string of indignant rhetorical questions for the President and Council. 'Has decency totally left the direction of the institution?' he inquired:

... or has the unblushing countenance of a P ... laughed you out of a sense of delicacy, that these figures which heretofore deterred ladies from ever entering the apartments of the old Academy are now drawn out in the full face of day and obtruded on their view without the least reserve? What sort of compliment is offered either to the ladies or to their Majesties that to have the pleasure of contemplating those masterly representations of the Royal Pair a woman must forfeit her claim to

* Mannings, cat. no. 1905, fig. 1338. The picture ('Well but too washy' in Horace Walpole's view) is now at Trinity College, Cambridge. The prince, who succeeded his father as Duke of Gloucester in 1805, was the first royal to be admitted to a Cambridge college. He later became Chancellor of the University.

decency? It was surely violence enough offered to that sentiment in the female mind to have passed with tolerable composure the figure of the Apollo Belvedere in the Vestibule without subjecting it to so formidable an ordeal as that in the Antique Room.[27]

'No Conjuror' was a well-informed observer of Academy affairs with a retentive memory. The unnamed Academician of the 'unblushing counten-ance' was Matthew William Peters, whose *A Woman in Bed* had caused a stir at the exhibition three years previously. 'In its present situation,' the critic of the *Morning Chronicle* had written indignantly, 'it serves to prevent the pictures round it from being so much seen and admired as their merit demand, for every man who has either his wife or daughter with him must for decency's sake hurry them away from that corner of the room'.[28] The remarks of 'No Conjuror' came at an embarrassing juncture for Peters, who now averted his eyes from smiling ladies on bed or sofa and was preparing for ordination.

There was also a flurry of press interest in Chambers while the exhibition was on, although not on account of what he had achieved architecturally at Somerset House. 'A subaltern in the royal works,' reported the *London Courant* on 18 May, 'who a few years ago was the hero of a celebrated Heroic Epistle, is reported to have disappeared, with a considerable sum of money in his pocket'. The rumour that ran round the town was more specific; Chambers was said to have misappropriated some of the funds made available to him for the conversion of Somerset House and fled the country.

Horace Walpole, always first with the latest, regaled William Mason with the details[29] – both men took a close and not entirely friendly interest in Chambers's affairs. The 'celebrated Heroic Epistle' mentioned in the *Courant* had been a satirical attack on Chambers's *Dissertation on Oriental Gardening* – which was not really a description of Chinese gardens, but a polemic on English gardening directed against the views of Capability Brown. Published anonymously in 1773, the *Epistle* was ostensibly a straightforward parody of Chambers's ideas. Its readers, however, were quick to recognize it for what it really was – a political squib aimed at the broader target of the Tory establishment, of which Chambers, an intimate of the king and Comptroller General of His Majesty's Works, was a leading light – 'by Fortune plac'd to shine the Cynosure of British taste', as the *Epistle* put it.[30] It ran into ten editions in the year of publication alone; Chambers had a broad back, but the ridicule inflicted a good deal of damage

on his reputation. What he did not know – although Reynolds quite possibly did – was that the *Epistle* was the work of Mason, aided and abetted by Walpole.

When Walpole next wrote to Mason, he had less dramatic news to impart:

The story of Sir William Chambers is odd. He is certainly in Flanders but there is no embezzlement; he has money in his banker's hands, writes to his family, and sends orders to his workmen at Somerset House.[31]

Four days later there were further developments to report:

Sir William Chambers has reappeared and been at the Royal Academy. His absence is now said to have been an équipée of gallantry.

Whether it was an affair of the heart or a matter of business which took Chambers to Flanders was never established. To check on his accounting, the Treasury insisted in 1781 that the Board of Works, which had hitherto only priced the continuing work at Somerset House, should henceforth also 'survey, examine, and measure'. James Paine was appointed as an impartial 'architect of credit' to certify the accounts. His reports, and those of his successor, George Dance the younger, regularly confirmed that everything was in order. The report for 1783 certified 'that the Money has been very properly expended . . . and with every due attention to the Interest and Advantage of the Public'.[32] Questions about the cost were quite often raised in the Commons, and Chambers was obliged to present himself at the Bar to explain the situation. He did so convincingly, and won the support of a number of powerful champions, including Burke.

The first exhibition held in the apartments Chambers had designed for the Academy was the most successful to date. Curiosity to see the new rooms no doubt helped, and receipts rose to over £3,000, an increase of more than £1,700 on the previous year. It was the last time a call had to be made on the privy purse; after twelve years the Academy was finally able to pay its way.

If Reynolds's treatment of his pupils sometimes appeared to amount to little more than benign neglect, there was never anything remotely grand about him. He was eminently approachable, and always generous to painters who came to him for advice or help. Shortly after the opening of the 1780 Exhibition, for instance, we find him writing a long letter of advice to a Nicholas Pocock,[33] a Bristol man in his late thirties, and the captain of a merchantman. A gifted watercolourist, he had recently tried his hand at oils,

but the marine picture which he had sent to the exhibition had arrived too late. 'It is much beyond what I had expected from a first essay in oil colours,' Reynolds wrote encouragingly; 'all the parts separately are extremely well painted; but there wants a harmony in the whole together; there is no union between the clouds, the sea, and the sails.' He recommended him to paint from nature instead of drawing. 'Carry your palette and pencils to the water side,' he urged him. 'This was the practice of Vernet, whom I knew at Rome.'*

Later in the year he exerted himself on behalf of a young Irish portrait painter. Thomas Hickey, who had exhibited at the Academy throughout the 1770s, had decided to try his luck in India, and Reynolds wrote a letter of introduction for him ('Mr Hickey is a very ingenious young Painter') to Warren Hastings, even though there had been no contact between them since Hastings sat to him in the mid-1760s:

At the distance of so many years, and the very small pretensions I have of claiming the honour of being known to you, tho it might prevent me from troubling you on other subjects, yet in the present instance I should hope you would think me excusable . . .[34]

It was some time before Hickey was able to present the letter. He sailed for India in July, but his ship was captured by a French and Spanish fleet; he spent the next four years in Spain and Portugal and did not arrive in Calcutta until 1784, little more than a year before Hastings's final return to England.†

Reynolds never regarded the weeks of the exhibition as a time to change down a gear, and in May of that year he was exceptionally busy. He put the finishing touches to his portrait of General James Oglethorpe, which had been commissioned by the Duke of Rutland.[35] Oglethorpe was a legendary figure from an earlier age. Now well into his eighties, he had served as a youth under Prince Eugene and Marlborough. In the 1730s he had been prominent in the settlement of Georgia, both as a refuge for paupers and a barrier against Spanish expansion. He was an early patron of Johnson, who in return had wished to write his life. The portrait was one of many which did not survive the 1816 fire at Belvoir Castle.

Another sitter with a distinguished and colourful past was Sir William James, who had run away to sea at the age of twelve, enjoyed the friendship of Laurence Sterne and may or may not have been married, first time round,

* Pocock persevered, and exhibited successfully at the Academy between 1782 and 1812. During the 1790s he worked as a war artist.
† Hickey prospered in the East. He accompanied Lord Macartney to China from 1792 to 1794 and subsequently returned to India for the rest of his life, dying at Madras in 1824.

to the landlady of the Red Cow at Wapping. He was now, at the age of fifty-nine, extremely rich and Chairman of the East India Company. As a much younger man he had commanded the Company's Bombay Marine, and was famous for his defeat in 1755 of the dreaded Kanhoji Angrey – pirate chief to the British, *Surkhail*, or Grand Admiral of their fleet to the Marathas, either way the scourge of the Honourable Company for twenty years. James's portrait[36] was destroyed, too, although not until the Second World War.

Reynolds was also at work on a much more ambitious group portrait or conversation piece. Horace Walpole told Mason about it in a letter at the end of May: 'Sir Joshua has begun a charming picture of my three fair nieces, the Waldegraves, and very like. They are embroidering and winding silk.'[37] The young women are all dressed in the then fashionable white muslin; their hair is lightly powdered, and though still built up, does not reach the vertiginous heights that would have been *de rigueur* a few years earlier.

Walpole had, in fact, commissioned the painting himself, and would take a keen interest in its progress, although his opinion of its merits would alter over the years. In 1781, when the picture was shown at the Academy, he pronounced it 'a most beautiful composition . . . the attitudes natural and easy'. After living with it for some years – it hung in the refectory at Strawberry Hill – he came to admire it less. The hands, he grumbles in a letter to Mason in 1783, are 'abominably bad', and although he still finds the whole effect charming, he now considers some of the details slovenly, 'the faces only red and white'. He also dislikes the detail Reynolds has allowed to appear in some of the background: 'his journeyman, as if to distinguish himself, has finished the lock and key of the table like a Dutch flower-painter'.[38] So he had, but Walpole was being uncharacteristically obtuse. The journeyman, whoever he was, may well have been displaying his virtuosity, but he was also, as Desmond Shawe-Taylor has pointed out, almost certainly following Reynolds's directions – a locked drawer is a traditional emblem of virginity.[39]

Reynolds continued to receive sitters even during the terrifying days of the Gordon Riots in early June, when much of London was at the mercy of the mob. The Roman Catholic Relief Bill had passed into law two years previously. It had been introduced by Sir George Savile, a leading opposition Whig (and a neighbour of Reynolds in Leicester Fields) and had received strong support from Cabinet ministers. The laws discriminating against Roman Catholics had not been enforced in recent years, but the new legislation removed a number of embarrassments to enlightened opinion. It did away with the prohibitive oaths technically required of those who served

in the forces of the Crown and permitted Catholics to be educated abroad without forfeiting their property; nor would popish priests any longer be guilty of a felony.

Anti-popish agitation was triggered only when it was proposed to extend these modest measures of toleration to Scotland, and the Protestant Association which then came into being in England offered its presidency to an eccentric sprig of the Scottish aristocracy. Lord George Gordon was the son of Cosmo, Third Duke of Gordon. He was now twenty-eight, and had sat in Parliament for the last six years for the Wiltshire borough of Ludgershall, which was in the pocket of Fox's friend George Selwyn. Gordon's hair was red and lank; he wore it long, and occasionally sported bright tartan trousers. He had initially formed an admiration for Burke and generally voted with the opposition. He was an infrequent speaker, and such parliamentary utterances as he made were not noted for their coherence; he had not, curiously enough, either spoken or voted against Savile's bill during its passage through the Commons. In March 1780 he informed the House that he had 160,000 Protestant men in Scotland at his command, and that if the king (who happened to be his godfather) did not keep his coronation oath, they were determined to cut off his head.

On 2 June a huge crowd crossed London Bridge from St George's Fields and marched to Whitehall to present a petition. They appeared in the main to be soberly dressed tradespeople. They were joined along the route by men of a rougher sort, some of whom had been drinking. The approaches to Parliament were soon blocked, and the coaches of peers and commoners were mobbed as they tried to pass through; Lord Mansfield, the Lord Chief Justice, had the windows of his coach broken and his wig removed. Gordon, in a state of high excitement, darted in and out, haranguing the crowd one minute, addressing the Commons the next.

After dark, the chapel of the Sardinian ambassador in Lincoln's Inn Fields was destroyed. The response of the magistrates was feeble, and by 5 June private houses were being looted as well as foreign chapels. Burke's house in Charles Street, off St James's Square, was threatened, and saved only by a garrison of sixteen soldiers. Sir George Savile's house on the north side of Leicester Fields – Reynolds could see it from his windows – was ransacked, and by the time the troops arrived most of his furniture was ablaze in the street outside. The following day the mob exploded distilleries in Holborn and added to their own number by bursting open Newgate prison. The Bank of England came under siege, but the rioters were driven off by a party headed by Wilkes; the mob turned their attention a second time on Lord Mansfield, and his house in Bloomsbury, with its celebrated library, was destroyed.

Panic drove many out of town, but Reynolds stayed put, although the appointments noted in his pocketbook between Monday and Thursday have a line drawn through them. On 7 June, 'Black Wednesday', distilleries were still being sacked; the streets ran with spirits, and the water supply of Lincoln's Inn became alcoholic; rioters, senseless with drink, were burned alive in the shells of the buildings they had set on fire. Johnson, who did not scare easily, walked out to look at Newgate, and found it in ruins, the fire still glowing. He sent a lively account of what he saw to Mrs Thrale:

As I went by, the Protestants were plundering the Sessions-house at the Old Bailey. There were not, I believe, a hundred; but they did their work at leisure, in full security, without sentinels, without trepidation, as men lawfully employed, in full day. Such is the cowardice of a commercial place.*

Reynolds was at the Academy by ten in the morning; there were mounting fears for the safety of Somerset House. On that day, however, the king's patience with the magistrates ran out, and he insisted that there must be a proclamation calling on all to restore public order. That evening the troops opened fire; two days later the mob was beaten and Gordon was in the Tower.

By the end of the week the cavalry pickets in the squares and the camp in St James's Park had become tourist attractions for the returning quality. More than 450 people had been killed or wounded. Of the fifty-nine rioters sentenced to death, twenty-one mounted the scaffold. The following year Gordon stood trial for treason. He was eloquently defended by Erskine; Lord Mansfield's summing-up, understandably, was not of the friendliest, but the jury took only half an hour to return a verdict of not guilty.† The events of the week, demonstrating as they did the virtual absence of adequate means for maintaining public order, were not quickly forgotten; memories of the Gordon Riots would heighten fears of violence in Britain during the French Revolution.

Reynolds picked up his brush again the day after the royal proclamation. Lady Laura, the eldest of the Waldegrave sisters, resumed her sittings at

* Boswell, 1934–50, iii, 429. Thrale had been ill and his wife had taken him off to Bath and Brighton to recuperate. Johnson told Boswell that their house and the stock at the brewery in Southwark had been in great danger: 'the mob was pacified at their first invasion, with about fifty pounds in drink and meat; and at their second, were driven away by the soldiers' (Boswell, 1934–50, iii, 435).

† Gordon later became a Jew. He underwent circumcision, and preserved the evidence of this rite in an appropriate box. Found guilty of libelling the British government and Marie Antoinette, he spent that last five years of his life in Newgate, where he gave kosher dinner parties and played the bagpipes. He died of a fever in 1793 – after, it is said, singing the 'Ça ira'.

noon, and William Strahan, the King's Printer, who had been roughly handled by the mob, had an appointment on Saturday morning. For some reason his portrait,[40] now in the National Portrait Gallery in London, was not exhibited at the Academy until 1783. 'Well executed,' pronounced the critic of the *Morning Herald*, 'but much too flattering.'

Lord Richard Cavendish also had a string of appointments in June, and Reynolds painted two autograph versions of the same portrait.[41] Cavendish, the bachelor second son of the Fourth Duke of Devonshire, was a great traveller, celebrated for his daring adventures in Africa. Reynolds portrayed him emblematically against a stormy sea, his right hand resting on a large rock. 'One of Sir Joshua's very best,' Horace Walpole thought when he saw it at the following year's exhibition; 'bold and stronger than he ever coloured', he wrote to Mason.[42] Unlike many of Reynolds's aristocratic sitters, Cavendish did not keep him waiting for payment – there is an entry in the ledger in August for 200 guineas. It was as well for Reynolds that he did; Cavendish set off for Italy shortly afterwards and died of dysentery in Naples the following year.

Reynolds's social engagements occasionally took him out of London in the course of the summer. He visited Lord Darnley at Cobham in June, and at the beginning of July he was the Duke of Rutland's guest at Cheveley Park. Towards the end of August, as town began to empty for the autumn, he set off for his beloved Devonshire. He made a brief visit to Keppel at Bagshot on the way, and by early September was with John Dunning at Spitchwick on Dartmoor. Dunning, who had been one of Keppel's defence lawyers, sat for Calne and was now very much the legal star of the parliamentary opposition. Earlier in the year he had dealt the most serious blow yet administered to the North ministry. His famous resolution, delivered in his rough Devon voice – 'that the influence of the Crown has increased, is increasing, and ought to be diminished' – did not rest on particularly convincing evidence, but had none the less been carried by a small majority.

Reynolds once again found that his visit to Devon coincided with an election campaign. Although the session of 1780 had been the worst that North had had to face, there had been dissensions in the opposition on the question of parliamentary reform, and the Gordon Riots had led to something of a revival in the government's fortunes. North saw his opportunity and called a snap election.

The opposition lost some ground. Three of Reynolds's friends – Keppel, Burke and Gibbon – were among those defeated at the hustings, although all immediately found seats elsewhere; it was at this election that Sheridan, Pitt the younger and William Wilberforce entered the Commons for the first time. The king later complained – although North disputed it – that his

expenses at the 1780 election were at least twice as much as they had been at any other election since he came to power. We now know that the sums known as 'secret service money' employed as an instrument of parliamentary corruption were relatively small; there was, as Lewis Namier memorably put it, 'more jobbery, stupidity and human charity about it than bribery'.*

Saltram – Plympton – Mount Edgcumbe – Port Eliot – for three weeks Reynolds pursued the familiar round of friends and family. It is plain, however, from a letter he wrote during the winter to his nephew William in India that relations with the Johnson side of the family were still distinctly scratchy:

Dear Nephew

You are totally mistaken in regards to the cause of my silence, it is no more nor less than a dislike of writing. I work hard all day and require rest in the evening from all kind of business . . . I have considered writing as a matter of ceremony which might be dispensed with by near relation, but I should be sorry that it should be interpreted as neglect or want of affection . . .

But then a good deal more came tumbling out:

. . . to speak to you now with the same openness and sincerity which you have wrote to me, it was impossible for me to get rid of a suspicion that the children of a father and mother who professedly hate me, have been set against me, your mother has given it under her own hand that she thinks me the greatest villain upon the earth, is it possible for children that hear such opinions from such an authority as a mother, not to be prejuded by them, and is it possible for me with such suspicion to act with that openess that so near relations might expect: this is my apology for not having had so much attention to the family of one sister as to another, – when I perceive that those prejudices are eradicated my suspicions shall be likewise thrown away.

Later in the letter it emerges that he has been exerting himself considerably on his nephew's behalf:

Mr Macpherson who is appointed one of the Supreme Council has promised me in a very emphatic manner to serve you, in whatever you want his assistance . . .

* Namier, 234. According to North, the expenses of the elections secretly paid for by government in 1779, 1780 and 1781 amounted to about £53,000. The preceding general election had cost them some £50,000, in addition to pensions of the annual value of £1,500 paid for the purchase of borough interest. See *Correspondence of George III with Lord North*, ii, 422.

Tho I have been some years acquainted with Mr Macpherson yet I have lately cemented that acquaintance on your account. I have dined twice this week in company with him and Mr Devaines whose acquaintance I am likewise cultivating for the same reason.*

Reynolds concluded with some shrewd advice. 'Make yourself master of the Politicks of India,' he urged his nephew:

With superior knowledge, things fall into your hands, and but little interest is required; I would learn at my leisure hours the Persian language which would certainly facilitate your progress, and contribute to make you a usefull man. To make it peoples interest to advance you, that their business will be better done by you than any other person, is the only solid foundation of hope, the rest is accident.[43]

The winter session of the Academy schools opened for the first time in the new building on 16 October, and Reynolds delivered a mini-Discourse. He paid a graceful compliment to Chambers – 'This Building, in which we are now assembled, will remain to many future ages an illustrious specimen of the Architect's abilities' – and combined it with a challenge to the students: 'It is our duty to endeavour that those who gaze with wonder at the structure, may not be disappointed when they visit the apartments.' He devotes the briefest of all his Discourses to the reiteration of a familiar theme – that the proper function of art is not merely to gratify the senses, but to appeal through them to the imagination:

Our art, like all arts which address the imagination, is applied to somewhat a lower faculty of the mind, which approaches nearer to sensuality; but through sense and fancy it must make its way to reason; for such is the progress of thought, that we perceive by sense, we combine by fancy, and distinguish by reason: and without carrying our art out of its natural and true character, the more we purify it from every thing that is gross in sense, in that proportion we advance its use and dignity; and in proportion as we lower it to mere sensuality, we pervert its nature, and degrade it from the rank of a liberal art . . .

Two months later, at the annual distribution of prizes, Reynolds delivered what is generally agreed to be the least impressive of his Discourses. Feeling

* John Macpherson (1745–1821), who had recently sat to Reynolds (Mannings, cat. no. 1169, fig. 1291), was currently the MP for Cricklade and had formerly been with the East India Company. He would succeed Warren Hastings as Governor-General in 1785, but was superseded within two years by Lord Cornwallis and returned home with a baronetcy. William Devaynes (c. 1730–1809) was a banker and a director of the East India Company.

perhaps that he must not, as President, neglect an important area of the Academy's activities, he ventured some way out of his depth:

I wish now to make some remarks with particular relation to Sculpture; to consider wherein, or in what manner, its principles and those of Painting agree to differ; what is within its power of performing, and what it is vain or improper to attempt . . .

He got off to a shaky start by observing that sculpture had only one style. Eighty-five years on, Charles Leslie was incredulous – it was, he wrote, 'an assertion which will astonish students of the Gothic and Renaissance, from the works of the Pisans, and the French cathedral sculptors, down to the workers in terra-cotta and marble, who have flung their wealth of invention so lavishly into the chapels and cloisters of the Certosa'.[44]

Reynolds makes plain that he has little time for the sculptors of modern time – as distinct, that is to say, from those of antiquity:

Of the ineffectual attempts which the modern Sculptors have made by way of improvement, these seem to be the principal: The practice of detaching drapery from the figure, in order to give the appearance of flying in the air; –
 Of making different plans in the same bas-relievos; –
 Of attempting to represent the effects of perspective: –
 To these we may add the ill effect of figures cloathed in a modern dress.

Not content with generalities, he is quite prepared to name names:

The folly of attempting to make stone sport and flutter in the air is so apparent, that it carries with it its own reprehension; and yet to accomplish this, seemed to be the great ambition of many modern Sculptors, particularly Bernini: his heart was so much set on overcoming this difficulty, that he was for ever attempting it, though by that attempt he risked every thing that was valuable in the art.
 BERNINI stands in the first class of modern Sculptors, and therefore it is the business of criticism to prevent the ill effects of so powerful an example.

Reynolds was, of course, doing no more than articulate the received opinion of his day. To the rational minds of the Enlightenment, with their veneration of what they saw as the simplicity and nobility of antiquity, the exuberance of Bernini and his fellow artists of the rococo was not simply unnatural, it was even licentious; the Italian critic Francesco Milizia, who saw the seventeenth century as an age of corruption, wrote extravagantly of 'a plague on taste'.[45]
 The reputation of the devout man who created The Ecstasy of St Theresa and the famous baldacchino of St Peter's – who was indeed able so magically

'to make stone sport and flutter in the air' – would remain in eclipse well into the nineteenth century. Only gradually would he emerge from the 'moral and aesthetic prison'[46] in which he was confined for so long by his neoclassical detractors.

18

'Eccentrick, Bold and Daring'

Reynolds was a guest of the Thrales at Streatham in the early days of 1781, and had agreed, unusually, to take his paints and brushes with him. 'My master has ordered your father to sit tomorrow, in his peremptory way,' Mrs Thrale wrote to Fanny Burney.

... I took ridiculous pains to tutor him to-day, and to insist, in my peremptory way, on his forebearing to write or read late this evening, that my picture might not have blood-shot eyes.

Reynolds painted him in the hood and gown of a doctor of music at the University of Oxford, a rolled sheet of music in his hand.[1] The portrait was destined to fill the last space on the library wall – 'the last chasm in the chain of Streatham worthies', as Mrs Thrale put it.

She was busy entering in her journal, in prose and verse, her unsparing sketches of each of those worthies. 'The great Orator Mr Edmund Burke,' she writes:

was the first Man I had ever seen drunk, or heard talk Obscænly – when I lived with him & his Lady at Beaconsfield among Dirt Cobwebs, Pictures and Statues that would not have disgraced the City of Paris itself . . . That Mrs Burke drinks as well as her Husband, & that their Black a moor carries Tea about with a cut finger wrapt in Rags, must help to apologize for the Severity with which I have treated so very distinguished a Character.

Reynolds fares little better under her cold, appraising gaze. 'I have hardly said good enough of Sir Joshua, but let it go – I wish it were more favourable too,' she writes apologetically:

Of Reynolds what Good shall be said – or what harm?
His Temper too frigid, his Pencil too warm;
A Rage for Sublimity ill understood,

To seek still for the Great, by forsaking the Good;
Yet all Faults from his Converse we sure must disclaim,
As his Temper 'tis peaceful, and pure as his Fame;
Nothing in it o'er flows, nothing ever is wanting,
It nor chills like his Kindness, nor glows like his Painting;
When Johnson by Strength overpowers our Mind,
When Montagu dazzles, or Burke strikes us blind;
To Reynolds for Refuge, well pleas'd we can run,
Rejoyce in his Shadow, and shrink from the Sun.[2]

The Gallery was completed only just in time. Three months later, the Club sat waiting for the arrival of Johnson one evening when a servant brought a note:

Mr Johnson knows that Sir Joshua Reynolds and the other gentlemen will excuse his incompliance with the Call, when they are told that Mr Thrale died this morning.

The Streatham circle rapidly dissolved. In the autumn of the following year Mrs Thrale let the house there and retired to Bath. Two years later came the news that she was to marry Piozzi, her daughter's music master – a foreigner, a Catholic and her social inferior. Old friends shunned her, and some of them – not Reynolds, it should be said – were a good deal more vicious than she had ever been about them in her journal.*

A fashionable new entertainment in 1781 was De Loutherbourg's 'Eidophusikon; or, Various Imitations of Natural Phenomena represented by moving Pictures'. Sensing perhaps that his differences with Sheridan over money must lead to a breach with Drury Lane, De Loutherbourg had been devoting himself to a new enterprise. It opened at the end of February in his house in Lisle Street, just off Leicester Fields. There, every night, on a miniature stage six feet wide by eight feet deep, the audience, who had paid five shillings for admission, was treated initially to five 'Imitations of Natural Phenomena':

AURORA; or, The Effects of the Dawn; with a View of London from Greenwich Park . . . NOON, the Port of Tangier in Africa, with the distant View of the Rock of Gibraltar and Europa Point . . . SUN-SET, A View near Naples . . . MOON-LIGHT, a View in the Mediterranean, the Rising of the Moon, contrasted with the

* Baretti, writing in the *European Magazine* for 1788, was particularly brutal; he describes her as 'the frontless female, who goes now by the mean appellation of Piozzi; La Piozzi, as my fiddling countrymen now term her, who has dwindled down into the contemptible wife of her daughter's singing-master'. Baretti had been provoked by certain passages in the correspondence she had recently published between herself and Johnson.

Effect of fire ... The conclusive Scene, A STORM and SHIPWRECK ... The
Music composed by Mr Arne, who will accompany the Performance on the
Harpsichord ...[3]

De Loutherbourg was continuing the experiments he had conducted at
Drury Lane in lighting, the movement of clouds and transparencies lit from
the rear; the spectacle was accompanied by sound effects of rain, hail,
thunder and the roar of the sea. By William Henry Pyne's account, Reynolds
recommended it to friends whose daughters were taught to draw 'as the
best school to witness the powerful effects of nature'.[4] Gainsborough, who
often painted his landscapes from models of cork and other materials, was
characteristically even more enthusiastic. Pyne says that he was 'so wrapt in
delight with the Eidophusikon that for a time he thought of nothing else –
he talked of nothing else – and passed his evenings at that exhibition in long
succession'.[5]

He was on friendly terms with De Loutherbourg, and had exhibited
his portrait at the Academy three years previously. One evening, a real
thunderstorm broke over London during the performance. This caused
something of a panic among the more suggestible members of the audience,
who were convinced that these imitations of the mysteries of nature were
tempting Providence. Unperturbed, De Loutherbourg took Gainsborough
and two or three others up to witness the storm from the roof. Gainsborough
watched and listened for a time with rapt attention and then turned excitedly
to his friend. 'De Loutherbourg!' he cried, 'our thunder is the best!'[6]

The spectacle ran on to the end of May. 'Loutherbourg, being employed
on his Eidophusikon, had no pictures for the Exhibition,' wrote Horace
Walpole. Another recently elected Academician was also unrepresented,
and this became a matter of some controversy. It was known that Copley
had recently finished work on *The Death of the Earl of Chatham*, and its
appearance at the Academy was eagerly awaited. Copley, however, was
anxious to see some return for a work which had occupied him for the best
part of two years, and arranged to have it shown privately in the gallery in
Pall Mall now occupied by Christie the auctioneer. This did not go down
well with the Academy, but for some reason it was Chambers rather than
the Secretary who made representations. He did so in a notably uncivil letter
in which he referred to Copley's forthcoming exhibition as 'a raree-show';
Christie buckled under pressure and went back on his agreement to allow
Copley the use of his gallery.

The American artist was understandably incensed at such bully-boy tac-
tics. Having secured the use of the great room in Spring Gardens to exhibit
his picture, he decided to make a public statement on the matter:

The causes that have obliged Mr Copley to change the place of the exhibition of his picture are the result of Sir William Chambers' apprehensions that it would be prejudicial to the exhibition of the Royal Academy, and Mr Christie's having been in consequence thereof prohibited from letting his room for that purpose. How far these apprehensions are founded and how far so powerful an interference was necessary for the security of the interests of the Royal Academy from being injured by the exhibition of a single picture is left to the public to decide. Mr Copley's most sanguine hopes of an approbation of his labours could never suggest so presuming an idea in his own favour, and Sir William Chambers alone must account to that distinguished body of artists for the propriety of the insinuation.[7]

The Death of the Earl of Chatham went on show in Spring Gardens on 1 May, shortly after the opening of the Academy. It made a profound effect on those who saw it. 'The room – whatever number of people it contains – is silent,' wrote a correspondent of the *St James's Chronicle*, 'or the company whispers as if at the bed of a sick person.' More than 20,000 visitors paid for admission; an engraving of the picture by Bartolozzi sold 2,500 copies in a matter of weeks; a report in the *Morning Post* some years later said that Copley had cleared in all some £5,000.*

Whether Copley's success had a direct effect on the attendance at the Academy is impossible to say; what is certain is that receipts fell by a third, to £2,141. Those who did not climb the winding staircase at Somerset House missed a great deal. Gainsborough was represented by seven pictures, including portraits of the king and queen and a pastoral study called *A Shepherd*. This is now known to us only through Richard Earlom's mezzotint but excited much admiration – 'the Freedom of Pencil is amazing', wrote a critic in the *London Courant*, while Bate, now ensconced at the *Morning Herald*, reached for superlatives – 'evidently the chef d'œuvre of this great artist, a composition in which the numberless beauties of design, drawing, and colouring are so admirably blended, as to excite the admiration of every beholder!'

Bate, clearly briefed by Gainsborough, reiterated his earlier criticism about the hanging of his landscapes. He complained that, as with his other productions, the effect of *River Landscape with Rustic Lovers* was 'shamefully destroyed, by the picture being hung almost too close to the ground'. 'Strange,' he added, 'that the fame of an artist who is honoured by the most flattering marks of his Sovereign's favour, should here be sacrificed,

* Copley sent a copy of the print to George Washington, and received a flattering acknowledgement: 'This work, highly valuable in itself, is rendered more estimable in my eyes, when I remember that America gave birth to the celebrated artist who produced it.'

on the pitiful shrine of ignorance, or jealousy!' – a fairly obvious thrust at Reynolds.

Bate was not Gainsborough's only champion in this matter. Another suspiciously well-informed piece about the iniquity of his landscapes being hung 'too near the eye' appeared in the *London Courant*, instancing a sea-piece – a new enthusiasm of Gainsborough – entitled *Rocky Coastal Scene*:

> Gainsborough's character as a landscape painter has been materially and constantly hurt by this very visible defect. If they were too far from the eye, it might perhaps be equally bad; but an artist of this gentleman's merit should be particularly accommodated, though inferior artists suffer from it . . . The distance from the eye should not be in proportion to the size of the picture, but in proportion to the breadth of light and shadow, and the high finishing: and those pictures which are unavoidably hung high, should lean much more forward than they do at present.[8]

Reynolds, too, however, had the odd journalist in his pocket, and he provided them with plenty to write about. He exhibited fifteen pictures in all, including the portraits of Burney and the Waldegrave sisters and full-lengths of the Duchess of Rutland* and the Countess of Salisbury – 'In the style of, and little inferior to Vandyke', enthused the *Morning Herald*.[9]

There were two more of the cardinal virtues – *Temperance* and *Fortitude*[10] – for the New College window, and several pictures of children, including one of the three-year-old Henry Bunbury, who was his godson. The reviewer in the *Gazetteer* wrote that the boy's expression 'was so vivacious that Sir Joshua could not have settled him in any steady posture if he had not told him an entertaining story, which fixed his attention'. This tale seems to have gone the rounds in London that spring; Beattie, who was visiting the capital, repeated it in a letter and it entered Bunbury family folklore – Sir Charles, the sitter's son, said many years later that the fairy tales told by Reynolds were indeed the cause of 'the pleased and wondering attention shown in the child's face'. The picture was not commissioned – Reynolds seems to have painted it for himself. It remained in his possession, and he bequeathed it in his will to the boy's mother, Catherine Horneck.†

Reynolds was devoting an increasing amount of his time to subject pic-

* Mannings, cat. no. 1212, fig. 1328. The picture was yet another of those destroyed in the Belvoir Castle fire.

† Mannings, cat. no. 276, fig. 1345. The picture is now in the Philadelphia Museum of Art. Bunbury, later the Seventh Baronet, had a distinguished career in the army, and subsequently served as Under-Secretary of State for War in three administrations.

tures. Northcote says that *The Death of Dido*,[11] which he showed that year, 'drew immense crowds to the Exhibition, exciting the applause not only of Englishmen, but of the most judicious foreigners, by the beauty of the countenance and the extreme richness of the colouring'.[12] The crowds were certainly not attracted by any novelty in the choice of subject. Angelica Kauffmann had shown what she could do with it in 1777, as had Cipriani two years later; it was one of several classical subjects set by the Council for the history painting prize in 1780. Reynolds had been at work on his version since 1779. Displeased with the result, he had started over again a year later; Fuseli, who spent a day with him in his painting room that August, reported in a letter that he remained dissatisfied – 'the same in every respect as the first but less promising in point of execution; he himself begins to think he has failed'.*

Another artist granted a sight of the work in progress was the young Thomas Stothard, then a student at the Academy. He noted that Reynolds had built up the composition with billets of wood; a rich drapery had been thrown over these, and on it was disposed a lay figure in the dress and attitude of the queen. When the picture went on show there was much praise for the beauty of Dido's face, but less for the rest of her person, which does indeed look somewhat dislocated.

The exhibition was enlivened that year by the publication of an anonymous quarto pamphlet called 'The Ear-Wig'.† This is thought to have been the work of a painter called Mauritius Lowe; Johnson, who took a kindly interest in him, and stood godfather to one of his children, told Boswell that he was a natural son of the Second Lord Southwell. A pupil of Cipriani, he had won the first gold medal awarded by the Academy for history painting and was the Academy's first travelling scholar. Once in Rome, however, he proved both indolent and dissipated, and his scholarship was withdrawn. Northcote says that he grumbled on his return about the inadequacy of the £50 a year allowed him in Italy; when Reynolds observed he knew from experience that it was sufficient, Lowe retorted crudely 'that it was possible for a man to live on guts and garbage'.[13]

* Fuseli, 1982, 19. The letter was to Sir Robert Smyth, the MP for Colchester, whom he had met in Italy. Fuseli seems to have been on terms of some intimacy with Reynolds. 'I know much more of Sir Joshua than you do,' he once said unkindly to Northcote, 'for while I was admitted always upon familiar terms you were considered as little better than his palette cleaner' (ibid., 507).

† The lengthy title of the pamphlet conveys something of its tone and style: 'The Ear-Wig; or an Old Woman's Remarks on the Present Exhibition of Pictures of the Royal Academy: Preceded by a Petit Mot pour Rire, Instead of a Preface. Including Anecdotes of Characters Well Known among the Painters; Observations on the Causes of the Decline of the Arts; a Description of the Buildings of Somerset House, and the Appartments occupied by the Royal Academy.'

'The Ear-Wig' – it bore an ironic dedication to Reynolds – declared that
The Death of Dido called 'for a criticism ... more severe than any of
his pictures have ever merited'. There was also a malicious reference to
Reynolds's *Thaïs*:[14]

This picture long remained in the Painter's Gallery, after the first sitting – the face
was painted from the famous Emily Bertie, to which the artist had added great
animation ... it was a cruel snouch in the Painter, a fine girl having paid him
seventy-five guineas for an hour's work, and being unable to pay for the other half
of her portrait, to exhibit her with such a sarcastic allusion to her private life – to
call her Thaïs – to put a torch in her hand, and direct her attention to set flames to
the Temple of Chastity.[15]

Thaïs was the Athenian prostitute who persuaded Alexander the Great to
set fire to the Royal Palace at Persepolis; Reynolds's subject certainly had
Emily as a christian name, but her surname altered depending on who
happened to be keeping her at the time – Emily Warren, Emily Bertie, Emily
Coventry, Emily Pott. She had learned her trade in the King's Place 'nunnery'
of Charlotte Hayes, one of the leading 'lady abbesses' of the day.* According
to William Hickey (a close friend, as it happened, of her current lover, Bob
Pott), Reynolds had painted her many times: 'He often declared every limb
of hers perfect in symmetry, and altogether he had never seen so faultless
and finely formed a human figure.'[16] There are, in fact, no other known
portraits of her by Reynolds, although she was also painted by Nathaniel
Dance and Romney. There is every reason to believe that Fanny Burney was
correct in stating that the portrait had been commissioned by the Hon.
Charles Greville, an earlier admirer. There is further evidence for this in
Reynolds's pocketbook for 1781. He had a dinner engagement with Greville
on 1 April, and jotted down on the page opposite 'Frame for Thais'. Another
note at the end of the book reads 'Thais – to Mr Greville'. Greville, up to
the ears in debt, soon sold it; he would soon, in any case, fall under the spell
of Emma Hart, the future Emma Hamilton. Emily, for her part, set off for
India with Pott, but died at sea during the voyage.

There was lavish praise in 'The Ear-Wig' for Gainsborough, whose royal
portraits were said to 'want very little of perfection'. West, however, who
also had portraits of the king and queen on show, had 'ascertained the exact
proportion of his Majesty, with a compass and taylor's measure, from head
to foot, and ... produced a stuffed pillow'.

* Mrs Hayes had spotted her as a girl of twelve leading her blind father through the streets.
She taught her to walk gracefully, though not to read and write.

A piece in the *Public Advertiser* suggests that the paper may have been offered some friendly guidance by Reynolds on the subject of the permanency of his pigments:

Fugitive colouring has often been, and in some instances not without reason, imputed to Sir Joshua Reynolds. This imperfection, wherever it was visible, always rose from an attempt to improve that part of the art, the Doctrine of Colours; and this imperfection, from the experience of repeated attempts, is now no more. By better ascertaining the proportions of vehicle and colour, and by more happily adjusting the qualities of his vegetable and mineral red, increasing the vermilion and diminishing the carmine, Sir Joshua has at length accomplished the one thing needful, and in the poet's wishful words, has taught 'His transient tints no more to fly.'*

Over the years there had been frequent references in the press – some of them wittier than others – to Reynolds's 'flying colours'. Such technical expedients, someone in the *St James's Chronicle* had recently declared, might be excusable in a poor painter whose Sunday dinner depended upon the rapid movements of his brush, but in a man of his eminence they were 'mean, reproachful and dishonest'.

The writer went on to tell a story about a portrait Reynolds had painted of Sir Walter Blackett – a recycled story, clearly, because although Blackett had sat to Reynolds several times, he had been dead since 1777. Sir Walter was the MP for Newcastle upon Tyne, a notable benefactor of the town and four times its mayor – 'He has been greatly addicted to Women,' wrote a contemporary, 'but his Amours have been chiefly among Servant Maids & Women of that Class.'[17] Once, while he was away in London, one of his portraits suddenly faded. His wife and daughters were terrified, taking it as a premonition of his death; Blackett, on his return, laughed at their foolishness, 'but in justice to the artist wrote the following epigram and inscribed it on the picture in letters of gold':

> The art of Painting clearly was designed
> To bring the features of the dead to mind,
> But this damned painter hath reversed the plan
> And made the picture die before the man.

Well, perhaps; although the *Chronicle* journalist plainly had some assistance from that prolific and ubiquitous storyteller Ben Trovato. There are four

* Whitley, 1928, i, 368–9. A technical note in Reynolds's ledger relating to the use of colour in *Dido* mentions Indian Red and Light Red (Cormack, 169).

recorded portraits of Sir Walter;[18] none of the three which are extant bears any sign of an inscription.

In the lively account which Fanny Burney had sent to her sister of her first visit to Leicester Fields two years previously, there had been a brief mention of a Mr Gwatkin – 'of whom I have nothing to say, but he was very talkative with Miss Offy Palmer, and very silent with everybody else'. Robert Lovell Gwatkin was the son of a Bristol merchant and soap manufacturer. He had recently come down from Cambridge, where he had distinguished himself as Thirteenth Wrangler in the mathematical tripos and been a friend of William Pitt. Now, in the summer of 1781, he and Offie were married. The wedding took place in the West Country, and Reynolds wrote an affectionate letter of congratulation – 'that you may be as happy as you both deserve is my wish and you will be the happiest couple in England'.*

Another family letter which he wrote at much the same time was markedly different in tone. Although Frances Reynolds was no longer a member of the household at Leicester Fields, her capacity to irritate her brother was undiminished:

Dear Sister

I am very much obliged to you for your kind and generous offer in regard to the house at Richmond not only on giving me leave to use it occasionally but even as long as I live provided I will give it to you, but as I have no such thoughts at present I can only thank you for your kindness – tho I am much older than you I hope I am not yet arrived to dotage as you seem to think I am, voluntarily to put myself in the situation of receiving the favour of living in my own house instead of conferring the favour of letting you live in it

 I am your most affectionate

 Brother

 J Reynolds

I have enclosed a Bank Bill of ten Pounds[19]

Fanny was still able to look for gentler treatment to Johnson. Since her departure from Leicester Fields she seems to have devoted more of her time to writing, and she now sent Johnson a draft of what she would publish some years later as her *Enquiry Concerning the Principles of Taste, and of the Origin of Our Ideas of Beauty, etc.* His reply could not have been kinder:

* Letter 93. It was a long and happy marriage. They bought an estate in Cornwall – Gwatkin was later High Sheriff of the county – and had ten children. The novelist Maria Edgeworth would later describe him as 'a true roast beef of Old England, king and Constitution man'. He sat to Reynolds shortly after his marriage (Mannings, cat. no. 787, fig. 1369).

Dearest Madam:

There is in these such force of comprehension, and such nicety of observation as Locke or Pascal might be proud of. This I say with intention to have you think that I speak my opinion.

They cannot however be printed in their present state. Many of your notions seem not very clear in your own mind, many are not sufficiently developed and expanded for the common reader; the expression almost every where wants to be made clearer and smoother. You may by revisal and improvement make it a very elegant and curious work. I am, Dearest Dear, Your most humble servant,

Sam. Johnson[20]

Reynolds had not been abroad since his visit to Paris a decade earlier. Now, in the summer of 1781, he set out for the Low Countries. Undeterred by the fact that Britain had been at war with the United Provinces since the previous November, he embarked on a two-month journey which would also take him to the Austrian Netherlands and the Rhineland. He travelled with his friend Philip Metcalfe, a bachelor ten years his junior who had made a lot of money out of his partnership in the Bissons & Metcalfe distillery. During a visit to Rome in the 1760s Metcalfe had sat to Batoni; a discriminating collector, he would later become Treasurer and Secretary of the Society of Dilettanti and enter Parliament.*

The two men set out on 24 July. 'Fifty six Guineas & seventeen shillings in my pocket,' Reynolds noted in his careful way. 'Gave Mr Metcalf 10 G.' The crossing from Margate to Ostend took twenty-one hours. They posted off almost immediately to Bruges, and as British travellers of the day generally did, put up at the Hôtel de Commerce. We know more about this journey than any of Reynolds's other travels. His own account of it was published posthumously in 1797,† and this can be fleshed out by the itinerary he recorded in his sitters' book for 1781 ('Sat out for Mechlin – arrived at 5 at the Stork Inn in the Great Square. No milk to our tea'), and by the four notebooks which he filled with impressions of paintings and people and what he saw about him ('Antwerp. The ordinary people very ordinary without one exception').

We also have a sequence of letters he wrote to Burke. The first of these – he was writing from Brussels at the beginning of August – opens on a distinctly insular note: 'Nothing hitherto has happened worth mentioning, nor have we seen any pictures better than we have at home.' He would

* He had been one of the signatories of the round robin sent to Johnson in 1776 concerning his Goldsmith epitaph (see p. 305 above).
† The most authoritative edition of Reynolds's *A Journey to Flanders and Holland in the Year 1781* is that by Harry Mount.

reach a more considered judgement when he came to write up his account of the journey. He had already, after all, in the cathedral at Bruges, seen Jan van Eyck's *The Virgin and Child with Saints** and at Ghent he had been able to examine Rubens's *The Conversion of St Bavo*. 'This picture,' he would later write, 'for composition, colouring, richness of effect, and all those qualities in which Rubens more particularly excelled, claims a rank amongst his greatest and best works.'†

He conceded, however, that if the pictures seen so far had been something of a disappointment, he and Metcalfe had been 'very well amused'. His reputation and his wide acquaintance at home meant that doors opened easily for him: the previous day, he told Burke, they had dined with Alleyne Fitzherbert, the British minister at Brussels:

... We all behaved very well. I don't know whether I might expect too much, but I thought Mr Fitz would have laid himself out more for our amusement, he has returned our visit, and given us a dinner, or rather, let us dine with him at the same time with the Duke of Richmond and thats all –[21]

They moved on to Antwerp, where they were to stay for six days. 'Dirty finery', Reynolds noted. 'Stinking streets and all inns, probably.' But not theirs, presumably, because they installed themselves at Le Grand Laboureur, generally reckoned one of the finest inns in Europe. They were received by the burgomaster, and he introduced them to someone described in Reynolds's travel notes as 'Mr Pieters the polite banker'. J. R. Peeters d'Aertselaer was indeed a banker; he was also the owner of some very fine pictures, which he was happy to show off to his English visitors – they included Rubens's *Cimon and Pero*, now in the Rijksmuseum in Amsterdam, and Van Dyck's *Philippe le Roy* and his wife *Marie de Raet*, now in the Wallace Collection in London.‡ Only once during the tour were they refused admittance to a private collection. This was in Dordrecht, their next port of call after Antwerp: 'Sent to see Mineer Van Slingelands collection,' Reynolds noted with some irritation, 'which was the cause of our going to Dort but refused.' His displeasure was understandable. Johan van der Linden van Slingeland had one of the finest collections in the Netherlands. When it went on sale four years later it consisted of more than 700 paintings, thirty-eight of them attributed to Cuyp.

* St-Donatianskathedraal was destroyed by the French in 1799. The picture is still in Bruges, at the Groeninge Museum.

† About Rubens's *St Roch*, which he examined in the St Maartenskerk in Aalst, he was less enthusiastic: 'I suspect it has been in some picture-cleaner's hands,' he wrote darkly.

‡ In 1794, after Antwerp had been occupied by the French, Peeters's descendants feared for the safety of the collection and sent it to America; it remained there until 1816.

Although Reynolds was now fifty-eight, he showed prodigious stamina. On one day alone in Antwerp he managed to visit seven churches; later, in Germany, having left Düsseldorf at six in the morning, he and Metcalfe arrived at Cologne at one in the afternoon; the following day, after making a round trip of three and a half hours to Bensberg, they set out in late afternoon on what proved to be a ten-hour journey to Aix-la-Chapelle.

Metcalfe looked at pictures as a collector; Reynolds looked at them as both collector and painter, and the minute and extended attention which he gave to a canvas must occasionally have proved tedious to his travelling companion. He seemed to recognize as much in the dedication to Metcalfe which he intended for his account: 'To which ever of your good qualities I am to attribute your long and patient attendance, while I was employed in examining the various works which we saw, it merits my warmest acknowledgments.'*

Just how much Reynolds absorbed from his scrutiny of the pictures they saw becomes evident from the account he later wrote of their journey. A good example is afforded by his treatment of Rubens's *Descent from the Cross*, which he studied in the cathedral in Antwerp. He confesses that it did not initially correspond to 'the highest idea of its excellence' which he had formed from the print:

However, this disappointment did not proceed from any deficiency in the picture itself; had it been in the original state in which Rubens left it, it must have appeared very different; but it is mortifying to see to what degree it has suffered by cleaning and mending: that brilliant effect, which it undoubtedly once had, is lost in a mist of varnish, which appears to be chilled or mildewed.†

He recognizes, however, that there was enough to be seen 'to satisfy any connoisseur, that in its perfect state it well deserved all its reputation'. But then Reynolds the connoisseur is elbowed aside by Reynolds the painter:

The greatest peculiarity of this composition is the contrivance of the white sheet, on which the body of Jesus lies: this circumstance was probably what induced Rubens to adopt the composition. He well knew what effect white linen, opposed to flesh, must have, with his powers of colouring; a circumstance which was not likely to enter into the mind of an Italian painter, who probably would have been afraid of

* The dedication, still in draft at the time of Reynolds's death, is now at the Royal Academy (MS REY/3/27, 470).
† Present-day visitors to the Onze-Lieve-Vrouwekathedraal will no longer see the deficiencies noted by Reynolds. The picture has been cleaned and restored several times since 1781, most recently in the 1980s.

the linen's hurting the colouring of the flesh, and have kept it down of a low tint. And the truth is, that none but great colourists can venture to paint pure white linen near flesh . . .

Writing in the 1980s, Svetlana Alpers, professor of the history of art at the University of California, Berkeley, found Reynolds's account of the work of Dutch artists 'boring, even inarticulate'.[22] The passage just quoted makes that seem almost as eccentric as her description of Reynolds as an 'antagon-ist' who had succeeded only in coming up with 'an annotated list of Dutch artists and subjects'.[23]

Having failed to gain admittance to the van Slingeland collection, Rey-nolds did not linger in Dordrecht. He found the town unattractive – 'many parts like the worst parts of Venice', he noted, 'the houses appear tumbling as much inclined forwerd from perpendicular as the leaning tower at Pisa'. He visited the Grote Kerk, but did not warm to it: 'The Cathedral stuck full of Escutions at least a thousand, which gives a melancholy air, like a room where a corps is lying in state.'

He now began to pay more attention to the countryside. 'Bad country for a Landskip painter,' he noted as they approached Rotterdam, 'too many strait lines the trees trimed everything too artificial, Sir W. Chambers and Brown the Gardener* would feel equally enraged, like Hogarth's enraged musician . . .'† Rotterdam and Delft had little to detain the travellers and they moved on towards The Hague – 'milk pails of brass like gold', Reynolds wrote:

. . . part of the way is through meadows with ship[s] that you wonder how the devil they got there . . . The Dutch have had the habit of fighting and overcoming Nature that they attack her wherever they see her nothing is seen in this country but what is artificial . . .

He was much gratified by the attention they received from Hendrik Fagel, the Greffier, or Secretary, of the States General. 'Plain simplicity of manners and even humility,' he noted, 'totally different from the hauteur one has been used to and expects from a man in so high an office.' He had returned their visit immediately, he told Burke, and they dined with him the next day:

* Lancelot 'Capability' Brown (1715–83), whose style of gardening aimed to bring out the undulating lines of the natural landscape.
† Hogarth's *The Enraged Musician* was published in 1741. The print shows a despairing violinist covering his ears as he contemplates the cacophonous disorder outside his window – ballad singers, scissor-grinders, chimney-sweeps and squalling children.

By the attention which has been paid to us by the Greffier, his nephew, and the rest of his family, the attention of the town upon us has been much excited, this is but a small place, and in many respects like Bath, where the people have nothing to do but talk of each other, and it may be compared to Bath likewise for its beauty . . .[24]

Fagel showed them his own collection, which included a Teniers, a Van Dyck and a large number of drawings, many of which had been bought in England; Reynolds noticed several which bore the marks of Sir Peter Lely and Richardson.

He retailed to Burke his impression of the Stadtholder, Willem V, whom he had watched reviewing troops in one of the town's elegant squares:

The Prince of Orange whom we saw two or three times is very like King George but not so handsome, he has a heavy look, short person, with somewhat a round belly.

Although his main interest was the large natural history collection he had inherited from his mother,* he also had a substantial collection of pictures, mainly of the Dutch school, and Reynolds and Metcalfe were shown round the gallery by the Landscape Painter to the Prince, Haag, who was its curator. They saw many of the best works of Philips Wouverman, the seventeenth-century artist noted for his silvery-grey landscapes and his paintings of horses – 'well worthy the attention and close examination of a Painter,' Reynolds thought. There was a *Susanna and the Elders*. Reynolds – mistakenly – took it for 'a study for the picture by Rembrandt which is in my possession', adding that it was the third study he had seen for this figure.† He also greatly admired Van Dyck's portrait of the painter Quintijn Simons: 'a perfect pattern of portrait painting', he later wrote – 'it is nature seen by common daylight'.‡

The Greffier expressed his regrets at not being able to introduce the travellers to the prince, but they did not lack for entertainment. They dined with Prince Alexander Golitsyn, the Russian minister to The Hague, visited the house of Jacob Cats at Zorgvliet, between The Hague and Scheveningen, and made an excursion to Leiden to see the celebrated Botanic Garden and Natural History Museum.

It was now the middle of August, and Reynolds and Metcalfe moved on to Amsterdam – a city 'more like Venice than any other place I ever saw'. Reynolds was greatly impressed to learn that the foundations of the buildings

* It consisted of some 15,000 items – corals, sea-shells, snakes, fish and a large variety of minerals and stuffed animals.
† The Stadtholder's version was, in fact, not a study but a completed painting, now in the Mauritshuis; the picture owned by Reynolds is now in the Gemäldegalerie, Berlin.
‡ Also now in the Mauritshuis.

cost as much as what showed above ground – the Town Hall, he informed Burke, 'is founded on 13659 piles'. When he viewed the pictures displayed there (it is now the Royal Palace), he was bowled over by Van der Helst's monumental *The Banquet of the Civic Guard to Celebrate the Peace of Munster, 1648.** 'Of this picture I had before heard great commendations,' (Golitsyn had enthused about it to him at The Hague), 'but it as far exceeded my expectation, as that of Rembrandt fell below it,' he wrote:

So far indeed am I from thinking that this last picture deserves its great reputation, that it was with difficulty I could persuade myself that it was painted by Rembrandt . . . The name of Rembrandt, however, is certainly upon it, with the date, 1642, It appears to have been much damaged, but what remains seems to be painted in a poor manner.

That is how Reynolds later wrote up his impressions for publication. The note he jotted down at the time reads more baldly: 'if it is by Rembrandt it is the worst of him I ever saw'. Well, perhaps the light was bad. Possibly he had dined too well the night before – he had been the guest in the country of the banker Henry Hope, a member of a Scottish family that had emigrated to Holland in the seventeenth century. The Rembrandt before which Reynolds stood in such incomprehension was *The Militia Company of Captain Frans Banning Cocq* – better known as *The Night Watch*.

By the time he visited the Surgeons' Hall to view *The Anatomy Lesson of Dr Nicolaes Tulp* his critical faculties had revived. 'The dead body is perfectly well drawn, (a little fore-shortened,) and seems to have been just washed,' he wrote:

Nothing can be more truly the colour of dead flesh. The legs and feet, which are nearest the eye, are in shadow; the principal light, which is on the body, is by that means preserved of a compact form.

About another of Rembrandt's dissection studies, *The Anatomy Lesson of Dr Jan Deyman*, which he saw in the same building, he was positively enthusiastic: 'There is something sublime in the character of the head, which reminds one of Michael Angelo; the whole is finely painted, the colouring much like Titian.'

Reynolds saw a great deal of Henry Hope during the week he spent in Amsterdam. 'We have been extraordinary well received by Mr Hope,' he wrote to Burke, 'we are every day dining or supping with him and one great

* The picture is now in the Rijksmuseum. It is 232 cm high and 547 cm long.

dinner seem'd to be made on purpose for us.'[25] Their meetings were not
purely social. Reynolds had come to Holland not just to view pictures: he
had also come prepared to buy – on his own account, and possibly on behalf
of friends in England. He jotted the name 'Lord Granby' in his notebook
during his stay in Amsterdam; Tom Taylor speculated that this referred to
a picture which he believed Granby – which is how he still thought of the
Duke of Rutland – would like, or had commissioned him to buy. Certainly
he either gave or sold to the duke a painting by Van der Heyden which he
acquired, and he may have done the same with another by Steen.

An entry in his travel notes records an appointment one afternoon with
the burgomaster of Amsterdam, Joachim Rendorp, 'to see Pictures for sale'.
This is thought to refer to a sale scheduled for September of the paintings
of Pieter Calkoen. Reynolds bought a number of paintings from a dealer
called Pieter Yver during his stay, and also commissioned him to buy on his
behalf at the Calkoen sale. Not for the first time, however, he lost out by
setting an unrealistically low limit on what he was prepared to pay; this was
the occasion on which, after his return to London, he received an apologetic
letter from Yver explaining why he had not been able to do better for him:

. . . La raison pour la quelle je n'ai fait pour vous Monsieur l'acquisition d'un seul
Tableau dans la vente de Mr. P. Calkoen, est que les autres ont excédé de beaucoup
les prix que vous m'avez marquez.*

Yver, who was clearly a methodical man, went on to itemize by just how
much Reynolds had underestimated what he would have had to pay to
secure the paintings he had been interested in.† In three instances they
realized almost twice as much as Reynolds's limit, and in one case a picture
by Bakhuizen, which he had hoped to get for £200, had eventually been
knocked down for £720.

He made use of Hope's services to pay for and dispatch the paintings he
acquired through Yver – a work of Steen's, one by Wynants with figures by
Wouwerman, two portraits by Hals and two *Marines de Ruijsdaal*. In all
he laid out the very substantial sum of £2,524 19s, the equivalent at
present-day prices of £150,000.

There were many excellent private collections to be seen in Amsterdam.
Hope's was particularly fine, and Reynolds greatly admired Albert Cuyp's
Cows and a Herdsman by a River, now in the Frick Collection in New York,
and Wouwerman's *The Rustic Wedding* – 'The best I ever saw'. He and

* 'The reason I was able to acquire only one picture for you at M. Calkoen's sale was that the
others went far beyond the prices you indicated as your limit.'
† The table he drew up appears in a footnote on p. 183.

Metcalfe found time, however, to make a day trip to Zaandam, where Peter the Great had gone to learn about shipbuilding ('Saw a sawing mill which is equal to the work of 500 men'), and a village to the north of Amsterdam called Broek-in-Waterland. 'Neat village Colours vermilion' was all he had to say about it in his travel notes, but when he wrote to Burke the next day, he waxed lyrical:

... it appeared rather like an enchanted village, such as we read off in the Arabian tales;* not a person to be seen, except a servant here and there; the houses are very low, with a door towards the street, which is not used nor ever has been used except when they go out of it to be married, after which it is again shut up, the streets, if they may be so called, for carriages cannot enter them, are sanded with fine inksand; the houses painted from top to bottom, green, red, and all sorts of Colours . . .[27]

The travellers now set out for Düsseldorf, where they hoped to see the celebrated Gallery of the Elector Palatine and the new Academy. Their route lay through Utrecht and Nijmegen, and they spent a night at Cleves – a town dismissed by Reynolds as having 'nothing remarkable', though he noted at their inn that 'the prices of the wine is fixed by an order which is stuck on the door of the public room'.†

'Dusseldorp', as Reynolds called it, proved a high point of the tour, even though he found the town ill-paved and noted that the common people in the market went without shoes and stockings. The town owed its pre-eminence in the arts to Jan Wellem, who had ruled as Elector Palatine of the Rhine between 1690 and 1716 and whose second wife was a Medici; the Gallery had been built to house his collection of several hundred paintings, mainly by Dutch and Flemish artists. 'Rubens reigns here and revels,'‡ Reynolds wrote to Burke. 'His Pictures of the fallen Angels – and the last Judgment, give a higher idea of his genius than any other of his works.'§ So

* Reynolds possessed a copy of *The Arabian Nights*. It is now in Yale University Library.

† He was always keenly interested in the price of things. Inside the front cover of the notebook he was using at Düsseldorf he recorded that 'two dining five times breakfasting six and two rooms cost not three Guineas'.

‡ He was quoting from *Paradise Lost*:

> Here Love his golden shafts emploies, here lights
> His constant Lamp, and waves his purple wings,
> Reigns here and revels . . .
> (Bk. iv, 763–5)

§ Letter 96. *The Fall of the Damned* and the so-called 'Small' *Last Judgment* are both now in the Alte Pinakothek, Munich. Much of the collection found its way there because Jan Wellem's successor once removed as Elector, Charles Theodore, also became Elector of Bavaria.

travel does sometimes broaden the mind – this was the same Reynolds who ten years earlier had declared that Rubens was grosser than the Venetians 'and carried all their mistaken methods to a far greater excess'.[28]

There were several Van Dycks to admire, though he had his reservations about a *Pietà*.[29] 'St John is blubbering in a very ungracious manner,' he wrote. 'The attitude of the Christ would be admirable, if the head had not so squalid an appearance.' The Gallery regarded Gerrit Dou's *The Quack*[30] as the jewel in its crown, but Reynolds could summon no enthusiasm for the work of this pupil of Rembrandt and most celebrated of the Leiden 'Fine' painters.* 'It is very highly finished, but has nothing interesting in it,' he wrote:

The heads have no character, nor are there any circumstances of humour introduced. The only incident is a very dirty one, which every one must wish had been omitted; that of a woman clouting a child.†

He was greatly impressed by the way things were organized at the Gallery, however, and flattered by the attention paid to him by its officials:

The ease with which this Gallery is seen, and the indulgence to the young Painters who wish to copy any of the Pictures is beyond any thing I ever saw in any other place,‡ We have had every attention possible from the Keeper of the Pictures who as soon as he knew who I was sent into the Country to his principal who is likewise President of the Academy, who immediatly came to town and has been attending us ever since.

The director was the painter and collector Lambert Krahe, who had been the pupil of Marco Benefial and Pierre Subleyras in Rome in the 1730s, and had brought back from Italy a collection of more than 12,000 drawings, some of which had belonged to Ghezzi. Krahe took his guests to the Academy, where there was an exchange of courtesies: Reynolds presented a copy of his *Discourses*, receiving in return a diploma.

Düsseldorf effectively marked the end of the tour. Early on 1 September the travellers began their homeward journey, which would occupy just over

* The 'Leidse fijnschilders' were known for their small paintings, genre scenes for the most part, characterized by a minute attention to detail and highly polished style. The name was given to a number of Dutch painters active in Leiden between the 1630s and the 1760s.
† Wiping its bottom, that is to say.
‡ Reynolds was told that students were provided with board and lodging for £15 per annum. They might copy pictures in the Gallery and attend the Academy without further charge, provided only that on leaving they presented a book to the library.

two weeks. They made brief stops at Cologne, Aix-la-Chapelle and Liège and encountered various English acquaintances along the way – Lord Kelly invited them to dine at the English Club in Spa, and in Brussels they again had supper with Lady Torrington, who had entertained them there on their outward journey.* They made better time from Ostend than they had done in the opposite direction, and stepped ashore at Margate after a crossing of only twelve and a half hours.

If Reynolds the collector had meagre returns to show for his journey, Reynolds the painter had learned a good deal, especially from the easy, unbuttoned mastery of Rubens. From now on, at least in portraiture, he is much less in thrall to the grand classical manner. A new directness and exuberance become apparent; the paint surface becomes more sophisticated, there is a greater clarity of tone, the colours are lovelier, because warmer.

An early example of this easier, less formal manner is the picture he painted the following year of his friend Keppel's natural daughter,† although it was a portrait to which Reynolds devoted no fewer than fifteen sittings. Some years later, when he painted Lady Anne Bingham,[31] there is evidence of how Rubens's celebrated *Susanna Fourment* had lingered in his mind.‡ Georgiana, Countess Spencer, received a letter from her friend the Hon. Mrs Howe. 'Sir Joshua is about an excessive pretty [portrait] of Nanette in a straw hat,' she wrote, 'and, as Rubens painted one which is called Chapeau de Paille, this is to be called Sir Joshua's.'[32]

But the painting with which Reynolds most triumphantly demonstrates what he had absorbed from the great masters of the seventeenth century is his *Georgiana, Duchess of Devonshire, with her Daughter, Lady Georgiana Cavendish*, first exhibited at the Academy in 1786.[33] The duchess wears black – she was in mourning for her father. Her expression is both tender and melancholy. The child on her lap raises both arms in the air, and its mother mimics the gesture with her own right arm. David Mannings calls it 'the glorious climax of Reynolds's late Baroque style'.

That style, happily, would not alter sensibly in the few years that were left to him as a painter, although Reynolds the critic would remain broadly loyal to the received opinion of the day about the respective merits of Italian and Dutch art. In 1788, for instance, when talking in Discourse XIV about the difficulty of uniting solidity with lightness of manner, he illustrated the

* Lady Torrington, the former Lucy Boyle, was the wife of the Fourth Viscount, a nephew of the hapless Admiral Byng. He would become minister plenipotentiary in Brussels in 1783.

† Mannings, cat. no. 1057, fig. 1388. The picture is now in the Ashmolean Museum, Oxford. Miss Keppel, who bears a pronounced facial resemblance to her father, was married in 1787 to a Captain Thomas Meyrick, who later became a general.

‡ He had seen it in a private collection in Antwerp.

point by reference to Rubens's *Christ's Charge to St Peter*, which he had seen in the Cathédrale St Michel in Brussels:[34]

... as it is the highest, and smoothest, finished picture I remember to have seen of that master, so it is by far the heaviest; and if I had found it in any other place, I should have suspected it to be a copy.[35]

Nevertheless, when Reynolds's *Journey to Flanders and Holland* eventually saw the light of day five years after his death, it was to Rubens that more than half the text was devoted and it was with an eloquent 'Character of Rubens' that it concluded. 'Genius is always eccentrick, bold, and daring,' he declared:

The works of Rubens have that peculiar property always attendant on genius, to attract attention, and enforce admiration, in spite of all their faults ...

The productions of Rubens ... seem to flow with a freedom and prodigality, as if they cost him nothing; and to the general animation of the composition there is always a correspondent spirit in the execution of the work ...

Rubens appears to have had that confidence in himself, which it is necessary for every artist to assume, when he has finished his studies, and may venture in some measure to throw aside the fetters of authority ... to risk and to dare extraordinary attempts without a guide, abandoning himself to his own sensations, and depending upon them ...

The criticisms which are made on him are indeed often unreasonable. his style ought no more to be blamed for not having the sublimity of Michael Angelo, than Ovid should be censured because he is not Virgil.

It hardly adds up to a full-blown recantation, but it is as perceptive and generous an essay about a fellow painter as Reynolds had written.

19

The Cornish Wonder and a
Shake of the Palsy

Suddenly, everybody was talking about 'The Cornish Wonder', a young man called John Opie. His picture, *A Boy's Head*, had been exhibited two years previously at the Incorporated Society of Artists and had caused quite a stir, mainly because it was described as 'an Instance of Genius, not having ever seen a picture'.

This was nonsense. Opie was the son of a carpenter who worked in the tin mines near Truro, and had initially been apprenticed to his father. His precocious talent for drawing was recognized by a man called John Wolcot, later well-known for the satirical squibs and verses he wrote as 'Peter Pindar'. Wolcot was a quarrelsome Devon man who had qualified in medicine at Aberdeen and subsequently, for purely mercenary reasons, taken holy orders. He had also, for a time, been a pupil of Richard Wilson, and he determined that he would set himself up as Opie's mentor and impresario. He fed him a diet of Rembrandt and the Tenebrists, presumably mainly through prints ('this was done', Ellis Waterhouse wrote, 'with something of the secrecy which now attends the training of a racehorse'[1]). Wolcot's wide acquaintance in the West Country had also given Opie the entrée to various country-house collections; by the late seventies, although not yet out of his teens, he was already a competent provincial painter.

Now, in 1782, still not twenty-one, he made his first appearance at the Academy. He exhibited a picture called *Country Boy and Girl*. It was received with uncritical rapture, some of it plainly engineered by his Svengali. 'Beyond even Rembrandt', burbled one reviewer. 'A genius, self-educated, till very lately from the mines of Cornwall, whose work rivals the great masters,' wrote another. A third review reads suspiciously like the work of Wolcot himself: 'There is a maturity and judgment, a truth and force of colouring in his portraits which are astonishing.' And he added an impertinent flourish: 'We hope Sir Joshua Reynolds will take some lessons of this young man before he leaves London.'

Reynolds had, in fact, been greatly impressed with the young man's talent and personal charm. None too tactfully – or possibly with a touch of malice

– he enthused about him to Northcote, who had not long returned from Italy and was struggling to attract commissions. 'Ah,' said Reynolds, 'you may go back now – you have no chance here. There is *such* a young man come out of Cornwall!' If he was amusing himself by trying to give his painstaking former pupil a turn, he succeeded. 'Good God! Sir Joshua, what is he like?' 'Like?' came the reply – 'like Caravaggio, only finer.'

Reynolds himself was busy with his pen as well as with his brush in the early months of 1782. His friend Mason had translated Dufresnoy's Latin poem *The Art of Painting* into English verse, and Reynolds had offered to annotate the text for him. He had been sitting on the manuscript since the end of 1780; now he put aside his notes on his travels in the Low Countries and gave his mind to Dufresnoy's poem. It had been one of the first books on the theory of painting to attract his interest in his youth, and there are frequent echoes of it in the Discourses. As he was writing with Holland and Flanders fresh in his mind, there are many allusions to what he had seen there, especially to Rubens. When the translation appeared the following year, Reynolds presented copies to various friends, including Johnson and Mrs Vesey.

The spring of 1782 was a time of high political excitement. When the news of Cornwallis's surrender at Yorktown the previous October reached England, Lord North had exclaimed, 'Oh God, it is all over.' In the Commons his majority rapidly declined, and when Henry Conway introduced a motion in favour of ending the war at the end of February, it disappeared altogether. Four weeks later his fate was sealed by the news of the loss of Minorca. On 18 March a group of North's independent followers, solid men from the shires who had supported him for ten years and more, told him they could do so no longer. North resigned – something for which the king never forgave him – and was succeeded by an unstable and short-lived coalition of Rockingham Whigs and former followers of Chatham.

The names of the new administration read like a page torn from Reynolds's sitters' book. Almost without exception, its members had already sat to him or would shortly do so. Many of them were his friends. Keppel was appointed First Lord of the Admiralty and became a viscount; Dunning also became a peer as Lord Ashburton and was the new Chancellor of the Duchy of Lancaster. The Lord Chancellor was Thurlow* and the Lord

* Thurlow was not, however, one of Reynolds's admirers, once describing him as 'a great scoundrel and a bad painter'. This may, as noted earlier, have been because Romney made him look more handsome and less forbidding. 'He was,' Wraxall wrote, 'of a dark complexion, harsh, but regular features; a severe and commanding demeanour, which might be sometimes denominated stern.'

President of the Council, Camden; the Secretaries of State were Shelburne and Fox (the animosity between them was the principal cause of the government's instability). Burke was not in the Cabinet, but became Paymaster of the Forces, an appointment which briefly eased his chronically strained finances; his brother Dick abandoned his practice at the Bar to become Secretary of the Treasury.

That year's exhibition aroused exceptional interest because it had become known from the press that Reynolds and Gainsborough were to show several portraits of the same subjects. Both had been painting a swaggering young colonel of light horse called Banastre Tarleton, recently returned from America under parole. Tarleton was the Oxford-educated son of a former mayor of Liverpool, where the family had long traded in cotton, sugar and slaves. He had fired the public imagination with his exploits in the war; interest in him was heightened by the fact that he had now become the lover of the Prince of Wales's discarded mistress, the actress 'Perdita' Robinson – who had also been sitting to both artists.

Mary Robinson ('Perdita' because it was in that role in *The Winter's Tale* that she had caught the eye of the prince – he called himself 'Florizel') had done rather well out of her brief encounter with the eighteen-year-old heir to the throne; by threatening to publish his letters she secured a lump sum of £5,000 and an annuity of £500, half of which would continue to her daughter after her death. It was this settlement which had enabled her to splash out not only on commissions to Reynolds and Gainsborough, but also on two to Romney.

A fortnight before the exhibition opened, however, the *Public Advertiser* obligingly washed a good deal of her linen in public; shortly afterwards it was announced that Gainsborough's portrait had been withdrawn. He may have been influenced by the unfavourable comparison the *Advertiser* drew between his portrait and that of Reynolds; the writer, who claimed to have seen both, declared that he had failed to achieve a likeness, and it was on catching a likeness that Gainsborough prided himself above all else. Or possibly he was sensitive to press comment about the extensive connection he was known to maintain among the *demi-monde* – he also had lined up for the exhibition a second picture of the notorious 'Dally the Tall', of whom he had shown an earlier canvas in 1778,* and a portrait of Giovanna

* Press comment on this 1782 portrait of Miss Dalrymple was certainly not of the most flattering. The *Advertiser* thought her eyes far too characteristic of her vocation, while the critic of the *London Courant* was clearly quite unsettled: 'A wanton countenance, and such hair, good God!'

Baccelli, the Italian dancer whom the Duke of Dorset currently had installed as his mistress at Knole.*

Reynolds, many of whose sitters – and friends – were every bit as louche as Gainsborough's, had an altogether thicker skin, and his canvas duly went on show – No. 22: *Portrait of a Lady*.[2] He had taken immense pains over it. There are eleven appointments with Mrs Robinson between the end of January and early April. She wears a black dress and a black hat with white feathers; Reynolds posed her against a red curtain. The composition obviously owes much to Rubens's hugely popular and much copied *Chapeau de Paille* – it was only a few months, after all, since Reynolds had seen several versions of it in Antwerp.†

Tarleton – there was also a full-length of him by Gainsborough – figured as *Portrait of an Officer*.[3] The posture is striking;‡ one foot resting on an artillery piece, he appears to be bending to adjust his leggings. The smoke of battle swirls behind him, and on the left of the picture we see the head of his horse, looking understandably startled (Reynolds's horses are not thought to be particularly convincing).

The temptation proved altogether too strong for the caricaturists. One anonymous etching published later in the year has been attributed to Gillray. It drips with sexual innuendo. Tarleton, identified by his tight breeches and plumed helmet, is no longer on the battlefields of South Carolina, but outside a seedy London chophouse with the Prince of Wales. He is represented as the braggart Bobadil from Ben Jonson's *Every Man in His Humour* – the suggestion is that his record in America had really been rather disastrous. Mrs Robinson also figures in the tableau. Legs and arms spread wide, she is mounted above the doorway like an inn sign – 'The Whirlygig' was a common punishment for army prostitutes. 'Whirlygigs' was also a low word for testicles.§

* Where she had a tower to herself and a large staff of servants. The duke, too, had his sensitivities. Gainsborough had intended to show his portrait, but it was also withdrawn. Years later, however, when he was ambassador in Paris, he felt less inhibited, and permitted La Baccella to dance at the Opera with his ribbon of the Garter – '*honi soit qui mal y pense*' – tied round her forehead as a bandeau.

† One of them, *Susanna Fourment*, is now in the National Gallery in London.

‡ Nicholas Penny, in the catalogue to the 1986 Reynolds Exhibition, pointed out the similarity of the attitude to that of the famous antique statue of Hermes, of which there was a cast in the Academy schools (exh. cat. RA 1986, 301).

§ 'I must tell you a saying of Sheridan, too sublime to be called a *bon mot*,' Horace Walpole wrote to Mason. 'Tarleton boasts of having butchered more men, and lain with more women than anybody. "*Lain with!*" said Sheridan. "What a weak expression; – he should have said *ravished* – rapes are the relaxation of murder"' (Walpole, 1937–83, xxix, 188–9, letter dated 23 February 1782).

When the exhibition opened, Bate, as usual, was in the Gainsborough corner and did his best for his friend in the columns of the *Morning Herald*. 'The royal patronage seems to have had the most happy influence in calling forth the full powers of Mr Gainsborough's pencil,' he wrote (Gainsborough had also submitted a full-length of the Prince of Wales):

The eleven pieces with which he has honoured the Exhibition, if they are not a satisfactory proof of the above assertion, demonstrate, however, that this celebrated artist has soared with genius to the highest regions of taste and may now content himself with a professional fame that few will ever arrive at, none excel!

Quite the most exotically coloured of the fifteen canvases with which Reynolds responded to the challenge was his *Portrait of a Grecian Lady*.[4] Mrs Baldwin, as she was called, was a native of Smyrna, the daughter of a Levant Company merchant – Mrs Thrale, who had resumed her tuft-hunting activities, called her 'my pretty Greca'.* Two whole-length versions of her portrait are extant. Reynolds seems to have painted them for his own pleasure, and he devoted nine sittings to the work in February and March. Mrs Baldwin sits on a red divan, dressed in a richly brocaded green and gold caftan and gazing at a large coin or medallion. She later said that after three sittings, Reynolds became dissatisfied with the likeness and started again, this time not in his painting room but at her house. When she became bored, he suggested that she read a book. It is a very lovely picture.

Reynolds's portrait of William Beckford,[5] also exhibited that year, looks conventional enough, although the light background is unusual. The young sitter was a much more exotic plant than Mrs Baldwin, however. At twenty-two he was wilful, capricious and immensely rich. (He was the only legitimate son of the William Beckford who had been Lord Mayor of London. The money came from sugar plantations in Jamaica; on coming of age, he had found himself master of £100,000 a year and £1 million in ready money). His Gothic extravagances at the family seat, Fonthill Abbey, still lay in the future, but he had already, at a single sitting of three days and two nights, dashed off his oriental fantasy *Vathek* – in French.

* Her husband, George, the son of a London hop merchant, had recently returned to England after twenty adventurous years in the Orient. Later, after some years as consul-general in Egypt, he came to believe that he was possessed of 'magnetic gifts', and wrote several books on this and on various political subjects. Of his first work, which he composed in poor and ungrammatical Italian, the *Dictionary of National Biography* wrote, 'It reads more like the raving of a maniac than a wholesome speculation on a subject of science.'

Reynolds records no fewer than eighteen appointments with Beckford between the middle of February and the opening of the exhibition at the end of April. That seems a great many for a portrait of such modest proportions (it measures 71.75 × 58.5 cm), although some of them may have been social occasions; ten further appointments are noted later in the year. Reynolds clearly found the company of his flamboyant young sitter congenial.

Beckford did not settle his account until 1785, but he paid much more promptly for another portrait which he had commissioned from Reynolds at the same time. This was of the fourteen-year-old Alexander Hamilton,[6] son and heir of the Ninth Duke – premier peer in the peerage of Scotland, Duke of Châtelherault in France, hereditary keeper of Holyrood House. Nicholas Penny's suggestion that the boy appealed to the pederast in Beckford is entirely plausible; although Beckford married in 1783 (his bride was the daughter of the Earl of Aboyne, and they would have two daughters), within twelve months he became embroiled in scandal because of a homosexual relationship with the young Lord Courtenay. Hamilton subsequently entered Parliament, and when the Whigs returned to power in 1806, he was sent as ambassador to St Petersburg. For many years he remained a bachelor. When he eventually married, at the age of forty-two, his bride – she was described as 'one of the handsomest women of her time' – was Beckford's daughter, Susan Euphemia.

One of the most popular pictures at Somerset House that year proved to be Gainsborough's *The Girl with Pigs*, now in the Castle Howard Collection. Having praised it in the *Morning Herald*, Bate, for once, found something agreeable to say about Reynolds, declaring that his liberality was equal to his genius, explaining that 'the moment he saw this picture he sent to know the price, and purchased it, sending a hundred guineas with half as many elegant compliments on the work of the artist'. Although he thought the girl might have been made more beautiful, Reynolds did indeed admire the picture greatly; some years later he described it to the Earl of Upper Ossory as 'by far the best Picture he ever Painted or perhaps ever will'.[7] What's more, it was generous of him to send 100 guineas because the asking price had been only 60. Gainsborough's brief but characteristic note of thanks is preserved in the Pierpoint Morgan Library in New York:

Sir Joshua,
I think myself highly honor'd, & much Obliged to you for this singular mark of

your favor; I may truly say that I have brought my Piggs to a fine market
> Dear Sir
>> your Ever Obliged &
>>> Obedient Servant
>>>> Tho Gainsborough.*

This was the year that Wolcot, writing as 'Peter Pindar', first enlivened the London season – and, it has to be said, improved the standard of writing about painting – with his *Lyric Odes to the Royal Academicians*. He could be savage, as in his handling of Northcote:

> I know
> A jew-like, shock-poll'd, scrubby short black man,
> More like a cobbler than a gentleman
> Working on canvas, like a dog in dough . . .†

About Reynolds, he was complimentary, if a shade condescending:

> Yet, Reynolds, let me fairly say,
> With pride I pour the lyric lay
> To most things by thy able hand exprest –
> Compar'd, to other painting men,
> Thou art an eagle to a wren!
> Now, Mistress Muse, pray visit Mister West.[8]

About the neglected and undervalued Richard Wilson, who had last exhibited in 1780, and had subsequently retired, bitter and broken in health, to his native Wales, he was both generous and perceptive, even though he could not resist describing him as 'red-nosed' (he was over-fond of porter‡):

* Hayes, 2001, 147. The phrase about bringing his pigs to a fine market is a quotation from Fielding's *Tom Jones*. The piglets were painted from the life; the rising young musician W. T. Parke, shortly to become principal oboe at Covent Garden, was on friendly terms with Gainsborough at the time, and remembered seeing them 'gambolling about his painting room, while he at his easel was catching an attitude or a leer from them' (Whitley, 1915, 187). Reynolds kept the picture for some years. After Gainsborough's death, 'as a particular favour', he sold it for 300 guineas to Charles-Alexandre de Calonne, Louis XVI's former Controller-General of Finance, who lived in exile in London for some years.

† Wolcot, i, 22. The dislike was mutual. Northcote, in a letter to his friend William Elford in Devon that spring, wrote that Wolcot was 'as conceited, vulgar and jawing as ever' (Whitley, 1928, i, 377).

‡ This was so well known that Zoffany had depicted him with a pot of it at his elbow in his 1773 group portrait of the Academicians. He painted it out when Wilson threatened to thrash him.

> But, honest Wilson, never mind.
> Immortal praises thou shalt find,
> And for a dinner have no cause to fear!
> Thou start'st at my prophetic rhimes;
> Don't be impatient for those times;
> Wait till thou hast been dead a hundred year.[9]

Whether Wilson ever saw Wolcot's prophetic doggerel is doubtful; he died in the middle of May, and was buried in the churchyard at St Mary-at-Mold.

There is no evidence to support the suggestion that Reynolds came to entertain feelings of hostility towards his old friend. Indeed it is recorded that shortly before Wilson left London in 1781, Reynolds was instrumental in securing for him two useful commissions for landscapes. What is the case, however, is that several years later, in his fourteenth Discourse, devoted chiefly to a consideration of Gainsborough, Reynolds did include a passage in which he was critical of Wilson – 'our late ingenious academician', as he rather patronizingly called him. 'His landskips,' he declared, 'were in reality too near common nature to admit supernatural objects,' and he asserted that Wilson, like many of his predecessors, had been guilty of introducing gods and goddesses into scenes 'which were by no means prepared to receive such personages'. To Ellis Waterhouse, that suggested that Reynolds was not at all keen on the idea that the grand style should be introduced into England by *two* people. And in what he went on to say, he might just be seen to be heading for an elephant trap of his own making:

To manage a subject of this kind, a peculiar style of art is required; and it can only be done without impropriety, or even without ridicule, when we adapt the character of the landskip . . . to the historical or poetical representation. This is a very difficult adventure, and it requires a mind thrown back two thousand years, and as it were naturalized in antiquity, like that of Nicolo Poussin, to achieve it.[10]

Some might think that a cap which the President could clap on his own head. At all events, one of Wilson's friends took exception to what had been said, and made plain in a letter to the *Morning Post* that he thought them mean-spirited.* 'Why was not the great artist mentioned in the President's discourse that succeeded poor Wilson's death?' he asked.

* The passage is, as it happens, one of only three references of any substance in the Discourses to deceased contemporaries, and it does strike a discordant note. The other two – to Hogarth and Gainsborough – are essentially tributes.

Fie, Sir Joshua! You disclaimed in your Academic discourse an imputed mean jealousy of Gainsborough. Upon what principle will you justify your long silence on the great abilities of Wilson, and the illiberal attack upon him when his universal fame forced him on your attention and rendered him an object of remark?[11]

Battles long ago. Wilson's influence on artists of the generation of Turner and Constable was immense. It was with him, declared Ruskin, that 'the history of sincere landscape art founded on a meditative love of nature begins in England'. Which is to say that he played as important a role in moulding the British landscape tradition as did Reynolds in that of portraiture.

Reynolds worked on busily through the summer and autumn of 1782, his pocketbook too full to permit of much, other than dining out, by way of distraction.* He declined an invitation to visit Bennet Langton in Lincoln-shire – 'it is too late in the season to think of any excursion into the country', he wrote, although it was only the second week in September.[12] As rich a variety of sitters passed through his painting room as in any earlier year. Henry Dundas, Scotland's Lord Advocate, had sat in May and June[13] and Charles James Fox had a string of appointments through the summer, although the portrait was not exhibited at the Academy until two years later.[14] It seems likely that it was about this picture that Henry Angelo recorded the comment by George III: 'Yes – yes, very like, very like. Sir Joshua's picture is finely painted – a fine specimen of art; – but Gillray is the better limner. Nobody hits off Mr Fox like him.'[15]

Gillray's satirical portrayals of Fox naturally lacked the gravitas with which Reynolds endowed him, and that suited his bitter enemy the king very well. In The Political-Banditti Assailing the Saviour of India, for instance, a 1786 etching satirizing the Whig opposition's campaign to impeach Warren Hastings, Fox, plump and wild-eyed, is portrayed as a ranting actor with exaggerated five-o'clock shadow who is about to plunge a dagger into Hastings's back.†

The energetic Josiah Wedgwood, radical in politics, Unitarian in religion, also sat that year. 'I shall Astonish the World All at Once,' he told his partner Thomas Bentley, 'for I hate piddling you know' – something he demonstrated by founding the Etruria pottery works and promoting the first major English

* He continued to entertain in Leicester Fields, however. In a letter preserved in the Belvoir Castle MSS, he thanks the Duke of Rutland for the offer of a buck from Chevely Park. 'I have company dine with me next Thursday,' he wrote, 'and should be glad to have it by that time' (Letter 106, dated 13 September 1782).

† The other two banditti are Burke and North, who are characterized equally disobligingly.

canal. Reynolds polished off his portrait in three sittings in the middle of May, and Wedgwood, unlike most of Reynolds's aristocratic sitters, paid on the nail; an entry for 50 guineas appears in the ledger one month later.*

Reynolds's purchase of Gainsborough's *The Girl with Pigs* clearly eased relations somewhat between the two rivals, and on 3 November – it was a Sunday – he had a preliminary sitting at Gainsborough's house for his portrait. He was due to sit again the following week, but in the interval he was taken ill, and the sittings were not subsequently resumed. Northcote believed that this was because Reynolds made no offer to paint Gainsborough in return. Bate, on the other hand, after Gainsborough's death, stated that 'the canvas was stretched for both'.

Reynolds's illness caused considerable alarm to his friends. Burney recounted the detail in a letter to his daughter Susan:

... I am heartly grieved to tell you that poor Sr Jos has had a paralitic stroke, wch drew his mouth very much out of its place, & distorted his whole Countenance! He is better, & I dined with him, & a very small party, on Saturday, only his Physician, Sir Geo. Baker, Will. Burke, & his relation E[d]mund's son – It was then resolved that he was to go out of Town to Morrow at farthest – He was to stop a Week at Burke's to give Miss Palmer time to meet him at Bath – he was far from being in spirits as you may imagine – and told me, if it went no farther, he shd think himself very well off. – Yesterday, on Enquiry, he was said to be better – to day when I called myself, he said he was so much better that he believed he shd not go to Bath – however he promised me, if Sr Geo. Baker made a very serious point of his going, he wd not rebel – Though I am extreamly pleased to find him so much better, yet after such an attack the sword hangs over his head by such a feeble Hair, that he's never safe – he says he had a slight stroke of the same kind in his face 30 years ago – & I can now fancy that on[e] side was fuller than the other before this last accident – He goes to Burke's to Morrow, but fights off the Bath Journey.[16]

Northcote states that he did make the journey to Bath – certainly there are no engagements in the pocketbook for the second half of November, although a letter from Johnson, who was in Brighton, confirms that he was on the road to recovery by the middle of the month:

Dear Sir:

I heard yesterday of your late disorder, and should think ill of myself if I had heard it without alarm. I heard likewise of your recovery which I sincerely wish to be

* Mannings, cat. no. 1850, fig. 1399. Now in the Wedgwood Museum, Barlaston. Mrs Wedgwood sat at the same time – her portrait is also at Barlaston – but she had six sittings (Mannings, cat. no. 1851, fig. 1398).

complete and permanent. Your Country has been in danger of losing one of its brightest ornaments, and I, of losing one of my oldest and kindest Friends, but I hope You will still live long for the honour of the Nation, and that more enjoyment of your elegance, your intelligence, and your benevolence is still reserved for, Dear Sir, Your most affectionate and most humble Servant,
Sam Johnson[17]

He was sufficiently recovered to deliver his eleventh Discourse on 10 December. 'I went to the Painters distribution of prizes,' Johnson wrote to Mrs Thrale. 'Sir Joshua made his Speech. The King is not heard with more attention.'[18] Reynolds returned in it to a favourite theme, the elusive question of the nature of genius – possibly he felt that he had previously left an impression that it was to be acquired by application and industry alone. The text gives no indication that his faculties had been in the least impaired by his illness.

He considers first that aspect of his subject which he terms 'the Genius of mechanical performance'. This, he believes, consists in 'the power of expressing that which employs your pencil, whatever it may be, *as a whole*', and he elaborates, not for the first time, on the importance of generalizing:

The detail of particulars, which does not assist the expression of the main character-istick, is worse than useless, it is mischievous, as it dissipates the attention, and draws it from the principal point. It may be remarked, that the impression which is left on our mind, even of things which are familiar to us, is seldom more than their general effect; beyond which we do not look in recognising such objects. To express this in Painting, is to express what is congenial and natural to the mind of man . . .[19]

Close resemblance to the original, he maintains, is not always pleasing:

To express protuberance by actual relief, to express the softness of flesh by the softness of wax, seems rude and inartificial, and creates no grateful surprise. But to express distances on a plain surface, softness by hard bodies, and particular colouring by materials which are not singly of that colour, produce that magick which is the prize and triumph of art.

Carry this principle a step further. Suppose the effect of imitation to be fully compassed by means still more inadequate; let the power of a few well chosen strokes, which supersede labour by judgment and direction, produce a complete impression of all that the mind demands in an object.[20]

He illustrates his argument by reference to Raphael and Titian. The Vatican frescoes of the former, he points out, are far from being minutely finished:

'his principal care and attention seems to have been fixed upon the adjustment of the whole, whether it was the general composition, or the composition of each individual figure'. For excellence in colour, light and shade, he turns to Titian:

He was both the first and greatest master of this art. By a few strokes he knew how to mark the general image and character of whatever object he attempted; and produced, by this alone, a truer representation than his master Giovanni Bellino, or any of his predecessors, who finished every hair. His great care was to express the general colour, to preserve the masses of light and shade, and to give by opposition the idea of that solidity which is inseparable from natural objects.[21]

Reynolds also warns against a preoccupation with high finish, as something which 'seems to counteract its own purpose':

That is, when the artist, to avoid that hardness which proceeds from the outline cutting against the ground, softens and blends the colours to excess: this is what the ignorant call high finishing, but which tends to destroy the brilliancy of colour, and the true effect of representation; which consists very much in preserving the same proportion of sharpness and bluntness that is found in natural objects. This extreme softning, instead of producing the effect of softness, gives the appearance of ivory, or some other hard substance, highly polished.[22]

He concludes by recalling something written by the poet Young – 'He that imitates the divine Iliad, does not imitate Homer.' A man will not become a great artist merely by furnishing his memory with details of the great works of the past; rather must he make himself master of the general principles which informed their creation: 'The great business of study is, to form a *mind*.'[23]

Reynolds was now fully restored, painting busily up to and indeed through the festive season – the chubby-faced Earl of Northington, a close friend of Fox and shortly to be dispatched to Dublin as Lord-Lieutenant, had sittings on both Christmas Eve and Christmas Day.*

On 28 December Reynolds gave a small dinner party. It was rare for him to entertain fellow artists other than on Academy business, but on this

* Mannings, cat. no. 874, fig. 1387. The portrait is now in the Musée Cognacq-Jay, Paris. Northington (1747–86), a bachelor, is described by Wraxall as 'unwieldy, vacillating, and destitute of grace'. This did not prevent him from becoming an excellent and much loved Lord-Lieutenant, who promoted Irish manufactures and encouraged the growth of flax and tobacco.

occasion his guests included Benjamin West – 'a very pleasing man', Fanny Burney thought, when they were introduced – 'gentle, soft-mannered, cheerful, and serene'. Dr Burney was also present, and the party was completed by Fanny Reynolds and the Exeter musician William Jackson, a close friend of both Gainsborough and Wolcot.*

'Sir Joshua took my hand and insisted upon wishing me a merry Christmas according to old forms,' Fanny told her sister – a kiss, presumably. The evening's entertainment was not of the most sophisticated; after dinner Jackson undertook to teach the company how to write with their left hands. Fanny noticed that Reynolds had two snuff-boxes in use, one made of gold, the other of tin:

I examined them and asked why he made use of such a vile and shabby tin one.

'Why,' said he, laughing, 'because I naturally love a little of the blackguard. Ay, and so do you too, little as you look as if you did, and all the people all day long are saying, where can you have seen such company as you treat us with?'

Reynolds, in congenial company, at his unbuttoned and amusing best, gently ribbing Fanny about her second novel, *Cecilia*, which had come out that summer and perpetrating quite a decent pun – 'blackguard' was the name of a popular brand of snuff.† Fanny was extremely fond of him. 'He never insists on keeping it up,' she wrote to Susan, 'but the minute he sees he has made me look about me or look foolish, he is most good-naturedly ready to give it up.'

Although Fanny was thirty years Reynolds's junior, those with an itch for matchmaking (they included Elizabeth Montagu – the bluestocking mind was not always fixed on higher things) thought that they were on to something. Miss Burney was altogether too sensible to entertain such a notion – as her sister discovered when she mentioned the possibility in a letter:

But how, my dearest Susy, can you wish any wishes about Sir Joshua and me? A man who has had two shakes of the palsy! What misery should I suffer if I were only his niece, from a terror of a fatal repetition of such a shock! I would not run voluntarily into such a state of perpetual apprehension for the wealth of the East![24]

* Jackson (1730–1803) had recently had great success with his music for the comic opera *The Lord of the Manor*, which had been produced at Drury Lane and would hold the stage for fifty years. He was also an accomplished landscape painter and an honorary exhibitor at the Academy.

† When he was a shop-boy, Lundy Foot, later a well-known Irish snuff-merchant, is said to have made a mistake in the preparation of some snuff, at which his master called him an 'Irish blackguard'.

20

Desire without Content

London Jan 19 1783

My Dear Nephew

I intended to have taken this opportunity of paying the debt I owe you of a long Letter, but delayed it on account of a violent inflammation of my Eyes which prevented me from writing . . .[1]

Reynolds was writing to William Johnson in Calcutta. Whether the inflammation was an after-effect of his stroke is not known. He told his nephew that he had not yet recovered, although he was well enough the following week to write, or possibly dictate, an elegantly turned obituary notice for his friend Moser, the first Keeper of the Academy.* If trouble with his eyes prevented him from writing, it presumably also affected his painting, but as the sitters' book for 1783 is missing, we do not know how seriously or for how long.

Certainly his social life was not affected for any length of time. Thomas Percy, since the previous year Bishop of Dromore, had sent the Club a hogshead of claret, and on 12 February Reynolds wrote to tell him how it had been received:

The wine was tasted, at the Turk's Head, the meeting before the last, and was pronounced to be good wine, but not yet fit for drinking; we have, therefore, postponed any further progress in it till next year, when, I hope, your Lordship will have an opportunity of tasting it yourself.[2]

Attendance at the Turk's Head had been falling away, but Reynolds was able to report an improvement. 'The Club seems to flourish this year,' he told Percy; 'we have had Mr Fox, Burke, and Johnson very often. I mention this because they are, or have been, the greatest truants.'† Fox and Burke

* Moser was succeeded as Keeper by the sculptor Carlini.

† The previous year, when the Club had met on sixteen occasions, Johnson and Burke had been present only three times and Fox only once.

could plead political preoccupations, but Johnson, now seventy-four, was in failing health. Boswell, arriving from Scotland towards the end of March, found him pale and with difficulty in breathing. 'I am glad you are come,' Johnson said. 'I am very ill.'[3] The chronic bronchitis which had plagued him for years was now accompanied by emphysema, and his struggle with rheumatoid arthritis – he applied to it the blanket eighteenth-century term 'gout' – was causing increasing discomfort. His temper frayed easily. One evening Boswell inquired whether he had been out that day. 'Don't talk so childishly,' growled Johnson. 'You may as well ask if I hanged myself today.'[4]

The mind was as lively as it had always been, however, and the interest in anything new just as keen. The young poet George Crabbe had become a frequent visitor to Reynolds's painting room* and now asked whether he would show his latest composition to Johnson. This was *The Village*, and Johnson thought it 'original, vigorous, and elegant'. He annotated the manuscript heavily, but assured Reynolds that he did not require the author to adopt his suggestions: 'He is not to think his copy wantonly defaced; a wet sponge will wash all the red lines away, and leave the pages clean.'[5] Reynolds conveyed the good news to Crabbe, now installed as chaplain to the Duke of Rutland at Belvoir. 'If you knew how sparing Dr. Johnson deals out his praises you would be very well content with what he says,' he wrote. 'I feel myself in some measure flatter'd in the success of my prognostication.'[6]

Unwell as he was, Johnson was determined not to miss the Academy dinner at the end of April. 'Our company was splendid,' he wrote to Mrs Thrale; 'whether more numerous than at any former time I know not.' It was, as it happens. The roll-call of 'noblemen and gentlemen, distinguished for their patronage and love of the arts' who dined with the President rose that year to eighty. The Archbishop of York and half the Cabinet were there, together with assorted dukes and marquesses. Boswell, a Scottish laird now, was invited, and so was his Corsican hero, General Paoli. Several Italian noblemen were also included in the guest list. When the Academy opened its doors to the public two days later, Johnson told Mrs Thrale, 3,800 spectators paid £120 for admission. He offered her a quick calculation: 'Supposing the door open ten hours, and the spectators staying, one with another, each an hour, the rooms never had fewer than three hundred and eighty jostling against each other.'

Not all of them were enthusiastic for what they saw. 'An indifferent Exhibition,' Horace Walpole thought; 'Sir Joshua seems to decline since his

* They had met through Burke, who had taken Crabbe under his wing.

illness.' Wolcot, in his second instalment of *Lyric Odes*, was of the same opinion:

> We've lost Sir JOSHUA, AH! that charming elf,
> I'm grieved to say hath this year lost *himself*.[7]

He was much kinder to Gainsborough:

> Who, mounted on thy painting throne,
> On other brushmen look'st contemptuous down
> Like our great admirals on a gang of swabbers.[8]

Gainsborough's major exhibit was a block of royal portraits. 'The King, Queen, and Royal Family (the Bishop of Osnaburgh excepted),' wrote *Parker's General Advertiser and Morning Intelligencer*, 'make a conspicuous show opposite the entrance to the room.' Gainsborough had exerted himself to see that they did, and in a letter to the hanging committee exploited his relationship with the Academy's royal patron quite shamelessly:

Mr Gainsborough presents his Compliments to The Gentlemen appointed to hang the Pictures at the Royal Academy; and begs leave to *hint* to Them, that if The Royal Family, which he has sent for this Exhibition, (*being smaller than three quarters*) are hung above the line along with full lengths, he never more, whilst he breaths, will send another Picture to the Exhibition –

This he swears by God[9]

He wrote a second note to the Secretary, Francis Newton. The tone of that was much more genial:

Dear Newton,

I would beg to have them hung with the Frames touching each other, in this order, the Names are written behind each Picture –

God bless you. hang my Dogs & my Landskips in the great Room. The sea Piece you may fill the small Room with –

Yo.rs sincerely in haste

T. Gainsborough*

* Hayes, 2001, 148. Gainsborough exhibited only one landscape in 1783. It is now in the National Gallery of Scotland, Edinburgh, its title lengthily extended to *Rocky Wooded Landscape with Dell and Weir, Shepherd and Sheep on a High Bank, Mounted Peasant and Another Figure, and Distant Village and Mountains.*

What the President of the Academy made of these communications is not known. If the committee had taken the view that the fifteen portraits *en bloc* constituted a picture larger than full length they might well have placed them above the line. Gainsborough's interest in not having them skied in this way – which would have made it more difficult to admire his virtuoso handling of paint – is understandable, but the lordly tone of his letters is breathtaking.

The 'Dogs' which Gainsborough asked to have hung in the Great Room along with his landscapes is the picture now at Kenwood called *Shepherd Boys with Dogs Fighting,* and he mentions it again in another letter he wrote at this time to Sir William Chambers:

. . . I sent my fighting dogs to divert you. I believe next exhibition I shall make the boys fighting & the dogs looking on – you know my cunning way of avoiding great subjects in painting & of concealing my ignorance by a flash in the pan.[10]

This deeply ironic passage is clearly a coded challenge to the dominant ethos of the Academy – far from 'avoiding great subjects', he is suggesting to Chambers that great subjects may well exist beyond the confines of the classical academic tradition which Reynolds so regularly expounded in his Discourses. *Shepherd Boys with Dogs Fighting,* as Michael Rosenthal has pointed out, 'juxtaposes a subject adapted from the first two of Hogarth's *Stages of Cruelty,* with colouring and composition from Titian'[11] – some flash in the pan.

As rebarbative as ever, and showing increasing signs of persecution mania, Barry had not exhibited at the Academy since 1776. For the past six years his energies had been totally consumed by the series of large canvases he had undertaken to paint for the Great Room of the Society of Artists. He took as his theme *The Progress of Human Culture.* 'No painter of his generation,' Ellis Waterhouse wrote silkily, 'took the President's encourage-ment towards the "grand style" so close to the letter and with so small a grain of the salt of common sense.' This epic work was now almost complete – six enormous canvases, two of them forty-two feet long.* It went on show on the day that the Academy exhibition opened. 'A book is published to recom-mend it,' Johnson wrote to Mrs Thrale, 'which, if you read it, you will find decorated with some satirical strictures on Sir Joshua Reynolds and others.'

Reynolds must have had a weary sense of *déjà vu.* A pamphlet Barry had

* The final canvas depicts Elysium and Tartarus. Barry's heaven contains 125 identifiable portraits of men and women of genius who had contributed to the march of civilization.

published some years previously[12] had made plain his contempt for portrait painting and those who did well out of it. This new offering combined extravagant praise for his own work with delusional references to 'the underhand malevolent attentions from a certain quarter, which had continually followed me, and which I well knew would not be wanting industriously to embroil and embitter matters on this occasion'.

Johnson's 'satirical', however, is hardly the *mot juste* for what followed. After deploring the predominance of portrait painting, and accusing certain practitioners of the art of 'what is not merely mercenary and sordid, but also vicious', Barry goes further:

Everything that is mean in art and meaner in morals may then naturally be expected; their houses (shame upon them!) will become convenient, and for other purposes to which those of painting portraits serve but as a blind –

The suggestion, clearly, is that Reynolds and others allowed their houses to be used as places of assignation.

Nor was it only in print that Barry found ways of making himself obnoxious. In 1782, when Penny resigned the professorship of painting at the Academy, Barry had been appointed in his place. However, he was so dilatory in preparing his lectures (the first was not delivered until March 1784) that the President and others felt obliged to remonstrate; whereupon Barry clenched his fist under Reynolds's nose and said, 'If I had no more to do in the composition of my lectures than to produce such poor flimsy stuff as your discourses, I should soon have done my work, and be prepared to read.'[13] All grist to the mill of Peter Pindar:

> Then there's among the Academic crew
> A man that made the President look blue,
> Brandish'd his weapon with a whirlwind's forces;
> Tore by the roots his flourishing Discourses;
> And swore his own sweet Irish howl could power
> A half a dozen such in half an hour.

> When Barry dares the President to fly on,
> 'Tis like a mouse that, worked into a rage,
> Daring most dreadful war to wage,
> Nibbles the tail of the Nemæan lion.

Reynolds also found himself at odds during the early summer with Valentine Green, one of the most distinguished mezzotint engravers of the

day.* Green had engraved many of his portraits – some, he declared, 'at a considerable loss'. Hearing that Mrs Siddons was sitting to Reynolds, Green applied for permission to engrave the portrait, addressing himself initially to Sheridan, who, when not taken up with affairs of state, was the actress's manager at Drury Lane. From Reynolds, he received a temporizing acknowledgement. If the choice of engraver depended on him, he wrote, he would certainly remember that Green had been the first to express an interest. Mrs Siddons, however, had appeared to have a preference for an engraved print, not a mezzotint – 'but the picture is just begun', he added, 'and in a state of uncertainty whether it will be a picture worth making a print from it or not'.[14]

This plainly did not constitute anything resembling a promise, but Green took it as one, and when he heard some weeks later that the commission had gone to the line engraver Francis Haward† he dashed off a lengthy and intemperate letter to Reynolds, challenging his version of events and announcing that he now demanded 'as a right what he originally solicited as a favour'. In future, he raged, Reynolds should 'give unequivocal answers to plain propositions, and so avoid the risk of sporting with any man's temper where his personal and professional character is concerned'.

That was altogether too much for the usually equable Reynolds, particularly as Mrs Siddons had now specifically asked for the work to be done by Haward.‡ 'You have the pleasure, if it is any pleasure to you of reducing me to a most mortifying situation,' he wrote stiffly to Green.

I must either treat your hard accusation of being a Liar with the contempt of silence, (which you and your friends may think implies guilt) or I must submit to vindicate myself like a criminal from this heavy charge ... I have the happiness of knowing that my friends believe what I say without being put to the blush, as I am at present, by being forced to produce proofs . . .[15]

* Green (1739–1813), the son of a dancing master, had originally been intended for the law. He first exhibited at the Academy in 1774 and was soon appointed Mezzotint Engraver to the King. In 1789 the Elector Charles Theodore granted him the exclusive privilege of engraving and publishing prints from the pictures in the Düsseldorf Gallery, and by 1795 he had completed twenty-two plates. The outbreak of war wrecked the enterprise, and the siege and destruction of the gallery by the French in 1798 involved him in serious loss.

† Haward (1759–97) had become a student of the Academy in 1776. He was elected an associate engraver in 1783, and was later appointed Engraver to the Prince of Wales.

‡ She had written to Reynolds asking 'with all submission to his better judgment, that the Picture should be put into the hands of that person, (whose name she cannot at this moment recollect) who has executed the Print of the children from a Picture of Sir Joshua, in so masterly a manner'. The letter, dated 7 May, is now at the Folger Library, Washington. Mrs Siddons seems to be referring to the picture of the future 'Beau' Brummell and his brother exhibited at the Academy that year (Mannings, cat. no. 269, pl. 110, fig. 1365. Now at Kenwood).

Sarah Siddons, at twenty-seven, was approaching the end of her first full Drury Lane season. After a disastrous London debut in Garrick's last year as manager* she had gone off to the provinces again. Only in the previous autumn had she returned to the capital and taken lodgings with her husband and four surviving children in the Strand. Her success was immediate and sensational. For her first role she chose to appear as the pathetic heroine of Thomas Southerne's *Isabella; or, The Fatal Marriage*. A storm of applause broke out before the final curtain, although by one account the greater part of the audience 'were too ill to use their hands in her applause'. When she appeared a month later as Jane Shore, men sobbed and women had hysterics – 'fainting fits were long and frequent in the house'. The management ceremoniously accorded her Garrick's dressing room on the stage level; during January, in an unprecedented flurry of theatre-going, the king and queen came to see her five times. The proceeds of her first benefit, augmented by gifts from admirers, amounted to more than £800, and she placed an advertisement in the press to express her gratitude; she had been told that her emoluments 'exceeded anything ever recorded on a similar account, in the annals of the English Stage'.

Even before the opening of the 1783 Exhibition, the fashionable painters of the day had been falling over each other to paint her. The *Morning Herald and Daily Advertiser* resorted to ponderous and heavily italicized irony:

Mrs Siddons will be so *numerously* exhibited in her tragic characters, that the very *daggers* she is to be in the act of drawing, will be sufficient to hang every second picture in the academy upon in case the President should think it expedient to convert them to *pegs*!†

In her *Reminiscences*, composed at the end of her life, Mrs Siddons, by then very much the *grande dame*, gives a theatrically improbable account of how the pose she adopts in Reynolds's portrait was arrived at:

When I attended him for the first sitting . . . he took me by the hand, saying, 'Ascend your undisputed throne and graciously bestow upon me some grand Idea of the Tragick Muse.' I walked up the steps and seated myself instantly in the attitude in which She now appears.[16]

* Garrick had used her as a weapon in his unending battles with Mrs Abington and various others of his leading ladies of the day.
† 23 April 1783. In fact the only portraits of her exhibited at the Academy that year were miniatures by Richard Crosse and William Birch; there were, however, two portraits of her by Thomas Beach at the Society of Artists.

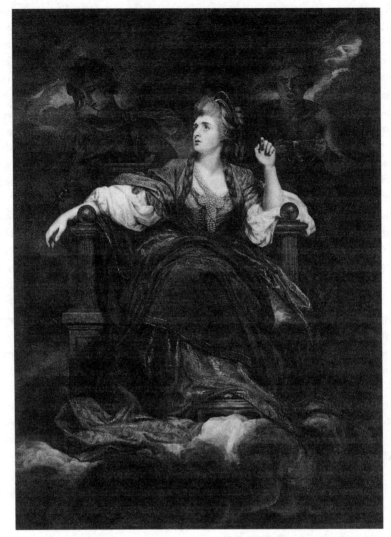

9. Mrs Siddons as the Tragic Muse. *Exhibited at the Royal Academy in 1784. Her own account of the origin of the painting – 'I walked up the steps and seated myself instantly in the attitude in which the Tragic Muse now appears' – is almost certainly nonsense. The cracking apparent in places, though not, happily, on the face, is due to Reynolds's extensive use of bitumen and multiple glazes.*

A more prosaic version is that given by the poet and art collector Samuel Rogers, who says that Mrs Siddons arrived somewhat out of breath in Leicester Fields, flopped into an armchair, removed her bonnet and asked how she should sit. 'Just as you are,' Reynolds is supposed to have replied.* The painter Thomas Phillips,† on the other hand, was told by Mrs Siddons that the pose came about quite by accident when she moved her head to look at a painting on the wall, and that this prompted Reynolds to make a fresh start.[17]

Modern X-ray examination demonstrates that Reynolds reworked the picture very considerably, and there is contemporary evidence to support this. The American painter Gilbert Stuart, for example, admired it as a work in progress, but was disappointed by the finished article. When Reynolds asked if he had not improved it, Stuart is supposed to have blurted out, 'It could not have been improved – why did you not take another canvas?'[18] Reynolds seems not to have taken offence at this expression of New World frankness – the following year he agreed to let Stuart paint his portrait.

The Siddons portrait would dominate the following year's exhibition, and has been extravagantly admired over the years (though Horace Walpole's beady eye told him that her left arm was too large). Even Barry, who, after Reynolds's death, discovered that he did after all have some redeeming features, found words of unqualified praise for it: 'The finest picture of the kind, perhaps in the world, indeed it is something more than a portrait.'[19] Which of course it is – possibly the outstanding example of Reynolds's ability to fuse portraiture, history painting and allegory in one majestic composition. It remained in his studio for several years – unsurprisingly, perhaps, as he asked 1,000 guineas for it. Eventually, in 1790, he let it go to the acquisitive M. de Calonne for 300 guineas less.

Mary Palmer, writing to her cousin William Johnson in the middle of June, told him that she was shortly going with Reynolds to visit the Duke and Duchess of Rutland at Belvoir Castle, and from there to Lord Harcourt's, near Oxford. 'You enquire after Dr Johnson,' she continued:

I wish I could give a good account of him; but his health seems very much impaired lately, and the world will, I fear, soon be deprived of one of the greatest men in it;

* Whitley, 1928, ii, 5. Rogers told Thomas Campbell, who was writing a life of Siddons, that he had been present when she arrived.

† Phillips (1770–1845) entered the Academy schools in 1791 and was briefly an assistant to West. He initially exhibited history paintings, but after 1808, the year in which he became an Academician, painted only portraits. He was elected professor of painting at the Academy in 1825. His best-known portrait is *Lord Byron in Albanian Costume*, now in the UK Government Art Collection.

he dines with us now and then, and is tolerably cheerful, yet it is easy to see that his constitution is breaking up.

Two days later, in the early morning of 17 June, Johnson woke to find that he was suffering a paralytic stroke. He offered up a prayer that however much his body might be afflicted, God would spare his understanding. 'This prayer,' he later told Mrs Thrale, 'that I might try the integrity of my faculties, I made in Latin verse.' He quickly regained the power of speech, and by the middle of July he was well enough to spend a couple of weeks with Bennet Langton at Rochester, but more and more after the stroke his mind turned to the text which had haunted him since his middle years and which was inscribed on his watch – 'The night cometh . . .' 'I hope God will yet grant me a little longer life,' he wrote to Boswell at the end of September, 'and make me less unfit to appear before him.'[20]

Reynolds went on from Belvoir and Nuneham to visit old friends in the West Country, accompanied for some of the time by the Burkes. From Saltram, in the middle of September, he sent an apologetic note to Offy:

I am very much mortified that I could not stay at Port-Elliot till your arrival which I hear will be on Saturday but it would disarange all our schemes Mr Burke wishes to get to Town as soon as possible, I have full as great a desire to be there.[21]

Burke's eagerness to return to Westminster reflected his unease and restlessness at the political situation. He and Reynolds's other friends in the administration were having a difficult time. The peace negotiated with America was not popular in the country – the Treaty of Versailles, signed that month, extended the frontiers of the United States to the Great Lakes in the north and the Mississippi in the west. The Fox–North coalition, formed in March, could rely on a handsome majority in Parliament, but had to contend with the implacable hostility of George III, and with certain items in the reforms they had brought forward for the East India Company – notably the proposal that the Company's affairs should be supervised by a commission composed essentially of Fox's cronies* – they played straight into the king's hands. Although he was powerless to prevent the bill's passage through the Commons, he killed it stone-dead in the Lords by letting it be known that 'he should consider all who voted for it as his enemies'. The constitutionality of the ploy was dubious, but as a crab-like device for turning the coalition

* The bill inspired James Sayers's memorable etching *Carlo Khan's Triumphal Entry into Leadenhall Street*, which is where the East India Company had its offices. Fox, attired as an Indian prince, sits astride an anxious-looking elephant, identifiable as North; the beast is led by Burke, who drafted the bill.

out of office it was highly effective. A week before Christmas the king dismissed his ministers – without audience – and the 24-year-old William Pitt was installed as First Lord of the Treasury.

'Pitt may do what he likes during the holidays,' said the witty Whig hostess Mrs Crewe, 'but it will only be a mince-pie Administration.' She was quite wrong. A full three years before it was required by the Septennial Act, the king called an election for the spring. The Whigs had been outmanoeuvred and had their proprietary rhetoric about corruption turned dramatically against them; they would now find themselves relegated to long years of opposition.

If Reynolds had been outshone by Gainsborough at the previous year's exhibition, his industry and application in the early months of 1784 suggest a determination that it should not happen a second time. As things turned out, there was no contest. Gainsborough had prepared several full-lengths, including a splendid group portrait of the three eldest princesses. He once again had firm views about how his pictures should be displayed, and communicated them to the hanging committee two weeks before the exhibition was due to open:

Mr Gainsboroughs Compts to the Gentn of the Committee, & begs pardon for giving them so much trouble; but he has painted this Picture of the Princesses in so tender a light, that notwithstanding he approves very much of the established Line for Strong Effects, he cannot possibly consent to have it placed higher than five feet & a half, because the likenesses & Work of the Picture will not be seen any higher; therefore at a Word, he will not trouble the Gentlemen against their Inclination, but will beg the rest of his Pictures back again –[22]

Gainsborough's tone was less peremptory than it had been the previous year. That was sensible of him, because this commission had come not from the king but from the Prince of Wales, and he must have known that his ground was less strong. The committee knew that too, of course, and decided on this occasion to stand firm. The Secretary was instructed to send the briefest of replies:

In compliance with your request the Council have ordered Your Pictures to be taken down & to be delivered to your order, when ever You Send for them.*

* Minute Books of the Royal Academy Council Meetings, i, 358. The members of the committee that year were Agostino Carlini, John Richards, M. W. Peters, George Dance and the Secretary, Francis Newton.

The breach did not immediately become public knowledge, and there is some evidence that there were attempts to reach a compromise. Once the news was out, however, well-briefed partisans of both sides quickly took up their positions. Bate, in the *Morning Herald*, wrote of the 'Royal Academy INQUISITION'. The Academy's brisk return of service, describing Gainsborough as 'fastidious', and 'too tenacious of Claims, which probably were exorbitant', appeared in the *Public Advertiser*:

The Fact was this – He sent Word that Pictures of such and such specific Dimensions would come from him; and he at the same Time directed, that they should all have such and such particular Situations in the Room. Those Directions were in part offered to be complied with. Entirely to follow them was impossible.[23]

After the exhibition had opened, a writer in the *Morning Post and Daily Advertiser* pointed out that works by Reynolds, 'who may justly be stiled the *Corregio* of the age', were distributed through several rooms and hung at different heights:

We cannot therefore discover why Mr Gainsborough should arrogate to himself an advantage, not allowed to a person, who added to his rank as president, has certainly greater ability in his profession.[24]

An article in the *St James's Chronicle* added a dash of political spice to the affair. The long-drawn-out Westminster election, where Fox was one of three candidates for two places, was still in progress when the exhibition opened. Gainsborough and Reynolds were both entitled to vote, and the writer claimed that Gainsborough, mindful of what he owed to his new patron the Prince of Wales, had cast an early vote for Fox. He also claimed that during the campaign, a peer of the realm had called on Reynolds – who had also, the previous year, been commissioned to paint the prince – to suggest that a vote for Fox would make it that much more likely that 'a certain young man' would honour the Academy with his presence at the annual banquet.

In the event he did not show up. 'The Prince of Wales had promised to be there,' Johnson wrote to Mrs Thrale, 'but when we had waited an hour and a half, sent us word that he could not come.' Possibly he was showing his displeasure at the Academy's treatment of Gainsborough; perhaps he was simply incapable – he had been too drunk for most of the election to be of the least use to man or beast.

Reynolds, at all events, had a good exhibition – amusingly enough, the subjects of the sixteen canvases he displayed included both Fox and the

prince. In his lushly baroque portrait of the latter, the tail and hindquarters of the horse occupy a good deal more space than the royal personage.* As well as the portrait of Mrs Siddons, there was one of her sister, Fanny Kemble,[25] which was the subject of some fawning doggerel in the *Gentleman's Magazine*:

> While hands obscene, at vicious grandeur's call,
> With mimic harlots cloathe th'indignant wall,
> Destructive snares for youthful passion spread,
> The slacken'd bosom, and the faithless bed,
> Thy pencil, *Reynolds*! innocently gay,
> To virtue leads by pleasure's flowery way . . .[26]

It is not clear which particular artists and patrons are under attack here. The Academy's President had painted his share of slackened bosoms over the years; indeed the poet seems not to have noticed that one of Reynolds's canvases displayed on the 'indignant wall' of Somerset House depicted a bare-breasted nymph who coyly shields her face as Cupid undoes the girdle round her waist.† The image is highly suggestive. Reynolds, in a note in the back of his sitters' book for that year, describes it as 'The half consenting'. The *Public Advertiser* thought it 'a most beautiful and bewitching picture' and saw in it – correctly – 'all the warmth and richness of the Flemish and Venetian Schools'.[27] Horace Walpole disagreed – 'Bad and gross', he wrote in his catalogue. It was snapped up by Reynolds's friend Lord Carysfort, who took it with him to St Petersburg, where he was to spend the next four years as ambassador. There it was admired by the Empress's lover, Prince Potemkin, who commissioned for himself the copy which now hangs in the Hermitage.[28]

Did Reynolds, capitalizing on Gainsborough's withdrawal, send more pictures to Somerset House than he originally intended? It was certainly one of his richest displays, particularly of female portraits. That of Emma Hart, the future Lady Hamilton, her long chestnut hair loosely held by a wreath of ivy, was originally exhibited as *A Boy Reading* – only in the reprint of the catalogue was this altered to *A Bacchante*.[29] Emma's life was already moderately complicated. Originally the mistress of Sir Harry Fetherstone of

* Mannings, cat. no. 719, fig. 1043. The prince presented the picture immediately to his friend Peniston Lamb, Viscount Melbourne. It remained at Brocket Hall until it was sold to Lord Lloyd Webber in 1996.

† Mannings, cat. no. 2125, fig. 1670. Now at the Tate Gallery. There has been some speculation that she was also the model for *Nymph and Cupid*. To the extent that one can judge what lies behind the raised hand, there is some facial resemblance.

Uppark, Cheshire, by whom she had a daughter, she had been kept, since 1782, by Charles Greville; this painting, however, was paid for by Greville's uncle, Sir William Hamilton, whose mistress she became only in 1786, five years before their marriage.

Reynolds's exhibits included one of the most delightful of his child portraits. Lady Catherine Manners was the five-year-old daughter of the Duke of Rutland; the picture was commissioned by the child's grandmother, the Duchess of Beaufort.[30] His latest homage to Mrs Abington also attracted attention – 'very arch', noted Horace Walpole.[31] She is depicted as Roxalana in Isaac Bickerstaffe's play *The Sultan*, a role she had created nine years previously at Drury Lane. Roxalana is an English slave who rebels in the seraglio and agitates for a reform in which men are to please the women. It was a part which suited Fanny Abington's pert talents down to the ground; she is depicted, the *Morning Herald* explained to its readers, 'in the act of drawing the curtain when she surprises the sultan in his retirement'. Reynolds painted his favourite actress in a white turban and white dress decorated with gold. He presented the portrait to her; she later presented it to another of her many admirers, the Earl of Fife.

Johnson had been in good form at the time of the Academy banquet. He had bought a new coat for the occasion, and the account of the evening he sent to Mrs Thrale exudes high spirits:

Much and splendid was the company, but like the Doge of Genoa at Paris, I admired nothing but myself. I went up all the stairs to the pictures without stopping to rest or to breathe,

'In all the madness of superfluous health.'*

Boswell, arriving in London early in May, thought him much recovered and in great good humour. 'O! Gentlemen,' he exclaimed at the Club one evening, 'I must tell you a very great thing. The Empress of Russia has ordered the "Rambler" to be translated into the Russian language: so I shall be read on the banks of the Wolga.' His friends remained concerned about him, however, and at the beginning of July, when several of them were gathered for dinner at General Paoli's, there was discussion of making it possible for him to travel to Italy – it had been his lifelong desire to see the country, and he would be spared the uncertainties of the English winter. Having consulted Reynolds, Boswell wrote to the Lord Chancellor to engage his interest. Thurlow had long admired Johnson, and it was felt that he was

* Johnson, Samuel, 1992–4, iv, 321, letter dated 26 April. He is quoting from Pope's *Essay on Man*, iii, 3.

the person best able to bring influence to bear on the king or Pitt to find the modest sum that would be required.

The Chancellor sent a promising reply: 'It would be a reflection on us all, if such a man should perish for want of the means to take care of his health.' Reynolds suggested that Boswell should hurry round to Bolt Court and tell Johnson what was afoot. He was greatly moved. 'This is taking prodigious pains about a man,' he said, and tears started to his eyes.

Reynolds also persuaded Boswell to delay his departure for Scotland by a day so that he and Johnson might dine with him and 'have it all out' about Italy. They were equally convinced that the matter was settled:

Both Sir Joshua and I were so sanguine in our expectations, that we expatiated with confidence on the liberal provision which we were sure would be made for him, conjecturing whether munificence would be displayed in one large donation, or in an ample increase of his pension.

. . . Sir Joshua and I endeavoured to flatter his imagination with agreeable prospects of happiness in Italy. 'Nay, (said he,) I must not expect much of that; when a man goes to Italy merely to feel how he breathes the air, he can enjoy very little.'

It was as well that he expected so little. Early in September Thurlow called on Reynolds to announce that his application had been unsuccessful. Clearly embarrassed by his failure, he asked Reynolds to convey an offer as delicate as it was generous: Johnson might draw on him personally for £500 or £600, this to be regarded as a mortgage on his future pension. 'After a long and attentive observation of Mankind,' Johnson replied, 'the generosity of your Lordship's offer, excites in me no less wonder than gratitude.' None the less, in a letter full of grace and dignity, he declined it:

. . . Your Lordship was Solicited without my knowledge, but when I was told that you were pleased to honour me with your patronage, I did not expect to hear of a refusal. Yet as I had little time to form hopes, and have not rioted in imaginary opulence, this cold reception has been scarce a disappointment . . .

Two years later Boswell secured an interview with Thurlow, and managed to worm out of him that the 'cold reception' had been on the part of the king. 'The Sovereign was much obliged to his Chancellor, who shielded him very ably,' he wrote in his journal:

I was however very sorry, and mentioned Sir Joshua's saying that he did not expect generosity from the King. But that merely as a good œconomist he wondered that the application was not successful, for how could he lay out his money so well in

purchasing fame? 'Then,' said Lord Chancellor, 'Sir Joshua is angry that the King is not so vain as he would have him (smiling). *That* is a good answer to Sir Joshua's argument.'

If Reynolds did not expect generosity from the king towards Johnson, there arose, in the autumn of 1784, another matter which concerned himself, and over that he acted ruthlessly to extract from the monarch a mark of recognition which he felt to be his due. The death on 10 August of Allan Ramsay meant that the position of Principal Painter in Ordinary to the King fell vacant. Gainsborough, with some reason, felt that he was on the inside track, and Bate was quickly shouting the odds. There was no one, he declared, with equal pretensions: 'No artist living has so much originality or so strong a claim, as far as genius is concerned, on the Patron of Science.'

Reynolds was determined that the royal 'Patron of Science' should be persuaded otherwise, but was at first reluctant, as was customary, to solicit the honour. He sought the advice of Johnson, who was away in Derbyshire, and his old friend's worldly-wise reply is extant. 'That the President of the Academy founded by the King should be the King's painter is surely very congruous,' he wrote:

If You ask for it I believe You will have no refusal, what is to be expected *without* asking, I cannot say. Your treatment at court has been capricious, inconsistent, and unaccountable. You were always honoured, however, while others were employed. If You are desirous of the place, I see not why You should not ask it. That sullen pride which expects to be solicited to its own advantage, can hardly be justified by the highest degree of human excellence.[32]

This does not seem to have satisfied Reynolds at first, and a second letter from Johnson suggests that before the matter was resolved, he had announced that he intended to force the issue by threatening to resign his position at the Academy. 'I am glad that a little favour from the court has intercepted your furious purposes,' Johnson wrote on 2 September:

I could not in any case have approved such publick violence of resentment, and should have considered any who encouraged it, as rather seeking sport for themselves, than honour for You. Resentment gratifies him who intended an injury, and pains him unjustly who did not intend it. But all this is now superfluous.[33]

As indeed it was. A note in Reynolds's pocketbook for the previous day reads, 'Sept. 1, 2½, to attend at the Lord Chancellor's Office to be sworn in painter to the King'. He had not achieved what he wanted solely by his own

efforts – Gainsborough, in a letter to the Earl of Sandwich later in the year, describes himself with a hint of bitterness as someone 'who was very near being King's Painter only Reynolds's Friends stood in the way'.[34]

Perversely, having got what he wanted, Reynolds almost immediately began to grumble to his friends about his new honour. 'If I had known what a shabby miserable place it is,' he wrote to Boswell, 'I would not have asked for it; besides as things have turned out I think a certain person is not worth speaking to, nor speaking of' – an allusion, presumably, to the king.[35] Some weeks later, in a letter to Shipley, the Bishop of St Asaph, he was still brooding sourly on what he had let himself in for:

Your Lordship congratulation on my succeeding Mr. Ramsay I take very kindly but it is a most miserable office, it is reduced from two hundred to thirty-eight pounds per annum, the Kings Rat catcher I believe is a better place, and I am to be paid only a fourth part of what I have from other people, so that the Portraits of their Majesties are not likely to be better done now, than they used to be, I should be ruined if I was to paint them myself.[36]

He must have directed a similar litany of complaint to Johnson, who, in reply, urged him to be philosophical:

All is not gold that glitters, as we have often been told; and the adage is verified in your place and my favour; but if what happens does not make us richer, we must bid it welcome, if it makes us wiser.

I do not at present grow better, nor much worse; my hopes, however, are some what abated, and a very great loss is the loss of hope. But I struggle on as I can.[37]

Back in London, that struggle lasted only a few weeks longer. Around the beginning of December he began to burn large quantities of his papers. For a time he exerted himself to be up and about. 'I will be *conquered*,' he said. 'I will not capitulate.' Only towards the very end did he lie helpless in bed and refuse further medicine; he had no wish, he announced, to 'meet God in a state of idiocy, or with opium in his head'.

In a memoir he later composed for Boswell, Reynolds recalled sitting with him one day together with Bennet Langton. 'His approaching dissolution was always present to his mind,' Reynolds wrote:

He said he had been a great sinner, but he hoped he had given no bad example by his writing nor to his friends; that he had some consolation in reflecting that he had never denied Christ, and repeated the text 'whoever denies me,' etc . . .

Sometimes a flash of wit escaped him as if involuntary. He was asked how he liked

the new man that was hired to watch by him. 'Instead of watching,' says he, 'he sleeps like a dormouse; and when he helps me to bed he is as awkward as a turnspit dog the first time he is put into the wheel.'[38]

This was presumably the occasion when Johnson requested three things of him – that he would forgive him £30 he had once borrowed of him; that he would read the Scriptures regularly; and that he would never paint on a Sunday. The first two presented no particular difficulty. On the evidence of the sitters' books, Reynolds assented to the third with his fingers discreetly crossed behind his back.*

Johnson died quietly on the evening of 13 December, and was buried a week later in the Abbey. In his will he left Reynolds, who was an executor, 'my great French dictionary, by Martiniere, and my own copy of my folio English Dictionary, of the last revision'. Reynolds also later acknowledged a less tangible, but infinitely more precious legacy:

He may be said to have formed my mind and to have brushed off from it a deal of rubbish. Those very people whom he has taught to think rightly will occasionally criticize the opinions of their master when he nods, but we should always recollect that it is he himself who taught us and enabled us to do it.[39]

* According to Croker, Reynolds observed the charge for a considerable time, breaking it only when someone eager for a sitting persuaded him that 'the Doctor had no title to exact such a promise' (Croker, ii, 34).

21

Wheeling and Dealing

As the man who had brushed a deal of rubbish from his mind lay dying, Reynolds was preparing to perform a similar service for those to whom he must shortly deliver his twelfth Discourse. Johnson had also occasionally brushed up his prose for him, but now he must look elsewhere. A note which he wrote at this time, preserved at the Folger Library in Washington, shows that he turned to Malone: 'I have sent by your servant my Discourse, which I shall take as a great favour if you not only will examine critically but will likewise add a little elegance.'[1]

Reynolds began by reverting to a question he had addressed sixteen years earlier – what advice should be offered to young artists intending to spend some years in Italy about how best to regulate their studies? He feared that his answers to such questions had not often given satisfaction. 'Indeed I have never been sure,' he continued disarmingly, 'that I understood perfectly what they meant, and was not without some suspicion that they had not themselves very distinct ideas of the object of their enquiry.'[2]

It would, he conceded, be entirely possible to draw up detailed instructions, and these 'might be extended with a great deal of plausible and ostentatious amplification'. But it would also be quite useless:

Our studies will be for ever, in a very great degree, under the direction of chance; like travellers, we must take what we can get, and when we can get it; whether it is, or is not administered to us in the most commodious manner, in the most proper place, or at the exact minute when we would wish to have it.[3]

Pretty subversive stuff, this, from the President, and there was more to come:

Whatever advantages method may have in dispatch of business, (and there it certainly has many,) I have but little confidence of its efficacy in acquiring excellence in any Art whatever. Indeed, I have always strongly suspected, that this love of method, on which some persons appear to place so great a dependance, is, in reality, at the

bottom, a love of idleness; a want of sufficient energy to put themselves into immediate action: it is a sort of apology to themselves for doing nothing.[4]

So what is the poor tyro to do? Borrow. Steal. Feed on the past. Raphael, after all, he reminds his listeners, helped himself generously from the work of Masaccio in designing his Cartoons:

The daily food and nourishment of the mind of an Artist is found in the great works of his predecessors. There is no other way for him to become great himself . . . The habit of contemplating and brooding over the ideas of great geniusses, till you find yourself warmed by the contact, is the true method of forming an artist-like mind; it is impossible, in the presence of those great men, to think, or invent in a mean manner; a state of mind is acquired that receives those ideas only which relish of grandeur and simplicity.[5]

As is so often the case in the Discourses, Reynolds's severely practical cast of mind leads him to buttress precept by example. Even if the original idea has been borrowed, he maintains, a painter has a 'just right' to consider what is taken from a model as his own property:

And here I cannot avoid mentioning a circumstance in placing the model, though to some it may appear trifling. It is better to possess the model with the attitude you require, than to place him with your own hands: by this means it happens often that the model puts himself in an action superior to your own imagination. It is a great matter to be in the way of accident, and to be watchful and ready to take advantage of it . . .

 Rembrandt, in order to take the advantage of accident, appears often to have used the pallet-knife to lay his colours on the canvass, instead of the pencil . . . Accident in the hands of an Artist who knows how to take the advantage of its hints, will often produce bold and capricious beauties of handling and facility, such as he would not have thought of, or ventured, with his pencil, under the regular restraint of his hand . . .[6]

He returns insistently, in conclusion, to one of his dominant themes – the vital importance of never losing sight of nature. 'The instant you do, you are all abroad,' he declares:

Those Artists who have quitted the service of nature, (whose service, when well understood, is *perfect freedom*) and have put themselves under the direction of I know not what capricious fantastical mistress, who fascinates and overpowers their whole mind, and from whose dominion there are no hopes of their being ever

reclaimed, (since they appear perfectly satisfied, and not at all conscious of their forlorn situation,) like the transformed followers of Comus, –

> Not once perceive their foul disfigurement;
> But boast themselves more comely than before.[7]

Did any of Reynolds's hearers regard this passage as *ad hominem*? Barry must be left aside as a special case, but increasingly as the century wore on there would be those in and around Somerset House who did not regard their President as the fount of all wisdom and who did not subscribe to every article of his philosophy.

It was, for instance, just over five years since a 22-year-old engraver called William Blake had presented his probationary drawings to the Academy's Keeper and been issued with the ivory ticket which entitled him to draw in the Plaster Gallery and attend lectures and exhibitions for a period of six years. From his earliest childhood he had shown a passion for art. What was less usual was the frequency with which he saw visions; once he was beaten by his mother 'for running in & saying that he saw the Prophet Ezekiel under a Tree in the Fields'.[8] As an apprentice he had been sent to make drawings of the Gothic monuments in Westminster Abbey and had been enchanted by them, but there was little that resembled their rugged grandeur in the Sculpture Hall at the Academy.

The friendships he formed there tended to be with young men whose radical religious and political views coincided with his own – the earnest young sculptor John Flaxman,* for instance, and Thomas Stothard, who had recently finished his apprenticeship to a designer of silk patterns.† His opinions, which he was in the habit of expressing with some vigour, soon became known to his elders and betters at Somerset House. 'Well, Mr Blake,' Reynolds said to him one day, 'I hear you despise our art of oil painting.' 'No, Sir Joshua,' came the reply. 'I don't despise it; but I like fresco better.'[9]

On another occasion, when Blake showed some designs to Reynolds, he was 'recommended to work with less extravagance and more simplicity, and to correct his drawing. This Blake seemed to regard as an affront never to be forgotten, He was very indignant when he spoke of it.'[10] Later, by the time he came to make his notorious jottings in the margins of the *Discourses*,

* Flaxman (1755–1826) was the son of a plasterer. Later professor of sculpture at the Academy, he would become the foremost monumental sculptor of the day.

† Stothard (1755–1834) became celebrated as a book illustrator, in later years illustrating many of the works of Scott and Byron. He became very active in Academy affairs, and from 1812 served as its Librarian.

he would be more indignant still: 'This Man was Hired to Depress Art,' he scrawled in a large hand on the title page of Malone's edition of Reynolds's *Works*, and on the verso he gave vent to an extended rant:

Having spent the Vigour of my Youth & Genius under the Opression of Sr Joshua and his Gang of Cunning Hired Knaves Without Employment & as much as could possibly be Without Bread, The Reader must expect to Read in all my Remarks on these Books Nothing but Indignation & Resentment. While Sr Joshua was rolling in Riches Barry was Poor & Unemployed except by his own Energy Mortimer was called a Madman* & only Portrait Painting applauded & rewarded by the Rich & great. Reynolds & Gainsborough Blotted and Blurred one against the other & Divided all the English World between them . . .

Although there is the occasional approving note – 'A Noble Sentence', 'Fine & Just Notions', 'Well Said enough' – there was little in the main thrust of the Discourses with which he could bring himself to agree:

There is no End to the Follies of this Man
 This is all Self-Contradictory: Truth & Falshood Jumbled Together
 Without Minute Neatness of Execution The Sublime cannot Exist! Grandeur of Ideas is founded on Precision of Ideas
 To My Eye Rubens's colouring is most Contemptible His Shadows are of a Filthy Brown somewhat of the Colour of Excrement these are filld with tints & messes of yellow & red His lights are all Colours of the Rainbow laid on Indiscriminate & broken one into another.
 Taste & Genius are Not Teachable or Acquirable but are born with us Reynolds says the Contrary

Blake had had a picture accepted at the annual exhibition during his first year as a student. *The Death of Earl Goodwin*, in pen and watercolour, depicts the noble lord at dinner with Edward the Confessor in 1053, when he called on the Almighty to choke him if he had had any hand in the death of the king's brother Alfred – whereupon 'a morsel choaked him immediately, to the great astonishment of the Stander-by'. He had followed this in 1784 with *A Breach in a City, the Morning after a Battle* and *War Unchained by an Angel, Fire, Pestilence, and Famine Following*. This was

* John Hamilton Mortimer, a pupil of Hudson's, was mainly a history painter, known for his depiction of picturesque *banditti*. He drew attention to himself by his dangerously bohemian way of life and his radical political views. He died at the age of thirty-nine, several months before Blake entered the Academy schools. He did much to form the stereotype of the 'Romantic artist'.

briefly noticed in the *Morning Chronicle*: 'Blake in his War, Fire and Famine, outdoes most of the strange flights in our memory.' The reviewer compared him with Fuseli; it was not meant as a compliment.

Now, in the spring of 1785, he carried to Somerset House from his print shop in Broad Street four ambitious history watercolours – *Joseph Making Himself Known to His Brethren, Josephs Brethren Bowing before Him, Joseph Ordering Simeon to Be Bound* and *The Bard*. To the extent that he was noticed at all – most newspapers simply listed him as a contributor – he was as unkindly received as before. 'Gray's Bard, W. Blake, appears like some lunatic,' wrote the *Daily Universal Register*, 'just escaped from the incurable cell of Bedlam; in respect of his other works, we assure this designer, that grace does not consist in the sprawling of legs and arms'.[11]

It was notable at that year's exhibition that the language of the critics was a good deal more intemperate than it had been in the past. Some of the severest reviews appeared in the *Morning Post*, whose editor had announced the previous year that with a view to rescuing the arts 'from such ignorant and prejudiced accounts as have heretofore been given in the public papers', he proposed to enlist the help of 'artists of abilities and judgment' to raise the standard of reviewing. One of his recruits was the young John Hoppner,* who soon found himself exposed to the sarcasms of Bate in the *Morning Herald*:

The unusual severity with which the painters at the Royal Academy have been treated this year in some of the morning papers have made many people doubt the candour of the critic . . . Mr Hoppner . . . deserves the thanks rather than the censure of the public for so ably pointing out to them the beauties in his own performances and the defects in those of any other painter.†

Without Gainsborough to promote, Bate was short of occupation, although in the *Public Advertiser* someone calling himself Timothy Tickle wrote a subtle piece whose tone and style strongly suggest that Gainsborough may have been guiding his pen:

Mr Gainsborough's pictures are said to possess one quality in common with those of Vandyke; they may be viewed at three, or at thirty feet distance with the same

* Hoppner (1758–1810) was then in his mid-twenties. He had entered the Academy schools in 1775, and modelled his style closely on that of Reynolds. He exhibited portraits of the three youngest princesses at that year's exhibition.
† 30 May 1785. Hoppner admitted to being the author of critical notices on West, Copley and the Cosways, but denied puffing his own work. Bate withdrew his 'unjust reflection', and friendly comment on Hoppner subsequently appeared from time to time in the *Morning Herald*.

effect on the spectator's eye. The works of his rival, the President, are strangers to this qualification. If, therefore, Gainsborough's requisition [i.e. to the hanging committee the previous year] had been complied with, one of Reynolds's pictures must have been placed in a similar situation, in which case it would have resembled the lime and rough cast upon a country hovel when compared with nature, or with Gainsborough, and the President's assumed superiority would have suffered by the comparison.[12]

Gainsborough was by no means the only absentee, however, and it was, in truth, as the *Morning Post* suggested, rather a thin year:

What can the public expect from an exhibition which is deprived of the masterly strokes of Romney, the elegance of Gainsborough, the noble horrors of Wright, and the merits of several other excellent artists whom the interested cabals of a few leaders have driven from Somerset House? It is fortunate that the restless hankering after every tolerable place on the walls has not yet disgusted Loutherbourg, Hoppner and Opie, to whom we may still look for taste and nature.[13]

At least that year's Academy dinner was not marred by a display of royal bad manners. 'The Prince behaved with great propriety,' Reynolds wrote to the Duke of Rutland, 'we were all mightily pleased with him.' The French royal house was also represented. The duc de Chartres, later duc d'Orléans, the phenomenally rich cousin of Louis XVI, was a frequent visitor to London, and he and the Prince of Wales had agreed that they would each sit to Reynolds and exchange portraits. Horace Walpole wrinkled his nose, describing him as 'devoted to Newmarket and the bottle, slovenly and unceremonious'. Farington, however, records that Reynolds was impressed:

He was in manner the most elegant man he had ever seen. He had noticed him at Court & remarked that many men appeared graceful when *in motion*, but that the Duke of Orleans was the only man who appeared so when *standing still*.*

Reynolds painted him in hussar's uniform, and the duke was able to sit beneath the portrait[14] when he returned as a guest to the Academy dinner the following year. It was hung at Carlton House, but when 'Philippe Egalité' threw in his lot with the revolutionaries, it was taken down, although the

* Farington, 1978–84, iii, 1101. Reynolds was also impressed by the duke's mistress, the comtesse de Genlis. 'I had the honour of her Company yesterday to dinner,' he wrote to the Duke of Rutland. 'She speaks English tolerably well and has very pleasing manners' (Letter 136). When she was again in London five years later the comtesse chose to sit to Romney.

Prince of Wales broadmindedly allowed artists to examine it from time to time.*

All but one of the sixteen pictures Reynolds sent to the 1785 Exhibition were portraits. He wrote about the exception to the Duke of Rutland:

I dont know how to give a description of my Venus as it is called[15]; it is no more than a Naked woman sitting on the ground leaning her back against a tree, and a boy peeping behind another tree, I have made the landskips as well as I could in the Manner of Titian. Tho it meets with the approbation of my friends, it is not what it ought to be, nor what I thought I should make it. The next I paint I am confident will be better.[16]

Mason was quite often in Reynolds's painting room while the picture was being painted, and believed that the attitude had been taken from an Old Master rather than from life:

I happened to visit him when he was finishing the head from a beautiful girl of sixteen, who, as he told me, was his man Ralph's daughter, and whose flaxen hair, in fine natural curls, flowed behind her neck very gracefully. But a second casual visit presented me with a very different object: he was then painting the body, and in his sitting chair a very squalid beggar-woman was placed with a child, not above a year old, quite naked on her lap.

Mason was taken aback:

I could not help testifying my surprise at seeing him paint the carnation of the Goddess of Beauty from that of a little child, which seemed to have been nourished rather with gin than with milk ... but he answered, with his usual *naïveté*, that, 'whatever I might think, the child's flesh assisted him in giving a certain *morbidezza* to his own coloring, which he thought he should hardly arrive at, had he not such an object, when it was extreme (as it certainly was) before his eyes.'[17]

We owe a good deal to Mason's insatiable curiosity about everything that went on at Leicester Fields; he remained interested not only in what he saw on Reynolds's easel but in his never-ending experiments with pigments and varnishes:

I observed at the time, there always stood two large gallipots of color, under water: one of a deeper, one of a lighter tinge, composed of vermilion and white, which

* The prince's former drinking companion did not prosper under the Revolution. He was one of the Convention members who voted for the execution of his cousin the king early in 1793. After the desertion of his son to the Allies later that year, however, he too was arrested and guillotined.

proved to me that he had now laid aside his first favourite lake; and indeed he, about that time, told me he had done so, preferring Chinese vermilion to it; of the durability of which, he however, afterwards doubted, and used in its stead the best he could find of English manufacture.[18]

Venus had a mixed reception when it went on display at Somerset House. Horace Walpole recognized that it was much admired, but thought the idea 'vulgar, and totally devoid of dignity'. The *General Advertiser* assumed the guardianship of public morals: 'It may not be amiss to remind the artist who has so wantonly displayed the bosom of a woman in the great room, that a little more decency would have had a much better effect.'[19]

Reynolds was unconcerned, and by the autumn he was at work on a second version. It did not clutter his studio for long. The Duke of Dorset gave him 400 guineas for it – 'not for himself', Reynolds explained to Rutland, 'but for a French marquis, whose name I have forgot'.[20]

'Sir Joshua's delicious Venus – is gone the way of all flesh – she is sold – and gone to Paris.' Given Dorset's reputation, the sniggering tone adopted by *The World* was perhaps inevitable:

The Duke of Dorset, the buyer – though the *French women*, some time since seem'd to think, it was *not necessary* to encrease the *female* part of his Grace's collection. None of *Sir Joshua's* women ever made themselves *cheap* – though this was such as to be *cheap at any price*. The Duke had her for four hundred – Others he has had, lost him infinitely *more*.*

Peter Pindar was in good form in his *Lyric Odes to the Royal Academicians for MDCCLXXXV*. He took his customary swipe at West, but also ridiculed the king for his continuing patronage of his American favourite and neglect of Reynolds:

> Thank God! that Monarchs cannot taste controul,
> And make each subject's poor submissive soul
> Admire the works that JUDGEMENT oft cries 'fie' on:
> Had things been so, poor REYNOLDS we had seen
> Painting a barber's pole – an ale-house queen,
> The cat and gridiron, or the Old red lion![21]

* 3 February 1787. Early in 1787, the *Morning Herald* reported – wrongly – that the original version of *Venus* had been bought by the King of France. In fact it remained in Reynolds's studio until his death. His will stipulated that a number of his friends should each have a picture. The Earl of Upper Ossory, who had first choice, chose *Venus*.

He also turned a sardonic eye on Reynolds's appointment as the King's Principal Painter:

> I've heard that RAMSAY, when he died,
> Left just nine rooms well stuff'd with Queens and Kings;
> From whence all nations might have been supply'd,
> That long'd for valuable things.
> Viceroys, ambassadors, and plenipo's,
> Bought them to join their raree-shows
> In foreign parts,
> And shew the progress of the British arts.
>
> Whether they purchas'd by the pound or yard,
> I cannot tell, because I have not heard;
> But *this* I know, his shop was like a fair,
> And dealt most largely in this ROYAL WARE.
>
> See what it is to gain a Monarch's smile!
> And hast thou missed it, REYNOLDS, all this while!
> How stupid! pr'ythee, seek the Courtier's School,
> And learn to manufacture oil of fool.[22]

Although more than nine months had passed since he had been sworn in as Principal Painter, Reynolds was still brooding over the discrepancy between his salary of £38 and the princely sum of £48 3s. 4d drawn by His Majesty's Rat Catcher. Towards the end of June, he reminded his patron the Duke of Rutland of the iniquity of this arrangement:

... As there is great difficulty of having the old salary restored as it would open the door to such numerous Sollicitations, I thought there was an opportunity of giving me a very honourable compensation in making me secretary & Register to the Order of the Bath; Upon this ground, by means of Mr Elliot* I asked for it, but it was too late Mr Pitt had already promised it to Mr Lake† a Gentleman who has some office in the Treasury. Since this negociation Mr Lake has been appointed one of the Commissioners of Accounts, a place of a thousand a year for life and is supposed to be incompatible with his holding this place of Secretary &c at the same time, this

* Presumably Reynolds's old friend and patron Edward Eliot, although he had in fact been created Baron Eliot of St Germans the previous year.
† Reynolds's deafness frequently caused him difficulties with the spelling and pronunciation of names. The man he sought to supplant was John Martyn Leake, one of the chief clerks of the Treasury.

latter is only three hundred a year so there can be no doubt if he can hold only one, which he will keep.

I have therefore to entreat Your Grace to procure from Mr Pitt that in case Mr. Lake relinquishes it, I may be the next oars.*

Not content to leave it there, Reynolds ploughed on, suggesting – none too diplomatically in the circumstances – that the prime minister was something of a philistine:

Mr. Pitt I fear has not much attention to the arts. If he had, he would think it reasonable, that a man who has given up so much of his time to the establishment of an Academy, and had attended sixteen years without any emolument whatever and who unluckily when made the Kings Painter was the first person in that place who had their salary reduced to a fourth part, that he should have some compensation. I am confident Your Grace would have seen it in this light had the place been in your Gift, but a thousand apologies are necessary for my presuming to hope for your Graces influence with Mr. Pitt in my behalf.

The duke's solicitations did not succeed. Mr Leake's place was conferred elsewhere. There is, however, a delicious irony here, and Reynolds's indignation was largely misdirected. The reduction in the salary of the King's Painter had its origin in measures first proposed in 1780 by the Whig opposition to Lord North. On the face of it, these were economic reforms aimed at reducing corruption, although they had important constitutional implications. They would have limited the extravagance of court expenditure and swept away many of the lavish pensions and pointless sinecures which had grown up over the years; these were a burden on the taxpayer and an instrument of jobbery and corruption. North cleverly succeeded in stifling the proposals at the time, but they had been reintroduced when the Rockingham Whigs came to power. The king was bitterly hostile, seeing them – quite correctly – as an attempt to whittle away the political power and influence of the court. When they were finally enacted, it was in a much watered-down form; they did none the less mark the establishment of the principle of parliamentary accountability for civil list expenditure. The main architect of these measures? Edmund Burke.

Reynolds was much involved at this time in advising the Duke of Rutland about acquisitions for his collection. One of the most active dealers in paintings and antiquities in Rome was a Scotsman called James Byers. The son of Jacobite parents from Aberdeenshire, he had originally gone to Italy

* An expression used by Thames boatmen.

in the 1750s as a student of painting. Although he seems not to have operated on as grand a scale as Thomas Jenkins, he had undoubted commercial flair. One of his more notable coups was the acquisition of the celebrated Barberini Vase, an outstanding example of ancient Roman glass using the cameo technique, which he sold to Sir William Hamilton. When it next changed hands, in 1783, it became known as the Portland Vase – Hamilton made a handsome profit by selling it to the dowager duchess.*

Byers, whose methods were no more unscrupulous than those of other antiquarians of the day, had recently written to Rutland to say that he was now in a position to buy the Poussin *Sacraments* from the Boccapaduli Palace – he had thoughtfully arranged to substitute copies for the originals so that the papal authorities would not be aware of their loss.[23] The duke consulted Reynolds, and Reynolds was enthusiastic:

In regard to the subject of Mr Beyers Letter I would by all means recommend Your Grace to close with it. Tho two thousand pounds is a great sum, a great object of art is procured by it, perhaps a greater than any we have at present in this nation. Poussin certainly ranks among the first of the first rank of Painters, and to have such a set of Pictures of such an Artist will really & truly enrich the nation. I have not the least scruple about the sending copies for originals, not only from the character of Beyers but if that trick had been intended he would not have mentioned a word about his having copies made. I dont wish to take them out of your Graces hands, but I certainly would be glad to be the purchaser myself. I only mean that I recommend only what I would do myself. I really think they are very cheap.[24]

When he wrote this, Reynolds's mind was very much on buying on his own account. Joseph II's most recent exercise in enlightened absolutism had taken the form of suppressing 738 religious houses in the Austrian Netherlands, ostensibly to fund other areas of Church life. Pope Pius VI had gone to Vienna in the hope of restraining him, but the Emperor, stubborn and opinionated, was not to be moved. The sale of the lands and treasures of these convents and monasteries meant rich pickings for collectors, and Reynolds's acquisitive instincts were roused. When he saw the catalogue of the pictures that were on view in Brussels, it occurred to him that he might also be of service to Rutland, whose pockets were a good deal deeper than his own:

* Hamilton had paid £1,000 for it, and sold it for £1,800. The duchess was the daughter of Edward Harley, Second Earl of Oxford, and had inherited the Harley passion for acquiring works of art and curiosities; she also kept a menagerie of exotic animals.

... Le Comte de Kageneck* informs me The Emperor has selected for himself some
of the principal pictures However there is one Altar Piece which belonged to the
Convent of the Dames Blanches at Louvain which is to be sold. The subject is the
adoration of the Magi, ten feet by seven feet eight Inches, which I take to be about
the size of your Picture of Rubens,† I do not recollect this Picture accurately ... I
have no notes to refer to, they are alas in Your Graces possession, This picture I
suspect is the only one worth purchasing.‡ If your Grace has any such intention, or
will honour me with discretionary orders in regard to other Pictures, I shall leave
order for your Letter to be forwarded to me at Brussels ... The principal object of
my journey is to reexamine and leave a commission for a Picture of Rubens of a
St. Justus a figure with his head in his hands after it had been cut off, as I wish to
have it for the exccellency of its painting, the boldness of the subject will I hope
make it cheap, whether it will be a bargain or not, I am resolved to have it at any
rate ...[25]

Reynolds left London on 20 July and was in Brussels four days later. He
was once again accompanied by Metcalfe. It was a much shorter excursion
than the one they had made together four years previously, although the
notes which Reynolds took show that they made brief stops in Saint-Omer,
Lille and Tournai on the way to Brussels and later managed to fit in short
visits to Mechelen, Ghent and Antwerp. They were back in London by 10
August.

The preview in Brussels – the sale was not due to begin until 3 September
– had been a disappointment. Reporting to Rutland on his return, he
described what he had seen as 'the saddest trash that ever was collected
together'. He had also been shown some of the pictures reserved by the
Emperor; they too were 'not a jota better than the common run of the rest
of the collection'. The journey had been far from fruitless, however, because
he made several purchases from private collections. 'I have bought a very
capital picture of Rubens of Hercules and Omphale,' he told the duke:

I have likewise a holy family, a Silenus and Baccanalians, and two Portraits all by
Rubens, I have a Virgin & infant Christ, and two portraits by Vandyck: and two of
the best Huntings of Wild Beasts by Snyders & De Vos that I ever saw. I begin now
to be impatient for their arrival, which I expect every day.

* The count was the Austrian minister plenipotentiary in London, 1782–6.
† This was *The Crowning of St. Catherine of Siena*, which the duke had acquired at a sale in
Brussels in 1779. It is now in the Toledo Museum of Art, Ohio.
‡ Reynolds's notes reveal, in fact, that he had not thought much of the picture when he had
seen it four years previously. 'A slight performance,' he wrote. 'The Virgin holds the Infant but
aukwardly, appearing to pinch the thigh' (Mount, Harry, 1996, 142).

He was rather pleased with himself. He felt he had brought home from Brussels and Antwerp everything that was worth having. There had, it is true, been a *Rape of the Sabines* by Rubens, but the asking price had been £3,500 – 'excepting this', he announced proudly, 'I have swept the country'.*

Reynolds continued his efforts on behalf of the duke after his return home, but with embarrassingly little success. He had been using an Antwerp painter called de Gree† as an agent, and had assured Rutland that he would be certain to secure the Rubens *Adoration* for 300 guineas and a *Crucifixion* by Van Dyck in which he was interested for 400. When both went for much more, Reynolds was reduced, somewhat unconvincingly, to telling the duke that he was well out of the affair:

I cannot think either the Rubens or Vandyck were worth half the money they sold for. The Vandyck was an immense Picture and very scantily filled, it had more defects than beauties, and as to the Rubens I think Your Graces is worth a hundred of them. They are so large that it would cost near two hundred pounds bringing them to England.[26]

This did not satisfy the duke, who asked Reynolds to get de Gree to pursue the purchasers and establish whether they would be prepared to part with the pictures for a higher sum than they had paid for them. They appear to have returned a dusty answer.

Reynolds also made an unsuccessful attempt to acquire for himself two pictures by Rubens which he had seen in the Capuchin church in Lille on his way to Brussels. He employed the services of a man called Cunningham who was then living there. Reynolds's two surviving letters to him make revealing reading. We see his eagerness to acquire the pictures struggling with his reluctance to pay a penny more than absolutely necessary; the letters are also a reminder that there is no natural affinity between commerce and virtue and that shady practice in the world of picture dealing has a long pedigree. 'I believe what I have offer'd, £300 for the two Pictures, is their full value, they have been much damaged and ill mended,' Reynolds wrote to Cunningham:

As they are at present they appear to be worth little or nothing. I go upon speculation that I can mend them, and restore them to their original beauty, which if I can

* Letter 140. His notes show that apart from the purchases he itemized to the duke, he acquired a further eight pictures. The *Public Advertiser* reported on 15 October that he was said to have spent £2,000, and that seems fairly near the mark.

† Pieter de Gree (1751–89) was a painter of *trompe-l'œil* bas-reliefs. He later settled in Ireland.

accomplish, I shall have got a prize, if they will not clean it will be so much money thrown away.

As in the case of the Poussins in which the Duke of Rutland was interested, there was no question of leaving empty walls behind:

In regard to the copies being made, I will be at that additional expence, I would send over a young Artist who formerly lived with me, for that purpose, and will give him proper directions how to give the copy an old appearance, so that few, even among the Connoiseurs shall distinguish the difference.

If it is represented to the family by whom the Picture was given, that they are allmost destroyed and will soon be totally lost, they may reasonably think that putting copies in their place, is the best means of preserving the remembrance of the gift of their family . . .

Then, in a final effort to clinch matters, Reynolds takes a deep breath and decides to think really big:

. . . I calculate the Copies to cost me about £100. When a man is about an object that will upon the whole cost £400 it is not worth while to bogle at small things, if making the principal of the family a compliment of a present of a Gold watch or any English trinket of the value of about twenty Pounds I should be glad to do it . . .[27]

His offer was not accepted, and Reynolds claimed that on reflection he was relieved. 'The great probability there is that the Pictures are beyond the powers of Art to restore,' he wrote to Cunningham, 'made me repent offering so much as I did in my last letter.'[28]

Boswell was in London for much of 1785, seeing through the press his *Tour to the Hebrides* – 'the first of the maggots', as Burke put it, 'that crept out of the great body of Samuel Johnson'.* Johnson's death had disoriented Boswell quite seriously, and he fell into a dangerous routine in which bouts of drinking alternated with random sexual encounters, mainly with streetwalkers.† Sometimes, indeed, the two coincided – on 13 May, for instance, he had wandered into St Paul's Churchyard, sung some ballads with two prostitutes in red cloaks, had his pocket picked and collapsed in

* Burke was offended by reading that Johnson did not think much of his sense of humour.
† He also had a brief affair with the miniaturist Maria Cosway, the young wife of Richard Cosway, Royal Academician, fop and friend of the Prince of Wales.

the street in a drunken stupor. By the middle of May he had notched up his sixteenth gonorrhoeal infection.

In the intervals of this disorderly round, he saw a good deal of Reynolds, dining at Leicester Fields in the company of Mrs Siddons and spending days at Richmond. He also persuaded Reynolds to join in another of his favourite diversions, and to accompany him to a multiple public hanging, although it appears that no great persuasion was needed; he had spoken about it the previous evening as they sat together over a bottle of port and a bottle of claret at the Club – 'Sir Joshua was drawn to it,' he wrote in his journal, 'and said he'd go.'[29]

They set off to Newgate very early the next morning in Reynolds's coach, and were given seats on the scaffold itself. Part of the attraction was that one of the five men to be hanged was an Irishman called Shaw, who had been a servant of Burke. Reynolds presumably did not know that Boswell, perennially strapped for cash, had arranged to make some money by contributing an account of the execution to the *Public Advertiser*. The piece appeared the following day under the heading 'Execution Intelligence'. Shaw, who was to be hanged for robbery, figured in it like the hero of some romantic drama – 'a tall, handsome fellow, a native of Ireland; his long hair hung flowing down his back, and his manners were much above those of an ordinary servant', Boswell had written:

He never once changed countenance or showed either fear or affectation. One very extraordinary circumstance marked his possessing himself perfectly: while he stood under the fatal tree and the awful moment was approaching, he observed Sir Joshua Reynolds and Mr. Boswell, two friends of his old master, Mr Burke . . . upon which he turned round, and with a steady but modest look made them a graceful bow.

Boswell's purple prose was not allowed to stand alone, however. Someone at the *Advertiser* had decided that it would read better if embellished with a short prefatory note:

While a great concourse of spectators were assembled, the first person who appeared upon the scaffold yesterday was Mr Boswell. *That* was nothing extraordinary, but it was surprising that he was followed by Sir Joshua Reynolds. – 'Evil communications corrupt good manners.' – It is strange how that hard Scot should have prevailed on the amiable painter to attend so shocking a spectacle.

The amiable painter himself – he had seen the Perreau brothers hanged in 1776 – seems not to have found the spectacle in the least shocking. 'I am much obliged to you for carrying me yesterday to see the execution of the

five Malefactors,' says a much-corrected note found among his papers –
clearly the draft of a letter to Boswell. 'It is a vulgar error, the opinion that
it is so terrible a spectacle or that it any way implies a hardness of heart or
cruelty of disposition . . . I consider it is natural to desire to see such sights
and if I may venture to take delight in them in order to stir & interest the
mind . . .'[30]

Reynolds was at work on a portrait of Boswell at this time, something
which the Laird of Auchinleck had prevailed on him to undertake with
characteristic brassiness. Having both dined and supped at Leicester Fields
one day early in June, he had returned to his lodgings and taken up his pen:

My Dear Sir, – The debts which I contracted in my father's lifetime will not be
cleared off by me for some years. I therefore think it unconscientious to indulge
myself in any expensive article of elegant luxury. But in the mean time, you may die
or I may die; and I should regret much that there should not be at Auchinleck my
portrait painted by Sir Joshua Reynolds, with whom I have the felicity of living in
social intimacy.

I have a proposal to make to you. I am for certain to be called to the English bar
by next February. Will you now do my picture, and the price shall be paid out of the
first fees which I receive as a barrister in Westminster Hall. Or if that fund should
fail, it shall be paid at any rate five years hence by myself or my representatives.

If you are pleased to approve of this proposal your signifying your concurrence
underneath upon two duplicates, one of which shall be kept by each of us, will be a
sufficient voucher of the obligation.[31]

Reynolds did signify his concurrence. Boswell had a number of sittings in
the course of the summer, the last of them after breakfasting with Reynolds
on 10 September. Five years later, when he conducted one of his periodic
reviews of his affairs, he showed a debt of £50 still outstanding for the
painting. When the *Life* was published in 1791 – it was dedicated to Reynolds
– the debt was forgiven, and Boswell struck the entry through – 'Sir Joshua
Reynolds handsomely and kindly made me a present of my picture.' A very
fine portrait it is – the frizzed wig, the ski-slope nose and the double chin,
the sitter's skin and linen both a little cleaner than they usually were in life.
It hangs today in the National Portrait Gallery in London.[32]

Reynolds also fulfilled a long-held ambition by painting Lord Mansfield,
the Lord Chief Justice.* Northcote says that during one sitting Reynolds
asked whether he thought he had caught a likeness:

* Mannings, cat. no. 1318, fig. 1456. 'He took a great deal of pains,' Mansfield told Rutland,
'and had been trying for a great many years to get me to sit to him.' The picture has remained
in the Murray family and is now at Scone Palace.

His lordship replied, that it was totally out of his power to judge of its degree of resemblance, as he had not seen his own face in any looking-glass, during the last thirty years of his life; for his servant always dressed him and put on his wig which therefore rendered it quite unnecessary for him to look at himself in a mirror.[33]

It is not certain, however, that the octogenarian Mansfield was as free of vanity as this suggests. The Duke of Rutland, hearing from Mansfield that the portrait was generally thought to be 'finely done', commissioned a copy of it, and early in the New Year Reynolds wrote to tell him he had made a start:

It is thought one of my best portraits, but he should have sat eight or ten years before, his countenance is much changed since he lost his teeth. I have made him exactly what he is now, as if I was upon my oath to give the truth and nothing but the truth. I think it necessary to treat great men with this reverence, tho I really think His Lordship would not have been displeased if this strict adherence to truth had been dispensed with . . .[34]

An entry in Reynolds's ledger for January 1787 records a payment of £100: 'Duke of Rutland, for Lord Mansfield'. The young duke, whose amiability was exceeded only by his extravagance, not only paid up a good deal more promptly than most of his peers were in the habit of doing, but allowed himself to be milked into the bargain. Reynolds charged his patron the same for the copy as his normal full price for an original of the same size.*

* The painting was yet another of those destroyed in the 1816 Belvoir fire.

Shadows Cast Before

Reynolds had also completed in the course of 1785 his last, rather poignant portrait of the ageing Keppel.[1] His old friend, who had retired from public life two years previously, was now in failing health. His doctors advised him not to risk the winter in England. He went to Naples for six months, but the change did little good, and he died the following autumn.

As the circle of the friends of his youth grew smaller, so the years began to leave their mark on Reynolds. Reporting to Rutland on the progress of what work he had in hand early in 1786, he added a qualification – 'if the Reumatism will give me leave, for I am very stiff and aukward at present'.[2]

It also seems certain that without his being aware of it – or perhaps without his wishing to acknowledge it – his sight had begun to deteriorate. (It is not known when Reynolds began to wear glasses. He first painted himself wearing them in 1788.) In an earlier letter to Rutland, he remarked, almost in passing, that he didn't know 'how to account for the Pictures at Antwerp not appearing so striking to me this last journey as they did the first'.[3] This is elaborated in a little-remarked passage in Northcote:

> On viewing the paintings of Rubens a second time, even they appeared much less brilliant than on a former inspection. This circumstance he was at first unable to account for, until he recollected, that when he first saw them he had his note book in his hand, for the purpose of writing down some remarks, which he considered as the reason of their now making a less vivid impression in this respect than they had done before; for by the eye passing immediately from the white paper to the picture, the colours derived uncommon richness and warmth; though for want of this foil they afterwards appeared comparatively cold.[4]

It is an ingenious theory; unhappily it was totally wide of the mark. To a modern ophthalmologist, Reynolds's description of change in his perception of colour would have set alarm bells ringing. Defects in colour vision can result from a variety of causes – inflammation or detachment of the retina, exposure to toxins, disease of the optic nerve. In the light of modern medical

knowledge, the 'circumstance he was at first unable to account for' had an altogether more sinister explanation than Reynolds surmised; his optic nerve was almost certainly already affected by a malignant tumour.

The impression he gave to those around him, as he approached his sixty-third birthday, was that he was at the height of his powers. 'My uncle seems more bewitched than ever with his pallat & pencils,' Mary Palmer wrote to her cousin William in Calcutta:

He is painting from morning to night, & the truth is, that every picture he does seems better than the former. He is now just going to begin a Picture for the Empress of Russia, who has sent to desire he will paint her an Historical one; the subject is left to his own choice, & at present he is undetermined what to chuse.[5]

He owed the commission to his friend Lord Carysfort, now ambassador in Russia, who had noticed that the English School was not well represented in the collection the Empress was assembling.* Hearing that she had asked Carysfort to order a painting from Reynolds, Potemkin requested that he should execute one for him too, the size and subject again to be at the discretion of the artist. At the end of January the *English Chronicle* told its readers that Reynolds had chosen as his subject 'a young Hercules strangling the serpents'. He told Rutland – in the letter in which he complained of rheumatism – that he had found his inspiration in Pindar, 'of which there is a very good translation by Cowley'.

He was hard at work on the picture during the early months of the year. 'His infant Hercules is at present a riot of colour,' the *Morning Herald* reported in April, 'but speaking of it as a sketch it certainly has the marks of genius to recommend it.' Not everyone thought well of his choice of subject. Hannah More told her sister that he had been offered an alternative suggestion:

Mr Walpole suggested to Sir Joshua an idea for a picture which he thought would include something honourable to both nations; the scene Deptford, and the time when the Czar Peter was receiving a ship-carpenter's dress, in exchange for his own, to work in the dock. This would be a great idea, and much more worthy of the pencil of the artist than nonsensical Hercules.†

Nonsensical Hercules it was, however, and the evidence is that it absorbed his attention to the exclusion of much else during the year. He gave it as an

* She had bought paintings by both West and Joseph Wright during the 1770s.
† Roberts, W., ii, letter dated 10 May 1786. Northcote says that before deciding on Hercules, Reynolds considered taking as his subject the visit of Queen Elizabeth to Tilbury at the time of the threatened Spanish invasion (Northcote, ii, 214).

excuse in June for not accepting an invitation from Rutland to visit Ireland,[6] and in July it was offered as the reason for not agreeing to a proposition made to him by Lord Ossory – 'My mind at present is entirely occupied in contriving the composition of the Hercules, otherwise I think I should close with your Lordship's proposal, which I acknowledge is very flattering to me.'[7]

His preoccupation with the commission from the Empress was not allowed to interfere with social pleasures, however. He was at Covent Garden on the famous night in February when Mrs Abington, very much against the advice of her friends, decided to play the part of Scrub, Lady Bountiful's factotum in *The Beaux' Stratagem*. It was said she did it for a bet – it was her benefit night, and she could therefore choose what role she was to appear in. She was roundly abused in the press, and figured in a number of satirical prints. 'Her appearance *en culottes*, so preposterously padded, exceeded nature,' Henry Angelo wrote in his memoirs. 'Her gestures to look comical could not get the least hold of the audience.'[8]

Reynolds was at the theatre again a few weeks later, on this occasion at Drury Lane, to see Mrs Siddons play Portia for the first time, and he also supported Mrs Jordan at her benefit at the end of April. One of his less conventional amusements that spring was a visit to the celebrated Polish dwarf who styled himself Count Boruslawski. Boruslawski – he had no legal right to the title – lived on the proceeds of concerts and gifts. In Vienna Maria Theresa had taken him on her lap and presented him with a ring. In Paris he had met Voltaire, and Bouret, one of the *fermiers-généraux*, had given an entertainment in his honour in which everything was in proportion to the size of the tiny guest. Boruslawski maintained the fiction that he did not exhibit himself for money – people merely slipped his valet a shilling for opening the door.

Nor did *Hercules* prevent Reynolds from submitting a powerful portfolio to that year's exhibition – a fancy picture entitled *A Child with Guardian Angels*, possibly a spin-off from his designs for the *Nativity*, and a dozen portraits, including that of the Duchess of Devonshire and her daughter and a powerful, Rembrandtesque study of the lawyer Joshua Sharpe, legal adviser to the Countess of Orford.* The *Morning Post* was indignant on Reynolds's behalf that his *Portrait of a Young Gentleman* was so disgrace-fully hung: 'Shame on you, ye Jack-ketches appointed for *hanging* the Pictures! for removing this gem of the first water to a height that renders it

* Mannings, cat. no. 1610, fig. 1469. Congratulated by a friend on the 'degree of truth' he had achieved in the Sharpe portrait, Reynolds modestly demurred. 'It was only making an exact copy of the attitude in which the old man sat at the time,' he said, 'and as he remained still and quiet, it became a matter of no more difficulty in the representation than that of copying from a ham or any object of still life' (Northcote, ii, 211).

almost invisible; and placing your own daubings in the most advantageous situations.'*

Horace Walpole thought the exhibition 'much better than the last two years'. Press comment was on the whole less carping than usual, although there was the usual mish-mash of rumour and tittle-tattle. There was a good deal of criticism of Gainsborough and those other artists – Romney, Dance, Wright of Derby – who chose not to exhibit. It was, the *Morning Chronicle* declared, 'a desertion of duty'. Bate, predictably, took a different view:

Much has been said in the public prints in reproof of Mr Gainsborough's continuing to withhold his works from the Academy. We cannot, however, but consider such remarks as unmeaning and impertinent, because those who are too much in the dark to judge of the affront offered to the celebrated artist and the feelings that were thereby excited are ill qualified to decide upon the propriety of his conduct.

The *Morning Herald* also found another stick with which to beat the Academy – and, by implication, its President:

The French, who visit our exhibitions, are shocked at the indelicacy of placing the portraits of notorious prostitutes, triumphing as it were in vice, close to the pictures of women of rank and virtue. In Paris, such portraits would, on no account be admitted; the name of the King is a sufficient check upon them to keep a just decorum in *his* academy; it is no small reflection upon our academicians here to have as little regard for the dignity of their master, as they seemingly have for their own.[9]

Summer came on, and Reynolds waited, a shade anxiously, for news from Rome of the Duke of Rutland's Poussins. 'I have heard nothing of the seven Sacraments,' he wrote to the duke towards the end of June. 'I hope no cross accident had happen'd. I wish they were safe landed.'[10] Then in the middle of July he at last received a bill of lading: 'I sent immediatly to the Custom house to know if the good ship called the Earl of Sandwich was arrived, but it is not.'[11] By the end of August he could report that the pictures had entered the Thames: 'I am expecting them in Leicester fields every hour.'[12] Their arrival threw him into a rare state of excitement: 'I hang over them all day and have examined every Picture with the greatest acuracy,' he told Rutland:

. . . They are in perfect condition, they are just as Poussin left them. I believe they have never been washed or Vanishd since his time. It is very rare to see a Picture of

* We no longer know the identity of the sitter victimized in this way. Ellis Waterhouse speculated he was a Master Elwin, a boy of about twelve who had six sittings with Reynolds in January and March 1786.

Poussins or indeed of any Great Painter that has not been defaced in some part or rather and mended by picture cleaners, and have been reduced by that means to half their value . . .

I think Mr Beyers managed very well to get them out of Rome, which is now much poorer, as England is richer than it was by this acquisition . . .[13]

He also had news for the duke of an acquisition of his own:

I have likewise made a great purchase at Mr Jenkins, a statue of Neptune and a Triton grooped together, which was a fountain in the Villa Negroni (formerly Montalto) it is near eight feet high and reckond Berninis greatest work it will cost me about 700 Guineas before I get possession of it, I buy it upon speculation and hope to be able to sell it for a thousand.

This, it will be remembered, was the statue Reynolds had referred to in his tenth Discourse in 1780, when he had spoken scathingly of 'the ineffectual attempts which the modern Sculptors have made by way of improvement':

The folly of attempting to make stone sport and flutter in the air, is so apparent, that it carries with it its own reprehension; and yet to accomplish this, seemed to be the great ambition of many modern sculptors, particularly Bernini . . .[14]

There was a cast of the head of the Neptune at the Academy – 'this will be sufficient to serve us for an example of the mischief produced by this attempt of representing the effects of the wind', Reynolds had told his hearers. Now, that 'entangled confusion' seemed less important. Where the eye of Reynolds the critic had discerned folly and mischief, the eye of Reynolds the speculative dealer saw only a profit of 300 guineas.* It was clearly not only his perception of colour that was becoming defective.

Rutland was by no means alone among Reynolds's aristocratic friends and patrons in seeking his advice and help. The Earl of Ossory consulted him that summer about a *Venus and Adonis* which he believed to be by Titian but which had been badly damaged and painted over. 'I am at a loss what to advise,' Reynolds told him:

The Picture cleaners will only make it ten times worse. The best advice I can give is that we make an exchange, by which each of us may have a bargain . . . I am confident

* A profit which he never realized. The sculpture was sold after his death to Charles Pelham, later the first Lord Yarborough, for £500. It is now in the Victoria and Albert Museum.

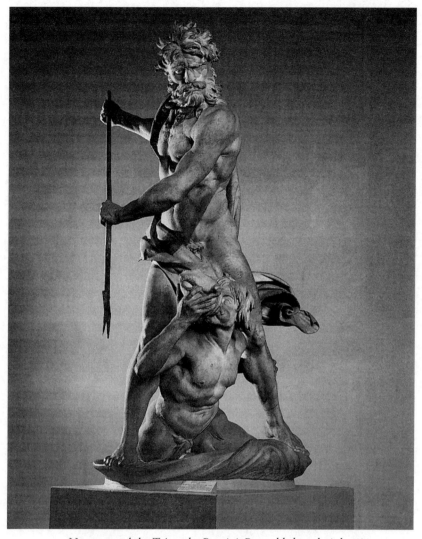

10. Neptune and the Triton *by Bernini. Reynolds bought it late in life. 'It will cost me about 700 Guineas before I get possession of it,' he told the Duke of Rutland. 'I buy it upon speculation and hope to be able to sell it for a thousand.' A hope that was unrealized. It was sold after his death for £500.*

I see the true *Titian tint* through the yellow dirty Paint and varnish with which the picture is covered.

If it was mine I should try to get this off, or ruin the picture in the attempt. It is the colour alone that can make it valuable. The Venus is not handsome and the Adonis is wretchedly disproportioned with an immense long body & short legs . . .

He added a postscript: 'I am thinking what picture to offer in Exchange – what if I give Gainsboroughs Pigs for it . . .'[15]

Reynolds's advice was also sought by his friend William Bentinck, the Third Duke of Portland. Portland had presided briefly over the Fox–North coalition as First Lord of the Treasury in 1783, and was still nominally head of the Rockingham Whigs, though he left party tactics largely to Fox and Burke, sensibly preferring to spend as much time as he could at Bulstrode Park, his seat in Buckinghamshire. He had turned to Reynolds for guidance that spring when his mother's estate came up for sale; he was determined in particular that the Portland Vase should stay in the family, and he acquired it for 900 guineas. His other purchases included a cameo head of Caesar; this was an item in which Rutland had expressed an interest, and Reynolds had to send him an apologetic note:

In regard to the Augustus I fear it is irretriveably gone. It was bought by the Duke of Portland for £125. The Duke of Marlborough told me he bid as far as – 120 – but the Duke of Portland was resolved to have it at any price.*

Reynolds's letters to Rutland that summer contain several references to his nephew Joseph Palmer, of whose talents as a dramatist he had tried to persuade Garrick a dozen years earlier. He had been given an Irish living by Lord Townshend in 1779 but remained eager for advancement; Rutland's position as Lord-Lieutenant placed in his hands a good deal of Church patronage, and this was not an opportunity to be neglected. 'I beg Your Graces pardon for returning to the subject of my Nephew,' Reynolds wrote in August:

If I can do nothing for him during Your Graces Administration I must give up all thought or rather he must give up all expectations from any advantage he is to receive from my interest with the Great. We are not so ambitious as to think of Bishopricks, but if Dean Marly succeeds to the next Bishoprick which according to report, is probable, if Your Grace would give to Mr Palmer his leavings either his deanery or the living of Loughilly, Your Grace would make him at once what you

* Letter 152. The sale began on 24 April and lasted until 8 June. The cameo head and the Portland Vase are both now in the British Museum.

was so good as to say you would do one time or another, an *independent Gentleman* and I shall never pretend to have any further demands on Your Grace on his account.[16]

Dogged does it. His nephew received the Dean's 'leavings' the following June, an appointment which, together with his living at Ferns, brought him £1,000 a year. But although Reynolds had renounced any further claim on Rutland's patronage, he saw no reason not to try his luck with his successor. The Marquess of Buckingham returned to Dublin for a second stint as Lord-Lieutenant in November 1787, a mere four months after Palmer had entered into his new life as an 'independent Gentleman'. Reynolds wrote to him immediately, with a reminder that he had recommended his nephew to his protection during his earlier term of office:

. . . he has since been promoted to the Deanery of Cashel, which is but of small value.

If your Lordship, when an opportunity offers, will give him a remove that his income may be a little encreased, it will be acknowledged with the greatest gratitude . . .[17]

This appeal fell on stonier ground. Palmer would remain at Cashel until his return to England during the Irish troubles in the late 1790s.

'Mercy on us!' Horace Walpole wrote to Lady Ossory towards the end of 1786:

Our painters to design for *Shakespeare*! His *commentators* have not been more inadequate. Pray who is to give an idea of Falstaff, now Quin is dead? And then Bartolozzi, who is only fit to engrave for the *Pastor-Fido*, will be to give a pretty enamelled fan-mount of a Macbeth! Salvator Rosa might; and Piranesi might dash out Duncan's castle – but Lord help Alderman Boydell and the Royal Academy!

The project exciting Walpole's ironic derision was John Boydell's Shakespeare Gallery, an ambitious scheme aimed at creating patronage for history painting in England – and, naturally, at securing an appropriate reward for his own entrepreneurial acumen. The son of a Shropshire land surveyor, Boydell had trained as an engraver, but had early seen the possibilities of the growing print market, not only in England but also on the continent. Now in his mid-sixties, he was immensely prosperous, had served as alderman for Cheapside, and in 1785 had been appointed Sheriff of London. Shrewdly banking on the popularity of Shakespeare and the stability of the European market, Boydell hoped to commission the leading artists of the

day to paint scenes from the plays, which would be exhibited in a gallery built for that purpose. He also planned a folio collection of engravings after the paintings and a new edition of Shakespeare which the engravings would serve to illustrate.

He had approached Reynolds during the summer – the two men had known each other for more than thirty years, although they had never been close. A June entry in the ledger reads 'Mr Alderman Boydell, for a picture of a Scene in Macbeth, not yet begun'. Reynolds described the scheme to Rutland with every appearance of enthusiasm:

... the greatest news relating to Virtù is Alderman Boydels scheme of having Pictures and Prints taken from those Pictures of the most interesting scenes of Shakespear by which all the Painters and Engravers find engagements for eight or ten years; He wishes me to do eight Pictures but I have engaged only for one he has insisted on my taking Earnest mony, and to my great surprise left upon my table five hundred pounds, – to have as much more as I shall demand . . .[18]

Reynolds's attitude to the project was always to be ambivalent, however. Boydell incurred his displeasure at an early stage when he published his advertisement for the gallery in the press:

Sir Joshua Reynolds presents his Compts to Mr Alderman Boydell He finds in his Advertisement that he is styled Portrait Painter to his Majesty, it is a matter of no great consequence, but he does not know why his title is changed, he is styled in his Patent Principal Painter to His Majesty.

Of no great consequence to the world at large, certainly, but of considerable consequence to Reynolds – Boydell had touched on a sore point. A month later a notice in the *Morning Herald* offered clear evidence that Reynolds was inclined to distance himself from the scheme:

Sir Joshua, we are assured, has made no formal promise of his aid to any of the works now carrying on by subscription. His name is inserted in the list of artists, merely on the score of some scenes from Shakespeare, which he has sketched at the desire of a nobleman a few years since.[19]

Some years later, not long before Reynolds died, he sent a letter to Boydell rehearsing at length his version of their original dealings:

This picture was undertaken in consequence of the most earnest sollicitations on Mr Boydell's part, since after Sir Joshua had twice refused to engage in the business, on

the third application Mr. Boydell told him that the success of the whole scheme depended on his name being seen amongst the list of the Artists. Thus flattered Sir Joshua said he would give him leave to insert his name, as one who had agreed to paint for him and that he would do it if he could, at the same time told him in confidence that his Engagements in Portraits was such as to make it very doubtful.

Boydell's advertisement had listed those artists who were 'decisively agreed' to take part in his scheme – West, Barry, Angelica Kauffmann, Joseph Wright, Fuseli, Opie and Northcote were all on board. It did not escape Northcote that Reynolds appeared, as he put it, 'to be rather shy in the business – as if he thought it degrading to himself to paint for a print seller'.[20] The reasons for Reynolds's reluctance were more complex than that, however. The world in which he felt comfortable was one that was still essentially ordered by the patronage of the great. He was not unhappy to live as a client of the aristocracy. Boydell represented an emerging economic order that was very different. The view he took of patronage was commercial; a later age would have called him a middleman. The creation of an English School of painting figured in the ambitions of both men, but their view of the role they saw for themselves in that process was poles apart. It is not altogether surprising that *Macbeth and the Witches* was still in Reynolds's studio, unfinished, at the time of his death.

Progress on *The Infant Hercules* was slow. Malone, in a letter to Bishop Percy at the end of September, wrote that the painting was 'yet but sketched out, but it promises great things'.[21] Home on a visit from St Petersburg, Carysfort had called on Reynolds four days earlier, eager no doubt to be able to report on progress to the Empress on his return to the Russian court. Reynolds adroitly stimulated interest in the work by the judicious admission of journalists to his painting room. '*Hercules* comes forward enriched,' *The Times* informed its readers on 21 October, 'and indeed loaded with all the treasures of the pallet – the graces of Nature are united with classical knowledge and allegorical taste!' Not everyone was allowed a view of the work in progress however, as Horace Walpole discovered when he called at Leicester Fields in November to examine the Rutland Poussins. 'He would not show me his Russian Hercules,' he wrote to Lady Ossory – 'I fancy he has discovered that he was too sanguine about the commission, as you say.'*

* Walpole, 1937–83, xxxiii, 538, letter dated 1 December 1786. Walpole liked the Poussins a little better than when he had seen them in Rome on the Grand Tour more than forty years previously – 'but they are really only coloured bas-reliefs', he told the countess, 'and old Romans don't make good Christians'.

The Poussins had continued to occupy a good deal of Reynolds's time and attention. By early October the process of relining and cleaning them was complete – 'performed in my own house under my own eye', as he was able to tell the duke:

I was strongly recommended to a Neopolitan as having an extraordinary secret for cleaning Pictures, which tho I declined listening to at first I was at length persuaded to send for the man, and tryed him by putting in his hands a couple of what I thought the most difficult Pictures to clean of any in my house, the success was so complete that I thought I might securely trust him with the Sacriments, taking care to be allways present when he was at work.

The restorer in question was a man called Biondi, whose workshop was in what is now Oxford Street. Reynolds, who later recommended him to the Earl of Hardwicke,[22] was intrigued by the apparent simplicity of his technique:

He possesses a liquid which he applied with a soft sponge only, and without any violence of friction takes off all the dirt & varnish without touching or in the least affecting the Colours; with all my experience in Picture cleaning he really amazed me. The Pictures are now just as they came from the Easel. I may now safely congratulate Your Grace on being relieved from all anxiety, we are safely landed all danger is over.[23]

The danger had been not inconsiderable. Later in the year Reynolds encountered the Italian man of letters Carlo Gastone Della Torre Di Rezzonico, who was then visiting London. Rezzonico, he told Rutland, had been 'much mortified' to see the *Sacraments* in London: 'I must write to my Brother, says he, who is Secretary of State, that he should reprimand the Inspectors for suffering those Pictures to come out of Rome.' Rezzonico was extremely well connected; a nephew of Clement XIII, he had both an older and a younger brother who were cardinals. Reynolds had also discussed the transaction with Countess Spencer, who had been in Italy with her husband the previous winter: 'Lady Spencer told me that in consequence of this smugling it is now Death to attempt sending Pictures out of Rome with out being first examined.'[24]

The *Sacraments* were obviously still very much in his mind as he was ordering his thoughts for that year's Discourse, and served to illustrate a sequence where he argues that in poetry and drama, as well as in painting, a higher and a lower style are to be distinguished:

The Theatre, which is said *to hold the mirror up to nature*, comprehends both these ideas. The lower kind of Comedy, or Farce, like the inferior style of Painting, the more naturally it is represented, the better; but the higher appears to me to aim no more at imitation . . . than Raffaelle in his Cartoons, or Poussin in his Sacraments, expected it to be believed, even for a moment, that what they exhibited were real figures.

This Discourse – it was the thirteenth – is by general consent the most lucid and powerfully reasoned of all. 'For this Discourse alone,' wrote Roger Fry, 'Reynolds deserves to be held in reverence by all those who think that art is more than a relaxation from the serious cares of the money market.'[25] He was concerned to set painting in the broader context of the arts generally:

To enlarge the boundaries of the Art of Painting, as well as to fix its principles, it will be necessary, that, *that* art, and *those* principles, should be considered in their correspondence with the principles of the other arts, which like this, address themselves primarily and principally to the imagination . . .

When this comparison of art with art, and of all arts with the nature of man, is once made with success, our guiding lines are as well ascertained and established, as they can be in matters of this description.[26]

The Discourse is notable for the emphasis placed on the importance of feeling, intuition and the imagination:

There is in the commerce of life, as in Art, a sagacity which is far from being contradictory to right reason, and is superior to any occasional exercise of that faculty, which supersedes it; and does not wait for the slow progress of deduction, but goes at once, by what appears a kind of intuition, to the conclusion. A man endowed with this faculty, feels and acknowledges the truth, though it is not always in his power, perhaps, to give a reason for it . . .

This is something the effect of which I mean to caution you against; that is to say, an unfounded distrust of the imagination and feeling, in favour of narrow, partial, confined, argumentative theories . . .

REASON, without doubt, must ultimately determine every thing; at this minute it is required to inform us when that very reason is to give way to feeling.[27]

His assault on the idea that painting is no more than an imitation of external nature is sustained over several pages. The word would not enter the language for many years, but the argument directed against those 'who have not cultivated their imaginations' is unashamedly élitist:

Such men will always prefer imitation to that excellence which is addressed to another faculty that they do not possess; but these are not the persons to whom a Painter is to look, any more than a judge of morals and manners ought to refer controverted points upon those subjects to the opinions of people taken from the banks of the Ohio, or from New Holland.[28]

Noble savages need not apply. There is an echo here of the mauling Boswell received over dinner at the Mitre one day when he was foolish enough to argue for the superior happiness of the savage life. 'The savages have no bodily advantages beyond those of civilised men,' Johnson told him. 'They have no better health; and as to care or mental uneasiness, they are not above it, but below it, like bears.'[29]

Reynolds's old friend was no longer there, either to brush his mind free of rubbish or to spruce up his text for the press. Diffidently, just as he had done immediately after Johnson's death two years previously, he turned once more to Malone: 'I wish you would just run your eye over my Discourse, if you are not too much busied in what you have made your own employment' (he knew how much time Malone was spending as a sort of literary midwife to Boswell – the *magnum opus* was proving difficult of delivery):

I wish that you would do more than merely look at it, – that you would examine it with a *critical eye*, in regard to *grammatical correctness*, the propriety of expression, and the truth of the observations.[30]

Malone, courteous and self-effacing, was only too happy to oblige. When his edition of Reynolds's works was published in 1797, he was precise about the nature and extent of his help:

Four of the latter Discourses, in his own handwriting, and warm from the brain, the author did me the honour to submit to my perusal; and with great freedom I suggested to him some verbal alterations, and some new arrangements, in each of them, which he very readily adopted.

Johnson's death had triggered a good deal of idle speculation about how much help Reynolds had had with the Discourses. 'We shall know now,' Bennet Langton had remarked to Sir John Hawkins, 'whether he has or has not assisted Sir Joshua in his Discourses.' Early in 1785, after reading the printed version of the twelfth Discourse, Horace Walpole had committed his thoughts on the matter to his unpublished 'Book of Materials':

Sr Joshua Reynolds's Last Discourse to the Royal Academy was observed to be much more incorrect in the style than any of his former & was therefore supposed to have wanted the assistance of his friend Dr Johnson, who was dying when it was composed.

Then, a characteristically feline thrust:

If Dr Johnson aided Sr Joshua in his Discourses, he was kinder to them than to his own compositions, for they are elegant, & have none of Johnson's awkward pedantic verbosity & want of grace. I have rather thought that Mr Burke, a far more polished Writer than Johnson assisted Sr Joshua – if he was assisted.

Walpole clearly did not believe he had been, but others did, or affected to do so – indeed an obscure memoir of Burke that appeared in 1797 asserted that 'Sir Joshua's literary fame owed not only its support but its very existence to Mr Burke,' and went on to suggest a connection between this and Reynolds's generosity to Burke in his will.

Malone, in the second edition of Reynolds's works, felt it his duty 'to refute this injurious calumny, lest posterity should be deceived and misled by the minuteness of uncontradicted misrepresentation'. Posterity has not been deceived. The Discourses are as manifestly the unaided work of Reynolds's hand and brain as the stiff portraits he produced as a young man at Plymouth Dock or the lively caricatures he painted in Rome.

The Death of Gainsborough

A whole length portrait of *Colonel Morgan* has been the work which has lately occupied *Sir Joshua*, and a little checked his progress with the *Prince of Wales*, and *Mrs Fitzherbert*. The great work for the *Empress of Russia* goes on, though but slowly.

This piece of intelligence appeared in *The World* on 3 February 1787; Reynolds was still keeping the press well supplied with such titbits. There was further news about 'the great work' in the *Morning Herald* on 11 April. By then it was reported to be 'an extensive work consisting of thirteen figures' although still far from completion – 'we doubt whether it will adorn the Academy in the ensuing Exhibition'. Reynolds told the poet Crabbe that there were four different versions of the painting on the same canvas; Northcote says that by the time it was ready to be packed off to Russia, Reynolds told a friend that 'there were ten pictures under it, some better, some worse'.[1]

If he was unable to let the king see *The Infant Hercules* when he attended him to Somerset House for the customary royal preview in April, the thirteen canvases which he did display once again dominated the exhibition. George III liked to show off his memory for faces by identifying the portraits of those of his subjects who were known to him – if he sometimes got one wrong, the fault naturally became that of the royal connoisseur's entourage. On this occasion, however, he passed by the largest and most prominently displayed of the President's canvases without remark, although the features of the subject were all too familiar to him.

Relations with his eldest son were particularly strained. The previous summer the disastrous state of the Prince of Wales's finances had obliged him to shut up Carlton House and decamp to Brighton; for his occasional visits to London, he was reduced to using the common post-chaise. A week before the opening of the exhibition, Alderman Nathaniel Newnham, an Independent MP who sat for the City of London, had been prevailed

upon to ask 'whether it was the design of Ministers to bring forward any proposition to rescue the Prince of Wales from his present very embarrassed situation'. This was a gift to the Tory squires. The prince's debts were a matter of indifference to them, but they now saw an opportunity to bring out into the open a matter which was not merely embarrassing but positively explosive: the heir to the throne's clandestine marriage two years earlier to Maria Fitzherbert, a woman six years his senior, twice widowed – and a Roman Catholic.

Reynolds had painted the prince in full Garter rig, but he is not the only figure occupying the large canvas (it measures 239 × 148 cm). He is attended by a black servant, who, for no apparent reason, is fiddling with his robes – his introduction into the composition is said to have been suggested by the duc d'Orléans. The newspapers had a field day with this rather odd image of the prince. One wag supposed 'that from his humbled state he has no white servant left. His Highness seems to take it very patiently and the Black is pushing him about as he chooses.' Bate's vehicle, the *Morning Herald*, got a good deal closer to the bone:

The Prince of Wales's portrait conveys an allegorical satire on those with whom his Highness has to contend. The Prince is in his robes of State, and a Black appears to be in the act of stripping them off. Some say the Black above mentioned is the prototype of Mr Rolle, and others apply it to a person of still higher consequence in the State.

John Rolle was the Member for Devonshire – colonel of the South Devon Militia, active magistrate, liberal benefactor to the Church, staunch supporter of William Pitt. It was he, when Alderman Newnham had asked his planted question, who had risen to warn the Whig opposition that an inquiry into the affairs of the prince might involve matters by which 'the constitution both in Church and State might be essentially affected'. No elaboration was required.

By the Marriage Act of 1772 a marriage contracted by a member of the royal family under twenty-five years of age without the king's consent was invalid; and by the Act of Settlement if the heir-apparent married a Roman Catholic he forfeited his right to the crown.

A matter of days after the king's visit to Somerset House, the debate on the prince's debts resumed. Fox, deceived by the prince, described Rolle's insinuation as 'a low malicious falsehood'. Challenged to say whether he spoke 'from direct authority', he declared that he did. Only later, at Brooks's, was he confronted with the enormity of his situation. He was approached

by Henry Errington, a member of an old Northumberland Catholic family – and Mrs Fitzherbert's uncle. 'Mr Fox,' he said, 'I hear that you have denied in the House the Prince's marriage to Mrs Fitzherbert. You have been misinformed. I was present at the marriage.'[2]

Did Reynolds tactfully allow his work on *The Infant Hercules* to prevent the completion of his portrait of Mrs Fitzherbert in time for the exhibition? In the event the picture remained unfinished, although a note in the pocket-book the following December indicates that Reynolds called on Mrs Fitzherbert at Nerot's Hotel in King Street, and there were two further appointments the following year, one of which may have been a sitting. An account which Reynolds submitted to the prince's sub-treasurer in April 1788 mentions a price of 200 guineas. The picture remained in store for many years at Carlton House; the face appears at some stage to have been completed by another hand. In 1830, seven years before her death, Mrs Fitzherbert received the portrait as a gift from William IV, the prince's brother.[3]

The canvas of Reynolds which attracted most attention was *A Child's Portrait in Different Views: a Study*. This was the picture now known as *Heads of Angels* which hangs in the Tate.[4] At first glance, the painting could be a preparatory sketch. The child's hair is a delicate copper colour, and the cluster of five heads merges into a background of swirling cloud – once again it is the palette of Rubens that comes to mind. By the addition of wings to the neck, a pretty, open-faced little girl with red hair becomes an angel from the Italian baroque. The subject's family background, as it happens, was far from angelic – it is entirely possibly that Reynolds's sardonic sense of humour was at play here. His sitter was Frances, the five-year-old niece of the notorious Lord George Gordon; her father, Lord William, was the MP for Inverness-shire and enjoyed the unexacting sinecure of Deputy Ranger of St James's and Green Parks.* There was also much praise for the President's colourful and lively portrait of Lady Smith and her three children.[5] The older daughter, with black hair and dark, laughing eyes, supports her fair-haired brother on her shoulder and clasps him under one knee; the younger girl gazes up at the boy, her back almost completely turned on the viewer and her face scarcely visible.

A bright new talent had appeared that year. Thomas Lawrence, barely

* Lord William was a more conventional figure than his younger brother, although he had blotted his copybook eighteen years previously, at the age of twenty-five, by eloping with Lady Sarah Bunbury, the sister of the Duke of Richmond. He visited Lord George in the Tower. Horace Walpole wrote in his journal that he 'seemed by his harassed and dishevelled appearance more of a gallowsbird than his brother'.

eighteen, had recently arrived in London from Bath. The portrait heads in oil and pastel which he exhibited attracted no great attention, but he did not lack confidence. 'Excepting Sir Joshua,' he wrote to his mother, 'for the painting of a head I would risk my reputation with any painter in London.' He wrote an account of what he saw at Somerset House to a friend in Bath:

The exhibition, I have heard from several whose judgment I can trust, has failed much this year. Sir Joshua certainly maintained his superiority above the rest. His portrait of Sir H. Inglefield was a specimen of the art that in my opinion could not be excelled.*

Although subject pictures and his occasional forays into history painting now occupied more and more of his time, Reynolds's pre-eminence in portraiture remained virtually unassailable – this was the year in which Lavinia, Countess Spencer, told her husband that 'a daub by Gainsborough' was quite good enough for her husband's old college.†

Earlier in the year Reynolds had proposed to the Duke of Rutland that before the Poussins were dispatched to Belvoir, they should be displayed at the Academy during the exhibition – 'to give an opportunity of their being seen by the Students as well as the Connoiseurs before they finally leave London'.[6] The duke gave his consent; there is no mention of the proposal in the minutes of the Academy, but a number of items that appeared in the press at the time suggest that the idea was not welcomed by some of Reynolds's fellow Academicians. 'The Council objected,' reported the *St James's Chronicle*:

The President, who is lately become a courtier, said they must be put up because the King wanted to see them. The Gentlemen acquiesced, provided they were taken down before the room was open to the public. He insisted they should be exhibited in defiance of the purpose of the Institution – the Encouragement of Living Artists. Proceedings were so high as to endanger the office of the President – the Council prevailed and the pictures were sent to the room below.[7]

* Whitley, 1928, ii, 331. Sir Harry Englefield, then in his mid-thirties, was well known as an antiquary and a writer on science and was a fellow member, with Reynolds, of the Society of Dilettanti. The present whereabouts of the portrait (Mannings, cat. no. 582, fig. 1509) are unknown.

† Reynolds's portrait of him as a young man of seventeen, very much in the style of Van Dyck (Mannings, cat. no. 1675, pl. 76, fig. 1128), had been exhibited at the Academy in 1776. It remains in the collection of the present Earl Spencer.

This sounds like a piece of mischief-making by someone ill-disposed to Reynolds – in his letter proposing the idea to the duke he had suggested specifically that the pictures should stand in a room by themselves. He was able at all events to report to Rutland that his royal patron had shown a gratifying interest in them:

The King when I accompanied him at the Exhibition took much notice of the Poussins, more than I expected, as they are of a different [kind?] from what he generally likes. He asked many questions where they came from? out of what palace? what they cost? and whether there was any suspicion of their being Copies to all which questions I answer'd to the best of my knowledge.[8]

It was the last letter Reynolds wrote to his young patron. Rutland was renowned for the magnificence with which he entertained at the vice-regal court in Dublin.* During that summer he set out on a tour of Ireland, and the noblemen at whose seats he stayed vied to return that hospitality. Wraxall has an account of the tour in his memoirs:

He invariably began the day by eating at breakfast six or seven turkey's eggs as an accompaniment to tea and coffee. He then rode forty and sometimes fifty miles, dined at six or seven o'clock, after which he drank very freely, and concluded by sitting up to a late hour, always supping before he retired to rest.[9]

On his return to Dublin he was seized with a violent fever; he died at Phoenix Lodge at the end of October at the age of thirty-three. 'I really condole with you on the loss of your patron the Duke of Rutland,' Reynolds wrote to his parson nephew, 'you are not likely to find another with whom I have equal interest. I had even a demand upon him having made him a considerable present of a Picture, indeed two Pictures, but so near his death that I never receiv'd his thanks for them.'†

At the end of August Reynolds spent a few days at Ampthill, the Bedford-shire seat of Lord Ossory. Horace Walpole took advantage of his absence from town to call at Leicester Fields, and sent his impressions of the *Hercules* to Lady Ossory:

* The *Dictionary of National Biography* describes him, somewhat unkindly, as 'an amiable and extravagant peer, without any particular talent, except for conviviality'.

† Letter 179. In his last letter to the duke Reynolds had announced his intention of sending with the Poussins a picture from his own collection: 'I have been often angry with myself for having declined parting with the portrait of Albert Durer as your Grace wished to have it in your collection.' It seems likely that this is the portrait, still at Belvoir, of Edzard I, Count of East Friesland. It is now attributed to Jacob Cornelisz van Oostsanen.

I did not at all admire it: the principal babe puts me in mind of what I read so often, but have not seen, *the monstrous craws*; Master Hercules knees are as large as, I presume, the late lady Guildford's. *Blind* Tiresias is *staring* with horror at the terrible spectacle. If Sir Joshua is satisfied with his own departed pictures, it is more than the possessors or posterity will be. I think he ought to be paid in annuities only for so long as his pictures last. One should not grudge him the first fruits.[10]

This is Walpole at his malicious best. He is referring to a raree-show that was currently drawing the crowds at the premises of a Mr Becket, trunkmaker, in the Haymarket:

. . . three wild human beings; each with a Monstrous Craw, being two females and a male, of a very small stature, and odd form, with natural large craws [i.e. goitres] under their throat, full of big moving glands, which astonishingly play all ways within their craws, according as stimulated by either their eating, speaking, or laughing. They have been admired by all Princes, celebrated anatomists, etc., to whom they have been shown since, saved from a wrecked ship near Trieste . . .[11]

An attraction of a rather different sort was a court case in which it was rumoured that Reynolds and Gainsborough would give evidence on opposite sides. The plaintiff was the French dealer and collector Noel Desenfans, who had been established in London since the late 1760s. The defendant was Benjamin Vandergucht, who had recently given up painting and turned instead to dealing and picture cleaning. He had sold Desenfans a large work called *La Vierge aux Enfants*, with a warranty that it was by Poussin. Desenfans was now persuaded that it was not, and was suing Vandergucht for the £700 he had paid for it.

The proceedings added considerably to the summer gaiety of the capital. Benjamin West was called and temporized outrageously – it was, he said, a maxim with him never to condemn what he could not applaud. Bate's *Morning Herald* described his conduct in the box as that of an American Loyalist, ready to join in turn the standard either of King or Congress:

Never yet was anything half so sceptical. 'Turn it,' says Mr West to the man who had the picture in court, 'a little towards me. And now from me. 'Tis very like Poussin – 'Tis very unlike Poussin' – and thus was an alternate preponderation in favour of and against the picture kept up to the embarrassment of all who had ears to hear the witness and eyes to see the picture. Mr. West understands this sort of light and shade as well as anybody, and like Polonius, can convert 'a whale to a camel, and a camel to an ouzel – yea, a black ouzel.'

Dr John Hinchcliffe, Bishop of Peterborough and Master of Trinity College, Cambridge, was next in the box. He *thought* it was a Poussin, although not the best he had seen; modestly, and no doubt to the chagrin of counsel, he desired that no reliance be placed on his judgement, as he had frequently found himself deceived in judging the works of the different masters.

Reynolds had been subpoenaed to appear and was to have taken the stand after the bishop, but when his name was called there was no reply. The court was treated instead to the views of Gainsborough, delivered with characteristic panache. He said that he had seen and studied most of the celebrated works of Poussin, and had always been charmed with the sweet simplicity of the effect and the elegance of the drawing, but that when he saw the present picture it produced no emotion:

On a closer inspection, if he had seen it in a broker's shop and could have bought it for five shillings he should not have done so. On being questioned whether something more than bare inspection by the eye was necessary for a judge of pictures, Mr. Gainsborough said he conceived the eye of a painter to be equal to the tongue of a lawyer.

Vandergucht's counsel did his best, but after a performance like that and further damning opinions from Richard Cosway and John Singleton Copley, his own witnesses, who were by no means nonentities,* could make little impression, and it did not take the jury long to decide in favour of Desenfans. Why Reynolds failed to appear is unknown. There had never, in any case, been any prospect of counsel pitting his expertise against Gainsborough's – the court record shows clearly that both men had been called to give evidence on the same side.

Reynolds continued to see a good deal of Boswell during his leisure hours in the course of 1787 – entertaining him to dinner with Warren Hastings and his wife in March,† accompanying him to the first night of Jephson's tragedy *Julia* at Drury Lane in April, dining together at the Club in June. Although the company included Malone and Adam Smith, it seemed to Boswell that things were no longer as they used to be:

* They included two picture dealers from Paris, one of them the husband of the painter Madame Vigée-Lebrun, and the landscape painter William Hodges, a pupil of Wilson, who had been the draughtsman on Cook's second expedition in the 1770s.

† Two weeks later the Commons would vote for Hastings's impeachment. 'Found him a sensible, reserved man,' noted Boswell, who had sat beside him. 'Felt how everything human tends to diminution. Here was a man who had been an oriental emperor' (Boswell, 1986, 122).

There was no force, no brilliancy; nothing as when Johnson, Goldsmith, or Garrick were with us . . . I took care not to introduce Johnson. But Sir Joshua did, and I observed that a great part of our conversation was about him.[12]

After dining at Leicester Fields in August, there was something different to complain about: 'Awaked *somewhat* dreary for the first time (I think) for several months, owing, I imagined, to my having drunk *too little* at Sir Joshua's. Sad slavery, if it was so!'[13] Boswell clearly found comfort in Reynolds's company; as he rode the big dipper of his own swings of mood, the steadiness of the older man was a source of reassurance to him. 'Rose restless,' says a diary entry in October. 'Breakfasted with Sir Joshua. Envied his activity and placid disposition.'[14]

Sir John Hawkins had beaten Boswell to it in the Johnson stakes. The first volume of his *Life and Works* appeared towards the end of 1787 (there would be ten more over the next two years), and when the Club assembled at the end of November, Boswell, who was comically jealous of his rival, would have us believe that there was talk of little else:

Windham was indignant against Sir John Hawkins, and expressed a strong desire to attack him. Malone suggested an admirable thought, which was to have a solemn protest drawn up and signed by Dr. Johnson's friends, to go down to posterity, declaring that Hawkins's was a false and injurious account. Sir Joshua alone hesitated. But it was generally approved. I resolved it should not sleep. Sir Joshua, Windham, Malone, and I sat a long while after the rest and drank tea, and then adjourned to Sir Joshua's and eat oysters and drank some punch very pleasantly.[15]

A Siddons first night at Drury Lane – a public execution – a fireworks display for the birthday of the Prince of Wales; theatre or spectacle of any description would excite Reynolds's interest to the last. On 13 February 1788 London witnessed a blaze of pageantry unequalled since the coronation. The occasion was the opening of the trial of Warren Hastings for his alleged misdeeds in India. Reynolds was eager to be present, but this necessitated a letter to the Earl of Salisbury in his capacity as Lord Chamberlain:

The liberty I take in requesting a favour from a person to who I have scarce the honour of being known, requires some apology – I wish very much to hear Mr. Burk open the business of the tryal, which he thinks will be probably on the first day, as my deafness debarred me from entertaining any hope of that kind, it prevented me from solliciting my friends for a ticket.

I have been this minute offer'd a place in the Managers Box, provided I can procure

to the person who thus accommodates me, a place in the Lord High Chamberlains Box.

I am conscious I have taken a great liberty but I still hope you will excuse it.*

Salisbury did excuse it, and Reynolds had his wish. 'To be in the lobby of the House of Commons a quarter before ten, full dress,' says a note in the pocketbook. In the vast improvised theatre which workmen had assembled in Westminster Hall, he sat together with Burke and Sheridan and the other managers, separated from the small box built for Hastings only by the witness stand; after the opening procession, the Prince of Wales made his way there, too, and was to be heard talking to Sheridan in an over-loud voice.

Fanny Burney had also been given a ticket, in her case by the queen, who not only dispensed with all attendance from her that morning after her first dressing, but pressed on her some cakes from her breakfast table. Installed in a box behind the defendant, she became agitated during the reading of the charges when Hastings – pale, thin, dressed in poppy-coloured silk – began to cast his eyes round the Hall. 'I felt shocked and ashamed, to be seen by him in that place,' she wrote in her diary:

I hope Mr. Hastings did not see us; but in a few minutes more, while this reading was still continued, I perceived Sir Joshua Reynolds in the midst of the Committee. He, at the same moment, saw me also, and not only bowed, but smiled and nodded with his usual good humour and intimacy, making at the same time a sign to his ear, by which I understood he had no trumpet; whether he had forgotten or lost it I know not.[16]

What seems more likely is that Reynolds, well aware that Miss Burney was a passionate supporter of Hastings, was trying to convey to her that notwithstanding his friendship with Burke and Sheridan, she saw him in the box of the trial managers only because of his deafness, and not because he was *parti pris*. Hastings, who must certainly have noticed him, clearly did not take it amiss, because we find him dining at Leicester Fields once more three months later.†

The reading clerks droned on for an eternity from their immense rolls of

* Letter 180. It was not, in fact, the case that Reynolds had not been soliciting his friends for a ticket. When Malone made a similar request, Burke wrote back explaining the difficulty he was in: 'Sir Joshua, who is deaf, and for whom no place but our box can secure a hearing, has been long at work on me; I am apprehensive, that I cannot accommodate him' (Burke, Edmund, 1958–78, v, 378, letter dated 12 February 1788).

† On 23 May. The other guests included Edward Gibbon and the poet Richard Cambridge.

parchment, and it was only on the third day that Burke rose to make his opening address. Reynolds had not been alone in his eagerness to hear him. More than fifty years later, Macaulay conjured up the scene in a celebrated passage in the *Edinburgh Review*:

The ladies in the galleries, unaccustomed to such displays of eloquence, excited by the solemnity of the occasion, and perhaps not unwilling to display their taste and sensibility, were in a state of uncontrollable emotion. Handkerchiefs were pulled out; smelling bottles were handed round; hysterical sobs and screams were heard; and Mrs Sheridan was carried out in a fit.[17]

How much of Burke's speech Reynolds sat through – it lasted for four days – is not known. Certainly the evidence of the pocketbook is that he had managed to free himself of all but a very few sitters. Public interest in the trial continued into the early summer, rising to a peak when Sheridan spoke in early June on the charge relating to the Begums of Oude. Horace Walpole says that 50 guineas was being offered for a ticket; Sir Gilbert Elliot, observing the crowd on the opening day of the speech wrote of 'a rush as there is at the pit of the playhouse when Garrick plays *King Lear*'.* Much of the audience was reduced to tears by Sheridan's high-flown eloquence. He concluded with the words, 'My Lords, I have done!' and fell back, apparently senseless, into the arms of Burke. 'A good actor,' Gibbon noted in his journal the following day. 'I saw him this morning; he is perfectly well.'†

Thereafter, the excitement abated. There remained endless examinations and cross-examinations, innumerable adjournments for the consideration of points of law; there remained, as Macaulay put it, 'the reading of papers filled with words unintelligible to English ears, with lacs and crores, zemindars and aumils, sunnuds and perwannahs, jaghires and nuzzurs'. Eventually, after seven long years, Hastings was acquitted of all the charges brought against him, and released into a world which had largely forgotten what his 'high crimes and misdemeanours' were supposed to have been.

Reynolds had continued to retouch *The Infant Hercules* during the months of winter and spring. 'I breakfasted this morning with Sir Joshua

* Elliot (1751–1841), then the MP for Berwick, had helped Burke prepare the case against Hastings. He later became Governor-General of India and in 1813 was created Earl of Minto.
† Gibbon, 1956, letter 689. He was writing to Lord Sheffield on 14 June 1788. Gibbon wrote in his memoirs that he could not hear without emotion the compliment paid to him by Sheridan 'in the presence of the British nation'. Asked, however, by a fellow Whig how he had come to refer in the speech to Gibbon's 'luminous philosophy', Sheridan replied in a half whisper, 'I said voluminous' (Moore, Thomas, 1825, i, 511).

and Miss Palmer,' Ozias Humphry wrote to William Johnson in Calcutta on the last day of March:

I left Sir Joshua about to give the last finishing to the 'Infant Hercules,' for the Empress of Russia . . . Sir Joshua looks as well, and paints as well, as ever he did in his life.[18]

Not everybody agreed. The picture's appearance at the Academy's twentieth exhibition three weeks later attracted decidedly mixed reviews. It so happened that patrons of Sadler's Wells were currently being diverted by an 'extraordinary and curious exhibition of Posture Work, and Exertions of Strength by the Infant Hercules, a child of Ten Years Old'. The temptation was too great for *The Public Advertiser*:

The INFANT HERCULES
of Sadler's Wells, to
The INFANT HERCULES
of the ROYAL ACADEMY
A CHALLENGE

You vye with me, you vulgar brat,
with *dabby* cheeks, all *pursed* and *fat*
For any thing unable!
With *daddles*, *feet*, and straining stare
why z—ds you look, all chased and bare
As if you p—'d the cradle.[19]

The World was measured, but severe. 'The INFANT HERCULES; though much mended of late, by entire new arrangement of the Female Groupe, still is liable to as much blame as praise,' it declared:

With resources such as Sir *Joshua* has, no subject, however poor, can be worthless. That this however is poor, we call to witness Mythology and Enigma. It is bad enough to paint emblematically – a bad emblem is yet worse! – if the Empire of RUSSIA is to be impersonified, the truth is not in Infancy – but in ADVANCED AGE.[20]

The *St James's Chronicle* tried hard to be judicious, but felt that Reynolds had rather let the side down; it also took an obscure swipe at Johnson:

The Composition is dignified and splendid and the character of the divine infant is finely conceived. As the national honour is in some respect concerned in this Pro-

duction, we wish the Imagination of the artist had been formed on Greek Literature, and not on the false splendour of Dr Johnson. His colouring might then have been as true and permanent, as it is now clear, beautiful and deceitful.[21]

None of this indicated that the writers had any great knowledge of painting. A critique of a very different order appeared in *The Analytical Review*. *The Infant Hercules*, it declared, 'might be called great if it were more correct; it might perhaps have been correct if it had not attempted to be great.' The writer was Henry Fuseli. Although it was only later that year that he would be elected an Associate of the Academy, he was now, in his mid-forties, emerging as the most important history painter of his generation. Much of Fuseli's subtle and penetrating analysis was probably over the heads of his readers; his scholarship, indeed, was far above that of most Academicians. 'Here may be seen what the steady pursuit of one single principle can do in art,' he wrote:

To him, who with a half-shut eye contemplates its effect, an illuminated torrent seems to wind between two darksome rocks from the top, and to lose itself in the lower parts of the picture. Of the colour it would be superfluous to say more. It is all ideal, and beyond all precedent, perhaps beyond all imitation expressive of the subject.[22]

Later critics have been less kind. Sir Walter Armstrong, the least admiring of Reynolds's nineteenth- and twentieth-century biographers, thought that *Hercules* and other historical paintings such as *Ugolino* should be labelled 'Tragedies of Compliance'. 'We must accept them as Sir Joshua's substitute for vices,' he wrote:

Most men of unusual powers have wasted part of them in proceedings which were detrimental to themselves and of no profit to their neighbours. Reynolds lived soberly and prudently, except when he over-weighted his easel with these quasi-historical machines. Let us take them as his tribute to human frailty, and give up all attempts to bring them within any reasonable view of art.[23]

The Infant Hercules was only one of seventeen canvases that Reynolds sent to the Academy in 1788 – the greatest number he had ever exhibited. Horace Walpole dismissed his *Girl Sleeping*[24] as 'coarse', but John Wolcot liked it enough to pay Reynolds 50 guineas for it two years later. He hung it in his house in Truro, and on the back he pasted the lovely lines Shakespeare puts in the mouth of Brutus when he discovers his servant, the boy Lucius, fast asleep:

Enjoy the honey-heavy dew of slumber.
Thou hast no figures nor no fantasies
Which busy care draws in the brains of men;
Therefore thou sleep'st so sound.[25]

Reynolds also exhibited several outstanding portraits. Number 219, *Portrait of a Lady*[26] was recognized by anybody who was anybody as Lady Elizabeth Foster, the daughter of the Bishop of Derry (who was also the Fourth Earl of Bristol), and the unhappy wife of John Thomas Foster, an Irish politician. A payment of 50 guineas by the Duke of Devonshire is recorded in the ledger – reasonably enough, as Lady Elizabeth was his mistress, as well as the intimate friend of Georgiana, his duchess. The picture – Ellis Waterhouse thought it one of the simplest and most penetrating he ever painted[27] – can still be admired in the Devonshire Collections at Chatsworth today.

Two particularly fine military portraits were those of Colonel Morgan, now in the National Museum of Wales in Cardiff,[28] and of Lord Heathfield, now in the National Gallery in London,[29] although the Morgan portrait has suffered from overcleaning and the Heathfield shows signs of Reynolds's passion for bitumen. George Augustus Eliott, a national hero for his defence of Gibraltar during the Spanish seige of 1779–83, had been raised to the peerage as Baron Heathfield of Gibraltar the previous year. Reynolds painted him against a menacing background of cloud and cannon smoke; he wears the red coat of the 15th Light Dragoons and in his right hand he grips the massive key of the Rock, the chain looped stubbornly – twice – around his fist. The picture was painted for Alderman Boydell, who presented it to the Corporation of the City of London. Martin Archer Shee, Reynolds's successor twice removed as President of the Academy, then a boy in his teens, saw it in Boydell's gallery later in the year and wrote to his brother that he had seen 'one of the finest portraits Sir Joshua ever painted'.

It was during the exhibition that the public first became aware that the Academy's most notable absentee was ill:

We state with infinite regret that Mr Gainsborough has been for some weeks past so much indisposed as to be unable to exercise his pencil. His indisposition proceeds from a violent cold caught in Westminster Hall; the glands of his neck have been in consequence so much inflamed as to require the aid of Mr John Hunter and Dr Heberden. The friendly attention of the latter is almost without intermission, and from Mr Hunter's skill it is hoped that ten days or a fortnight may restore him to the practice of that science of which he is so distinguished an ornament.

Gainsborough had certainly attended some of the sittings of the Hastings trial, and may well have caught a chill there, but the truth of the matter was more sinister. He had been aware for some three years past of a growth on his neck. Hunter had prescribed the application of sea-water poultices, but to no effect; 'now it is painful enough indeed', he admitted to a correspondent in April, 'as I can find no position upon my pillow to admit of getting rest in Bed'.[30]

Four or five days before the press announcement quoted above, he made his will. 'God only knows what is for me, but hope is the Pallat of Colors we all paint with in sickness,' he wrote towards the end of May to Thomas Harvey, the amateur artist and collector:

> ... 'tis odd how all the Childish passions hang about one in sickness, I feel such a fondness for my first imatations of little Dutch Landskips that I can't keep from working an hour or two a Day, though with a great mixture of bodily Pain – I am so childish I could make a Kite, catch Gold Finches, or build little Ships –[31]

He was dying of cancer, and by now he knew it:

> June 15th, 1788
> It is my strict charge that after my decease no plaister cast, model, or likeness whatever be permitted to be taken: But that if Mr Sharp, who engraved Mr Hunter's Print, should chuse to make a print from the ¾ sketch which I intended for Mr Abel painted by myself, I give free consent.
> Tho. Gainsborough[32]

Who this note was addressed to is not known, but the identity of another correspondent to whom he wrote a month or so later is not in doubt:

> Dear Sir Joshua
> I am Just to write what I fear you will not read, after lying in dying state for 6 month The extreem affection which I am informed of by a Friend which Sir Josha has expresd induces me to beg a last favor, which is to come once under my Roof and look at my things, my Woodman you never saw, if what I ask more is not disagreable to your feeling that I may have the honor to speak to you. I can from a sincere Heart say that I always admired and sincerely loved Sir Joshua Reynolds.
> Tho Gainsborough*

* Hayes, 2001, 176. *The Woodman* had been painted the previous summer, and Gainsborough regarded it as his masterpiece. The Earl of Gainsborough bought it at the studio sale held at Schomberg House in 1789. It was destroyed in a fire at his home, Exton Park, Rutland, in 1810.

Reynolds did go to Schomberg House – and acted as a pallbearer shortly afterwards.* The funeral, by Gainsborough's wish, was private. He was buried in Kew churchyard, next to the grave of his Suffolk friend Joshua Kirby.

In the *Morning Herald*, Bate, Gainsborough's pugnacious long-time champion, wrote movingly about his friend, and not just about his gifts as an artist. His correspondence, he declared, 'possessed the ease of *Swift*, and the nervous force of *Bolingbroke*'; a selection of his letters would offer to the world 'as much originality and beauty, as is ever to be traced in his PAINTING!' Bate also watched unforgivingly for an opportunity to settle old scores. He saw his chance in November, when there were reports of an irregularity in Fuseli's election to an Associateship, and he rounded ferociously on both the Academy and its President. He reminded his readers of what had caused Gainsborough to withdraw *The Three Eldest Princesses* four years previously – he had wanted it displayed at the height at which it was intended to be hung at Carlton House:

There were, however, those of you who dreaded comparison with this artist, and who became Romans on this occasion. 'Depart from the Academy rules! Impossible!' . . . If your refusal bore at the time, which it did, the construction of being malignant, that censure is established by some late proceedings. And it will appear in the sequel that the laws which you affect to revere are sometimes broken when a petty purpose requires it. I need not remark that it is an annual practice to leave a list open at the Academy for a limited time after the exhibition closes wherein the artists who wish to become Associates may insert their names. The fixed time was this year elapsed, and the list shut when it occurred to Mr Fuseli to put in his claim for this scarce-desirable honour. But the Book of Graphic Destiny, the Institute of Academical Dignity, was shut for the year, and what was to be done? Mr Fuseli knew well. He knocked at the President's door, and made his request known. A *deaf ear* was not turned to his demand – Fuseli's branch of the art interferes not with Sir Joshua – he is not a Gainsborough! 'Pshaw,' said the President, 'never heed the rules. I'll take care of your name.' Accordingly the printed list appeared with Fuseli's name, to the astonishment of all the brethren.[33]

The story is improbable. Fuseli was chosen to fill the vacant Associateship by ten votes to eight; the other candidate was the Italian architect Bonomi, who, then and later, enjoyed the President's warm support. Reynolds, however, was far too old and wise a dog to respond directly to Bate's attack. He found his own way of doing so some weeks later when, after the annual

* The others were Bartolozzi, Chambers, Cotes, Sandby and West.

distribution of prizes at the Academy, he rose to deliver his fourteenth Discourse. 'We have lately lost Mr Gainsborough, one of the greatest ornaments of our Academy,' he told his hearers:

It is not our business here to make panegyricks on the living, or even on the dead who were of our body. The praise of the former might bear the appearance of adulation; and the latter, of untimely justice; perhaps of envy to those whom we have still the happiness to enjoy, by an oblique suggestion of invidious comparisons. In discoursing therefore on the talents of the late Mr Gainsborough, my object is, not so much to praise or to blame him, as to draw from his excellencies and defects, matters of instruction to the Students in our academy.[34]

It was one of Reynolds's most characteristic performances – candid, measured, judicious, equally free of exaggeration and false sentiment. But there was praise in plenty for his dead rival: 'If ever this nation should produce genius sufficient to acquire to us the honourable distinction of an English School, the name of Gainsborough will be transmitted to posterity, in the history of the Art, among the very first of that rising name.'

He measured him against contemporary painters of the Roman school – 'to whose reputation ancient prejudices have certainly contributed: the way was prepared for them, and they may be said rather to have lived in the reputation of their country, than to have contributed to it.' He was prepared to name names, and ventured to prophesy that those of Mengs and Batoni would very soon fall 'into what is little short of total oblivion.' And he conceded that he was sticking his neck out:

I am well aware how much I lay myself open to the censure and ridicule of the academical professors of other nations, in preferring the humble attempts of Gainsborough to the works of those regular graduates in the great historical style. But we have the sanction of all mankind in preferring genius in a lower rank of art, to feebleness and insipidity in the highest.[35]

He passed in review – not always approvingly – certain aspects of Gainsborough's working methods – 'the customs and habits of this extraordinary man', as he termed them:

. . . from the fields he brought into his painting room, stumps of trees, weeds, and animals of various kinds; and designed them, not from memory, but immediately from the objects. He even framed a kind of model of landskips, on his table; composed of broken stones, dried herbs, and pieces of looking glass, which he magnified and improved into rocks, trees, and water . . . such methods may be nothing better than

contemptible and mischievous trifling; or they may be aids. I think upon the whole, unless we constantly refer to real nature, that practice may be more likely to do harm than good. I mention it only, as it shows the solicitude and extreme activity which he had about every thing that related to his art . . .[36]

He touched, but with tantalizing discretion, on their last meeting:

Of Gainsborough, we certainly know, that his passion was not the acquirement of riches, but excellence in his art; and to enjoy that honourable fame which is sure to attend it. – That *he felt this ruling passion strong in death*,* I am myself a witness . . . I am aware how flattering it is to myself to be thus connected with the dying testimony which this excellent painter bore to his art. But I cannot prevail on myself to suppress that I was not connected with him by any habits of familiarity; if any little jealousies had subsisted between us, they were forgotten in those moments of sincerity . . .[37]

'On pronouncing the eulogium at the Royal Academy,' wrote Reynolds's friend William Seward, 'his praises of Mr Gainsborough were interrupted by his tears.' Tears from Reynolds? The 'most invulnerable man' that Johnson knew? A rare occurrence. But men weep for many reasons, and sometimes surprise not just others but also themselves when they do. Possibly he had suddenly regretted that lack of familiarity, had felt a pang when he recalled those 'little jealousies'. Or perhaps it came to his mind, as he faced his audience in Somerset House, that he was eulogizing a man who had been four years his junior.

* Reynolds is quoting from Pope's *Epistles to Several Persons (Moral Essays)*:

> And you! brave COBHAM, to the latest breath
> Shall feel your ruling passion strong in death:
> (Ep. I, ll. 262–3)

24

Bereaved of Light

The nature of the Prince of Wales's relationship with Mrs Fitzherbert – the menacing clouds gathering over the monarchy in France – the latest developments in the trial of Warren Hastings – these staples of London drawing-room gossip were engulfed in the winter of 1788–9 by the violent debates which raged on the question of regency.

The first signs of George III's mental derangement had appeared in late October. 'The King is better and worse so frequently, and changes so, daily, backwards and forwards, that everything is to be apprehended, if his nerves are not some way quieted,' wrote Fanny Burney on 3 November. 'I dreadfully fear he is on the eve of some severe fever. The Queen is almost overpowered with some secret terror.'[1] His condition deteriorated by the day. Her husband's eyes, the queen told her Lady of the Bedchamber, 'she could compare to nothing but black currant jelly.' He talked incessantly – on one occasion for nineteen hours almost without intermission. Much of the time he was deluded: 'He fancies London is drowned,' noted Lord Sheffield, 'and orders his yacht to go there.'

The royal physicians were totally at sea – the rare metabolic disorder known as porphyria would not be clinically defined until the twentieth century. The king was insane, and that was an end of it – at the gambling tables at Brooks's, members throwing down a king said 'I play the lunatic.' By the end of November the monarch was being physically restrained, first in an 'envelopement' of linen, then in a strait-waistcoat. In early December the Reverend Francis Willis was called in, a 'mad-doctor' who ran a private asylum in Lincolnshire and who believed that patients must be broken in 'like horses in a manège'.

The political struggle over the regency divided the court, Parliament and society. It even caused dissension in the Club. 'I wish politics at the devil,' Sir William Jones wrote to Sir Joseph Banks from Calcutta later in the year, 'but hope, that when the King recovered, Science revived. It gives me great pain to know, that *party*, as it is called, (I call it *faction*, because I hold party to be grounded on principles, and faction on self-interest,) has found its way

into a Literary Club, who meet reciprocally to impart and receive new ideas.'*

The behaviour of the Prince of Wales was that of a man who had already stepped into his father's shoes. In the absence of Fox – he was holidaying abroad with his mistress, Mrs Armistead – the prince's secret negotiations about the formation of an administration were conducted mainly through Sheridan; it was he who composed the prince's reply to Pitt's offer of a conditional regency. The *Morning Post* chanced its arm by publishing the names of those who were to be the new ministers – Portland prime minister, Fox a secretary of state, Burke Paymaster-General, Sheridan Treasurer of the Navy.

Reynolds was undoubtedly privy to much of what went on behind the scenes. Richard Warren and Sir George Baker,† two of the physicians in attendance on the king, were both old friends; it also happened that Sheridan was sitting to him that winter, and it would have been quite out of character if he had made any effort to rein in that famously loose Irish tongue during his half dozen appointments in Leicester Fields. The hopes of the Whigs were dashed, however – partly by chance, partly because they were out-generalled by Pitt. By the middle of February the king was playing the flute, reading Pope and Shakespeare, and pottering in his hothouses. When Parliament reassembled on 10 March the Regency Bill was formally abandoned.

Reynolds submitted to the Council drafts of loyal addresses to both the king and queen, and they were then entrusted to his friend Thomas Tomkins, the most celebrated calligrapher of the day, who was an old hand at richly ornamental addresses to royalty, honorary freedoms and the like.‡ Reynolds unaccountably failed to get a ticket for the solemn service in St Paul's – it was held on St George's Day – to give thanks for the king's restoration to reason, and had to make do with watching the procession from Somerset House. He did, however, attend the grand ball which had been sponsored by Brooks's two days previously.

That Brooks's was a home from home for many of those who had recently been straining every nerve to have the Prince of Wales installed in his father's place was neither here nor there. If White's and Boodle's were putting on a

* Northcote, ii, 249. 'If, on my return to Europe, ten or twelve years hence,' Jones continued, 'I should not find more science than politics in the club, my seat in it will be at the service of any politician who may wish to be one of the party.' He did not, however, live to return to England, dying in Calcutta in 1794 at the age of forty-eight.

† Baker, a fellow Devonian, President of the College of Surgeons, was Reynolds's own doctor. His wife had sat to Reynolds in 1770, shortly after her marriage (Mannings, cat. no. 96, fig. 994).

‡ Tomkins sat to Reynolds during May and June for the fine portrait now in the Guildhall Art Gallery, London (Mannings, cat. no. 1754, fig. 1568).

celebratory show of loyalty, Brooks's must clearly follow suit – indeed, ironically, the moving spirit behind the elaborate gala evening arranged at the Opera House in the Haymarket was Sheridan.* Reynolds made up a party with his niece Mary and Sir John D'Oyly† and his wife; Mary, who had a friend called Miss Cocks in tow, sent a long account of the occasion to her sister Offy:

About eleven we all went to the Opera house which was decorated to be sure in the most beautiful manner possible, had it been for a small company, but as it was it appeared like an immense body of people shut up in a fine purse, or rather in a Ballon. It was all hung round with blue Silk which drew up in the middle of the Ceiling like the Hood of a Cloak, round by the boxes the blue silk was intermix'd with buff, and all trim'd with blue and silver fringe drawn up in festoons with silver cord. The pillars were twined round with scarlet sattin ribbon & the whole lighted with wax candles instead of lamps. Air seem'd quite excluded and every lady appear'd to dread the effects of the heat, & added to this not a tenth part of the company could get seats.

For the first two hours, Mary told her sister, she 'saw everything with a disposition to be pleased (but even then White's was in my opinion fifty thousand times superior)'. Then things began to go badly wrong. Just as Mrs Siddons, got up as Britannia, began to declaim a patriotic ode,‡ Miss Cocks, 'tired to death with standing', fainted away; when the doors were opened for supper, 'the Company rush'd in & the tables (of which there were about 20) were instantly filled'. Mary and her friend became separated from Reynolds and the D'Oylys and did not find them again until between three and four in the morning:

They had all been comfortably at supper concluding we were gone home. It seems when my Uncle attempted to return to us, the waiters refused him admittance ... when supper was announced my Uncle got into another room & had forgot the way to that where he left us.

* The queen and the princesses had made their first public appearance since the king's illness on 15 April at Covent Garden – a club snub to Sheridan as the manager of Drury Lane. The queen wore a bandeau of black velvet on which were set in diamonds the words 'Long live the king'. In the course of the evening the national anthem was sung six times.

† D'Oyly (1754–1818), formerly Collector of Calcutta and a friend of Warren Hastings, had returned to England in 1785 because of his wife's ill-health, but not before restoring the family fortunes, which had been much depleted by his spendthrift forebears. He had sat to Reynolds the previous year (Mannings, cat. no. 473). The picture is untraced.

‡ At the end of it she sat down, to great applause, in the exact posture of the figure on a penny piece.

All these tormenting circumstances made the Evening to me irksome beyond expression, & I was so out of love with Balls that when I came home I believe I should have rejected a ticket for the finest ever was plan'd. So much for Brooks . . .

Reynolds had been a member at Brooks's since 1785. At sixty-five, his clubbability was undiminished. The previous year he had become a member of the Eumelian Society, formed by his friend Dr John Ash, a social and literary club which met at the Blenheim Tavern in Bond Street.* The only time he is known to have declined an invitation to join anything was in 1783, when Johnson formed the Essex Head Club, which was to meet three times a week in a tavern off the Strand kept by an old servant of Thrale's. 'The Company is numerous, and as You will see by the list, miscellaneous,' Johnson wrote. 'The terms are lax, and the expences light.'[2] The list included the name of Barry, however, and that made it too miscellaneous for Reynolds's liking. He chose not to join. Now, however, in the spring of 1789, a somewhat gnomic paragraph in the *Morning Post* indicated that he had been denied membership of a body that he very much did want to join:

To blackball Sir Joshua, who is so superior to the world of artists, does no honour to the Club at White's. Nevertheless we are not displeased at the Knight's disappointment, who, after the many mortifying insults he has received from a certain quarter, is still the humble idolator of a Court.[3]

Although he had shown little sign of stirring himself to have *Macbeth and the Witches* ready for the opening of Boydell's Shakespeare Gallery, the winter of 1788–9 had found Reynolds busy on two other paintings for the Alderman. Boydell had offered him 500 guineas for a depiction of the scene from *Henry VI, Part 2*, where the king, accompanied by Salisbury and Warwick, witnesses the death of his great-uncle, Cardinal Beaufort, Bishop of Winchester.

William Mason, still a frequent visitor to Reynolds's studio, once again provides a detailed account of a work-in-progress. At that stage Reynolds had simply scumbled in the positions of the several secondary figures, and was at work on the head of the dying cardinal:

He had now got for his model a porter, or coal-heaver, between fifty and sixty years of age, whose black and bushy beard he had paid him for letting grow; he was

* The club's name came from the Greek word for 'ash'; the question of whether it should not rather be called the Fraxinean, from the Latin, had been solemnly put to the vote. Ash, an eminent physician who was the founder of the General Hospital in Birmingham, had sat to Reynolds in 1788 (Mannings, cat. no. 78, fig. 1530).

The self-portrait Reynolds painted for the Thrales. It hung in their house at Streatham along with those of Goldsmith, Burke and Johnson. The position of the left hand is clearly an allusion to his deafness.

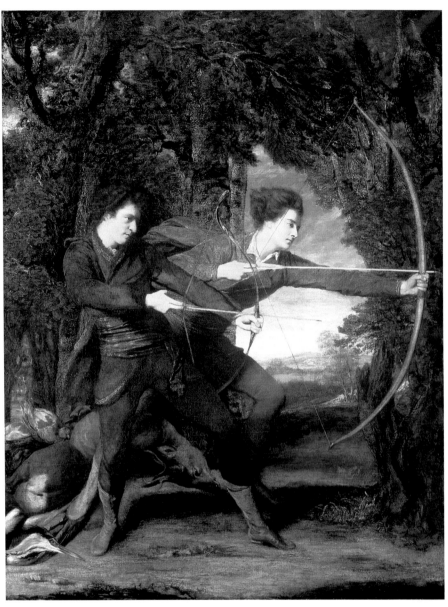

The Archers. *Exhibited at the Academy in 1770. The sitters, Colonel Acland and Lord Sydney, subsequently quarrelled, each declining to pay for the picture. Acland eventually settled Reynold's bill – for £300 – nine years later. The painting most recently came up for sale at Sotheby's in 2000, and realised £1.5 million.*

The Italian man of letters Giuseppe Baretti, translator of Reynolds's first seven Discourses *into Italian. This is another of the portraits painted for the Thrales.*

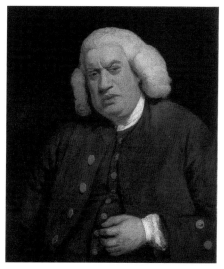

Samuel Johnson. This too was one of the Streatham commissions. Johnson, it seems, was not flattered. Reynolds, he told Mrs Thrale, could not paint himself as deaf as he chose, but 'I will not be blinking Sam'.

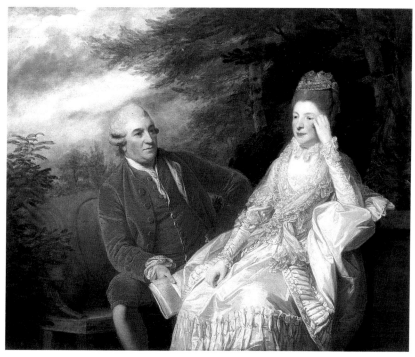

David Garrick and his wife Eva Maria, a Viennese dancer who had come to England in 1772, four years before the great actor's retirement from the stage.

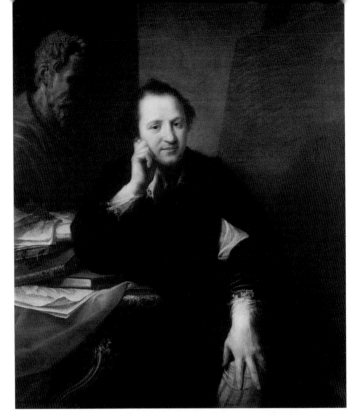

Reynolds sat to other artists on relatively few occasions. Angelica Kauffmann's portrait (top) was painted in 1767, a year after her arrival in England, when Reynolds was in his early forties. The portrait below by the American painter Gilbert Stuart dates from 1784.

The Dilettanti Society. *One of the pair of group portraits which Reynolds painted for the Society in the late 1770s. The member seated in the centre, pointing to the folio, is Sir William Hamilton, later the husband of Nelson's Emma; behind him, holding a lady's garter, stands Sir John Taylor, of Lysson Hall, Jamaica.*

The Marlborough Family. *Painted 1777–8. In Ellis Waterhouse's view,*
'the most monumental achievement of British portraiture'.

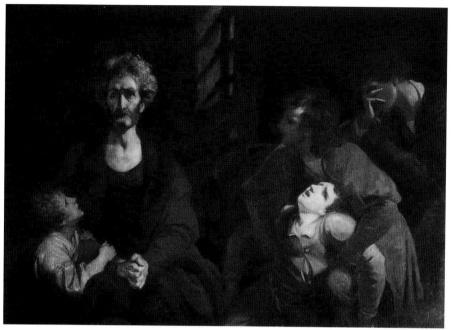

Ugolino and His Children in the Dungeon. *Not universally admired when it was exhibited at the Academy in 1773. 'The rude disorderly abortions of an unstudied man,' wrote an abrasive correspondent in the* Morning Chronicle. *'Be advised, Sir Joshua, keep to your portraits, which will do yourself and your country credit.'*

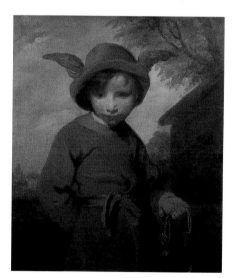
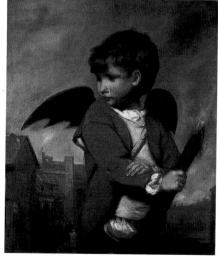

Mercury as a Cutpurse *(left) and* Cupid as a Link Boy. *Painted as pendants, and heavily charged with sexual innuendo, they were bought in 1774 by the Duke of Dorset, who built up a notable collection of Reynolds's subject pictures at Knole, the Sackville family seat in Kent.*

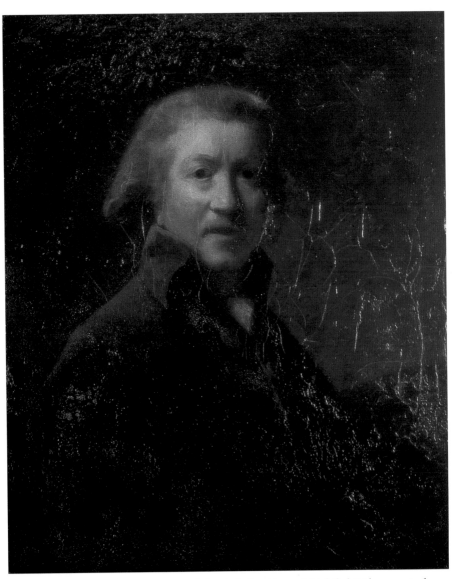

Reynolds's last self-portrait, painted shortly before his eyesight failed. 'It has a sort of pulled up look,' wrote Boswell 'and not the placid gentleness of his smiling manner.' He thought it, for all that, 'the best representation of my celebrated friend.'

stripped naked to the waist, and, with his profile turned to him, sat with a fixed grin, showing his teeth. I could not help laughing at the strange figure, and recollecting why he had ordered the poor fellow so to grin, on account of Shakespeare's line,

Mark how the powers of death do make him grin.

I told him, that in my opinion Shakespeare would never have used the word 'grin' in that place, if he could have readily found a better; that it always conveyed to me a ludicrous idea; and that I never saw it used with propriety but by Milton, when he tells us that death

grinned horribly
A ghastly smile.

He did not agree with me on this point, so the fellow sat grinning on for upwards of one hour, during which time he sometimes gave a touch to the face, sometimes scumbled on the bedclothes with white much diluted with spirits of turpentine. After all, he could not catch the expression he wanted, and, I believe, rubbed the face entirely out . . .[4]

The other picture for Boydell shows a naked, grinning, slit-eyed infant with faun-like ears; he waves his left arm in the air, clutches a posy in the right and is perched on top of a truly enormous mushroom. William Cotton had an account of its genesis from the grandson of the publisher George Nicoll, who had accompanied Boydell to Reynolds's studio to inspect *The Death of Cardinal Beaufort*:

Boydell was much taken with the portrait of a naked child, and wished it could be brought into the Shakspeare. Sir Joshua said it was painted from a little child he found sitting on his steps in Leicester Fields. My Grandfather then said, 'well Mr Alderman, it can very easily come into the Shakspeare if Sir Joshua will kindly place him upon a mushroom, give him fawn's ears, and make a Puck of him.' Sir Joshua liked the notion, and painted the picture accordingly.[5]

Reynolds presumably also liked the notion of thus economically converting a fancy picture, for which he would usually have charged 50 guineas, into a history painting for which he was able to ask twice as much. When it was exhibited at the Academy that year as *Robin Goodfellow*,[6] it was not particularly well received. 'This is a fairy whom fancy may endow with the creation of a midnight mushroom, a snow drop, or a violet,' wrote Fuseli,

'but he surely cannot be mistaken for the Robin of Shakespeare or Milton.'[7]
The *Morning Post* was much less polite:

Beyond the merit of fine colouring this picture has no claim to praise, but is rather disgusting, as it seems to be a portrait of a *foetus* taken from some anatomical preparation. It is really offensive, and we wonder the taste and feeling of this admirable artist should ever have been employed on such a subject. The *toad-stool* on which this praeternatural infant is sitting, is one of such disproportionate magnitude, that it seems to have been brought from *Brobdingnab* for the occasion . . .[8]

The exhibition had opened only four days after the service at St Paul's. For the first time since the foundation of the Academy, the President did not have to escort his royal patron through the rooms before the official opening; the king, still suffering from dejection and lassitude, remained convalescent at Windsor.* Lawrence, who had celebrated his twentieth birthday a few days earlier, made a strong showing with thirteen works, which included a pastel study of the Duke of York and a portrait of William Linley, Sheridan's young brother-in-law, then a scholar at St Paul's; but Reynolds's ascendancy was not seriously challenged.

His portrait of Sheridan[9] – no payment is recorded in the ledger, but it was said to have been painted for the Duchess of Devonshire – depicts him standing at the table of the House of Commons, speaking on the Regency Bill. It was greatly admired by Horace Walpole – 'It is not canvas and colour, it is animated nature.' The subject himself was less happy. Sheridan was sensitive about the acne rosacea from which he suffered. Reynolds had made no attempt to disguise it, but Sheridan later paid several visits to the workshop of the engraver John Hall,† intent on seeing that it should not feature in the print. Abraham Raimbach, later known for his collaboration with David Wilkie, was a boy of thirteen at the time and had recently been articled to Hall. 'I was most struck with what seemed in such a man an undue and unbecoming anxiety about his good looks,' he wrote in his memoirs:

I need scarcely say that Hall set his mind at ease on this point; but I could not but wonder that a matter that might be excused in the other sex should have had power to ruffle the thoughts of the great wit, poet and orator of the age.[10]

* In June he would accept the advice of his physicians and spend three months at Weymouth, where he bathed, yachted and visited the ships at Plymouth.
† Hall (1739–97) had been historical engraver to George III since 1785. He engraved many of West's history paintings.

Reynolds also exhibited a powerful full-length of Lord Rodney, apparently painted for the Prince of Wales.[11] The contrast with the handsome, almost foppish figure who had sat to him three decades earlier – that picture is now at Petworth[12] – could not be more stark. 'His person was more elegant than seemed to become his rough profession,' wrote Wraxall. 'There was even something that approached to delicacy and effeminacy in his figure.'[13] But the hero of Cape St Vincent and Dominica was now seventy, racked with gravel and gout; Reynolds has unsparingly captured the long nose, the hollow eyes, the toothless mouth. It has something of the same bleak quality as his last self-portrait, painted at much the same time.[14] Boswell saw it when he visited Offy and her husband in Cornwall not many months after Reynolds's death. 'It has a sort of *pulled up* look,' he wrote, 'and not the placid gentleness of his smiling manner, but the features, though rather too largely and strongly limned, are most exactly portrayed . . . I think it is the best representation of my celebrated friend.'

Some years previously, as a gift to Offy's husband, Reynolds had painted their daughter Theophila, then a child of three or four. Now, in 1789, this enchanting portrait[15] was exhibited at the Academy and subsequently sent to Bartolozzi to be engraved. When the picture came back from the engraver, Mary Palmer gave it as her opinion that her niece's rose-tipped fingers, intertwined in her lap, resembled nothing so much as a dish of prawns. Reynolds did not disagree, and obligingly placed in the small chubby hands the posy which can now be seen in the picture.

A few days after Somerset House opened its doors, *The Gazetteer and New Daily Advertiser*, tongue well in cheek, offered some entertaining 'HINTS *Recommended to the Attention of such* GENTLEMEN *as visit the* EXHIBITION':

It is earnestly recommended to every Gentleman to look at all the Paintings through his glass; if he examines them with the naked eye only, he may miss beauties in the composition, which, not being very obtrusive, will require a quick sight to find them out. Whatever you say of a picture must be spoken in half sentences, and then it may stand for either praise or censure. Be especially careful to examine your Catalogues, and determine upon the name of the artist, and before you pronounce upon his work; for should you censure the performance of a Reynolds, or any other great artist, it may cause some doubts about your judgment. Whatever you praise, stile *splendid, brilliant, spirited, exalted,* and full of *mind*; and if a picture is to be abused, stile it *mean art, vulgar nature, execrable daub*; or if you wish to carry your censure still farther, *vile, infamous, d—d stuff, wretched colouring*, or any other pretty little short epithet expressive of contempt. If you are at a loss for words, purchase a shilling dictionary, and you may find a sufficient number to establish your character,

and get you the name of a connoisseur of the first water. If you are inspecting a high finished little picture, keep at a sufficient distance; and then you may safely abuse the artist for want of *strength of outline*, or *weakness of colouring*, &c. but if you inspect a bold spirited sketch, get as close to it as you can, that you may have a clearer view of its inaccuracies; and then fire away your criticism upon the whole. The worst they can say is, that you are like the fly upon a pillar of St Paul's cathedral. Talk at the very top of your voice, by which means every person in the room will have the benefit of your remarks; so shall you escape the censure of hiding your candle under a bushel; and an authoritative tone will impress your auditors with such an opinion of your judgment, they will not dare to contradict you. By this means you cannot fail of being classed in the very first rank of amateurs of the fine Arts.

The evidence of the pictures exhibited by Reynolds that spring is that he was still at the height of his powers. He was busy in his painting room on into the summer, but then, in the middle of July, his world was abruptly and permanently changed. In his pocketbook, in the blank space to the right of his appointments, he scrawled eight words – 'prevent'd by my Eye beginning to be obscured'.

Mary Palmer, who had gone off on what was meant to be an extended visit to family and friends in the West Country, hurried back to town. She later told her cousin William, in Calcutta, that Reynolds's eye had been troubling him before her departure, but that they had thought it was of no consequence: 'Alas, he very soon totally lost it, and when I returned to him he was under the most violent apprehension that the other was going too.'

After Mary's return she and Reynolds spent some time at Richmond; towards the end of July, accompanied by Windham, Malone and John Courtenay, the MP for Tamworth,* they made an excursion to Beaconsfield and spent three days with Burke. Mary told her cousin that she still hoped to slip away to Torrington, but that it would have to be a brief visit – Reynolds had already become very dependent on her:

I may say, without vanity, that my presence is now very necessary to my uncle, as he never reads himself, and his evenings are principally passed in playing at cards, which might possibly not always be the case if I did not make up his parties; and I could not bear the thought of his spending much of his time alone.[16]

Bate, as always, had his ear close to the ground, and before the month was out, Reynolds's condition was public knowledge:

* Courtenay (1741–1816), a grandson of the Earl of Bute, had entered the Commons in 1780. He lent vitriolic support to the proceedings against Warren Hastings, and later expressed ardent sympathy with the French Revolution.

Appointments, Bills due, and occasional Mem.	JULY, 1789.
	Monday 13.

Brought forward.

Monday 13. 4 Mrs Garrick *preventd* 10½ Miss *by my Eye* 1 Lady Beau*cham* *beginning to be obscured*

Tuesday 14. 10 1½ Lady Beau champs

Wednesday 15. 11 Mrs Cox 1 Lady Beauchamps

Thursday 16. 1 o model Mr Windham

Friday 17. 11 Mrs Cox

Saturday 18.

Sunday 19.

Carried over.

11. 'Preventd by my Eye beginning to be obscured.' The entry in
Reynolds's pocketbook for the day in July 1789 – the day before
the storming of the Bastille – when he realized that his eyesight was
seriously affected. His painting days were effectively over.

Sir Joshua has mentioned to several of his friends that his practice in future will be very select in respect to portraits and that the remnant of life will be applied chiefly to fancy subjects which will admit of leisure and contribute to amuse. Sir Joshua feels his sight so infirm as to allow of his painting about thirty or forty minutes at a time only; and he means in a certain degree to retire. We should think more seriously about this had not Sir Joshua said the same thing to Lord Courtenay ten years ago.[17]

The somewhat flippant tone Bate permitted himself suggests that Reynolds's friends may initially have tried to disguise the gravity of what had happened. A paragraph in the *Herald* a month later makes it plain that the true situation was now much more widely known:

It is with extreme concern we announce the infirmity which lately attacked Sir Joshua has been attended with such severe consequences that the sight of one eye is gone for ever. The fellow organ may possibly assume hereafter an energy beyond what it at present possesses; but Sir Joshua relinquishes from this moment all the inferior branches of the art, and will dedicate his remaining powers to historical and fancy subjects. While we lament this serious loss, so immediately after the departure of the admired Gainsborough, we cannot estimate it at less than a national concern.[18]

Enforced inactivity made Reynolds restless. Early in August he went down to Brighton to take the sea air, and from there he travelled about Sussex. At Chichester there was the elegant eleventh-century cathedral, with its detached campanile, to admire; at Petworth, the magnificent park and the Great Chamber by Grinling Gibbons. In the 'close walks' at Cowdray, built by the Earls of Southampton, Queen Elizabeth had brought down a deer during her triumphal progress after the scattering of the Armada; for Reynolds there were Holbeins and miniatures by Isaac Oliver* to examine, and several Van Dycks, including the splendid *Queen Henrietta Maria with Sir Jeffrey Hudson*, Charles I's wife portrayed with the fourteen-year-old midget who was her trusted attendant, and his pet monkey, Pug.[19] Johnson had made a very similar tour seven years previously in the company of Philip Metcalfe, Reynolds's travelling companion in the Low Countries. 'I should like to stay here four-and-twenty hours,' he had declared at Cowdray. 'We see here how our ancestors lived.'†

Reynolds was back at Wick House again in September, and a fortnight

* Oliver (?1558–1617), brought to England as a child from Rouen, is now seen by some as the foremost miniature portraitist of the late Elizabethan and Jacobean age, no longer ranking second to his master Hilliard.

† Boswell, 1934–50, iv, 160. We see it no longer. 'That loveliest and perfectest of all ancient mansions,' as Horace Walpole described it, burned to the ground in six hours in 1793.

later he travelled for the second time that year to Beaconsfield. Burke was at a low ebb. Increasingly at odds with his own party, he was watching with mounting foreboding the events that were unfolding in France. On 14 July – in the very week that Reynolds's eyesight had failed – the Parisian mob had seized control of the Hôtel des Invalides and taken possession of 32,000 muskets; that afternoon the Bastille surrendered; the governor and the chief municipal magistrate were butchered and their heads, mounted on pikes, were paraded all the way to the Palais Royal. Fox was in raptures: 'How much the greatest event it is that ever happened in the world!' he wrote fatuously, 'and how much the best!' Burke struck a very different note, and viewed the Constituent Assembly with suspicion. How could its members exercise 'any function of decided authority', he inquired, 'with a mob of their constituents ready to hang them if they should deviate into moderation?' The eloquent condemnation of the French revolutionaries and their British sympathizers which he would publish the following year was already taking shape in his mind. Reynolds was one of several friends to whom he showed *Reflections on the Revolution in France* in draft, and Malone records that he endorsed its judgements:

He was indeed never weary of expressing his admiration of the profound sagacity which saw, in their embryo state, all the evils with which this country was threatened by that tremendous convulsion; he well knew how eagerly all the wild and erroneous principles of government, attempted to be established by the pretended philosophers of France, would be cherished and enforced by those turbulent and unruly spirits among us, whom *no* King *could govern, nor no* GOD *could please*; and long before that book was written, frequently avowed his contempt of those 'Adam-wits,' who set at nought the accumulated wisdom of ages, and on all occasions are desirous of beginning the world anew.*

Further evidence of how he viewed events in France is provided by Fox's niece, Caroline. Sitting beside Reynolds at dinner at Holland House at this time, she 'burst out into glorification of the Revolution – and was grievously chilled and checked by her neighbour's cautious and unsympathetic tone'.

His social life continued as busy as ever – it is interesting to note that one

* Reynolds, 1819, i, lvii. He is quoting from Dryden's *Absalom and Achitophel*, ll. 51–6:

> These Adam-wits, too fortunately free,
> Began to dream they wanted liberty:
> And when no rule, no precedent, was found
> Of men, by laws less circumscrib'd and bound,
> They led their wild desires to woods and caves,
> And thought that all but savages were slaves.

of his first engagements on returning from visiting Burke at Beaconsfield was to dine with Warren Hastings. He also saw a good deal of Boswell, who was all too easily distracted from the task of revising the enormous manuscript of his *magnum opus*: in November he was Reynolds's guest at dinner on five consecutive evenings.

At the end of the month they dined together at Malone's to discuss yet again the question of a monument to Johnson in the Abbey – Metcalfe, Windham, Courtenay and Sir Joseph Banks were also present. They had been trying for almost five years to raise the necessary funds, but the response had been abysmal.* Matters had not been helped by disagreements over what form the memorial should take. Writing to Banks earlier in the year about 'all the cavils' raised, Malone had called Reynolds in evidence to support the case for a statue:

One man wd have a picture in mosaick; another a bust; another a statue; and a fourth neither bust nor statue, but emblematical figures. The objection, however, to a whole length statue is very silly, for Sir J.R. says that Johnson's limbs were so far from being unsightly that they were uncommonly well formed, & in the most exact & true proportion: and even if this were not the case, what would it signify? The scheme is not to set up an Antinous, but to transmit to posterity a true & perfect exhibition of the entire man.[20]

Over dinner at Malone's, the Friends to the Memory of Dr Johnson, as they called themselves, resolved their differences and decided to call a public meeting. It took place on 4 January at Thomas's Tavern in Dover Street, where the Club met at that time. Banks was in the chair, and a resolution was adopted:

That a sum of Six Hundred Guineas will be requisite, to erect a Monument, in Westminster Abbey, to the memory of Dr. Samuel Johnson, consisting of a single statue, according to a plan and estimate made by Mr Bacon, sculptor, and approved of by Sir Joshua Reynolds.

To date, barely a third of that sum had been raised, and the Friends formed themselves into a committee to drum up the rest. It appears to have met regularly on Saturdays, although according to Boswell it 'had more good-living

* 'After the Doctor's death,' Horace Walpole wrote in 1791, 'Burke, Sir Joshua Reynolds and Boswell sent an ambling circular-letter to me, begging subscriptions for a monument for him – . . . I would not deign to write an answer; but sent down word by my footman, as I would have done to parish officers with a brief, that I would not subscribe' (Walpole, 1937–83, xi (i), 276, letter to Mary Berry dated 26 May 1791).

than business'. A list of subscribers was published, and the Friends urged greater liberality on the part of the peerage, the bench of bishops and 'the Rich and the Great'. It was uphill work, and five more years would pass before the monument was unveiled. 'You cannot well conceive,' Malone wrote feelingly to Percy, 'when money is to be got from gentlemen, and the application is to be made by a gentleman, how many delays & obstructions there are.'[21]

Although the vision of Reynolds's left eye had been entirely lost in ten weeks, the other eye was not affected. He had turned initially for advice to Sir George Baker, and it was presumably he who first spoke of gutta serena, the term employed by Mary Palmer in one of her letters to her cousin. Gutta serena – amaurosis – was something of a catch-all diagnosis for loss of vision unaccompanied by any obvious organic change; whether it was then known that it arose from disease of the optic nerve is uncertain. What seems most likely is that there had been a detachment of the retina caused by the growth of a tumour. Whitley suggests that Reynolds may subsequently have sought other, less reputable, opinions than Baker's, but this rests on nothing more than tittle-tattle in the press – he records a reference in one paper to the 'old women' who were alleged to have made matters worse, but there is no conclusive evidence that Reynolds resorted to quack remedies.

In a further letter to William Johnson at the end of December, Mary reported that her uncle's general health was perfect, and that he was in good spirits – 'surprisingly so, considering what a loss an eye is to him', she added:

I expected he would have been depressed by such an event, almost to melancholy; but far from it, he enjoys company (in a quiet way), and loves a game of cards as well as ever.

Reading, writing and painting were now almost entirely denied him. His fellow Devonian, Ozias Humphry, found a discreet way of repaying some of the kindness he had received from Reynolds as a younger man. He had recently spent three highly profitable years painting in India, but had been driven home by ill-health. Now, if Mary Palmer happened to be away, he took to dropping in at Leicester Fields at breakfast time to read the newspaper to Reynolds – this despite the fact that his own eyesight was far from good.* Reynolds showed his appreciation by having two different pictures from his collection placed on show in his drawing room each day 'for their mutual consideration and benefit'.[22]

* His sight had been affected by a fall from a horse in 1772. Appointed Portrait Painter in Crayons to the King in 1792, he went on exhibiting at the Academy until he went blind in 1797.

He had always been fond of birds. Northcote says that he was devoted at this time to a tame canary, but that one day it escaped through an open window – 'its master wandered for hours in the square before the house in hopes to reclaim it, yet in vain'.[23] There were other ways of filling the daylight hours. 'He now amuses himself by sometimes cleaning or mending a picture,' Mary wrote, 'for his ruling passion still continues in full force.' So did his interest in buying and selling. At Peter Delme's sale at Christie's, in February 1790, his agent Grozier bought on his behalf a study of horses attributed to Van Dyck, now in the National Gallery.

A month earlier, Sheridan, perennially impecunious, had at last scraped together enough to be able to buy the portrait of his wife painted fifteen years earlier. 'I have according to your orders bespoke a very rich frame to be made for Mrs Sheridans Picture,' Reynolds informed him, but he also wanted to impress on him that he was getting a bargain: 'You will easily believe I have been often sollicited to part with that Picture and to fix a price on it, but to those sollicitations I have always turned my deafest ear,' he wrote virtuously:

I really value that Picture at five hundred Guineas – in the common Course of business, (exclusive of its being Mrs Sheridans Picture) the price of a whole-length with two children would be three hundred, if therefore from the consideration of your exclusive right to the Picture, I charge one hundred and fifty Guineas, I should hope you will think me a reasonable man . . .*

In spite of his impaired vision, he continued to give diligent attention to the affairs of the Academy, where he was now to be seen wearing spectacles with one opaque lens. The ranks of those who had been founder members were thinning by the year. Zuccarelli, who had returned to Italy in 1773, had died in 1788, ruined by the suppression of a monastery in Florence in which he had invested his savings. His death was followed early in 1789 by that of Jeremiah Meyer, on whose initiative the Academy's pension fund had been set up in 1775. He had lived latterly at Kew, and was buried in the graveyard there close to Gainsborough. Gainsborough's place among the Forty was filled by William Hamilton, who had made a name for himself with his theatrical portraits but would later turn increasingly to history painting.†

* Letter 191. Twenty-five years later, just before he was imprisoned for debt for the second time, Sheridan sold the portrait. 'I shall part from this Picture as from Drops of my Heart's blood,' he said (letter dated 23 November 1815, reproduced in Wellek and Ribeiro, 319). He did, however, manage to hang on to a copy of it he had commissioned from Sir William Beechey.
† Hamilton (1751–1801) was the son of one of Robert Adam's Scottish assistants and had trained as an architectural draughtsman under Zucchi. He had been exhibiting at the Academy since 1774, and painted a number of large pictures for Boydell's Gallery.

This made necessary an election to fill Hamilton's place as an Associate, and two candidates presented themselves. One was Sawrey Gilpin, an animal painter of some distinction; as a painter of horses, in particular, he was regarded as second only to Stubbs.* The other was an Italian architect called Giuseppe Bonomi, who had come to England in the 1760s at the invitation of the Adam brothers, and whose wife was a cousin of Angelica Kauffmann.

The result of the vote was a tie, and the decision went to Bonomi on the casting vote of the President. It was a decision which came close to blighting Reynolds's remaining time at the Academy.

* He was the younger brother of the Reverend William Gilpin, the writer on the picturesque.

25

Cabals and Juntos

It might have been better if Reynolds had given up the presidency when his sight began to fail. He was now quite elderly, more settled in his ways; he had become, as F. W. Hilles delicately puts it, 'more positive in his opinions and less inclined merely to take snuff or shift his trumpet'.[1] 'Sir Joshua has been shamefully used by a junto of the Academicians,' Boswell wrote to Percy in March 1790, but there was more than one view about that. In those last two years of his life he became involved in a series of painful quarrels with his colleagues at the Academy – quarrels in which he was not always in the right.*

The Bonomi affair had really begun in 1786 with the death of Samuel Wale, the Academy's first professor of perspective.† The story of how matters developed between then and the events of late February and early March 1790 must be pieced together from a variety of sources – Academy minutes, items in the press, accounts left by several of those involved. Northcote's version differs from that of Malone, and Farington, an Academician since 1785, wrote his account because he thought Malone had made unjust accusations against the Academy and 'in the warmth of his zeal for his friend Sir Joshua, departed from his usual prudence and fidelity of statement'.[2] There are also several letters by Reynolds, and the extraordinary manuscript, preserved at the Academy, known as his 'Apologia' – hastily written, sometimes intemperate, not always entirely coherent.‡

* Boswell later changed his mind about the rights and wrongs of the affair. Three years after Reynolds's death, he told Farington that although he had 'serious intentions' of writing his life, he 'hesitated a little' about Reynolds's niece, Mary, 'as in describing the dispute with the Academy he must acknowledge Sir Joshua to have been to blame' (Farington, 1978–84, ii, 319, entry for 27 March 1795).
† Wale had suffered a paralytic stroke in 1778 and from then on had instructed the students by giving private lessons at his home. This did not prevent the Academy appointing him to succeed Richard Wilson as Librarian in 1782; he held both positions until his death.
‡ Quotations from the 'Apologia' are identified by reference to page numbers in F. W. Hilles's *The Literary Career of Sir Joshua Reynolds*, the only place where the text has been published in full, rather than by reference to the confusing collection of folios which constitutes the original manuscript preserved in the Library of the Royal Academy.

There had been no great interest among the ranks of the Academicians to succeed Wale. Reynolds had urged several of them to volunteer – 'begging them', as he put it, 'to accept the place and save the Academy from the disgracefull appearance of there not being any member in it capable of filling this office or that they were too indolent to undertake its duty'.[3] When there was no response, the Council agreed to a proposal – it was made by Chambers – that they should seek a suitable outsider and elect him an Academician: this, he informed his colleagues, was the practice in the French Academy. For a time, the matter was put on the back-burner. Subsequently an offer by Edward Edwards, an Associate since the early 1770s, to teach the students privately, was accepted; this arrangement began in January 1789, and public lectures were for the time being suspended.

Then came the election at which Bonomi was elected an Associate on the casting vote of the President. Farington says the meeting was thinly attended, and that Reynolds 'thought it necessary to apologise' for voting as he had done, explaining that it was with a view to Bonomi's becoming an Academician and therefore eligible for appointment to the chair of perspective:[*]

The members present were surprised at the inconsistency of the President; and it was generally believed, that he had been induced to depart from his usual delicacy on such occasions, by his respect for the Earl of Aylesford and some others, who were the avowed patrons of Bonomi.[4]

Aylesford, then in his late thirties, had developed an interest in architecture during the Grand Tour; he admired Bonomi's work and had enlisted his help with new designs for his seat at Packington Hall in Warwickshire. He was well known to Reynolds, having sat to him twice and himself exhibited at the Academy; they also met at the Society of Dilettanti.

Reynolds complained frequently to his colleagues – rather too frequently for their liking – about the continuing failure to fill the chair of perspective, and he was clearly aware that this was beginning to irritate them. It was, he wrote in the 'Apologia', 'full as disagreable to him to drop council in unwilling Ears as it was irksome to them to hear it'.[5] In defending his persistence, he takes a swipe at Chambers:

. . . it could not be question'd that it was as much His duty as President and general Superintendent, to preserve and keep the Academy in repair, as it would be the duty

[*] Reynolds describes Gilpin in the 'Apologia' as 'an Artist of acknowledged merit' and refers to his giving the casting vote against him as 'a very irksome task' (Hilles, 1936, 254).

of Sir Wm Chambers when a Pillar of the Academy was decayed to supply the deficiency with a new one.[6]

Edwards, eager to secure the chair, had proposed that he should be permitted to deliver what he described as a 'probationary' lecture before the Academicians and Associates. 'He will rest his success,' he wrote, 'on the Judgment of Mr. Thomas Sandby, Mr Richards, Mr Rooker & Mr Bonomi & a fifth Person who is not of the Academy which is Mr. T. Malton, Junior.'* The Council rejected the idea, ruling at a meeting on 11 December 1789 that 'whoever is a Candidate to be an Academician, for the purpose of being hereafter Professor of Perspective: must produce a Drawing'.[7] Edwards, now in his early fifties and an Associate for more than fifteen years, thought this beneath his dignity. 'If specimens are required,' he wrote to Reynolds, 'he is past being a boy and shall produce none.'[8]

When it came to the President's ears that Edwards was not without his supporters, his natural calm and restraint deserted him. John Bacon – the Academician who had been commissioned to execute the monument to Johnson – received a very angry letter:

There is a report circulated by busy people, who interest themselves about what is going on in the Academy with which they have no business That you have declared your intention of giving your vote for Mr. Edwards whether he produces a drawing or not. This report I have treated with the contempt such a calumny deserves, that neither yourself Mr Hodges nor any of the rest of the Council were capable of such duplicity of conduct I repeated to my informer, the Letter which was sent to Mr. Edwards That it was the unanimous opinion of the Council that he could not be a candidate unless &c.

The Gentleman still persevering in his opinion, I beg you would give the means of confuting him under your own hand . . .[9]

In describing the Bonomi affair, Reynolds's 'Apologia' and the accounts of his opponents both draw heavily on the vocabulary of insurrection and revolt. As in revolutionary France, so at Somerset House – the peasantry was restless. The Academicians, like artists in any age, were more likely to be found drilling with the awkward squad than sitting patiently in commit-

* Michael 'Angelo' Rooker (1747–1801) – the middle name was bestowed on him by Paul Sandby, under whom he studied – was a topographical painter who had been an Associate since 1770. He was for several years the principal scene-painter for the Haymarket Theatre. Thomas Malton (1748–1804), like his father an architectural draughtsman, had won the Academy gold medal with a design for a theatre in 1782. Turner, to whom he taught perspective, often said, 'My real master is Tom Malton.'

tee. Their ailing President could no longer, as he had done for more than two decades, effortlessly demonstrate his ascendancy simply by pointing to his latest picture. What they now saw before them was an elderly man with an ear-trumpet and funny spectacles who kept on at them in a not always audible Devonian mumble about the need to fill a vacant professorship – a position, which, as Farington put it, 'was then looked upon rather as a matter of show than of actual use to the students; and on this account there was no desire to fill the vacancy'.[10]

On 7 February, three days before the date appointed for the election, Reynolds received a letter from Chambers. He had, he announced, *'heartily joined in opinion with much the greater number of our members who are convinced that no such election* meaning the professor *can be necessary'.*[11] Reynolds therefore went to the Academy on 10 February – he and Aylesford had met earlier in the day – well aware that he had a fight on his hands, but still reasonably confident that he could command a majority. He very quickly changed his mind. The backwoodsmen – Reynolds's word for them is 'outlyers' – had turned out in force. General meetings of the Academy were normally attended by no more than eighteen, but today there were thirty – 'a greater number than were ever known to have assembled upon any other occasion'. Not only the numbers were different. 'The whole appearance was new to me,' Reynolds wrote in his 'Apologia':

Instead of the members as usual straggling about the room, they were allready seated in perfect order and with the most profound silence. I went directly to the Chair and looking round for the Candidates drawings I at last spyed those of Mr. Bonomi thrust in the darkest corner at the farthest end of the room. I then desired the Secretary to place them on the side tables where they might be seen. He at first appeard not to hear me. I repeated my request. He then rose and in a sluggish manner walked to the other end of the room (passing the drawings) rung the bell and then stood with his folded arms in the middle of the room; Observing this extraordinary conduct of the Secretary, *I found he had joined the Party which I considered as a rebellion . . .*

Reynolds got up and moved one of the drawings to a side table himself. The display of insolence by John Richards both shocked and outraged him:

. . . not deigning to touch them he only said he had rung the bell for the servant, which servant it is curious to remark (as it shows their rude spirit and gross manners of this cabal) was to mount that long flight of steps in order to move two drawings from one side of the room to the other.[12]

Reynolds then formally opened the business of the meeting, but there was worse to come:

As soon as the Prst. sat down, Mr Tyler, an Academician who is & has been long considered as the spokesman of the party demanded in a peremptory tone who ordered those drawings to be sent to the Academy. the President answerd it was by his order. he asked a second time in a still more peremptory tone. the President said I did. I move that they be sent out or turned out of the room. Does any one second this motion –

Then, a surprise: a vigorous show of support for Reynolds from an unexpected quarter:

Mr. Barry rose with great indignation No says he Nobody can be found so lost to all shame as to dare to second so infamous a Motion. Drawings that would do honour to the greatest Academy that ever existed in the world &c. *he said much more with great vehemence.*

A seconder was found, however, and on a show of hands there was a large majority for the removal of the drawings:

The President then rose to explain to them the propriety of Mr. Bonomi's drawings being there to oppose Mr. Edwards which were expected and orderd by the Council but he was interrupted from various quarters / that the business was over, they would hear no explanation, that it was irregular Mr. Copley said to talk upon business that was past & determin'd. The Prest. acquiesced and they proceded in the Election when Mr. Fusely a very ingenious Artist but no candidate for the Professors Chair – was elected an Academician by a majority of 22 against 8 . . .[13]

'The election having terminated,' wrote Farington, 'the President quitted the chair with evident signs of dissatisfaction.'[14] That was a sizeable understatement. Reynolds was not just dissatisfied; he was sick at heart and bitterly angry. The next morning he wrote a letter of apology to Bonomi:

I am sorry for the ill-success we have met with in our business, and that I have been the cause of giving you so much trouble needlessly. I can only say I did not think it possible, to have made such a combination against merit . . . However I may flatter myself in my vain moments that my leaving the Academy at this time may be some detriment to it, I cannot persuade myself any longer to rank with such beings, and have therefore this morning ordered my name to be erased from the list of Academicians.[15]

History was repeating itself, only some of the actors were now cast in different roles. In 1768 democratic stirrings within the Society of Artists had led to the ousting of Chambers, deemed by the membership to be unacceptably autocratic. His quick footwork on that occasion had led to the formation of the Academy, although the Presidency which he coveted had gone to Reynolds. Now he had thrown in his lot with those who believed, as one of them put it, that Reynolds 'had been so long in the habit of dictating from his gilded chair'.

Reynolds's resignation caused a sensation, and all manner of people leapt into print on the subject, in prose and verse of varying quality. One of the more bizarre offerings, from the pen of some poor man's Peter Pindar, essayed a comparison between the head of Reynolds and that of Orpheus, which, when he was torn to pieces, drifted down the stream and was carried to the island of Lesbos:

> Now I've been thinking, if our Reynolds' head
> Should, on his palette, down the Thames drive souse,
> And mindful of the wall he once arrayed
> Bring to, a bit, at Somerset new house;
> What scramblings there would be, what worlds of pains
> Among the artists to possess his brains . . .[16]

The elderly poet and dramatist Edward Jerningham* struck a more elevated note. 'Lines on a Late Resignation at the Royal Academy' dealt severely with the 'wild Faction' who had set out to insult 'the Father of the modern school':

> Mark, mark the period, when the children stung
> The parent's feelings with their serpent tongue;
> It was while dimness veil'd the power of sight,
> And ting'd all nature with the gloom of night.†

Jerningham's (and Reynolds's) friend the Earl of Carlisle – 'a nobleman of Genius', as Northcote generously described him, was also early out of the trap:

* 'A mighty delicate gentleman,' Fanny Burney thought when she encountered him in 1780: 'looks to be painted, and is all daintification in manner, speech, and dress'.

† There could be a connection between Jerningham's poetic support and an undated note to him from Reynolds preserved in the Huntington Library: 'Sir Joshua Reynolds presents his Compts to Mr Jerningham and begs he would make use of his House as his own he has sent the person who keeps his house at Richmond in his absence to receive his friend' (Letter 243). Jerningham is known to have been staying at Richmond with the Earl of Mount Edgcumbe in October 1791 (Bettany, 9, 184, 315, 368).

Too wise for contest, and too meek for strife,
Like Lear, oppress'd by those you rais'd to life,
Thy scepter broken, thy dominion o'er,
The curtain falls, and thou'rt a king no more . . .[17]

Reynolds's opponents did not remain silent, and on the whole displayed more sophisticated forensic and literary skills than his supporters. Northcote, who along with Opie and Barry, had remained in the Reynolds camp,* suspected that Fuseli had a lot to do with an anonymous pamphlet called 'Observations on the Present State of the Royal Academy'. Reynolds's Presidency, it asserted, had been characterized by 'the love of power – the thirst of rule, – and a dictatorial spirit'. His resignation would be entirely to the good, because it would put an end to 'patronage, caprice, and ambition'.

Northcote says that the language in which Reynolds couched his original letter of resignation was 'intemperate' and that he was persuaded to withdraw it.[18] Several days' reflection did nothing to change his mind, even though during that time he had received through Chambers a message to say that the king 'would be happy in Sir Joshua's continuing in the President's chair'. He wrote again to the Secretary on 22 February:

I beg you would inform the Council, which I understand meet this Evening, with my fixed resolution of resigning the Presidency of the Royal Academy, and consequently my seat as Academician. As I can be no longer of any service to the Academy as President, it would be still less in my power, in a subordinate station; I therefore now take my final leave of the Academy with my sincere good wishes for its prosperity, and with all due respect to its members.[19]

He added a postscript: 'Sir Wm Chambers has two Letters of mine, either of which, or both, he is at full liberty to communicate to the Council.' He had written to Chambers because he believed that his reasons for resigning had been misrepresented (it seems likely that he had by then seen the hostile 'Observations' pamphlet). 'I am indifferent about the opinion of such people as I know to be injudicious as the spredders of the Reports

* These three, together with Rigaud, Nollekens and Zoffany, put their names to a strongly worded statement dissociating themselves from the conduct of the majority on 10 February. They were particularly critical of the removal of Bonomi's drawings – 'the irregularity of this proceeding was much aggravated by its having the appearance of offering an unprovoked and unmerited personal insult to the President, from whose performances the Arts have received so much honour, and from whose services the academy has received so many important benefits' (Leslie and Taylor, ii, 583).

are malicious,' he told Chambers, but he was anxious not to be thought unappreciative of the 'gracious and condescending message' he had received from the king:

Lay me most humbly at his Majesty's feet, and assure his Majesty that in quitting the Presidency of the Royal Academy I felt the most sensible pain and that nothing could remove me from it but the certainty that it was absolutely impossible for me to perform my duty any longer.[20]

Chambers had urged him to remain as an Academician, and Reynolds's second letter is mainly taken up with explaining why he would find that impossible. He concludes by reiterating the central reason for his resignation: 'it was done on account of your departure from the most essential rules of the Academy, without the observance of which the choice to officers in the Academy & to the Rank of Academicians itself must in future become a matter of party and Cabal and not of open & honourable competition'.[21]

The tone of these letters is relatively measured. Only from the manuscript of the 'Apologia' can it be seen how profoundly shocked and outraged Reynolds was by what had taken place. It was written in haste and never completed or revised. He seems to have intended to arrange it for publication in two parts, the first explaining the genesis of the dispute and the reasons for his resignation, the second dealing with what lay behind the opposition to Bonomi.

One argument deployed against the election of Bonomi had been that he was a foreigner. 'This extraordinary objection was first started by Sir William Chambers in Council,' Reynolds wrote:

He asked the P. in a peevish tone why he would persevere in favour of this Foreigner but recollecting that a Foreigner Mr Rigaud was present he added, not that I have any objection to foreigners, but that it will appear to the world as if no Englishman could be found capable of filling a Professors Chair. This speech I heard with great surprise and I confess with some indignation in hearing a sentiment which appeared to me so illiberal, and so unworthy the person it came from.[22]

He goes on to point out that Bonomi 'was not a temporary sojourner among us' – he had lived in England for twenty-five years and had an excellent grasp of the language:

I might have added that he probably has been in England as many years as Sir Wm Chambers himself before he was an Academician – how many years Sir Wm. has been in England I never was informed.

This was a shrewd thrust – the Knight of the Polar Star had, after all, been born in Stockholm into a family of Scottish émigrés. 'The intent of the institution was to raise a School of Arts in this Nation,' Reynolds writes, adding, somewhat earthily, 'that if we could accelerate their growth by foreign manure, it was our duty to use it'. And he reinforces the point by informing his putative readers that twenty years previously, when he had been entertained at the famous Gobelins tapestry establishment in Paris, his host had been a Scotsman.[23]

He also tackles head-on the question raised by his opponents of Bonomi's (and his) association with Aylesford – 'a noble Earl for whom I have too great respect to mention his name upon this trivial occasion', as he describes him. 'What in the name of goodness would these Gentlemen be at?' he inquires. 'To be serious, Is it to be a fixed principal with the members of the Academy to set their faces against every artist that has had the good fortune to find a patron?'[24] Another good question for Chambers, who had, after all, been set on the high road to fame and fortune as long ago as 1749 by the patronage of Frederick, Prince of Wales.

'There are offences given and offences not given but taken.' Old Izaak Walton knew about human nature as well as about angling. Reynolds regarded the way in which a motion of thanks had been conveyed to him – it had been passed at the meeting of the General Assembly on 3 March – as downright insulting:

I had the honour of receiving the thanks of the Academy for *the able and attentive manner* in which I had discharged my duty. But as if some daemon still preserved his Influence in this Society, that nothing should be rightly done, those thanks were not signed by the Chairman according to regularity and custom but by the Secretary alone and sent to the Ex President in the manner of a Common Note closed with a Waver and without even an envelope and presented to the Ex president by the hands of the common arrant boy of the Academy . . . Whether this was studied neglect or ignorance of propriety I have no means of knowing.[25]

In a bitter conclusion he once again accuses Chambers of desertion. The manuscript then peters out in an angry jumble of scorn and reproach – 'The whole Fabric, the work of years, was shaken to its very foundation and all its glory tarnishd.' Although no name is mentioned, one particularly savage passage is clearly directed at his bugbear William Tyler, who was an architect, and who some years previously had designed the Freemasons' Tavern in Great Queen Street – 'Men who have been accustomed to lay down the law in Alehouses to Masons & Bricklayers,' Reynolds writes, his syntax collapsing under the weight of his indignation,

'presume to interfere in a higher station where he has crept in by mere accident.'*

There were those who thought Reynolds could have handled matters better. 'Sir Joshua sure has managed ill to have such a majority agt him,' wrote the antiquary Michael Lort, 'and will make me and others not in the least suspect he must have been in the wrong – in chusing a nail that would not drive.'† Even his opponents recognized, however, that the position Reynolds had won for himself in society guaranteed that most people in the wider world would accept his version of events. Edward Gibbon, who was not much interested in the merits of the argument, made the point to him with cynical economy – 'I hear you have had a quarrel with your Academicians,' he wrote. 'Fools as they are! for such is tyranny of character, that no one will believe your enemies can be in the right.'[26]

Something which his enemies fairly quickly realized. After several weeks of to-ing and fro-ing behind the scenes, matters were arranged. 'Every Academician now regretted the unforeseen consequence of the unfortunate disagreement,' wrote Northcote:

however, the whole body shewed so liberal a desire to retain Sir Joshua in the chair, that, after agitating those unpleasant differences between the president and the academy with as much delicacy as possible, it was determined that a delegation of the following gentlemen, to wit, Messrs. West, Farrington, Cosway, Catton, Sandby, Bacon, Copley, Russel, and the Secretary, should wait upon Sir Joshua, and lay before him the resolution which the Academy had come to in order to produce a conciliatory effect.

The resolution in question – it had been proposed by Thomas Sandby – conceded that in directing Bonomi to submit drawings, Reynolds had indeed been acting in conformity with the wishes of the Council:

But the General Meeting not having been informed of this new regulation of the Council, nor having consented to it, (as the Laws of the Academy direct) The generality of the Assembly judged their introduction irregular, and consequently Voted for their being withdrawn. –[27]

* Hilles, 1936, 276. 'Tyler was an odd man,' mused George III years later in conversation with West. 'How came he to be an Academician?' 'When the Royal Academy was formed,' West replied, 'there was not a choice of Artists as at present, & some indifferent artists were admitted' (Farington, 1978–84, vi, 2214, entry dated 8 January 1804).
† Lort was writing to the Shakespearean scholar George Steevens. His letter, which is preserved in the Hyde Collection, is dated 19 February, which was only nine days after the meeting which provoked Reynolds's resignation.

Not the most subtle of face-saving formulae, but it worked:

The above delegates accordingly waited upon Sir Joshua, to entreat him to withdraw his letter of resignation, and resume his situation as President of an institution to which his talents had been so long an essential support. They had an interview with him at his house in Leicester Square, and were received with great politeness; and every mark of respect was expressed by those who had hitherto been deemed least cordial to the interests of the President.[28]

Gorged with humble pie, the delegation waited for their ex-President's response. It came in the form of an expression of gratitude 'for this honourable proceeding towards him' and an invitation to stay and dine – 'in order to convince them that he returned to his office with sentiments of the most cordial amity'.

That return was agreed for 16 March. One of his Johnson nieces happened to be up from Devon at the time and saw him on that day. 'My uncle was in high spirits, and the moment he saw us he began telling us he was going that evening to reassume his seat at the Academy,' she wrote in a letter home:

He told me he would rather have declined accepting it again, as he feels himself getting old: but it was impossible after the concessions they had made him. Indeed he has reason to feel himself in spirits from the honour he gains by this affair, for all the kingdom have been interested about him, and that his resignation would be a public loss. The King has behaved very handsomely to my uncle; at first in expressing his wish that he should not resign; and on Wednesday at the levee, when my uncle's message was delivered to him (I think by Lord Heathfield), whether he had his Majesty's permission to take his seat again, the King bid him 'tell Sir Joshua that it was his most earnest wish that he should do so.'

Reynolds had to leave for the Academy at eight, but he was desperately eager to get in a rubber of cards before he went. 'He is become so violently fond of whist, that he scarcely staid to give the gentlemen (who were dining with him) time to drink their wine,' his niece wrote.

He is not tied down to common rules, but has always some scheme in view, and plays out his trumps always; for it is beneath his style of play ever to give his partner an opportunity of making his trumps: but notwithstanding, he generally wins from holding such fine cards. I was very sorry I did not sit up to hear what his reception had been; but I knew that as there would be just a sufficient number to make a

card-table after his return, there would be no getting away from him till a very late hour.[29]

By the time he came to give his fifteenth Discourse at the end of the year, Reynolds seemed disposed to brush the Bonomi affair aside as no more than a little local difficulty:

Among men united in the same body, and engaged in the same pursuit, along with permanent friendship occasional differences will arise. In these disputes men are naturally too favourable to themselves, and think perhaps too hardly of their antagonists. But composed and constituted as we are, those little contentions will be lost to others, and they ought certainly to be lost amongst ourselves, in mutual esteem for talents and acquirements: every controversy ought to be, and I am persuaded, will be, sunk in our zeal for the perfection of our common Art.[30]

Well, perhaps. But it is not certain that in the two years of life that remained to him it was ever 'glad confident morning again'. For all his appearance of magnanimity, there is evidence to suggest that Reynolds remained bitterly contemptuous of his colleagues at the Academy. Benjamin Haydon heard the story from Bonomi many years later and noted it in his diary. Reynolds had pointed one day to a hackney coachman in Leicester Fields. 'I would sooner belong to a club of such people as these,' he said to Bonomi, 'than to that body.'[31]

26

The Bending Sickle

As balm for a bruised presidential ego, it could hardly be bettered – a gold snuff-box, set in diamonds and adorned with the profile of the Empress of All the Russias. It contained, what's more, a slip of paper with a message in her Imperial Majesty's own hand: 'Pour le Chevalier Reynolds en temoignage du contentement que j'ai ressentie à la lecture de ses excellens discours sur la peinture.'* With fan mail from Catherine the Great to show to one's friends, the Knight of the Polar Star and his treacherous junto suddenly seemed rather small beer.†

When *The Infant Hercules* had finally been shipped off to St Petersburg the previous year, it had been accompanied by a long letter, in slightly suspect French, to Potemkin.‡ With it, Reynolds enclosed two copies of the Discourses – the first seven, that is to say, which had been collected and published in 1778. He informed the Empress's lover that this first volume had been dedicated to the king of England and begged permission to dedicate the second to the Empress.

The snuff-box had been delivered by Count Vorontsov, the Russian minister in London. He also left with Reynolds a copy of the flattering covering letter he had received from the Empress. Reynolds clearly felt that this deserved a wider readership than the circle of his friends, and an English translation found its way into the following day's *London Chronicle*:

I have read, and, I may say, with the greatest avidity, those discourses pronounced at the Royal Academy of London, by Sir Joshua Reynolds, which that illustrious

* 'For Sir Joshua Reynolds in recognition of the pleasure afforded by his excellent discourses on painting.'

† At a dinner party several years after Reynolds's death at which Farington was a guest, Desenfans described how on the day he had received the snuff-box, Reynolds had called on him 'in a transport of Joy, flattered by so high a compliment' (Farington, 1978–84, iii, 1088, entry dated 10 November 1798).

‡ Letter 188. The letter, now in the Hermitage Museum, is not in Reynolds's own hand.

artist sent me with his large picture; in both productions one may easily trace a most elevated genius.

I recommend to you to give my thanks to Sir Joshua, and to remit him the box I send, as a testimony of the great satisfaction the perusal of his Discourses has given me, and which I look upon as, perhaps, the best work that ever was wrote on the subject . . .[1]

Reynolds was extraordinarily slow to acknowledge this mark of royal favour – his letter is dated 6 August. 'The approbation which your Imperial Majesty has been graciously pleased to express of the Academical Discourses which I presumed to lay at your Majesty's feet, I truly consider as the great honour of my Life,' he wrote:

That condescending acceptance of my attempts raises me in my own estimation & must of course advance my reputation in the Eyes of my Countrymen. Your Imperial Majesty has left nothing undone to give all possible lustre to this most gracious mark of your protection by the magnificent present which encloses it. This I shall carry about as my title to distinction & which I can never produce but with a sight of that August personage who whilst by her wise government she contributes to the happiness of a great portion of mankind under her dominion, is pleased to extend her favorable influence, to whatever may decorate Life in any part of the World, that whilst I endeavour to demonstrate my gratitude for the distinction I have received I may have further motives to such gratitude by receiving accessions to my reputation, & that Posterity may know (since now I may indulge the hope that I may be known to Posterity) that your Imperial Majesty has deign'd to permit me to sollicit the patronage of a Sovereign to whom all the Poets, Philosophers, & artists of the time have done homage & whose approbation had been courted by all the Geniuses of her Age. With every sentiment of profound veneration and attachment I am your Majesty's most humble & most devoted Servant.[2]

To Reynolds's request to be allowed to dedicate the Discourses to Catherine, no reply has been traced, and in the event he never brought out a second volume. That was not the end of his dealings with the Russian court, however. Soon afterwards, Catherine decided that she would like to be able to call on the services of a resident British portrait painter. Vorontsov consulted Reynolds over dinner on 23 May and received a speedy response:

Sir
In consequence of the conversation which I had the honour of having with your Excellence on Sunday last I have spoken to Mr Lawrence. He says his engagements are such that he could not be absent from England above one year, He wishes

therefore to know whether that time would be sufficient, or whether it is expected that he should reside in Russia a longer time.[3]

Nothing came of the idea.* Lawrence had been extravagantly praised for the works he had submitted to that year's exhibition and commissions were flowing in much as they had done to Reynolds thirty years previously. His portrait of Queen Charlotte, now in the National Gallery in London, was almost universally admired, although not, it seems by the royal family[†]; that of Elizabeth Farren, at that time the mistress, later the wife, of the Earl of Derby, captivated everyone except the subject herself, but that appears to have had little to do with its merits as a painting and everything to do with its title, which was simply *Portrait of an Actress*. Lawrence, who was a quick study, saw to it that in later editions of the catalogue this became *Portrait of a Celebrated Actress*.[‡]

Reynolds was much too old a hand to make such an elementary mistake. He too exhibited a theatrical portrait, but his picture of the actress and singer Elizabeth Billington, in which he depicted her, surrounded by cherubs, as St Cecilia, carried the title *Portrait of a Celebrated Singer* from the start.[§] It was hung in the Great Room not far from Lawrence's *Farren*, and it is said that at the private view Reynolds found generous things to say to his young rival. 'In you, Sir,' he declared, 'the world will expect to see accomplished what I have failed to achieve.'[¶] He did not exhibit again.

Relations with Chambers remained strained. He too was now in indifferent health, increasingly plagued by asthma and intolerant of what he saw as breaches of protocol. The removal of a picture of the Duke of Gloucester from the exhibition – the reason remains obscure – earned Reynolds a sour note from him:

* Reynolds and Carysfort subsequently put their heads together and came up with the name of Hoppner, but that too came to nothing.

† Possibly because Lawrence painted what he saw too faithfully. 'Her Majesty's nose, indeed, appears sore from taking snuff,' wrote the *English Chronicle*, 'but that is not the fault of the painter' (Whitley, 1928, ii, 131).

‡ Lawrence claimed that it had been sent in as *Portrait of a Lady*, but that it had been altered by an official of the Academy. The painting is now in the Metropolitan Museum, New York.

§ Mannings, cat. no. 172, fig. 1557. The picture is now in the Beaverbrook Art Gallery, Fredericton, New Brunswick. 'Sir Joshua's portrait of Mrs Billington failing to answer most people's expectations,' said a paragraph in the *Public Advertiser* on 6 May, 'Sir Joshua said smartly – "I cannot help it – how can I paint her *voice*?" ' Haydn was in London at that time, and Whitley says that Mrs Billington took him to Leicester Fields to see the portrait. 'It is like,' he said, 'but there is a strange mistake.' 'What is that?' asked Reynolds. 'You have made her listening to the angels; you should have made the angels listening to her' (Whitley, 1928, ii, 129).

¶ Whitley, 1928, ii, 129. He is, of course, said to have made a similarly flattering remark to Opie some years previously.

I am very much Surprised to find a picture taken out of the Exhibition by Your private Order, Contrary to a positive law of the Academy, it is a precedent which may be attended with very ill consequences, and a Stretch of power in You, which it will be difficult to Justify. You had an excuse at hand, and I cannot help wondering You did not Make use of it.*

There was choppy water at the Academy again later in the year when the king, greatly taken with Lawrence, tried to engineer his election as an Associate. The records of the Academy are discreetly silent on the detail of the affair, but there was some press interest, and the *Public Advertiser* carried an account of what had transpired on 1 November when the Academicians met to fill the vacancy:

Sir Joshua Reynolds informed them that his Majesty had spoken in very warm terms in favour of Mr Lawrence, whose early display of genius has been so much admired, declaring that it was the Royal desire that the Academy should afford its countenance to such distinguished talents, and enrol the artist as soon as an opportunity offered among its highest members.

Reynolds had plainly been aware that he was treading on dangerous ground:

Sir Joshua added that he had asked his Majesty whether he should communicate such a message to the Academy, and it was by his Majesty's orders that he had addressed them on the subject.

The meeting showed what it thought of being addressed 'by his Majesty's orders' by casting one vote for Gainsborough Dupont, three for Lawrence, four for Beechey and sixteen for Wheatley. Peter Pindar was moved to compose an ode entitled 'The Rights of Kings':

> How, Sirs! on Majesty's proud corns to tread!
> Messieurs Academicians, when you're dead,
> Where can your Impudencies hope to go?
>
> Refuse a Monarch's mighty orders!—
> It smells of treason – on rebellion borders! . . .

* Reynolds, 1929, 256. Reynolds simply endorsed the letter 'Sir Wm Chamber / Duke of Glocester / Picture / May 27 /1790'.

Go, Sirs, with halters round your wretched necks,
Which some contrition for your crime bespeaks,
 And much-offended Majesty implore:
Say, piteous, kneeling, in the Royal view –
 'Have pity on a sad abandon'd crew,
 And we, great King, will sin no more:
 Forgive, dread Sir, the crying sin,
 And *Mister* LAWRENCE shall come in.[4]

Which indeed he did, just a year later, by twenty votes to twelve.

Reynolds was also now experiencing some difficulty in persuading his fellow members of the merits of those he proposed for the Club. Perhaps in return for his poetic support over the Bonomi business, he had nominated his friend the Earl of Carlisle, but at a meeting on 1 June he was not successful. Six months later General Burgoyne, whose nomination by Boswell had been seconded by Reynolds, was up for election. 'I was sadly mortified at the Club on Tuesday, where I was in the chair,' Boswell wrote to Malone, 'and on opening the box found three balls against General Burgoyne.' Another of Reynolds's candidates was Dr Charles Blagden, the Secretary of the Royal Society. Johnson, years previously, had pronounced him 'a delightful fellow,' and he was a corresponding member of the Académie des Sciences in Paris, but he too was rejected, prompting Reynolds to move that one blackball should not exclude a candidate.* He was equally unsuccessful with his next nomination, French Lawrence, early in 1791. 'Sir Joshua has put up Dr Lawrence,' Boswell told Malone, 'who will be blackballed as sure as he exists.' Which he was; he did not succeed in becoming a member until 1802.†

No longer able to do any serious work in his painting room, Reynolds did occasionally take up his pen, and to some effect. Boswell records in his diary that on 9 September 1790 he played whist at Leicester Fields, and that after supper his host 'entertained Dr Lawrence and Malone and me with a dialogue which he had composed between himself and Dr Johnson'.[5] This was the time at which Boswell was reading aloud the proof-sheets of the

* Blagden, who was later knighted, was finally elected in March 1794, two years after Reynolds's death. He was a frequent guest at Reynolds's house, and he was rumoured to be one of Mary Palmer's many admirers; in the summer of 1791 there was talk in the press of an engagement. Edward Eliot, the son of Reynolds's old friend, was also said to have been a suitor, but in the event he married Pitt's sister, Harriet.

† Reynolds was also unsuccessful in proposing his friend Philip Metcalfe, who had recently been acting as treasurer to the committee for Johnson's monument and would shortly become the MP for Plympton.

Life to Reynolds, and it may well have been this which turned his mind to witty but affectionate reflection on the foibles of his old friend. Two such dialogues were among the vast horde of Boswell papers that came to light in a stable loft at Malahide Castle during the Second World War. Essentially, they are an amplification of a remark by Reynolds quoted by Boswell – 'that Johnson considered Garrick to be as it were his *property*. He would allow no man either to blame or to praise Garrick in his presence, without contradicting him.' In the first dialogue Reynolds himself tries, unavailingly, to wring out of Johnson a single good word about Garrick; in the second, when Gibbon attempts constantly to belittle him, Johnson enters a vigorous defence of his fellow townsman and former pupil:

GIBBON. I think he had full as much reputation as he deserved.
JOHNSON. I do not pretend to know, Sir, what your meaning may be by saying he had as much reputation as he deserved. He deserved much, and he had much.
GIBBON. Why, surely, Dr. Johnson, his merit was in small things only. He had none of those qualities that make a real great man.
JOHNSON. Sir, I as little understand what your meaning may be when you speak of the qualities that make a great man. It is a vague term. Garrick was no common man . . .[6]

In December Reynolds delivered his fifteenth Discourse. 'My age, and my infirmities still more than my age,' he told his audience, 'make it probable that this will be the last time I shall have the honour of addressing you from this place.' The evening was eventful in more senses than one. Dr Burney was in the audience (Reynolds had reserved 'a very good seat' for him), and he sent a lively account of the occasion to Fanny. 'There were fewer people of fashion & dilettanti there than usual, though a croud of young Artists & mixtures,' he wrote:

Sir Jos. had but just entered the room, when there happened a violent and unaccountable crack wch. astonished every one present. But no enquiry was made or suspicion raised of danger till another crack happened, wch. terrified the Compy. so much that most of them were retreating towards the door with great precipitation, while others call out – gently! gently! or mischief will be anticipated. Well – no acct. arriving of the cause of this Alarm – we looked at each other (I mean those who had the courage or the folly if you will to stay) as much as to say, won't *you* go first, & shew the example? But nobody had the courage to leave Sir Joshua in sight of 2 or 300 people, & we staid in spite of prudence & the suggestion of fear till the whole of an excellent discourse was read to a very turbulent audience (I mean of young students & other

behind) who seemed unable to hear & diverted themselves with conversation & peripatetic discourses more audible than that of poor Sr. Jos . . .*

Reynolds had prepared himself with characteristic thoroughness for this last performance, and pronounced himself modestly pleased with what he had achieved over the past twenty years:

In reviewing my Discourses, it is no small satisfaction to be assured that I have, in no part of them, lent my assistance to foster *newly-hatched unfledged* opinions, or endeavoured to support paradoxes, however tempting may have been their novelty, or however ingenious I might, for the minute, fancy them to be; nor shall I, I hope, any where be found to have imposed on the minds of young Students declamation for argument, a smooth period for a sound precept.†

The heart of the Discourse, however, is an extended and passionate appreciation of Michelangelo – if Burney's 'young Artists and mixtures' had paid more attention they would have learned much:

That Michael Angelo was capricious in his inventions, cannot be denied; and this may make some circumspection necessary in studying his works; for though they appear to become him, an imitation of them is always dangerous, and will prove sometimes ridiculous. 'Within that circle none durst walk but he.'‡ . . .

Many see his daring extravagance, who can see nothing else. A young Artist finds the works of Michael Angelo so totally different from those of his own master, or of those with whom he is surrounded, that he may be easily persuaded to abandon and neglect studying a style, which appears to him wild, mysterious, and above his comprehension, and which he therefore feels no disposition to admire . . .[7]

* Hilles, 1936, 182–3. Recollections differed as to exactly when the 'unaccountable crack' occurred. Northcote says it was 'when Sir Joshua was delivering his oration'. Burke, on the other hand, who subsequently called the attention of the Commons to the state of the fabric of Somerset House, said in his speech that it happened as Reynolds was handing the medal for historical painting to Henry Howard.

† Reynolds, 1959, 269. Reynolds is adapting Polonius's advice to Laertes:

> The friends thou hast, and their adoption tried,
> Grapple them to thy soul with hoops of steel,
> But do not dull thy palm with entertainment
> Of each new-hatched unfledged comrade.
> (*Hamlet*, I, iii, 62–5)

‡ The line is from Dryden's 'Prologue to *The Tempest*':

> But *Shakespear*'s Magick could not copy'd be,
> Within that Circle none durst walk but he.

He acknowledges that there are great difficulties to be faced – 'The style of Michael Angelo, which I have compared to language, and which may, poetically speaking, be called the language of the Gods, now no longer exists, as it did in the fifteenth century.' But by constant study of his works, a relish for the style may be acquired; the student will develop 'a power of selecting from whatever occurs in nature that is grand' and will reject whatever is commonplace or insipid.[8]

Reynolds recognizes that in tendering such advice, he has laid himself open to 'the sarcasms of those criticks who imagine our Art to be a matter of inspiration.' But he reminds his hearers that Michelangelo was distinguished from his earliest years by his 'indefatigable diligence'; he appeared, throughout his life, 'not to have had the least conception that his art was to be acquired by any other means than by great labour'.[9]

He moves to his conclusion. Even today, after more than 200 years, it reads poignantly. He trusts it will not be thought presumptuous if he ranges himself in the train of Michelangelo's admirers – 'I cannot say of his imitators':

I have taken another course, one more suited to my abilities, and to the taste of the times in which I live. Yet however unequal I feel myself to that attempt, were I now to begin the world again, I would tread in the steps of that great master: to kiss the hem of his garment, to catch the slightest of his perfections, would be glory and distinction enough for an ambitious man.[10]

Burke was in the audience, and at the end of the Discourse he went up to Reynolds, and, taking him by the hand, declaimed some lines from *Paradise Lost*:

> The Angel ended, and in Adam's ear
> So charming left his voice, that he awhile
> Thought him still speaking, still stood fix'd to hear.

It is not known how well Burke recited poetry; we do know that his contemporaries generally preferred to read his orations than to hear them;* his affecting tribute to Reynolds for the largely inaudible Discourse which he had just delivered was therefore not without a comic aspect.

* Thomas Erskine told Richard Rush, the one-time American minister to Great Britain, that Burke's delivery was execrable, and that his great speech on American conciliation largely emptied the House. 'I wanted to go out with the rest but was near him and afraid to get up. So I squeezed myself down and crawled under the benches like a dog until I got to the door without his seeing me, rejoicing in my escape.' He conceded, however, that the printed version was a very different matter: 'I carried it about and thumbed it until it got like wadding for my gun' (Whitley, 1928, ii, 136).

Burney, Boswell and others also went up to the tribune to say appropriate things, and Reynolds declared they had paid him the highest possible compliment by staying 'perhaps at the risk of our lives' – some of the principal arches of Somerset House had given way two years previously. Reynolds and his friends moved towards the door:

As we were descending . . . Barry the painter met us on the stairs, and said that our danger had been very real, and our escape fortunate; for he had been examining the room under the exhibition room & found that the chief beam had given away! – why it did not go further, especially after the 2nd crack, I know not –[11]

Here and there in Northcote there are passages which suggest that Reynolds was not above gently pulling his old pupil's leg from time to time. He observed to him on this occasion that if the floor had collapsed, most of those present would certainly have been crushed to death – 'and if so', he added dramatically, 'the arts, in this country, would have been thrown two hundred years back'.[12]

Reynolds's friends increasingly exerted themselves to provide him with diversion and entertainment. New Year's Day 1791 found him setting out to spend a week at Beaconsfield with the Burkes, and as he waited for his coach to be brought to the door, he snatched a moment to explain to Lady Ossory that this precluded him from accepting her invitation to visit Ampthill. He also had to thank her for a tambour-worked waistcoat she had sent him:

I really think, as it is the work of Your ladyships own hand, it is too good to wear. I believe I had better put it up with the Letter which accompanyed it, and shew it occasionally as I do the Empress of Russias Box and letter of her own hand writing.

I will promise this at least that when I do ware it I will not take a pinch of snuff that day – I mean after I have it on,
Such a rough beast with such a delicate wastcoat.[13]

Lady Ossory was not to be denied, however. She renewed her invitation in a letter to Beaconsfield, enclosing with it a copy of the prologue to a play by her brother-in-law, Richard Fitzpatrick, which was to be acted at Ampthill the following week. Reynolds capitulated by return:

Madam
Your eloquence is irresistable. I am resolved to set out next Monday, and call in my way at Woburn Abby* and from thence gladly accept of Your Ladyships kind offer of a conveyance to Ampthill.

* To take up yet another invitation, this time from the Duke of Bedford.

Perhaps if I was cunning I should throw some difficulties in the way, and by that means procure more flattering Letters, and more good Verses, but I have heard say that too much cunning destroys its own purpose, and I fear that my coyness in the present case would make you all so angry, that you would never more invite me or think me worth saying a civil thing to, which would break my heart.[14]

It is plain that Reynolds now believed that it was only a matter of time before his sight failed completely. While he was at Beaconsfield he had spent some time discussing a memorial to Burke's sister, Juliana, Mrs Patrick French, who had died the previous year, and on his return to London at the end of the month he wrote to Burke to report progress:

I have settled every thing with Bonomi relating to the Obelisk. I represented to him the shortness and uncertainty of life, I cannot boast indeed that I said anything new on the subject, except what related to myself, that I wished to *see* it up, and therefore beged it might be done as soon as possible.[15]

The fifteenth Discourse was not the last thing Reynolds wrote. It was almost impossible in the early months of 1791 to avoid discussion of the French Revolution. Reynolds might be a Whig in politics, but by temperament he was profoundly conservative. Burke's *Reflections* had been published the previous October, and Reynolds shared his view that from the imposition of an artificial equality and the mindless destruction of the past there could result only tyranny and bloodshed. He seems to have spent some time ordering his own thoughts on the subject; on the back of two of the pages on which his niece Mary had made a fair copy of the fifteenth Discourse, he began to sketch a thesis on why it was that the old regime had come to grief on the other side of the Channel. The Bourbons had devoted undue attention 'to the splendor of the foliage, to the neglect of the stirring the earth about the roots', he argued:

They cultivated only those arts which could add splendor to the nation, to the neglect of those which supported it – They neglected Trade & substantial Manufacture, for the sake of supporting the large looking Glass Manufacture the Tapestry of the Goblins and the Seve Manufacture which was a loosing trade and could not have continued a year without the aid of the Crown – The trade of France was at last reduced to mere baubles ... The people who require Baubles are few and consequently little revenue is acquired to the general purse, the nation can no longer go on. but does it follow that a total revolution is necessary that because we have given ourselves up too much to the ornaments of life, we will now have none at all ...[16]

Sometime in the course of 1791 Reynolds also used the verso of his final Discourse to draft a more substantial essay. This too reflected, although more obliquely, on the drama that was unfolding in France. He explains in a preface that this 'ironical discourse' grew out of a conversation on Burke's *Reflections* – a conversation which turned 'on the power which is lodged in majorities'. Although he describes it as a 'playful trifle', he says that he is persuaded by his friends 'to let it bring up the rear of his last volume'. He had already asked Malone to be his literary executor, and he was busy revising the text of the Discourses for inclusion in a collected edition of his writings.

He sets out his aim in his preface:

. . . he would undertake to write a discourse on those obvious and vulgar principles, which should come home to the bosoms of the ignorant (which are always the majority) and which should be thought to contain more sound doctrine than those which he had delivered at the Academy; and such doctrine, proceeding *ex cathedra*, would probably so poison the minds of the students as might eventually keep back the harvest of arts which we expect from the nation, perhaps for fifty years.[17]

He then proceeds to stand on their heads a selection of the most important principles and arguments which had formed the bone structure of the doctrine he had dispensed from the President's chair over so many years:

We know that if you are born with a genius, labour is unnecessary; if you have it not, labour is in vain; genius is all in all.

What is the use of rules, but to cramp and fetter genius? The rules which dull men have introduced into liberal arts smother that flame which would otherwise blaze out in originality of invention.

It is necessary that you should be aware that our art is in a corrupted state, and has been gradually departing from simple first principles ever since the time of Michael Angelo, the first grand corrupter of the natural taste of man.

It has often been remarked by many of our learned connoisseurs that painters are the worst judges of pictures; and the reason why they are so, is from their imbibing prejudices. A man who never saw a picture is therefore the best judge.

Let us imitate the great Mirabeau.* Set fire to all the pictures, prints, and drawings of Raphael and Michael Angelo; *non talis auxilio.†* Destroy every trace that remains

* Mirabeau, although a member of the aristocracy, had been elected to the Third Estate for Aix in 1789. Quick-witted, disorganized, venal, he emerged during the sessions of the Estates General as a leading advocate of the rights of the new National Assembly against royal opposition. He died in April 1791.

† 'They are of no use to us.' Reynolds is quoting from the *Aeneid*, II, 521.

of ancient taste. Let us pull the whole fabric down at once, root it up even to its foundation. Let us begin the art again upon this solid ground of nature and of reason. The world will then see what naked art is, in its uneducated, unprejudiced, unadulterated state.[18]

The business of the cracked beam at Somerset House had made Chambers the object of what one newspaper called 'much indecent sarcasm and obloquy'[19] and he had moved swiftly to ward off damage to his reputation by inviting a group of well-known architects and surveyors to examine the state of the floor in the exhibition room. (Rather surprisingly the group included his arch-rival Robert Adam, whom he had long been suspected of keeping out of the Academy.) They had reported early in January that in their opinion there had been no danger to the floor from the weight that was on it at the time the noise was heard: 'we also find that such precautions have since been taken, as must effectually preclude every cause of alarm in future.'[20]

This does not, however, seem to have satisfied the Lords Commissioners of the Treasury, who asked for a second survey of the whole of Somerset House. The result of this was submitted to them in the middle of March but not immediately made public. As the time of the exhibition grew near the Academy obviously detected some lingering anxiety about safety; on 20 April Reynolds wrote on the Council's behalf to ask that the report should be published. The Treasury agreed, and it appeared in several newspapers the following week. The group had examined Chambers's plans and con- sulted the Clerks of the Works and several of the principal workmen. They had found nothing amiss: 'We are of opinion that the general construction of the Buildings we have surveyed, and the execution of their various parts, have been attended to and performed in a substantial and workman-like manner.'

Not everyone was convinced; that at least was one reason adduced for the poor attendance in the early days of the exhibition. The opening was also delayed because the king declined to pay his customary visit during Holy Week.* The press could summon up no great enthusiasm for what was on offer. The critic of the *Evening Mail* was in no doubt about why the walls of Somerset House seemed so blank and featureless:

If Sir Joshua Reynolds feels an higher sense of his personal fame, than the reputation of the Academy over which he has so long presided, he will certainly experience no common exultation, on perceiving what is so evident to every one, – that the first

* It was customary for the theatres to remain closed during Holy Week at this time.

exhibition which has been offered to the public, in which his works do not appear, is the worst, in every branch of the art, that has invited the attention of the public since the establishment of the Royal Academy.

When the President's works were seen in every part of the Exhibition, we have heard it frequently observed, that he engrossed the walls, as it were, to himself, – to the exclusion of emulating genius, of which he was jealous, or the misplacing of merit, that claimed some share of the attention which he considered as due to none but himself. It may now be seen, however, whether such a complaint was founded in justice, in ignorance, or in envy.

Envy was quick to find another focus, however. The previous year the French painter Jean-Laurent Mosnier had fled to London. An Academician, and *peintre de la reine* to Marie-Antoinette, he had installed himself at 50 Leicester Fields, a few doors away from Reynolds. The speed with which he had attracted valuable English patronage aroused jealousy, as did an invitation to attend the Academy banquet.* When nine of his pictures were accepted for the exhibition, there was a paragraph in one of the papers charging Reynolds with favouritism, and referring sneeringly to Mosnier as his 'élève'.†

Another exhibition, which had opened earlier in the month, may also have had the effect of denting attendance at the Academy. Reynolds still derived pleasure from his collection of paintings, and as late as the spring of 1791 his agent, Grozier, was active on his behalf in the salerooms, acquiring four lots for him at Richard Dalton's sale at Christie's early in April. His mind had already turned to its disposal, however, and his initial thought had been to offer it to the Academy. Details of what he proposed are sketchy; Northcote says that he named 'a very low price' but made a condition that the Academy would acquire the Lyceum in the Strand as an exhibition room. A draft note survives which indicates that Reynolds had given the matter a good deal of thought and that he was reasonably confident that his offer would be accepted:

It is proposed to annex the whole Premises called the Liceum to the Royal Academy, for the purpose of placing the Laacoon and other large Casts which they hope to procure, and for which they have not room in the Academy. there is likewise wast ground on those premises on which may be erected a large room which may serve

* Among artists, the only outsider previously honoured with such an invitation had been Allan Ramsay.

† Whitley, 1928, ii, 141. Mosnier stayed in London until 1796. Later he went to Hamburg, and then to St Petersburg, where he was made a professor at the Academy. He died there in 1808.

either for a Painting room if the Keeper of the Academy be an Historical Painter or for a shop if he be a Sculptor, there will [be] sufficient Space likewise to erect sheds which may serve as lumber rooms which are likewise wanted to the Academy.[21]

The Academy decided against the idea, largely it seems on grounds of expense. Another, much corrected, rough draft has survived which shows that Reynolds was both disappointed and indignant:

This project was not receiv'd with that warmth as I thought I had reason [to] expect in short it was rejected the great expence of the Room and servants was made indeed the principal objection, if the expence was thought too much for a Royal Academy it may well be thought too great for an individual to bear, It becomes therefore necessary that the public or that part [that] take a pleasure in Picture[s] pay the expences . . .

It is not altogether clear from those brooding phrases how Reynolds's mind was moving at that point, but what he did was to rent two large rooms in the Haymarket and put on display 176 paintings, three drawings and his Bernini sculpture. The catalogue was entitled 'Ralph's Exhibition'. The proceeds from the admission fee of a shilling were to go to Reynolds's long-time servant Ralph Kirkley.*

Reynolds compiled a catalogue, for which there was no charge. Prices were available on request, but he valued three of the pictures so highly that they were not for sale. None of these is today accepted for what Reynolds believed them to be. He was convinced that the picture described in the catalogue as *Lionardo da Vinci – The Giocondo*, which he had been given by the Duke of Leeds, was the original *Mona Lisa*. Now in the collection of Lord Brownlow, it carries the attribution 'after Leonardo'. Reynolds similarly believed that *The Marriage of St Catherine*, for which he had paid 200 guineas at Christie's three years previously, was the original by Correggio, rather than the version at Naples. Now described as 'after Correggio', it is in the collection of the Duke of Northumberland.

The third of Reynolds's swans which has turned out to be a goose was precisely that – the *Leda*, now in the National Gallery in London, which today carries only an 'after Michelangelo' attribution.† Whoever painted

* 'This was never intended as a scheme of getting mony,' says another rather puzzling note at Yale, 'but mony at any rate must be taken for the same reason it is taken at the Exhibition even of a R.A. as no other means can be suggested to keep out the Mob.'

† Although there is some evidence that Rosso Fiorentino (1494–1540) made a copy of Michelangelo's *Leda*, the Gallery believes that the stylistic evidence for attributing it to him is inconclusive and the circumstantial evidence weak.

it, this highly explicit treatment of the Leda and the Swan myth excited a good deal of comment, some of it rather crude. The *Public Advertiser* published some 'Verses to Ralph', which concluded:

> However Ralph, your Exhibition,
> Is, I confess in good condition;
> But tell me truly how come you,
> So very *strong* a thing to do
> As shewing Leda and the swan,
> For Miss to peep at through a fan.*

When the original was at Fontainebleau, Des Noyers, Louis XIII's *Surintendant*, had tried to have it destroyed as immoral. Reynolds stated that he had acquired the picture 'by the favour of the present Earl Spencer', although he did not say how or when. An unidentified contemporary press cutting preserved at the Courtauld Institute (it is dated 1791 in ink), says that it used to hang in the dining room at Althorp:

– the Dutchess of Devonshire, then a child, one day called to her mother, Lady Spencer, in the presence of a large company – 'La Mamma, what is that *goose* come to that *Lady* for?' In consequence of this innocent question, it was thought proper to remove it into a garret.†

Bernini's Neptune, which had cost Reynolds 700 guineas five years earlier, and which he had told the Duke of Rutland he hoped to be able to sell for 1,000 guineas, carried a price tag of 1,500 guineas. It remained unsold, as did almost everything else. Although about two dozen of the paintings do not show up in the succession of sales at which the collection was dispersed after Reynolds's death, that could be accounted for in part by changes in attribution. Only two of those exhibited in the Haymarket can be shown conclusively to have been sold. Sir William Hamilton became the owner of the *Portrait of Helena Fourment*, now in the Barber Institute of Fine Arts at the University of Birmingham,‡ and the Earl of Darnley bought *Summer, Represented by Boys Reaping*.§ Both believed they were acquiring works by Rubens. In neither case is that attribution accepted today.

* 16 April 1791. 'Strong' sometimes carried the sense of 'coarse' or 'gross'.
† Courtauld Newspaper Cuttings, I, 100. When the Duke of Northumberland gave the picture to the National Gallery in 1838, he expressly stated that it was not suitable for public display. The Gallery did not include it in its catalogues until 1915.
‡ It was described in Reynolds's catalogue as 'Rubens – Rubens Wife'.
§ Now entitled *Cupids Harvesting*, the picture is in the Alleyn's College Collection at Dulwich.

If the object of the exercise had been purely to raise money, Ralph's Exhibition was clearly a disaster, but the manuscript notes preserved at Yale suggest that that was not Reynolds's sole concern. There are sequences which read quite coherently – passages cut from the draft text of the catalogue perhaps, or intended for publication in a newspaper or elsewhere. In other passages, the jumbled, disjointed prose almost suggests someone who is parting company with reality; if he was not disoriented, he was certainly extremely agitated:

I do not expect many, tho the Exhibition is crouded pe[o]ples curiosity are excited to see of the state of the Arts and judge themselves of the emulation of living artist[s] and care but little for the works of the dead of which they wou[l]d have neither tats[e] or judgment, none but real lovers will desire to [see] it & those do not make the bulk of the people . . .

Another more coherent fragment suggests that he had it in mind to set up some sort of permanent exhibition open to the public:

The Palaces of Rome that have Collections of Pictures or Statues are allways open allways to be seen at the fixed price for the servant of three Pauls which is little more than a shilling English . . . and [on] a very slender recommendation any student/ Person has leave to copy what Picture he pleases the want of this advantage in England is much to be regretted. this project is therefore undertaken in order in some measure to supply this deficiency . . .

In another paragraph he seems to be toying with the idea of setting up in competition with the Academy schools, with himself as some sort of resident guru:

In the large Room which is already built S.J.R. proposes to hang up all his Collection of Pictures of which Collection he will write for the use of the Students a Catalog[u]e Raisonee but so far different from those which generally goes under that name that instead of solely giving encomiums to what is excellent and worthy of attention, he will as liberally/carefully bestow his Censure of their defects. The younger students to whom it may be usefull to copy, shall have that liberty, on which Copys and of their work when finished or in its progress Sir J. will be allways ready to give his opinion and assistance . . .

Of this phantom Academy, nothing more was heard.

The saga of the monument to Johnson continued to unfold in majestic slow motion. Something over £700 had now been raised, but in the

meantime Reynolds had come to the view that St Paul's was to be preferred to the Abbey. The committee was divided, with Banks and Metcalfe still strongly in favour of the original proposal. Banks set out their differences with impressive fairness in a good-natured and entertaining letter to Malone:

Sr Joshua who preferrs St Pauls says that the honor as well as the interest of the arts are materialy at Stake in the business & will receive a material advantage if we set the example of erecting a monument in a church which has hitherto Lain Fallow for the harvest of the Chisel, that Westminster is already so stuffd with statuary it would be a deadly sin against taste to increase the squeeze of Tombs there & that St Pauls is the most honorable station for the monument of a Great Man. Burke says waggishly this is Borrowing from Peter to give to Paul but he supports Sr Joshua Fully & Firmly. On the other hand the sticklers for Westminster say they are engagd to the body of Johnson to the Public & to the Dean & Chapter to erect his monument there, that they ardently wish to make an end of a business which has already been kept in suspence so very Long & that they Fear their Funds between 7 & 800*l* will be very inadequate to the erection of such a monument as the Dean & Chapter of St Pauls are expected to require which they understand is to be of Collossal dimensions, to this last argument however Sr Joshua has answerd by declaring that if by Further sollicitations in which he expects the Commee to cooperate sufficient money cannot be raised he himself will supply the deficiency.[22]

Reynolds's offer to make good any shortfall clinched the matter. The subscribers gave their approval at a meeting on 16 April, and the writer of a report that appeared in the *Public Advertiser* may well have been favoured by a briefing from the President:

The Royal Academy must look forward with pleasure at the very splendid theatre that is now opened to them for their exertions, by the admission of sculpture into the fabric of St Paul's; and there can be no doubt that they will afford their assistance, as well pecuniary as professionally.[23]

All very reasonable. Johnson, after all, had been professor of ancient literature to the Academy – 'I could wish that this title might be on the monument,' Reynolds confided later in the year to Dr Samuel Parr, who was to compose the epitaph, and he added, 'it was on this pretext that I persuaded the Academicians to subscribe a hundred guineas'.[24]

 Not quite all the Academicians, however. What he omitted to tell Parr was that at the General Assembly the previous week, there had been a determined effort by Chambers to torpedo the idea. The Treasurer had

not himself been present – 'Some very particular business prevents my Attendance this Evening,' he wrote in a letter read out to the meeting:

... but there is reason to apprehend that a proposal is to come forwards, totally foreign to the business and views of the Academy: a proposal, which if it is agreed to, must open the door to all sorts of innovation, must weaken the Academy in its revenues, & disable us from pursueing with proper Spirit and full effect, the true objects of our institution.

If Chambers had not been an architect, he would have made a cunningly persuasive lawyer:

Our business is to establish schools for the Education of young Artists; Premiums for their encouragement; Pensions to enable them to pursue their studys; an Exhibition, wherein they may set their talents to public view; and honorary titles of distinction, to be confer'd on such as are deemed to deserve them. The Royal Academy has it still farther in view, to maintain itself; to reward its Members for services done; to assist the Sick or distressed Artist; to extend its beneficience to the relief of his family; to help the Widows and Children, of such, as leave them unprovided for. – All these, I apprehend are sufficient objects for any Society to carry in view, without going astray to hunt for more. We find it very difficult to fulfil even these; our Donations do not by any means equal the necessities of our distressed Suitors, and our Travelling Pensions are too few, for so respectable an Establishment as Ours. If therefore we judge it expedient to tap the fund of the Academy, let it flow into these, its proper channels; and let it not be spillt in useless driblets, on things absolutely foreign to the intent and Purpose of our Establishment.

And so to the particular 'useless driblet' he had in his sights – that which would flow from Reynolds's proposal that the Academy should 'contribute largely' to the monument to Johnson:

To me it seemed, I freely confess, that one might with equal propriety have proposed the erection of a triumphal arch to Lord Heathfield, or a Mausoleum to the Inventor of Fire Engines, or a Statue to any other person, whose pursuits, and whose excellence lay totally wide of ours. If Monuments were to be our objects, how could we without Shame and contrition, Vote one to Dr Johnson, whilst Cipriani, – Moser, – Gainsborough, – Cotes, – Wilson; and so many other of our departed Brother-Academicians, are left unnoticed and forgotten, in the dust. Let us therefore save our Credit, and spare our repentance, by Voting no Monument at all.[25]

The meeting was not persuaded, but Chambers still had the ear of the Academy's royal patron. He was more easily swayed. Two proposals were submitted to him on the same sheet of paper. The first – that Boswell should be elected Secretary for Foreign Languages – gained his approval. The second, which concerned the monument, the king struck out – or, as Reynolds put it, with some bitterness, 'was *graciously* pleased to draw his pen across'. He was bringing Thomas Barnard, now Bishop of Killaloe, up to date on Club and Academy affairs:

I had unwittingly told the Academy that I had no doubt but that this donation would be very agreable to His Majesty as I had so often heard him speak with the highest admiration of the Learning and Piety of Dr Johnson. How inscrutable are the hearts of Princes.

Do you find it so My Lord that the longer you live the less confidence you have in your sagacity?[26]

There were occasional boosts to his flagging spirits. In the early summer he received a letter from the President of the Royal Academy of Sweden, T. P. Adelcrantz, describing him as 'the most celebrated artist of this century'. Adelcrantz explained that Carl Fredrik von Breda, a Swedish painter then in his early thirties who had been living in London for some years and had exhibited at Somerset House, had recently been elected to the Swedish Academy, and was therefore required to present a picture:

I make bold to propose to you to honour this able artist with the preference of performing the picture of a Great Man, the memory of which will for ever be in veneration by those who esteem and profess the art of painting.

Not quite as flattering as a jewel encrusted snuff-box from an Empress, perhaps, but gratifying for all that. For the last time, Reynolds sat for his portrait.[27]

The renewed friction between the President and the Treasurer had inevitably become public knowledge, but it was apparent at the annual dinner held on 4 June to mark the king's birthday that both sides were intent on keeping up appearances. The dinner was given at the Freemasons' Tavern. The *Public Advertiser* reported that 'this constellation of genius was in number between two and three hundred'. The style and content of its account – and the fact that *The Life of Samuel Johnson, LL.D.*, dedicated to Reynolds, had at last been published a couple of weeks previously – strongly suggest that it was from the pen of the Academy's new Secretary for Foreign Languages:

James Boswell, Esq., was invited as a friend of the arts and one whose works though not actually exhibited *in Somerset Place*, have been lately exhibited *to the world* with general applause. He was placed on the right hand of Sir Joshua Reynolds, the President, who filled the chair with a most convivial glee, and on whose left hand sate Sir William Chambers, between whom and the worthy President it was evident, that all misundertandings were forgotten. GOD *save the* KING! resounded in full chorus with loud acclamations of loyalty, and 'May our glorious Constitution under which the arts flourish, be immortal!' was drunk with a fervour truly patriotick. A number of excellent songs went round, with a general emulation who should do his best to carry on the festivity. Sir William Chambers himself condescended to entertain the company with a short Swedish love song, at the earnest request of Mr Boswell, who undertook, if a hint of its purport were given to him, to sing it instantly in English rhime, which he accordingly effected, with the addition of some sounds, which he called a Swedish chorus, and produced much merriment. – It was truly pleasing to see the great architect of our time, and the Biographer of Johnson, thus uniting in playful gaiety. –*

Reynolds was no longer much seen in public, although he still gave the impression of a man whose general health was reasonably robust. 'Early in September 1791,' Malone writes, 'he was in such health and spirits, that in our return to town from Mr Burke's seat, near Beaconsfield, we left his carriage at the Inn at Hayes, and walked five miles on the road, in a warm day, without his complaining of any fatigue.'[28]

Within a matter of weeks, however, there would be a rapid and ominous deterioration in both health and spirits. During September he suffered great distress from inflammation and swelling over the left eye. A surgeon called Cruikshank was called in, who purged him, bled him with leeches and repeatedly blistered him, all to no effect. The minutes for October record that a letter was read from the President to Chambers requesting that he take his place in the chair – 'he being too much indisposed to risk the coolness of the evening'.

One evening in November Fanny Burney and her father called at Leicester Fields. 'I had long languished to see that kindly zealous friend, but his ill health had intimidated me from making the attempt,' she wrote in her diary:

Miss Palmer hastened forward and embraced me most cordially. I then shook hands with Sir Joshua. He had a bandage over one eye, and the other shaded with a green half-bonnet. He seemed serious even to sadness, though extremely kind. 'I am very

* 7 June 1791. Boswell had for many years been a frequent contributor to the *Advertiser*. He had indulged in a similar bout of self-advertisement at the time of Garrick's Stratford Jubilee in 1769, when his book on Corsica had just appeared.

glad,' he said, in a meek voice and dejected accent, 'to see you again, and I wish I could see you better! but I have only one eye now, and hardly that.'

I was really quite touched. The expectation of total blindness depresses him inexpressibly; not, however, inconceivably. I hardly knew how to express, either my concern for his altered situation since our meeting, or my joy in again being with him: but my difficulty was short; Miss Palmer eagerly drew me to herself, and recommended to Sir Joshua to go on with his cards. He had no spirit to oppose; probably, indeed, no inclination.[29]

On 5 November he decided that he must put his affairs in order. 'As it is probable that I may shortly be deprived of sight,' he wrote, 'and may not have an opportunity of making a formal will, I desire that the following memorandum may be considered as my last will and testament.' Burke, Malone and Metcalfe were named as executors.

Boswell, writing to his friend Temple later in the month, struck a sombre note:

My spirits have been still more sunk by seeing Sir Joshua Reynolds almost as low as myself. He has, for more than two months past, had a pain in his blind eye, the effect of which has been to occasion a weakness in the other, and he broods over the dismal apprehension of becoming quite blind. He has been kept so low as to diet that he is quite relaxed and desponding. He, who used to be looked upon as perhaps the most happy man in the world, is now as I tell you. I force myself to be a great deal with him, to do what is in my power to amuse him. Your friend Miss Palmer's assiduity and attention to him in every respect is truly charming.

Boswell's power to amuse was somewhat diminished. Waiting despondently for business at the English bar that never came, he was once again drinking heavily. He felt no pleasure in existence, he told Temple, 'except the mere gratification of the senses'. But as he sat with Reynolds, he was not concerned solely with raising his friend's spirits. He was also taking notes for a possible Life.

Reynolds sent a letter to West on 10 November requesting him to take the chair at that evening's meeting of the General Assembly:

I beg at the same time, that you will acquaint the Academicians, that however desirous I am, and ever shall be, to contribute every service in my power towards the prosperity of the Academy, yet, as I feel myself incapable of serving the office of President for the ensuing year, I think it necessary that this should be declared at the present Meeting, that the Academicians may have time to consider between this and the 10th of December of a proper successor.

It was generally felt, however, that Reynolds should continue in the presidency. He was accordingly re-elected on 10 December, with Chambers and West designated to deputize for him at future meetings.

Some years after Reynolds's death, Farington recorded in his diary a lengthy conversation with Mary Palmer (by then Lady Inchiquin) about her uncle's last months. The doctors still plainly had little notion of what was wrong with him. 'Dr Warren, Sir George Baker &c did not penetrate into the cause of his disorder, and thought it was upon *the spirits*,' he wrote. That did not prevent them from casting round for physical remedies, and one procedure which they attempted caused his niece considerable alarm:

A Seaton* was aplied to Sir Joshuas neck with a view of drawing the humour from his eyes, but the seaton produced no effect whatever which seemed to her ladyship as if the *principle of life* were gone.

'He said that when He *retired to rest* He had a sensation of extreme light in the eye which had no sight, and this to a painful degree.' Reynolds's constant fear that his sound eye would fail was not lessened when Philip Metcalfe somewhat obtusely presented him with a *Life* of Milton in which he read that eight months after losing one eye, the other also went.

His condition deteriorated sharply on New Year's Day 1792. Mary told Farington that after dinner he had been 'seized with sickness', and that from then on food always produced that effect:

Still the Physicians did not perceive his disorder. Sir Chas. Blagdon was the only one who came near it. He was of opinion that either the Liver or the Kidneys were affected. – Dr. Warren ordered him *Larks* and fried bread – a greasy dish. – One day Sir George Baker felt his pulse & looked in his face, and declared him a sound man. –[30]

Warren and Baker cannot have been entirely discreet about their belief that it was all in the mind. On 3 January a crassly insensitive paragraph appeared in *The World*:

In life's last scene what prodigies surprize!
Fears of the brave, and follies of the wise.

Sir JOSHUA, with no *actual complaint*, lives to realize what Johnson wrote: – The sight of one eye is gone – but a nervous apprehension torments him that he shall lose

* A seton is a thread of silk or other material laid down in a wound in order to initiate a passage for drainage.

the other; though his PHYSICIAN assures him there is nothing to fear. He shuns company – he avoids conviviality – and refuses himself to all the pleasures of the table, in which he once indulged himself. It may however give pleasure to those who justly venerate the talents of this GREAT MAN, to be informed, that a *nervous complaint* is his only Indisposition.

Burke, writing to his son Richard on the same day, was full of foreboding: 'Our poor dear friend Sir Joshuas melancholy and obstinacy growing worse and worse.'[31]

Reynolds now took to his bed. In the middle of February Boswell sent a bleak communiqué to Barnard in Ireland:

A few days ago they thought they had discovered it to be a diseased liver, and they are now treating him accordingly, but have no hope of his recovery. He does not wish to see his friends, takes laudanum, and dozes in 'tranquil despondency,' as Burke expressed it . . . I am very sorry that he did not imbibe christian piety from Johnson. No clergyman attends him; no holy rites console his languishing hours. I heartily wish that your Lordship were here.

Although Reynolds had included in his will the phrase 'I resign my Soul to God in humble hopes of his Mercy', it is unlikely that he would have appreciated Bozzy's soapy tone.* In the absence of clergy he was mainly attended by his niece and by the faithful Ralph, who rarely left him. 'He lay whole nights seemingly without sleep,' Ralph later told Lawrence, 'but *silent*, except that after a long interval in the night He wd. hastily call out *Ralph* as if to assure Himself that He was not alone.'[32]

He died on 23 February, between eight and nine in the evening. The next day Baker called in John Hunter, Reynolds's neighbour in Leicester Fields, to perform a post-mortem, and Hunter brought with him his pupil and brother-in-law Everard Home.† All three put their names to the report of the examination, which established that Blagden's hunch had been correct:

In examining the body of the late Sir Joshua Reynolds we found no marks of disease in the cavity of the breast, except only a slight adhesion of the lungs to the surrounding membrane on the left side.

* Malone's account says that he 'awaited the hour of his dissolution . . . with an equanimity rarely shewn by the most celebrated Christian philosophers'.

† Home (1756–1832) later became Sergeant-Surgeon to the King and was created a baronet. In 1821 he became the first to hold the title of President of the Royal College of Surgeons of England. He is notorious in medical history for having destroyed Hunter's notebooks and manuscripts after using them to prepare papers he passed off as his own.

In the cavity of the belly the only diseased part was the liver which was of a magnitude very uncommon, and at least double of what is natural: it weighed eleven pounds, and was of a consistance which is usually called scirrhous. It had lost its natural color and become of a pale yellow.

We found the optic nerve of the right side [they meant left] shrunk and softer than natural. There was more water in the ventricles of the brain than what is generally found at so advanced an age.

Malone, writing a month after Reynolds's death, claimed that his physicians had been negligent, and that if they had exerted themselves sooner there would have been some chance of saving him – 'In the East Indies by annointing the body with Mercury, extraordinary cures have been performed in this disease, and had a consultation been held in December to investigate his malady and the remedy been tried the world would probably not have been deprived of this most amiable and accomplished man for some years.'[33] Malone, however, was ignorant of the true nature of the disorder, and given the state of medical knowledge at the time, it is difficult to see what more might reasonably have been expected of the doctors. The first description of a melanotic tumour of the eye with metastasis did not appear until 1811; no accurate account of the microscopic structure of tumours is known before 1838.[34]

Burke and his brother Richard had both been at Leicester Fields on the night Reynolds died, and both speedily put pen to paper. To Richard fell the prosaic task of summoning the executors. 'Our good good excellent friend is gone from us,' he wrote to Metcalfe. 'Miss Palmer and my Brother request you earnestly to be here to morrow at two O'clock that his will may be opened in your presence.'[35] Burke, meanwhile, the plaything, as always on such occasions, of powerful emotions, struggled to satisfy the demands of the public prints for some words of tribute:

He was the first Englishman who added the praise of the elegant Arts to the other glories of his country. In taste, in grace, in facility, in happy invention, and in the richness and harmony of colouring, he was equal to the great Masters of the renowned ages. In Portrait he went beyond them; for he communicated to that description of the art, in which English Artists are most engaged, a variety, a fancy, and a dignity derived from the higher branches, which even those who professed them in a superior manner, did not always preserve when they delineated individual nature. His Portraits remind the spectator of the invention of History, and the amenity of Landscape. In painting Portraits, he appeared not to be raised upon that platform, but to descend to it from the highest sphere. His paintings illustrate his lessons, and his lessons seem to be derived from his paintings.

He possessed the theory as perfectly as the practice of his art. To be such a painter, he was a profound and penetrating Philosopher.

In full affluence of foreign and domestic fame, admired by the expert in art, and by the learned in science, courted by the great, caressed by sovereign powers, and celebrated by distinguished poets, his native humility, modesty, and candour never forsook him, even on surprise or provocation, nor was the least degree of arrogance or assumption visible to the most scrutinizing eye, in any part of his conduct or discourse.

His talents, of every kind, powerful from nature, and not meanly cultivated by letters, his social virtues in all the relations and all the habitudes of life rendered him the centre of a very great and unparalleled variety of agreeable societies, which will be dissipated by his death. He had too much merit not to excite some jealousy, too much innocence to provoke any enmity . . . HAIL! AND FAREWELL!

It went down extremely well. 'The eulogium of Apelles pronounced by Pericles', enthused one journalist. But there was one particular in which the latter-day Pericles was mistaken. There had certainly been jealousy, but there had been enmity, too; and there would be another manifestation of it before Reynolds was in his grave.

27

The Top of a High Mountain

It came – unsurprisingly – from the Knight of the Polar Star.

One of the first acts of the executors was to request that on the evening before the funeral Reynolds's body might be conveyed to Somerset House to lie in state. Several newspapers got wind of the fact that the proposal had not gone through on the nod:

At a meeting of the Royal Academicians a few evenings since, it was proposed that, previous to the interment of their late President, his remains shou'd be brought to Somerset House; and as the last tribute they could pay to his memory, lie in state in the place which the magic labours of his pencil had so often decorated. This was almost unanimously agreed to by all present, except Sir William Chambers, who observed that they could not, with propriety, appropriate the rooms to such a purpose, as they had at the first institution determined, and solemnly agreed, that the rooms should be used for no purposes but the exhibition of the pictures, &c. or studies of the artists.

This staggering display of meanness of spirit had been immediately challenged:

One of the Members observed, that if this was the original determination, there had been a deviation from the plan; for at the time his MAJESTY went to St Paul's, seats, *et cetera*, had been put up for Sir William's friends to see the procession, to the exclusion of the Royal Academicians themselves.[1]

Chambers had an arrogant and overbearing manner which did not endear him to his fellow Academicians. Some years later Farington heard from West that on this occasion the Treasurer had drawn up a letter 'in which, as was not uncommon with Him, there were some coarse passages'.[2] And it was by West, who, like Chambers, was in a position to drop the occasional word in high places, that the matter was resolved. He sought an audience, the upshot of which was that the king signified 'His Royal Will that that mark of respect shou'd be shown'.[3]

With the Treasurer back in his box, the Academicians fell to squabbling over precedence in the procession to St Paul's. Barry, pointing to his position as professor of painting, laid claim to be the Academy's representative mourner. This was disputed, and tempers rose. When someone mentioned Chambers, Barry became enraged. 'What, the bagman!' he shouted. 'Why you might as well put Judas Iscariot in competition with St Luke.'[4] It was finally agreed that the first place in the procession should be taken by members of the Council, and that they should be immediately followed by the professors.

'Did you go to Sir Joshua's burial?' Samuel Parr inquired anxiously of Dr Burney some weeks later. 'I hope he had a complete service, not mutilated and dimidiated, as it was for poor Johnson at the Abbey, which is a great reproach to the lazy cattle who loll in the stalls there.'[5] Dr Parr need not have worried. Although Reynolds had directed that his executors should go to no expense, Burke knew of his wish to be buried at St Paul's. The funeral was one of the most magnificent ever accorded to an English artist.

The body had been taken from Leicester Fields on the evening of Friday, 2 March. The coffin, covered in black velvet, was placed in the Model Room of the Academy, which was draped in black and lit by wax-lights in silver sconces. The funeral procession moved slowly away from Somerset House the next morning at half-past twelve, a mute walking on either side of each carriage. The company was conveyed in forty-two mourning coaches, followed by forty-nine coaches belonging to the nobility and gentlemen among the mourners, empty but for their livery servants. Twelve peace officers went in front to clear the way; shops along the route were closed, and when the cavalcade had passed through Temple Bar, the gates were shut by order of the Lord Mayor to prevent any interruption from traffic to and from the City. By the time the hearse, drawn by six horses, reached the western gate of the cathedral, the tail of the procession had still not left Somerset Place.

The chief mourner was Offy's husband, Robert Gwatkin. There were ten pallbearers – the Dukes of Dorset, Leeds and Portland, the Marquess Townshend and the Marquess of Abercorn, the Earls of Carlisle, Inchiquin and Upper Ossory, Viscount Palmerston and Lord Eliot. Rather touchingly, precedence was given next to two 'Attendants of the family' – Marchi and Ralph Kirkley. They were followed by Burke and the other executors and the officers and members of the Academy. At the head of a phalanx of friends came William Markham, Archbishop of York; Windham was there, and Charles Burney; Lord Carysfort, and the banker Thomas Coutts; Sir Charles Bunbury, and John Philip Kemble, the brother of Mrs Siddons.

The coffin was placed in the centre of the choir, and Evensong was sung, with an anthem by Boyce:

When the funeral service was ended, the Chief Mourners and executors went into the crypt, and attended the corpse to the grave, which was dug under the pavement.*

A century and a half earlier Van Dyck had been buried in Old St Paul's. Now Reynolds's grave was dug in the same earth, next to that of his friend Newton, who had been Bishop of Bristol, and close to that of Wren.

Although more than a week had passed since Reynolds's death, Burke was still deeply affected:

The Members of the Academy returned to Somerset-House, when the mournful ceremony concluded, in order to partake of a cold collation that was prepared for them in the large Exhibition-Room. Mr Burke came into the room, to express, in the name of the Family and Executors, their grateful thanks to the Academy for their respectful homage to the deceased; but was prevented, by the violence of his feelings, from saying more than a very few words.[6]

After the funeral, Burke invited Mary Palmer and the Gwatkins to join him at Beaconsfield. 'I begin to think, that these women look better already,' he wrote to his son; 'they are to stay here for some time.' His duties as Reynolds's executor were already engaging his attention. 'We do not know his Circumstances exactly,' he told Richard, 'because we have not been able to estimate the immense collection of Pictures, drawings, and Prints.'[7]

There was one thing, however, that everyone knew already, and that was that Mary Palmer was now an extremely wealthy woman. Reynolds had left her the bulk of his property, real and personal. This included the house in Leicester Fields and the villa at Richmond, his money in the funds, and all his pictures, furniture, books and plate not disposed of in other bequests.† Richard Burke, writing to William, expressed what seems to have been general surprise: 'I own I had no idea, nor did outward appearance shew it, that she held so high and so just a place in his affections; so little judges are we of the interior mind of those we know best . . .'[8]

Offy was to have £10,000 in 3 per cent Consols. His sister Fanny, to whom Reynolds had been making an allowance for some years, was to have

* From an account published by Malone, which he says 'was written by a friend the day after the funeral, and published in several of the Newspapers'.

† This gave Boswell the idea of proposing to her, but his friend Temple discouraged him, foreseeing – correctly – that she would be setting her sights higher than on a penniless and promiscuous Scottish laird who drank too much.

the interest on £2,500 to be placed in the funds, the principal to devolve on her death to Mary.* To his nephew William, in Calcutta, he left his watch and seals. News that there were no further family bequests had travelled fast; Joseph Palmer sat fuming in the Irish Deanery which Reynolds had procured for him and refused to come to the funeral. Burke believed the omission had arisen simply because Reynolds had been obliged to take to his bed sooner than he expected. 'This is the only unlucky thing,' he told his son. 'They are deeply hurt and I do not much wonder at it.'[9] Malone thought differently, however. 'Sir Joshua had served the Dean, though he was not partial to him,' he told Farington. 'The Dean is an ordinary & conceited man.'†

Of his friends, it was Burke whom Reynolds remembered most generously, leaving him £2,000 and cancelling a debt for the same amount.‡ He was also, along with his fellow executors and with Boswell, to have £200, to be spent, if they so wished, at the sale of his paintings. The Earl of Upper Ossory was given the choice of any of his pictures and Lord Palmerston was to have second choice. Sir Abraham Hume was to have the choice of his Claudes; to the Duke of Portland he bequeathed the large *Angel Contemplating the Cross*, which forms the upper part of the *Nativity* painted for the New College window.§

The executors did not take their duties lightly. It was decided that as a token of remembrance, each mourner should be presented with a letter of thanks, the decoration engraved by Bartolozzi. A weeping muse, clasping an urn, bows her head over a sarcophagus, on which are ranged a palette, brushes and a maulstick; at her feet, on the plinth, an inverted and extinguished torch and a plump cherub, who points to an inscription. But what should the inscription say? This was the subject of earnest and learned

* She was not grateful. 'Miss Reynolds speaking of him since His Death,' Malone told Farington, 'said she saw nothing in him as a Man, but a gloomy tyrant' (Farington, 1978–84, iv, 1137–8, entry dated 17 January 1799).

† Farington, 1978–84, ii, 466–7, entry dated 4 January 1796. Reynolds left £1,000 to Ralph Kirkley, but of Giuseppi Marchi there was unaccountably no mention. Mary Palmer made good the omission, and Marchi, who was engaged at the time in finishing several of the portraits left incomplete by his master, continued to receive £100 a year.

‡ He also remembered Burke's son, Richard, to whom he bequeathed his miniature of Oliver Cromwell by Samuel Cooper.

§ There is some evidence that Reynolds had written, or at least drafted, an earlier will. Years later Mary Palmer told Farington that at one time he had intended to leave Gibbon £500: 'When Gibbon published the last Volume of His History He did not send one to Sir Joshua who was fond of receiving their works from the Authors. Sir Joshua had the omission *signified to Gibbon*, who replied, That He sent them only to particular friends. – Sir Joshua upon hearing this cancelled the legacy of £500' (Farington, 1978–84, vii, 2612, entry dated 6 September 1805).

12. *The card, engraved by Bartolozzi, presented as a token of
remembrance to the mourners at Reynolds's funeral. The choice
of an inscription occasioned much learned debate between
Burke and Malone.*

exchanges between Malone and Burke. Malone originally favoured some-
thing from Virgil; Burke, who found the lines 'perhaps too common',
countered with Tacitus and Lucretius; a line from elsewhere in the *Aeneid*
eventually carried the day.[10]

They also had to work their way through the contents of Reynolds's
studio, where there was a sizeable accumulation of portraits which had not
been paid for. The Duchess of Gordon, having called to see hers – it had
been painted in 1778 – refused it, saying that her eyes were not green, as
those in the picture were.* Another picture was a head of a man called
Bennet, which Reynolds had painted some thirty years previously, when his
price was 25 guineas. Ralph Kirkley was dispatched to see whether he would
take his portrait; he encountered Mrs Bennet, who told him from her
husband that 'The Executors might put it on a Post.'[11]

* Farington, 1978–84, i, 180. The picture (Mannings, cat. no. 745, fig. 1260) was bought for
the Earl of Fife at Reynolds's studio sale in April 1796. It is now in the Norton Gallery and
School of Art, West Palm Beach, Florida.

There were more substantial sums to be recouped further afield, however. Reynolds had received no payment for the painting commissioned by the Empress Catherine in 1785, and the executors felt they must attempt to collect what was due to the estate. Burke drafted a long letter, full of compliments, which was translated into French by Desenfans. After several paragraphs of flowery throat-clearing – the admiration and gratitude in which she was held by the human race – the great efforts which Reynolds had made to show himself worthy of his 'auguste Protectrice' – they got down to brass tacks:

Quant au prix, Madame; loin d'en fixer aucun, nous préférerions de le laisser absolument à la générosité de Vôtre Majesté imperiale, quoique nous sachions que le Chevalier eut demandé quinze cens guinées de ce tableau . . .*[12]

A price of 1,500 guineas had indeed been marked on the picture when it had been exhibited at the Academy in 1788. The executors begged Her Imperial Majesty to excuse the liberty they were taking in writing to her on such a matter – it was, they explained, something imposed on them by the 'sacred duty' entrusted to them by Reynolds. While they were about it, they felt equally obliged to mention Reynolds's collection of paintings and drawings, assembled at great expense over a period of thirty-five years. His heirs now intended to dispose of it; it clearly merited a place in Her Imperial Majesty's 'riche et superbe galerie'; they humbly presumed to make her the first offer of it.

Vorontsov, the Russian ambassador, forwarded the letter to the Empress's secretary, Count Bezborodko. There was no reply. In January 1794 Vorontsov wrote to the Vice-Chancellor, Count Ostermann, saying that he was being badgered by Burke, 'the well-known Member of Parliament', as to why they had heard nothing. Ostermann took the matter up with Popov, the *chef de cabinet*, who replied that the Empress had expressed surprise at the request – had she not made Reynolds the gift of a handsome snuff-box? She had indeed. But she had clearly forgotten that she had also, in writing to Vorontsov at the time, said, 'J'attends que vous m'informiez du prix du grand tableau.' She did have one or two other things on her mind, after all – fending off the Swedes, invading Poland, joining forces with Austria to defeat the Turks.

To the offer of Reynolds's collection there was no response, but the matter of the *Infant Hercules* was graciously settled. On 7 April 1794 Vorontsov reported that 1,500 guineas had been paid to Reynolds's estate. Whether

* 'So far as price is concerned, Ma'm, that is a matter which we should prefer to leave entirely to the generosity of Your Imperial Majesty, although we know that Sir Joshua would have asked 1,500 guineas for this picture.'

the executors ever received payment for *The Continence of Scipio*, the picture painted for Potemkin, is unknown. The prince had died in 1791; Burke, Malone and Metcalfe were in correspondence with his heirs as late as 1797, requesting the payment of 500 guineas or the return of the painting to England.[13] But the painting had been in the Hermitage since 1792, and there it remains to this day.

The executors had more complicated matters to attend to closer to home. Within months of Reynolds's death, Mary Palmer, now a considerable heiress, had accepted a proposal of marriage from Lord Inchiquin, an Irish peer who had long been deeply in debt. 'He is ugly in looks and sixty-nine!' Fanny Burney wrote in her diary. 'But they say he is remarkably pleasing in his manners, and soft & amiable in his disposition.'[14] Another diarist of the day, Lord Glenbervie, saw him rather differently – 'a true Paddy of high rank, spouting hackneyed verses, talking a good deal'.[15] The discrepancy in age (the Fifth Earl, a widower, was twenty-four years older than his bride) gave rise to some ribald comment in the newspapers, *The Times* descending to a reference to a 'junction between January and May'.[16]

The concern of Burke and his colleagues was to recover Inchiquin's chief English estate, at Cliveden, from his creditors, something requiring an outlay of £20,000. A trust deed was drawn up, but the arrangements eventually fell through, and Cliveden was not redeemed. The wedding went ahead for all that. It took place at Beaconsfield on 21 July; Miss Palmer was married from Burke's house, and he and his wife signed the church register as witnesses. The new countess must have been relieved to get away on her honeymoon; Burke did not take his responsibilities as an old family friend lightly:

When the marriage articles were brought to be signed, Mr Burke addressed her in an elegant and impressive speech applicable to her intended change of condition, which, however, agitated her so much as to render her utterly incapable of holding the pen. Every effort was made to calm her in order to procure the signature, but in vain; all his soothing powers were exerted endearingly and perseveringly without effect; and the party separated for the time unable to accomplish the purpose of their meeting.[17]

Given the state of the Inchiquins' finances, it was inevitable that the abortive approach to the Russian Empress about Reynolds's collection would be followed by others. The dispersal proceeded neither smoothly nor speedily, however, and it is plain that there were disagreements between the family and the executors about how best to proceed. 'I can do nothing against folly and madness,' says an undated note from Burke to Malone: 'They are going to throw away their fine Collection of Pictures, the Bulk of their fortune.'[18]

Less than a year after their marriage, the Inchiquins approached James Christie, and a sale was advertised, to take place over four days in May 1793. It is not known who composed the notice that appeared in the newspapers, but Sheridan's Mr Puff would have doffed his hat:

The Collection was made by one, whose knowledge of the theoretic and practical Principles of the Art, and whose perfect acquaintance with the Style, the mode of Composition, and the manner of handling of every Master, rendered it impossible for him to be deceived, so as to take a Copy for an Original, or the work of an Imitator for that of a Capital Master.

It is amongst the largest, and for its magnitude, probably the purest in Europe. Every Picture has something to recommend it to the curious and judicious eye. The far greater number are chosen for their general excellence. Some few, because though inferior in many respects to others in their general effect, may possess some particular excellence, in the conception or execution, in a far higher degree than those that are more equally studied in all the parts. The one or the other of these considerations influenced him in the purchase of every Picture he bought.

To perfect this Collection, Sir Joshua himself went several times into Foreign Countries; and he appointed Agents to attend the Sales of the principal Cabinets which were disposed of abroad during his time. – At home, it is known that he lost no opportunity, and spared no expence, in making purchases and exchanges.

After the practice of his own Art, in which he had obtained such deserved renown, this Collection was his favourite object for thirty-five years, and he expended in it the greater part of his fortune. He showed no marked predilection for any School or any Master. The collection therefore contains the best specimens of the Roman, Venetian, Flemish, and French Schools. No collection ever made so completely illustrates the History and Progress of the Art, and the comparative merit of the several Schools.[19]

The sale, however, was cancelled. No reason was given. Several months passed before it was readvertised for the following March, but as the time approached numbers of Lady Inchiquin's friends warned her that the economic climate remained unfavourable. Christie, understandably, argued strongly for the sale to go ahead, but was finally obliged to announce a postponement to the following spring – 'by order of the Executors'.[20]

It would be many years before economic conditions became any more favourable to the sale of pictures. Early in 1795 Farington warned the Inchiquins that if they did not dispose of the collection soon, they might have to wait another four or five years. That proved absurdly sanguine – they would have had to wait very much longer than that. Pitt had taken Britain into war with France in 1793 with strictly limited aims, but the

conflict was to last for twenty-two years, and its impact would be felt in every area of the national life.

Farington and Sir George Beaumont agreed to help in settling reserve prices, but when the sale went ahead in March 1795, the result fell miserably below expectation. Of the 466 paintings offered for sale, almost a hundred had to be bought in. The profit amounted to little more than £7,000; Christie was slow to settle the account, claiming that the nobility were slow to pay; Inchiquin complained that he was still waiting to receive the full amount after twelve months. A further auction took place three years later, conducted by Harry Phillips. Bidding was once again sluggish, and about one in three of the lots offered was bought in – many of them by Farington, who recorded in his diary that he had been 'engaged to support prices'.

Only two short chapters of the melancholy saga remained, although they were more than twenty years in the writing. When the lease of the house in Leicester Fields expired in 1807, a number of pictures were included in the sale of contents. The occasion generated little interest. Farington looked in '& found in the room few but Picture dealers & Brokers'.[21] Mary Palmer – in 1801 she had become the Marchioness of Thomond – lived on till 1820; her property was sold the following year at Christie's, and with it her uncle's collection – 'after the practice of his own Art, his favourite object for thirty-five years' – was finally dispersed.*

Reynolds had been succeeded in the presidency by West. John Copley had put himself forward for the office, but his fellow Academicians were unimpressed, and West was elected by twenty-nine votes to one.† It would be his pride and duty, he assured the Academicians, to maintain the credit of their institution:

Therefore, gentlemen, not on account of any personal merits on my part, but to do honour to the office to which you have so kindly elected me, I shall presume in future to wear my hat in this assembly.‡

* Her husband had died in 1808, at the age of eighty-two, after a fall from his horse.

† He had been talked about as the likely successor for some time. The day after Reynolds died, the *Morning Herald*, unaware of the fact, had published a paragraph of the sort which makes editors wish for the earth to open and swallow them: 'Sir JOSHUA still refuses to see even the most intimate of his friends; to refuse that consolation, which in the decline of life all men prize. He is much depressed in spirits. WEST, like the figure in the Dutch weatherglass, of course proportionally elevated.'

‡ Whitley, 1928, ii, 161. West possibly got the idea from Joseph Banks, who was in the habit of wearing his hat in the chair of the Royal Society, which was, like the Academy, housed in Somerset House. West also introduced the custom of having the Academy porters wear red and gold braid gowns on formal occasions.

He presided smoothly over his first annual dinner, and the usual toasts were drunk – the King (three cheers), the Queen, the Prince of Wales, the Princess Royal, the Duke of York and the Army, the Duke of Clarence and the Navy, prosperity to the Academy (three more cheers), success to the exhibition. Then, just as the company was about to disperse, Boswell rose to his feet, possibly not entirely steadily, and said a few highly inappropriate words:

This is the first Exhibition at which we have met without seeing in the Chair that excellent and eminent person of whom I cannot speak, and you cannot hear, without emotion. Gentlemen, it was a day of anxiety to us all; not, I am sure, from any apprehension of deficiency in the respectable gentleman who now so worthily presides . . .*

Damned with faint praise by the Academy's fuddled Secretary for Foreign Correspondence, West also had to put up with abuse from a more predictable quarter. His old *bête noire*, Peter Pindar, decided to mark his election with an 'Ode to the Academic Chair', in which he has the king musing on his Favourite's elevation:

> I like WEST'S works – he beats the RAPHAEL school:
> I never liked that REYNOLDS – 'twas a fool –
> Painted too thick – a dauber – 'twon't, 'twon't pass –
> WEST, WEST, WEST'S pictures are as smooth as glass:
> Besides, I hated REYNOLDS from my heart:
> He thought that I knew nought about the art.[22]

West had no great cause to worry. Although one observer wrote that Reynolds's death 'seemed to diffuse a momentary torpor over the arts', the 1792 Exhibition attracted 780 entries, 654 of them by non-members, and admission receipts came to a healthy £2,602. Reynolds had bequeathed to his successor an institution in good order. The Academy was making a profit of some £400 a year; by 1796 it would hold stocks to the value of £16,000. Gainsborough and Wilson and Reynolds had gone, but a new generation full of promise was emerging in their place – Lawrence, Martin Arthur Shee from Dublin, and a thick-set youth of seventeen called Turner, a barber's son, who would one day leave his pictures to the nation and ask to be buried beside Reynolds in St Paul's.

* Boswell clearly got to hear that his remarks had not been well received. He made amends at the next dinner of the Royal Academy Club by singing a 'complimentary strain' in the President's honour. He had composed it, he informed the company, 'on the way from St James's' (Whitley, 1928, ii, 175).

Boswell's enthusiasm for writing the life of his friend cooled fairly rapidly. 'The world will have it that I am to be his biographer,' he wrote to Barnard towards the end of 1792:

I did begin last winter to collect some particulars of his early life from him. Tomorrow I am to set out on a jaunt into Devonshire and Cornwall and, I doubt not, shall pick up a variety of materials for his history. But whether I shall attempt what as yet seems not quite well suited to me I know not. Sir Joshua was indeed a man of pleasing and various conversation, but he had not those prominent features which can be seized like Johnson's. Our friends of the Royal Academy urge me to the task by telling me that I may make a very good book of the late President's life, interwoven with the history of the arts during his time, and they will contribute all their lights.[23]

Some months earlier Bishop Percy had told Mrs Piozzi that Boswell was to undertake the task. 'Let us be careful of our health, my Lord,' she replied grimly, 'or he will write our lives too.' Boswell, however, was to die in the spring of 1795; his few jottings about Reynolds were discovered many years later among his papers at Malahide Castle.

The following year Chambers also died. Lord Charlemont wrote in an epitaph of the 'Immaculate Purity' of his heart, illustrating the aptness of Johnson's dictum that 'in lapidary inscriptions a man is not upon oath'. Chambers was succeeded as Treasurer by John Yenn, also an architect, who had been elected an Academician in 1791. Some years later, when the question of a monument to Reynolds was under discussion, it fell to Yenn to discover the king's wishes and convey them to his fellow Academicians:

Yenn then stated that he was with the King last night at 6 o'clock & His Majesty directed him to communicate to the President & Council That His commands respecting a Monument to Sir Joshua Reynolds shd. be entered on the minutes, viz: 'That His Majesty wd. not suffer the money of the Academy to be squandered for purposes of vain parade and Ostentation'.[24]

Something of the spirit of Chambers clearly lived on in his royal patron. It was not until 1813, two decades after his death, that a monument to Reynolds was erected in St Paul's; by then the Regency had been inaugurated, and George III, with his wild white beard and his purple dressing gown, had passed into a world of shadows, playing on his harpsichord and talking unceasingly of men and women long dead. The monument was the work of John Flaxman, the news of whose marriage,

many years before, Reynolds had received with such disconcerting lack of tact.*

The same year saw a Reynolds memorial exhibition at the British Institution. Mary was concerned to note that some of the portraits had faded, but when she wrote to Offy it was to express her pride in what she had seen – the catalogue listed 142 works, eighteen of which were left to be studied and copied by students after the exhibition had closed:

My heart swells when I contemplate the works of this great Man & the public estimation of them, not but what it is wormwood to many, & I have no doubt but you will see many attempts to depreciate what is not to be equal'd, certainly not excell'd.†

Reynolds's sisters were all dead by this time. Mary had survived her brother by only two years, Elizabeth had died in 1797 and Johnson's admired 'Renny' ten years later. She, as we have seen, never subscribed to the view of her brother as a great man, and Elizabeth, too, remained bitter and resentful to the end. A letter survives which she wrote to Fanny when Malone was gathering material for the biographical essay with which he prefaced Reynolds's *Works*:

You know Mr Malone I believe, the greatest friend and admirer of Sir Joshua that he ever had perhaps, and such an immaculate character as he will I suppose draw of him, will be held up no doubt for humanity to copy after! such perversions in life are melancholy, particularly to his nearest Relations, awakening painful remembrances. such was Mr Burks character of him – in the news paper extolling him for his kindness to all his Relations![25]

One suspects that Reynolds, for his part, might have assented wryly to much of Charles Lamb's anatomy of the poor relation – 'a haunting conscience – a preposterous shadow, lengthening in the noontide of our prosperity – a drawback upon success – a rebuke to your rising'.

A rebuke to his rising – a bridle on the desire to excel of the youth who would rather have been an apothecary than an *ordinary* painter. The

* Flaxman, now an artist of international renown, had in 1810 been appointed the Academy's first professor of sculpture.

† Another visitor to the exhibition was the 27-year-old Benjamin Robert Haydon, high-minded and penniless, then at work on his monumental *Judgment of Solomon*. He was less impressed, for all that he had been head boy at Plympton Grammar School: 'I must own, in walking round the room and perpetually coming to the same thing, I felt a sort of contempt for a man who could pass forty years in painting cheeks, noses, & eyes, with no object but individual character, and no end but individual gratification' (Haydon, 1960–63, i, 309).

amiable, bland, slightly aloof exterior masked powerful ambitions – for himself, for the art which he had embraced, for the institution over which he had presided. He knew that no amount of patronage could take the place of application; he knew that although he mingled with the great, and was on terms of friendship with many men and women of rank and power, it was only by his own efforts that he could rise. Farington records a conversation between Reynolds and the Duke of Devonshire, who expressed surprise that an artist of his distinction and fortune 'did not retire from further exertion':

Sir Joshua replied 'To me the practise of my profession is everything; it is a constant occupation for my mind, gives me further hopes of reputation & such other advantages as arise from it.' He then added, 'Your Grace's situation is very different. You are in possession of all that can enable You to make a choice, of what may be agreeable to you. Rank; Princely fortune you possess; but in my situation I have a constant impulse to one thing . . .'[26]

Reynolds expresses no resentment at the divide which separates him from his patron. They inhabit different worlds; that is in the nature of things; he knows his place. He believes, what's more, that that natural order confers on him a precious advantage. He held forth on the subject one night at the house of Dudley Long North, a close associate of Fox, famous for his political dinners.* Several peers of the realm were present. The conversation had turned to the nature of happiness. Reynolds, as he quite often did, sat silent for a time, but then delivered himself of what his fellow guest Charles Burney described as a 'harangue':

You none of you, my lords, if you will forgive my telling you so, can speak upon this subject with as much knowledge of it as I can. Dr. Burney perhaps might; but it is not the man who looks around him from the top of a high mountain at a beautiful prospect on the first moment of opening his eyes, who has the true enjoyment of that noble sight: it is he who ascends the mountain from a miry meadow, or a ploughed field, or a barren waste; and who works his way up to it step by step; scratched and harassed by thorns and briars; with here a hollow, that catches his foot; and there a clump that forces him all the way back to find out a new path; – it is he who attains to it through all that toil and danger; and with the strong contrast on his mind of the miry meadow, or ploughed field, or barren waste, for which it was exchanged, – it is he, my lords, who enjoys the beauties that suddenly blaze upon him. They cause an expansion of ideas in harmony with the expansion of the view. He glories in its

* North (1748–1829) was a prominent and influential Whig, although he was prevented from speaking in the Commons by a speech impediment. He was one of the managers at the trial of Warren Hastings and a pallbearer at the funeral of Burke.

glory; and his mind opens to conscious exaltation; such as the man who was born and bred upon that commanding height, with all the loveliness or prospect, and fragrance, and variety, and plenty, and luxury of every sort, around, above, beneath, can never know . . .*

Not a harangue, though. Rather a brief supplementary discourse. On the view from the summit.

* Burney, Dr C., 1832, ii, 280–82. Richard Wendorf has pointed out the similarity between this remarkable passage and a line in the second of Reynolds's two Dialogues, in which he imagines Gibbon trying to manoeuvre Johnson into attacking Garrick: 'What fell into his lap unsought, I have been forced to claim. I began the world by fighting my way' (Hilles, 1952, 113–14).

Notes

I

Roots

1. Hoskins, xx.
2. Hyde, Edward, 1888, iv, 32.
3. Waterhouse, 1973, 13.
4. Leslie and Taylor, i, 3. Leslie (1794–1859), born of American parents in London, was educated at the University of Pennsylvania. He returned to London to study at the Royal Academy schools, and was elected to the Royal Academy in 1826. His *Life of Reynolds* was unfinished at his death, and was completed by Taylor (1817–80), prolific playwright and biographer and editor of *Punch*.
5. Northcote, i, 11.
6. Leslie and Taylor, i, 3.
7. Northcote, ii, 50.
8. Farington, 1978–84, x, 3577. Farington visited Plympton in 1809 and was shown round the school and the house by the then master.
9. Namier, 35.
10. Hudson, 13–14. The friend, whose name was Bulteel, lived in Flete, some six miles from Plympton.
11. Leslie and Taylor, i, 19.

2

Apprentice and Journeyman

1. Walpole, 1828, iv, 23–4.
2. *Paradise Lost*, Book iv, ll. 266–8.
3. *L'Abrégé de la vie des peintres . . . avec un traité du peintre parfait*, which de Piles had published in Paris in 1699, came out in London as *The Art of Painting and the Lives of the Painters* in 1706.
4. Hickey, i, 27. Hickey's father, an Irishman, was Hudson's neighbour at Twickenham. Hickey senior was a successful attorney, and became the legal adviser of both Burke and Reynolds. When the latter had a house built at Richmond in the 1770s,

it was Hickey who drew the conveyance. Reynolds's portrait of him (Mannings, cat. no. 902) was shown at the Academy exhibition of 1772.

5. Walpole, 1828, iv, 106.

6. Farington, 1819, 16–17.

7. Leslie and Taylor, i, 21. Letter dated 30 December 1740.

8. Waterhouse, 1981, 249.

9. Northcote, i, 18.

10. Cotton, 1856; 214. An amusing story that bears on this appears in the journals of the historical painter Benjamin Robert Haydon. Haydon went up to London from Devon as an eighteen-year-old in 1804 with a letter of introduction to Northcote from the artist Prince Hoare, who was then honorary foreign secretary of the Academy. Long years in London had done nothing to modify Northcote's strong Devonshire accent:

'I zee Mr Hoare zays you're studying anatomy; that's no use – Sir Joshua didn't know it; why should you want to know what he didn't?'

'But Michael Angelo did, sir.'

'Michael Angelo! What's he tu du here? you must peint pertraits here!'

 (Haydon, 1950, 23).

11. Public Records Office, series Cust 3, quoted in Pears, 207, 211.

12. Northcote, i, 19–20.

13. Leslie and Taylor, i, 24. Letter dated 3 August 1742.

14. Farington, 1819, 17–18.

15. Penny, 1986 (catalogue).

16. Leslie and Taylor, i, 27.

17. Ibid., letter dated 3 January 1744. He was once again writing to Cutcliffe.

18. Girouard, Mark, 'English Art and the Rococo', *Country Life*, 13 January 1966. Two further articles appeared on 27 January and 3 February.

19. Leslie and Taylor, i, 28. He was writing to Cutcliffe.

20. Reynolds, 1819, I, ix–x.

21. Reynolds, 1959, 117. The passage occurs at the beginning of Discourse VII, delivered in December 1776.

22. Wolcot, i, 23.

23. Mannings, cat. no. 1519, fig. 26.

24. Ibid., cat. no. 1515, fig. 24.

25. Ibid., cat. no. 1017, fig. 33.

26. Ibid., cat. no. 2, fig. 43.

27. Ibid., cat. no. 576, pl. 1, fig. 20.

28. Ibid., cat. no. 818, fig. 22. It now belongs to the Trustees of the Abercorn Heirlooms Trust.

29. Mannings, cat. no. 1372, pl. 3, fig. 48.

3

Light from Italy

1. Burnet, ii, 429.

2. Macaulay, v, 310.

3. Letter 6. He was writing some months later from Rome to Lord Edgcumbe.

4. Northcote, i, 31–3.

5. Letter 5.

6. 'Proceedings with the States of Algiers, Tripoli, and Tunis, in the Years 1749, 1750, and 1751, and Renewal of Peace with These States' by the Honourable Augustus Keppel.

7. Letter 5.

8. Letter 7.

9. Leslie and Taylor, i, 37.

10. Quoted in Pastor, xxxv, 182–3.

11. Kirby, 76.

12. Letter 6.

13. Leslie and Taylor, i, 48.

14. Reynolds, 1959, 28.

15. Waterhouse, 1973, 16.

16. Reynolds, 1819, I, xiv–xv.

17. Ibid., xvi.

18. Ibid., lxxxix fn.

19. Whitley, 1928, ii, 308.

20. Farington, 1819, 34n.

21. Letter 8.

22. Ingamells, 745.

23. Mannings, cat. no. 1962, fig. 61.

24. Ibid., cat. no. 1964, fig. 64.

25. Fleming, 146, 226.

26. Northcote, i, 46.

27. Reynolds, 1959, 29.

28. Ibid., 30.

29. The passage is reproduced in Hilles, 1936, 204–6.

30. Ingamells, 1007.

31. *British Painting in the Eighteenth Century*, British Council, London, 1957, 22.

32. Soane Museum Notebook.

33. Ibid.

34. British Museum Notebook.

35. Cotton, 1859, 16.

36. Mannings, cat. no. 1915, fig. 69.

37. Farington, 1819, 36.

38. 201.a.10.

39. The sentence occurs in his second Discourse, delivered in December 1769.

40. Reynolds, 1959, 123–4. The passage occurs in the seventh Discourse, delivered on 10 December 1776.
41. Waterhouse, 1941, 8.
42. In his fourth Discourse.
43. Leslie and Taylor, i, 65–6. The notes Reynolds made in Venice and Bologna appear in full in Leslie and Taylor's first volume, those on Venice on pp. 67–84, those on Bologna in an appendix on pp. 467–79.
44. Reynolds, 1959, 156–7.
45. Leslie and Taylor, i, 68.
46. The passage occurs in the eleventh Discourse, delivered in 1782.
47. Leslie and Taylor, ii, 449.
48. Northcote, i, 58.
49. Ibid., 48.
50. Reynolds, 1959, 63.
51. Harris, 5.
52. Mannings, cat. no. 342, pl. 19, fig. 187.
53. Fleming, 160.

4

A Sort of Sovereignty

1. Walpole, 1937–83, xx, 357. He was writing to Horace Mann.
2. Boswell, 1950, 255.
3. Northcote, i, 52.
4. Mannings, cat. no. 1219, fig. 77. The picture is at the Royal Academy.
5. Northcote, i, 53.
6. Mannings, cat. no. 1036, fig. 57. The picture is now in the Maritime Museum at Greenwich.
7. Ibid., cat. no. 1037, fig. 70. This too is at Greenwich.
8. Reynolds, 1959, 26–7.
9. Mannings, 288.
10. Letter 9.
11. Whitley, 1928, i, 154.
12. Smart, 1998, 98–104.
13. Schama, 295.
14. Mannings, cat. no. 4, pl. 7, fig. 93. The picture is now in the Tate Gallery.
15. Fletcher, 219.
16. Gwynn, 112.
17. Mannings, cat. no. 832, fig. 81.
18. Ibid., cat. no. 1788, fig. 84.
19. Ibid., cat. no. 323, fig. 91.
20. Ibid., cat. no. 406, fig. 336.
21. Boswell, 1986, 205.
22. Wendorf, 1996, 65.
23. Piozzi, 1951, i, 382.

24. Letter 63.
25. Northcote, i, 213.
26. Fletcher, 79.
27. Burney, Fanny, 1904, ii, 166.
28. Burney, Dr C., 1832, i, 331–2.
29. Mannings, cat. no. 324, fig. 97.
30. Ibid., cat. no. 1706, fig. 108.
31. Ibid., cat. no. 532, fig. 100.
32. Letter 10.
33. Penny, 1986 (catalogue), 184.
34. Walpole, 1937–83, xxiii, 465.
35. Smith, John Thomas, 1828, ii, 292.
36. Northcote, i, 83.
37. Mannings, cat. no. 200, pl. 8, fig. 96.
38. Ibid., cat. no. 472, fig. 110.
39. Ibid., cat. no. 231, pl. 74, fig. 1130.
40. Ibid., cat. no. 368, fig. 117.
41. Ruggles, 16–23.
42. This first volume is in the Cottonian Library in Plymouth. All the others known to survive are in the Library of the Royal Academy; the missing years are 1756, 1763, 1774, 1775, 1776, 1778, 1783 and 1785.
43. Now in the Fitzwilliam Museum in Cambridge.
44. Fletcher, 221.
45. Mannings, cat. no. 1497, fig. 161.
46. Ibid., cat. no. 42, fig. 118.
47. Fitzgerald, i, 197–8.
48. Mannings, cat. no. 984, fig. 133. The picture is now at Muncaster Castle, Cumbria.
49. Ibid., cat. no. 1262, fig. 137. There are two later portraits of Molesworth. All three are still at Pencarrow.
50. Ibid., cat. no. 208, fig. 155.
51. Ibid., cat. nos. 208 and 210, figs. 155 and 119.
52. Ibid., cat. no. 1606, fig. 144.
53. Ibid., cat. no. 1151, fig. 135.
54. Ibid., cat. nos. 784 and 785, figs. 129 and 30.
55. Boswell, 1934–50, i, 165.
56. Ibid., 246.
57. Mannings, cat. no. 1011, pl. 23, fig. 237.
58. Reynolds, 1959, 118.
59. Reynolds, 1819, i, 51.
60. Northcote, ii, 22.
61. Walford, iv, 270.
62. Mannings, cat. no. 1001, fig. 205.
63. Ibid., cat. no. 387, fig. 190.
64. Ibid., cat. no. 917, fig. 201. See Appendix B, 'Reynolds's Painting Technique', by Horace A. Buttery, in Hudson, 248–50.

65. Ibid., cat. no. 1191, fig. 211. The portrait is now in the Musée Jacquemart-André in Paris.

66. Ibid., cat. no. 1366, pl. 11, fig. 216.

67. Whitley, 1928, i, 175.

68. Mannings, cat. no. 1366, pl. 11, fig. 216.

69. Ibid., cat. nos. 342 and 344, figs. 187 and 188.

5
Questions of Style

1. The picture forms part of the collection of the Marquess of Bute at Mount Stuart.

2. Bute's portrait now belongs to the National Trust for Scotland.

3. The portrait (Mannings, cat. no. 1173, fig. 431) is now in the Art Gallery of New South Wales, Sydney.

4. Mannings, cat. no. 1342, fig. 280.

5. Northcote, i, 76.

6. Mannings, cat. no. 1085, fig. 466. The picture now belongs to the National Trust, and is at Gunby Hall, Lincolnshire.

7. Hazlitt, 1830, 122.

8. Mannings, cat. no. 1660, fig. 288.

9. Ibid., cat. no. 260, fig. 260.

10. Ibid., cat. no. 1105, fig. 270.

11. Ibid., cat. no. 634, fig. 317.

12. Ibid., cat. no. 1431, fig. 324.

13. Ibid., cat. no. 1462, fig. 284. The portrait, bought from Agnew's in 1946 for the Seventeenth Duke of Alba, is now in the Fundación Casa de Alba in Madrid.

14. Ibid., cat. no. 1392, fig. 330.

15. Ibid., cat. no. 822, fig. 331. The portrait is now in the Toledo Museum of Art, Ohio.

16. Ibid., cat. no. 604, fig. 265. The picture was destroyed in the fire at Uppark, Sussex, in 1989.

17. The picture is now in the Timken Art Gallery, San Diego.

18. Johnson, Samuel, 1992–4, i, 173.

19. Northcote, i, 83.

20. Waterhouse, 1941, 11.

21. Walpole, 1937–83, xxi, 284.

22. Mannings, cat. no. 1035, pl. 29, fig. 427.

23. Reynolds, 1959, 88.

24. Hilles, 1936, 17–22.

25. Mannings, cat. no. 565, fig. 393. This now belongs to Mr Allan Riley of New York. There are two later portraits of the duke by Reynolds in the Royal Collection.

26. The picture (Ibid., cat. no. 715, pl. 28, fig. 422) is in the Royal Collection.

27. Ibid., cat. no. 500, fig. 456. The portrait is now in the Wallace Collection.

28. Ibid., cat. no. 1512, fig. 472.

29. Ibid., cat. no. 612, fig. 418.

30. Ibid., cat. no. 618, fig. 888.
31. Leslie and Taylor, i, 430.
32. Walpole, 1937–83, xv, 47.
33. Mannings, cat. no. 611, fig. 417.

6

Gallipots of Varnish and Foolish Mixtures

1. Whitley, 1928, i, 151.
2. The chimney-piece is illustrated in Paine, ii, plate xcvii.
3. Northcote, i, 102.
4. Clifford and Royalton-Kisch, 66.
5. Smith, John Thomas, 1828, ii, 194.
6. Whitley, 1928, i, 167.
7. Mannings, cat. no. 1801, fig. 325. The picture has now found its way to the Ponce Museum, Puerto Rico.
8. Ibid., cat. no. 1069, fig. 502.
9. Dodsley, 441. The picture, now at Dulwich, seems to have survived remarkably well (Mannings, cat. no. 512, fig. 495).
10. Whitley, 1928, i, 174.
11. Northcote, ii, 21.
12. Ibid., 20.
13. Ibid., 83–4.
14. Leslie and Taylor, 215, n. 1.
15. Mannings, cat. no. 1575, fig. 513. National Maritime Museum, Greenwich.
16. Ibid., cat. no. 529, fig. 496. The portrait is in the collection of the National Gallery of Scotland.
17. Ibid., cat. no. 1092, fig. 537.
18. Smith, John Thomas, 1828, i, 37.
19. Mannings, cat. no. 1128, fig. 503.
20. Ibid., cat. no. 1171, fig. 514.
21. Penny, 1986 (catalogue), 200.
22. Reynolds, 1959, 59.
23. Jameson, 330. Mrs Jameson was the daughter of the Irish miniature painter Denis Brownell Murphy, for a time Painter in Ordinary to the Princess Charlotte.
24. Mannings, cat. no. 700, pl. 42, fig. 531.
25. Wind, 38. This is a translation of a paper Wind originally delivered at the Warburg Library in Hamburg in 1931 under the title 'Humanitätsidee und heroisertes Porträt in der englischen Kultur des 18. Jahrhunderts'.
26. Fitzgerald, Percy, *The Life of David Garrick*, new and revised edn, London, 1899, 449.
27. Hilles, 1952, 98.
28. Waterhouse, 1973, 22.
29. Walpole, 1937–83, ix, 321.
30. Pasquin, 1796, ii, 69.

31. Mannings, cat. no. 716, pl. 44, fig. 559.

32. Ibid., cat. no. 1052, pl. 45, fig. 567. The picture is now at Woburn.

33. Cunningham, 1829–33, v, 39.

34. Mannings, cat. no. 165, fig. 743.

35. Ibid., cat. no. 1722, fig. 741.

36. There is a portrait of the father by Hogarth in the Beaverbrook Art Gallery at Fredericton, New Brunswick.

37. The painting is at Audley End, Essex.

38. Johnson, Samuel, 1992–4, i, 199, 10 June 1761.

39. Whitley, 1915, 36.

40. The picture is in the collection of Earl Spencer at Althorp.

41. Mannings, cat. no. 1353, fig. 667.

42. Boswell, 1934–50, v, 99–102.

43. Anderson, 467.

44. Greig, 47. The portrait (Mannings, cat. no. 1594, pl. 47, fig. 640) is now in the Thomas Gilcrease Museum, Tulsa, Oklahoma.

45. Farington, 1819, 43–4.

46. Northcote, i, 80.

47. Hilles, 1952, 76.

48. Mannings, cat. no. 225, fig. 555.

49. Boswell, 1934–50, v, 82.

50. Ibid., i, 145.

51. Palmer.

52. Hill, G. B., ii, 299.

53. Johnson, Reverend Samuel, 111. The handwriting in the notebook is that of Elizabeth's youngest child, Mary, and her daughter, Elizabeth Yonge.

54. Mannings, cat. no. 394, fig. 649.

55. Boswell, 1934–50, i, 377.

56. Northcote, i, 118.

57. Hill, G. B., ii, 278.

58. Northcote, i, 116.

59. Ibid., 118.

60. Ibid., 119.

7

Our Late Excellent Hogarth

1. Mannings, cat. no. 7, fig. 809.

2. Knight, Cornelia, 1861, i, 9.

3. Walpole, 1937–83, xxiii, 345.

4. Northcote, ii, 9.

5. Mannings, cat. no. 2106, fig. 1653.

6. Cotton, 1859, 58.

7. Northcote, ii, 62.

8. Whitley, 1928, ii, 283.

9. Northcote, ii, 180–81.

10. Ibid., 7.

11. Ibid., 7–8.

12. Ibid., 25–6.

13. Ibid., 26–7.

14. Mannings, cat. no. 1019, fig. 718.

15. *Maryland Historical Magazine*, xi, 1916, 329. The portrait (Mannings, cat. no. 318, fig. 686) is now at the Yale Center for British Art, New Haven, Conn.

16. Mannings, cat. no. 296, fig. 681.

17. Ibid., cat. no. 381, fig. 690.

18. Northcote, ii, 8.

19. Mannings, cat. no. 1272, fig. 732. The picture is in the collection of the Duke of Buccleuch at Bowhill.

20. Letter dated 20 June 1763 (Little and Kahrl, i, 375).

21. Mannings, cat. no. 1522, pl. 49, fig. 735.

22. *European Magazine and London Review*, lxiv (1813), 516.

23. Mannings, cat. no. 28, pl. 60, fig. 833. Now at Waddesdon Manor, the property of the National Trust.

24. Ibid., cat. no. 1891, fig. 799. The picture is in the Royal Collection.

25. Ibid., cat. no. 1164, fig. 87. Now at Petworth, the property of the National Trust.

26. Ibid., cat. no. 1598, fig. 798. Now at Lambeth Palace.

27. Ibid., cat. no. 524, fig. 783. Now in the Scottish National Portrait Gallery, Edinburgh.

28. Ibid., cat. no. 760, fig. 791.

29. The portrait (Ibid., cat. no. 1475, fig. 814) still hangs there today.

30. Ibid., cat. no. 614, pl. 53, fig. 765. The picture, which is unfinished, is at Bowood House.

31. Ibid., cat. no. 140, fig. 771. Now at Kenwood.

32. Ibid., cat. no. 480, pl. 54, fig. 780.

33. Northcote, ii, 94–5.

34. Ibid., 96.

35. Prior, 1860, 88.

36. Boswell, 1934–50, i, 416.

37. Ibid., 480.

38. Johnson, Samuel, 1992–4, i, 243–4.

39. Reynolds, 1959, 51.

40. Hill, G. B., i, 240.

8

Foreign Bodies, Foreign Parts

1. Northcote, i, 142–3.

2. Farington, 1978–84, ix, 3192, entry dated 6 January 1808.

3. Ibid.

4. Her portrait of Reynolds now belongs to the National Trust at Saltram. Reynolds's portrait of Angelica (Mannings, cat. no. 1026, fig. 1251), previously in the collection of Earl Spencer at Althorp, was sold in 1980 and is now in a private collection.

5. Quoted in Whitley, 1928, i, 373.

6. The sketch appears as an illustration in Penny, 1986 (catalogue), 340.

7. Mannings, cat. no. 934, fig. 44.

8. Ibid., cat. no. 935, fig. 408.

9. Ibid., cat. nos. 937 and 938, figs. 848 and 847.

10. Ibid., cat. no. 936, fig. 1159.

11. Waterhouse, 1953, 192.

12. The picture is now in the John and Mable Ringling Museum, Sarasota, Florida.

13. The portrait was destroyed in a fire at Stratford Town Hall in 1946.

14. Now at Burghley House, Cambridgeshire.

15. The picture of Caroline, wife of the Fourth Duke of Marlborough, with her daughter, Lady Caroline Spencer, painted 1764–67, is at Blenheim (Mannings, cat. no. 1659, fig. 815).

16. Hayes, 2001, 17. Gainsborough was writing to his friend James Unwin in July 1763, apologizing for leaving a letter so long unanswered.

17. Ibid., 38.

18. Farington, 1978–84, ii, 306–7.

19. Cardiff Public Library, Bute MSS., no. 128.

20. *Correspondence of John, Fourth Duke of Bedford Selected from the Originals at Woburn Abbey with an Introduction by Lord John Russell*, 3 vols., London, 1842–6, iii, 224, letter dated 2 April 1763.

21. Wolcot, i, 109.

22. *Le Pour et le Contre. Being a Poetical Display of the Merit and Demerit of the Capital Paintings Exhibited at Spring Gardens*, London, 1767, iv.

23. Burke, Edmund, 1958–78, i, 308, letter dated 26 April 1767.

24. Whitley, 1928, i, 222. The passage quoted appeared in a pamphlet called 'The Conduct of the Royal Academicians' by the engraver Robert Strange, published in 1771.

25. Now the property of the National Trust and displayed at Ickworth.

26. Letter 18.

27. Barry, 1809, i, 101–3.

28. Letter 107.

29. Letter 18.

30. Hill, G. B., ii, 455–6n.

31. Northcote, i, 202–3.

9

From Accommodations to Ornaments

1. Waterhouse, 1941, 15.

2. Whitley, 1928, i, 226.

3. Letter 19.

4. Royal Academy General Assembly Minutes, i, 1–4.

5. Harris, 166.

6. Armstrong, 71.

7. Letter 21.

8. Historical Manuscripts Commission, Hardy, i, 292.

9. Farington, 1978–84, vi, 2467, entry dated 10 December 1804.

10. Reynolds, 1959, 267.

11. *Gentleman's Magazine*, xxxix, 98, February 1769.

12. Royal Academy Council Minutes, i, 4–6.

13. Garrick, i, 333.

14. Farington, 1978–84, iv, 1330, entry dated 22 December 1799.

15. Waterhouse, 1965, 71.

16. Mannings, cat. no. 186, fig. 934.

17. Ibid., cat. no. 1271, fig. 901. The picture is now at Wimpole Hall, Cambridge-shire, the property of the National Trust.

18. Northcote, i, 186.

19. Boswell, 1934–50, ii, 82–3.

20. Ibid., 88.

21. Prior, 1860, 381.

22. Johnson, Samuel, 1958–90, x, 338.

10

Calipash and Calipee

1. Mannings, cat. no. 396, fig. 968.

2. Ibid., cat. no. 1012, fig. 673 and cat. no. 736, fig. 1004. They are at Knole, Sevenoaks.

3. Penny, 1986 (catalogue), 240.

4. Johnson, Samuel, 1992–4, i, 372.

5. Goldsmith, 84.

6. Mannings, cat. no. 41, pl. 68, fig. 961.

7. Letter 43.

8. Letter 45. Charles Brandoin's drawing of the 1771 Exhibition shows how the hanging committee shaped up to its task at these early exhibitions. The number of works exhibited in 1770 was 234.

9. Garrick, ii, 781.

10. Letter 26.

11. Mannings, cat. no. 1033, fig. 1002.

12. Mr Montagu was Montagu Parker, John Parker's younger brother. He had sat to Reynolds two years previously (Ibid., cat. no. 1399, fig. 952). The picture is still at Saltram.

13. Mannings, cat. no. 2172, pl. 136, fig. 1707.

14. Whitley, 1928, i, 283.

15. Mannings, cat. no. 2178, fig. 1713. The picture, part of the Iveagh Bequest, is now at Kenwood House.

16. Baker, R., 'Observations on the Pictures Now on Exhibition', no. 156, in Graves and Cronin, iv, 1480.

17. Whitley, 1928, i, 284.

18. Ibid., i, 282.

19. Mannings, cat. no. 29, pl. 67, fig. 1017.

20. Ibid., cat. no. 1504.

21. Little and Kahrl, iii, 935.

22. Highfill, Burnim and Langhans, vii, 162.

23. Whitley, 1928, ii, 280.

24. Ibid., 280–81.

25. Gwynn, 49.

26. Whitley, 1928, ii, 281. Northcote was writing to his brother. The letter is dated 10 August 1771.

27. Gwynn, 66.

28. Johnson, Samuel, 1992–4, i, 376–7.

29. Walpole, 1937–83, xxxix, 146, letter dated 30 July 1771.

30. Tronchin, 311.

31. Stuffmann; Hilles, 1969, 201–10. See also Hilles's 'Horace Walpole and the Knight of the Brush' in Smith, Warren Hunting, 141–66.

32. Letter 30.

33. Highfill, Burnim and Langhans, i, 18.

34. The painting is now in the National Museum in Stockholm. At the Salon in 1771 it was entitled *Gustave, Roi de Suède, dans son Cabinet d'Etudes, s'entretenant sur des plans de Fortification, avec les Princes Charles et Adolphe-Frédéric, ses Frères.*

35. 'Lettres sur l'Académie Royale de Sculpture et de Peinture et sur le salon de 1777', reprinted in *Revue Universelle des Arts*, xix, 1864, pp. 185–6 (quoted in Crow, 4).

36. Collé, iii, 322–4.

37. Whitley, 1928, ii, 282.

38. Ibid.

39. Goldsmith, 102.

40. Mannings, cat. no. 2189, fig. 1724. The picture, painted in 1784, is now in the Tate Gallery.

41. British Museum. Add. MSS. 41133.

42. Ibid.

43. Ibid.

44. Court Rolls of the Manor of Richmond, p. 1972, entry dated 12 August 1772.

45. Hilles, 1929, 241.

46. Smith, John Thomas, 1828, ii, 128.

11

A Tendency to Mischief

1. Reynolds, 1959, 57.
2. Ibid., 62–3.
3. Leslie and Taylor, ii, 139.
4. Ibid., i, 418.
5. Ibid., 432.
6. Gibbon, 1796–1815, ii, 74.
7. Boswell, 1934–50, ii, 169.
8. Mannings, cat. no. 444, fig. 992.
9. Ibid., cat. no. 1427, fig. 1028.
10. Northcote, ii, 32–3.
11. Mannings, cat. no. 902. The portrait, which last surfaced at a sale at Agnew's in 1894, is now untraced.
12. Ibid., cat. no. 1528, fig. 1057. The picture is now in the Scottish National Portrait Gallery in Edinburgh.
13. Letter 54.
14. 23–26 April 1772.
15. Fletcher, 159.
16. Walpole, 1937–83, xxiii, 345.
17. *London Magazine*, 1772, 156.
18. Auckland, ii, 280.
19. Letter 30.
20. Mannings, cat. no. 290, pl. 97, fig. 1352.
21. Ibid., cat. no. 107, pl. 72, fig. 1067.
22. Ibid., cat. no. 285, fig. 1100.
23. Ibid., cat. no. 737, fig. 1005.
24. Ibid., cat. no. 1014, fig. 1070.
25. Ibid., cat. no. 118, fig. 1151.
26. Leslie and Taylor, i, 427.
27. Mannings, cat. no. 106, pl. 73, fig. 1040.
28. Whitley, 1928, ii, 291.
29. Gwynn, 73–4.
30. Mannings, cat. no. 707, fig. 1050.
31. Gwynn, 88–9.
32. Whitley, 1928, ii, 293.
33. Ibid., 292.
34. Northcote, ii, 315.
35. Whitley, 1928, ii, 293.
36. Reynolds, 1959, 83–4.
37. Ibid., 85.
38. Ibid., 86–7.
39. Ibid., 90.

12

Two Score Years and Ten

1. Goldsmith, 116.
2. Johnson, Samuel, 1992–4, ii, 25, letter dated 25 March 1773.
3. Letter 33.
4. Hist. MSS. Comm. XII, 1891, Hardy, i, 344.
5. Boswell, 1934–50, v, 76.
6. Letter 66.
7. One is now at Bowood, the other in the Wallace Collection (Mannings, cat. nos. 2165–6, figs. 1702–3).
8. Northcote, ii, 7.
9. Hilles, 1952, 135.
10. Cunningham, 1829–33, i, 217.
11. *Morning Chronicle*, 6 May 1773.
12. Northcote, ii, 196.
13. Letter 35.
14. Postle, 1995, 147.
15. Letter 35. Dr Robert Vansittart was Regius Professor of Civil Law.
16. Northcote, i, 294.
17. Beattie, entry for 3 June.
18. Ibid., 11 August.
19. Forbes, Sir William, i, 336.
20. Letter 39.
21. Northcote, ii, 305.
22. Mannings, cat. no. 1396, pl. 82, fig. 1013.
23. Letter 66.
24. Mannings, cat. no. 16, fig. 1149. The picture is now in the Uffizi.
25. Ibid., cat. no. 1876, fig. 1090.
26. Whitley, 1928, ii, 295–6.
27. Mannings, cat. no. 382, pl. 75, fig. 1074.
28. Shawe-Taylor, 186–8.
29. 'On Reynolds's Art of Borrowing: Two More Italian Sources', *Burlington Magazine*, cxxxvi, January 1994, 26–9.
30. Northcote, ii, 29.

13

Stop Thief!

1. Hilles, 1952, 44. 'Reigns here and revels' occurs in *Paradise Lost*, iv, 765.
2. Ibid., 44–57.
3. Letter 40.
4. Waterhouse, 1941, 17.
5. Mannings, cat. no. 1904, fig. 1112. Now in the Royal Collection.

6. Ibid., cat. no. 1902, fig. 1106. Also in the Royal Collection.

7. Ibid., cat. no. 417, fig. 1075. The picture is now in the National Gallery of Ireland, Dublin.

8. Ibid., cat. no. 1338, fig. 1084.

9. Ibid., cat. no. 107, pl. 72, fig. 1067.

10. Ibid., cat. no. 1282, fig. 1078.

11. Letter 34.

12. Steegman, 1933, 85.

13. Letter 41.

14. Letter 42.

15. Little and Kahrl, iii, 954–5.

16. Letter 43.

17. Little and Kahrl, iii, 1002.

18. Leslie and Taylor, ii, 88–9.

19. Lipking, 179.

20. Reynolds, 1959, 99.

21. Ibid., 95, 96.

22. Ibid., 98–113.

23. Waterhouse, 1941, 25.

24. Roberts, W., i, 58.

25. Mannings, cat. no. 1007, fig. 1123.

26. Northcote, i, 290.

27. Boswell, 1934–50, ii, 324.

28. Ibid., 361–2. This did not, by his own account, stop him sitting to Fanny on some ten occasions.

29. Ibid., 364–5.

30. Letter 46.

31. British Museum, Add. MS 41135, f. 589.

32. Mannings, cat. no. 1614, fig. 1154. The picture is now at Waddesdon Manor, a property of the National Trust.

33. Walpole, 1937–83, xxiv, 92.

34. Mannings, cat. no. 1752, fig. 1164.

35. Walpole, 1937–83, xxi, 439

36. Mannings, cat. no. 744, fig. 1141.

37. Burney, Fanny, 1988–90, ii, 68.

38. Boswell, 1934–50, ii, 369.

39. Northcote, ii, 85n.

40. Catalogue of *The Exhibition of Pictures, by Nathaniel Hone, R.A., Mostly the Works of His Leisure, and Many of Them in His Own Possession*, 1775, preface.

41. Royal Academy, Council Minutes, C1, 198–9.

42. Reynolds, 1959, 107.

43. Penny, 1986 (catalogue), 344–54.

44. Ibid., 353.

45. Butlin, 1–9.

46. Royal Academy Archives 5B/5.

14

Intimations of Mortality

1. Letter 54.
2. Hill, G. B., i, 230.
3. Whitley, 1928, ii, 297.
4. *Gentleman's Magazine*, February 1776, 75.
5. Whitley, 1928, ii, 298. Letter dated 25 January 1776.
6. Boswell, 1982, 339, entry for Sunday 28 August 1785.
7. Roberts, W., i, 80–81.
8. Northcote, ii, 38.
9. Little and Kahrl, iii, 995.
10. Roberts, W., i, 90.
11. Boswell, 1934–50, ii, 292.
12. Ibid., iii, 41.
13. Mannings, cat. no. 367, fig. 519. The picture is today untraced.
14. Walpole, 1937–83, xx, 49.
15. Mannings, cat. no. 1137, pl. 81, fig. 1171.
16. Reynolds, 1959, 19.
17. Johnson, Reverend Samuel, 198.
18. Mannings, cat. no. 1363, pl. 101, fig. 1191. The picture, formerly in the Castle Howard Collection, was sold at Sotheby's for £10.3 million in 2001. Its export was temporarily blocked by the government in December 2002.
19. Burke, Joseph, 205.
20. Mannings, cat. no. 449, fig. 1132.
21. Walpole, 1828, iv, ixn.
22. Whitley, 1928, ii, 298–9.
23. Johnson, Samuel, 1992–4, ii, 330, letter dated Thursday 16 May 1776.
24. Ibid., 345–6, letter dated Saturday 22 June 1776.
25. Farington, 1978–84, iii, 1046, entry for 17 August 1798. Farington had the story from Hoppner.
26. Mannings, cat. no. 1751, fig. 1359.
27. Northcote, ii, 23.
28. Ingamells, 306.
29. Collection of the Rt Hon. the Viscount Boyne.
30. 'The Disabled Debauchee', 1680, ll. 37–40.
31. Mannings, cat. no. 2101, fig. 1650.
32. Now in the collection of the National Galleries of Scotland in Edinburgh.
33. Fletcher, 121.
34. Mannings, cat. no. 2037, fig. 1596.
35. Sandby, i, 108.
36. Constable, 55.
37. Northcote, ii, 237–8.

38. Reynolds, 1959, 117.

39. In Chapters xvi and xx. See Thompson.

40. Johnson, Samuel, 1992–4, ii, 353, letter dated 3 August 1776.

15

Sacred and Profane

1. 26 April 1777.

2. Now in the National Gallery in London.

3. Mannings, cat. no. 104, pl. 83, fig. 1179.

4. Ibid., cat. no. 1581, fig. 1194. The picture is in the collection of the Duke of Buccleuch at Bowhill.

5. Walpole, 1937–83, xxxii, 337–8.

6. Mannings, cat. no. 2069, pl. 127, fig. 1622.

7. Ibid., cat. no. 813, fig. 1208.

8. *The Speeches of Mr Wilkes in the House of Commons*, London, 1786, 142–3.

9. Walpole, 1937–83, xxiii, 510–11.

10. Letter 62.

11. Letter 70.

12. Cotton, 1859, 58.

13. Northcote, ii, 104n.

14. Cotton, 1859, 58.

15. Waterhouse, 1941, 18.

16. Mannings, cat. no. 1674, pl. 90, fig. 1246.

17. Leslie and Taylor, ii, 199.

18. Waterhouse, 1953, 169.

19. Johnson, Samuel, 1992–4, i, 343–4, letter dated 15 June 1776.

20. Ibid., iii, 151, letter dated 15 February 1779.

21. Hill, G. B., ii, 455–6.

22. Johnson, Samuel, 1992–4, iii, 194, letter dated 21 October 1779.

23. Ibid., 201, letter dated 28 October 1779.

24. British Museum Add. MSS. 36,596, f.208.

25. Piozzi, 1942, i, 79–80, entry dated June 1777.

26. Letter 68.

27. Boswell, 1934–50, iv, 556.

28. Northcote, ii, 71.

29. *British Patents*, progression number 1183, Description dated 4 March 1778.

30. Mannings, cat. nos. 510 and 511, figs. 1235 and 1237.

31. Ibid., cat. no. 2167, pl. 135, fig. 1075.

32. In the collection of the Rt Hon. the Viscount Boyne.

16

Sword of Honour

1. Letter 71.
2. Roberts, W., i, 146.
3. Boswell, 1934–50, iii, 252.
4. Ibid., 260–61.
5. *London Magazine*, January 1778, 37.
6. Boswell, 1934–50, iii, 328–9.
7. Ibid., 331–2.
8. Quoted in Asfour, Williamson and Jackson, 29. The letter, dated December 1778, is now in the Bodleian (MS Montagu D8, fols 23–7).
9. Hayes, 1982, i, 129. The transactions appear in the Gainsborough ledger at Hoare's Bank.
10. *Morning Post and Daily Advertiser*, 27 and 29 April 1778.
11. Mannings, cat. no. 1221, fig. 1221.
12. Ibid., cat. no. 303, fig. 1262. The picture is now at Cawdor Castle, Nairn.
13. Ibid., cat. no. 889, fig. 1253. Now at Powis Castle, Welshpool, the property of the National Trust.
14. Ibid., cat. no. 1750, pl. 89, fig. 1248.
15. Her portrait (Ibid., cat. no. 1268, fig. 1241) is now in the Tate Gallery.
16. Ibid., cat. no. 1727, fig. 1256.
17. Leslie and Taylor, ii, 279.
18. Penny, 1986 (catalogue), 292.
19. Mannings, cat. no. 1695, pl. 85, fig. 1281. The picture is now in the Huntington Art Gallery, San Marino, California.
20. Shawe-Taylor, 156
21. Mannings, cat. no. 346, fig. 1296. The portrait remains in the possession of the Royal Academy.
22. Quoted in Graves and Cronin, ii, 501. The picture (Mannings, cat. no. 981, fig. 1271) hangs in the National Gallery of Ireland, Dublin.
23. Mannings, cat. no. 1713, pl. 104, fig. 1283.
24. 'A Record of Pictures Seen, Beginning 1924', seventy-two notebooks of MS notes.
25. Letter 73.
26. Walpole, 1937–83, xxx, 54.
27. Ibid., xxiv, 384.
28. Northcote, ii, 80–81.
29. Mannings, cat. no. 105, fig. 1254.
30. Ibid., cat. no. 1837, fig. 1236. Now in the Ashmolean Museum, Oxford.
31. 10 March 1779.
32. Quoted in Hudson, 251. The recognizance is preserved in the Middlesex County Records, Ref. SR (W). 3368. Recog. 36.
33. See Bampfylde.
34. Burney, Fanny, 1994, 224.

35. Letter 72.
36. Burney, Fanny, 1994, 139.
37. Ibid., 200–201.
38. Ibid., 217.
39. Ibid., 234.
40. Reynolds, 1959, 153.
41. Ibid., 157–8.
42. Ibid., 162.
43. See Murphy, Appendix XX.
44. Walpole, 1845, ii, 333.
45. Letter 81.
46. Hilles, 1952, 97–8.
47. Keppel, ii, 95.
48. Mannings, cat. nos. 1040 and 1041, figs. 831 and 832.
49. Keppel, ii, 217.

17

Alarums and Excursions

1. Mannings, cat. no. 2106, fig. 1653.
2. Cotton, 1859, 58.
3. Ibid., 59.
4. 26 April 1779.
5. Mannings, cat. nos. 2115, 2119 and 2116, figs. 1664, 1666 and 1665.
6. 27 April 1779.
7. Mannings, cat. no. 2120, fig. 1667.
8. Ibid., cat. nos. 2113 and 2114, figs. 1662 and 1663.
9. 29 April 1780.
10. Letter 107.
11. Boswell, 1934–50, iii, 381.
12. Ibid., 391.
13. Mannings, cat. no. 725, fig. 1298. The portrait is now in the collection of the Earl of Rosebery at Dalmeny.
14. Reynolds, 1819, i, xxiv.
15. *Town and Country Magazine; or, Universal Repository of Knowledge, Instruction, and Entertainment*, August 1779, 401–4.
16. Burney, Fanny, 1994, 414–15.
17. Letter 84.
18. Mannings, cat. no. 623, fig. 1307.
19. Ibid., cat. no. 477, fig. 1027. The picture is now at the Yale Center for British Art, New Haven.
20. Letter 233.
21. Cotton, 1859, 54.
22. Boswell, 1934–50, iii, 420.
23. Mannings, cat. nos. 347–9, figs. 658, 900 and 659.

24. Sandby, i, 156.

25. Baretti, 1781.

26. Mannings, cat. no. 2168, fig. 1704.

27. Whitley, 1928, i, 348.

28. Ibid., i, 349.

29. Walpole, 1937–83, xxix, 37–8, 42, 47.

30. *An Heroic Epistle to Sir William Chambers*, London, 1773, 5, ll. 1–2.

31. Walpole, 1937–83, xxix, 42.

32. *Journals of the House of Commons*, xxxix, 837–8.

33. Letter 86.

34. Letter 88.

35. Mannings, cat. no. 1359.

36. Ibid., cat. no. 998.

37. Walpole, 1937–83, xxix, 45–6. The picture (Mannings, cat. no. 1810, pl. 102, fig. 1340) is now in the National Gallery of Scotland, Edinburgh.

38. Ibid., xxix, 285.

39. Shawe-Taylor, 117.

40. Mannings, cat. no. 1717, fig. 1331.

41. Ibid., cat. nos. 331 and 332, figs. 1321 and 1322. The first picture is in a private collection; the second is in the Devonshire Collection at Chatsworth.

42. Walpole, 1937–83, xxix, 137–8, letter dated 6 May 1781.

43. Letter 91.

44. Leslie and Taylor, ii, 310–11.

45. *Dizionario delle belle arti del disegno*, Bassano, 1797.

46. The phrase is Rudolf Preimesberger and Michael P. Mezzatesta's, writing about Bernini in the *Grove Dictionary of Art*.

18

'Eccentrick, Bold and Daring'

1. Mannings, cat. no. 290, pl. 97, fig. 1352.

2. Piozzi, 1942, entry dated 10 January 1781.

3. *Public Advertiser*, 27 February 1781.

4. Pyne, i, 282.

5. Ibid., 295–6.

6. Whitley, 1915, 369–70.

7. Whitley, 1928, i, 357.

8. *London Courant*, 3 May 1781. The picture is now in the collection of the Duke of Westminster.

9. Mannings, cat. no. 339, pl. 113, fig. 1343. Now at Hatfield House.

10. Ibid., cat. nos. 2113 and 2114, figs. 1662 and 1663.

11. Ibid., cat. no. 2065, pl. 129, fig. 1619. The picture is now in the Royal Collection.

12. Northcote, ii, 121.

13. Ibid., 139–40.

14. Mannings, cat. no. 2167, pl. 135, fig. 1705. The picture is now at Waddesdon Manor.

15. 'The Ear-Wig', 5–6.

16. Hickey, ii, 250.

17. Trevelyan, R., 16.

18. Mannings, cat. nos. 178, 179, 180 and 181, figs. 474, 907 and 962 (no. 178 untraced).

19. Letter 98.

20. Johnson, Samuel, 1992–4, iii, 355, letter dated Saturday 21 July 1781.

21. Letter 94.

22. Alpers, 1983, xviii.

23. Ibid., xvii.

24. Letter 96.

25. Ibid.

26. Yale Center for British Art, MS Reynolds 10.

27. Letter 96.

28. Discourse IV, delivered in 1771 (Reynolds, 1959, 68).

29. Also now in Munich.

30. Now in the Boymans-Van Beuningen Museum, Rotterdam.

31. Mannings, cat. no. 173, pl. 121, fig. 1471. It is now in the Spencer Collection at Althorp.

32. Althorp MSS.

33. Mannings, cat. no. 328, fig. 1425.

34. It is now in the Wallace Collection.

35. Reynolds, 1959, 260.

19

The Cornish Wonder and a Shake of the Palsy

1. Waterhouse, 1953, 204.

2. Mannings, cat. no. 1529, fig. 1390. The picture is now at Waddesdon Manor.

3. Ibid., cat. no. 1733, pl. 116, fig. 1400. The picture is now in the National Gallery, London.

4. Ibid., cat, no. 100, pl. 107, fig. 1374. The portrait is now at Bowood House, Wiltshire.

5. Ibid., cat. no. 149, fig. 1375. Now in the National Portrait Gallery, London.

6. Ibid., cat. no. 807, fig. 1384. It is now in the National Gallery of Scotland, Edinburgh.

7. Letter 153, dated July 10 1786.

8. Wolcot, i, 17.

9. Ibid., 29.

10. Reynolds, 1959, 255–6.

11. Whitley, 1928, i, 382–3.

12. Letter 105.

13. Mannings, cat. no. 534, fig. 1377. Now at Arniston House, Midlothian, the property of the Dundas-Bekker family.

14. Ibid., cat. no. 674, fig. 1380. Now at Holkham Hall.

15. Angelo, i, 363.

16. Burney, Dr C., 1991, 353–4, letter dated 11 November 1782.

17. Johnson, Samuel, 1992–4, iv, 87, letter dated Thursday 14 November.

18. Ibid., 95–6, letter dated Wednesday 11 December.

19. Reynolds, 1959, 192.

20. Ibid., 193.

21. Ibid., 195.

22. Ibid., 197–8.

23. Ibid., 203–4.

24. Burney, Fanny, 1904, ii, 163.

20

Desire without Content

1. Letter 108.

2. Letter 109.

3. Boswell, 1934–50, iv, 164.

4. Ibid., 173.

5. Johnson, Samuel, 1992–4, iv, 116, letter dated 4 March 1783.

6. Letter 110.

7. Wolcot, i, 20.

8. Ibid., i, 63.

9. Hayes, 2001, 150.

10. Ibid., 152.

11. Rosenthal, 266.

12. 'An Inquiry into the Real and Imaginary Obstructions to the Acquisition of the Arts in England', 1775.

13. Northcote, ii, 146.

14. Letter 112.

15. Letter 113.

16. Siddons, 17–18.

17. Whitley, 1928, ii, 4.

18. See Mount, Charles Merrill, 87.

19. Barry, 1809, i, 553.

20. Boswell, 1934–50, iv, 241.

21. Letter 114.

22. Hayes, 2001, 160.

23. 24 April 1784.

24. 28 April 1784.

25. Mannings, cat. no. 1027, fig. 1414. The picture is now in the Cuban National Museum, Havana.

26. liv, part 1, 285.

27. 28 April 1784.
28. Mannings, cat. no. 2127, fig. 1672.
29. Ibid., cat. no. 815, fig. 1421.
30. Ibid., cat. no. 1183, fig. 1438.
31. Ibid., cat. no. 32, fig. 1396.
32. Johnson, Samuel, 1992–4, iv, 374, letter dated 19 August 1784.
33. Ibid., 387–8.
34. Hayes, 2001, 161.
35. Letter 123.
36. Letter 125.
37. Johnson, Samuel, 1992–4, iv, 412.
38. Hilles, 1952, 89–90.
39. Ibid., 74.

21

Wheeling and Dealing

1. Letter 132.
2. Reynolds, 1959, 207.
3. Ibid., 208.
4. Ibid., 209.
5. Ibid., 217–18.
6. Ibid., 222–3.
7. Ibid., 225. The quotation from Milton is from *Comus*, II, 74–5.
8. Tatham.
9. Recounted as an anecdote 'Blake used to tell' in Gilchrist.
10. Ibid., citing a letter from 'a surviving friend'.
11. 23 May 1785.
12. 26 May 1785.
13. Whitley, 1928, ii, 37.
14. Mannings, cat. no. 1145, fig. 1467. Badly damaged by fire in 1824, the picture is now in the Royal Collection.
15. Ibid., cat. no. 2174, fig. 1708.
16. Letter 134.
17. Cotton, 1859, 55.
18. Ibid., 55–6.
19. 2 May 1785.
20. Letter 154.
21. Wolcot, i, 108.
22. Ibid., 109–10.
23. HMC *Rutland*, iii, 214.
24. Letter 136.
25. Letter 139.
26. Letter 142.
27. Letter 146.

28. Letter 148.

29. Boswell, 1982, 318.

30. Letter 137.

31. Boswell, 1982, 308–9.

32. Mannings, cat. no. 214, fig. 1449.

33. Northcote, ii, 98.

34. Letter 149.

22

Shadows Cast Before

1. Mannings, cat. no. 1049, fig. 1460. Now in the Royal Collection.

2. Letter 150.

3. Letter 141.

4. Northcote, ii, 162.

5. Leslie and Taylor, ii, 482.

6. Letter 152.

7. Letter 155. The nature of Ossory's proposal is not known.

8. Angelo, ii, 281–2.

9. 9 May 1786.

10. Letter 152.

11. Letter 154.

12. Letter 157.

13. Letter 160.

14. Reynolds, 1959, 182–3.

15. Letter 153.

16. Letter 157.

17. Letter 178.

18. Letter 171.

19. 9 January 1787.

20. Northcote, ii, 226.

21. Tillotson, 36.

22. Letter 175.

23. Letter 162.

24. Letter 164.

25. Reynolds, 1905, 348.

26. Reynolds, 1959, 229.

27. Ibid., 230–31.

28. Ibid., 233.

29. Boswell, 1934–50, ii, 73.

30. Letter 166.

23

The Death of Gainsborough

1. Northcote, ii, 219.

2. Leslie, 72.

3. Mannings, cat. no. 627, fig. 1503. The picture is now the property of Tweed Investments Ltd.

4. Ibid., cat. no. 742, fig. 1494.

5. Ibid., cat. no. 1635, pl. 124, fig. 1519.

6. Letter 171.

7. Whitley, 1928, ii, 77.

8. Letter 172.

9. Wraxall, v, 34.

10. Walpole, 1937–83, xxxiii, 571–2, letter dated 6 September 1787.

11. *Morning Chronicle*, 29 January 1787.

12. Boswell, 1986, 140–41.

13. Ibid., 144.

14. Ibid., 147.

15. Ibid., 156.

16. Burney, Fanny, 1904, iii, 416.

17. *Edinburgh Review*, October 1841.

18. Cotton, 1856, 170.

19. 19 May 1788. 'Dabby' means damp or moist. 'Daddle' is an old dialect word for hand.

20. 15 May 1788.

21. 26–29 April 1788.

22. *The Analytical Review*, May–August 1788, vol. 1.

23. Armstrong, 178.

24. Mannings, cat. no. 2077, fig. 1627. The painting, with Colnaghi in 1942, is now untraced.

25. *Julius Caesar*, Act 2, sc. 1, ll. 229–32.

26. Mannings, cat. no. 668, pl. 118, fig. 1506.

27. Waterhouse, 1941, 20.

28. Mannings, cat. no. 1292, fig. 1515.

29. Ibid., cat. no. 578, pl. 115, fig. 1507.

30. Hayes, 2001, 170.

31. Ibid., 174.

32. Ibid., 175.

33. Whitley, 1915, 317–18.

34. Reynolds, 1975, 247–8.

35. Ibid., 249.

36. Ibid., 250.

37. Ibid., 252.

24
Bereaved of Light

1. Burney, Fanny, 1904, iv, 125.
2. Johnson, Samuel, 1992–4, iv, 256–7, letter dated 4 December 1783.
3. Whitley, 1928, ii, 119.
4. Cotton, 1859, 56–7.
5. Cotton, 1856, 174.
6. Mannings, cat. no. 2142, fig. 1687.
7. *The Analytical Review*, May–August 1789, iv, 106.
8. 1 May 1789.
9. Mannings, cat. no. 1612, fig. 1553.
10. Raimbach, 9–10.
11. Mannings, cat. no. 1545, fig. 1555. It is now in the Royal Collection.
12. Ibid., cat. no. 1544, fig. 253.
13. Wraxall, 190.
14. Mannings, cat. no. 27, fig. 1540.
15. Ibid., cat. no. 788, fig. 1461. The painting, sometimes given the name *Simplicity*, is now at Waddesdon Manor.
16. Leslie and Taylor, ii, 543.
17. *Morning Herald*, 27 July 1789.
18. Whitley, 1928, ii, 123.
19. Now in the National Gallery of Art, Washington.
20. Boswell, 1934–50, iv, 465.
21. Ibid., 467.
22. Northcote, ii, 248.
23. Ibid.

25
Cabals and Juntos

1. Hilles, 1936, 174.
2. Farington, 1819, 98.
3. Hilles, 1936, 251.
4. Farington, 1819, 100.
5. Hilles, 1936, 253.
6. Ibid., 253–4.
7. Ibid., 257–8.
8. Ibid., 252.
9. Letter 192.
10. Farington, 1819, 101.
11. Hilles, 1936, 258.
12. Ibid., 262.
13. Ibid., 264–5.

14. Farington, 1819, 102.
15. Letter 194.
16. Northcote, ii, 257.
17. Ibid., 254.
18. Gwyn, 213.
19. Letter 197.
20. Letter 195.
21. Letter 196.
22. Hilles, 1936, 268–9.
23. Ibid., 270.
24. Ibid., 271.
25. Ibid., 274.
26. Gibbon, 1956, iii, 194.
27. Royal Academy General Assembly Minutes, 3 March 1790.
28. Northcote, ii, 259.
29. Leslie and Taylor, ii, 585–6.
30. Reynolds, 1959, 265.
31. Haydon, 1960–63, iv, 573.

26

The Bending Sickle

1. It appeared in the issue dated 8–10 April 1790. The letter is reproduced in the original French in Bond, 267–77.
2. Letter 207.
3. Letter 204.
4. Wolcot, iii, 11.
5. Boswell, 1989, 108.
6. Hilles, 1952, 108.
7. Reynolds, 1959, 276–7.
8. Ibid., 278–9.
9. Ibid., 280–81.
10. Ibid., 282.
11. Hilles, 1936, 183.
12. Northcote, ii, 263.
13. Letter 211.
14. Letter 212.
15. Letter 213.
16. Hilles, 1936, 188–9.
17. Hilles, 1952, 146–7.
18. Ibid., 148–58.
19. *The Diary; or Woodfall's Register*, 5 January 1791.
20. 11 January 1791.
21. The manuscript is in the Yale Center for British Art.
22. Boswell, 1934–50, iv, 468. British Museum, Add. MS 22549.

23. 16 April 1791.

24. Letter 226.

25. Minutes of the General Assembly. Quoted in Harris, 168–9.

26. Letter 227.

27. Now in the collection of the Royal University College of Fine Arts, Stockholm.

28. Reynolds, 1819, I, cviii–cix, note 61.

29. Burney, Fanny, 1904, i, 86–7.

30. Farington, 1978–84, iv, 1295.

31. Burke, Edmund, 1958–78, vii, 12.

32. Farington, 1978–84, viii, 3002, entry dated 3 April 1807.

33. Irons, 130.

34. Ibid., 137.

35. Burke, Edmund, 1958–78, vii, 74.

27

The Top of a High Mountain

1. *The Star*, 3 March 1792.

2. Farington, 1978–84, iv, 1174, entry dated 16 March 1799.

3. General Assembly Minutes, 28 February 1792.

4. Whitley, 1928, ii, 155.

5. Parr, vii, 412.

6. *Lloyd's Evening Post*, 2–5 March 1792.

7. Burke, Edmund, 1958–78, vii, 92, letter dated March 1792.

8. Ibid., 142, letter dated 16 May 1792.

9. Ibid., 93.

10. Ibid., 99–100, letter to Malone dated 18 March 1792.

11. Farington, 1978–84, ii, 534. The picture (Mannings, cat. no. 153) is now untraced.

12. Burke, Edmund, 1958–78, vii, 335–7.

13. Ibid., ix, 311.

14. Burney, Fanny, 1904, i, 157.

15. Douglas, i, 329.

16. 13 April 1792.

17. Prior, 1826, ii, 189n.

18. Burke, Edmund, 1958–78, ix, 456.

19. Courtauld Newspaper Cuttings, I, 156.

20. *Morning Post*, 3 February 1794.

21. Farington, 1978–84, viii, 3105, entry dated 14 August 1807.

22. Wolcot, iii, 192.

23. Hilles, 1952, 21.

24. Farington, 1978–84, vii, 2581, entry dated 28 June 1805.

25. Yale Center for British Art, MS Reynolds 57, letter dated 4 December 1796.

26. Farington, 1978–84, x, 3645.

Bibliography

Alberts, Robert C., *Benjamin West, a Biography*, Boston, 1979

Alexander, D. and Godfrey, R., *Painters and Engraving: the Reproductive Print from Hogarth to Wilkie*, New Haven, 1980

Allen, Brian, *Francis Hayman*, New Haven and London, 1987

— et al., *The British Portrait, 1660–1960*, Woodbridge, 1991

Alpers, Svetlana, *The Art of Describing*, Chicago, 1983

—, *Rembrandt's Enterprise: the Studio and the Market*, Chicago, 1988

Anderson, Fred, *Crucible of War: the Seven Years War and the Fate of the Empire in British North America, 1754–1766*, London, 2000

Angelo, Henry, *Reminiscences, with Memoirs of His Late Father and Friends*, 2 vols., London, vol. 1, 1828; vol. 2, 1830

Anon., *An Essay in Two Parts on the Necessity and Form of a Royal Academy*, London, 1755

—, *The Conduct of the Royal Academicians, while Members of the Incorporated Society of Artists of Great Britain*, London, 1771 [Possibly by Robert Strange]

—, *Observations on the Discourses delivered at the Royal Academy*, London, 1774

—, *A Poetical Epistle to Sir Joshua Reynolds*, London, 1777

—, *A Candid Review of the Exhibition*, London, 1780

—, 'The Ear-Wig; or an Old Woman's Remarks on the Present Exhibition of Pictures at the Royal Academy . . . Dedicated to Sir Joshua Reynolds', London, 1781

—, *More Lyric Odes to the Royal Academicians by a Distant Relation to the Poet of Thebes*, London, 1785 and 1786 [By an imitator of 'Pindar', 1785]

—, *Observations on the Present State of the Royal Academy by an Old Artist*, London, 1790 [Possibly by James Northcote]

Armstrong, W., *Sir Joshua Reynolds*, London, 1900

Asfour, A., Williamson, P. and Jackson, G., ' "A Second Sentimental Journey": Gainsborough Abroad', *Apollo*, cxlvi, August 1997

Aspinall, A. (ed.), *The Letters of King George IV 1812–1830*, 3 vols., Cambridge, 1938

Aston, Nigel, 'Lord Carysfort and Sir Joshua Reynolds: the Patron as Friend', *Gazette des Beaux-Arts*, cxii (1988): 205–10

Auckland, W., Lord, *Journal and Correspondence*, 2 vols., London, 1861

Baker, C. H. Collins and James, M. R., *British Painting*, London, 1933

Balkan, K. S., 'Sir Joshua's Theory and Practice of Portraiture: a Reevaluation'

(thesis presented to the University of California, 1972), University Microfilms International, 1979

Bampfylde, John, *The Poems of John Bampfylde* (ed. Roger Lonsdale), Oxford, 1988

Baretti, Giuseppe, *A Journey from London to Genoa, through England, Portugal, Spain and France*, 4 vols., London, 1770

—, *A Guide through the Royal Academy*, London, 1781

Barrell, John, *The Political Theory of Painting from Reynolds to Hazlitt: 'The Body of the Public'*, New Haven, 1986

— (ed.), *Painting and the Politics of Culture: New Essays on British Art, 1700–1850*, Oxford, 1992

Barry, James, *A Letter to the Dilettanti Society*, London, 1798

—, *The Works of James Barry* (ed. E. Fryer), 2 vols., London, 1809

Bate, Walter Jackson, *From Classic to Romantic: Premises of Taste in Eighteenth Century England*, New York, 1961

Beattie, J., *London Diary 1773* (ed. R. S. Walker), Aberdeen, 1946

Beechey, H. W., 'Memoir' attached to *The Literary Works of Sir Joshua Reynolds*, 2 vols., London, 1835

Bettany, L., *Edward Jerningham and His Friends*, London, 1919

Black, Jeremy and Penny, Nicholas, 'Letters from Reynolds to Lord Grantham', *Burlington Magazine*, 129 (1987): 730–34

Bleackley, R. M., 'The Beautiful Misses Gunning', *Connoisseur*, xii, 1905, 158ff, 227ff; xiii, 1906, 198ff

Blunt, R., *Mrs Montagu, 'Queen of the Blues'*, 2 vols., London, 1925

Bond, W. H. (ed.), *Eighteenth-century Studies in Honor of Donald F. Hyde*, New York, 1970

Boswell, James, *Life of Johnson* (ed. G. Birkbeck Hill and L. F. Powell), 6 vols., Oxford, 1934–50

—, *Boswell's London Journal 1762–63* (ed. Frederick A. Pottle), London, 1950

—, *The Correspondence of James Boswell with Certain Members of the Club* (ed. C. N. Fifer), London, 1976

—, *The Applause of the Jury 1782–1785* (ed. Irma S. Lustig and Frederick A. Pottle), London, 1982

—, *Boswell: The English Experiment 1785–1789* (ed. Irma S. Lustig and Frederick A. Pottle), London and New York, 1986

—, *Boswell: the Great Biographer 1789–1795* (ed. Marlies K. Danziger and Frank Brady), London, 1989

Boulton, W. B., *Sir Joshua Reynolds*, London, 1905

Bowron, Edgar Peters and Rishel, Joseph J., *Art in Rome in the Eighteenth Century*, Philadelphia, 2000

Brewer, John, *The Pleasures of the Imagination: English Culture in the Eighteenth Century*, London, 1997

Brilliant, Richard, *Portraiture*, Cambridge, Mass., 1991

Brosses, Charles de, *Lettres familières écrites d'Italie en 1739 et 1740*, 2 vols., Paris, 1799, 1927

Broun, F. J. P., 'Sir Joshua Reynolds' Collection of Paintings', 2 vols. (unpublished Princeton University Ph. D. thesis, 1987)

Brownell, Morris, *Samuel Johnson's Attitude to the Arts*, Oxford, 1989

—, *The Prime Minister of Taste: a Portrait of Horace Walpole*, New Haven and London, 2001

Burke, Edmund, *The Speeches of the Rt Hon. Edmund Burke*, London, 1816

—, *The Correspondence of Edmund Burke* (ed. Thomas W. Copeland et al.), 10 vols., Cambridge, 1958–78

—, *A Philosophical Enquiry into the Origin of Our Ideas of the Sublime and Beautiful* (ed. James T. Boulton), London, 1958 (1st and 2nd edns 1757, 1759)

Burke, Joseph, *English Art, 1714–1800*, Oxford, 1976

Burnet, Gilbert, *A History of His Own Times*, 2 vols., London, 1723–34

Burney, Dr C., *Memoirs of Doctor Burney* (ed. F. Burney), 3 vols., London, 1832.

—, *Letters, vol. 1, 1751–1784* (ed. A. Ribeiro), Oxford, 1991

Burney, Fanny (Mme d'Arblay), *The Diary and Letters of Madame d'Arblay* (as edited by her niece Charlotte Barrett, with Preface and Notes by Austin Dobson), 6 vols., London, 1904

—, *The Journal and Letters of Fanny Burney* (ed. Joyce Hemlow), 12 vols., London, 1972–82

—, *Early Journals and Letters* (ed. L. E. Troide), 2 vols., Oxford, 1988–90

—, *The Early Journals and Letters, Vol. III, the Streatham Years, Part I; 1778–1779* (ed. L. E. Troide and Stewart Cooke), Oxford, 1994

Butler, M., *Romantics, Rebels and Reactionaries*, London, 1981

Butlin, Martin, 'An Eighteenth-century Art Scandal: Nathaniel Hone's "The Conjuror"', *Connoisseur*, clxxiv, 1970

Buttery, Horace A., 'Reynolds's Painting Technique', in Hudson, D., *Sir Joshua Reynolds: a Personal Study*, London, 1958

Byng, Hon. John, *The Torrington Diaries Containing the Tours through England and Wales of the Hon. John Byng (Later Fifth Viscount Torrington) between the Years 1781 and 1794* (ed. C. B. Andrews), 4 vols., London, 1938

Casanova, J. de S., *Memoirs* (trans. A. Machen), 6 vols., London, 1894 (repr. New York, 1958–60)

Church, A. H., *The Chemistry of Paints and Painting*, London, 1890

Clark, Anthony M., *Pompeo Batoni: a Complete Catalogue of His Works with an Introductory Text*, Oxford, 1985

Clifford, James L., *Dictionary Johnson: Samuel Johnson's Middle Years*, New York, 1979

—, 'Johnson and the Society of Artists', in *The Augustan Milieu* (ed. Henry Knight Miller), Oxford, 1970

Clifford, Timothy, Griffiths, Anthony and Royalton-Kisch, Martin, *Gainsborough and Reynolds in the British Museum*, London, 1978

Collé, Charles, *Journal et mémoires* (ed. H. Bonhomme), 3 vols., Paris, 1868

Collison-Morley, Lacy, *Giuseppe Baretti, with an Account of His Literary Friendships and Feuds in Italy and in England in the Days of Dr Johnson*, London, 1909

Constable, W. G., *Richard Wilson*, London, 1953

Cormack, Malcolm, 'The Ledgers of Sir Joshua Reynolds', *Walpole Society*, xlii (1968–70)

Cotton, William, *Sir Joshua Reynolds and His Works. Gleanings from His Diary, Unpublished Manuscripts, and from Other Sources* (ed. J. Burnet), London and Plymouth, 1856

—, *Some Account of the Ancient Borough Town of Plympton . . . with Memoirs of the Reynolds Family*, London, 1858

—, *Sir Joshua Reynolds's Notes and Observations on Pictures . . . also, the Rev. W. Mason's Observations of Sir Joshua's Method of Colouring . . .*, London, 1859

Courtenay, John, *Poetical Review of the Literary and Moral Character of Dr Samuel Johnson*, London, 1786

Croker, John Wilson, *The Croker Papers*, 2nd edn, 3 vols., London, 1885

Cross, W. L., *The Life and Times of Laurence Sterne*, 3rd edn, New Haven, 1929

Crow, Thomas E., *Painters and Public Life in Eighteenth-century Paris*, New Haven and London, 1985

Crown, P., 'Portraits and Fancy Pictures by Gainsborough and Reynolds: Contrasting Images of Childhood', *British Journal for Eighteenth-century Studies*, vii, Autumn 1984

Cumberland, R., *Memoirs*, London, 1806

Cunningham, Allan, *The Lives of the Most Eminent British Painters*, London, 1829–33

—, *The Life of Sir David Wilkie*, 3 vols., London, 1843

Cust, Lionel, *History of the Society of Dilettanti* (ed. Sidney Colvin), London, 1898

Davies, M., *The British School*, National Gallery, London, 1946; 2nd revised edn, London, 1959

Dillenberger, John, *Benjamin West: the Context of His Life's Work*, San Antonio, 1977

Dodsley, R., *Correspondence 1733–64* (ed. J. E. Tierney), Cambridge, 1988

Doerner, M., *The Materials of the Artist*, New York, 1949

Douglas, S., *The Diaries of Sylvester Douglas, Lord Glenbervie* (ed. F. Bickley), 2 vols., London, Boston and New York, 1928

Dunthorne, Hugh, 'British Travellers in Eighteenth-century Holland: Tourism and the Appreciation of Dutch Culture', *British Journal for Eighteenth-century Studies*, 5, 1982

Eastlake, Charles L., *Methods and Materials of Painting*, 2 vols., London, 1847

—, *Materials for a History of Oil Painting*, 2 vols., London, 1869

Eaves, Morris, *The Counter-arts Conspiracy: Art and Industry in the Age of Blake*, Ithaca and London, 1992

Edgcumbe, J., 'Reynolds's Earliest Drawings', *Burlington Magazine*, cxxix, November 1987

Edwards, E., *Anecdotes of Painters*, London, 1808

Etlin, Richard A. (ed.), *Nationalism in the Visual Arts*, National Gallery of Art, Washington, distributed by the University Press of New England, Hanover and London, 1991

Farington, Joseph, *Memoirs of the Life of Sir Joshua Reynolds*, London, 1819

—, *Diaries* (ed. K. Garlick, A. Macintyre and K. Cave), 16 vols., London and New Haven, 1978–84

Feiling, C. A., *Warren Hastings*, London, 1954

Felton, Samuel, *Testimonies to the Genius and Memory of Sir J. Reynolds*, London, 1792

Fitzgerald, B. (ed.), *Correspondence of Emily, Duchess of Leinster*, 3 vols., Dublin, 1949–53

Fleming, J., *Robert Adam and His Circle in Edinburgh and Rome*, London, 1962

Fletcher, E. (ed.), *Conversations of James Northcote R.A. with James Ward on Art and Artists*, London, 1901

Forbes, Margaret, *Beattie and His Friends*, Constable, 1904

Forbes, Sir William, *An Account of the Life and Writings of James Beattie, LL.D.*, 2 vols., London, 1824

Ford, B., 'Sir Watkin Williams-Wynn, a Welsh Maecenas', *Apollo*, June 1974

Fortescue, Sir John (ed.), *The Correspondence of King George the Third from 1760 to December 1783*, 6 vols., London, 1927

Fothergill, B., *The Strawberry Hill Set*, London, 1983

Frankau, J., *John Raphael Smith, His Life and Works*, London, 1902

Friedman, W. H., *Boydell's Shakespeare Gallery* (thesis presented at Harvard University, 1974), New York, 1976

Frith, W. P., *My Autobiography and Reminiscences*, 3 vols., London, 1889

Fuseli, Henry, *The Life and Writings of Henry Fuseli* (ed. John Knowles), 3 vols., London, 1831

—, *Collected Letters* (ed. D. H. Weinglass), New York, 1982

Galt, John, *The Life, Studies, and Works of Benjamin West*, 2 vols., London, 1820

Gamelin, H., *George Romney and His Art*, London, 1894

Garrick, David, *The Private Correspondence of David Garrick with the Most Celebrated Persons of His Time* (ed. James Boaden) 2 vols., London, 1835

George, M. D., *English Political Caricature*, 2 vols., London, 1959

Gerard, Frances, 'Angelica Kauffmann and Joshua Reynolds', *Art Journal* (1897): 82

Gettens, R. J. and Stout, G. L., *Painting Materials: a Short Encyclopaedia*, New York, 1966

Gibbon, Edward, *Miscellaneous Works*, 3 vols., London, 1796–1815

—, *The Autobiography . . . as Originally Edited by Lord Sheffield*, London, 1901

—, *The Letters of Edward Gibbon* (ed. J. E. Norton), 3 vols., London, 1956

Gibson-Wood, Carol J., 'Jonathan Richardson and the Rationalization of Connoisseurship', *Art History*, vii, 1984

Gilchrist, Alexander, *Life of William Blake, 'Pictor Ignotus'*, London, 1863

Ginger, John, *The Notable Man: the Life and Times of Oliver Goldsmith*, London, 1977

Girouard, Mark, 'English Art and the Rococo', *Country Life*, 13 January 1966

Godfrey, F. M., *Child Portraiture from Bellini to Cézanne*, London, 1956

Goldsmith, Oliver, *The Collected Letters of Oliver Goldsmith* (ed. Katharine C. Balderston), London, 1928

Gombrich, E. H., 'Reynolds's Theory and Practice of Imitation', *Burlington Magazine*, lxxx, February 1942

Goodwin, G., *James McArdell*, London, 1903

Gordon, Archie, *A Wild Flight of Gordons; Odd and Able Members of the Gordon Families*, London, 1985

Graves, A. and Cronin, W. V., *A History of the Works of Sir Joshua Reynolds*, 4 vols., London, 1899–1901

Gray, T., *The Letters of Thomas Gray* (ed. D. Tovey), 3 vols., London, 1904

Greer, Germaine, *The Obstacle Race: The Fortunes of Women Painters and Their Work*, New York, 1979

Greig, J. (ed.), *The Diaries of a Duchess: Extracts from the Diaries of the First Duchess of Northumberland*, London, 1926

Gross, Hanns, *Rome in the Age of the Enlightenment*, Cambridge, 1999

Gwynn, Stephen, *Memorials of an Eighteenth-century Painter (James Northcote)*, London, 1898

Hamilton, E., *The English School*, 4 vols., London, 1831

Harcourt-Smith, C., *The Society of Dilettanti: Its Regalia and Pictures*, London, 1932

Hardy, Francis, *Memoirs of the Political and Private Life of James Caulfeild, Earl of Charlemont*, 2nd edn, 2 vols., 1812

Harley, R. D., *Artists' Pigments c. 1600–1835: a Study in English Documentary Sources*, London, 1970

Harris, John, *Sir William Chambers, Knight of the Polar Star*, University Park and London, 1970

Hartcup, Adeline, *Angelica*, London, 1954

Haskell, F. and Penny, N., *Taste and the Antique*, New Haven and London, 1981

Haslewood, J., *The Secret History of the Green Rooms*, 2 vols., London, 1790

Haydon, B. R., *Autobiography and Memoirs* (ed. A. P. D. Penrose), London, 1927

—, *The Autobiography and Journals of Benjamin Robert Haydon (1786–1846)* (ed. Malcolm Elwin), London, 1950

—, *The Diary of Benjamin Robert Haydon* (ed. W. B. Pope), 5 vols., Cambridge, Mass., 1960–63

Hayes, John, *The Landscape Paintings of Thomas Gainsborough; a Critical Text and Catalogue Raisonné*, 2 vols., London, 1982

—, *The Portrait in British Art*, London, 1991

— (ed.), *The Letters of Thomas Gainsborough*, London, 2001

Hazlitt, William, *Conversations of James Northcote, Esq., R.A.*, London, 1830

—, *Essays on the Fine Arts*, London, 1873

—, *Collected Works* (ed. A. R. Waller and Arnold Glover), 12 vols., London, 1903

—, *Complete Works* (ed. P. P. Howe), 21 vols., London and Toronto, 1930–34

Hibbert, C., *George IV Prince of Wales*, London, 1972

Hickey, W., *Memoirs* (ed. A. Spencer), 4 vols., London, 1913–25

Highfill, Philip, Jr, Burnim, Kalman A. and Langhans, Edward (eds.), *A Biographical*

Dictionary of Actors, Actresses, Musicians, Dancers, Managers and Other Stage Personnel in London, 1660–1800, 16 vols., Carbondale, Ill., 1972–93

Higonnet, Anne, *Pictures of Innocence: the History and Crisis of Ideal Childhood*, London, 1998

Hill, D., *Mr Gillray, the Caricaturist. A Biography*, London, 1965

Hill, G. B. (ed.), *Johnsonian Miscellanies*, 2 vols., London, 1897

Hilles, F. W., *Letters of Sir Joshua Reynolds*, Cambridge, 1929

—, *The Literary Career of Sir Joshua Reynolds*, New York and Cambridge, 1936 (repr. 1967)

—, *Portraits by Sir Joshua Reynolds*, New York, Toronto and London, 1952

—, 'Horace Walpole and the Knight of the Brush', in *Horace Walpole: Writer, Politician, and Connoisseur* (ed. Warren Hunting Smith), New Haven and London, 1967

—, 'Sir Joshua at the Hôtel de Thiers', *Gazette des Beaux-Arts*, October–December 1969

—, 'Sir Joshua and the Empress Catherine', in *Eighteenth-century Studies in Honor of Donald F. Hyde* (ed. W. H. Bond), New York, 1970

Hine, James, *Sir Joshua Reynolds of Plympton*, Plymouth, 1887

Hipple, Walter John, *The Beautiful, the Sublime, and the Picturesque in Eighteenth-century British Aesthetic Theory*, Carbondale, Ill., 1957

Hoskins, W. G., *Devon*, London, 1954

Hudson, Derek, *Sir Joshua Reynolds: a Personal Study*, London, 1958

Hutchison, S. C., *The History of the Royal Academy*, London, 1968

Hyde, Edward, First Earl of Clarendon, *The True Historical Narrative of the Rebellion and Civil Wars in England*, 3 vols., Oxford, 1702–4; 6 vols. (ed. W. D. Macray), Oxford, 1888

Hyde, Ralph, *The A to Z of Georgian London*, London, 1982

'I.N.', *A Critical Review of the Pictures, Sculptures, Designs in Architecture, Drawings, Prints, etc. Exhibited at the Great-Room in Spring Gardens* [London], 1765

Ingamells, John, *A Dictionary of British and Irish Travellers in Italy 1701–1800*, New Haven and London, 1997

Irons, Ernest E., MD, 'The Last Illness of Sir Joshua Reynolds', in *Bulletin of the Society of Medical History of Chicago*, v, 2, May 1939

Jameson, A., *Companion to the Most Celebrated Private Galleries of Art in London*, London, 1844

Jarrett, D., *England in the Age of Hogarth*, London, 1974

Jesse, J. H., *George Selwyn and His Contemporaries, with Memoirs and Notes*, 4 vols., London, 1843–4

Johnson, E. M., *Francis Cotes*, London, 1976

Johnson, Reverend Samuel, *Sir Joshua's Nephew, Being Letters Written 1769–1778, by a Young Man to His Sisters* (ed. S. M. Radcliffe), London, 1930

Johnson, Samuel, *The Yale Edition of the Works of Samuel Johnson* (ed. E. L. McAdam Jr with Donald and Mary Hyde), 13 vols., New Haven, 1958–90

—, *The Letters of Samuel Johnson* (ed. Bruce Redford), 5 vols., Oxford, 1992–4

Jones, Robert W., *Gender and the Formation of Taste in Eighteenth-century Britain: the Analysis of Beauty*, Cambridge, 1998

Joppien, R., 'Philippe Jacques de Loutherbourg's Pantomime "Omai, or a Trip round the World" and the Artists of Captain Cook's Voyages', *British Museum Yearbook*, 1979

Keay, John, *The Honourable Company: a History of the English East India Company*, London, 1991

Kelly, Linda, *Richard Brinsley Sheridan: a Life*, London, 1997

Kenwood (Iveagh Bequest), *Exhibition of Paintings by Angelica Kauffmann* (by Anne Crookshank), 1955

—, *Pompeo Batoni and His British Patrons* (by E. P. Bowron, Anne French et al.), 1982

Keppel, Thomas, *The Life of Augustus Viscount Keppel*, 2 vols., London, 1842

Kerr, S. P., *George Selwyn and the Wits*, London, 1909

Kirby, Paul Franklin, *The Grand Tour in Italy (1700–1800)*, New York, 1952

Knight, Cornelia, *Autobiography* (ed. J. W. Kaye), 2 vols., London, 1861

—, *The Autobiography of Miss Knight* (ed. Roger Fulford), London, 1960

Knight, R. P., anonymous review of 'The Works of James Barry', *Edinburgh Review*, XVI, 1810

Langford, Paul, *A Polite and Commercial People*, Oxford, 1989

Lansdown, H. V., *Recollections of the Late William Beckford of Fonthill, Wilts., and Lansdown, Bath*, Bath, 1893

Lee, R., *Names on Trees: Ariosto into Art*, Princeton, 1977

Leslie, Anita, *Mrs Fitzherbert*, London, 1960

Leslie, C. R. and Taylor, T., *Life and Times of Sir Joshua Reynolds with Notices of Some of His Contemporaries*, 2 vols., London, 1865

Levey, Michael, *The Painter Depicted: Painters as a Subject in Painting*, London, 1981

Lewis, Lesley, *Connoisseurs and Secret Agents in Eighteenth Century Rome*, London, 1961

Lindsay, Jack, *Thomas Gainsborough: His Life and Art*, London, 1981

Lipking, Lawrence, *The Ordering of the Arts in Eighteenth-century England*, Princeton, NJ, 1970

Lippincott, L., *Selling Art in Georgian London: the Rise of Arthur Pond*, New Haven and London, 1983

Little, D. M. and Kahrl, G. M., *The Letters of David Garrick*, 3 vols., Oxford, 1963

Lloyd, Christopher, *Gainsborough and Reynolds: Contrasts in Royal Patronage*, (exhibition catalogue), London, 1994

Lobban, J. H. and Hayward, A. (eds.), *Dr. Johnson's Mrs. Thrale*, Edinburgh and London, 1910

Luke, H., 'Omai: England's First Polynesian Visitor', *The Geographical Magazine*, April 1950

Macaulay, Thomas Babington, *The History of England from the Accession of James I* (edited by his sister, Lady Trevelyan), 5 vols., London, 1861

Mack, Maynard, *Alexander Pope, a Life*, New Haven and London, 1985

Magnus, P., *Edmund Burke*, London, 1931

Mairobert, Pidansat de, 'Lettres sur l'Académie Royale de Sculpture et de Peinture et sur le salon de 1777', reprinted in *Revue Universelle des Arts*, xix, 1864

Mandowsky, E., 'Reynolds's Conception of Truth', *Burlington Magazine*, December 1940

Manners, Lady V. and Williamson, G. C., *Angelica Kauffmann R.A.*, London, 1924

Mannings, David, 'Reynolds and the Restoration Portrait', *Connoisseur*, clxxxiii, July 1973

—, 'The Sources and Development of Reynolds's Pre-Italian Style', *Burlington Magazine*, cxvii, April 1975

—, 'A Well-mannered Portrait by Highmore', *Connoisseur*, clxxxix, June 1975

—, 'Two More Pre-Italian Portraits by Reynolds', *Burlington Magazine*, cxviii, August 1976

—, 'Reynolds's Portraits of the Stanley Family', *Connoisseur*, cxciv, February 1977

—, 'Notes on Some Eighteenth-century Portrait Prices in Britain', *Eighteenth-century Studies*, vi, 1983

—, 'Reynolds, Garrick and the Choice of Hercules', *Eighteenth-century Studies*, spring 1984

—, 'Reynolds, Hogarth and Van Dyck', *Burlington Magazine*, cxxvi, November 1984

—, *Sir Joshua Reynolds PRA (1723–1792): the Self Portraits*, Plymouth, 1992

—, *Sir Joshua Reynolds: a Complete Catalogue of his Paintings. The Subject Pictures Catalogued by Martin Postle*, 2 vols., New Haven and London, 2000

Manvell, Roger, *Sarah Siddons: Portrait of an Actress*, New York, 1971

Mayoux, Jean-Jacques, *La Peinture Anglaise: de Hogarth aux pré-Raphaelites*, Geneva, 1988

McCreery, Cindy, 'Keeping up with the Bon Ton: the Tête-à-Tête series in the Town and Country Magazine', in *Gender in Eighteenth-century England: Roles, Representations and Responsibilities* (ed. Hannah Barker and Elaine Chalus), London, 1997

McKendrick, Neil, Brewer, John and Plumb, J. H., *The Birth of a Consumer Society: the Commercialization of Eighteenth-century England*, London, 1982

Mikhail, E. H. (ed.), *Goldsmith: Interviews and Recollections*, London, 1993

Miles, Ellen G. (ed.), *The Portrait in Eighteenth-century America*, Newark, Del., 1993

Miles, Ellen G. and Simon, Jacob, *Thomas Hudson 1701–1779, Portrait Painter and Collector*, London, 1979 (catalogue of a bicentenary exhibition at The Iveagh Bequest, Kenwood)

Miller, Mrs Anne, *Letters from Italy . . . in the Years MDCCLXX and MDCCLXXI by an English Woman*, 3 vols., London, 1776

Mitchell, C., 'Three Phases of Reynolds's Method', *Burlington Magazine*, lxxx, February 1942

Molloy, Fitzgerald, *Sir Joshua and His Circle*, 2 vols., London, 1906

Monod, Paul, 'Painters and Party Politics in England, 1714–1760', *Eighteenth-Century Studies*, xxvi (1992–3)

Moore, R. E., 'Reynolds and the Art of Characterization', in *Studies in Criticism and Aesthetics 1660–1800* (ed. H. P. Anderson and J. S. Shea), Minneapolis, 1967

Moore, Thomas, *Memoirs of the Life of the Right Honourable Richard Brinsley Sheridan*, 2 vols., London, 1825

Morison, Samuel Eliot, *John Paul Jones; a Sailor's Biography*, London, 1960

Moritz, C. P., *Travels of Carl Philipp Moritz in England in 1782*, London, 1795 (repr. with an introduction by P. E. Matheson, London, 1924)

Morris, Desmond, Collett, Peter, Marsh, Peter and O'Shaughnessy, Marie, *Gestures, Their Origins and Distribution*, London, 1979

Moser, Joseph, 'Vestiges, Collected and Recollected, by Joseph Moser, Esq', *The European Magazine*, 13, July–December 1803

Mount, Charles Merrill, *Gilbert Stuart: a Biography*, New York, 1964

Mount, Harry (ed.), *Sir Joshua Reynolds: a Journey to Flanders and Holland*, Cambridge, 1996

Munby, A. N. L., 'Letters of British Artists', Prt 1, *Connoisseur*, cxix, September 1946

—, 'Nathaniel Hone's Conjuror', *Connoisseur*, cxx, December 1947

Murphy, Arthur, *The Life of David Garrick*, 2 vols., London, 1801

Murray, P., 'The Source of Reynolds's "Triumph of Truth"', *Aberdeen University Review*, xxx, 3, 1944

Musser, J. F., 'Sir Joshua Reynolds's Mrs Abington as "Miss Prue"', *The South Atlantic Quarterly*, Spring 1984

Namier, Lewis, *The Structure of Politics at the Accession of George III*, 2nd edn, London, 1961

— and Brooke, J., *The House of Commons, 1754–1790*, 3 vols., London, 1964

National Portrait Gallery, *Sir Godfrey Kneller* (by J. D. Stewart), 1971

—, *Johann Zoffany* (by M. Webster), 1976

Northcote, James, *The Life of Sir Joshua Reynolds*, 2 vols., 2nd edn, London, 1819

O'Brien, Conor Cruise, *The Great Melody: A Thematic Biography and Commented Anthology of Edmund Burke*, Chicago, 1992

O'Connor, Cynthia, 'The Parody of the School of Athens', *Bulletin of the Irish Georgian Society*, xxvi, 1983

—, *The Pleasing Hours: James Caulfeild, First Earl of Charlemont 1728–99, Traveller, Connoisseur and Patron of the Arts in Ireland*, Cork, 1999

Oliver, J. W., *William Beckford*, London, 1932

O'Toole, Fintan, *A Traitor's Kiss: the Life of Richard Brinsley Sheridan*, London, 1997

Owen, Felicity and Brown, David Blayney, *Collector of Genius: a Life of Sir George Beaumont*, New Haven and London, 1988

Paine, James, *Plans, Elevations, and Sections of Noblemen and Gentlemen's Houses*, 2 vols., 2nd edn, London, 1783

Palmer, Mary, *A Devonshire Dialogue* (ed. Mrs Gwatkin), London, 1839

Papendiek, Mrs, *Court and Private Life in the Time of Queen Charlotte: Being the Journal of Mrs Papendiek, Assistant Keeper of the Wardrobe and Reader to Her Majesty* (ed. Mrs V. Delves Broughton), 2 vols., London, 1887

Parr, Samuel, *The Works of Samuel Parr, LL.D.* (ed. J. Johnstone), 8 vols., London, 1828

Pasquin, A. [John Williams], *The Royal Academicians*, London, 1786

—, *An Authentic History of the Professors of Painting, Sculpture and Architecture, who Have Practiced in Ireland; Involving Original Letters from Sir Joshua Reynolds, which Prove Him to Have Been Illiterate. To which Are Added, Memoirs of the Royal Academicians . . .* London, 1796

Pastor, Ludwig von, *The History of the Popes from the Close of the Middle Ages: Drawn from the Secret Archives of the Vatican and Other Original Sources, from the German of Dr. Ludwig Pastor*, 6th edn, 40 vols., London and St Louis, 1938–53

Pears, Iain, *The Discovery of Painting: the Growth of Interest in the Arts in England, 1680–1768*, New Haven and London, 1988

Penny, Nicholas, 'Reynolds and Picture Frames', *Burlington Magazine*, cxxviii (1986): 812

— (ed.), *Reynolds*, London, 1986 (catalogue of the Royal Academy's 1986 Reynolds Exhibition)

Pevsner, N., *South Devon*, Harmondsworth, 1952

—, *The Englishness of English Art*, London, 1956

Philips, C., *Sir Joshua Reynolds*, London, 1894

Phillips, Hugh, *Mid-Georgian London*, London, 1964

Piles, Roger de, *The Principles of Painting*, translated by a painter, London, 1743

Piozzi, H. L. (formerly Thrale), *Anecdotes of the Late Samuel Johnson*, London, 1786

—, *Autobiography, Letters and Literary Remains* (ed. with an introductory account of her life and writings, by A. Hayward), 2 vols., 2nd edn, London, 1861

—, *Thraliana: the Diary of Mrs. Hester Lynch Thrale (Later Mrs. Piozzi). 1776–1809* (ed. Katharine C. Balderston), 2 vols., Oxford, 1942

Pointon, M., 'Portrait-painting as a Business Enterprise in London in the 1780s', *Art History*, June 1984

—, *Hanging the Head: Portraiture and Social Formation in Eighteenth-century England*, New Haven and London, 1993

Postle, Martin, *Sir Joshua Reynolds: the Subject Pictures*, Cambridge, 1995

—, 'An Early Unpublished Letter by Sir Joshua Reynolds', *Apollo*, cxli (June 1995): 17

Potterton, H., *Reynolds and Gainsborough* (Themes and Painters in the National Gallery), London, n.d. [1976]

—, 'Reynolds's Portrait of Captain Robert Orme in the National Gallery', *Burlington Magazine*, cxviii, 1976

Pressly, William L., *The Life and Art of James Barry*, New Haven and London, 1981

Prior, Sir James, *Memoir of the Life and Character of Edmund Burke*, 2 vols., 2nd edn, London, 1826

—, *Life of Edmond Malone, Editor of Shakespeare*, London, 1860

Prochno, Renate, 'Nationalism in English Eighteenth-century Painting: Sir Joshua Reynolds and Benjamin West', in *Nationalism in the Visual Arts* (ed. Richard A. Etlin), Hanover and London, 1991

Pyne, William Henry ('Ephraim Hardcastle'), *Wine and Walnuts, or After-dinner Chit-Chat*, 2 vols., London, 1823

Raimbach, M. T. S., *Memoirs and Recollections of Abraham Raimbach*, London, 1843

Rather, Susan, 'Stuart and Reynolds: a Portrait of Challenge', *Eighteenth-century Studies*, xxvii, 1993–4

Reynolds, Sir Joshua, *The Works of Sir Joshua Reynolds, Knight ... to Which is Prefixed an Account of the Life and Writings of the Author by Edmond Malone*, 5th edn with an additional memoir by Joseph Farington, 3 vols., London, 1819 (Memoir also published separately)

—, *Discourses Delivered to the Students of the Royal Academy by Sir Joshua Reynolds, Kt*, with Introductions and Notes by Roger Fry, London, 1905

—, *The Letters* (ed. F. W. Hilles), Cambridge, 1929

—, *Discourses on Art* (ed. Robert R. Wark), New Haven and London, 1959 (later editions 1975, 1997)

—, *The Letters of Sir Joshua Reynolds* (ed. John Ingamells and John Edgcumbe), London, 2000

Ribeiro, Alvaro, *The Dress Worn at Masquerades in England 1730–1790, and Its Relation to Fancy Dress in Portraiture*, New York, 1984

Richardson, Jonathan, the Elder, *An Essay on the Theory of Painting*, London, 1715

—, *Two Discourses*, London, 1719

Ricraft, Josiah, *A Survey of England's Champions and Truths, Faithfull Patriots, or a Chronologicall Recitement of the Principall Proceedings of the Most Worthy Commanders of the Prosperous Armies Raised for the Preservation of Religion, the Kings Majesteys Person*, London, 1647

Riely, J. C., *Henry William Bunbury*, Sudbury, 1983

Roberts, K., *Reynolds*, London, 1966

Roberts, W., *Memoirs of the Life and Correspondence of Mrs Hannah More*, 4 vols., 2nd edn, London, 1834

Roche, S. von La, *Sophie in London 1786; Being the Diary of Sophie von La Roche* (trans. and ed. C. Williams), London, 1933

Roe, A. S., 'The Demon behind the Pillow: a Note on Erasmus Darwin and Reynolds', *Burlington Magazine*, cxiii, August 1971

Rogers, S., *Recollections of the Table-talk of Samuel Rogers* (ed. A. Dyce), London, 1856

—, *Reminiscences and Table-talk of Samuel Rogers: Banker, Poet, and Patron of the Arts, 1763–1855* (ed. G. H. Powell), London, 1903

Roscoe, E. S. and Clergue, H., *George Selwyn, His Letters and His Life*, London, 1899

Rosenblum, R., *Transformations in Late 18th-century Art*, Princeton, 1967

—, 'The Dawn of British Romantic Painting, 1760–1780', in *The Varied Pattern:*

Studies in the 18th Century (ed. Peter Hughes and David Williams), Toronto, 1971

Rosenthal, Michael, *The Art of Thomas Gainsborough*, London and New Haven, 1999

Rouquet, A., *The Present State of the Arts in England*, London, 1755

Rowe, J. Brooking, *A History of the Borough of Plympton Erle*, Exeter, 1906

Roworth, Wendy Wassyng (ed.), *Angelica Kauffmann: a Continental Artist in Georgian England*, London, 1992

Royalton-Kisch, Martin, 'Reynolds as a Collector', in *Gainsborough and Reynolds in the British Museum* (exhibition catalogue), London, 1978

Ruggles, M., 'A Reynolds Revived', *Bulletin: National Gallery of Canada, Ottawa*, xvii, 1971

Sandby, William, *The History of the Royal Academy of Arts from Its Foundation in 1768 to the Present Time*, 2 vols., London, 1862

Saxl, F. and Wittkower, R., *British Art and the Mediterranean*, London, 1948

Schama, Simon, *Rembrandt's Eyes*, London, 1999

Shawe-Taylor, Desmond, *The Georgians: Eighteenth-century Portraiture and Society*, London, 1990

Shee, M. A., *The Life of Sir Martin Archer Shee*, 2 vols., London, 1860

Sheppard, F. H. W. (ed.), *The Parish of St James, Westminster, South of Piccadilly*, 2 vols. (xxix and xxx of *The Survey of London*), London, 1960

Sherbo, A., *Memoirs and Anecdotes of Dr Johnson*, London, 1974

Sheridan, Betsy, *Betsy Sheridan's Journal. Letters from Sheridan's Sister, 1784–86 and 1788–90* (ed. William Le Fanu), London, 1960

Siddons, Sarah, *The Reminiscences of Mrs Sarah Siddons, 1773–1785* (ed. W. van Lennep), Cambridge, Mass., 1942

Simon, Robin, *The Portrait in Britain and America*, Oxford, 1987

Sloman, Susan, 'Mrs Margaret Gainsborough, "A Prince's Daughter"', *Gainsborough's House Review*, 1995–6

Smart, Alastair, *The Life and Art of Allan Ramsay*, London, 1952

—, *Allan Ramsay, Painter, Essayist, and Man of the Enlightenment*, New Haven and London, 1992

Smith, John Thomas, *Vagabondia*, London, 1817

—, *Nollekens and His Times Comprehending a Life of That Celebrated Sculptor; and Memoirs of Several Contemporary Artists, from the Time of Roubiliac, Hogarth and Reynolds, to That of Fuseli, Flaxman, and Blake*, 2 vols., London, 1828

—, *A Book for a Rainy Day*, London, 1845

Smith, Warren Hunting (ed.), *Horace Walpole, Writer, Politician, and Connoisseur*, New Haven and London, 1967

Solkin, D., 'Great Pictures or Great Men? Reynolds, Male Portraiture, and the Power of Art', *Oxford Art Journal*, 9:2, 1986

—, *Painting for Money: the Visual Arts and the Public Sphere in Eighteenth-century England*, New Haven and London, 1992

— (ed.), *Art on the Line. The Royal Academy Exhibitions at Somerset House 1780–1836*, New Haven and London, 2001

Spence, J., *Polymetis*, London, 1747

Steegman, John, *Sir Joshua Reynolds*, London, 1933

—, 'Portraits of Reynolds', *Burlington Magazine*, lxxx, February 1942

Stephens, F. G., *English Children as Painted by Sir Joshua Reynolds: an Essay on Some of the Characteristics of Reynolds as a Designer, with Special Reference to His Portraiture of Children*, London, 1867

Stirling, G., 'Sir Joshua Reynolds at Richmond', *Country Life*, 25 October 1950

Strange, R., *An Inquiry into the Rise and Establishment of the Royal Academy of Arts*, London, 1775

Stuart, Lady L., *Notes on George Selwyn and His Contemporaries by John Heneage Jesse* (ed. W. S. Lewis), New York, 1928

Stuffmann, Margret, 'Les Tableaux de la Collection de Pierre Crozat', *Gazette des Beaux-Arts*, July–September 1968

Sutton, D., 'The Roman Caricatures of Reynolds', *Country Life Annual*, 1956

—, *France in the Eighteenth Century* (exhibition catalogue, Royal Academy of Arts Winter Exhibition), London, 1968

— (ed.), *An Italian Sketchbook by Richard Wilson, R.A.*, 2 vols., London, 1968

Talley, M. K., *Portrait Painting in England: Studies in the Technical Literature before 1700*, London, 1981

Tatham, Frederick, MS 'Life of Blake' (first printed with *The Letters of William Blake*, ed. A. G. B. Russell, London, 1906)

Thompson, E. M. S., 'The *Discourses* of Sir Joshua Reynolds', *Proceedings of the Modern Language Association*, xxxii, 1917

[Thompson, William], *The Conduct of the Royal Academicians*, London, 1771

Tillotson, A. (ed.), *The Percy Letters: the Correspondence of Thomas Percy and Edmond Malone*, Baton Rouge, La., 1944

Tinker, C. B., *Painter and Poet*, Cambridge, Mass., 1938

Trevelyan, G. O., *The Early History of Charles James Fox*, London, 1880

Trevelyan, R., *Wallington, Northumberland*, The National Trust, 1994

Tronchin, Henri, *Le Conseiller François Tronchin et ses amis Voltaire, Diderot et Grimm etc.*, Paris, 1895

Turberville, A. S. (ed.), *Johnson's England*, 2 vols., Oxford, 1952

Turner, Jane (ed.), *The Dictionary of Art*, 34 vols., London, 1996

Twiss, H., *The Life of Lord Chancellor Eldon*, 2 vols., London, 1844

Vasari, Giorgio, *Lives of the Most Eminent Painters, Sculptors and Architects*, trans. Mrs Jonathan Foster, 5 vols., London 1878–81

Vertue, George, 'The Note-books', *Walpole Society*, xxx (1934)

Wagner, E., 'The Pornographer in the Courtroom', in *Sexuality in Eighteenth-century Britain* (ed. P. G. Boucé), Manchester, 1982

Walch, P. S., *Angelica Kauffmann* (Princeton Ph. D. thesis of 1968), University Microfilms International, 1980

Walford, Edward, *Old and New London*, 4 vols., London, 1897

Walkley, Giles, *Artists' Houses in London, 1764–1914*, Aldershot, Hants, 1994

Walpole, Horace, *Anecdotes of Painting in England* (ed. Reverend James Dallaway), 5 vols., London, 1828

—, *Memoirs of the Reign of George III* (ed. D. Le Marchant), 4 vols., London, 1845

—, *Correspondence* (ed. W. S. Lewis and others), 48 vols., London and New Haven, 1937–83

—, *Miscellany 1785–1795* (ed. L. E. Troide), New Haven, 1978

Ward, Aileen, ' "Sir Joshua and His Gang": William Blake and the Royal Academy', in *William Blake and His Circle*, San Marino, Ca., 1989

Wark, R. R., *Sir Joshua Reynolds's Portrait of Mrs Siddons as the Tragic Muse*, San Marino, 1965 (repr. as Chapter IV in *Ten British Pictures, 1740–1840*, San Marino, 1971)

Waterhouse, Ellis, *Reynolds*, London, 1941

—, *Painting in Britain 1530–1790*, Harmondsworth, 1953; 4th (revised) edn, 1978

—, *Gainsborough*, London, 1958

—, *Three Decades of British Art* (Jayne Lectures, 1964), Philadelphia, 1965

—, 'Reynolds's Sitter Book for 1755', *Walpole Society*, xli, 1966–8

—, *Reynolds*, London, 1973

—, *The Dictionary of British 18th Century Painters in Oils and Crayons*, Woodbridge, 1981

—, 'Reynolds, Angelica Kauffmann, and Lord Boringdon', *Apollo*, 122 (1985): 270–74

Weinsheimer, J., 'Mrs Siddons, the Tragic Muse, and the Problem of As', *Journal of Aesthetics and Art Criticism*, xxxvi, spring 1978

Wellek, Rene and Ribeiro, Alvaro, *Evidence in Literary Scholarship: Essays in Memory of James Marshall Osborn*, Oxford, 1979

Wendorf, Richard, *The Elements of Life: Biography and Portrait Painting in Stuart and Georgian England*, Oxford, 1990, corrected edn, 1991

—, *Sir Joshua Reynolds: the Painter in Society*, Cambridge, Mass., 1996

— and Ryskamp, Charles, 'A Blue-Stocking Friendship: The Letters of Elizabeth Montagu and Frances Reynolds in the Princeton Collection', *Princeton University Library Chronicle*, 41 (1979–80): 173–207

Whitley, William T., *Thomas Gainsborough*, London, 1915

—, *Artists and Their Friends in England 1700–1799*, 2 vols., London, 1928

Wind, Edgar, *Hume and the Heroic Portrait. Studies in Eighteenth-century Imagery*, Oxford, 1986

Windham, W., *The Diary of the Right Hon. William Windham* (ed. Mrs Henry Baring), London, 1866

Wolcot, John, *The Works of Peter Pindar*, 5 vols., London 1794–1801.

Woodforde, C., *The Stained Glass of New College, Oxford*, London, 1951

Wraxall, N. W., *Historical and Posthumous Memoirs* (ed. H. B. Wheatley), 5 vols., London, 1884

Index

Note: Page references in *italics* indicate illustrations. The following abbreviations are used in the index: ISA for the Incorporated Society of Artists of Great Britain; SJ for Dr Samuel Johnson; JR for Sir Joshua Reynolds; RA for the Royal Academy